Baroque & Rococo

ART & CULTURE

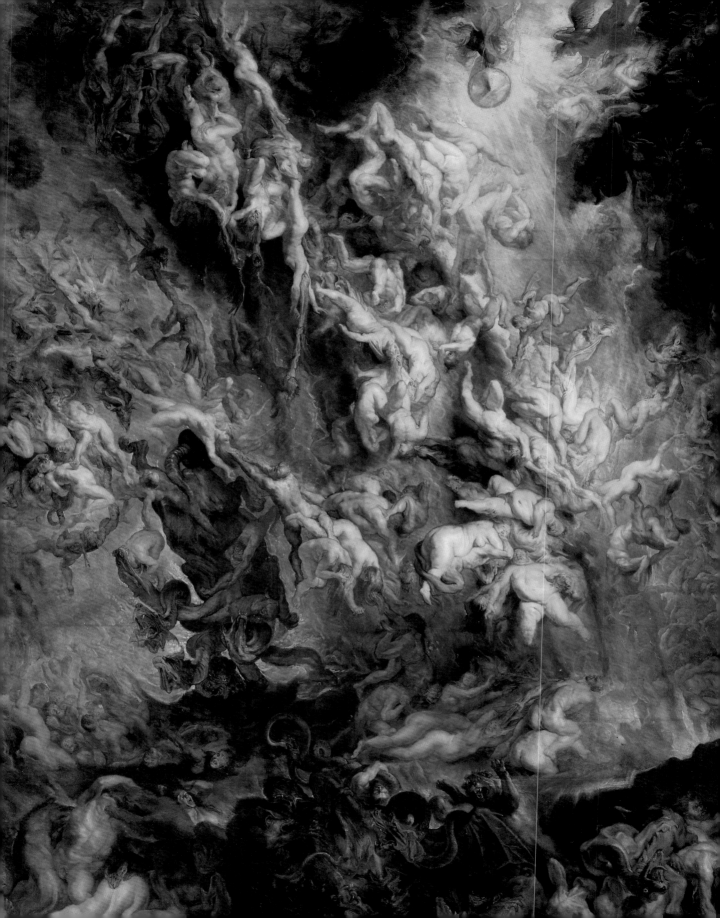

Baroque & Rococo

ART & CULTURE

VERNON HYDE MINOR

 LAURENCE KING

For Sam & Will

Published in 1999 by Laurence King Publishing
an imprint of Calmann & King Ltd
71 Great Russell Street
London WC1B 3BN
Tel: + 44 171 831 6351
Fax: + 44 171 831 8356
email: enquiries@calmann-king.co.uk
www.laurence-king.com

A catalogue record for this book is available from the British Library

ISBN 1 85669 173 X

Designed by Cara Gallardo, Area
Picture research by Susan Bolsom
Printed in China

Frontispiece: PETER PAUL RUBENS, *The Fall of the Damned*, c. 1620. Oil on panel, 9 ft 4½ in x 7 ft 4 in (2.86 x 2.24 m). Alte Pinakothek, Munich.

Contents

PREFACE

Baroque and Rococo. For some years I have been struck by how literary and art historians have been beating a retreat from both these terms, as if they were redolent of an unseemly preoccupation with styles, and highly suspect styles at that. Many scholars feel more comfortable with phrases such as "Early Modern," whose meaning may be no clearer but whose overtones seem more neutral.

So what is so pernicious about "Baroque" and "Rococo," and why has an entire generation passed since the last appearance of a general textbook on the art of the seventeenth and eighteenth centuries? First, because Baroque and Rococo were styles of courtly societies (whether religious or secular) the public of the new millennium, with its fairly consensual beliefs in a pluralist and meritocratic culture, may feel uncomfortable with the bombast and immodesty of these self-aggrandizing civilizations. Inevitably, we are reminded of the arrogant authoritarianism endemic in such centralized, statist governments. We recall all too quickly that the words "Baroque" and "Rococo" are highly implicated in displays of imperial power. Another problem is that we tend to reify the terms, to talk about the Baroque, for instance, as if it were a thing. When one writes of a "Baroque mind" or a "Baroque sensibility" one is using a permissible intellectual shorthand; but we need to remind ourselves that Baroque and Rococo were (and are) terms invented by historians and that they function as handy labels; they should not be seen as somehow living, breathing, historical entities that cross the centuries like phantoms. Perhaps it is feared that such vivid terms as Baroque and Rococo can summon to life a slumbering *Zeitgeist* and set back historical criticism a century or more.

On a basic level, I would argue that there is enough artistic cohesion and distinctiveness to the period to justify devoting a book to it. But more deeply, my intention in *Baroque & Rococo: Art & Culture* has been to brave the currents of the potentially unfashionable and anachronistic while addressing legitimate concerns about the ways in which we art historians have gone about our business. I believe that we should not flinch from artistic manifestations of power (be they of courtly or capitalist societies), but should look upon, analyze, and – another dangerous verb! – appreciate them.

Contextualization is one important facet of the so-called "new art history." For more than a century, major Western museums have been displaying works as artistic strays, images and objects pulled from their original locations and placed on pedestals or mounted on walls. To a certain extent, the same holds true of architecture: photography has allowed us to study buildings as if they were framed, isolated *objets d'art*. To "recontextualize" art means to attempt to see works as they were seen (and where they were seen) by representative viewers at the time of their production. It is foolish to imagine that we can somehow shed our modern identities and re-enter the seventeenth century as typical citizens, worshippers, businessmen, prelates, lords and ladies, intellectuals, workers, and so on; yet the attempt is interesting and worthwhile. We study the past to increase our awareness and consciousness of what it has meant and what it does mean to be human and to be alive. By contextualizing art we can have a rich understanding of the human interest in the use of images to express emotions and ideas, assert authority and presence, concretize beliefs and summon supernatural aid, increase awareness of self and other, reflect, refract, and project one's own identity through the present and into the future.

To my mind, the best general text on the Baroque has been John Rupert Martin's *Baroque* (Harper and Row, 1977). Martin did not erect a historical structure and then prevail upon it to produce his examples; rather, he allowed certain circumstances and ideas to surface. He wrote essays on style, naturalism, passions of the soul, space, time, light, and so on. The result was a singular view of the Baroque, one that is at the same time personal and grounded in history. Donald Posner and Julius Held, two important scholars in Baroque and Rococo studies, produced the widely used textbook, *Seventeenth and Eighteenth-century Art* (Prentice-Hall/Abrams, 1971). They followed the standard practice in traditional art history of dividing the material along geographical and chronological lines. One can read, for instance, chapters on France in the seventeenth century, or Germany and Austria in the seventeenth and eighteenth centuries, or Dutch painting in the seventeenth century. This kind of book has the virtue of providing straightforward forms of organization. But it over-

looks the obvious cosmopolitanism of the period and fails to take into account the ways in which the academies themselves divided up the visual arts. The traditional survey text accepts the nineteenth-century notion that one can best understand art along two basic axes: as it develops ("perfects itself") through time and as it is an expression of "national character."

I have departed from earlier models in several important ways. The present text abandons the simpler forms of chronological and geographical organization (although these are mostly retained within individual chapters) in order to cut into the substance of seventeenth- and eighteenth-century art along different grains and for the purpose of revealing different patterns. The main form of organization is both thematic and idea-oriented. One important theme, or site, is the church. I have described representative examples from the outside in, concentrating on the basic structure and its symbolic significance. Then a survey of the church interior follows, with considerations of altarpieces, ceiling paintings, and funerary monuments. One confronts the central ideological imagery of Catholicism in altarpieces, experiences the mind's road to God on ceilings, and contemplates the church's magisterium in tombs. In addition, I have borrowed a page from the academies of art by concentrating on categories of art, such as portraits and still lifes, landscapes, genres, and views. After these comes a separate chapter on town and country, which enables readers to compare urban planning in Amsterdam and Rome and examine the construction of grand country estates, such as Versailles. Then one turns to different kinds of environments, such as domestic interior spaces (sometimes as mediated through paintings) and gardens.

Several of the over-arching themes of this text have to do with theory. Chapter 1 introduces the terms "Baroque" and "Rococo" as they have been employed by critics, scholars, and teachers of art and art history. Chapter 5 returns the discussion to elements of rhetoric, the deployment of styles in the seventeenth and eighteenth centuries for the purposes of persuasion and pleasure. Then in Chapter 10, the epilogue, I revisit some of the theories actually discussed in the seventeenth and eighteenth centuries.

The movement of the text is centripetal rather than forward and linear. Instead of beginning at the beginning and working toward the end, *Baroque and Rococo* circles the art of two centuries, continually pushing the discussion back toward the center. Nevertheless, we have striven to show consideration to those concerned about chronology. As mentioned before, *within* most chapters the progression is from early Baroque to late Rococo. And Chapter 2 is an important scene-setter, providing country-by-country background information on the politics, wars, religious upheavals and artistic milieux of the seventeenth and eighteenth centuries. Finally, on page 371 readers will find a ten-page illustrated timeline, which places the great artworks of the epoch in the context of broader social, cultural, and political events.

Every teacher of art history has his or her own way of organizing the material. No single approach, or textbook, is "right," because there is no *single* ideal sequence of artists and topics. It is my hope that this text will nonetheless serve the needs of students and teachers alike, that however the art of the Baroque and Rococo is presented in class, reading this text will provide important information and perspectives on a core set of issues and works of art. Above all, it has been my intention to keep works of art at the heart of the book, not to use them as punctuation marks within a narrative of cultural history. I have tried to provide readings of buildings, statues, and paintings that demonstrate the complexity of visual ideas and that respect an art that we see imperfectly (if not darkly) through the glass of the present.

Boulder, Colorado
May 1999

ACKNOWLEDGMENTS

It is always hard to know where to begin. There are those people and institutions who contribute directly to the writing of a book; there are others in the background who are facilitators of another sort. I would not have had much luck in the writing of this book were it not for both kinds of people.

But let me start with those who contributed most directly. My editor at Calmann & King, Damian Thompson, saw me through the greater part of this book. Except for brief meetings in London and New York, Damian and I communicated by letter and by e-mail. With sharp eye and ready wit, he helped me to shape my ideas and clarify my writing. I thank him for his shepherding of the text and absolve him from any of my shortcomings that remain.

In the early stages of the conceptualization and writing of the text, Melanie White was my editor. Largely because of her clear conception of the basic contours of this text and her soothing ways we were able to satisfy the editors at Prentice Hall and Harry N. Abrams of the validity of the project. I have indeed been fortunate to have both Melanie and Damian giving me aid and comfort as well as effective guidance.

Susan Bolsom in her role as picture editor was skillful in commissioning several beautiful new transparencies and tireless in tracking down some of my more obscure sources. And Cara Gallardo at Area managed to create an elegant layout with a subtly Baroque feel – thanks to her, the book feels spacious even though it is densely packed.

My numerous exchanges with Frances Wilson and Lee Ripley Greenfield were always pleasant and helpful. It was Lee, the Editorial Director, who first caught up with me at a College Art Association book exhibition in San Antonio and broached the subject of a book on the Baroque.

My copy editor, Kim Richardson, saved me from infelicities of expression too numerous to mention. Those that remain are, of course, evidence of my own stubbornness. The art historians (see reviewers' list below) who generously agreed to read the text in its earlier stages provided detailed and pertinent comments. I appreciate their help.

I have been especially fortunate in the help that I have received from libraries and librarians. Liesel Nolan, art librarian at the University of Colorado Library, has been solicitous of my needs for books and periodicals for the better part of two decades. Mary Larson has never failed to help me find what I probably should have been able to find on my own, but my resourcefulness could never match hers.

Janice Powell, of the Marquand Library of Art and Architecture, Princeton University, has been unfailingly helpful, friendly, and encouraging. She provided a "carrel with a view" and saw to it that I had full access to one of the finest art libraries in the world. Her assistance to me, above and beyond what one could ever reasonably expect, fills me with gratitude. And the professionalism, graciousness, and warmth of Olga Evanusa-Rowland and Denise G. Weinheimer at Marquand made every day of my work there pleasurable.

While preparing another project at the Institute for Advanced Study in Princeton, New Jersey, in 1997/98, I also was able to work on some details of this text. Numerous staff and faculty members at the Institute helped to make my stay enjoyable, stimulating, and profitable. Although they were not in any way involved in the writing of this text, Irving and Marilyn Lavin provided invigorating and generous intellectual support during my tenure there. Allen Rowe, the Associate Director and Treasurer, became a good friend. Marian Gallagher Zelazny, the Administrative Officer, gives new meaning to efficiency, competence, and friendliness. Marcia Tucker, librarian for Historical Studies and Social Science at the Institute, granted us members virtually unlimited access to the library; also with much patience, she helped me on research problems and use of on-line resources.

My wife Heather Hyde Minor, who assisted me in every aspect of this book, has been by my side with ready support and great understanding. While pursuing her own art historical career with considerable success, she has remained ever mindful of my projects and is a wonderful partner in teaching and research.

ACADEMIC REVIEWERS
Joseph M. Hutchinson, Texas A&M University
Julie Anne Plax, University of Arizona
Wendy W. Roworth, University of Rhode Island

Baroque & Rococo

ART & CULTURE

CHAPTER I

Baroque & Rococo

IDEA & IMAGE

JOHN WEBB,
Double Cube Room,
Wilton House, England,
1649–50.

The original aristocratic
residence was gutted by
fire in 1647 or 1648.
After the house had been
rebuilt, Webb, with help
from classical architect
Inigo Jones, designed
magnificent interiors such
as this, which incorpo-
rates portraits by Van
Dyck. The inspiration for
this Baroque scheme,
which was new in Britain,
probably came from
France, and particularly
Jean Barbet's influential
Livre d'Architecture (*Book
of Architecture*), published
in 1633.

aroque and Rococo are elusive and emotive terms. The word Baroque conjures up strangeness and the bizarre, as well as a certain ostentation and over-ornamentation. A sense of bewilderment and unease about the Baroque has been expressed by critics since the period itself that the term describes. In the seventeenth century the French writers of the *Dictionnaire de l'Académie française* defined the Baroque as "irregular, bizarre, uneven." In the early eighteenth century, Italian *cognoscenti* (intellectuals) saw the Baroque as a deviant, injured, disoriented phenomenon. Over a century later, in the *Vocabolario della Crusca*, then Italy's most authoritative dictionary, the Baroque was still being described as "strange and awkward." It is only fairly recently that both the use of the term Baroque, as well as the way in which the art of the period has been viewed, have lost much of the prejudice of earlier times.

Not surprisingly, the word Baroque itself has an origin shrouded in mystery and complexity. One theory has the word deriving from the Spanish *barroco*, which is a large and irregular pearl (it is still a jeweler's term); the implication is that something precious has become deformed. Some believe the term may have derived from the Latin *verruca*, meaning a wart. But most scholars now believe that Baroque derives from a rare and curious form of syllogism. A student of logic in the middle ages could use the word "baroco" as an aid to memorizing a form of argumentation that has a universal and affirmative major premise, a negative and particular minor premise, producing a negative and particular conclusion. (Each letter of the word probably stood for a different element in the syllogism.) The thirteenth-century logician William of Shyreswood gave this coincidentally appropriate example: Every pearl is a stone; some men are not stones; therefore some men are not pearls.

The term Baroque was not in fact used to characterize or distinguish an entire artistic period until the middle of the nineteenth century, when German academics employed it to cover European art of the seventeenth century. There probably remains no more contested

notion in cultural studies. The Baroque is not a set of stylistic qualities (although such lists have been made; see box, "The Wölfflin principles," pp. 28–9 below), nor can it define a unified period, although it generally describes an age in Europe and Latin America from the late sixteenth century until about 1700. The very ambiguity of the term, its association with the fiendish and the subversive, makes it appropriate for a troubled, turbulent time. Chapter 2 explores this turbulent time through discussions of the histories of Baroque institutions, personalities, and politics.

The term Rococo also was used at first with some distaste, and the study of that period still remains mired in controversy and prejudice. The word itself, however, has generated less dispute than "Baroque." Its original meaning is fairly clear: the term seems to derive from the French *rocaille*, which is pebble or shell work. According to the *Oxford English Dictionary*, the style is "old fashioned, antiquated. Of furniture or architecture: Having the characteristics of Louis Quatorze or Louis Quinze workmanship, such as conventional shell- and scroll-work and meaningless decoration; excessively or tastelessly florid or ornate." Of course, these connotations reflect the Victorian values of the writers of the dictionary. H. W. Fowler, a quirky but reputable commentator on language in the early twentieth century, had the following to say about Rococo:

> This and baroque are epithets applied, sometimes indifferently, sometimes with the distinction noted below, to tendencies prevailing in the architecture & furniture of the early 18th century in France & imitated elsewhere. Departure from the normal or expected, incongruous combinations, bristling surfaces, profuse ornament, strange or broken curves or lines, are the characteristic features. The distinction referred to is that rococo is regarded as a form taken by baroque when it aimed no longer at astounding the spectator with the marvellous, but rather at amusing him with the ingenious. (p. 616)

Although Fowler is somewhat less critical in his language than the *OED*, he emphasizes the strangeness and incongruousness of the style. Like the Baroque, the Rococo is deviant – perhaps demented. Nineteenth-century critics have also commented on an old-fashioned quality to Rococo, perhaps because it was associated with the taste of the *ancien régime* in France (before the Revolution). The period – and the style – still appears to many as archaic and strange.

Although an art historian today would not say that either the Baroque or the Rococo is an errant, outmoded, or ridiculous style, he or she might admit that there is something irregular and anomalous about each. It is their departure from the "classic" and normal that lends to the Baroque and Rococo much of their interest.

Defining Periods in Art History

Historical categories can impede our understanding of art, as well as assist it. Perhaps we should abandon historical categories and just look backward at the grand sweep of history, its cultures, institutions, and art in unbroken totality. After all, time moves continuously, without ruptures and without signposts. But to abandon historical categories would make the writing of art history more difficult (maybe not a bad thing) and it would ignore that difficult-to-define quality of the character, mood, or spirit of an age.

Even in the earliest mythic writings, certain "ages" were proposed: the Golden, Silver, Bronze, and Iron, which begin with the happiest times and lead to the later and most troubled ages. And writers since Roman times have found it convenient and meaningful to divide up events of the past so as to create appropriate contexts for studying history.

German-speaking art historians have come up with various words to name the spirit of an age. *Zeitgeist*, literally a "time ghost," comes quite close to the English "spirit of the age." Other

variants, such as *Weltgeist* (world spirit) and *Geistesgeschichte* (history of the spirit, or intellectual history), also show a persisting desire on the part of historians to find the spirit, soul, or character of an age. In the writings of the German philosopher Georg Wilhelm Friedrich Hegel (1770 –1831), the existence of the spirit is absolute and is located at the center of the universe. All change comes about by the working out of this "world soul" along the pre-ordained path of history. Less idealistically or transcendentally minded historians at the end of the twentieth century generally shun discussions of non-physical, non-spatial entities that push history into the inevitable but unknown future.

Nevertheless, because we tend to think in terms of broad spreads of time with some identifiable character, art historians are loath to abandon periods and labels altogether. The title of this book, *Baroque and Rococo*, continues the tradition of dealing with periods. Even if the title were *Seventeenth- and Eighteenth-century Art* (perhaps more neutral, but certainly less interesting), we would still be encountering the issues of periodicity. Furthermore, the words Baroque and Rococo are not just convenient and fairly conventional handles for writing and thinking about epochs of art history. Both terms suggest not just a period but an overarching philosophy, style, and vision; using these terms connotes some basic similarities among objects and attitudes throughout the two periods.

If an art historian concedes, however much against his or her will, that our terminology leads us back to the premise that nearly all cultural products of a particular age share something in common, then we once again encounter the problem of *Zeitgeist* and those annoying "ghosts." A way out of these difficulties is to declare Baroque simply *one* style, a style shared by some artists, such as Bernini, Rembrandt, Rubens, Pietro da Cortona, and Borromini, but not by all. Paintings by Poussin do not look very much like paintings by Rembrandt, for instance. But if Baroque – and the same can hold true for Rococo – is simply one style among several in the seventeenth century, then we need to dethrone

the word, take away its capital letter, and replace it with something broader, such as "the art of the seventeenth and eighteenth centuries."

In this book, Baroque and Rococo are used as terms that tell us something about the periods, and that also have certain stylistic connotations. An attempt is made to build up a picture not so much of unity but of prevailing patterns, or syndromes (rather than symptoms) of the age, as found in the art as well as in the broader cultures and institutions. Art historians of an older generation who wished to see some informing spirit in each age often would refer to paintings, sculptures, and buildings as symptoms of an age; that is, as phenomena that would lead the observer back to the essential cause – the spirit. A symptom always refers to something else, a prior entity or force. The conjecture that any cultural production – a painting, an automobile, even such human behavior as etiquette – is symptomatic of something deeper characterizes the theories of social historians and Marxists. In contrast, by choosing the idea of a syndrome, one recognizes a pattern among various objects and events in a culture – say, between clothing styles, advertising, films, music, politics – but one does not attempt to reduce these circumstances and occurrences to a more fundamental single cause. Rather, we see the interconnectedness of things without assuming that there is a common, driving force somewhere in the background. This book is concerned with those connections.

It is for this reason that the major boundaries of the book are not defined along chronological and geographical lines. Although styles change (in part at least) because each generation of artists responds to its predecessors and leaves behind something for successors to rebut, accept, or build upon, art history is not simply about artists influencing artists. The story is larger; it is also about institutions – such as monarchy and the Church – and economic systems – such as capitalism – that have a vital function in constructing the market, the desire, and the style for works of art. Chapters 2 to 4, therefore, examine the culture of the period through the lens of its various institutions. Likewise, Chapters 5 to 7

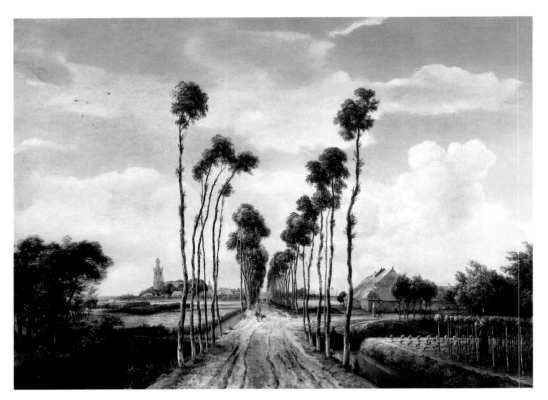

1.1 MEYNDERT HOBBEMA, *The Avenue, Middelharnis,* 1689.
Oil on canvas,
3 ft 4¾ in x 4 ft 7½ in
(1.03 x 1.41 m).
National Gallery, London.

In his youth Hobbema trained with the great landscape painter Jacob van Ruisdael (see p. 280 and FIGS 7.15, 7.16), and he traveled around much of the Netherlands with his master, painting local scenes. By the time he painted this work, full of strong vertical and horizontal lines, Hobbema had virtually retired from painting, after his marriage and his appointment as municipal wine gauger for the Amsterdam district.

approach Baroque and Rococo art through extensive discussions of its rhetorical styles, genres, and subject matter. Chapters 8 to 9 reflect on the way in which Baroque and Rococo artists both planned their cities and countryside, and organized their domestic spaces. An epilogue details certain aspects of Baroque art theory.

Style, Rhetoric, Genres

This section introduces some important ideas about the Baroque and Rococo. The outlines that follow are intended not to define either period, but to direct the reader's attention to distinguishing elements; to provide the reader with diagnostic tools.

STYLE

Style is a common notion in art history, but one that is hard to define. It has to do with *how* something is made as opposed to what it is made

of or what it appears to represent. The style of a landscape by Meyndert Hobbema (1638–1709) arises not from the existence of trees, lane, and strolling figures, nor from the particular kinds of paints that are used (FIG. 1.1). Style has to do with his manner of presentation, the particular way Hobbema has of rendering leaves, grouping trees, arranging forms within the painting so as to create a composition. Style is the record of the act of painting, the signature or handwriting of the artist, the marks left behind by his gestures on the surface of the canvas. One element of style that is personal to Hobbema is the way he renders leaves. Rather than producing a mass of foliage, Hobbema attends to individual outlines that make each leaf specific and observable in terms of color, shade, and shape.

Style may also stand for the recognizable manner of an entire culture or period. Fairly typical of Dutch painters of the Baroque is the tactic of arranging a landscape according to a convention. Here the road that leads to Mid-

delharnis is in the "middle" of the composition, which is more than just a play on the name of the village – it is a device that calls upon an implicit understanding between the painter and his audience. In this case the audience is not just one of "ordinary" purchasers of landscape paintings, but one of sophisticated critics.

The avenue traces the line from the centrally located observer toward the horizon, thereby creating an obvious and convincing display of linear (one-point) perspective, a technique well established by the seventeenth century. The horizon line – where sky meets earth – is precisely bisected by the road, thereby creating the "vanishing point." Although human vision is not, strictly speaking, comparable to linear perspective – we see binocularly (we have two eyes), we scan a wide area, and we see in terms of curved space; linear perspective is monocular, has a smaller field of vision, and is flat – nevertheless, linear perspective provides an interesting and useful model for how we see. It also carries cultural values. Above all, it is a rational system, based upon optics, for organizing a composition. Linear perspective arranges elements so that they seem to "fit" our rational, perceiving mind. As further evidence of a pervasive interest in a scientific way of seeing, one can point to the production in seventeenth-century Holland of important optical devices, such as the microscope and the telescope.

This particular artistic maneuver of placing a road midway in the composition, at the centric point of a perspective system, had already been used by the Dutch artist Albert Cuyp (1620–91) in *Avenue at Meerdervoordt* (Wallace Collection, London). Repeating a device used by an earlier artist both demonstrates an artist's learning and carries with it the authority of visual quotation. In all these ways, Hobbema had painted a landscape whose hidden stylistic references would be discernible by an educated elite.

RHETORIC

Rhetoric, originally the ancient art of persuasion, is a kind of traditional pictorial device or point of view, a way of using recognizable imagery to mean something else. In language, rhetorical devices lead one away from the normal and literal meaning of words; in the visual arts, rhetorical devices lead one away from the normal and literal meaning of images. In language, rhetorical devices are such things as metaphors and similes; in the visual arts, rhetorical devices are images that take a certain visual "turn."

For instance, the tightly compressed, nervous drapery patterns on the angels by Gianlorenzo Bernini (1598–1680) that flank the throne of St. Peter in Rome (FIG. 1.2) function as visual metaphors for the mystical idea of empyrean (divine) flames. The clothing is not aflame, it is flame-like. There is good evidence that Bernini was familiar with the writings of an early Catholic mystic known as Dionysius the (Pseudo-) Areopagite, who wrote about the ecclesiastical and celestial hierarchies. The ecclesiastical hierarchy is for members of the earthly Church. The celestial hierarchy is populated mainly by angels (and, of course, God). According to Dionysius, "the similitude of fire denotes the likeness of the Heavenly Minds [angels] to

1.2 (*right*)
GIANLORENZO BERNINI, Angels on the Throne of St. Peter, 1665. Bronze, marble, and stucco. St Peter's, Rome.

Counter-Reformation artists such as Bernini were keen to reassert the primacy and unique authority of the pope (see pp.47–9). Here, on the chair back, the artist has inserted a relief of Christ saying "Pasce Oves Meas" (Feed My Sheep); on the side He is shown giving St. Peter the keys of Heaven and Hell. Hovering above, on an oval-shaped piece of amber glass, is a transparent image of a dove, representing the Holy Spirit.

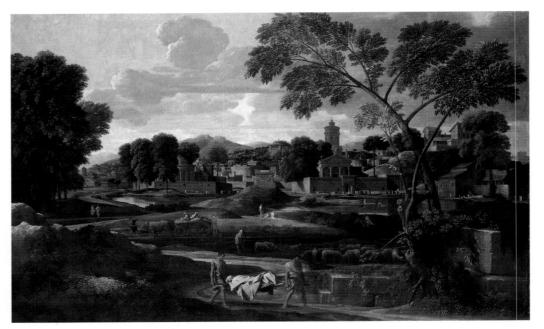

1.3 NICOLAS POUSSIN, *Landscape with the Funeral of Phocion*, 1648. Oil on canvas, 3 ft 9 in x 5 ft 9 in (1.14 x 1.75 m). Earl of Plymouth, Oakley Park, Shropshire; on loan to National Museum of Wales, Cardiff.

Phocion was forced to drink poisonous hemlock and then forbidden burial within Athens, where he had been governor. Poussin depicts the body being taken to a funeral pyre outside the city, and he gives the scene a subtle combination of drama and classical restraint by setting it within a semi-circular arch formed by the way the clouds continue the sweep of the tree on the right.

God in the highest degree," because fire is pure, insubstantial, and of a hidden essence. Bernini is doing something here with sculptural form that is very close to the function of a simile or metaphor in linguistic terms. Baroque artists also perform other rhetorical moves, some of which are close to language and some peculiar to the visual arts (see further, pp. 20–5 below).

In ancient theories of rhetoric, there are "modes of eloquence," which are forms of speech appropriate for different occasions (high, middle, and plain). High speech, known as epideictic oratory, was meant for display and was used on formal occasions; the middle style was meant for less formal occasions, and the plain was for speaking informally. The French painter Nicolas Poussin (1594–1665) claimed to follow a theory based on rhetoric and Greek musical modes. Musical modes for the Greeks were somewhat akin to modern musical keys, but as Poussin explained it, each of the modes – the Dorian, Ionian, Phrygian, Lydian, and so forth – was appropriate for a different "mood."

The Dorian mode was solemn and austere, and was intended to lead the viewer to virtue. Poussin's *Landscape with the Funeral of Phocion* (FIG. 1.3) demonstrates the characteristics of a painting in the Dorian mode. The theme is lofty, the composition is mathematically arranged, and the colors are muted. Phocion was a Greek general who died an honest man, although denounced by the rabble. Poussin knew the story of Phocion from the writings of Plutarch (46?–120 C.E.), a Greek biographer and writer whose *Parallel Lives* recounts moral tales of ancient Greeks and Romans. Just as Plutarch's tale is meant to edify, so too does Poussin's painting, through conveying an exalted and noble visual message. As he wrote: "The first thing that is required, as the foundation of everything else, is that the matter and the subject should be something lofty, such as battles, heroic actions, religious themes" (Blunt, *Poussin*, p. 219). The patterns of lighter and darker tonalities in the painting are grouped in such a way that the viewer's eye moves methodically throughout the space from lighter to darker to lighter to darker, and so on, until it reaches the horizon. The clouds, buildings, and trees are arranged in a system of parallels; again, using a geometrical form for the placement of elements in a work of art imposes the kind of rigor that Poussin found appropriate to the Dorian mode. On either side of the foreground are trees that bend toward the

center of the composition. These are called *repoussoir*, devices of visual rhetoric used to direct the viewer's eye into the narrative scene.

The importance of Poussin's theory of modes is that it introduced into the art world of the seventeenth century a vocabulary for assigning a place and value to a painting. Soon such paintings as *The Burial of Phocion* came to be seen as forming a part of the "grand manner." Because it mediates between us and reality, the development of a mood in a painting – even in the conventional vocabulary of a mode – also has quite an impact on the viewer. Rhetorical devices that get us *in* to the painting, rather than keep us at an aesthetic distance (as often happens in the Renaissance), make us part of something both strange and knowable at the same time. Paintings with a mood bring us into contact with, and allow us to respond to, other worlds – both those that are inviting and those that are frightening.

Genre

The word genre in art history can mean two things. Either it refers to a "low-life" image of peasants or workers, like *The Forge* (FIG. 1.4) by Louis Le Nain (1593–1648), or it directs one's attention to *kinds* of images. In the seventeenth and eighteenth centuries, critics recognized a hierarchy of categories of art, with history painting at the top. A history painting is generally one that has a biblical, historical, or legendary subject matter, and tends to be multi-figured (anywhere from four to twelve main figures) and arranged so that a story or narrative is rendered through setting, gesture, expression, and placing of fig-

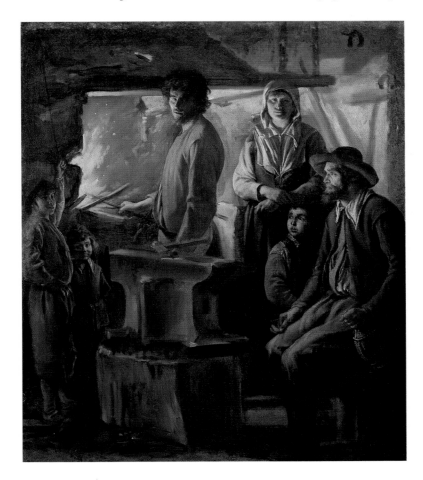

1.4 Louis Le Nain, *The Forge*, 1641. Oil on canvas, 27¼ x 22½ in (69 x 57.1 cm). Louvre, Paris.

In this painting, each generation seems to have its own way of looking, and its own way of responding to the artist: the blacksmith and his wife are politely and calmly responsive, while the grandfather is absorbed in his own reflections and the children are alert but shy. Le Nain came from a family of artists, and often collaborated with his brothers Antoine and Mathieu.

ures. The French Academy recognized any number of other genres below history painting, such as landscape, portraiture, still life, and so on.

The "common" themes, such as Le Nain's images of those at the bottom of society, often carry with them the same kind of dignity found in the highest genres. On the other hand, the colors, composition, and gestures of figure 1.4 are very different from those of history painting. In fact, the gray tonalities, apparently simple and direct presentations of the members of the family, and fairly rough texture of the paint match the character of the subject matter. It is that very frankness that marks Le Nain's paintings as sincere and honest presentations of the working class. He portrayed them not as subhuman or foolish, as one often reads, but as individuals with as much humanity and worth as those at the top of society.

Topics

This section investigates in greater detail certain subjects, styles, rhetorical devices, and genres that characterize the Baroque and Rococo periods. The discussion that follows is by no means complete, but it does begin to illustrate the attitudes and concepts that inform the cultures and the artistic practices of the respective periods. The purpose of much of the rest of this book is to flesh out this armature of concepts.

BAROQUE

Because of the close connection between word and image in the seventeenth century, especially in Catholic Rome, it makes sense to begin with ideas that have a strongly rhetorical quality. As we have seen, rhetoric is the ancient art of persuasion in public speaking. In order to convince an audience of the validity of their arguments, speakers drew upon a large number of rhetorical or literary devices. The visual rhetoric of Baroque art has a similar persuasive quality and function.

The visual inventions of the Baroque have another quality; they can nudge us out of our usual experiences, out of our normal ways of thinking.

Although it can be disconcerting to be invited to let go of our common sense, to undergo a conversion of sorts, the world we enter through much of Baroque art is in fact a better world, whether sacred or secular. The rhetorical devices described below provide the gateways to this dream world of Baroque art, this place where we meet with – or merge with – a divine or beautiful presence.

Concettismo

Concettismo is the rhetorical use of the **concetto**. This term is close to the English "conceit," but because of that word's egotistical overtones, it is better understood as "concept." The concept (or conception) may be literary or visual. In literature, one draws out or extends a metaphor or simile. In a book published in 1564 with the title *Concetti divinissimi* (divine conceits), one reads that a good *concetto* has the "the wit of a fine saying" ("l'acutezza d'un bel detto"), suggesting that a good *concetto* is poignant or acute. In this passage from the Baroque poet Giovanni Battista Marino we can see how the comparison between a beloved's hair and a lover's fear of shipwreck (the heart is engulfed by love) centers on images of an ivory comb, tempestuous hair, and diamonds (Marino, p. 7):

Through waves of gold, the waves which were
 her hair,
 A little ship of ivory sailed one day,
 A hand of ivory steered it on its way
 Through precious undulations here and there.
And while along the tremulous surge of beauty
 She drove a straight and never-ending furrow,
 From the rows of tumbled gold Love sought
 to borrow
 Chains to reduce a rebel to his duty.
My shipwrecked heart veers down to death
 so fast
 In this stormy, blond and gilded sea that I
 Am caught forever in its waves at last.
In golden gulfs, at least, I come to my
 Tempestuous end, on rocks of diamond
 pressed,
 – O, rich disaster in which submerged I die.

1.5 GIANLORENZO BERNINI, *Ecstasy of St. Teresa*, 1645–52.
Marble,
height of group 11 ft 6 in (3.51 m).
Detail of Cornaro Chapel altar, Santa Maria della Vittoria, Rome.

Teresa's ecstasy was a mystical experience. For Bernini and the Baroque, mysticism was not just an inward and hidden experience, but one that involved a direct intuition of the divine, one so clear and palpable that it could be described with vivid language and concrete, visual forms.

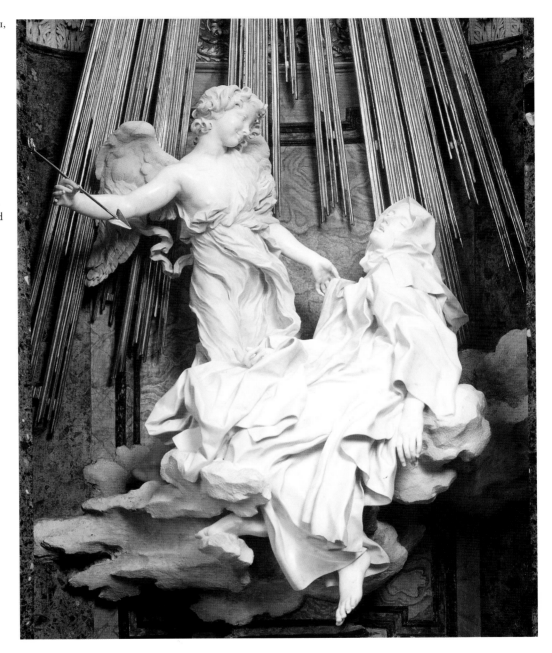

In the visual arts, the word *concetto* was often used by Michelangelo (1475–1564). He sensed that there was a potential image within a block of stone, but the only way that he could realize and liberate that image was to draw upon the *concetto* in his own mind. He did not use the word "idea" – which would be literary – but *concetto*, which for

Michelangelo arose as an image in his imagination.

For a concrete example of a *concetto* on more than one level, let us look briefly at Gianlorenzo Bernini's *Ecstasy of St. Teresa* (FIG. 1.5; see further pp. 174–6 below). Bernini's concept is part of a complex mystical tradition, a tradition that was of immense importance to St. Teresa. In short,

Bernini gives us a vision. A vision, as the word suggests, is visible, but on an entirely different level from "normal" experience. A vision may *seem* real enough, but it is the product of someone's imagination.

In this vision we have a clear view of Teresa "transverberated" (shot through with an arrow) by an angel. Bernini also painted a vision of the Holy Spirit – a dove among golden clouds – on the chapel's ceiling, thereby giving to the viewer a heavenly source for the energy that throbs throughout the ensemble. A glorious golden hue envelopes this dove as it hovers in an empyrean realm apparently above and beyond the chapel. The image in the **tabernacle** is illuminated by this source, and the tabernacle itself appears to bend outward by the sheer force and heat of the vision. We witness and experience a divine event – given to us as *concetto* – as if it were a hallucination, an image originating as much from within our imagination or memories as "out there" in the chapel, or in the historical circumstances of Teresa's life.

Meraviglia

The rhetorical device of **meraviglia** (the marvelous) is about pleasure and surprise. Vincenzo Borghini, a sixteenth-century writer and friend of Michelangelo, defined the marvelous as that which is "extravagant" and "rare." He went on, "There is no doubt that extravagant things, never before seen or heard, or that have in themselves such a rare excellence, delight extraordinarily, and this extraordinary delight is called *meraviglia*" (Summers, pp. 172–3). The painter, sculptor, or architect of the marvelous renders that which we cannot imagine – a bunch of grapes so life-like that birds will actually try to pick them. Something so new creates a sense of awe.

Francesco Borromini (1599–1667), one of Rome's most important architects in the seventeenth century, created a marvelous sense of vertical space in the interior of the relatively small and intimate Roman church of San Carlo alle Quattro Fontane (St. Charles of the Four Fountains). The

visitor, in a state of near bewilderment, stands in the middle of the floor and gazes heavenward through jumbled zones of an architecture composed of (apparently) misplaced elements. The organization of the walls of the church is complicated enough, but as one's eye reaches the **entablature**, an entirely new system of patterning begins. There are concave and convex edges to the architectural elements, arches reaching upward, smaller roundels captured in **pendentives** (triangular areas), all of which then is surmounted by an oval ring giving onto a dome honeycombed with octagonal and cross-shaped coffers (FIG. 1.6). Above the oval ring (in the first course of the octagons and crosses) discrete windows seem to

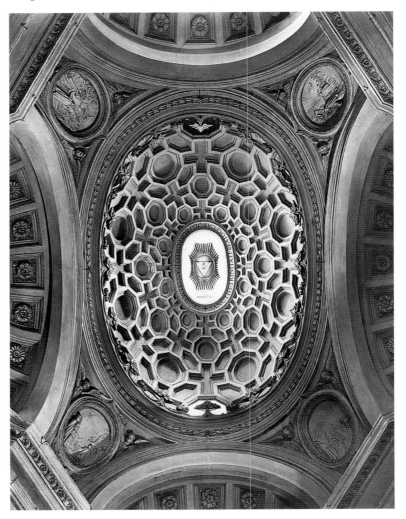

1.6 Francesco Borromini, view into dome, San Carlo alle Quattro Fontane, Rome, 1638–41.

Borromini, who was an almost exact contemporary (and bitter rival) of Bernini, had the reputation of being reclusive, frugal, and depressive. His buildings, though, are full of life and ingenuity; one contemporary said of S. Carlo: "nothing comparable in terms of artistic merit, imagination, excellence, and singularity can be found in any part of the world."

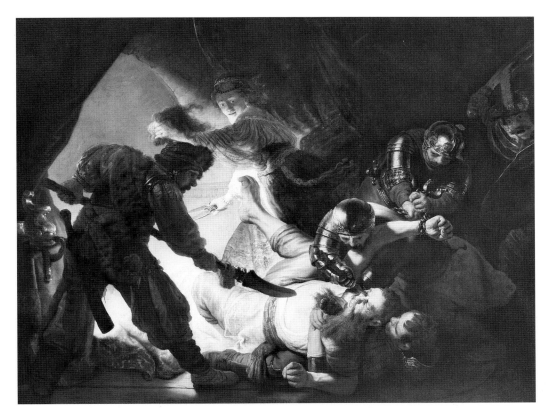

1.7 REMBRANDT,
The Blinding of Samson,
1636.
Oil on canvas,
7 ft 9 in x 9 ft 11 in
(2.36 x 3.02 m).
Städelsches Kunstinstitut,
Frankfurt.

As in so many Baroque
paintings, the artist has
created an essentially tri-
angular composition,
with the fleeing Delilah,
half-smiling, at the apex.
Rembrandt was of course
an incomparable por-
traitist and a good deal of
the drama of this scene
comes from the horror
expressed in the faces of
the soldiers.

emit (rather than admit) dazzling light. What is
marvelous here is the unexpected. Borromini has
given us illusions of deeper "arms" at the level
above the **architrave**, as if the church interior were
not a single vessel, but were arranged like a Greek
cross (that is, with equal arms). The trellis-like
webbing of the pattern inside the dome dimin-
ishes rapidly in size, giving the illusion that the
dome is much loftier than it is in "reality."

Then there is the dark side to the marvelous.
Lodovico Castelvetro, a widely read Renaissance
critic who brought out an edition of Aristotle's
Poetics in 1571, wrote about the marvelous as an
essential element of a tragic plot, saying that it
was about more than the excellent and magnifi-
cent. Because a plot in tragedy moves the
beholder to a state of catharsis – of being first
shaken, then purged (purified, cleansed) – the
marvelous should also appeal to our compassion
and sense of *terribilità*. *Terribilità* is not just "the
terrible"; rather, it refers to a high form of dis-

course, to a grand style. But it also can evoke the
awesome, the horrible, and the hideous.

In Rembrandt's (1606–69) *Blinding of Sam-
son* (FIG. 1.7), the *meraviglia* and *terribilità* focus
on Delilah, the famous enchantress, beguiler,
and betrayer of the mighty Samson. Castelvetro
writes that "[t]he marvelous among men [here
we should add "and women"] who do something
horrible with deliberate intention is much
greater in proportion as the cause is less able to
bring it about … And however marvelous his act
may be, it does not produce compassion for him
but a great deal for the sufferer, who has not mer-
ited death at the hands of one not his enemy."
The nearly life-size Philistine soldiers in the fore-
ground gouge out Samson's eyes (one can even
see the blood squirting upward) as Delilah,
caught in a yellowish shaft of light, dashes from
the murky confines of the tent. The dramatic size
of the painting, the saturated yellows and reds,
the tantalizing image of Delilah fleeing in an

apparent mood of horror and fascination, the striking effects of back-lighting, the emphasis upon diagonal patterns – all these are part of the horrific, the Baroque marvelous.

Spectacle

Spectacle in this context has to do with modes of imitation and style. Aristotle, a favorite source for Renaissance and post-Renaissance critics, lists spectacle as one of the six elements of tragedy, describing it not as that which is imitated but as staging or "the manner of imitation." In other words, style, but a style of particular dimensions and characteristics. Because he was writing about a literary genre, Aristotle endorsed the linguistic at the expense of the visual: "It is necessary for the plot to be so put together that, without seeing, one who hears

what has been done is horrified and feels pity at the incidents" (Chapter XIV 53bI; Gilbert, p. 87). In the visual arts, the situation is precisely reversed, and one is to keep his or her eyes open at all costs; what was marginal at best in Aristotle's scheme becomes central to the painting, sculpture, and architecture of the Baroque.

A painting or sculpture must "acknowledge" its beholder. To put it another way, an object of visual art *requires* an observer; otherwise, it would make no sense. The question then arises, how obvious should the artwork be in its appeal to its audience? To what extent might an artist declare the inherent theatricality of his or her act of representation? To approach this very complex question, let us look at a Dutch group portrait by Frans Hals (1580–1666), *The Banquet of the Officers of the St. George Civic Guard Company* (FIG. 1.8) and compare it with a painting

1.8 FRANS HALS, *Banquet of the Officers of the St. George Civic Guard Company*, 1627. Oil on canvas, 6 ft 10½ in x 8 ft 5¼ in (1.79 x 2.57 m). Frans Hals Museum, Haarlem.

Hals himself became a member of the St. George Company in 1612. He captures the hierarchy of the company with almost nonchalant ease – from the colonel, seated at the head of the table, to the ensigns opposite him – but the poses are entirely natural, with the guards seemingly absorbed in the social occasion.

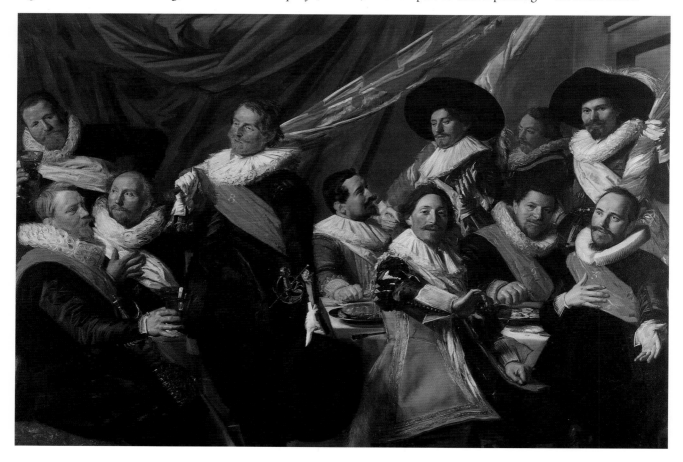

1.9 CORNELIS VAN
HAARLEM,
*The Banquet of the Offi-
cers of the St. George Civic
Guard Company*, 1599.
Oil on canvas,
5 ft 6½ in x 7 ft 4 in
(1.69 x 2.23 m).
Frans Hals Museum,
Haarlem.

Each of the individual
figures in van Haarlem's
painting is impeccably
portrayed, and the com-
position is not without
symbolism: the empty
chair in the foreground
indicates a vacant posi-
tion in the company. But
there is little interplay
between the characters,
who are either staring
rather blankly at the
viewer or gazing into the
middle distance.

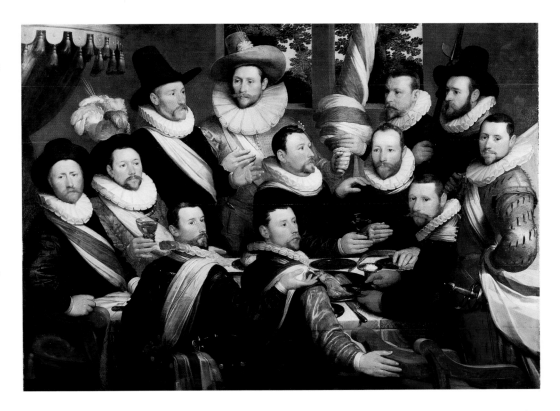

(FIG. 1.9) by the leading painter of Haarlem of
the previous generation, known as Cornelis van
Haarlem (1562–1638).

From the early years of the sixteenth century,
Dutch civil guard companies had hung group
portraits of their members in their guard
houses. Because of the fairly general peace in
the Northern Netherlands by the second decade
of the seventeenth century, these guards were
largely ceremonial. The earlier painting by van
Haarlem is not without spectacle: the men are
richly dressed, emblazoned with their colored
sashes, and ornamented by their ruffs. But the
space is cramped and the gestures contrived or
stiff. The men are expressionless. The artist
seems a little uneasy with the presentation, the
staging. Hals, on the other hand, achieves not
just pictorial unity but a commanding, theatri-
cal presence for the individuals and for the
group. The Baroque artist seizes the worldly
moment and creates a worldly spectacle. What
Hals has done with his staging is to give us men

who are conscious of their social position, who
seem fully self-aware and self-possessed, and
who care about cutting an impressive figure in
their world.

In this new Dutch world of capitalists and
burghers, each person could see his or her role as
an important part of a community. In the tradi-
tion of Renaissance humanism – such as we find
in sixteenth-century Italy, for example – individ-
uals understood their ability to define themselves
through learning and in terms of a courtly soci-
ety. In this Dutch middle-class culture of capital-
ism, individuals learned to invent their identi-
ties. There undoubtedly was a new kind of pride
in these prosperous and powerful citizens. The
middle class largely wished for and cherished its
new-found fame. They paid to have their images
displayed to their colleagues, and they certainly
wanted to look grand. Film director Alfred
Hitchcock said that "drama is life with the dull
bits cut out"; Baroque art is life with the dazzling
bits kept in.

1.10 Guercino,
Aurora, 1622–3.
Fresco,
Villa Ludovisi, Rome.

The theme of dawn dispelling night was a popular one among Baroque painters, providing the opportunity for the dramatic treatment of light and shade. Here, the straight lines of the soaring architecture, and the dramatic foreshortening, provide a strong contrast to the fluid style in which Guercino paints his mythological subject.

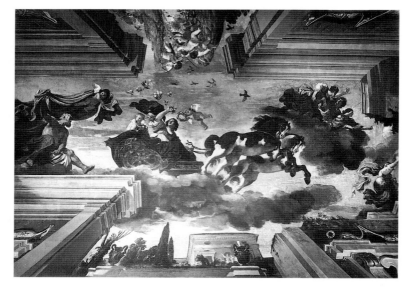

Quadratura, Quadro Riportato, & Di Sotto in Su

Several technical terms used by Italian painters in the seventeenth century refer to certain illusionistic contrivances. These devices of Baroque visual rhetoric order the visual field and therefore orient, displace, and excite the observer.

Quadratura is the painting of illusionistic architecture. For instance, in Guercino's (1599–1666) *Aurora* (FIG. 1.10) for the Villa Ludovisi in Rome, the architecture (painted by Guercino's assistant Agostino Tassi – a specialist, or *quadraturista*, in such illusionistic painting) extends the space of the room. Because architecture, whether feigned or real, depends upon geometry, we have a system of grids, along with horizontal, vertical, and diagonal lines that direct our attention into another realm. One of the aims of spectacle and the marvelous can be to remove barriers from between the viewer and the "other" reality of the work of art. In Guercino's painting, there is a continuum from the floor, where the viewer stands, into the mythic realm of Aurora and her bringing of the dawn. The marvelous and the spectacular both have a way of sweeping us off our feet, of eliminating the distinction between real and fictive spaces, of persuading us that we can live somewhere other

than on this earth. In addition, Aurora, her horses, chariot, and attendants are seen as if from below – ***di sotto in su*** (literally "from below up").

Although we realize that Bernini's *St. Teresa* is a work of art and not an actual mystical experience, just as Guercino's *Aurora* does not make us believe that we too live in mythic space where celestial maidens assist in the coming of dawn, nevertheless the paintings demand that we give ourselves over to these thrilling experiences. We are asked not simply to stand and examine the effects of *quadratura* and *di sotto in su*, but to abandon ourselves (or at least our interior selves) to this rapture. It is important to examine not just Baroque paintings and buildings, but their spectators. Trying to analyze Baroque art without studying its effects on its audience ignores much of its power.

Quadro riportato, a "transported painting," refers to a painting that seems to have been moved from one place and put somewhere else. The Farnese Ceiling (FIG. 1.11) by Annibale Carracci (1560–1609) shows paintings as if they were suspended above the viewer. The larger and smaller scenes are enclosed by apparently giltwood and plain stucco frames, all of which are concocted by Carracci. The entire ceiling is painted in fresco; all the elements that appear to

1.11 (*opposite*)
Annibale Carracci,
Farnese Ceiling,
1597–1600.
Fresco,
c. 68 x 21 ft
(20.7 x 6.4 m).
Palazzo Farnese, Rome.

The Carracci family originated in Bologna and ran a painting academy there, helping to make the city the center of *quadratura* painting in the seventeenth century. Here the artistic illusion is heightened by patches of blue sky painted in the angles at each end of the ceiling. Such was the acclaim accorded to the Farnese ceiling that Annibale was considered by his contemporaries to be a rival to Michelangelo and Raphael.

The Wölfflin Principles

HEINRICH WÖLFFLIN (1864–1945) taught art history at Basle, Berlin, Munich, and Zurich. He came up with a scheme for distinguishing between the Baroque and the art of the previous period, the Renaissance, by opposing the stylistic principles that he called the linear and the painterly. Wölfflin remains an important figure in art history because he was one of the first scholars to treat the Baroque as an independent period rather than as a degenerate phase of an earlier style. Below is a summary of the categories that he developed in *Principles of Art History: The Problem of the Development of Style in Later Art* (6th edn, trans. M. D. Hottinger, New York, 1960).

The Wölfflin Principles
(synopsis provided by James Connelly)

LINEAR
(Classic – Renaissance; FIG. 1.12)

Linear. Emphasis on line. The line as the path of vision, the guide for the eye, creating structures of tangible solidity. Draughtsmanship (drawing) is emphasized.

Plane. Careful registers and sequences of space are established, creating a box-like stage from which the actors do not emerge. The "picture plane" is always respected, the composition is not thrust out at the viewer.

Closed form. The line defines and limits the forms and structures. Forms are solid and self-contained. Compositions are closed by effects of formal balance. Quality of control.

Multiplicity. Independence of the parts within the whole. Every part so clear and articulated that it could stand alone. Harmony of free parts. (Note: All works of art seek an effect of unity. The term "unity" as posed in the Wölfflin principles is used in a special descriptive sense which does not mean to imply that linear art

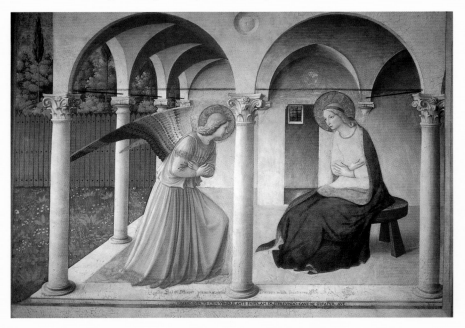

1.12 FRA ANGELICO, *Annunciation*, after 1450. Fresco, 7 ft 1 in x 10 ft 6½ in (2.16 x 3.21 m). San Marco, Florence.

In this Renaissance fresco, note the even quality of the light, the solidity and self-containment of the figures, the emphasis on line, and the boxlike "stage" in which the events are depicted.

lacks unity as the word is used in its usual and broader
connotation.)

Absolute clarity. Plastic feeling of forms emphasized
(roundness, solidity). Clear light falling evenly. No
emphasis on certain parts. Color and light subordinate
to structural clarity and line. Static quality, smooth
finish.

Summary:
• Clear
• Calm
• Controlled
• Rational
• Harmoniously balanced

PAINTERLY

(Baroque – Romantic; FIG. 1.13)

Painterly. Volumes and outlines merge. Edges blur,
creating a shifting or moving quality. Paint is empha-
sized and used for its own sake.

Recession. The creation of depth by dramatic diago-
nals. The "picture plane" is broken and the composi-
tion is projected toward the viewer. The artist may
deliberately obscure spatial relationships in order to
create drama, movement, and mystery.

Open form. Forms are loose and explode from some
central area. Outer limits of forms may fade away into
shadow or merge into other forms and volumes. Line is
allowed to disintegrate, and replaced by emphasis on
light and shadow and color.

Unity. Subordination of parts to overall effect. Parts so
dependent upon each other as to be relatively meaning-
less when considered alone. No emphasis on clarity of
individual parts. Artist primarily interested in total
impression.

Relative clarity. "Non-plastic" quality emphasized. Use
of dramatic shadows, brilliant spot-lighting or high-
lighting of certain parts. Triumph of color and lighting
effects over line. Diffusion of light in atmospheric
effect. Movement. Rough or agitated surface, eroded by
light or space.

Summary:
• Light and shadow
• Drama
• Movement
• Color
• Emotion

1.14 Giovanni Battista
Gaulli (Baciccio),
*Triumph of the Holy Name
of Jesus and the Fall of the
Damned*, 1672–85.
Fresco, on the vault of the
nave. Il Gesù, Rome.

Gaulli's theme, popular
among Counter-
Reformation artists,
comes from St Paul: "at
the name of Jesus every
knee should bow, of
things in heaven and
things in earth and things
under the earth." The
influence of Bernini,
under whom Gaulli
worked early in his career,
is evident here in the
interplay of painting,
stucco, and architecture,
and in the powerful con-
trast of light and dark.

be three-dimensional are in fact feigned. You can
see at the corners small patches of sky, suggesting
that this arrangement of pictures, bronze
roundels, and supporting statues is somehow
grouped over our heads out of doors. Although
our space is not continuous with the pictorial
space, we are made to marvel at what manner of
art exhibition this may be.

Baciccio, the nickname of Giovanni Battista
Gaulli (1639–1709), employs elaborate illusion-
istic devices in his scene of the *Triumph of the
Holy Name of Jesus and the Fall of the Damned*
(FIG. 1.14). Here the entire curved ceiling of the
Church of Il Gesù, roughly forty feet across and
one hundred feet long, becomes the field for
Baciccio's presentation. He had the smooth ceil-

ing covered with stucco (a combination of plas-
ter and cement) that was molded into coffers
(three-dimensional panels), which were in turn
painted gold with blue highlights. Large and
small angels, also made of stucco, are attached to
the vault at critical points around the heavier
molding that acts as a frame for the central pic-
torial space. The area within the frame appears to
be infinite, with a myriad of angels encircling
and adoring a ribbon-like scroll displaying IHΣ,
the first three letters of the Greek word for Jesus
(eponym or namesake for the Society of Jesus –
the Jesuits – whose mother church Il Gesù was).

The miraculous light surrounding the name of
Jesus also has the power to cast damned souls into
darkness, as we see in the area of the ceiling closest

to the crossing. Here Baciccio, with assistance from Gianlorenzo Bernini, employs the visual *concetto* of a *quadro riportato*, but then violates the very role of a frame by having the damned spill out of the pictorial space and into (simulated) shadow. This act of trespass, of transgressing the very rules the artist has set up for himself, conveys the power of the Name of Jesus – and of the Baroque.

ROCOCO

Good Taste

Good taste (*bon goût, buon gusto*) is one of those phrases that has no meaning outside of particular social circumstances. By the later years of the seventeenth century there was considerable reaction against the "extravagances" of the Baroque, such as those elements discussed above. For many reasons, some of them political, European intellectuals of the eighteenth century returned to a more rational and "natural" basis for literature and art. Today we are apt to think of taste as something more instinctive than rational, a faculty that reveals basic attitudes about an individual and his or her particular cultural interests. But in the eighteenth century, there arose an interest in universal taste, the kind of taste that is normative, that we should all agree upon. Bad taste may be relative; good taste is absolute. It is no coincidence that this is the same period that saw the rise of aesthetics as an independent philosophical category. According to the German philosopher Immanuel Kant (1724–1804), humans have autonomous capacities for rationality, morality, and judgment of beauty. It is this last aptitude that allows us to assume that there is such a thing as good taste.

We can approach the idea of good taste in the eighteenth century by describing some of the elements of the Rococo that are anti-Baroque (without necessarily suggesting that the Rococo is against the Baroque in all matters). The Baroque style is big, the Rococo is small. As we have seen, the word Rococo derives from shell and rock motifs, which makes of this style a combination of the artificial and natural, of culture and nature. In the chest of drawers, known as a commode (FIG. 1.15), produced in France about 1730, probably by the cabinetmaker Nicolas Pineau (1684–1754), all of the metal leaves (which "rise in the round" to become drawer handles), shells, scrolls, and even the dragons are typical of the custom-made and expensive

1.15 NICOLAS PINEAU, commode, inlaid wood and ormolu, c. 1730. Wallace Collection, London.

The dragon motifs used for decoration here were probably inspired by Japanese or Chinese art, both of which became popular in Europe during the eighteenth century. Many Rococo artists reveled in using exotic elements such as these to create an exciting visual rhythm within a rigorously controlled overall scheme.

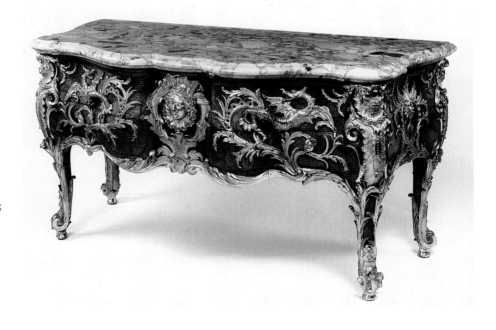

1.16 Jean-Antoine Watteau, *L'Indifférent*, c. 1716. Oil on board, 10 x 7½ in (25.5 x 19 cm). Louvre, Paris.

There is an almost dream-like quality to this painting, but behind the softness and lightness of the execution is a meticulous composition: the trees behind the dancer echo the shimmering green of his costume, and the rose on his shoe matches that of his cape. And instead of Baroque drama there is a Rococo tension in the artificiality of the pose and the slight tilt of the head.

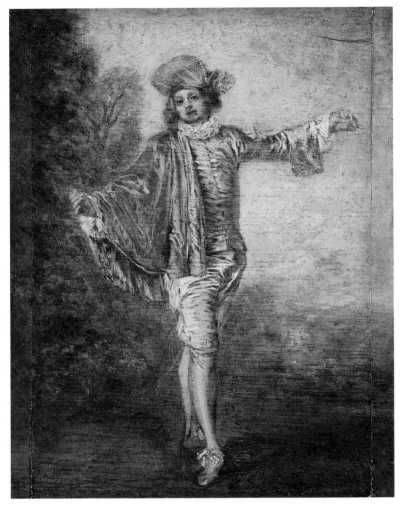

1.17 (*opposite*) François Boucher, *Pan and Syrinx*, 1759. Oil on canvas, 12¾ x 16½ in (32.4 x 41.9 cm). National Gallery, London.

The theme of seeing and being seen, with all its potential for irony, eroticism, and dramatic tension, is a popular one in Rococo art. Boucher has heightened the sensual charge of this painting by depicting not only a nude Syrinx, but also (rather gratuitously) a nude personification of the river, and by contrasting the voluptuous flesh of these two with the muscular torso of Pan.

Rococo furniture of this time (known to furniture historians as the Regency period). The face of the woman in the center, with her feathered hat and frilly collar, resembles those in paintings by Watteau (1684–1721) (see FIGS 1.16, 1.18).

This combination of stylized motifs from nature and painting may strike someone who is used to more utilitarian styles of furniture as odd and precious. Just the same, we can see here that the Rococo style shows how domestic it can be, comfortable, and part of the aesthetics of everyday life. Although this table could only have been afforded by the top 10 percent of town dwellers in eighteenth-century France, it was an important part of a particular kind of domestic

and familiar experience. It is private art rather than public; relatively small rather than grand, and – within its context – not ostentatious. It is an example of good taste.

So far as the Rococo style in painting is concerned (FIG. 1.16), the composition is frequently off-center, and the figures are often spiraling and dance-like in their movement. There are few visual tensions. In terms of color, we see pastel hues, high values (lots of white mixed in with the colors), a pervading atmosphere of colored mist, and the blurring of details. Subjects are often of aristocratic lovemaking in settings that are outdoors, idyllic, and lush. These, then, are the elements of good taste in French Rococo painting.

The Place of Love: the Grove & the Bower

In François Boucher's *Pan and Syrinx* (FIG. 1.17), the lecherous god Pan seeks the beautiful nymph Syrinx, but he misses his mark by groping reeds along a river bank. Syrinx, apparently now invisible to Pan, recoils and lunges for protection toward her sister, a river nymph who has brought about the deception. This is a place of love (**locus amoenus**), even if it is of love frustrated. While Pan's gaze is misled (although he eventually makes of the reeds his panpipe, the musical instrument of breathy lust), the beholder's gaze is rewarded with the image of two reclining, naked women. The pleasure here is reserved for the male gaze, a viewing from without, an inspection that surely is meant to result in gratification, in finding an object of one's desire and (eventual) fulfillment.

Pilgrimage to Cythera (FIG. 1.18) by Jean-Antoine Watteau provides one of the best-known instances of the place of love in early eighteenth-century painting. Pilgrims, dressed in the contemporary finery that Watteau popularized, are approaching (or perhaps departing from) the island of Cythera. This mythic island, sacred to Venus, not only provides the pilgrims with privacy, with isolation if not solitude, but also with freedom. The pleasure ground has a deep associ-

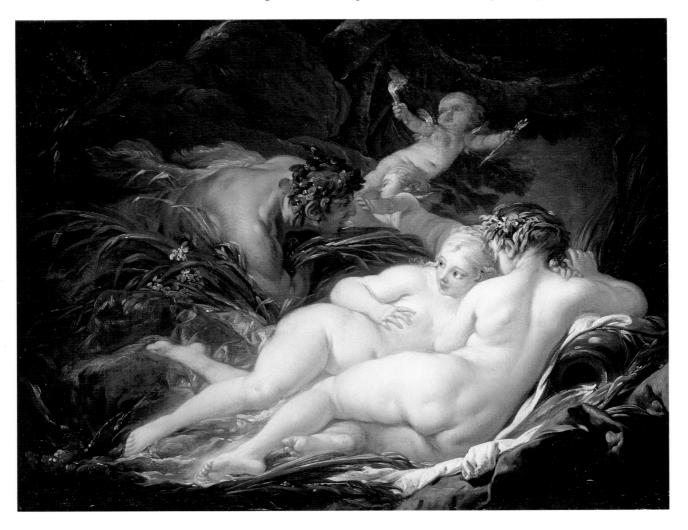

ation with human feelings and passions; there is a melding of nature and the human.

This grove, this sacred isle of love, summons up a pleasurable association between painting and observer. The French literary critic Saint-Lambert wrote in 1769 that "if the young and amorous are placed in a delightful grove, reclining on beds of flowers, in the midst of a happy country, and under a bright and serene sky, these beauties of nature will increase the pleasing sensations that arise from representations of love" (cited in Rosenmeyer, p. 179). The place of love offers comfort not just for those lovers within it, but for all of us, who are potential lovers, watching. We watch because we are curious and sometimes covetous.

The Pastoral/Arcadian

These terms refer originally to a genre of poetry about the love of shepherds and shepherdesses (the Latin *pastor* means shepherd) and their home in Arcadia. There are two Arcadias – the geographical one in Greece and the spiritual Arcadia. The ancient Greek historian Polybius, who was born in the geographical Arcadia, reported that the shepherds of his homeland from time immemorial had lived in simplicity, practiced the musical arts, and had instituted musical contests. By the early Roman period, Arcadia in poetry had come to represent the Golden Age, something hazy and far-off, yet intensely desirable. It is that melancholy sense of something regrettably past that fires the imaginative longing of so many later views of Arcadia as a landscape or island of dreams and wishes.

Shepherds and shepherdesses have appeared in the pastoral tradition of poetry since about 600 B.C.E. An early story tells of Daphnis and Echnais. The shepherd Daphnis was a son or

1.18 Jean-Antoine Watteau, *Pilgrimage to Cythera*, 1721. Oil on canvas, 4 ft 2¾ in x 6 ft 4¼ in (1.29 x 1.94 m). Louvre, Paris.

Art historians have failed to agree on the central subject of this painting: are the couples about to embark for the island of Cythera, or are they are about to return from it? Perhaps it is deliberately ambiguous, like the mood, which could be one of mild eroticism or melancholy.

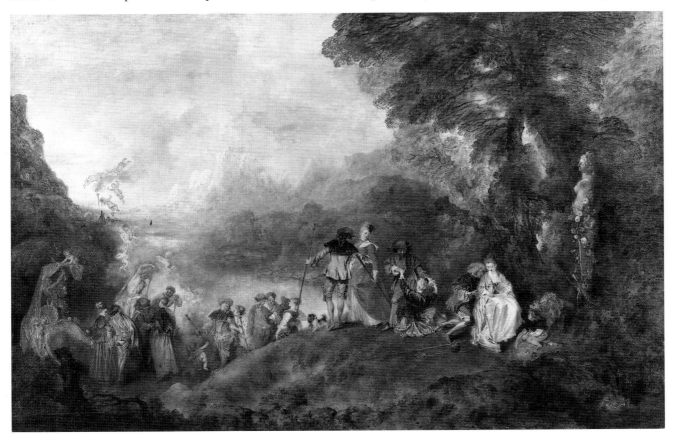

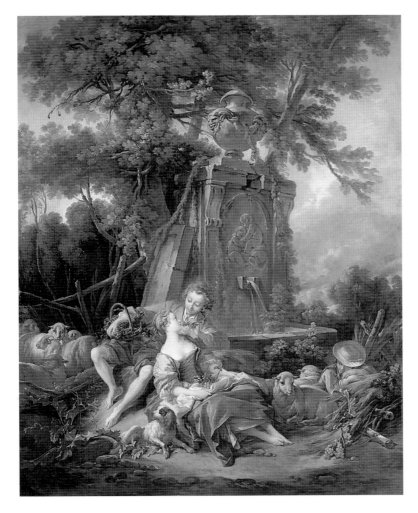

1.19 FRANÇOIS BOUCHER, *Autumn Pastoral*, 1749. Oil on canvas, 8 ft 7½ in x 6 ft 7¼ in (2.63 x 2.01 m). Wallace Collection, London.

In *Autumn Pastoral* (FIG. 1.19), for example, by François Boucher (1703–70), a shepherd and shepherdess display their tender feelings and dulcet voices while lounging and eating grapes. A dog sprawls in the noon heat while the herds lie in shadow. The shepherd flirts. He has neither the vulgarity of the peasant nor the questionable sophistication of the urbanite: he is in Arcadia. This is not a realm of heroic events, great deeds, or significant human actions. Our attention is drawn to the unremarkable, those normal things that do not usually command artistic scrutiny. This is not part of the grand manner.

So who looked at these paintings? They certainly were not intended for shepherds; rather, they were viewed by those sophisticated urbanites who longed for less complicated times when human relations were not so compromised by the competing demands of social living. These paintings also appealed to those who loved the games of life. Role playing and gamesmanship constituted a large part of the rituals, protocols, etiquette, and enjoyment of daily life for the aristocrats and newly rich who populated the salons of eighteenth-century Paris. The incongruity of a sophisticated lover searching for the simplicity of an earlier time is at the heart of games. A social group that values secrecy and wishes to distinguish itself from others, often will dress up, don masks and eccentric outfits. The masked balls and rustic posturings of Marie Antoinette, Queen of France, at Versailles' Petite Trianon may have seemed odd and scandalous to some. Yet it was part of the tradition of French high culture throughout the eighteenth century.

The Place of Excitement (locus uberrimus)

There is another place of pleasure, the **locus uberrimus**, from the Latin word for the rich and fertile. *The Swing* (FIG. 1.20) by Jean-Honoré Fragonard (1732–1806) presents us with a typical instance. An oddly radiant light wells up within the left-hand corner and enchants this overly luxuriant glade. Nature explodes with leaves and flowers. As if the force of nature were somewhat demented, trees erupt violently from the ground

favorite of the god Hermes and the beloved of the nymph Echnais. He pledged his love to Echnais, but a princess seduced him with wine and beauty. In revenge, Echnais blinded Daphnis, who – according to some accounts – turned to music for solace. Thus began the pastoral tradition dedicated to loss and founded on the need for comfort through music, which, much like the tradition of modern American country music, sings of our misfortunes. According to Bruno Snell, "From that time onward the shepherds have been in love usually without hope of success; either they indulge in their own suffering, or they wring a poetic expression of sympathy from their friends" (p. 285).

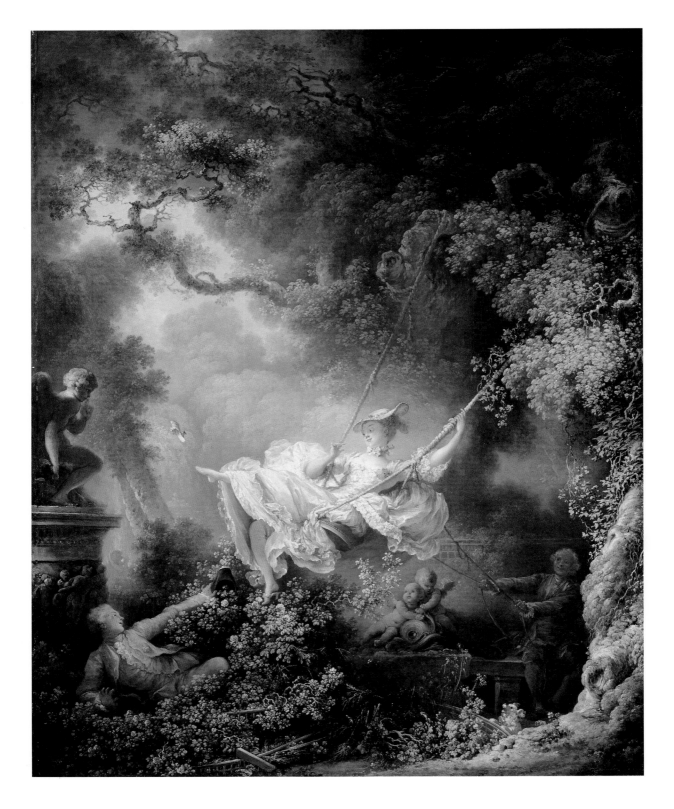

1.21 François Boucher, *Rape of Europa*, c. 1734. Oil on canvas, 7 ft 8¼ in x 9 ft ¾ in (2.34 x 2.76 m). Wallace Collection, London.

The Rococo delight in decoration for its own sake is obvious here in the evident pleasure with which Boucher has painted details such as the drapery of Europa and her handmaidens, the flowers, and landscape features such as the waterfall and palm tree in the background. Boucher also worked as a tapestry designer, which perhaps partly accounts for his lavish attention to decorative detail.

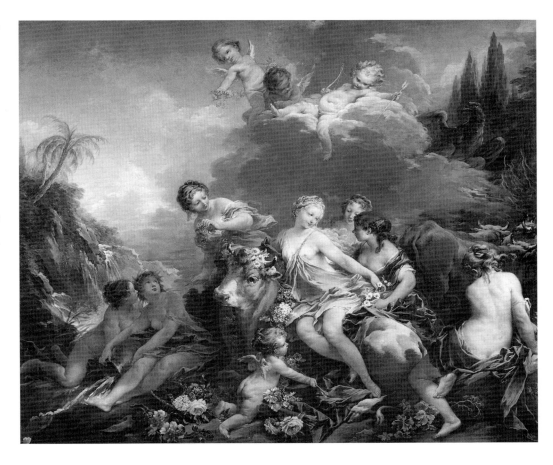

1.20 (*opposite*) Jean-Honoré Fragonard, *The Swing*, 1767. Oil on canvas, 32¾ x 26 in (82.9 x 66 cm). Wallace Collection, London.

The subject of this painting was suggested by the Baron de St Julien, who commissioned it and who is depicted in it as the rakish voyeur. Fragonard skillfully frames the scene in foliage, and uses all sorts of detail to add tension: the slipper which has flown off, the slightly frayed and slightly twisted ropes, and the tortuously curving branches.

and twist tortuously. Certainly, not everything is charmed here; there is more than a hint of perversity. How these blasted, intertwining, haunting trees can tether a swing so that it moves in a reasonably regular arc is astonishing. The statues, the rhythmically rocking young woman, a voyeur, and a yammering lap dog create a disturbing, fertile excitement and sensibility.

Tranquillity (otium)

Otium, the Latin word for ease, suggests that one takes up a spot, languishes, sings, and makes love. Boucher's paintings, such as the *Rape of Europa* (FIG. 1.21), where languorous, groggy, and inert figures doze or relax their lives away in various pastoral contexts, are redolent of *otium*. There are numerous traditions of love, one demonstrating the stressful and troubled, another the more wildly erotic (as with Fragonard's *Swing*), a third the light-hearted and casual. It is this last form that seemed to interest Boucher the most. His figures generally recline. Love entails no exertion, but is free from stress, worry, or work. Some of Boucher's little cupids are so indolent they seem to have no capacity for movement; they don't shoot arrows, they just drop them like water balloons.

This is the mood depicted in *Rinaldo and Armida in Her Garden* (FIG. 1.22) by Giovanni Battista Tiepolo (1696–1770). The love story of Rinaldo and Armida comes from the sixteenth-century epic poem *Jerusalem Delivered* (*Gerusalemma Liberata*) by Torquato Tasso. In the grand tradition of love poetry, the Christian crusader Rinaldo has been bewitched by Armida, sent by Satan to waylay the formidable knight and the crusaders bent on delivering Jerusalem from the infidel Turks. Two other soldiers come

as the Fortunate Isle. Rinaldo, unaware of the
intruders, gazes lazily at his beloved, while she
reflects upon her mirror.

The place of love – this time a bedroom –
and the sweet sleepiness of *otium* are combined
in a painting by Charles-Joseph Natoire of
Cupid and Psyche (FIG. 1.23), part of the deco-
ration of the Hôtel de Soubise in Paris. The god
Cupid, leaning back on his wings, dozes in a
pose that does not so much suggest sleeping in a
bed as it does a kind of peaceful relaxation on a
sofa. Psyche, his earthly beloved, holds up a
lantern to gaze upon his face. He has forbidden
her to see him. Her position on the couch of
Cupid hardly suggests the deceit and surrepti-
tious nature of her mission. All seems quite
lovely and relaxed – but we know that she is
about to spill the wax from her lamp and
awaken him. Once he discovers her looking at
him, he disappears.

Relaxation, tranquillity, and peacefulness are
elements found throughout European art (and
literature) in the eighteenth century. The enjoy-
ment of art involved no struggle, just as the
subjects of that art were also at ease. This indo-
lence and peacefulness of our being in the world
is a remarkable vision, so different from the
spectacle, and sometimes the horror, of the
Baroque vision.

1.23 CHARLES-JOSEPH
NATOIRE,
Cupid and Psyche, 1738.
Spandrel painting.
Hôtel de Soubise, Paris.

Great Rococo art often
appears so effortless that
the skill of the artist is
not always appreciated.
Here Natoire has man-
aged to turn the appar-
ently awkward shape of
the framing to advantage,
emphasizing the contrast
between the languid body
of the sleeping Cupid
and the angular tension
of Psyche.

1.22 (*opposite*)
GIOVANNI BATTISTA
TIEPOLO,
*Rinaldo and Armida in
Her Garden*, 1742.
Oil on canvas,
6 ft 1½ in x 8 ft 6¼ in
(1.87 x 2.6 m).
Art Institute of Chicago.

This was a popular
story among eighteenth-
century artists, and the
composer Haydn based
an opera on it. Tiepolo
emphasizes the central
themes – pleasure versus
duty, romance versus
religion – by contrasting
soft, flowing drapery and
lush colors with firm lines
and regular geometric
shapes.

Conclusion

In this first chapter we have explored the range of subjects and attitudes typical of Baroque and Rococo art. But we have also touched on the importance of the audience. When writing about the Baroque and Rococo, we should keep in mind the roles and reactions of beholder and participant. We do not experience the world directly, but must have some form of mediation. That is why we read, write, listen, look, pray, think, paint, sculpt, build – even sleep and dream. Today the media, travel, sports, and that growing area known as "leisure activities" mediates between us and reality. In the seventeenth and eighteenth centuries, the visual arts (along with other aspects of culture, and the pressing needs of daily life) provided much the same function. In a world that was seen as divinely organized, the visual arts reflected and refracted both that organization and social reality. The man and woman of the Baroque and Rococo recognized "texts" – paintings, statues, buildings – and came to understand his or her relation to the powers of the political, religious, and social systems.

We might be led to assume that Baroque power is primarily intimidating, and to a certain extent this is true at a place like the Palace at Versailles (see pp. 327–35). But the huge scale of the Basilica of St. Peter's in Rome, for instance (see pp. 82–3), is meant to welcome the worshipper, even as it occasions awe. One's exchange with a painting, a statue, or a location in the seventeenth and eighteenth century was more often than not comfortable, pleasurable, reassuring, and confirming. When looking at a Baroque or Rococo artwork, a citizen of those periods probably found something of himself or herself there, something about his or her identity, values, or being in the world, whether this was experienced consciously or unconsciously.

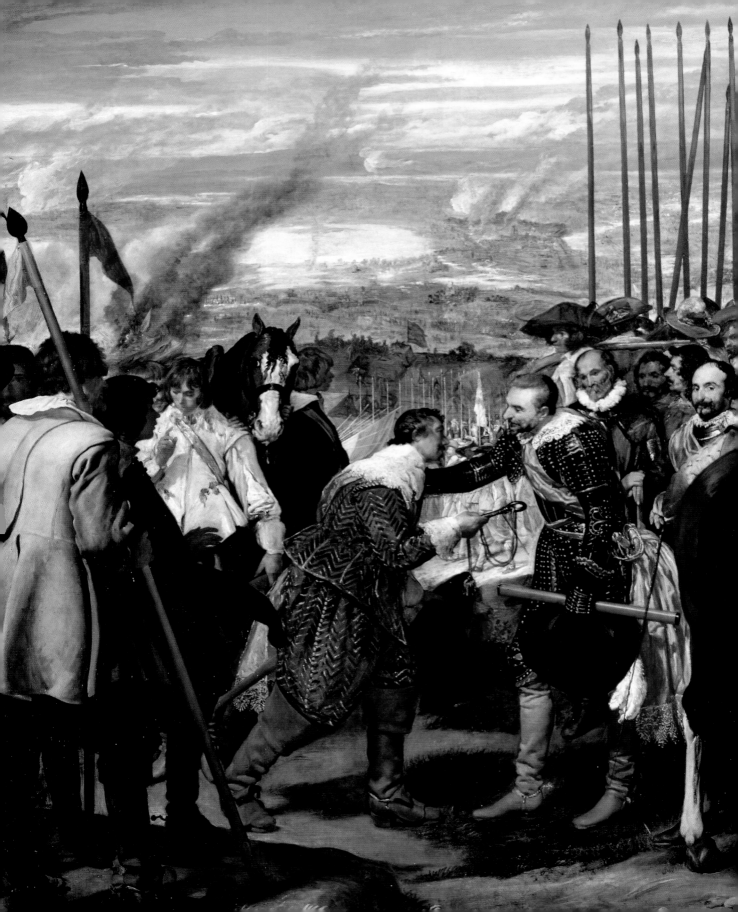

CHAPTER 2

Setting the Stage
SOCIAL, CULTURAL, & ARTISTIC
INSTITUTIONS

DIEGO VELÁZQUEZ,
The Surrender at Breda
(detail), 1634–5.
Oil on canvas,
10 ft 1 in x 12 ft
(3.1 x 3.16 m).
Museo del Prado,
Madrid.

The Spanish enjoyed a
short-lived victory over
the Dutch, when in 1625,
owing to a lack of provi-
sions, Justin of Nassau
ceded the city of Breda to
the Spanish commander
Ambrosio Spínola.
Velázquez emphasizes the
magnanimity of Spínola,
and further distinguishes
between the rag-tag
defenders of the town and
the aristocratic Spanish
soldiers. Spain could
not hold the rebellious
Dutch, who finally won
their independence in
1648.

Setting the stage means literally to arrange, before the actors have taken their places, stage machinery – furniture, props, or scenery – in preparation for the raising of the curtain. In this chapter I plan to do what a stage manager does; that is, before bringing on the artists (the actors), their lives and their art, I want to set out the circumstances of the times and places where Baroque and Rococo art appeared. Although this chapter will recount some of the important political events of the times, its main interest is with what French historians call *la longue durée* – the long haul. It is those persisting attitudes and institutions, even as they are undergoing change, that determine much of a period's culture and the art it produced. What was it like to live and produce art in these centuries? What was it like to see the art? How did it affect one?

Europe in the Sixteenth & Seventeenth Centuries

After the voyages of discovery and conquest at the end of the fifteenth century, the sixteenth century saw European countries begin to dominate much of the world through colonization and the control of trade. The sixteenth century was also a time of profound religious, economic, and political upheaval. As David Hume, the Scottish philosopher, observed in 1757, the world of the 1500s was a time when "America was discovered: Commerce extended: the Arts cultivated: Printing invented: Religion reform'd: And all the Governments and Empire almost chang'd" (p. 200). He was describing those early years of the modern world which correspond roughly to the beginnings of the Baroque age.

In the early decades of the sixteenth century, the Augustinian monk and priest Martin Luther (1483–1546) challenged the authority of the Roman Catholic Church. Luther appealed to the Bible to claim that the only mediation between humans and God is Christ; the Church, he observed, had intervened and had reinterpreted in self-serving ways the original message of Jesus and the Bible. Not only did he find the theology of the Roman Church wrong-headed, he decried the Church's corrupt practices, particularly the selling of indulgences (pardons for sins). In 1517 he nailed his Ninety-five Theses against this practice to the door of the church in Wittenberg. He was excommunicated in 1521, but his demands for reform spread – aided by the invention of the printing press – and influenced other reformers in Western and Central Europe such as Jan Hus, Huldrych Zwingli, and John Calvin. This movement culminated in the Protestant Reformation, which opened the door to new intellectual and political developments and shattered the unity of Catholicism in Western Europe. The Roman Catholic Church responded to the Protestant challenge by calling the Council of Trent (1545–63); here they attempted to come to terms with some aspects of modernity by remedying numerous abuses.

The rise of powerful monarchies in France, England, and Spain in the sixteenth century resulted in part from the confused social and sometimes anarchic conditions of the previous centuries. France and England had been locked in the Hundred Years' War until 1453, and in England there were other disturbances, such as the Wars of the Roses and popular rebellions. The King of France and the Holy Roman Emperor, in contention with one another, invaded Italy on more than one occasion.

During the early modern period, monarchs sought to centralize their power and assert more authority over local lords. The medieval economic system of manorialism, which depended upon a fairly stable relationship between lords and vassals, gradually broke down. Under this system lords had allowed peasants to till the land on their estates in return for services and taxes and certain rights over what was produced. Increasing monarchical control, higher taxes, and a growing population led peasants to leave the countryside for the cities. This migration led to the rapid growth of many cities, such as Naples, Paris, and London, during the second half of the sixteenth century.

This growing urban population, dependent upon the more efficient cultivation of the surrounding countryside for their food, turned increasingly to mercantilism – the production and distribution of goods on a large, sometimes international scale. The French term *bourgeoisie* describes this rising middle class who were active in commerce and industry. In the seventeenth century, the British writers Thomas Hobbes and John Locke, recognizing the importance of the new manufacturing classes, promoted ideas of self-interest and a social compact that exists to protect the rights – especially the property rights – of individuals. There were other changes in how work was done and how money was controlled. The power of the medieval guilds of merchants and artisans declined somewhat as manufacturers "put out" certain kinds of work, such as the finishing and dying of wool, to peasants and others hired by the hour or by the piece of work. Certain industries, such as printing, shipbuilding, and mining, were by their nature international and dependent on huge capital investments. In order to assure the free flow of money, local regulations and politics became less important, or were bypassed altogether.

As cities and capital grew, as trade and exploration expanded, and as governments and institutions reformed, so artists too searched for new identity and prestige; the first academy of art was founded in Florence in 1563. Further academies were set up to educate artists in Bologna and Rome, and in the eighteenth century in Madrid, Paris, London, Düsseldorf, and Munich.

If the sixteenth century was a time of dramatic change, European society and culture in the seventeenth century was in a nearly perpetual state of crisis. The rival religious claims following the Protestant Reformation became a reason for

armed combat; the first half of the seventeenth century witnessed the Thirty Years' War (1618–48) and other devastating conflicts between Catholics and Protestants. And there were severe social crises that did not break out in open conflict. Throughout the continent, the nobility asserted its position with increasing repression and aggressiveness. The "betrayal of the bourgeoisie" refers to the shrinking of an already modest middle class. The poor, whether on the land or in the cities, remained in their squalid condition, with little relief from their suffering.

Much of the crisis resulted from rigid social schemes that allowed for little change. Baroque society was absolutist by nature, whether that absolutism was monarchical or ecclesiastical. During the seventeenth century and well into the eighteenth, rulers who believed they held their power by divine right, directly from God, settled local wars, unified their states, centralized administration, created a degree of peace, and helped create national identities. The Spanish crown, however, could not manage its finances. Louis XIV of France entered into fiscally disastrous wars at the end of the seventeenth century, as did the Dutch. The Catholic Church continued to lose authority throughout the seventeenth and eighteenth centuries. The English monarchy suffered too; indeed, King Charles I was beheaded by an Act of Parliament in 1649, ultimately as a result of his absolutist demands that his subjects pay for military expenses and that Parliament acquiesce with his orders.

All the collisions, the violence, and the shocks of the seventeenth century took their toll and impressed themselves upon the art of the times.

Italy: the Papacy & the Church

Pre-Baroque Italy

At the beginning of the Baroque age, Italy was a loose arrangement of duchies, cities, and territories under various forms of foreign and domestic rule. Charles VIII, King of France, and Charles V, the Holy Roman Emperor as well as King of Spain (where he was known as Charles I), invaded Italy in the late fifteenth and early sixteenth century. The Spanish took control of Lombardy in northwestern Italy, the island of Sicily, Naples, then the largest city in Europe, and the island of Sardinia. These cataclysmic events were widely seen as divine punishment for Italy's cosmopolitan and affluent ways. The "calamities of Italy," as they were called by the contemporary historian Francesco Guicciardini, demonstrated the precarious position of Italy in the face of hostile foreign forces (often assisted by Italian soldiers of fortune) and the peninsula's own lack of unity. The French and Spanish monarchies, and that loose assembly of German territories known as the Holy Roman Empire, were growing rapidly in power and organization and the Italians, once relatively safe because of their strong local armies and the disarray of the rest of Europe, were now vulnerable.

Later, the Reformation begun by Luther and the Counter-Reformation launched in reply by the Roman Church aided Italy by dividing German princes into opposing Protestant and Catholic camps, but not before Imperial troops had entered and occupied Rome in 1527 and captured Florence in 1530. In Florence, the Empire ended the republic and restored the Medici (who became Dukes and later Grand Dukes of Tuscany). In Rome, the pope suffered humiliation. In tradition and theory, the Holy Roman Emperor as leader of the secular arm of the Roman Catholic Church was crowned by the pope and served him. Now the pope was virtual prisoner to the emperor. Nearly a decade later, in 1536, Charles V marched again through Italy, this time northward after a decisive battle against the Turks in Tunisia. Pope Paul III, fearing another sack of Rome, attempted to assuage the Emperor by arranging an imperial reception for him. Not since antiquity had there been an emperor accorded such a triumphal entry into the Eternal City.

One of the effects of these incursions in the sixteenth century was, ironically enough, the creation of a stronger sense of Italian identity. Machiavelli called for an Italian voice; the poet

Trial before the Holy Tribunal

THE MINUTES OF THE session of the Inquisition Tribunal of Saturday, the 18th of July, 1573. Today, Saturday, the 18th of the month of July, 1573, having been asked by the Holy Office to appear before the Holy Tribunal, Paolo Caliari of Verona, domiciled in the Parish Saint Samuel, being questioned about his name and surname, answered as above.

Questioned about his profession:
Answer. I paint and compose figures.
Question. Do you know the reason why you have been summoned?
A. No, sir.
Q. Can you imagine it?
A. I can well imagine.
Q. Say what you think the reason is.
A. According to what the Reverend Father, the Prior of the Convent of SS. Giovanni e Paolo, whose name I do not know, told me, he had been here and Your Lordships had ordered him to have painted [in the picture] a Magdalen in place of a dog. I answered him by saying I would gladly do everything necessary for my honor and for that of my painting, but that I did not understand how a figure of Magdalen would be suitable there for many reasons which I will give at any time, provided I am given an opportunity.
Q. What picture is this of which you have spoken?
A. This is a picture of the Last Supper that Jesus Christ took with His Apostles in the house of Simon.
Q. Where is this picture?
A. In the Refectory of the Convent of SS. Giovanni e Paolo. …
Q. At this Supper of Our Lord have you painted other figures?
A. Yes, milords.
Q. Tell us how many people and describe the gestures of each.
A. There is the owner of the inn, Simon; besides this figure I have made a steward, who, I imagined, had come there for his own pleasure to see how the things were going at the table. There are many figures there

which I cannot recall, as I painted the picture some time ago. …
Q. In this Supper which you made for SS. Giovanni e Paolo, what is the significance of the man whose nose is bleeding?
A. I intended to represent a servant whose nose was bleeding because of some accident.
Q. What is the significance of those armed men dressed as Germans, each with a halberd in his hand?
A. This requires that I say twenty words!
Q. Say them.
A. We painters take the same license the poets and the jesters take and I have represented these two halberdiers, one drinking and the other eating nearby on the stairs. They are placed here so that they might be of service because it seemed to me fitting, according to what I have been told, that the master of the house, who was great and rich, should have such servants.
Q. And that man dressed as a buffoon with a parrot on his wrist, for what purpose did you paint him on that canvas?
A. For ornament, as is customary.
Q. Who are at the table of Our Lord?
A. The Twelve Apostles.
Q. What is St. Peter, the first one, doing?
A. Carving the lamb in order to pass it to the other end of the table.
Q. What is the Apostle next to him doing?
A. He is holding a dish in order to receive what St. Peter will give him.
Q. Tell us what the one next to this one is doing.
A. He has a toothpick and cleans his teeth.
Q. Who do you really believe was present at that Supper?
A. I believe one would find Christ with His Apostles. But if in a picture there is some space to spare I enrich it with figures according to the stories.
Q. Did anyone commission you to paint Germans, buffoons, and similar things in that picture?
A. No, milords, but I received the commission to decorate the picture as I saw fit. It is large and, it seemed to

2.1 Paolo Caliari (Veronese), *Feast in the House of Levi*, 1573. Oil on canvas, 18 ft 3 in x 42 ft (5.56 x 12.8 m). Accademia, Venice.

me, it could hold many figures.

Q. Are not the decorations which you painters are accustomed to add to paintings or pictures supposed to be suitable and proper to the subject and the principal figures or are they for pleasure – simply what comes to your imagination without any discretion or judiciousness?

A. I paint pictures as I see fit and as well as my talent permits.

Q. Does it seem fitting at the Last Supper of the Lord to paint buffoons, drunkards, Germans, dwarfs and similar vulgarities?

A. No, milords.

Q. Why did you do it then?

A. I did it because I supposed these people were outside the room in which the supper took place.

Q. Do you not know that in Germany and in other places infected with heresy it is customary with various pictures full of scurrilousness and similar inventions to mock, vituperate, and scorn the things of the Holy Catholic Church in order to teach bad doctrines to foolish and ignorant people?

A. Yes, that is wrong, but I return to what I have said, that I am obliged to follow what my superiors have done.

Q. What have your superiors done? Have they perhaps done similar things?

A. Michelangelo in Rome in the Pontifical Chapel painted Our Lord, Jesus Christ, His Mother, St. John, St. Peter, and the Heavenly Host. These are all represented in the nude – even the Virgin Mary – and in different poses with little reverence.

Q. Do you not know that in painting the Last Judgment in which no garments or similar things are presumed, it was not necessary to paint garments, and that in those figures there is nothing that is not spiritual? There are neither buffoons, dogs, weapons, or similar buffoonery. And does it seem because of this or some other example that you did right to have painted this picture in the way you did and do you want to maintain that it is good and decent?

A. Illustrious Lords, I do not want to defend it, but I thought I was doing right. I did not consider so many things and I did not intend to confuse anyone, the more so as those figures of buffoons are outside of the place in a picture where Our Lord is represented.

After these things had been said, the judges announced that the above named Paolo would be obliged to improve and change his painting within a period of three months from the day of this admonition and that according to the opinion and decision of the Holy Tribunal all the corrections should be made at the expense of the painter and that if he did not correct the picture he would be liable to the penalties imposed by the Holy Tribunal. Thus they decreed in the best manner possible.

(Elizabeth Holt, *A Documentary History of Art*, vol. II, New York: Doubleday & Company, Inc., 1958, pp. 66–70)

Ludovico Ariosto and the writer and courtier Baldassare Castiglione (see FIG. 6.1) wrote in the now (more-or-less) official Tuscan Italian. Italian manners swept European courts, while humanistic education, with its emphasis upon the values of Latin and classical literature, dominated much of European instruction. The emergence of an Italian identity was not lost on the Church and noble patrons of art. In fact, the bourgeoisie, which had become relatively prosperous in the fifteenth and sixteenth centuries, turned from commerce to art. With merchants and bankers paying less attention to commerce and more to high culture, this growing "aristocratization" augured well for the visual culture but not so well for the Italian economy. Nonetheless, Church income, which exceeded state income in the period, allowed Rome to remain a fairly comfortable city, even for the poor. But first the Church had to sort out some difficult matters of doctrine and organization.

THE COUNCIL OF TRENT

Throughout the middle decades of the sixteenth century the papacy was embroiled in the political quandaries and quarrels of the Council of Trent (FIG. 2.2). The purposes of the Council were manifold: to correct the corruption not of power but of certain "disciplines" (practices) of the Church, and to propound, certify, and reassert the Church's position on matters of doctrine in the light of Luther's revisionist theology. But just getting underway proved difficult. The French king, Francis I (r. 1515–47), worried that a major church council would benefit the Habsburgs, who not only were the royal family in Spain – and therefore rivals – but also were the family of the Holy Roman Emperors. In his concern over the balance of power in Europe, Francis feared anything that might benefit the emperor Charles V (r. 1519–56). The popes were no great lovers of councils either, since an ecu-

2.2 PASQUALE CATI DA IESI, *The Council of Trent*, 1588. Fresco. Chapel of Cardinal Marco Sittico Altemps, Santa Maria in Trastavere, Rome.

menical (universal) council might question papal infallibility. Nonetheless, there were three sessions to the Council (1545–7, 1551–2, and 1562–3) during the papacies of three different popes before Pope Pius IV (r. 1559–65) ratified the decrees in 1564.

Although the Council outlawed the sale of indulgences, this was not to be of great consequence in the cultures of the Baroque and Rococo. Far more important was the increase in the power of the pope, that vigorous leader typical of the Baroque age, who now ruled as a monarch. This was an ironic and unexpected development from the conciliar movement, which was based in part upon the idea that Church councils were supreme and that the pope had to accept their dictates. But Pius IV was an artful politician and administrator. Because many of the details of reform were left undecided at the end of the final session, it remained for Pius to prepare the formulation that would henceforth be known as the Tridentine Decrees. This he did in his bull (a papal edict, from the Latin word for seal) *Benedictus Deus* (1564). He diminished the authority and size of the College of Cardinals, but doubled the admin-

istrative staff so as to make his autocratic rule all the more efficient. One immediate consequence of the increase in papal power and authority was military in nature. The next pope, Pius V, helped to direct the Holy League – a coalition of the great fleets of Genoa, Spain, Venice, and the Papal States – in their defeat of the Ottoman Turks at the Gulf of Lepanto in October 1571. This was the first time that Christian forces had been able to check the immense power of the Ottoman Empire. Although the Turks soon rebuilt their navy, the Pope could exult in his victory. That very power and exhilaration of the Roman Church accounts for much of the artistic production of the seventeenth century.

As we can read in the edicts of the Council, the Roman Catholic Church defended the use of sacred images. The last official statement by the Church on this matter had been the condemnation of the iconoclasts – those who destroyed sacred images in the belief that they were idols (FIG. 2.3) – at the Second Council of Nicaea in 787. According to the twenty-fifth session of the Council of Trent, because saints intercede for us by praying to God on our behalf, their images

2.3 FRANS HAGENBERG, *The Iconoclasm*, 1566 (showing events of 20 August 1566 in Antwerp). Engraving, 8¼ x 11 in (21 x 28 cm). British Museum, London.

The Council of Trent warned against the destruction of images, as shown in this Dutch Protestant engraving. The Council wrote, in part, that "Bishops should teach with care that the faithful are instructed and strengthened by commemorating and frequently recalling the articles of our faith through the expression in pictures or sacred images ... "

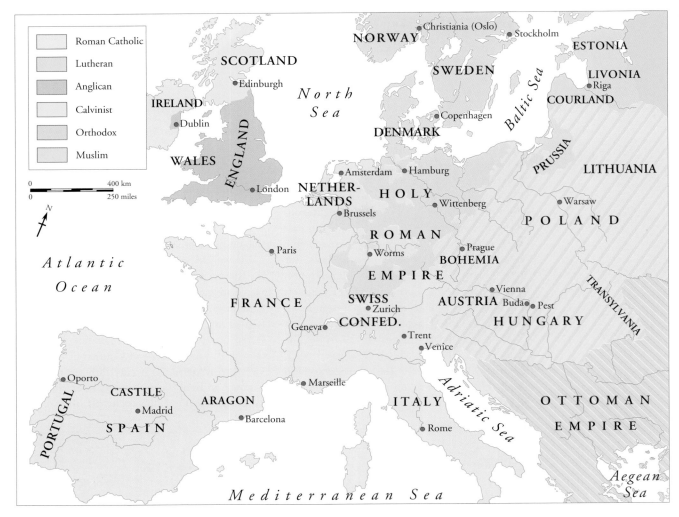

The map legend contains the following:

- Roman Catholic
- Lutheran
- Anglican
- Calvinist
- Orthodox
- Muslim

0 400 km
0 250 miles

N

Map labels include:

Christiania (Oslo), Stockholm, NORWAY, ESTONIA, SCOTLAND, SWEDEN, LIVONIA, Riga, Edinburgh, North Sea, COURLAND, IRELAND, DENMARK, Copenhagen, Baltic Sea, PRUSSIA, LITHUANIA, Dublin, ENGLAND, WALES, Amsterdam, Hamburg, Wittenberg, Warsaw, London, NETHER-LANDS, HOLY, POLAND, Brussels, ROMAN, Prague, Atlantic Ocean, Paris, Worms, BOHEMIA, EMPIRE, Vienna, TRANSYLVANIA, FRANCE, SWISS, AUSTRIA, Buda, Pest, Zurich, CONFED., HUNGARY, Geneva, Trent, Venice, Oporto, Marseille, ITALY, Adriatic Sea, OTTOMAN, CASTILE, ARAGON, EMPIRE, Madrid, Rome, PORTUGAL, Barcelona, SPAIN, Aegean Sea, Mediterranean Sea

(and relics) are appropriately "invoked" (called upon, prayed to) so as to provide aid and blessings. We are to honor the images of Mary, Christ, and the saints; we are to go down upon our knees and to give adoration to these images, not because they are idols but because they refer to "the original which they represent." The devoted are instructed by such images, reminded of the stories and articles of faith, miracles, and grace of God. And if anyone disagrees with this, "let him be anathema." There also is the warning that the unschooled must be defended against superstition, and that there should be no "base profit" or "sensual appeal" in these images: there should be nothing "disorderly," "exaggerated," "riotous,"

"unseemly," or "profane." Given that Baroque artists are not infrequently boisterous and unrestrained, if not precisely "riotous," one wonders at how few were found in violation of the Church's decrees. The Jesuits especially championed a form of devotion that called upon so many theatrical devices to move and persuade the worshipper that there hardly could be any criticism of exaggeration or even sensual appeal, so long as these appeared to be in the service of the Church. Because their main concern was matters of faith expressed in political actions and writings, it was unusual for the Office of the Inquisition to bother with artists and their works. The overwhelming majority of artists was left alone.

THE REFORMATION IN EUROPE
The sixteenth century saw a tide of religious reform sweeping through Europe that changed the political map. The early commitment of most of northern Europe to Calvinism, Lutheranism, or Anglicanism was counterbalanced by the recovery to Catholicism of France and Poland. Counter-Reformation zeal, as seen at the Council of Trent, culminated in the Thirty Years' War (1618–48).

One artist who was not so lucky was Paolo Caliari of Verona, better known as Veronese (1528–88), a Renaissance painter whose style anticipates the Baroque. The Holy Office, or Office of Inquisition, greatly strengthened as a result of the deliberations and decrees of the Council of Trent, kept the artist in line by forcing him to defend his painting of the Last Supper (FIG. 2.1) (see box, pp. 44–5). Veronese's transgression was that he had assumed a kind of artistic license in fleshing out his picture of the Last Supper with a number of entertaining but wholly superfluous – as the Holy Office saw it – individuals. He made an ingenious move: instead of changing the picture, he renamed it *Feast in the House of Levi*, a scene perfect for the inclusion of indecorous, unseemly, and vulgar figures. When Christ went to the house of Levi for dinner, he was accompanied by tax collectors and sinners. When he was criticized for the company that he kept that evening, Christ responded, "Those who are well have no need of a physician, but those who are sick; I have come to call not the righteous, but sinners."

Most artists, writers, and intellectuals avoided censure by the Church or other absolutist regimes. Because the arts and literature were the only areas in which a degree of freedom was possible, their energy was all the greater.

ROME

The city of Rome was undergoing many changes in the later sixteenth century. Before the Council of Trent, Rome's reputation as a religious city was almost literally fetid. One Christian spoke of Rome as "the bilgewater and sewer of every disgraceful deed." By the reign of Pope Sixtus V in the 1580s, one writer was moved to observe: "But what about the city of Rome? How great is the pristine splendor she seems to be restored to? Do we not see this in her new fountains and basilicas …?" According to an orator in 1591, by driving straight avenues through the city and creating stately vistas, Sixtus enabled everyone to see "the most holy testimonies of our redemption and the images of the founders of the Apostolic See." Sixtus wanted these sights to "animate the sacred images that he carried within his heart. And he especially rejoiced if ever the same thing should happen to us when we traveled throughout the city."

Sixtus V wanted Rome to be a showpiece for Catholic renewal; he set up ministries known as Congregations to oversee the maintenance of roads and aqueducts. Employing the architect Domenico Fontana, he developed a master plan for the city. The major pilgrimage churches were connected by a network of boulevards, which joined the hills and valleys of Rome by a modern street system.

The ancient Romans had brought obelisks from Egypt as symbols of conquest and as markers for stadiums and city squares. Sixtus had these broken, nearly forgotten obelisks dug up and re-erected as terminal points of the major thoroughfares everywhere in his modern Rome – once again as symbols of power and conquest, but this time celebrating the triumph of the Church over pagan Rome (FIG. 2.4). Using a complex system of tunnels and aqueducts, Sixtus' engineers reconstructed the Aqua Felice (named after the pope, Felice Peretti),

2.4 DOMENICO FONTANA, *Transporting the Vatican Obelisk*, 1590. Engraving.

2.6 NICOLA SALVI,
Trevi Fountain, Rome,
1732–62.

Built against the wall of
the Palazzo Poli, the Trevi
Fountain is fed by one of
Rome's ancient aque-
ducts, the Aqua Vergine.
Salvi created a stage set
that combines a palace
front and a triumphal
arch. Neptune, flanked
by allegorical figures of
health and fertility,
stands on top of a shell,
celebrating the fresh
water that nourishes the
city of Rome.

which brings water from the town of Praeneste,
outside of Rome (FIG. 2.5). As with so much
else in the Baroque, a practical and technical act
of enlightened civic government – increasing
the water supply – resulted in artistic expres-
sion. The fountains of Rome, especially Gian-
lorenzo Bernini's Fountain of the Four Rivers in
Piazza Navona (see FIG. 8.14) and the Trevi
Fountain (FIG. 2.6) celebrate the life-giving and
refreshing attributes of so common an element
as water.

By the end of the eighteenth century, Rome
contained more than 300 grand palaces and
nearly 350 churches – a remarkable show of
dignity, abundance, and luxury, and a signifi-
cant accomplishment in a city whose popula-
tion increased from about 100,000 to only
150,000 during the Baroque age. Although pri-
vate living quarters tended to be very small,
public space – streets, piazze, churches, and the
palaces whose doors and courtyards often stood
open – was generous. In Rome's mild climate,

residents spent much of their time out of doors.
Street shrines, ancient and modern public stat-
ues, and paintings in the palaces and churches
were in such profusion as to be a part of one's
normal experience. (For further detail on the
urban development of Rome, see Chapter 8.)

PATRONAGE

The Church had been a good patron of the arts
from its very beginnings. Now in the seventeenth
century, painting, architecture, and sculpture
had reached new heights of prestige and served
the interests of a class of rich noblemen as well as
the papal family. Nobles understood the impor-
tance of art to their status, and so often amassed
great collections of paintings, statues, medals,
and curiosities. Papal nephews and their
entourage realized that their fortunes would be
relatively short-lived (lasting only as long as the
pope lived), so they collected art with a greed
and impatience not seen in earlier times.

2.5 (*opposite*)
DOMENICO FONTANA,
Aqua Felice, Rome,
1585–8.

One of the most avid and unscrupulous collectors of art at the turn of the seventeenth century was Pope Paul V's nephew, Scipione Borghese (FIG. 2.7). He simply confiscated paintings or had them stolen. He wanted Raphael's *Entombment*, but it was in a church in Perugia, so he sent agents to remove it by night, causing a great uproar in that city. As his uncle was pope, he had full immunity. On another occasion, the painter Caravaggio (1573–1610), having murdered a tennis rival (see p. 164), requested a pardon for his crime from Paul V. To make certain of the deal, he sent two paintings, a *David with the Head of Goliath* and a *St. Jerome,* to Scipione. Apparently the artistic "tribute" worked, for the pardon arrived – though several days after Caravaggio's death. Scipione Borghese also discovered the talents of the young Gianlorenzo Bernini (whose father worked in the Villa Borghese), and employed him to make numerous statues for his new villa on the Pincian Hill.

Borghese's collection eventually grew to more than 1,700 paintings. A near rival was the Marchese Vincenzo Giustiniani, who filled his palace with more than 600 paintings and nearly 2000 ancient sculptures. He especially liked Caravaggio, and, with admirable discretion, kept the enigmatic and shocking *Love Conquers All* (see FIG. 5.6) behind a green curtain.

Toward the middle of the seventeenth century, the patronage of Pope Urban VIII (Maffeo Barberini) made Rome the European center for the arts. Even before his elevation to the papacy, Barberini had amassed a famous collection of paintings. As pope he could command anyone to work for him. He appointed Bernini (somewhat to Scipione Borghese's chagrin) the architect of St. Peter's and kept him busy throughout his pontificate. In the building of his urban "villa," the Palazzo Barberini (see FIGS. 8.7, 8.8), he employed legions of painters, sculptors, and architects. Everyone of any artistic note had employment during Urban's reign. Pietro da Cortona (1596–1669) painted the ceiling of the main room of Urban's palazzo (see FIG. 4.32) with an immense and abstruse allegory of Urban's personal and ecclesiastical triumph. Bernini, Carlo Maderno (1556–1629), and Borromini worked on the construction of the building itself. And in St. Peter's, Bernini employed as many as 100 assistants, many of them well-established artists – including his own father, a sculptor – for the furnishing of the cavernous building.

In the eighteenth century, the political fortunes of the Catholic Church and the papacy deteriorated, while Rome's literary, cultural, and artistic fortunes continued and in some cases rose. Although Rome had less of a say in the contemporary world of European politics, it maintained its authority as a city of great tradition and culture. The refurbishing of ancient monuments and the restoration of more recent church buildings, along with some urban renewal throughout the eighteenth century, served to glorify the identity and righteousness of the Roman Catholic Church and Rome as a place of near majesty. The papacy stood for permanence and endurance; as the worldly kingdom shrank, the heavenly kingdom endured.

Although patronage of contemporary Italian artists in the eighteenth century could not match

2.7 (*left*)
GIANLORENZO BERNINI, *Portrait of Scipione Borghese* (detail; see also back cover), 1632. Marble, lifesize. Borghese Gallery, Rome.

The shrewd Cardinal turns his head and opens his mouth as if to speak to someone who has just entered the room. Through the shifting patterns of drapery, a button slipping open on his *mozzetta*, and his keen eyes with their deeply drilled pupils, Borghese comes alive and engages us in our own space and time. Renaissance portrait busts rarely broke free of the artistic sphere and spoke to the living.

2.8 (*opposite*)
FILIPPO DELLA VALLE, *Monument to Innocent XII*, 1743. Marble, over-lifesize. St. Peter's, Rome.

Seventeenth- and eighteenth-century papal tombs invariably show the pontiff enthroned above his own coffin, flanked by two or more cardinal virtues (in this case Justice and Charity).

One of the purposes of such tombs was to remind the faithful that although individual popes die, the papacy, as an institution, lives on. The papal monument also underscores the magesterium, which is the traditional role of teaching by popes and the Church.

what went on in the seventeenth century – especially during the reign of Urban VIII – the process of maintaining the city's ancient buildings and filling its churches with statues and paintings kept the artistic community alive, if not rich. Innocent XII (r. 1691–1700; FIG. 2.8) in his brief papacy enacted one reform that was to have a profound impact upon artists. In his bull *Romanum decet pontificem* (1692) he outlawed nepotism, a practice – already condemned

at the Council of Trent – that may have been an abuse of power but that was generous to artists. It is somewhat ironic that Innocent's own nephew paid for an elaborate monument for the pope – when all Innocent wanted was a simple plaque – nearly a half century after his death.

Like powerful men, women patronized the visual arts for the purpose of promoting status, identity, and religious values. The Roman Catholic Church provided an opportunity for a number of women who either had substantial money or were connected with noble families or members of the ecclesiastical hierarchy. For example, as Carolyn Vallone has shown, women patrons took an active part in the promotion of Catholic reform and the renovation of Rome's Quirinal Hill in the later sixteenth century. Pope Sixtus V's sister Camilla Peretti convinced the Pope to hand over the abandoned church of Santa Susanna to a newly formed group of Cistercian nuns. She supervised and paid for restorations to the interior of the church (Carlo Maderno – see pp. 82–3 – was later to build a new façade), expanded an attached convent, and provided dowries for young girls entering the order.

Furthermore, wives and mothers of sovereigns saw to it that their husbands were remembered and their sons encouraged in their rule. We will see in Chapter 6 (pp. 219–21) that Marie de' Medici, wife of the king of France, Henry IV, commissioned paintings from Peter Paul Rubens in order to glorify her part in her husband's reign. In an act of devotion, Anne of Austria, wife of Louis XIII (the son of Marie) directed François Mansart to build the church of Val-de-Grâce at the place where she conceived the future king Louis XIV (see FIGS. 3.26–28).

ITALIAN ACADEMIES

As the visual arts became an important cultural and professional category in the Renaissance, and as artists outgrew the guild system, they sought new forms of association. The academy, with the prestige of the name and its humanistic associations via Plato's Academy in Athens, seemed the logical structure. Artists preferred an

2.9 GIOVANNI BATTISTA BONZI, *Academy*, n.d. Red chalk, 8½ x 14¼ in (21.7 x 37.5 cm). Staatliche Kunstakademie, Düsseldorf.

The seated men who are deeply involved in their sketching are identified as the three Carracci, Guido Reni, Giovanni Lanfranco, and Domenichino.

academy to a guild for several reasons. Not only did they see themselves as more illustrious when belonging to an academy, they also saved a lot of money and had considerable personal freedom. The guilds charged hefty fees and forced artists to conform to strict standards.

The guilds of the late middle ages not only restricted artistic autonomy, but they were associations of *workers*, those who lived by the production of their hands rather than their minds. At least since the time of Leonardo da Vinci (1452–1519), artists had prided themselves on their knowledge of scientific and humanistic subjects, the former including perspective, anatomy, light, color, and proportions, the latter including a knowledge of the Bible, mythology, legends, and literary history. Artists knew the old stories and how to put them into visual form. That translation from word to image required that an artist learn the tools of the trade and have some sense of rhetoric, the art of communication. Beyond these curricular matters, humanism was a philosophy of life, a concept of the worth and dignity of the individual. Through a liberal education one grew in virtue and self-realization, and took an important place in society. Guilds were not schools, and could not educate artists in this new and civilizing manner.

The first modern artistic academy, the Accademia del Disegno (Academy of Design) in Florence, was founded in 1563. The very name of Florence's first art academy put the practice of

design to the fore. First of all, **disegno** has something to do with an artist's ideas or creative capacity. The artist was regarded as already having an image in mind, something as yet incomplete and somewhat vague, drawn from years of experience observing the world and making art. That image is the *disegno interno* – the internal design – and cannot be taught. What can be conveyed through an academic setting, however, is the way *disegno* is conceived as an external design or structure. How the idea gets from inside to outside is suggested by the other meaning of *disegno* – drawing. An artist's sketch brings forth an original idea, usually based upon a model, straight from his creative mind. From this drawing, larger constructs can emerge. Composition, involving the arrangement of all the elements or objects in a painting, statue, or building, is the crystallization of design. *Disegno*, then, forms an important and central element in the academic curriculum.

The brothers Annibale and Agostino Carracci (1557–1602), along with their cousin Ludovico (1555–1619), founded the first of the Italian Baroque academies in Bologna in 1582. Its name, the Accademia degli Incamminati – literally the academy of "those on the go" – derives from the current university vocabulary describing students well on their way in the *corso di perfezionamento*, the course of improvement. The academy as originally constituted combined formal study, including drawings from live models (FIG. 2.9), with artistic theory.

Agostino and Annibale moved to Rome in 1595, leaving Ludovico to maintain the family's academy. Realizing that he needed to join with a larger institution, he sought association with the Compagnia dei Pittori, the guild of painters in Bologna, but not until he could change its title and give it the name of academy. He failed: the Company fell into bankruptcy early in the seventeenth century, probably from mismanagement of funds and the allure of Rome for the best Bolognese artists.

Ludovico Carracci's model for an art academy was that of the Academy of St. Luke in Rome. It had been founded in 1593, based in part upon the belief expressed by Pope Sixtus V that "the fruits that spring from the study of the fine arts are pleasing to God, useful to the universal Christian republic, and nourishing to the souls of all the faithful." The first *principe* (an academy required someone of princely status as its leader), Federico Zuccaro, pronounced the need for theoretical discussion each day after lunch. He also proposed that visiting artists present lectures and teach for about one month each. Students were to study the relative merits of painting and sculpture, the meaning of *disegno*, the *affetti* or expression of human emotion through the movement of the body, decorum – which had to do with appropriate or decorous figures – and composition. Architecture too was to be taught and discussed. In addition to the lectures (which may not have been very religiously attended), students worked from plaster casts and live models.

As a sign of the establishment of the Academy, Pietro da Cortona, its *principe* in the 1630s, built the church of Ss. Luca e Martina, the artists' church of Rome (FIG. 2.10). The

2.10 PIETRO DA CORTONA, church of Ss. Luca e Martina, Rome, 1635–64.

While Cortona was rebuilding the original church of the Academy of St. Luke in order to provide space for his own tomb, the body of St. Martina was discovered. At that point, church officials decided that a much grander building was in order. The sense of spectacle and monumentality is achieved by a façade that rises in two full stories, with the outer piers seemingly anchoring a restless building that bulges in the center.

Academy met on a regular basis in rooms behind the church until early in the twentieth century, when a new building was chosen. It is perhaps a sign of shifting powers in the art world that by the second half of the seventeenth century, first a Flemish and then a French artist was nominated for the post of *principe*. By the middle of the seventeenth century there were as many as 100 members – a number which declined somewhat toward the end of the century but then held fairly steady in the eighteenth.

The Academy of St. Luke maintained a prize-giving throughout most of the Baroque and Rococo periods. So much of the practical training and theoretical instruction of the Academy was based upon the past, that its role in the present was not clear. By making a display of presenting prizes to young painters, sculptors, and architects, the Academy made a gesture toward the future. In 1750, Pope Benedict XIV held an especially lavish ceremony for the giving of prizes to young artists. He invited his fellow Bolognese Francesco Maria Zanotti to deliver an oration in praise of the fine arts. From the Capitoline Hill, Zanotti admired the virtues of the arts, and demonstrated how they were above other human pursuits. He claimed that "there could be neither art nor any discipline, which in the course of exploring its own subject did not meet beauty at every step. This the anatomists find in the structure of bodies, botanists in the tissues of plants, chemists in the elements of bodies, physicists in the laws of gravity and motion, astronomers in the disposition and revolution of the stars" (p. 720). But Zanotti was not just praising beauty – still an integral element in the visual arts – but the power of art to represent nearly anything, whether visible or invisible. He only wished that art could imitate art:

> O painting, O sculpture, ornament of the world, light and decorum of every noble studio, as a rare gift of Heaven, born among us to realize the beauty of the universe! You with your faithful companion architecture, imitating and making beautiful things, are yourselves even more beau-

tiful than what you make. O, if only one of your excellent artisans could paint you perfectly, and sculpt you, and represent you! How many passions would your images excite in the souls of men and how many flames would they ignite in the hearts of those who love you? (p. 723)

Spain, France, & England: Monarchy

By centralizing power and thereby creating a more orderly system of laws, banks, and trade, the new monarchies in the sixteenth and seventeenth centuries abetted the rise of capitalism; at the same time, these very governments were eventually weakened by the middle classes and their demands that government be more efficient, more accountable to a constitution or parliament, and less meddlesome in commercial affairs. Rule by a single and autonomous man or woman had been the most prevalent form of government for millennia. But the absolutism of these monarchs was something new in European history, and went far in determining the character of life and the cultivation of the arts throughout Europe.

Spain

For a while in the sixteenth century, Spain's empires were so vast – including as they did the territories of the New World – that some believed in the possibility of a world-wide government comparable in its glory and immensity to the ancient Roman Empire. Spain's pretensions to universality and world dominance, though short-lived, created a cultural climate ripe for the Baroque. .

The reign of Philip III (1598–1621) was marked both by Baroque opulence and economic decline. As much as he loved his festivals, Philip, the only surviving son of Philip II, also withdrew from the affairs of life and monarchy, and practiced a piety that was as intense as it was

EUROPE IN 1648
The Treaty of Westphalia (1648) brought to an end the ruinous Thirty Years War, which had pitted Protestant against Catholic nations. In the same year, after decades of debt and disaster, Philip IV of Spain was forced to grant independence to the northern Netherlands. The economic rise to power of the Dutch Republic, mostly through foreign trade, was one of the great phenomena of the seventeenth century. France, too, under Cardinals Richelieu and then Mazarin, neutralized the threat of the Spanish-Austrian Habsburg alliance. England, meanwhile, was in the grip of a civil war. This would culminate in the victory of Oliver Cromwell and the Roundheads and, in 1649, the execution of King Charles I.

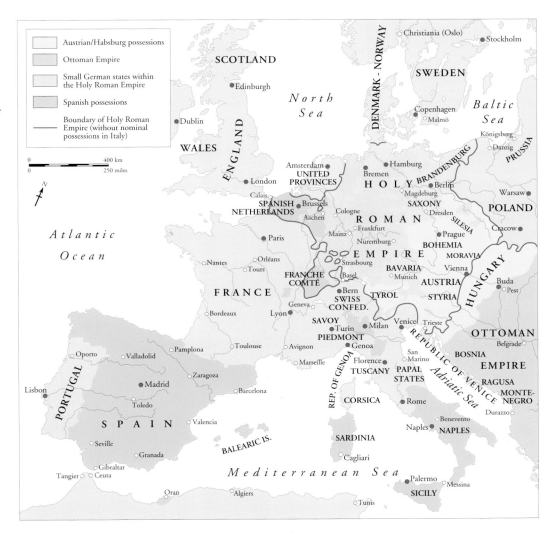

(according to contemporary and somewhat bitter reports) childish. He turned over nearly all responsibility for the running of the government to the Duke of Lerma, who was ousted in 1618 by his own son, the Duke of Uceda. Neither father nor son responded effectively to the growing sense of crisis. Although Spain remained outwardly powerful, its government was intransigent in the face of social ills, rigidly controlling society, politics, and the class system while the foundations of that society were being sapped. Spain spent an inordinate amount of money for maintenance of the court – which, of course, helped Baroque art to blossom – and on the military and

navy, which were essential to Spain's international dominance.

Before Philip II acquired Portugal in 1580, the two countries were rivals in their exploration and exploitation of foreign lands. In 1498 the Portuguese Vasco da Gama had navigated around Africa and arrived on the southwest coast of India. He returned there in 1502 with a fleet of fighting ships, realizing the strategic importance of an Asian trading port. Eventually the Portuguese established a trading empire from East Africa to Singapore and on to eastern Indonesia and the Spice Islands (known today as the Moluccas). To the west, Pedro

Alvares Cabral claimed Brazil for the Portuguese in 1500.

Christopher Columbus came in contact with the Caribbean Islands in 1492. In short order, the *conquistadores* followed Columbus. Cortés crushed the Aztecs in Mexico, as did Pizarro the Incas in Peru. In 1520 Magellan found a way around South America, sailed the Pacific Ocean, went on through the Indian Ocean, and finally to Spain. Within a relatively short period of time knowledge of the globe was hugely expanded, and the possibilities of trade on a grand new scale realized. By the middle of the sixteenth century, a vast silver mine was discovered in Potosì, Peru. The Spanish used the natives as forced labor and mined the silver, which kept the Spanish monarchy afloat for nearly a century.

The persecution of the Moriscos during the reign of Philip III was a calamitous development. The Moriscos were people of Islamic religion and Arabic language who, after the expulsion of the Moors from Spain in the previous century, largely converted to Christianity. Philip III, however, was dubious about their loyalty. Indeed, throughout the country there was suspicion of these people, who were perhaps the most industrious farmers and accomplished artisans in Spain. Beginning in 1609 and continuing for the next several years, the Moriscos were put to sea with whatever possessions they could bring along. Not only was this banishment a crime against humanity, it was economic suicide for Spain. For a country whose population already was declining (perhaps a quarter of a million fortune-seekers had left for the New World), to lose in this barbaric fashion 300,000 of its most productive citizens was a disastrous step, though typical of some of the misguided policies of the period.

During the reign of Philip IV (1621–65), Spain's power and prosperity continued to decline. Like his father before him, Philip IV handed over much of the government of the country to a trusted adviser, this time Gaspar de Guzmán, the Conde de Olivares. Count Olivares attempted to promote Spain's international position, but finally, melancholic and embittered, he

failed, primarily because Spain could not afford its foreign wars. Taxation had become unbearable for its citizens. Nor could Olivares maintain his position within a government where the centralization of power was undermined by revolts in Catalonia and Portugal, both countries refusing to supply soldiers for Spain's foreign wars. Olivares was overwhelmed by his enemies and finally abandoned by Philip IV.

The Image of Philip IV

As the Spanish economy shrank and the government continued its deficit spending, Philip managed to maintain an impressive court. Born in Valladolid, Philip ruled Spain (and until 1640, Portugal) from the age of sixteen until his death at sixty in 1665. Although not judged by historians as either an effective or vigorous leader, who in his long rule depended heavily upon prime ministers such as Olivares, his sense of kingship and glory was strong. In his palace of Buen Retiro, Philip directed that a huge room be erected and decorated with images of sovereignty and

2.11 DIEGO VELÁZQUEZ, *Equestrian Portrait of Philip IV*, 1634–35. Oil on canvas, 9 ft 10½ in x 10 ft 3½ in (3.01 x 3.14 m). Museo del Prado, Madrid

2.12 ANONYMOUS, *Equestrian Statue of Marcus Aurelius*, c. 165 C.E. Bronze with traces of gilt, lifesize. Capitoline Museum, Rome (shown here on its previous site in the Piazza del Campidoglio).

Although a unique example of an equestrian portrait surviving from antiquity, there were undoubtedly many of these erected in the cities of the Roman empire. Their purpose was to instill in the population a respect for command, authority, and bravery. Marcus Aurelius, wearing a military tunic and cloak, dominates his horse while gesturing to his troops. This type of portrait inspired many artists from the fifteenth through the nineteenth centuries.

empire. The Hall of Realms, as it was called, contained twelve large battle pictures, allegories of the Labors of Hercules that referred to the struggles of the Habsburg monarchy, and equestrian portraits of the royal family. Diego Velázquez (1599–1660) was put in charge of the equestrian portraits.

His *Equestrian Portrait of Philip IV* (FIG. 2.11) is part of a long tradition of rulers on horseback. The ancient Roman writer Pliny, who was read widely by artists and intellectuals from the Renaissance on, describes a painting of Antigonus on horseback by Apelles, the famous Greek artist in the service of Alexander the Great. Antigonus was a successor to Alexander and was noted for his military valor; Apelles painted him in profile (Antigonus had lost an eye in battle) and in full armor. In another famous example, Roman emperor Marcus Aurelius was shown astride his horse (FIG. 2.12); there was also a long tradition of images of Christian knights, such as St. George, displaying their power on horseback.

By minimizing the setting to a bush, some horizontal clouds, and a green landscape of foreground and far distance, Velázquez in his own painting was able to silhouette the King against the sky, and suggest that he was controlling his rearing horse at the crest of a hill. The tradition of a strict profile view has great antiquity; it was often used in ancient coins, for example, to represent the ruler. The King's beautifully plumed hat and black armor inlaid with gold provide royal accents to a portrait that in reality aspires to the status of an image of a saint, before which one is supposed to kneel in reverence.

FRANCE

France almost completely remade herself in the seventeenth century. The Wars of Religion (1562–98), a disastrous series of civil and religious conflicts, profoundly weakened the monarchy and left France exhausted and her culture

depleted at the end of the sixteenth century. But by the middle of the seventeenth century, under the magisterial statesmanship of the Cardinals Richelieu (1585–1642) and Mazarin (1602–61), France had modified every aspect of politics, religion, culture, art, and society.

After the assassination of Henry IV in 1610, his wife, Marie de' Medici (1573–1642), ruled France as regent during the minority of their son, Louis XIII (b. 1601). But the relation between mother and son was rancorous – just as it had been between Henry and Marie – and soon after Louis's marriage at age fourteen to Anne of Austria, daughter of Philip III of Spain, he exiled his mother to Blois and resisted several attempts on her part to reassume power (see p. 219 and FIG. 6.5). During Marie's reign, both the nobility and the French parliament maneuvered for a stronger political position. Louis, known as a devout and private man, did little to reverse the trend toward shared power, but in turning over the control of government to Cardinal Richelieu in 1624, he gave France a strong leader who brought the country into a position of international influence and restored many of the powers of the monarchy.

After a long and barren marriage, Anne of Austria, the wife of Louis XIII, conceived the future king of France in 1638. At the site of this conception, the cloisters of Val-de-Grâce, she commanded François Mansart (1598–1666) to build a church in commemoration of this unexpected but consequential event (see FIGS. 3.26–3.28). Her son, Louis XIV, came to maturity in 1661, assuming leadership upon the death of Mazarin. The Sun King ruled France somewhat in the guise or personhood of Apollo, the ancient Greek god of culture, civilization, and principles of rationality. It was indeed his awareness of play-acting, of using the symbols and images of kingship – especially that of Apollo – that gave him such miraculous authority. And it is his establishment of a Baroque court society that recommends him to art history as a king worth studying for his handling of images and the ritualization of daily life.

Louis XIV kept the aristocracy at Versailles as virtual prisoners within an intricate web of rela-

tionships and artifice. The court became the arbiter of taste, even if the French Royal Academy for Painting and Sculpture provided the theoreticians. Roger de Piles (1635–1709) wrote in 1702 about the *grand goût* (the highest taste in art) that

this *grand Gusto* in the Works of the Painters is the use of the choicest Effects of Nature, such as are Great, Extraordinary and probable. Great, because things are so much the less sensible to us, by how much they are little and divided. Extraordinary, because what is ordinary does not strike us, nor draw our attention. Probable, because 'tis requisite that these great and extraordinary Things should appear to be Possible, and not Chimerical. (Cited in Barasch, p. 346.)

He continued that the great taste or grand manner is "not to be accommodated to ordinary Things. A Mediocrity is not allowable but in the arts which are necessary for common use." And the arts of the court were anything but "common use." De Piles' articulation of a universal taste fits the ideology of Louis's court at Versailles, where the courtiers lived and dressed not so much as Frenchmen but as the nobility of Europe, as cosmopolitans, a class whose identity transcended a particular time and place. The architectural style of Versailles also fits that sense of the grand manner and internationalism (see also Chapter 8).

The Image of the King

Louis XIV used imagery as an important element in the machinery of propaganda. In 1704, when he was in his sixty-sixth year, Louis planned to pass on his (visual) legacy as the Sun King and first gentleman of the court to his grandson Philip V of Spain in the form of a portrait by Hyacinth Rigaud (1659–1743) (FIG. 2.13). In fact, Rigaud's ability to use his brush loaded with thick and richly colored pigments to render the lavish ermine-lined mantle worn by the King and the luxurious setting so impressed Louis' courtiers that they encouraged him to keep the

2.13 (*opposite*)
HYACINTH RIGAUD,
Portrait of Louis XIV,
1704.
Oil on canvas,
8 ft 1 in x 6 ft 4½ in
(2.77 x 1.94 m).
Louvre, Paris.

Rigaud positions two things on the cushioned stool next to Louis: Charlemagne's sword, called La Joyeuse, and the scepter with its Hand of Justice. These emblems, along with the numerous fleurs-de-lys, create an ambiance rich with regal messages.

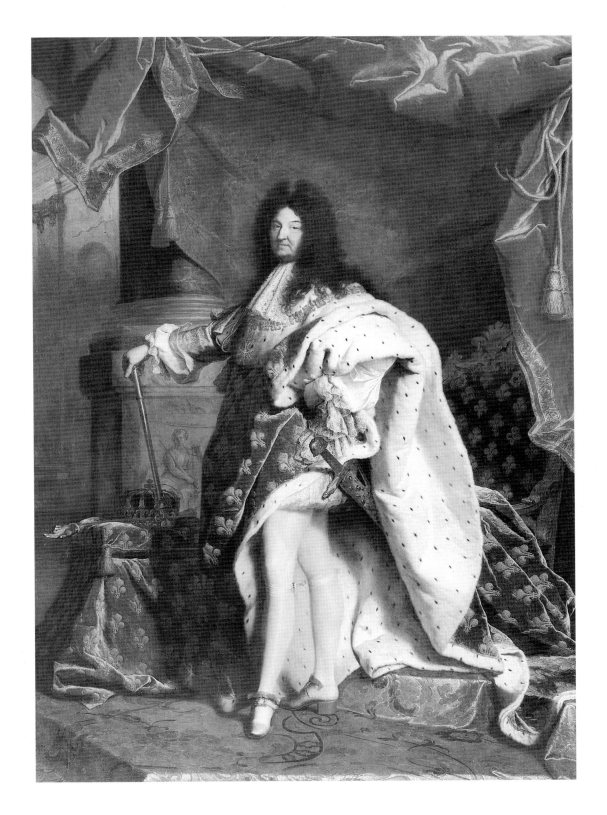

portrait. They and he understood the power of an image. Louis had maintained his near omnipotence in part at least because of his ability to play the part with regal aplomb. And whereas seventeenth-century philosophers debated the differences between appearance and reality, statesmen and princes realized that appearance *was* reality. As Louis, like the other leaders of the seventeenth and eighteenth centuries, pursued his absolutist policies (suspending the French parliament in the 1660s, for example), he realized that he was, quite literally, the "head" of state and that his physical appearance and surroundings must embody that status. In strengthening the state, Louis strengthened the social order, of which he was the apex.

By the middle of the eighteenth century, however, one finds portraits of lords and ladies in far greater profusion than images of monarchs. Absolutism was failing in France and Spain, and in Britain the divine right of kings was much reduced when William and Mary were imported from the Netherlands in 1688 as the sovereigns. Louis XV (r. 1715–74) found himself increasingly embattled on the international stage and threatened within France by a restive public and demands for fair taxation. Before his death in 1774 he prophesied "After me, the deluge." It was soon to come, in the form of the French Revolution.

The French Royal Academy

The Royal Academy (Académie Royale de Peinture et de Sculpture) was founded in 1648 but did not take its mature form until the 1660s. When Louis XIV took over as head of state in 1661, he appointed Jean-Baptiste Colbert (FIG. 2.14), Mazarin's protégé, as his chief adviser, Controller General of Finances, Secretary of State for the Royal Household, Superintendent of Public Buildings, and a key member of the French Royal Academy – elected as Vice-Protector in 1661 and Protector in 1672.

A contemporary said of Colbert that "it was not particularly that he loved artists and intellectuals; it was as a man of state that he protected

them, because he recognized that the fine arts alone are capable of forming and immortalizing grand empires" (Blunt, *Baroque …*, p. 123). Colbert took the arts in hand for the purpose of creating "la gloire" – the glory of France and of Louis. Rarely have the arts been marshaled for so specific a purpose, and – outside of Periclean Athens – never with such success. Louis's immense project at Versailles will be examined in more detail in Chapter 8, but here we will consider Colbert's contributions first of all to royal manufactories and then to the Royal Academy.

The National Manufactory of Gobelins had been founded in the fifteenth century as a place for making dyes; in the early seventeenth century it began producing tapestries. Colbert reorga-

2.15 (*opposite*) *Château de Vincennes*, 1670–1700. Gobelins tapestry, 11 ft x 11 ft 4 in (3.35 x 3.45 m). Victoria and Albert Museum, London

2.14 *Portrait of Jean-Baptiste Colbert.* Book engraving.

nized it in 1664 to provide furnishings and tapestries for the royal palaces, thereby creating an art industry of unparalleled dimensions. Its director was Charles Le Brun (1619–90), who guided a workforce of more than 250 in the production of silver ewers, furniture, tapestries, carpets, and many other luxury goods. The Gobelins was not just a shop for craftsmen, however; Le Brun instructed that the artists be trained in drawing and be relieved of their duties to the guilds. Several tapestries from the Gobelins illustrate both the official royal style and the nature of the manufactory's products. The first (FIG. 2.15) shows Louis XIV hunting at the Château de Vincennes; another (FIG. 2.16), based upon a design by Le Brun, records a visit of Louis XIV to the Gobelins.

The Royal Academy of Painting and Sculpture moved its headquarters into rooms at the Louvre in 1656. In 1661, when Colbert was elected Vice-Protector of the Academy, Charles Le Brun became its Chancellor, as well as the First Painter of the King. He was to become the Director in 1683. And as a sure sign of the tri-

2.16 (*right*) After Charles Le Brun, *Louis XIV visiting the Gobelins,* 1663–75. Gobelins tapestry, 12 ft 3¾ in x 19 ft ¼ in (3.75 x 5.8 m). Châteaux de Versailles and Trianon.

Louis and his entourage visit the shop of the greatest producers of luxury goods in the Baroque age. A profusion of brocaded fabrics, inlaid woods, silver ewers, carpets, furniture, and vases populate this sumptuous scene, woven from cartoons prepared by Charles Le Brun. The artist advertises himself within the tapestry by depicting another of his tapestry designs, for the life of Alexander the Great.

umph of French art, Le Brun was also elected the *principe* of the Roman Academy of St. Luke in 1675. Colbert saw to it that all court painters joined the Academy; Le Brun worked on establishing an official, academic style. The academic movement, which had at its inception been dedicated to raising the status of artists and to freeing them from the stultifying rules of the guilds, now repressed them anew. By breaking down local tariffs and centralizing control of trade, Colbert reorganized French finances through a system of mercantilism, which, because of its efficiency and power, became known internationally as "Colbertism." He simply followed the same path in the Academy. Everything was organized not so that the artist would have freedom and independent authori-

ty, but so that the King and the state would be served. Other academies soon followed: the Academy of Dance (1661), the Academy of Music (1669), and the Academy of Architecture (1671).

Now that the practices of painting, sculpture, and architecture were institutionalized throughout Europe as liberal arts, it remained for the French Royal Academy to develop a curriculum and a pedagogical stance that would be most effective in training artists in an official style. The most obvious choice for Colbert and Le Brun was the style of Rome during the reign of Urban VIII (see Chapters 3 and 4). This, however, was in the service of the Church, and therefore not altogether appropriate for Louis' secular interests. When Bernini was brought to

2.17 (*opposite*)
NICOLAS POUSSIN,
*The Gathering of the
Manna*,
1638.
Oil on canvas,
4 ft 10¾ in x 6 ft 6¾ in
(1.49 x 2 m).
Louvre, Paris.

Poussin was the master of
the *paysage composé*, or
composed landscape. All
the elements have been
composed to frame the
central scene and to
embody principles of rec-
tilinearity. The large rock
formation in the left
background is balanced
by trees on the opposite
side. Figures are carefully
spaced from left to right
and from foreground to
background, with their
gestures often paralleling
one another. His interest
was in coherence
and harmony.

Paris in 1665, his designs for new projects to complete the Louvre were judged by Colbert as "superbe et magnifique," and his marble bust of Louis XIV (see FIG. 6.9) was well received. But in the end, the French were not ready to import his form of the Baroque. Neither Spanish, Flemish, nor Dutch art had precisely the right ingredients either. What the Academy finally settled upon was a secularized version of the Roman Baroque mediated by the styles of Raphael, the Carracci, and Nicolas Poussin in painting, a modified and simplified rendering of Bernini in sculpture, and for church architecture, the style of Maderno (see FIG. 3.8). For royal palaces, the old château style was drasti-cally modified and replaced by a severe form of Greek temple architecture and a highly con-trolled but embellished form of da Sangallo's and Michelangelo's Farnese Palace in Rome. From this synthesizing of available forms of visual culture, with a strong mixture of ancient art, the French Royal Academy came up with a new style, now known as French Classicism.

As an example of how this style was taught, let us recreate Charles Le Brun's analysis of Nicolas Poussin's painting of *The Gathering of the Manna* (FIG. 2.17) for the Academy's stu-dents (Félibien, pp. 76–102). The source for the narrative is the Book of Exodus, which tells of the Israelites following Moses and Aaron out of Egypt and into the wilderness. They com-plained bitterly of their want of food. God pro-vided them with a flaky substance – manna – found beneath the morning dew. In the methodical fashion of the academician, Le Brun breaks the painting down into four areas for criticism: disposition, drawing and proportion, expression, and color and light. By disposition he means something close to composition: how the figures are dispersed overall, and how the smaller groupings are clear, coherent, and aid us in our "reading" of the picture. Drawing and proportion are both functions of design, having to do with figures that have ideal proportions and that will remind the viewer of certain antique prototypes. By expression, Le Brun means the way in which the artist reveals the passions of the soul, the emotions of the starv-ing Israelites as they discover food falling from the heavens. Poussin conveys these psychologi-cal states through the placement of the figures and their gestures and facial expressions. And finally Le Brun wants the students to under-stand how the descriptive and normative use of color and light assists the eye in its scanning and perusing of the picture.

ENGLAND

As king of both England and Scotland, James I (r. 1603–25) found himself among fiercely com-peting forces in England. His mother, Mary Queen of Scots, a Catholic, had abdicated her throne for James. It was his desire to support the Church of England against the plots of the Catholics on the one hand and the extreme Protestant party known as the Puritans on the other. He managed to antagonize both sides. In what is known as the Gunpowder Plot, the Catholics planned to blow up Parliament on its opening in 1605. The scheme unraveled when one of the conspirators warned a friend not to attend that day. With the death of his minister Robert Cecil, Earl of Salisbury, in 1612, and his dissolution of Parliament, James ruled alone, claiming his divine right as king.

His successor, Charles I (r. 1625–49), followed closely in his father's path. Charles was forced by Parliament in 1628 to accept the Petition of Rights, which defended the rights of Parliament, forbade Charles to billet soldiers in private homes or to declare martial law in times of peace, demanded that no one be imprisoned without being given just cause, and restricted his practice of levying taxes without the consent of Parliament. Charles capitulated because he needed funds for foreign wars – and then he ignored the Petition of Rights. Charles' autocratic behavior, his arrogation of all power to himself by divine right, led directly to the English Civil War in 1642.

Charles surrendered to the Roundheads, part of the Puritan element in the English Parliament, in 1646, then escaped and launched a second civil war in 1648. Defeated once again,

the King eventually was tried and executed in 1649 (FIG. 2.18) by Oliver Cromwell's "Rump" Parliament (consisting of those who would follow Cromwell (1599–1658) and the dictates of the army). The monarchy and the House of Lords were abolished and England was declared a commonwealth.

Cromwell was not particularly supportive toward the arts, although the Lord Protector of the Commonwealth did allow his portrait to be painted (FIG. 2.19). Court patronage was virtually non-existent. The middle class employed stone-masons to cut conservative statues and build simple homes. Puritanism banned religious art in churches, and artists had to turn to portrait painting. The Baroque styles of Italy, France, and Spain were not particularly welcome in England during the Commonwealth. But at the Restoration in 1660, the monarchy again brought sumptuous and engaging art to England.

After his father's death, Charles II (r. 1660–85) (FIG. 2.20) lived for years in exile, first in the Netherlands, then, after an abortive strike against Cromwell, in France. It was Cromwell's death in 1658 that led two years later to the Restoration and a royalist Parliament. Charles II angered many of his Scottish supporters when he accepted Anglicanism rather than Presbyterianism as the official English religion. He attempted war against the Dutch in 1665, but was quickly subdued and had to agree to embarrassing conditions of peace in 1667. Joining with the French in 1670, Charles again fought against the Northern Netherlands in the Anglo-Dutch War, but with no greater success than before. Louis XIV had sent Charles money in the hope that Roman Catholicism would be restored in England, but the English monarch, wily though he was, failed even to convince Parliament to guarantee the rights of Catholics (or Puritans, for that matter). The Test Act of 1673 required that all office holders be members of the Anglican Church. The Merry Monarch – so-called by virtue of his many loves and blithe spirit – converted to Catholicism on his deathbed in 1685.

2.18 WEESOP,
The Execution of Charles I,
n.d.
Oil on canvas,
5 ft 4 in x 9 ft 7½ in
(1.63 x 2.96 m).
Private collection.

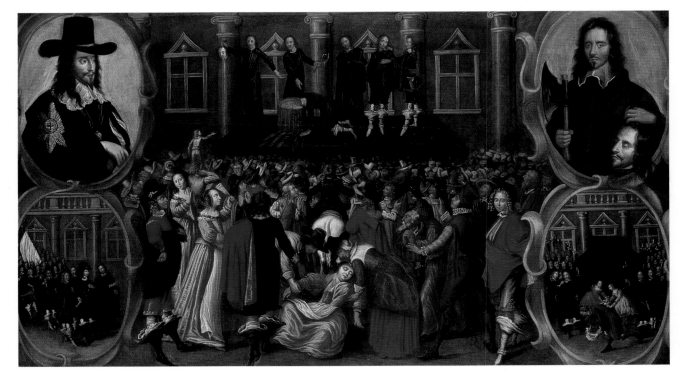

2.19 *Portrait of Oliver Cromwell.*
Book engraving.

and Catholicism. Within a year James II had escaped to France, and William and Mary were crowned as the monarchs of England, Scotland, and Ireland, thus successfully completing the bloodless Glorious Revolution. Henceforth, the doctrine of the divine right of kings lost much of its influence and the Catholic Counter-Reformation, which had signal success in Poland, Bohemia, and (to a lesser degree) in France, could not cross the Channel.

The Royal Academy of London

The best of the artists working in England formed a Royal Society of Arts in 1754, with hopes that eventually they would have an acad-

2.20 *(right)*
Portrait of Charles II.
Book engraving.

Charles was succeeded by his brother James II, who already had converted to Catholicism. His rule was not to last long. William of Orange, who as Stadholder (city holder) of the Netherlands had made peace with England in 1674, was son of Mary, sister to Charles II and James II, and therefore nephew to his one-time enemy. He married his cousin, also named Mary, daughter of James II. In an age when rule was by inherited monarchy, intermarriage between royal families led to complicated alliances. Charles II and James II were affiliated with Louis XIV, but William of Orange was a Protestant and the French king's foe. In 1688 he and Mary were brought to England by the opponents of James II

emy, based upon the Academy of St. Luke in Rome and the French Royal Academy. With assurances from King George II (r. 1727–60) that he was "graciously pleased to declare his Royal intention of taking the Academy under his protection," the artists bided their time. In November 1768, under the auspices of his son, King George III (r. 1760–1820), the "Royal Academy of Arts in London, for the Purpose of Cultivating and Improving the Arts of Painting, Sculpture, and Architecture" was founded. In its desire to be free from the fetters of government, the Royal Society had as one of its chief aims an "Annual Exhibition, open to all artists of distinguished merit." Royal support lasted but a short time, for the entrance fees charged for the exhibitions raised enough money to support the Academy in all of its functions. The Royal Academy also remained relatively small, never teaching more than thirty students at a time (FIG. 2.21). It was the annual exhibitions, which were big draws in fashionable and artistic circles of London, and

the biannual lectures by the President of the Academy, rather than its teaching programs, that established the Royal Academy of Arts in London as such a significant cultural and artistic institution.

Sir Joshua Reynolds (1723–92) (FIG. 2.22), then England's most fashionable portrait painter, became the first President of the Academy in 1768. He gave his first lecture to the academicians in 1769, and was appointed as Painter-in-Ordinary to the King in 1784. Reynolds' presentations were gathered together and published in 1778 as the *Discourses*. His theory of art derived from the academic tradition of the Renaissance and Baroque periods, especially as articulated in the French Royal Academy under the leadership of Charles Le Brun. He preferred the grand manner in art, which is, roughly speaking, the style of art from Raphael to Poussin and Bernini (see Chapter 1). Although there is certainly evidence of a Rococo style in England in the eighteenth century, there was no expressed theory of the Rococo.

2.21 JOHANN ZOFFANY, *Gathering of Members in the Life Room at the Royal Academy*, 1772. Oil on canvas, 3 ft 4 in x 4 ft 10 in (1.02 x 1.47 m). The Royal Collection, Windsor Castle.

A male model is being instructed on the precise pose that he should hold. Meanwhile, surrounded by plaster casts of famous Renaissance and antique statues, the male members pose for their portrait. The two original women members, Angelica Kaufmann and Mary Moser, appear only as portraits on the wall; they were not permitted to draw from the nude and therefore could not enter the Life Room.

2.22 SIR JOSHUA
REYNOLDS,
Portrait of the Artist, 1780.
Oil on panel,
3 ft 4 in x 5 ft
(1.02 x 1.52 m).
© Royal Academy
of Art, London.

Reynolds claimed that he
could paint a portrait in
four one-hour sittings.
Even though he had the
assistance of specialist
painters in drapery and
accessories, this was a
remarkable feat. If any-
thing, he was probably
even faster with his own
image, showing us here a
serious if slightly supercil-
ious man, gazing down
toward his admirers.
Reynolds painted this to
commemorate his receiv-
ing an honorary Doctor of
Civil Laws degree from
Oxford in 1773.

The Northern Netherlands: Capitalism

The seven northern provinces of the
Netherlands (Holland, Utrecht, Zeeland,
Gelderland, Overjissel, Groningen, and
Friesland) united against successive Spanish
kings, beginning with Charles I of Spain
(r. 1516–56, who also ruled as Charles V the
Holy Roman Emperor). The Dutch especially
objected to Charles' suppression of
Protestantism, and to the employment of his
notorious Inquisition in dealings with the
Netherlands. The Twelve Year Truce of 1609
ended with the resumption of warfare in 1621.
The Peace of Münster, the final peace that
secured the freedom of the Northern
Netherlands from Spain, was signed in 1648.

Their High Mightinesses, the regents of the
Estates-General of the United Provinces – as the
Dutch government was known in the seven-
teenth century – were by no means absolute
monarchs. They were burghers – town dwellers –
and as representatives of their individual
provinces they encouraged a government and
economic system of great freedom and strength.

The Bank of Amsterdam, founded in 1609, was
perhaps the most secure in all of Europe, mint-
ing the steadiest currency of the times, the gold
florin. The bank accepted deposits, lent money,
and encouraged commercial growth. The Dutch
East India Company, one of Europe's first incor-
porated entities, had a trading monopoly in the
Malay Peninsula, Japan, China, India, Iran, and
what today is Indonesia. In fact, the Dutch East
India Company weakened Spain considerably by
raiding these territories from Portugal, then part
of the Spanish Empire. With its control of trade
in Central and East Asia, its colonies in southern
Africa, its powerful fleet of warships, soldiers,
and an extensive merchant fleet, the Dutch East
India Company was the most fabulously success-
ful of Baroque corporations.

The General Stadholder, or head of the
Estates-General, was a descendant of William I
of the House of Orange, who was an aristocratic
leader of the Dutch revolt in the sixteenth cen-
tury (and who came to be known as the "father
of the fatherland"). Although nominal leadership
lay with a nobleman, the regents held most of
the political and economic control. The
provinces were independent, though they band-
ed together with the Stadholder in times of mil-
itary crisis.

THE DUTCH ART WORLD

The culture of the Northern Netherlands differed
significantly from that of the other states of
Europe. Here capitalism and Calvinism reigned.
John Calvin (1509–64) had led the Protestant
Reformation in the Swiss town of Geneva; his pro-
posals for refining Church doctrine led to the
foundation of Calvinism, the forerunner of
Presbyterianism. Because Calvinism is an aniconic
religion – one that does not permit images –
Dutch artists were forced to turn to the often fick-
le and volatile art market. There were royal com-
missions from the House of Orange in The
Hague, and there were numerous orders for por-
traits, both group and individual. But Dutch
artists very often had no prior arrangement with a
patron, and therefore were compelled to exhibit

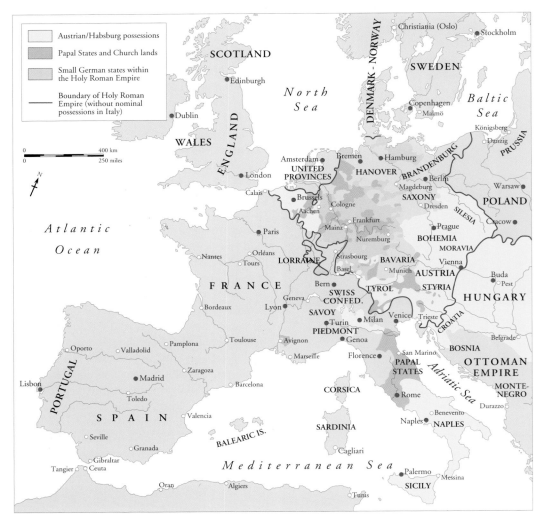

EUROPE IN 1730
The period 1648–1721 witnessed the undisputed ascendancy of France and the Bourbon Dynasty in Europe. Louis XIV, and his absolutist government, was the aggressor in four wars that escalated throughout Europe. In particular, the Sun King's support for a Bourbon candidate, Philip of Anjou, to succeed to the Spanish throne led to England, the Netherlands, Hanover, Prussia, Austria, and Portugal forming a Grand Alliance against him. Though France's cultural style remained dominant well into the eighteenth century its political power waned. In the early 1700s Britain, with its party system and parliamentary government, provided an alternative to the despotic regimes of mainland Europe. It became an important inspiration to French Enlightenment thinkers and was a key ideological influence in the age of revolutions that followed.

their works in bookshops, open fairs, at art dealers', or in their own studios. Rather than produce large history paintings, which would be very expensive to execute and not easy to sell, Dutch painters usually responded to popular taste. Many citizens of the middle and upper middle class collected art, so the market was lively if not always profitable for the artists.

There is evidence that Karel van Mander (1548–1606), a Dutch painter, playwright, and biographer, together with several other artists founded an academy in the Dutch town of Haarlem in the 1580s. This was a private academy intended solely for artists to work from live models. Van Mander's *Het Schilderboeck* (1604) combined biographies of Dutch, Flemish, and German artists with practical advice to the painter. Like his Italian contemporaries, van Mander was desirous of raising the standard and prestige of the artist's life and profession. He wrote in the *Schilderboeck* with some dismay that "the noble art of painting has been turned into a guild … Oh, noble art of painting … how little distinction is made between thy noble followers, and those who have acquired just a shadow and shimmer of art" (Pevsner, p. 81).

An official organization for artists was founded in The Hague, the "capital" of the Netherlands where the Stadholders lived, in 1655. It was not, properly speaking, an academy, but a confraternity, an organization of about fifty artists, much like the medieval guilds in its structure and rules. After 1682, there were life classes. Small drawing schools were also set up from time to time, one in Utrecht in 1696 and another in Amsterdam in 1718. But mostly artists had little institutional or academic support.

View painting was much sought after in the Baroque Netherlands, especially in the second half of the seventeenth century. The Dutch wanted to see their own world, their cities, their houses, and their countryside. Until the general economic troubles of the 1670s, which were brought about by the war between the Netherlands and an alliance between England and France, Jan Vermeer (1632–75) was for a while a successful painter who charged fairly steep prices for his paintings. Sometime in the later 1650s he changed his subject matter from history paintings – narratives from the Bible, history, mythology, and legend – to scenes of interiors and cityscapes. *The Little Street* (FIG. 2.23), for example, portrays a typical scene of some anonymous houses in Delft.

Vermeer's method of layering paint, contrasting relatively thick globs of white with much thinner glazes, and his use of the very best materials, such as lead-tin yellow and ultramarine, allowed him to catch something of the effect of crannied walls, cobble-stone walks, and roughly

2.23 JAN VERMEER, *The Little Street*, c. 1657–8. Oil on canvas, 21½ x 17¾ in (54.3 x 44 cm). Rijksmuseum, Amsterdam.

Although this location was once tentatively identified as an almshouse located just across from Vermeer's studio, that hypothesis has been challenged. One can demonstrate with certainty that the building on the right side of the painting was never there. In other words, the painting does not record a specific location; instead, it captures something more archetypal, the spirit of domesticity.

2.24 Camera obscura. Copper engraving from pamphlet, *A Short Description of a Completely New Type of Camera Obscura, with which All Types of Objects May Be Drawn,* Augsburg, 1767.

shingled roofs. Observing the great precision of linear perspective in his cityscapes, some scholars have maintained that Vermeer used an optical device known as the camera obscura (FIG. 2.24), which literally means "dark room." Such devices, some the size of a small room, were used by artists who wished to employ optical and mechanical tools to achieve a "true" rendering of space. Light would enter a lens, be projected into a darkened space, and by reflecting off a mirror, would throw an image onto a flat surface. The artist then could trace the picture.

Because of his techniques, interest in perspective (whether or not he actually used a camera obscura), and ability to portray a place that seems so realistic and recognizable, Vermeer's paintings display an uncanny degree of familiarity. We cannot be sure if Vermeer brings us into the real world of Delft in the mid-seventeenth century, or one that is his creation. Does it really make any difference? Perhaps in some unconscious sense it does: the viewer may feel more at home in the artist's creation than in a replication of a particular street. Like other Dutch works of the Baroque, Vermeer's paintings of exterior and interior views refer not to a religious realm, an historical event, a biblical narrative, but point to the *idea* of home, comfort, and daily routines. In

The Little Street, for example, domestic virtue is represented by the woman sitting in her doorway sewing. These are values closely allied with Dutch Baroque culture.

Conclusion

No more than other institutions could the visual arts escape their times. In this chapter we have examined some of the historical events of the seventeenth and eighteenth centuries, and how the arts reflected the conditions of their age.

But perhaps the word "reflect" is not precise. Paintings in the Renaissance tradition – which effectively means paintings from shortly after 1400 until at least the early twentieth century – do seem to present likeness or recognizable imagery. Italian (and Flemish) painters and sculptors in the fifteenth century devised and perfected certain methods, studies, and technologies – linear perspective, shading, oil paint, symmetrical schemes for arranging compositions, anatomical study – to produce an imitative art. This apparently mimetic quality often invites the viewer to look upon Baroque and Rococo art as if it were a window onto a further, but nonetheless comparable, world.

Yet because Baroque and Rococo images seem to be "about" certain conventional stories and recognizable individuals, one is apt to miss some of the deeper or hidden persuaders embedded within them. Louis XIV and his ministers and advisers understood that to control the social order one needed to control the instruments of representation – in short, art. Rigaud's portrait of Louis (see FIG. 2.13) visualizes a conflation of the state and the king ("l'état, c'est moi") in a way that the King himself could never achieve. Were one to place Louis next to the portrait, one would have to choose the portrait as the true, absolute monarch.

The monarchies of the seventeenth and eighteenth centuries were assertive, repressive, inefficient, and crisis-ridden. There were uprisings, protests, and outright revolutions in France and America. Some economies showed remarkable strength for a while, while others lurched and stalled. Throughout these social upheavals and remarkable changes, the arts grew and often thrived. The system of the three major art forms – painting, sculpture, and architecture – was established, and the arts were firmly incorporated into the cultures of the age. Neither the needs of monarchs and popes, the impact of reform as well as stagnation, the shock of crisis, nor the new public art market brought about by budding capitalism by themselves determined the styles of the arts. That remained in the hands of the practitioners, the artists themselves.

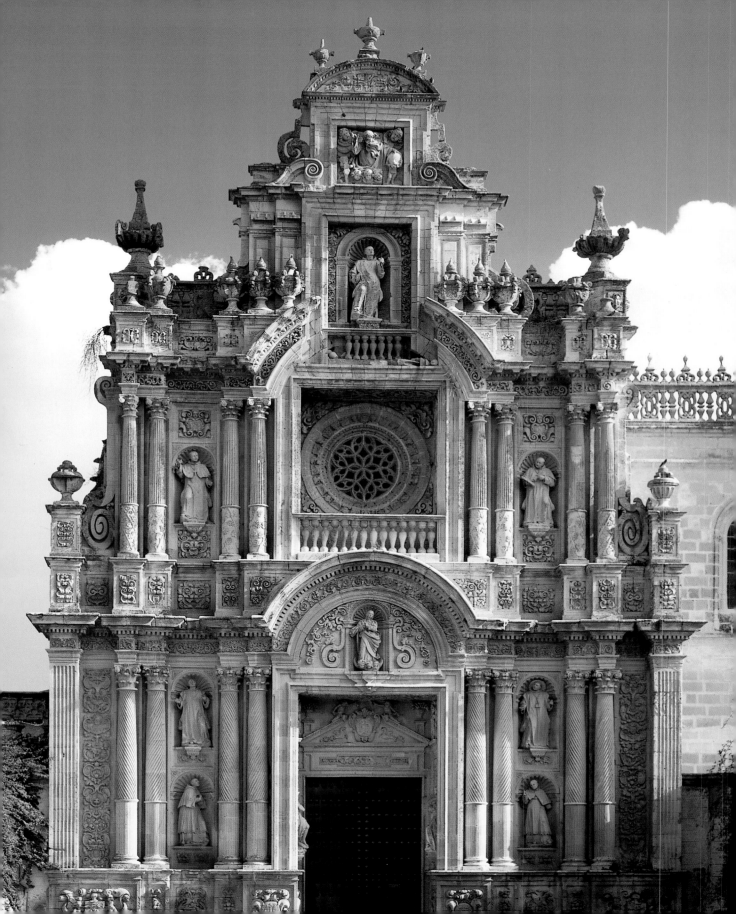

CHAPTER 3

The Baroque Church

SETTING FOR MYSTERY, PROPAGANDA,
& WORSHIP

PEDRO DEL PIÑAR AND
FRANCISCO DE GÀLVEZ,
façade of Santa Maria de
la Defensíon, Jerez de la
Frontera, 1667.

The wonder of a Baroque church shows up as soon as one enters the nave. Because of the church's "poetics" of space, its glitter and opulence, and the myriad of details that the eye can barely sort out, the worshipper is swept away. There is indeed something different about the Baroque church; the details, styles, and effects let you know almost immediately that you are in an altered spiritual realm. Why are these buildings different in structure and decoration from those which came before?

First of all, one must remember that the main function of a church building is to be a model of the Heavenly Jerusalem. Most worshippers in and visitors to the churches of Europe are familiar with the idea of the Gothic cathedral as a total environment that symbolizes the kingdom of Heaven on earth. As the worshipper walks in to the church, everlasting life and God's kingdom are revealed as symbol; Heaven, the angels, and all the saved souls seem to penetrate and occupy this world. The church as symbol of Heaven does not merely point to another reality,
it is saturated with it, so that in a metaphorical but powerful sense, when setting foot in a church one enters Heaven. What was true of the Gothic cathedral remains true of the Baroque church, but with a difference. Especially in Rome, but throughout Europe and in the Spanish provinces of the New World as well, the Baroque spirit is identified with the triumph of Catholicism.

In order to understand the new attitude of the Church in the seventeenth century, and therefore the impulse to build so many churches in a new style, one has to look back to the earlier sixteenth century and the reforms demanded, first of all, by Martin Luther (see p. 42). The pope responded to Luther's request for reform by excommunicating him. But the need for change within the Church was widely recognized, and finally, between 1545 and 1563, the Council of Trent proposed a number of recommendations for correcting abuses and amending practices. These counsels were adopted by Pius IV in 1564 as the Profession of Tridentine Faith (after the Roman name Tridentum for the Italian city Trento).

The decrees of the Council of Trent centralized all decisions relating to the conduct of the liturgy in the hands of the Catholic Church's bureaucratic arm, the Roman Curia. The Mass continued, as it had in the middle ages, to be performed with the priest's back to the congregation. Only at three points during the celebration were the worshippers actively engaged: when the bread and the wine were "offered," when they were consecrated, and when they were given as communion to the faithful. Throughout the rest of the Mass the worshippers were involved in their own devotional practice, whether praying the rosary, singing hymns, or performing some other mass devotion.

But what was different from the medieval celebration of the Mass was the encouragement of the lay public to attend in large numbers. There was also more emphasis upon the use of decoration to assist in the celebration and to underline the messages of the sermons. If the liturgy changed relatively little from the medieval to the Renaissance and Baroque periods, Tridentine sermons certainly were of a different order. Priests roused their congregations with reminders of the accomplishments of the Church's reformation, called the congregation to renewed and constant discipline, reminded them of the horrors of Protestant violence, the threat of the Ottoman Empire (the Turkish fleet had been destroyed by the Holy League at the Battle of Lepanto in 1571, only to be rebuilt to greater strength than before), and the need for vigilance. As important as the reforms, therefore, was the renewed spirit of Catholicism and the inauguration of what the Church calls the Tridentine Era (also known as the Catholic Reformation or the Counter-Reformation), which corresponds in its early years to the Baroque age.

Before the Tridentine Era, Leonbattista Alberti (1404–72) and other Renaissance architects believed that the ideal church was centrally planned (FIG. 3.1). He saw that Heaven and God's blueprint might best be revealed to us through one of nature's perfect forms, the circle. Theologians and philosophers had since earliest times related geometry to the harmony of the universe, and the simplest and most self-contained form – the circle – was regarded as reflecting the ideal structure of the universe. This

3.2 (*opposite*)
FILIPPO BRUNELLESCHI, interior of Pazzi Chapel, S. Croce, Florence, begun 1430–3.

Brunelleschi's chapel adheres closely to the Renaissance ideal of a centralized, geometrical space, with relatively simple ornamentation. Alberti claimed that architectural beauty is achieved when there is a harmony and accord of all parts, arranged in such a way that nothing can be altered without weakening the sense of proportion.

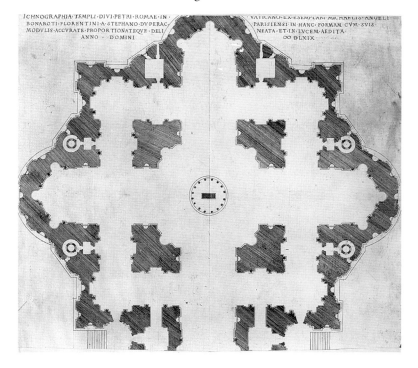

3.1 MICHELANGELO, ground plan, St. Peter's Church, Rome, 1603–26.

Michelangelo's original plan was for a Greek-cross church (with both the horizontal and the vertical axes being equal), surmounted by a dome. By so doing he could make reference to the ancient Roman Pantheon (second century C.E.), and combine both the circle and the square, the geometrical forms promoted by the Emperor Augustus' architect Vitruvius (active 46–30 B.C.E.).

same character of simplicity and self-sufficiency, Alberti believed, demanded an austere church interior with gray or white walls, and windows only at the upper levels so that nothing of the everyday could be seen (FIG. 3.2).

But the Baroque church was not to look like Alberti's ideal. In fact, architects of the seventeenth and eighteenth century often went back to the Latin cross design, typical of medieval church buildings. This return to a longitudinal church may not have resulted in an ideal temple plan, like that of the circular church, but it was practical and served the needs of preaching. And as Charles Borromeo observed, the circular plan is, after all, pagan (see box, p. 78 below). Centrally planned buildings were also constructed, however, especially when the churches were conceived as large chapels.

This chapter will look at a range of Baroque churches, beginning in Rome, continuing throughout Europe, and ending with those constructed under Spanish rule in the New World. Forms of churches changed depending upon location, but what remained fairly constant was the exuberance of Baroque design, the love of copiousness and dramatic effect, often regardless of size. There are many reasons why a church was built in the Baroque period – as a symbol of

Charles Borromeo's
INSTRUCTIONS FOR BUILDING & DECORATING CHURCHES, 1577

3.3 ERCOLE ANTONIO RAGGI, statue of St. Charles Borromeo, 1680, from the façade of San Carlo alle Quattro Fontane. Rome, begun 1638.

Charles Borromeo (FIG. 3.3) (1538–84) was dedicated to the reform of the Church. He was made cardinal and Bishop of Milan by his uncle, Pius IV. It was largely through his support and energy that the last sessions of the Council of Trent were begun and successfully completed. Because of his selfless acts during the plague in Milan of 1576–8, which saved many lives, he was canonized in 1610. His instructions on the building and decorating of churches reflect his long-standing interest in the arts and confirm the dictates of the Council of Trent (see pp. 47–9). His prescriptions for the design of churches had a powerful impact on the architects of the Baroque.

This is what he had to say about church design:

There are a great many different designs, and the bishop will have to consult a competent architect to select the form wisely in accordance with the nature of the site and the dimensions of the building. Nevertheless, the cruciform plan is preferable for such an edifice, since it can be traced back almost to apostolic times, as is plainly seen in the buildings of the major holy basilicas of Rome. As far as round edifices are concerned, the type of plan was used for pagan temples and is less customary among Christian people.

Every church, therefore, and especially the one whose structure needs an imposing appearance, ought to be built in the form of a cross; of this form there are many variations; the oblong form is frequently used, the others are less usual. We ought to preserve, therefore, wherever possible, that form which resembles an oblong or Latin cross in constructions of cathedral, collegiate or parochial churches.

This cruciform type of church, whether it will have only one nave, or three or five naves as they say, can consist not only of manifold proportions and designs but also again of this one feature, that is, beyond the entrance to the high chapel, two more chapels built on either side, which extended like two arms ought to project for the whole of their length beyond the width of the church and should be fairly prominent externally in proportion to the general architecture of the church.

The architect should see that in the religious decoration of the façade, according to the proportions of the ecclesiastical structure and the size of the edifice, not only that nothing profane be seen, but also that only that which is suitable to the sanctity of the place be represented in as splendid a manner as the means at his disposal will afford. (Voelker, pp. 51–2, 63)

church power (St. Peter's), to promote the prestige of a particular religious organization (Il Gesù and Sant'Andrea al Quirinale), to make a votive offering (Santa Maria della Pace and Santa Maria della Salute), to house an important relic (Santissima Sindone), to serve the interests of pilgrims (Die Wies), to commemorate a significant royal event (Val-de-Grâce), or to proclaim the Church's authority in a new land (San Francisco in Lima).

Rome

The preaching church was important in Baroque Rome. Sermons delivered in the new churches of the seventeenth century offered splendid visions of the mysteries of the faith, the divine order, and, above all, the glories of the city and its Church. These sermons, as with much of Baroque literature and art, depended upon extended and elaborate metaphors; like Baroque architecture, a sermon was meant (as one priest put it) "to hold the eyes of viewers with its workmanship and artistry." Nothing was to be held back. The seventeenth century was not an age for austerity, but for celebration: Rome was Peter's city, the *caput mundi* – the capital of the world.

Apart from constructing a suitable space for the sermon to be delivered and heard, another concern of Tridentine builders was to emphasize the altar through dramatic, even theatrical, means. The essential Catholic doctrine of the literal transubstantiation of the host and the wine into the body and blood of Christ – the Real Presence of Christ in the Eucharist – dictated this accentuation of the central altar. In addition, the importance of saints as intercessors between the individual and God, the desire of wealthy patrons for their own private chapels, as well as to be buried *ad sanctos* (with a line of sight to the high altar), led to intricate decorative schemes for elaborate chapels, mausolea, and numerous images of saints and the Madonna and Child. This bountiful appearance of Baroque church interiors contrasts remarkably with contemporary Protestant churches.

The Jesuit Church: Il Gesù

In the middle of the sixteenth century, just as the Council of Trent was completing its deliberations, the mother church of the Jesuits, Il Gesù, was under construction in Rome. This building established a type for the Baroque church while helping to define Rome as a renewed community of Christians and as the home for one of the most characteristic of Counter-Reformation religious organizations, the Society of Jesus.

Ignatius of Loyola (1491–1556), the Spanish founder of the Society of Jesus and its first "general" (he was to be made saint in 1622), had hoped for some time to erect a large church for his company, but was frustrated by landlords in Rome's center. Along with St. Francis Borgia, the Jesuits' third general, he wanted to build a fairly simple structure, box-like in appearance, without a **crossing**, and with a wooden ceiling that, in his estimation, made for excellent acoustics. Cardinal Alessandro Farnese (1545–92), who had the money and the authority to build the church, desired something grander and more opulent. He, of course, carried the day. He informed the architect of Il Gesù, Giacomo Barozzi da Vignola (1507–73), Rome's leading architect after the death of Michelangelo in 1564, that the Jesuit church should be spacious and acoustical, but vaulted (he disagreed emphatically that a flat ceiling allowed for more audible and resonant preaching), with a formal, portico-styled façade, a shallow crossing arm, and smaller chapels along the sides and around the apse – but no side aisles (FIG. 3.4).

The function of Il Gesù, like that of subsequent post-Reformation churches, was to offer a large space for numerous worshippers and an uninterrupted view of the altar. Now that preaching went on year round, along with a need for more than one Mass to be celebrated at a time, it was sensible that the church be broad and open and have numerous small chapels with altars. The detailing of the inside is done with fairly traditional **pilasters** that flank the arched opening of each side chapel. These pilasters become strengthened by virtue of their overlap-

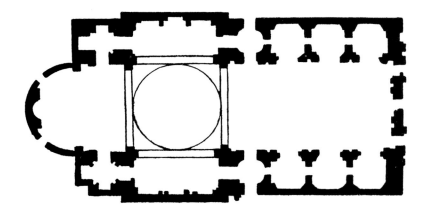

ping at the area of the crossing, which is sur-
mounted by a cylindrical dome. The worshipper
therefore is drawn by the strong, continuous
architrave, and the evenly spaced and fairly large
windows in the direction of the central area of
the church — toward, in other words, the high
altar and the area from which the priest delivers
his sermon and celebrates the Mass (FIG. 3.5).
The original interior was simply whitewashed.
Only later, in the full flowering of the Baroque,
was the ceiling painted by Giovanni Battista
Gaulli, with strongly three-dimensional coffering
and sculpture (see FIG. 1.14).

After Vignola's death in 1573, Giacomo della
Porta (c. 1533–1602), a disciple of Michel-
angelo, executed the façade following fairly
closely the designs as initially given by Vignola
(FIG. 3.6). The two-story façade screens both the
lower and the upper sections of the interior with
architectural forms deriving from the classical
orders via Alberti. The scrolls mask the awkward
transition between the wider lower section with

3.5 (*right*)
Andrea Sacchi
and Jan Miel,
*Urban VIII visiting Il
Gesù, Rome*, 1639–41.
Oil on canvas,

11 ft ¼ in x 8 ft 1¼ in
(3.36 x 2.47 m)
Galleria Nazionale di Arte
Antica at the Palazzo
Braschi, Rome.

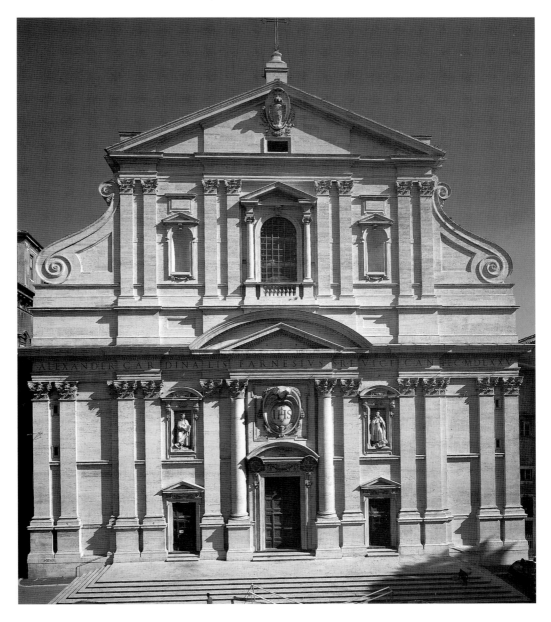

3.6 GIACOMO
DELLA PORTA,
façade of Il Gesù, Rome,
1575–84.

As a result of della Porta's
flattening of Vignola's
original design, one senses
the nervousness of
Mannerist rather than
Baroque design, with ele-
ments projecting and
receding within a fairly
shallow space. The cap-
turing of a triangular
pediment within a round-
headed pediment above
the main door accentuates
the sense of irresolution
and tension.

its side chapels, and the narrower **clerestory**
above. The arrangement of columns across both
the lower and the upper area of the façade is reg-
ular, with paired pilasters at the corners leading
toward heavier, engaged columns parallel to both
the main door and the window in the upper
story. The whole is surmounted by a pediment.
It had been Vignola's intention to set the central
five bays of the façade in front of the outside

bays, thereby creating a more dynamic sense of
projection. Della Porta, for reasons that are not
clear, decided to maintain a sense of flatness to
the surface, thereby diminishing one of those
Baroque devices for focusing the attention of the
viewer on the goal of his or her pilgrimage.

The church of Il Gesù marks the beginning of
the Baroque. Its ground plan, elevation, and join-
ing or articulation of the various elements serve

the needs of the Counter-Reformation church while at the same time evoking the nobility and enduring elements of the Roman tradition.

THE REBUILDING OF ST. PETER'S

Throughout the construction of Il Gesù, the rebuilding of St. Peter's was continuing. In fits and starts, the Renaissance popes, beginning with Nicholas V in the mid-fifteenth century, had attempted to renew, patch up, and otherwise save the aging basilica, built originally in the fourth century under the aegis of Constantine the Great. It was Pope Julius II who made the decision, in 1505, to tear down the revered basilica and to replace it with something new. One can imagine the horror of the Romans at destroying what had been the world's greatest Christian church, dating from very nearly the beginnings of Christianity. It is a long and complex story to tell of the rebuilding of St. Peter's throughout the sixteenth century. The task was enormous, spanning the lives of many artists and popes. In sum, what probably began as a centralized plan eventually developed

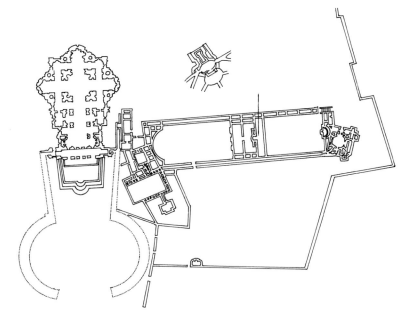

into another of the Tridentine basilicas, but this time of enormous proportions (FIG. 3.7).

Carlo Maderno was appointed "Architect of St. Peter's" in 1603 and was given the task of

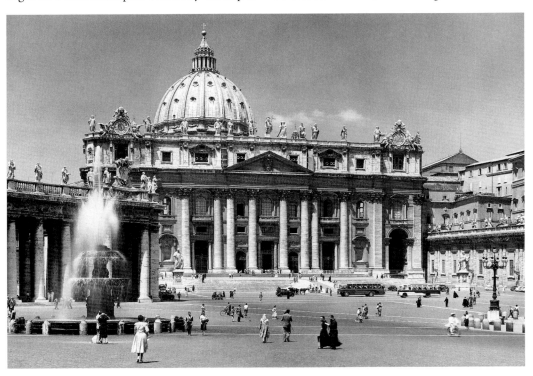

3.8 CARLO MADERNO, exterior of St. Peter's, Rome, 1607–26.

Gianlorenzo Bernini began constructing towers at either end of Maderno's façade, but because of unstable foundations, these were torn down before they were finished. However, their bases were left behind, and now appear to be part of the front of the church. The result is that the façade is overly wide in relation to its height. As a way of "correcting" this imbalance, Bernini kept the height of the columns in the piazza (visible behind the fountain) lower than Maderno's, thereby increasing the sense of verticality in the façade.

3.7 (*opposite*)
CARLO MADERNO,
plan of St. Peter's, Rome,
1603–26.

Both the original
(c. 320–27) and the
new St. Peter's were
constructed on top of an
early Christian burial
ground, where, according
to tradition, St. Peter had
been buried. Because the
emperor Constantine's
masons had to adapt
their building to a (now
leveled) burial ground,
they found it difficult to
place the apse in its usual
place, toward the east;
instead they turned the
building so that it faced
Rome. That orientation
was maintained in the
rebuilding of the six-
teenth century.

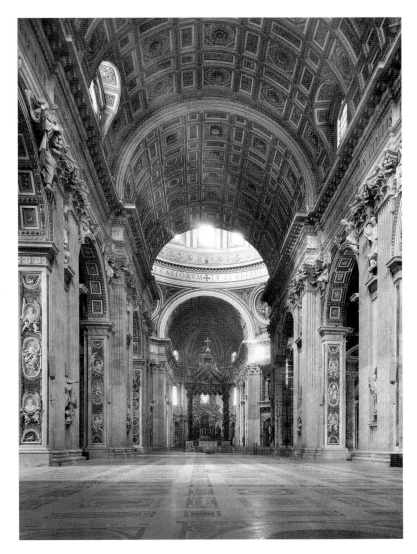

3.9 CARLO MADERNO,
interior of St. Peter's,
Rome, showing nave,
1624–33.

To underscore the vast-
ness of the interior of St.
Peter's, there are indica-
tions – not entirely exact
– on the pavement of the
nave of the lengths of
other large churches. St.
Peter's remains the largest
Catholic church in the
world, except for a copy
of St. Peter's, recently
completed in the Ivory
Coast, west Africa.

altering and elongating Michelangelo's centrally
planned church. The façade (FIG. 3.8) was com-
pleted in 1626. The new basilica did indeed ful-
fill the wishes of Julius, at least in terms of its
astonishing scale. It has nearly a quarter of a mil-
lion square feet of floor space and is more than
700 feet long. From floor to the top of the
lantern at the crossing is about 450 feet. Those
who advised the Pope, both architects and eccle-
siastical officials, generally believed that a Latin
cross for St. Peter's was better than the earlier
centralized plan of Michelangelo because it
allowed for more space, and because its cross

shape suggested Christ's crucifixion.

The interior of St. Peter's (FIG. 3.9), with
Maderno's nave and what is essentially Michel-
angelo's crossing of colossal white pilasters, is sim-
ilar to but more elevated than Vignola's interior of
Il Gesù (compare with FIG. 3.5). The large and
unobstructed space fitted the ideological and aes-
thetic needs of Counter-Reformation Rome. The
vaulted ceiling, side chapels, triumphal arch just
before the crossing, huge openings throughout
the interior, and Bernini's Baldacchino and
throne of St. Peter (see FIG. 1.2) work together to
create a Baroque space.

Baroque Spaces

What, then, is a Baroque space? Obviously it is ample and unimpeded, and, at its limits, ornate. Grandeur, which is the effect of Baroque space, has boundaries only in the sense that it is not infinite, so that when we say Baroque space is embellished, we mean that the walls and domes that limit that space have upon their surfaces the kinds of details that dazzle our eyes, and then lead us back, in our meditative state, to a dream-like and mystical experience. We have a (semi-) consciousness of enlargement.

The Baroque period neither invented the idea of hugeness nor did any writer of the period specify its necessity in so many words. One looks in vain for discussions of the "poetics of space" in seventeenth-century writing. One can only infer, therefore, from the buildings, paintings, and sculpture that the Baroque "spirit" is one of grandeur, and that magnitude, prodigality, and power have their ideological and metaphysical purposes in aiding the propagation of the Catholic faith, and the glorification of the Catholic Church.

Just as the Baroque preachers studied classical rhetoric, so too did Baroque architecture share in the values of sacred oratory. Ideas of invention (the idea of creating a new form), wisdom, revival (rejuvenating the spirit of the Catholic Church), and the golden age (a mythical period in history when all was well and everyone was at peace) have as much to do with the architecture of the Baroque as they do with the oratory. The Baroque painter Annibale Carracci said that painters speak with their hands. In other words, painting may not be identical to writing, but it conveys a message, it has a language, it *talks* to us. If painting speaks with its images, then architecture speaks with its structure and its spaces.

For instance, the façade of the new St. Peter's invoked those old forms of Greek and Latin architecture as part of the Tridentine program of reviving classical culture. See how each column runs through more than one section of the façade: that is the idea of the "colossal" order, which would have been regarded as noble, logical, and appropriate for the position of leader-ship and authority occupied by the mother church. Again, it is not as if Maderno and other architects of the Baroque invented these forms. But their clear and logical use here, especially as they create sequences or continuities from one section of the façade to the next, building in thickness toward the entrance bay, is intended to lead to a climax. This sense of cumulative and increasing weight becomes part of the architectural practice of the Baroque period, responding to the mission of the *ecclesia triumphans*, the triumphant church of the Counter-Reformation.

THE CHURCH AS THEATER: SANT'ANDREA AL QUIRINALE

Of a somewhat different order of Baroque rhetoric is the church of Sant'Andrea al Quirinale, built by Gianlorenzo Bernini between 1658 and 1671 for Camillo Pamphilj, nephew to Pope Innocent X. Bernini was a huge presence in seventeenth-century Rome; more than any other artist, he defined the Baroque. Throughout his career, he received sculptural and architectural commissions from popes, cardinals, religious organizations, and the wealthiest nobles. He could do almost anything. The British diarist John Evelyn reported that Bernini "gave a public opera wherein he painted the scenes, cut the statues, invented the engines, composed the music, writ the comedy, and built the theatre."

3.10 GIANLORENZO BERNINI, plan of Sant'Andrea al Quirinale, Rome, 1658–70.

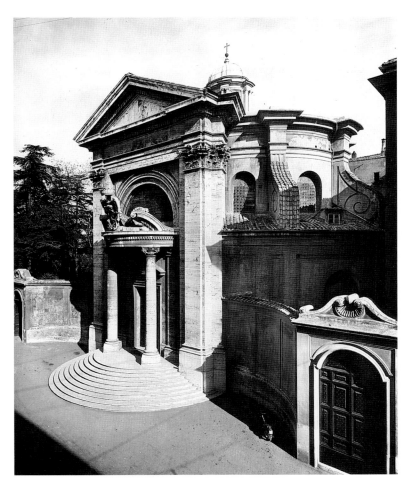

3.11 GIANLORENZO BERNINI, exterior of Sant'Andrea al Quirinale, Rome, 1658–70.

Already during the reign of Innocent X (1644–55) there had been plans for Francesco Borromini to build a church here, but the Pope disliked the idea of a large building so close to his summer palace. Nothing happened until the reign of Alexander VII (pope from 1655–67), who agreed with his predecessor's nephew Prince Camillo Pamphilj to go ahead with plans for a church for the Jesuits. Pamphilj, however, found Borromini difficult and hired Bernini instead.

He loved spectacle. His "special effects" in his theatrical presentations included creating apparent floods and fires that terrified the audience. When Maffeo Barberini became Pope Urban VIII in 1622, he used Bernini's talents to his benefit, as we can observe in the Pope's tomb (see FIG. 4.3), and those colossal adornments for the interior of St. Peter's, the Baldacchino and the throne of St. Peter (see p. 118 and FIG. 1.2).

Sant'Andrea al Quirinale (FIG. 3.10), a church built especially for Jesuit novitiates (religious novices), is situated on a relatively restricted space on Rome's Quirinal Hill, just opposite the pope's summer palace (now Italy's Presidential Palace). That it is today one of Rome's favorite churches for weddings suggests something of the unusual appeal and elegance of this building. Baroque architectural rhetoric is active. The traditional role of a church or temple as a somewhat "passive" cubical building was replaced in the seventeenth century by architecture that, in its most radical forms, aggressively seeks out its visitor. The entrance bay (FIG. 3.11) stands virtually alone as if it were a monumental gateway into a spiritual realm. The rest of the building either curves away from it, or, because of the quadrant walls (each describing a quarter of a circle) on either side, pulls you in. Once inside, the visitor is confronted with an unusual but highly appealing elliptical space and a narrative that unfolds within different levels of (un)reality. Because Bernini had little depth to work with, he compressed the space so that the shortest axis of the interior is between the viewer

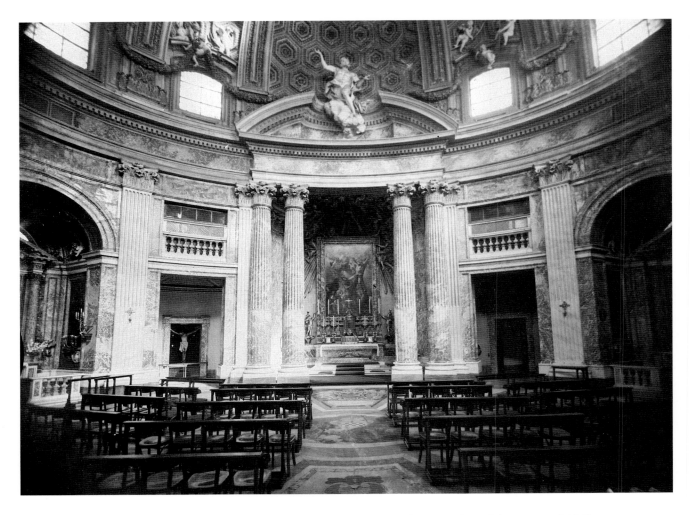

and the high altar. To left and right, the space stretches out so that you almost want to open your arms after walking the few paces from the front door. Bernini arranged the lower level of the center of the church as a series of arches that lead to small, relatively dark side chapels. At the end points of the longitudinal axis, the worshipper's eye finds not the opening of a chapel, but an engaged pilaster decorating a **pier** (FIG. 3.12). The effect of closing these end points with a pilaster is to keep the eye moving throughout the sumptuous interior.

Cardinal Camillo Pamphilj spent generously on the interior, even to the point of worrying some of the Jesuits that their needs would be better served by a simpler and more austere build-

ing. Even within the religious orders of the period, there was some concern about expense and lavishness. But the Jesuit General, Gian Paolo Oliva, Cardinal Pamphilj, and the Pope believed differently. The purpose of such an interior was not to overwhelm with opulence but to carry one heavenward for (as the Jesuit motto says) "the greater glory of God and the Church" (*ad majorem Dei gloriam*).

Having employed the finest marbles for the interior so as to create a sense of richness and other-worldliness, Bernini turned to a sculptor and a painter to help use the architectural space as the setting for a mystical event: the ascension of St. Andrew to Heaven. The portico-like frame for the high altar, known as an **aedicula**

3.12 GIANLORENZO BERNINI, Interior of Sant'Andrea al Quirinale, Rome, 1658–70.

or tabernacle, appears to have been affected by some miraculous event. As we know from studying the Jesuits' *Spiritual Exercises* (see p. 358), the religiously devout could be led into a visionary experience by employing their imagination in a vivid and sensuous fashion. As the altar tabernacle appears to bend, the columns spread apart and reveal a painting of the martyrdom of St. Andrew on an X-shaped cross – the cross of St. Andrew. The painting, by a French painter from Burgundy, Jacques Courtois (1627–79), known as Il Borgognone, is illuminated by a "miraculous" light, which comes from a hidden lantern constructed by Bernini above the altar chapel. A second representation of St. Andrew rises into the golden dome of the church. This Andrew is a stucco figure by Antonio Raggi (1624–86), a sculptor who frequently worked with Bernini. The saint appears to be riding on a cloud toward the opening of the lantern in the center of the dome, where numerous angels await him

(FIG. 3.13). Thus Bernini combines architecture, sculpture, and painting to create a unified effect of awe, joy, and rapture in the witnessing of a saintly ascension in a supernatural setting.

THE CHURCH AS *CONCETTO*: SANT'IVO DELLA SAPIENZA

Bernini's rival and sometime collaborator Francesco Borromini built Baroque churches whose structural and emblematic complexity amazed (and sometimes offended) his contemporaries. Borromini did not enjoy the same success as Bernini. He came to Rome from his native Bissone on Lake Lugano and was employed by Carlo Maderno, to whom he was distantly related, as a stone carver at St. Peter's. He also worked with Bernini in a somewhat menial position, but soon grew to despise Bernini both for his fame and, as Borromini saw it, his poor engineering. They parted company in 1633. Borromini scorned the melding of narra-

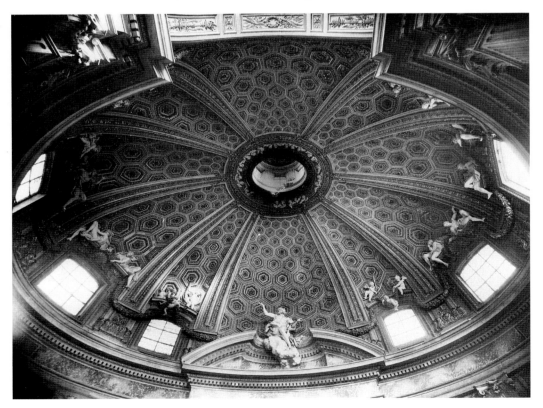

3.13 GIANLORENZO BERNINI, dome in Sant'Andrea al Quirinale, Rome, 1658–70.

tive and architecture that Bernini's more sculptural sensibility favored. His Sant'Ivo della Sapienza (St. Ivo of Wisdom) (FIG. 3.14) appeals to principles of design and symbolic representation rather than to the demands of telling a story. In the earlier Tridentine period, there was the general feeling that heretics were everywhere, and that the church was under attack. Because of this threat from the Protestants, there was ever more need for Christian eloquence in support of Christian virtue and submission to absolute authority. Church leaders recalled that Cicero, the ancient Roman statesman and rhetorician, had termed oratory "Wisdom speaking copiously." Borromini's church is a paean to wisdom, and speaks in architecturally copious terms.

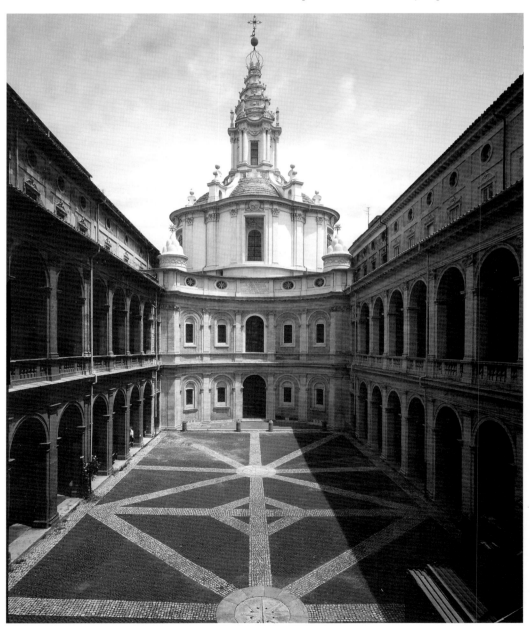

3.14 FRANCESCO BORROMINI, exterior of Sant'Ivo della Sapienza, Rome, begun 1642.

Borromini used the church to complete the courtyard, built by Giacomo della Porta for Pope Sixtus V. In both stories of the concave façade he continued the form of della Porta's arcade, but placed windows inside each arch. The concave façade does not reveal the shape of the church's interior, nor does the pulsating drum. The small steps on the roof and the curving lantern lead the viewer's eye upward to the point that architectural forms dissolve against the background of the sky.

3.15 Francesco Borromini, plan of Sant'Ivo della Sapienza, Rome, begun 1642.

Sant'Ivo, built for the Roman Archiginnasio (a center of learning, later to become the University of Rome), is not a longitudinally planned church set up for large congregations and sermons. Its plan is based upon the star-hexagon, an ancient emblem of wisdom (FIG. 3.15). (The inscription in the **attic** story welcomes us to the "Aedes Sapientiae," the House of Wisdom.) The plan was probably also conceived as a geometric form that resembled a bumble bee, the personal heraldic device of Pope Urban VIII. That the bee also stood for divine wisdom deepens the prevailing symbolism. The manner in which the complex ground plan and the undulating wall surfaces on the inside finally resolve themselves in the simple purity of the dome (FIG. 3.16) and the lantern demonstrates the cleansing effect of divine wisdom in the service of the Church and the city of Rome. As the architect wrote, the dove at the top of the lantern (FIG. 3.17) descends from heaven "with its rays making tongues of fire signifying the coming of the Holy Spirit which

3.16 Francesco Borromini, dome in Sant'Ivo della Sapienza, Rome, 1642–60.

Although the interior of the dome was painted, gilded, and covered in marble in the nineteenth century, there is no evidence that Borromini ever intended it to be anything but white or off-white. More recent restorations have eliminated those additions, and so the dome shimmers in a blissful white above the large, clear windows immediately above the architrave.

3.17 FRANCESCO BORROMINI, lantern of Sant'Ivo della Sapienza, Rome, begun 1642.

Scholars have noted the similarity between the corkscrew crowning element of the lantern and other recognizable forms. The ziggurats of ancient Mesopotamia had similar shapes. It is reminiscent, too, of a lighthouse, with its obvious symbolism of the searchlight (for truth), warning about unseen promontories, and perhaps promise of safe harbor (Jesus had said "I am the light of the world"). The slender, metal flames at the top remind us also that this is the tower of wisdom, representing the descent of the Holy Spirit at Pentecost, which granted the apostles the gift of tongues and inflamed them to spread the word of Jesus.

brings the true Wisdom." (The dove has since broken loose and fallen from its place.) The wisdom that Borromini's church represents is that which comes from contemplation, study of the arts and sciences, revelation, and commitment to the ideals of the triumphant Catholic Church. It is at once private, public, academic, and mystical.

The critic Pietro Bellori (1613–96) wrote that Borromini was "a complete ignoramus, the corrupter of architecture, the shame of our century." Perhaps he found Borromini's architectur-al language too arcane and eccentric, but Bellori was by no means alone in condemning Borromini. Many of his contemporaries believed that this lonely, melancholic, and socially inept architect – he eventually fell on his sword in an acute state of despondency – had been seized by a frenzy and had forsaken all the rules of ancient architecture. In actual fact, his buildings, although daring and sometimes almost tortuous in plan and execution, are intricately woven structures firmly rooted in traditional architectural practices.

Ecclesiastical Architecture as Baroque *Disegno*: Santa Maria della Pace

One of the most rigorously intelligent architects of the seventeenth century was Pietro Berretini, known as Pietro da Cortona, from his native city of Cortona, where his father was a stonemason. His main patron in Rome came to be Francesco Barberini, Pope Urban VIII's nephew and a leader of the intellectual community. His churches function as structures that seem to reach out to the public and use the elements of design to persuade them of the legitimacy of Catholicism. With some urgency Pope Alexander VII called upon Cortona to rebuild Santa Maria della Pace (St. Mary of Peace) in 1656. The Pope feared the plague, which had taken 10 percent of the Roman population that year, and he dreaded the French, whose troops were poised to invade the Papal States. The church of Santa Maria della Pace was thus a votive offering to Our Lady, appealing for her help in these difficulties. Within the church, Alexander's family also had a chapel that was decorated by Raphael.

The Pope therefore had a number of reasons for wanting this whole area redesigned. And simply for practical reasons, such as his inability to bring his coach close to the church, he desired a reworking of the surrounding space. The two streets flanking the church in this congested area of Rome were not wide enough for coaches to pass; on the other side, city planners had to create one-way traffic, perhaps the first time this technique was tried in Rome.

Cortona must have felt challenged by the restrictions of the site, but his solution was elegant and effective. He created concave walls on either side of the portico with passageways for traffic built into their lower stories (some structures had to be torn down to widen the space in front), and then continued the decoration of these walls into the adjacent edifices, uniting them with the church by creating the effect that these buildings are not only part of the church itself but are theatrical wings (FIGS. 3.18, 3.19). The theatrical motif was important because, as a kind of virtuosic set piece, it would strike one as marvelous, a *meraviglia* (see p. 22). In the middle of this stage set Cortona erected a projecting portico that calls to mind the round temples of antiquity. Above

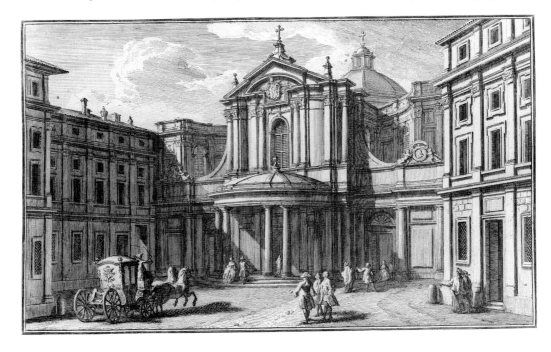

3.18 Engraving of Piazza, Santa Maria della Pace, Rome, from Giuseppe Vasi, *Delle Magnificenze di Roma Antica e Moderna,* Book 7, plate 121.

3.19 Pietro da Cortona, plan of Santa Maria della Pace, Rome, begun 1655–6.

disegno suggests not only design and drawing, but also the intellectual process of inventing and executing a composition. There is a degree of playfulness in Baroque architectural compositions, evidence of the willingness on the part of the architect to invent, to engage in fantasy, caprice, and whimsy. None of this is to say that a Baroque architect like Cortona was casual and flippant in his architecture, but that he was willing, like Bernini, to bend the rules, to push the accepted forms in exciting new directions. The curves, edges, and profiles of his designs are of

3.20 Pietro da Cortona, exterior of Santa Maria della Pace, Rome, begun 1655–6.

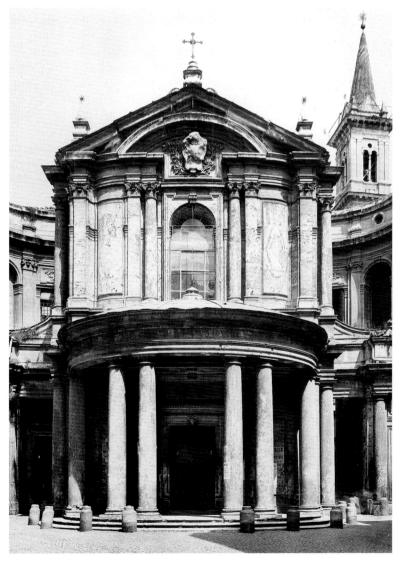

this temple form soars a façade (FIG. 3.20) that at first might look a little like Il Gesù (see FIG. 3.6), but which in fact is more complex.

The classic notion of architecture is that it is straight: flat planes and rigid verticals and horizontals define the constructive principles of ancient and Renaissance architecture. If a wall curves, it is because the structure is round, not undulant. In contrast, an important part of the temperament of the Baroque age is the willingness found on the part of many (such as Bernini, Borromini, and Cortona) to experiment with new combinations of forms.

What seems to have captivated Cortona, in addition to making references to theatrical sets, was the abstraction of design, or, as the Italians referred to it, *disegno.* As we have seen, the word

3.21 GUARINO GUARINI, interior of the chapel of the Holy Shroud, Turin, begun 1668.

Late in the evening of April 11, 1997, a fire burst from electrical cords and wooden scaffolding that were in place for renovations of the Chapel of the Holy Shroud. Amid the crashing debris from the cathedral's dome, several firemen were able to shatter with their bare hands and sledgehammers the bulletproof glass that protected the Shroud. To the thunderous applause of terrified on-lookers, they carried it triumphantly out the front door of the cathedral. Guarini's chapel, alas, suffered extreme damage, with as much as two-thirds of the marble ruined by the intense heat of the fire. According to accounts from Turin, the Shroud has escaped two earlier fires, one in the sixteenth century, and another in the middle ages.

remarkable clarity. Although these architectural forms are not imitative in the way painting and sculpture may seem to be, they are just as expressive, by virtue of their ability to invoke a sense of deep structure.

The effect of **chiaroscuro**, which involves playing the lighted areas against the darker, shadowy ones, serves the Baroque purpose of suggesting something visionary, a movement or an entity that is not immediately apprehensible by the worshipper's capacity for logic. Cortona's use of *disegno*, therefore, however logical and intellectual on his part, also appeals to the observer's sense of the miraculous. This façade is a *meraviglia*, something so astounding that it overwhelms the mind.

Maderno, Bernini, Borromini, and Cortona were largely responsible for defining the Baroque style in architecture in seventeenth-century Rome. The style eventually spread across much of Europe and even reached the New World. This was partly because architects from all over Europe came to Rome to study its buildings. They took note of the forms and spaces of the Roman Baroque and adapted them to the specific circumstances of their locales and their buildings. Secondly, of course, the Catholic Church as one of the most powerful institutions in the Western world served as a conduit for the Baroque style. The energy of the Tridentine Era was not to be contained in a single city.

Northern Italy & Venice

BAROQUE ARCHITECTURE OF THE MARVELOUS: CHAPEL OF THE HOLY SHROUD, TURIN

In the north-eastern Italian city of Turin, Guarino Guarini (1624–83), deeply inspired by Francesco Borromini, created Baroque architecture of the "marvelous." His chapel of the Holy Shroud (FIG. 3.21) is as intricate and involved in its structure as anything produced by those

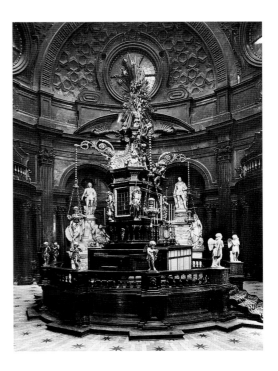

members of the older generation of architects, Bernini, Borromini, or Cortona. The chapel houses the famed "Shroud of Turin," a cloth that bears the miraculous image of the body of Christ. Although the Church repudiated the authenticity of the Shroud in the middle ages, the House of Savoy, which ruled Piedmont (of which Turin was the capital), venerated the Shroud and wished to have a chapel built for it that would be midway between the Cathedral and their royal residence.

Guarini inherited a chapel begun by another architect, but transformed the fairly conventional circular form with the addition of new doors, **pendentives**, and conical dome. The result is a three-dimensional exposition of the miraculous. The chapel is reached by either of two rising passageways that exit from the side aisles of the Cathedral. A third door leads to the Royal Palace, which is on the same elevation as the chapel. The fact that one does not enter directly into the space from the outside prolongs the anticipation and further perplexes the worshipper, who sets foot into a relatively dark space made elaborate by black polished marbles.

Guarini supported the **drum** and dome with three pendentives. Four pendentives were generally used to mark the transition from a quadrilateral lower story to a circular drum, but here the lower area is already circular. A concern for figuring the mystical Trinity may also have determined the architect's choice. The drum of the dome has high, arched windows that flank concave and convex tabernacles within tabernacles (FIG. 3.22). In the next zone, Guarini created a forest of horizontally slung ribs, each of which arches over an almond-shaped, double-lighted window. There are six rows of these stick-like ribs, with six arching ribs in each row. It is as if the light coming into the dome must first pass through a myriad of stylized, half-closed eyes. At the top is a shape like a twelve-pointed sunburst. The critic John Varriano has written about the "distinctly Baroque notion of spiritual apotheo-sis" in this space (p. 218). As the light washes in through these extraordinary windows, the Shroud is glorified and the worshipper elevated.

The Church as Votive Offering: Santa Maria della Salute

An appeal for divine intervention marks the conception of Baldassare Longhena's Santa Maria della Salute. Longhena (1598–1682) was, like a number of architects of this period, the son of a stone carver. And like other artists of the Baroque, he improved his lot in life by becoming an architect – in fact Venice's most famous architect of the seventeenth century. In 1630 Venice found herself in the grip of a plague, a recurring scourge in this rat-infested city. The Senate wished to build a church as an *ex voto*, an offer-

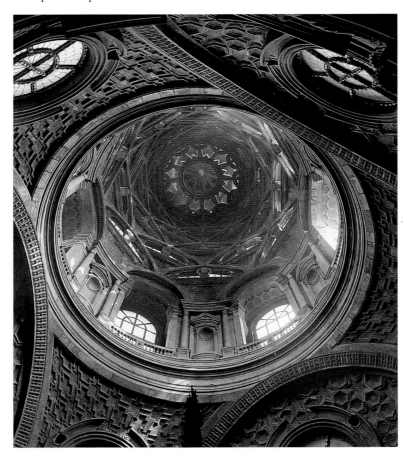

3.22 GUARINO GUARINI, interior view of the dome of the chapel of the Holy Shroud, Turin, begun 1668.

3.24 Baldassare Longhena, exterior of Santa Maria della Salute, Venice, begun 1631.

3.23 (*below*) Baldassare Longhena, plan of Santa Maria della Salute, Venice, begun 1631.

ing to the Blessed Virgin Mary in her aspect as a giver of health. The Senate made it clear that this should be a church "magnificent and with pomp." Longhena himself later wrote in response to some critics, "The dedication of this church to the Blessed Virgin made me think of designing the church, with what little talent God has bestowed on me, in forma **rotunda**, i.e. in the shape of a crown." The Baroque sense of ostentation, devotion, and the regal all combine in an unusual and creative form at Santa Maria della Salute (FIG. 3.23).

From across the Grand Canal, the façade of Santa Maria della Salute (FIG. 3.24) appears with all of its rich relief carving, **volutes**, rounded Palladian-styled windows (like half moons), its several domes (one larger for the circular area of

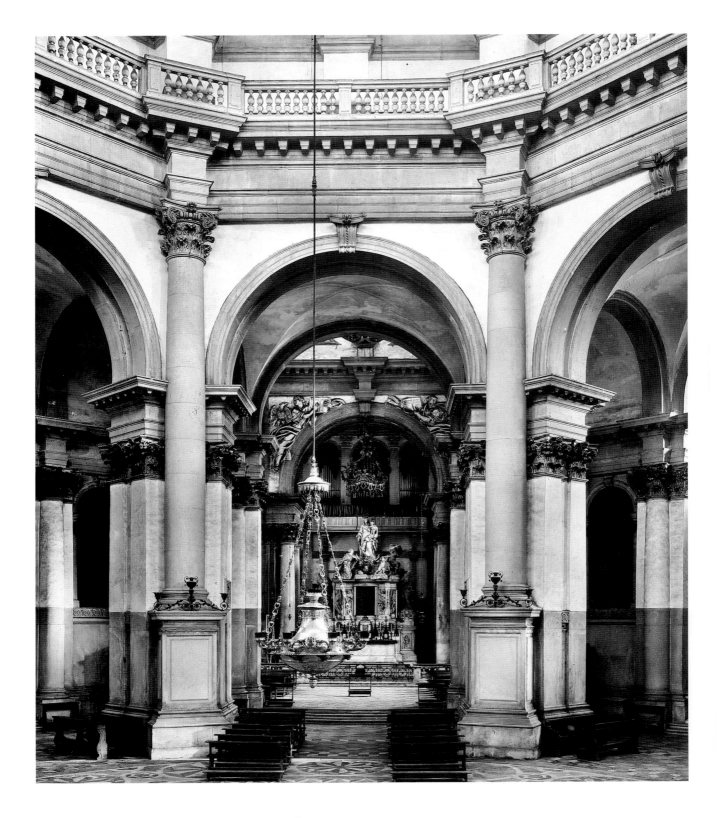

3.25 Baldassare Longhena, interior of Santa Maria della Salute, Venice, begun 1631.

The scenographic or theatrical effect is what sets off the soul's rising toward heaven in a Baroque ecclesiastical interior. The Jesuits, fully aware of its dramatic potential in the service of religion, were supporters of the theater. They understood what Thomas Aquinas, perhaps the most important of medieval theologians, did not: that a concept of divine illumination is important to Christians. Baroque architecture did everything it could to actualize one's desire for rapture and transport.

the church, a smaller one for the altar), and, for the main entrance, a copiously decorated triumphal arch. The rotunda is composed of eight facets, each of which carries on the outside a tabernacle design. Corresponding to these eight sides are the giant scrolls – the jewels on Mary's crown – which are arranged in pairs as they fan out above the lower story. The many openings created by large windows, doorways, and niches filled with sculpture create a luxuriant patterning everywhere the eye seeks to rest.

Having taken the Accademia bridge to the so-called Dorsoduro side of Venice, the worshipper finds his or her way down to the church, climbs the steps, and enters. If the main door is open, the visitor then can turn back toward the Grand Canal, look out and see only water between the church and the other side. One experiences a sense that the church perpetually floats at the entrance to the Grand Canal. This buoyant sensation – quite fitting for the Baroque – is unique to Venice, which is built upon pilings sunk into the lagoon. Turning back to the interior (FIG. 3.25), the visitor has a choice of circling the rotunda and passing all of the altars in the eight sections, or of proceeding straight toward the high altar, which is located in a separate and somewhat darker space, behind which is a monks' choir.

This visual effect of spaces receding from the viewer into smaller and darker units has been referred to as scenographic, as if here the worshipper were a spectator at a theatrical performance. Aiding the ascent of the Christian soul was achieved by various and even deceptive means in the Baroque age. One commences this rising in the material world and goes up by acts of the imagination, an imagination aided and abetted by the visual arts; painting, sculpture, and architecture work both separately and in concert. In Santa Maria della Salute the worshipper is propelled not so much upward, although the rotunda is capped by a dome, but toward the high altar. And on this short pilgrimage, the worshipper passes through spaces and details of splendor – the spaces of the Baroque.

France

The Italian style of Baroque church as developed by Vignola, Maderno, and especially Bernini was picked up in France in the mid-seventeenth century by Jacques Lemercier (c. 1585–1654) and François Mansart. Since the reign of King Francis I (1494–1547), France had been growing richer and more powerful. Francis began the effort to centralize power in the monarchy. Under Louis XIII and his chief minister Cardinal Richelieu, France positioned herself to resist the Habsburgs in Spain and the Holy Roman Empire (also ruled by the Habsburgs). During the Thirty Years' War (1618–48), the French joined forces with King Gustavus Adulphus of Sweden against the Empire. By mid century, the French were strategically placed to resist the Church – but not necessarily Italian art and culture. Cardinal Mazarin was Italian by birth and Jesuit educated. He loved things Italian – opera, theater, festive extravaganzas, painting, sculpture, and architecture. Much to the chagrin of some French nobles and artists, he imported Italian theatrical designers, painters, sculptors, and architects.

THE CHURCH AS COMMEMORATION: VAL-DE-GRÂCE

Co-regent with Cardinal Mazarin was Anne of Austria, Louis XIV's mother. Anne and Louis XIII had spent little time together, but on one occasion the King found it convenient to stop and spend the night at the cloisters of Val-de-Grâce before continuing on to the royal château at Fontainebleau. Here occurred the late, unexpected, but ardently wished-for conception of the future Sun King, and Anne vowed to build a church on the spot.

Two architects worked at Val-de-Grâce, which was completed in 1667. The first was François Mansart, the best known of the "classic" architects of this period. For reasons that are not altogether clear, Anne dismissed Mansart and brought in Jacques Lemercier, who had experi-

frames a window, which gives on to the interior. This progressive retrogression of framing elements toward the center is what the French call *mise-en-abîme*. But we are not so much given a passage to the abyss as we are led into a Baroque church.

Although the interior differs somewhat from Mansart's plans, it retains in essence what he projected. Like St. Peter's in Rome and many other Tridentine churches, the broad nave is barrel vaulted. The side chapels open into the nave from arches that nearly reach to the entablature, thereby allowing considerable light to penetrate to the center of the church. In contrast, the pro-

3.26 (*far left*)
FRANÇOIS MANSART,
plan of Val-de-Grâce,
Paris, begun 1645.

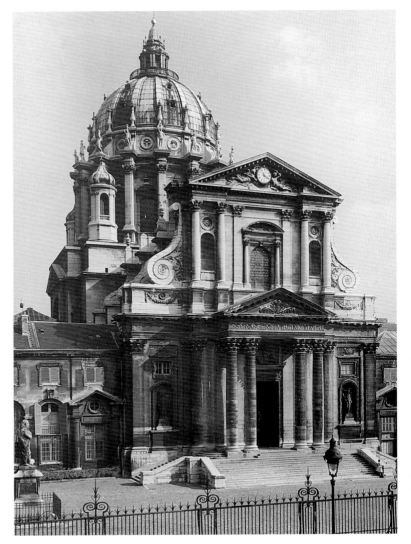

ence in Roman architecture from a stay there of several years earlier in the century. Mansart planned the church (FIG. 3.26) and built it up to the level of the entablature of the nave. Lemercier constructed the dome (but after Mansart's plans) and designed the second story of the façade (FIG. 3.27).

Mansart erected a powerful portico of Corinthian columns and sharply defined projections for the **frontispiece**. Immediately behind this portico (intentionally reminiscent of the Pantheon in Rome) is another plane, which abruptly breaks backward to the next plane, which in turn establishes the flanking walls. As was traditional for the upper level, Lemercier used a lighter version of classical elements. Paired columns at the outsides frame empty niches; the entablature then disengages from the established plane and falls back to another level. Instead of strengthening the order at the center bay, as Mansart had done below, Lemercier used flat, unfluted pilasters flanking a smaller version of the portico (what is, in fact, a tabernacle), which

3.28 FRANÇOIS MANSART AND JACQUES LEMERCIER, high altar of Val-de-Grâce, Paris, begun 1645.

According to contemporary accounts of Gianlorenzo Bernini's trip to France in 1665, Le Duc's design for the baldacchino was shown to him. In typical fashion (as the French perceived it) the irascible Italian took an immediate dislike to the French sculptor's homage and suggested alterations, which never were carried out. The design of Bernini's Roman baldacchino (see p. 118) turns up one more time in Paris, at the Invalides, where a nineteenth-century version now stands in the apse of the church.

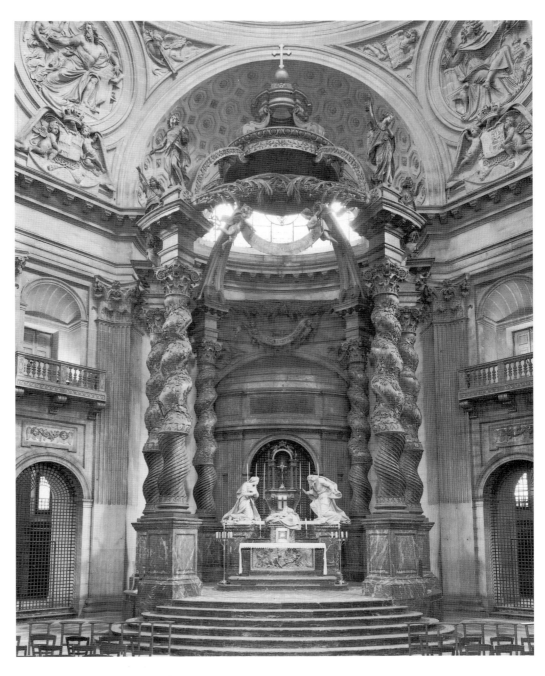

3.27 (*opposite*) FRANÇOIS MANSART AND JACQUES LEMERCIER, exterior of Val-de-Grâce, Paris, begun 1645.

clivity in the seventeenth century was for relatively small and dark side chapels. The crossing piers have the substance and weight of those at St. Peter's (perhaps Lemercier had this in mind), except that these open up with passageways from the crossing into the **ambulatory** area. The presentation of these traditional elements on an imposing scale was intended to impress the viewer. As a tribute to Gianlorenzo Bernini's art, Gabriel Le Duc copied the helical columns of the Italian's famous Baldacchino in St. Peter's for the high altar of Val-de-Grâce (FIG. 3.28).

THE REASSERTION OF ROMAN BAROQUE: CHURCH OF THE INVALIDES, PARIS

In the middle of the seventeenth century much of French art was dominated by Charles Le Brun, the president of the French Royal Academy. The style he preferred leant more toward the classical than the full-blown Baroque (see Chapter 5). But by the 1670s and 1680s, Le Brun's power had abated and a taste for something akin to Roman Baroque asserted itself.

François Mansart's great-nephew Jules Hardouin (1646–1708; he was later to add the name "Mansart" as a gesture of respect to his great-uncle) built the Parisian church of the Invalides on a Greek cross plan (FIG. 3.29), although the longitudinal arrangement was gen-

erally preferred in the seventeenth century. Hardouin-Mansart planned the façade (FIG. 3.30) as so many planes stepping forward, with the entrance bay the most prominent; colossal Doric columns stand on either side of the entrance. The upper portico is of a traditional format, with paired columns supporting a triangular pediment. Hardouin-Mansart used the centrally planned lower stories as a base for a tall dome. The worshipper's eye ascends from the cube of the lower story into the cylindrical forms of the drum, and then – following the high, arcing curve of the dome itself – to the relatively simple **pavilion** and spire at the top. Although the arrangement of columns is similar to that of St. Peter's, Hardouin-Mansart achieved a greater sense of soaring heights. The gold decoration

3.30 (*opposite*)
JULES HARDOUIN-MANSART, exterior of church of the Invalides, Paris, begun 1674.

Although recognized as one of the great churches of the French Baroque, the Invalides is visited most often today by tourists eager to view the tomb of Napoleon I, whose ashes were brought by King Louis-Philippe from St. Helena to the Invalides in 1840. The church of the Invalides is joined to another church behind, St. Louis des Invalides, and both are part of the complex formerly known as the Hôtel des Invalides (now the Musée de l'Armée), a hospice for casualties of war.

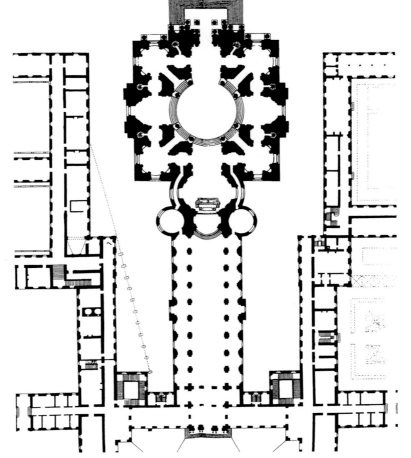

3.29 JULES HARDOUIN-MANSART, plan of Church of the Invalides, Paris, begun 1674.

Taking a page from Bernini's book, J.H. Mansart planned two arms reaching out to embrace the broad space in front of the Invalides. These quadrant (quarter-circle) arcades were anchored at either end by pavilions that repeat in reduced scale the basic form of the entrance bay of the church.

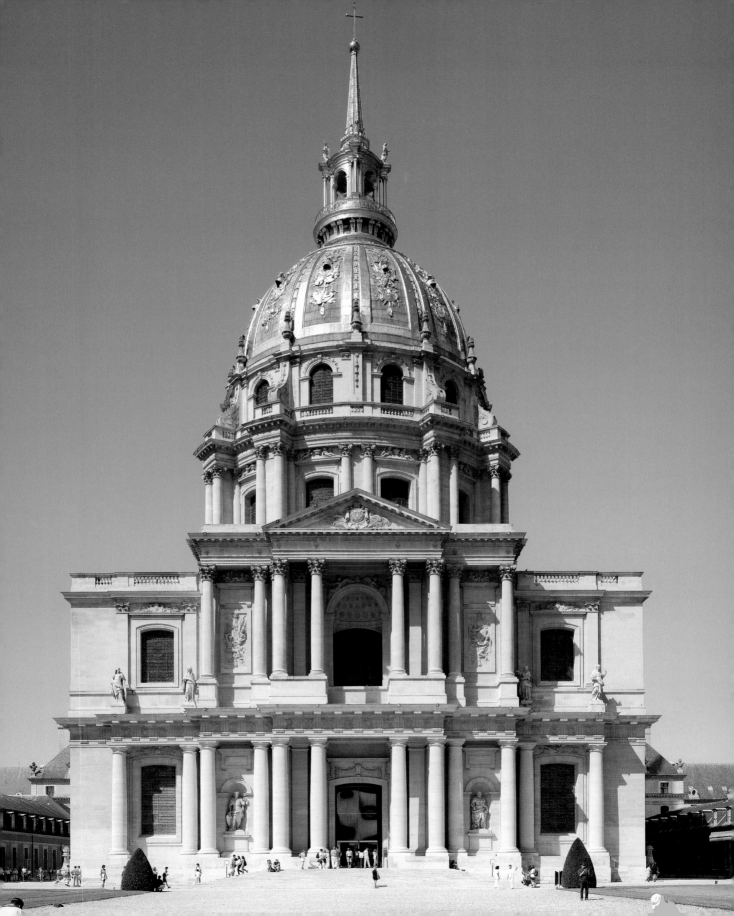

between the ribs of the dome looks heavenly, especially when seen from a distance, and the entablatures and columns project and recede in an imposing manner.

Val-de-Grâce contains both classical and Baroque elements, with the restrained and academic side perhaps taking precedence. In the church of the Invalides the interior articulation is far richer and more dazzling. The interior of the dome has an opening that leads the worshipper's eye into another region, one that is blissful and celestial. This setting up of levels of unreality is fully Baroque and depends upon a degree of artistic chicanery that rarely is found in earlier (or, for that matter, later) European art.

England

The Baroque church came to England as an import. Unlike the circumstances of papal Rome, where the Baroque exists in its purest form, England was Protestant and ruled by king and Parliament in collaboration. The English inclination toward conservative architecture undoubtedly hindered somewhat a style that by its very nature celebrated superabundance and mystical joy.

THE REBUILDING OF LONDON: ST. PAUL'S CATHEDRAL

The leading architect of the time, Sir Christopher Wren (1632–1723), began his career as scientist and geometrician. He was hailed in his early years by the diarist John Evelyn as a "miracle of a youth" and in his maturity as an "incomparable genius." He lived through remarkable times in England, growing up under Charles I, witnessing the Civil War, the Commonwealth, and the Restoration, then growing old in the reign of Queen Anne, and dying in the reign of George I. His impact was huge: his tomb in St. Paul's carries the epitaph *Si monumentum requiris, circumspice* ("If you seek his monument, look about you").

Although he did not visit Rome, Wren met the master of the Italian Baroque, Gianlorenzo

Bernini, in France in 1665. His travels probably were undertaken not just for study, but to avoid the plague. Nearly 70,000 Londoners died in 1665 alone. Disaster followed disaster. Within months of Wren's return in 1666, nearly all of London within the old walls burned in the Great Fire. Because only stonemasonry was permitted in the rebuilding of London, Wren's services were dearly needed.

Even before the catastrophes of 1665–6, Wren had envisioned the grand church of St. Paul's. His so-called Great Model for St. Paul's, however, drew the ire of conservative and Protestant-minded officials. It reminded them too much of St. Peter's – it was, in short, too Baroque. Wren himself declared that he abhorred "fancy," which is a code word for the imaginative and playful elements of the Roman Baroque, but his knowledge of that quintessence of the Baroque – the architecture of Rome – was decidedly second-hand. His meeting with Bernini probably allowed him to see the older Italian's sumptuously dynamic, potent, and energetic plan for the Louvre (which was rejected; see

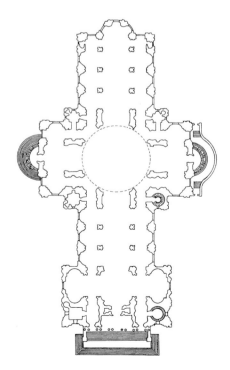

3.31
SIR CHRISTOPHER WREN, plan of St. Paul's Cathedral, London, 1675–1710.

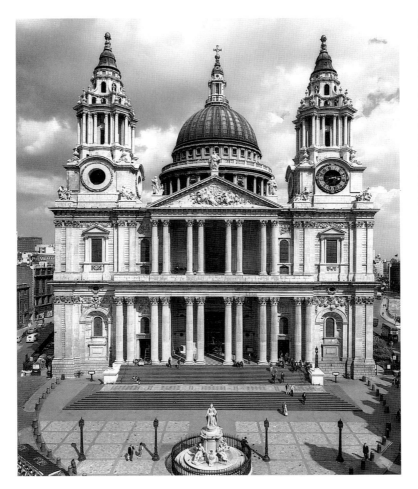

3.32
Sir Christopher Wren, exterior of St. Paul's Cathedral, London, 1675–1710.

The dome of St. Paul's is 112 feet (34.1 m) in diameter and 300 feet (91.4 m) high, second in size only to St. Peter's in Rome. Even today, the dome dominates the London skyline, though the lower façade is easily visible only from nearby.

p. 224), and his knowledge of Borromini's architecture was limited to whatever engravings he could find (the bell towers at St. Paul's are unmistakably Borrominesque).

Despite Wren's and his English contemporaries' aversion to Italian *fantasia*, St. Paul's Cathedral (1675–1710; FIGS. 3.31, 3.32) is in its impact and meaning Baroque. As at St. Peter's the order is colossal and the horizontal molding fit for a giant's eye (although not quite so high as originally intended). As at the Invalides and Val-de-Grâce, the frontispiece advances toward the visitor in an assertive and insistent fashion. The lower story is a horizontal colonnade of cyclopean proportions; above is a portico motif of a similarly generous scale. The cylinder of the dome finds contrast in the concave/convex forms of the later-

al towers. Although St. Paul's has many classical elements of restraint, this great pile of architecture imprints on the mind of the worshipper all the messages and meanings of the Baroque.

The Dean of St. Paul's Cathedral had written to Wren on behalf of the Archbishop of Canterbury and the Bishops of London and Oxford that he was to "frame a Design, handsome and noble, and suitable to all the Ends of it, and to the Reputation of the City, and the Nation, and to take it for granted, that Money will be had to accomplish it." This affirmation that, at all costs, the results must be worthy of the city and nation and must be handsome and noble is squarely within the traditions of the Baroque. When Sir Christopher stated that "it is enough if they [Roman Catholics] hear the

Murmur of the Mass, and see the Elevation of the Host, but ours are to be fitted for Auditories," he misread what actually was important to Roman Baroque church building. Il Gesù is as "auditory" (that is, it has good acoustics) as St. Paul's. Although the Anglican cathedral differs from Roman Baroque prototypes, it differs less than one might think. And yet, despite the enormity of scale and the richness of decorative effect (such as the use of coffers within the many arches and the choice of Corinthian capitals throughout), some judge the experience of St. Paul's to be cold and very clearly Protestant.

The nave (FIG. 3.33) consists of a series of relatively independent bays kept separate from one another by heavy, transverse arches. Each bay has a hemispherical dome. The spaces, therefore, are coordinated rather than merged; harmonized rather than flowing; equalized rather than subordinated to an overall impression. But the crossing and dome evoke a powerfully Baroque effect. The area beneath the dome remains open by virtue of those arched openings below the pendentives that support the dome. The interior of the dome rises at a fairly steep angle and then opens into conical space, which hides the more sedate and cylindrical shape of the exterior. Probably contrary to Wren's wishes, Sir James Thornhill was engaged to paint frescoes of an empyrean realm on the innermost dome, that area viewed by the worshippers below.

Austria & Germany

Religious hatred had festered in Central Europe since the beginning of the Protestant Reformation. What ensued was the Thirty Years' War, a series of bloody and destructive conflicts among German princes and other European powers (such as Sweden and France) who wished to curb the powers of the Holy Roman Empire, which had been ruled for centuries by the Habsburg family. The consequences of these unsettled times for architecture were disastrous. Money went into the war, not into patronage. And at the war's end, even for the rulers of the larger territories such as

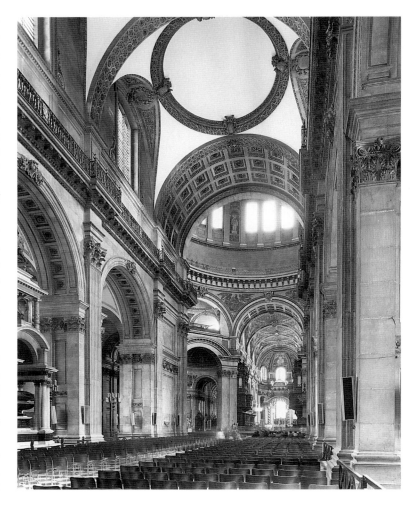

Prussia and Austria, there were at first relatively few resources for the arts. By the eighteenth century, however, the Catholic parts of Central Europe (such as Bavaria), and much of Austria were ready to rebuild.

The approach was cosmopolitan. There were German craft builders, whose experience was largely local, and German or Italian architects, who brought with them a direct knowledge of the Roman Baroque. In addition, after the end of the War of Spanish Succession in 1714, and the arrival of a peace that had been so elusive for nearly a century, French ornamental designs, the *rocaille* (see p. 14) came to replace some of the heavier embellishments of an earlier period.

3.33
SIR CHRISTOPHER WREN, interior of St. Paul's Cathedral, London, 1675–1710.

Even after more than twenty years of construction the cathedral had no dome, and members of the government insisted that half of Wren's salary be withheld until completion. Finally in 1710 his son placed the last piece of Portland stone into the dome's fabric, and Wren, nearly eighty, was able to collect his back pay.

3.34 JOHANN FISCHER
VON ERLACH,
plan of Karlskirche,
Vienna, 1716–33.

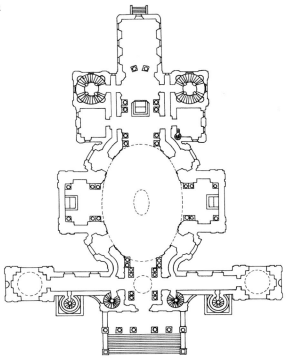

IMPERIAL STYLE: THE KARLSKIRCHE, VIENNA

Post-war ecclesiastical architecture in Central Europe found an early home in Vienna, seat of the Habsburgs and a city whose wealth and size rivaled that of Paris, Rome, and London. The first of the Austrian Baroque architects was Johann Fischer von Erlach (1656–1723), who began his career as a sculptor, studying in Rome in the circle of Gianlorenzo Bernini. He was well trained, highly literate, and strategically placed to get the best commissions. His book *Entwurff einer historischen Architectur* (An Outline of Historical Architecture) demonstrates his wide knowledge of architecture and architectural types. His position as tutor in architecture to the Crown Prince Joseph pretty much guaranteed Fischer imperial commissions. But it was not until after the end of the War of Spanish Succession that Fischer was to receive his first, major ecclesiastical project. It was for the Karlskirche (FIGS. 3.34, 3.35).

3.35 JOHANN FISCHER
VON ERLACH,
exterior of Karlskirche,
Vienna, 1716–33.

The striking feature of
this monumental church
is that despite its eclectic
blend of styles, its overall
design succeeds in being
visually coherent. In front
of an oval nave, oriented
lengthwise, stands an
unusually broad façade
comprising a bizarre mix-
ture of elements. The
entrance to the church
is represented by a
Corinthian hexastyle
temple portico on top of
a stepped podium, indis-
tinguishable in design
terms from a Roman
temple front.

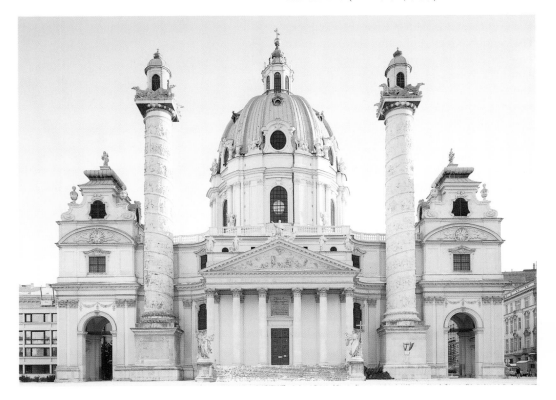

Because of St. Charles Borromeo's heroic efforts during the plague of 1576–8 in Milan, Charles VI (Holy Roman Emperor 1711–40) had promised to build a church dedicated to the saint if Vienna was delivered from the plague of 1713. The resulting church demonstrates clearly Fischer's Roman experience. The two columns in front of the church, which depict events in the life of the Emperor's namesake, are copies of Trajan's Column, which dates from the first century C.E. and still stands in Rome's Forum of Trajan near the foot of the Capitoline Hill. In addition, these columns recall two freestanding bronze towers, known as Boaz and Jachin, which were placed before the palace of Solomon in Jerusalem (as described in the First Book of Kings). The names Boaz and Jachin mean something like "He comes with Power" and "God establishes." By erecting these towers, Fischer engages a particular aspect of the Austrian Baroque called *Reichsstil*. Literally this means "imperial style"; expressively, it means to celebrate the emperor and the empire.

There is a certain amount of pedantry here. The portico clearly derives from the Pantheon. The concave wings connecting the frontispiece with the flanking towers are similar to well-known but unexecuted plans for St. Peter's in Rome and also to Borromini's church of Sant'Agnese in Piazza Navona, also in Rome. The dome, too, is a duplicate of domes by Mansart, Borromini, and others. It is as if standard references from Rome and the Catholic South needed to be transferred piecemeal to Vienna in order to satisfy the imperialist claims of Charles VI.

The Church as Pilgrimage Center: Die Wies, Bavaria

A far less pretentious building is the rural and popular mid-eighteenth-century Bavarian pilgrimage church. Johann Baptist Zimmermann (1680–1758), trained as a painter and plasterer, in collaboration with his architect brother Domenikus (1685–1766), built and decorated

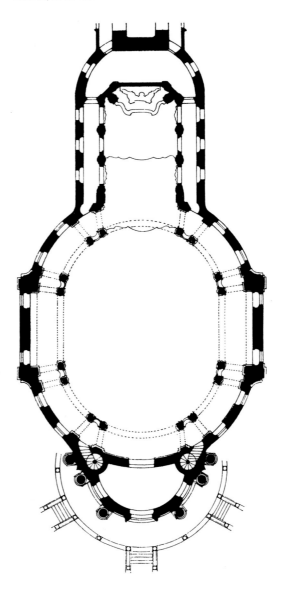

3.36 Domenikus Zimmermann, plan of Die Wies Pilgrimage Church, Bavaria, 1745–54.

several small, gem-like rustic churches in the decades preceding 1750. Die Wies (FIG. 3.36), perhaps their most mature construction, has an elongated oval nave surrounded by an arcaded ambulatory (FIG. 3.37). Zimmermann's training

3.37 Domenikus Zimmermann, interior view of Die Wies, Bavaria, showing southern ambulatory, 1745–54.

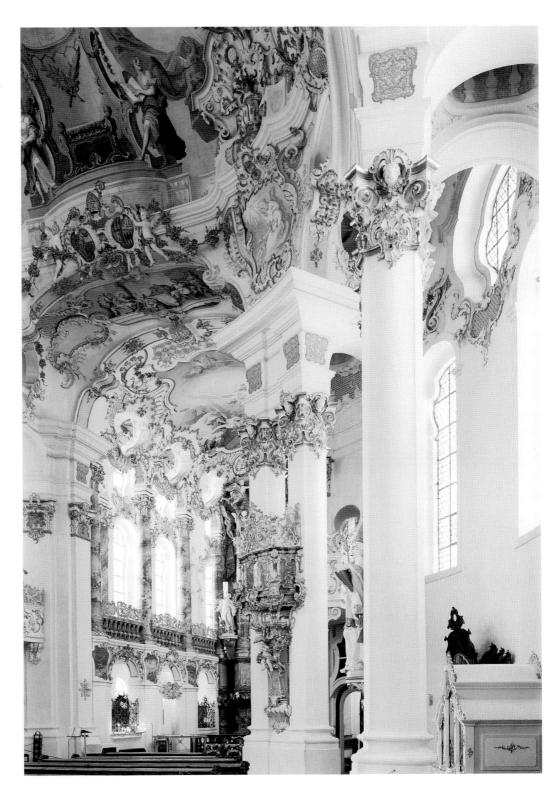

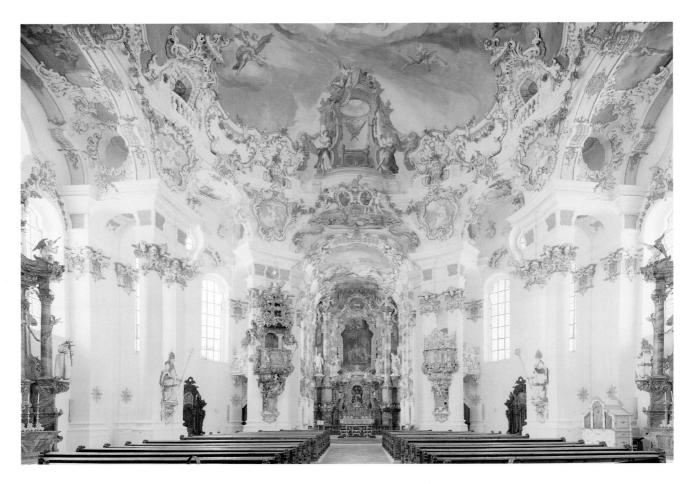

in plaster work and fresco painting shows in the extraordinary decoration of the interior (FIG. 3.38).

As a pilgrimage church, Die Wies allows, even impels, the pilgrim to walk around the central area and about the altar, which contains a miraculous image of Christ. The paired columns of the arcade are separated from one another and from the outside walls by arches. Above eye level in the ambulatory, large lancet styled windows, alternating with substantially higher oval windows at the ends of the transverse axis, admit the light that lets worshipper and pilgrim read the decoration. Spaces, whether from the entrance, the chancel, or the ambulatory merge with one another, creating a sense of vague, insubstantial boundaries. A necessary part of a pilgrim's journey is mystical, and the theatricality of the

Bavarian Rococo church assists in that experience of Divine "touching." In Johann Baptist Zimmermann's fresco of the *Last Judgment* (FIG. 3.39), one sees a panoply of divine figures – angels, blessed souls, saints, and allegorical figures – floating in the empyrean mists. In the center of this visible Heaven sits Christ in Judgment atop the rainbow, ancient symbol of concord between God and human. The "Bavarian manner" of decoration, what appears to be white plaster with gold highlights, shapes the boundaries to this vast domain, but does not create a clear border between the human and spiritual realms. The first line of eccentric and wildly curvilinear patterns is not three-dimensional architecture: it is painted. The next range of **cartouches** and irregularly shaped cornices is part of the "real" architecture of the church. If the wor-

3.38 DOMENIKUS ZIMMERMANN, Interior of Die Wies, Bavaria, 1745–54.

3.39 (*opposite*) JOHANN BAPTIST ZIMMERMANN, *Last Judgment*, c. 1750. Ceiling painting of Die Wies.

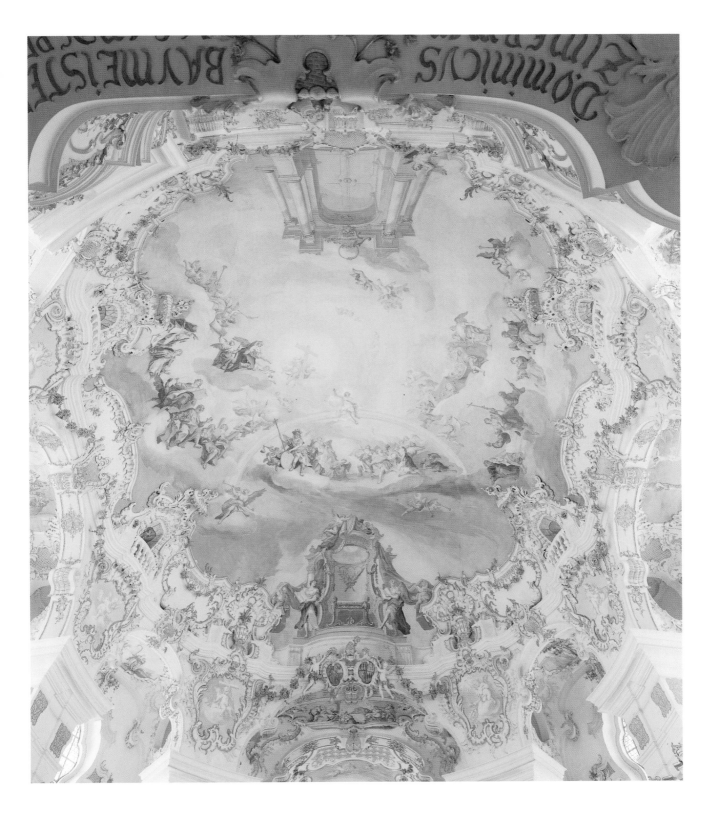

shipper cannot easily tell the difference between physical architecture and painted architecture, then he or she becomes confounded, and that very perplexity helps to loose their earthly bonds. German historians sometimes refer to the Baroque idea of a *Gesamtkunstwerk*, a synthesis of the arts in which painting, sculpture, and architecture meld in an indissoluble unity.

Zimmermann painted an elaborate, Baroque throne in the area of Heaven that is just above the chancel. As the worshipper looks from the empty throne (which is a symbol of wisdom and will be occupied by Christ at the Second Coming) downward through the arches within arches of the chancel, and finally to the altarpiece and altar, his eye moves easily but without certainty as to the degree of reality of each zone and each space. Zimmermann's fresco has widely dispersed figures and no *quadratura*. As a self-contained painting, it would not be very gripping. But as part of the architectural complex, it comes alive and is a necessary part of the entire experience.

These charming pilgrimage churches in Bavaria did not gain favor in the more official circles; perhaps they were seen as too theatrical and, because of their locations, countrified. Many were of wooden construction and were, therefore, not considered very grand. By the end of the eighteenth century, these sometimes whimsical creations of almost delicious ornament were superseded (but not destroyed) by the much more staid churches of the Neoclassical style.

Spain & the New World

In the nearly half century of Philip II's rule (1556–98), Spain's political and economic fortunes first rose and then declined. His participation in the Battle of Lepanto won him fame; his loss of the Spanish Armada in 1588 in his battle with England brought him humiliation. But his empire was vast: all of North and South America was Philip's, and in 1580 he inherited Portugal, so that the entire Iberian Peninsula was under Spain's control. He commanded the seventeen provinces of the Netherlands. A collateral branch

of the Habsburg family ruled the Holy Roman Empire. As a zealous Catholic, he was largely responsible for the Inquisition and was a vigorous supporter of the Catholic Reformation. The period from about 1550 until 1650 has come to be known as the *siglo de oro* – Spain's golden age of culture. Cervantes wrote *Don Quixote*, the artists El Greco (1541–1614), Murillo (1617 –82), and Velázquez flourished. This also was the century of Spanish mystics and founders of religious orders such as St. Teresa of Avila, St. Ignatius of Loyola, and St. Francis Xavier. Perhaps a third of the population of Spain in some form or another held a position in the Catholic Church.

In the seventeenth century, however, the Spanish crown lost much of its powerful international presence. The Northern Netherlands became officially independent in 1648. Portugal was granted sovereignty in 1668, and the American silver mines gave out by the middle of the century. Spain's control of Naples and southern Italy continued, but was fiercely challenged and somewhat weakened by a revolt there in 1648.

Given the importance and centrality of the Spanish government in international politics and the Catholic Church, it is no wonder that its style of architecture should be both strongly influenced by native styles and open to international currents. Spanish ecclesiastical architecture of late sixteenth through eighteenth centuries felt the influence of Baroque Rome, but fused its own indigenous styles with the Baroque. Spanish church façades, for example, could sometimes be relatively plain and almost medieval, or elaborately and fantastically Baroque.

LATE BAROQUE: CATHEDRAL OF GRANADA & SANTIAGO DE COMPOSTELA

The cathedral of Granada was begun in 1528 by Diego de Siloe (c. 1495–1563) but left unfinished at his death. The Spanish painter and sculptor Alonso Cano (1601–67) added the façade (FIG. 3.40) in 1664 using Siloe's original foundations. It is an odd arrangement of three

3.40 Diego de Siloe and Alonso Cano, façade of cathedral of Granada, 1664.

The strong sense of projection and recession emphasizes the mass, the sheer weightiness of the materials, used to construct Cano's façade. As a sculptor, Cano was also very attentive to surface designs, which usually have rich details. He may have learned from the *mudejár* tradition, which developed from Arabic and Muslim practice (*mudejár* is an Arabic word referring "to those who remain," the Muslims who stayed on as a minority population in Spain) in the ornamenting of textiles, wood, ceramics, metal, and ivory.

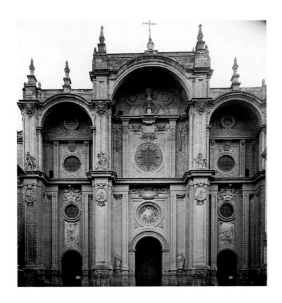

deep arches that frame the three main divisions of the interior. One would be hard pressed to fit this building into any stylistic category. It also contrasts with the more involved and almost tangled façades built after 1700.

The so-called Plateresque style of the earlier sixteenth century derived its name from complex and highly detailed silver work. This love of surface detail continued into the late Baroque, as evident in the façade of Santiago de Compostela (FIG. 3.41), begun by Fernando de Casas y Nova (1691–1749) in 1738. The church itself had existed since the early middle ages as an important pilgrimage site (it contains the remains of the apostle James, the patron saint of Spain). There is a slightly bizarre quality to the way in which the surface is detailed. Casas used volutes not unlike those along the roof of the Santa Maria della Salute in Venice (see FIG. 3.18) all over the front of the church as if they were frosted decorations on a cake. Combining with the volutes are freestanding columns and numerous statues to create a Baroque version of the Plateresque style. The Baroque came somewhat late to Spanish churches, and it came often as surface decoration, whether of the exterior of the church or as part of elaborate altarpieces or the articulation of

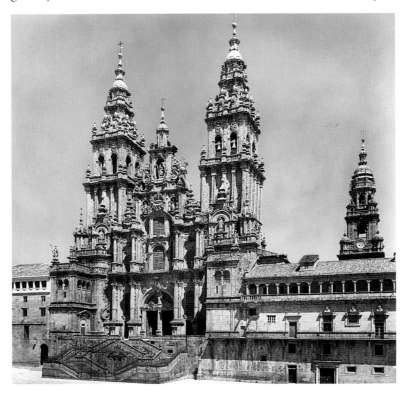

3.41 Fernando de Casas y Nova, façade of Santiago de Compostela, Spain begun 1738.

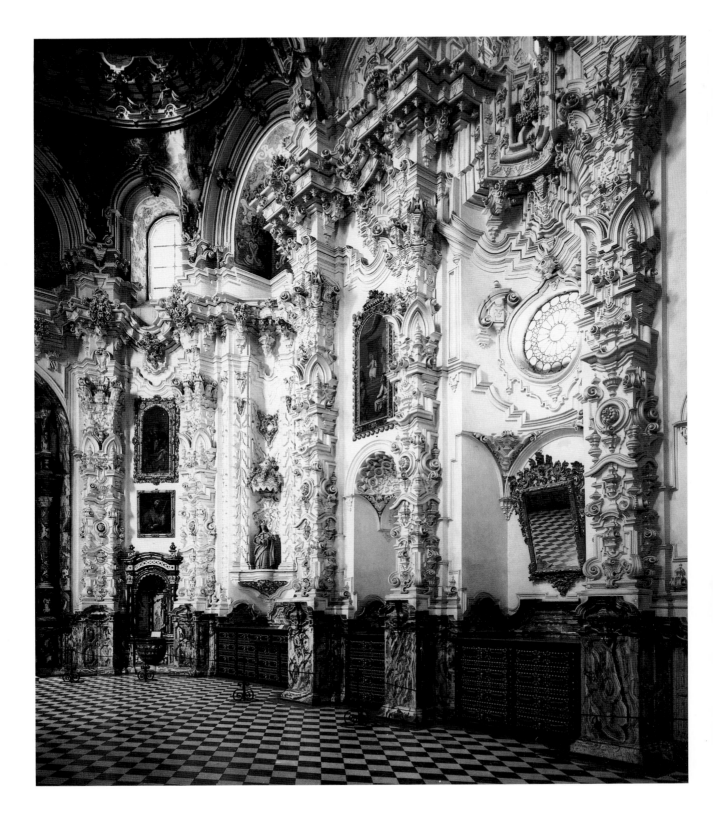

wall surfaces, such as in the sacristy of the Cartuja, Granada (FIG. 3.42). Because Plateresque ornamentation is sculptural rather than architectural, such detail can be highly disorientating and unrelated to the structure of the building. This is far from the nature of the Roman Baroque.

BAROQUE & ROCOCO IN CENTRAL & SOUTH AMERICA

The Spanish were the first Europeans to enter North America and establish a colonial presence, and they brought the Church with them. The powerful Aztec empire, famous for its rich farming, artificial lakes, and temple complexes, finally fell to the Spanish explorer and conquistador Hernán Cortés in 1521. The Aztec capital of Tenochtitlan was razed by Cortés and replaced by what came to be known as Mexico City. Here the Spanish grandees lived in splendor, built the University of Mexico, and oversaw the construction of the first Catholic churches in North America. Nearly a hundred years before settlers arrived in Jamestown, Virginia, the conquistadors had established a colonial civilization of unrivaled splendor in Mexico, and Franciscan and Jesuit friars were spreading the Christian religion throughout the Southwest, from Texas to California.

By the eighteenth century there was a marvelous style of church architecture in Mexico City, a style that is perhaps Rococo in its decorativeness, but is more aptly described as "ultra-Baroque." The perpendicular and decorative elements of the façade were strongly emphasized. The massing of ornamentation, with every conceivable space taken up with niches, shell and leaf motifs, statues, and architectural decoration is referred to by the Spanish word *estípites,* which literally means an elaborate pilaster. During the succeeding Neoclassical period – when these buildings fell out of favor – such intricacies were referred to condescendingly as *estípites impertinentes.*

Mission churches, such as the one at Acoma, New Mexico, built in 1629–42 (FIG. 3.43,

3.42 (*opposite*) LUIS DE ARÉVALO (attributed), detail of sacristy of the Cartuja, Granada, 1730–47.

3.43 Plan of San Esteban, Acoma, New Mexico, 1629–42.

Although it serves a small pueblo, San Esteban is one of the largest mission churches to survive. It is 150 feet (45.7 m) long by 33 feet (10 m) wide. The walls are 10 feet (3.1 m) thick. Without a transept, it looks like a large boat. Supporting the roof the *vigas* (beams) are 40 feet (12.2m) long.

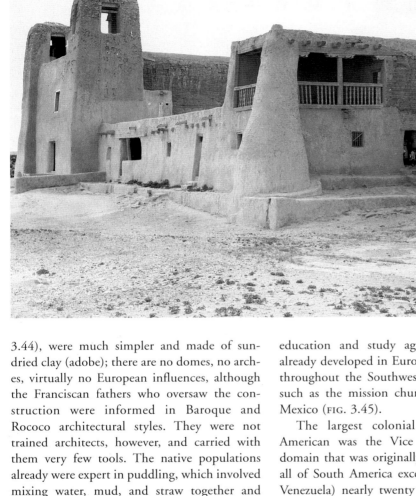

3.44 Exterior of San Esteban, Acoma, New Mexico, 1629–42.

The church sits on a 400-foot-tall (122 m) mesa as part of a pueblo known as Sky City. The only way that one could bring water, food, and building materials to the site was either by donkey or by climbing through treacherous crevices. The first encounter of the Acoma people with the Spaniards in the sixteenth century was described in a Spanish text in these terms: "The Acomas received the wondrous strangers kindly, taking them for gods … " However, terrific battles ensued, with the Acoma initially attacking a squad of Spanish soldiers, killing most, and forcing the rest to jump from the sheer cliffs. But the Spanish retaliated and subdued the tribe.

3.44), were much simpler and made of sundried clay (adobe); there are no domes, no arches, virtually no European influences, although the Franciscan fathers who oversaw the construction were informed in Baroque and Rococo architectural styles. They were not trained architects, however, and carried with them very few tools. The native populations already were expert in puddling, which involved mixing water, mud, and straw together and applying it by hand to construct walls for their houses, known as pueblos. What the priests may have passed on was the European method of arranging the mud in squared wooden forms, which allowed the workers (primarily women and children) to create masonry-like blocks of adobe. Because these parish churches were built by and for indigenous peoples, their style differed from that of the cosmopolitan centers. They served as gathering places for Native Americans, where they could receive a basic education and study agricultural techniques already developed in Europe. Mission churches throughout the Southwest followed this style, such as the mission church of Cimayo, New Mexico (FIG. 3.45).

The largest colonial territory in Latin American was the Vice Royalty of Peru, a domain that was originally (when it comprised all of South America except for what today is Venezuela) nearly twenty times the size of its ruling country, Spain. When the Vice Royalty was established in 1542 all violence toward the native people, the Incas, was put to an official end. In 1569 Francisco di Toledo arrived in South America to establish the rule of the Spanish government. A majority government of Spanish administrators directed the minority government of Native Americans in their rule over the native populations. This system of government lasted until the end of the eighteenth century, when a spate of rebellions by Native

Americans and later by natives of Spanish descent eventually led, by 1821–2, to the independence of what today is Peru.

Ciudad de los Reyes (City of the Kings; now Lima) became the most important city in all of South America, and it is here that one finds the most impressive colonial architecture. The Franciscans established a monastery in Lima, with land granted to it by the first of the conquistadors, Francisco Pizarro, in the middle of the sixteenth century. A century later it had grown into the largest religious company in Lima, with over 200 inhabitants. Because Lima is far from the Andes, relatively little stone was used in the construction of its buildings, which normally were built of stucco over brick. Just the same, at the Baroque church of San Franciso (FIG. 3.46), the elaborate main portal is of stone. The entrance evinces that love of the marvelous that is common in the Baroque age. The architect, a Portuguese named Constantino

Vasconcellos (d. 1668), designed a strongly horizontal frontispiece of paired columns, half arcs (broken arches), and niches with statues, all of which is crowned by an oval window and a curving balustrade that carries a design resembling a sunburst (it probably represents the monstrance, which is a shrine used to display the consecrated Host). This wonderfully detailed surface has been referred to as a "retable façade," and is the first of its kind in Latin America. (A **retable** is the elaborately painted and sculpted altar, rising like a large tablet, in Spanish-inspired churches.) The heavily rusticated flanking towers create a nearly mesmerizing effect by virtue of their horizontal accents.

The doorway to the sacristy, built in the eighteenth century by Luis Meléndez (1716–80), matches the main doorway to the church, but contains more and finer detail, fitting for its domestic setting. It also shows the more sinuous curves of the Rococo.

3.45 Exterior of mission church of Cimayo, New Mexico, 1816.

With its simple nave and lack of transept, the sanctuary at Cimayo looks like a descendant of the church of San Esteban. It has been a pilgrimage site for several centuries. Today pilgrims visit the image of the Virgin of Guadalupe. In the past their goal was geophagy, the consuming of small pats of clay to cure rheumatism, cold symptoms, the pain of childbirth, and paralysis.

3.46 CONSTANTINO
VASCONCELLOS,
exterior of church of San
Francisco, Lima, Peru,
completed c. 1674.

Conclusion

The history of the Baroque church began in Rome, the center of Catholicism and home to the pope. From there it spread throughout Europe and into the vastness of the New World. Whether one visits ecclesiastical buildings in Mexico City, Lima, Vienna, Paris, or Rome, the architectural message remains constant. The Heavenly Jerusalem as City of God, figured in the brick and stone of Baroque churches, reigns on this earth. That more than 90 percent of Peruvians today call themselves Catholic (it is the official religion of the country) demonstrates the lasting effect and lingering power, for both good and sometimes ill, of a spiritual system that sought to dominate Europe and its colonies and to leave its stamp on the artistic production of the age.

The typical Baroque church is an articulate, aristocratic, cosmopolitan protagonist of the world stage who speaks to her contemporaries (and continues to speak to us today) of matters spiritual, of faith and virtue, of the glory of God and His only true Church. The varieties of the Baroque church attest to the sense of play one associates with a dramatic performance; the church is always one and singular, yet ironically, manifold. Its very diversity suggests that the Catholic identity, never in doubt, can at once take on other identities, whether Italian, French, German, even English (although St. Paul's is officially Protestant), or Incan. The Baroque architectural style, vital and exclamatory, asserts primacy and authority in religious and social terms. To Romans, a Baroque church affirms their righteousness and centrality to the political, ecclesiastical, and spiritual worlds; to a Native American, the Baroque church is the entrance to a new but everlasting, foreign but "true" world. The Baroque church appeals to passionate emotions through spiritual discipline manifested in sophisticated designs of theatrical and dramatic intent.

CHAPTER 4

Sacred Interiors

PAPAL TOMBS, ALTARPIECES,
& CEILING PAINTINGS

GIANLORENZO BERNINI,
Baldacchino in St. Peter's,
Rome, 1624–33.

So that worshippers
would be attracted toward
the altar, Bernini needed
to reduce the huge vault
of the crossing to a more
human scale; he did so by
building the bronze
Baldacchino, or canopy,
over the high altar above
St. Peter's tomb. Even so,
the structure's height is
equivalent to a nine-story
building. Four twisted
columns, adorned by
vinescrolls and topped by
angels, hold up a bronze
valance similar to the
tasseled cloth canopy used
in religious processions.
At the top a golden cross
surmounts an orb.

The church building is a setting for mystery and ideology. Because the "furnishings" of the church serve in every way the meaning of the worshipper's encountering of a religious space and feelings about his or her beliefs, a discussion of the architecture alone ignores the totality of the religious and aesthetic experience.

Most Baroque churches pull the worshipper right off the street, transporting him or her from the brightness and noise of city life to a region of half-light and incense. Although temporary benches would be set up toward the high altar for Mass, Baroque churches generally were open spaces. Because the services were now, as a result of the decisions of the Council of Trent (see pp. 47–9), oriented toward the laity or congregation, all those devices such as rood screens and chancels that gave priests their privacy when performing their duties were taken down so as to make the interior more like a huge theater. One could walk from the dark side chapels with their tombs and altarpieces, to the crossing and on into the transepts, finally arriving at the apse – the back area of the building – where stood the high altar. Baroque churches usually have clerestory windows, which admit light from the upper parts of the side walls. These windows were not "stained," that is with pictures, but normally were made of translucent yellow glass, which admits a weak and smoky light. The only other source of illumination was that of flickering candles.

Paintings designed for churches are obviously important to the Roman Catholic hierarchy, for its audience was even in the seventeenth and eighteenth centuries largely illiterate. In the early sixth century, Pope Gregory the Great had said that images were crucial to the Church because what one cannot read in the Bible one can understand in a picture. The pictures of the Baroque, whether altarpieces or ceiling paintings, are enormous and elicit an awed or contemplative response.

A Baroque interior thus controls the worshipper by virtue of complete management of space and its details. The artist, working under the dictates of patrons and officers of the Church, cre-

ated imagery that furthered "right thinking" – to encourage men and women to be at home with their beliefs, to see the Church, its leadership, its stories, its sacraments, its buildings, altars, reliquaries, pictures, and sculptures as natural and inevitable.

The Papal Tomb

What may not seem so natural is burying someone in a church – a practice that offended even the earliest Church authorities. St. John Chrysostom (346–407 C.E.), for instance, objected in no uncertain terms when he asked, "What would you do if someone were to leave a corpse in the place where you eat and sleep? And yet you leave the dead not where you eat and sleep but next to the body of Christ … How can one visit the churches of God, the holy temples, when they are filled with such a terrible odor?" But the practice persisted, largely because burial in a church (better yet, with an unobstructed line of sight to the high altar) was considered good for the soul, whose journey to the Heavenly Jerusalem at Christ's Second Coming would be expedited by its privileged resting place. And of course a fine monument of bronze and marble glorified Church leaders and provided a visual reference for visitors of Catholicism's power and glory. The papal tomb is the most magnificent of all Baroque sculptural monuments, a signal of a transition, but not a break, in what the Church calls the Apostolic Succession, that continuous line of authority that can be traced back to the first pope, St. Peter, who received from Jesus Christ the keys to the kingdoms of heaven and earth. In its monumentality the tomb conveys to the worshipper, pilgrim, or visitor that sense of grandeur befitting Christ's Vicar on earth, who belongs in St. Peter's, where indeed most papal tombs are located.

Like bookends, the tombs of Urban VIII Barberini and Paul III Farnese bracket the apse of St. Peter's in Rome, the former monument balancing and commenting on the latter which was put in place a good seventy-five years earlier. In the *Tomb of Paul III* (FIG. 4.1), by Guglielmo della Porta, the pontiff leans slightly forward and

gestures mildly with his hand toward the faithful. Testifying to Paul's honor and repute, allegorical representations of Prudence (on the right, with a mirror to indicate her self-knowledge) and Fidelity (with a key to lock away secrets) look toward one another with equanimity. They are "one-idea" statues, simple stand-ins for abstract character traits. Della Porta put the bronze pope atop a marble sarcophagus which he set partially in a niche. By these simple choices of arrangement and placement he established a certain formality and impressiveness. A pyramid-like ordering asserts balance, permanence, and weightiness. The niche with its surmounting arch was known in antiquity as an *arcosolium*, a place of dignity set apart to honor a deity or great man. Della Porta established the basic premises and elements of the Baroque papal tomb but did

4.1 GUGLIELMO DELLA PORTA, *Tomb of Paul III*, 1551–75. Marble and bronze. St. Peter's, Rome.

The original intention was that this sculpture should be free-standing, so that the viewer could walk around it; it was Michelangelo who suggested the niche setting. The pope is shown as regal, but also as deeply human, his brow furrowed by anxiety and his pose full of tension.

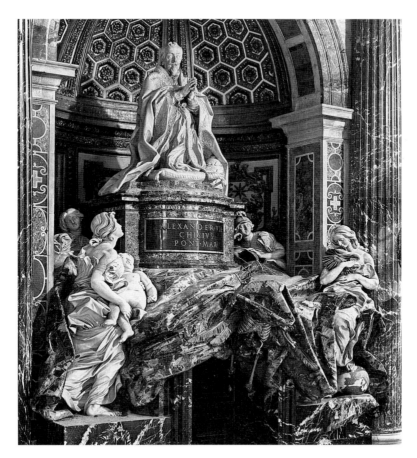

4.2 Gianlorenzo Bernini, *Tomb of Alexander VII*, 1671–78. Bronze, marble, and jasper, over lifesize. St. Peter's, Rome.

Bernini was almost seventy years old when he began work on this project, and he finished it, with assistance from Giuseppe Mazzuoli and Giulio Cartari, only two years before his own death. Although still a highly dramatic work, Bernini's emphasis here is not on papal authority but on the universality of death, and the focus of attention is the pontiff's face and hands.

so in a quiet and passive way, however majestic and imposing the overall effect may be. It remained for Gianlorenzo Bernini to bring life and drama to the papal tomb.

Bernini's most shocking tomb, if not necessarily his best, is that of Alexander VII (FIG. 4.2), placed above a door just behind the left transept in St. Peter's, Alexander sinks to his knees in prayer. The allegorical figures surrounding the base upon which Alexander kneels seem absorbed in their own thoughts and actions. In the background, Justice (to the right) and Prudence gaze mindfully out into the vastness of the church, while in the foreground Charity rests her enormous baby on the jasper folds of drapery (a kind of funeral pall) and gazes in fascination toward the Pope. Truth clings tightly to her emblem, the sun, while pulling a patch of the colored stone to cover her nakedness (a later

pope who was offended by such nudity had her breast covered with bronze drapery painted white). In the most extraordinary event, a bronze skeleton careers up through the door, pushes at the great jasper cloth, and shakes the hour-glass in front of the Pope, who is beyond caring that the moment of death has arrived. The skeleton on Urban's tomb, by contrast, is almost whimsical, but here he is clearly menacing, impatient, and violently intrusive. The spectator is reminded with all the subtlety of a hammer blow that the hour of our death is always near.

In his tomb of Urban VIII (FIG. 4.3) Bernini animates the narrative with the Pope's commanding gesture, the skeleton's frightening emergence from the coffin, Justice's swoon, and Charity's smiling face. A child runs off with the fasces (the bound rods and hatchet, ancient symbol of judgment), and another wails and stamps his foot for

4.3 GIANLORENZO
BERNINI,
Tomb of Urban VIII,
1628–47.
Marble and bronze,
height 18 ft 4 in (5.6 m).
St. Peter's, Rome.

In his childhood Bernini's
training was supervised by
Cardinal Maffeo
Barberini, and after the
Cardinal's election as
Pope Urban VIII the two
men continued to be
close friends. This is not
an intimate portrait, how-
ever. Instead, the animat-
ed yet dignified pose, the
extravagant drapery, the
exaggerated pyramid
structure and the stark
contrast between the dark
gilt bronze and the milky
white marble combine to
make it undoubtedly
more dramatic than della
Porta's work nearby.

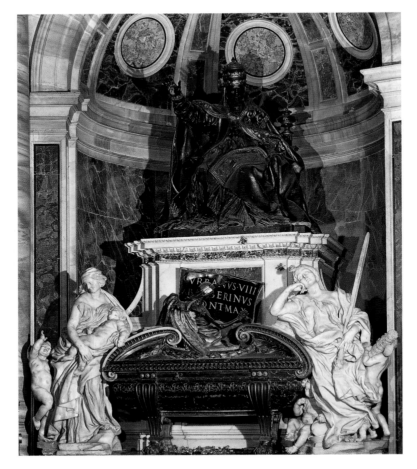

his mother's attention. This is almost a free-for-
all, as if the sculptor could not successfully stage
manage the action. But of course Bernini knew
just what he was doing, which was to create as
much excitement and visual interest as he could
within the tradition of the funerary monument.
Death pulls a plaque from the pedestal and begins
to write Urban's epitaph. Bumble bees, which are
Urban's personal symbols, land pretty much
wherever they please. And the allegorical figures
escape their strict allegorical functions – step out
of character, as it were.

The Church was activist in the seventeenth
century, claiming its authority and privileges
with as much energy as it could muster. When
the Spanish priest Miguel de Molinos published
his *Spiritual Guide* in 1675 the Vatican reacted
swiftly and punitively. Molinos was a proponent

of a personal religious approach that he called
Quietism, which urged the worshipper to oblit-
erate his or her own will and to await passively
the visit of the Holy Spirit. Molinos reacted
against the agitation and propagandizing of the
Counter-Reformation Church: in Quietism, the
Church had no role to play. Jesuits and
Dominicans, the most vociferous and propagan-
dist of orders, led the investigation against
Molinos, who was arrested, condemned, and
jailed. Bernini, a great believer in the Jesuit
Spiritual Exercises, would have seen Molinos'
approach, which was very popular in Rome, as
blasphemous. Because Quietism advocated the
utter passivity of the human soul, no active form
of piety – and therefore no religious art – was
required. Bernini's faith and art were at the
opposite end of the religious spectrum.

Everything in Bernini is excitement, participation, even aggression.

In a niche not far from Bernini's *Urban VIII* resides the *Tomb of Gregory XIII* (FIG. 4.4) by Camillo Rusconi (1658–1728). In the eighteenth century the elaborate and witty visual devices of the Baroque period began to fall out of favor. But Rusconi honors the tradition of grandeur and commemoration and gives us an arrangement that continues to impress the visi-

tor to St. Peter's. In an unusual gesture, the figure of Justice pushes aside the funeral cloth so as better to study a relief on the tomb, which depicts Gregory's reform of the Christian calendar in 1582. As the Pope had already been dead for well over a century when this tomb was erected, we are given a glimpse backward in time toward an event of enormous – even astronomical – importance. As the pilgrim walks down this relatively narrow side aisle of St. Peter's (one

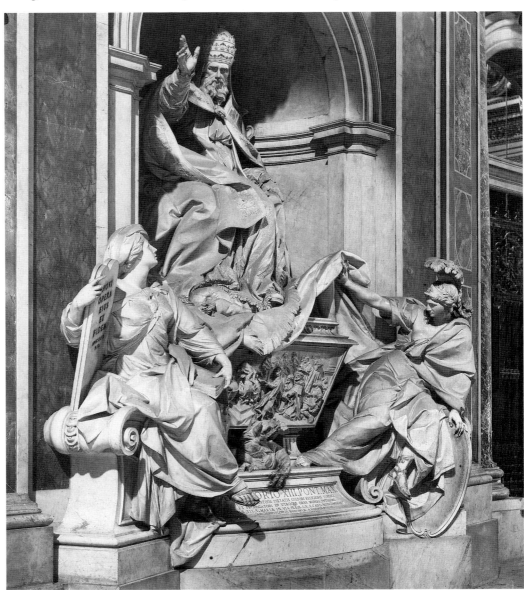

4.4 CAMILLO RUSCONI, *Tomb of Gregory XIII*, 1719–25. Marble, St. Peter's, Rome.

is obliged to see the tomb from the angle represented in the photograph), his or her attention is solicited by the conspicuous and flamboyant gesture of Justice drawing our attention to a picture within a larger work of art. There undoubtedly was some propaganda value here, as Protestants had yet to adopt Gregory's reforms; they finally did so in 1752.

Filippo della Valle's (1698–1768) *Monument to Innocent XII* (see FIG. 2.8), by contrast, makes no attempt to grab our attention. In a soft and luxuriating style, compressed folds of drapery encase a sickly pope who manages a timid benediction. The tomb is placed above a door in a dark area of the church, imprisoned in a relatively shallow setting between colossal pillars. Although the sculptor was constrained by the limited number of places for a papal tomb left in St. Peter's by the mid-eighteenth century, and although the basic design was given to him as a wooden model by a supervising architect, Ferdinando Fuga, its style befits the new stance of the Catholic Church. The combative period of the Counter-Reformation was now past, and the Church saw itself as well along in its reforms, rational in its reorganization, and holding its own as a player on the international stage. It had little need for the exuberant and declamatory style of Gianlorenzo Bernini.

Altars & Altarpieces

By the fifth and sixth centuries C.E., stone altars replaced wooden ones in Early Christian churches. The stone altar, also a symbol of the Lord's table, often was placed above the tomb of a martyred saint so as to share with the tomb the idea of sacrifice (Christ's death on the cross; the saint's martyrdom), to communicate to the worshippers the life of the saint, and to allow the relics (usually bones) of the saint to assist as intercessor between the worshipper and Christ. The square and box-like altar tables came to have within them hollowed spaces, known as sepulchers, for relics that could be brought from elsewhere. Those churches that had important relics would

build large containers for them, known as reliquaries, that were visible to the congregation. Churches without prestigious relics often built retables or altarpieces on the backs of the altars. In the Baroque period it became the fashion to make altars that looked like ancient coffins or sarcophagi.

Because most churches built in Europe after the year 1000 were apse-oriented – that is, with the apse rather than the front portal facing east – the priest would stand in front of the altar, with his back to the congregation, facing the east, location of the rising sun and therefore symbol of rebirth. Because of the practice throughout the middle ages of constructing screens that separated the laity – the worshippers – from the clergy, altars and retables were not always very visible. The Council of Trent (see pp. 47–9) called for the chancel area to be cleared out, so as to reunite the clergy and the congregation in the celebration of the Mass. From the Renaissance, and especially in the Baroque period, altars – now more visible than ever – came to be overwhelmed by grandiose works of art.

GOTHIC & RENAISSANCE ALTARPIECES

By the late 1200s the altarpiece had grown from a relatively small panel to one of considerable proportions, often ten feet or more in height. The larger altarpieces of an earlier age had often been painted crucifixes, but influenced by the enormously popular cult of the Virgin through Europe in the later middle ages, altarpieces began to show scenes of the Virgin and Child. *Madonna and Child Enthroned* (FIG. 4.5) by Giotto (1267–1337) is among the first of the large paintings attached to the back of an altar, a substantial image as it had to be visible to a congregation who were some distance away. The altarpiece shows Mary sitting on her throne as the Queen of Heaven, offering to the faithful her Son, Jesus. This presenting of Christ to the people mirrors the sacrifice of Christ's blood and body during the celebration of the Eucharist or communion. A prosperous Florentine merchant of the early fourteenth century, who would be a

creating solid figures in a fairly convincing three-dimensional setting.

The Virgin and Child (FIG. 4.6) by Tommaso di Giovanni di Simone Guidi (1401–28), known as Masaccio, follows some of the conventions of the previous century, but adds those pictorial devices that were being developed in Florence in the early fifteenth century. Masaccio's panel, originally part of a larger polyptych (a many-paneled altarpiece), depicts Mary on an ancient throne, locating her according to the laws of perspective, and makes Jesus a real baby eagerly eating a bunch of grapes (which is a symbol of consecrated wine – his own blood). Like Giotto's panel, this painting has a gold background and an arch-shaped top. But now Mary is bathed in sunlight and appears less Byzantine. The angels in front of her throne

4.5 GIOTTO, *Madonna and Child Enthroned* (*The Ognissanti Madonna*), c.1310. Tempera on wood, 10 ft x 6 ft 8¼ in (3.05 x 2.04 m). Uffizi, Florence.

4.6 MASACCIO, *The Virgin and Child,* 1426. Tempera on wood, 53¼ x 28¾ in (135.3 x 73 cm). National Gallery, London.

typical and important member of the congregation, surely admired the use of the semi-precious stone lapus lazuli to produce the blue of the Virgin's gown. He might also have approved of the elaborate employment of very thin sheets of gold attached to the wood support so as to create an otherworldly effect. Mary and the infant Jesus are types, not individuals. Her face has the Byzantine look of almond-shaped eyes, pursed mouth, long, straight nose, and arching eyebrows. The Christ Child, making the sign of the benediction, has the pious demeanor of a middle-aged priest.

Although large altarpieces like this were a relatively recent phenomenon, the overall style, the immobility of the figures, and their hieratic (priest-like) quality – in other words, the appearance of the figures in a sacred state of being – were part of a tradition of Byzantine and Italian altarpieces that dated back centuries. But in a move that foreshadowed the Renaissance, Giotto brought changes to this tradition by

play lutes that are carefully arranged in a per-spectival system. The importance of Masaccio to the history of altarpieces, therefore, lies in his imitation of figures that do not follow Byzantine convention and that are firmly fixed in space; he made of spiritual shapes something solidly human.

BAROQUE & ROCOCO ALTARPIECES

From Titian to Carracci

A comparison of Titian's (1488–1576) pre-Baroque altarpiece of the *Assumption of the Virgin* (FIG. 4.7) with Annibale Carracci's *Assumption* (FIG. 4.8) reveals something of the change from the High Renaissance to the Baroque altarpiece. In Titian's account of the Assumption, when Mary was drawn bodily into heaven by God the Father, God hovers above her at a slight angle, aided by two angels, as if to receive Mary into his body. She stands on a cloud, spiraling almost into a dance-like pose with drapery moving against the force of her body, eyes heavenward, arms and hands gestur-ing toward the Father. Despite the imagery of glory and drama, Titian's Madonna is of a Renaissance rather than Baroque substance (although making these distinctions is not always simple); whatever energy she displays is contained within the painting. Annibale's Madonna, on the other hand, has an explosive power that threatens to break through the artis-tic confinement of the frame and shape of the canvas; she "spills" into our space.

Titian's large painting (it is 22 feet high), with its vibrant colors, is composed into three orderly tiers (God at the top, Mary in the mid-dle, disciples below); it is immediately visible to the worshipper, even though it has to be viewed through a doorway in the monks' choir, upon entering the church. By making the Madonna so conspicuous, he anticipated the Baroque, whose religious paintings often establish a dynamic and theatrical link with spectators. Annibale Carracci drew many lessons from Venetian painting, and one can surmise that he

4.8 Annibale Carracci,
*The Assumption of the
Virgin*, 1601.
Oil on wood,
8 ft ½ in x 5 ft 1 in
(2.45 x 1.55 m).
Cerasi Chapel, Santa
Maria del Popolo, Rome.

4.7 (*opposite*)
Titian,
Assumption of the Virgin,
1516–18.
Oil on panel,
22 ft 6 in x 11 ft 10 in
(6.9 x 3.6 m).
Santa Maria Gloriosa dei
Frari, Venice.

The clear, vivid colors are
characteristic of painting
in Venice, where Titian
was the leading painter
for most of his long
career. Although the fig-
ures are arranged in three
quite distinct tiers, the
composition is held
together by a triangular
pattern created by the
reds which connect the
Virgin with the two
disciples beneath her.

saw and appreciated the boldness of Titian's
efforts. What makes Annibale's painting
"Baroque" is above all his use of densely packed
figures and sense of mass. It is as if he has com-
pressed both the space and the bodies in Titian's
painting and then heightened the contrasts
between the lighter areas and the darker ones.
Rather than looking toward God within the
painting, Mary enacts what the art historian H.
W. Janson called the "invisible complement,"
which means that (in this case) God is implied
but is not present. Like God, the worshipper is
outside the frame, and therefore may feel the
excitement of sharing God's "space." With
angels crowding around her like pets, her eyes
slightly upturned, she leaps from her tomb and
gazes into an alien space, a space beyond the
pictorial. This is both the space of the spectator,
and a mystical realm beyond the physical, the
place of God and her returning.

Caravaggio

Michelangelo Merisi da Caravaggio's *Madonna of Loreto* (FIG. 4.9) is an altarpiece of a very different kind. Known as a rebellious and sometimes hostile artist, Caravaggio was a notorious figure in Rome in the early years of the seventeenth century. His nemesis Giovanni Baglione (they were adversaries in a famous civil trial) wrote that "the populace made a great clamor over the disparaging treatment of certain elements [in the *Madonna of Loreto*] which should have been handled with more respect in such an important work." Baglione is referring to the muddy feet and generally unlovely treatment of the worshippers. By treating the pilgrims as poor and barefoot, the painter contravened the accepted rhetoric, in which religious figures should be idealized. Another contemporary commented that the painting lacked "proper decorum, grace and devotion."

From these observations one might be tempted to see this painting as revolutionary and as undercutting official religious messages. But Caravaggio was not irreligious. By creating an altarpiece that spoke to the poor, he simply was operating outside of certain official circles. Even one of Caravaggio's detractors wrote that "whoever looks at this painting must confess that the spirit of the pilgrims is well rendered, and shows their firm faith as they pray to the image in the pure simplicity of their hearts." This, then, is different from the typical Baroque altarpiece. Its treatment was perceived to lack the proper esteem for religious subject matter, yet it was not rejected by the Church or any of its officials.

The painter shows pilgrims "kneeling-in" for contemporary worshippers before an image of the Virgin and blessing Child. The painting thus directly seeks the sympathy of the poor, who would see surrogates of themselves beseeching the Madonna and Child, thereby involving them emotionally in the devotional act. Yet, we are not to read Mary and Jesus as existing in exactly the same kind of space as the pilgrims. As the theologian Thomas Aquinas said in a different context, Mary here is not so much contained by a "corporeal space" as she contains it. She hovers slightly above the step, appearing as a miraculous vision to the faithful, or as if she were a popular street shrine that seems to have come alive. Visions that transform the ordinary into the ethereal abound even in Baroque treatments of the apparently everyday.

Reni

Guido Reni (1575–1642), like many other painters in Baroque Rome, was first impressed by Caravaggio and then quarreled with him. His altarpiece of *The Annunciation* (FIG. 4.10) done for Pope Paul V's private chapel in Rome's Quirinal Palace (the papal summer residence), shows Reni returning to the style of his teacher Annibale Carracci, while retaining something of Caravaggio's mystery. The announcing angel (he is telling Mary that she will bear the Son of God) is highlighted against a dark cloud, his body leaning in the direction of Mary as he points upward toward the miraculous image of a glowing dove, symbol of the Holy Spirit. A Renaissance version of the Annunciation often created a geometric space by placing the event in an architectural setting. Reni's space — murky, not quite empty, almost of some tangible substance – is characteristic of the Baroque. Baroque space in a painting is often what the ancient philosophers, following Aristotle, called a "plenum," a substance without voids. Baroque artists also understood the power of the *affetti* ("affects") in a work of art, those elements of painting that move us emotionally. They work on at least two levels. First of all, a painter or sculptor will try to show how the inner soul (or motivation) of a represented figure asserts itself through gesture and expression. Mary is demure, shy; the archangel Michael is joyous and has unbounded energy: their faces, body language, and placement within the work convey those emotions and character traits. On a somewhat deeper level, the artist will use the space of a work — that which bounds and

4.9 (*opposite*) CARAVAGGIO, *Madonna of Loreto*, c. 1604–5. Oil on canvas, 8 ft 6¾ in x 4 ft 11 in (2.61 x 1.5 m). Sant'Agostino, Rome.

The Italian town of Loreto contained a famous pilgrimage site known as the Holy House of Loreto. Here was kept an ancient wooden statue of the Virgin, which was said sometimes to come miraculously to life. Caravaggio seems to have been attempting to depict such an occasion, with the trusting faith of the poor receiving its reward.

4.10 (*right*)
Guido Reni,
The Annunciation, 1610.
Oil on canvas,
10 ft 10 in x 6 ft 6¾ in
(3.3 x 2 m).
Quirinal Palace, Rome.

In his youth Reni was
influenced by Caravaggio,
who apparently threat-
ened to kill him if he per-
sisted in imitating his
style. Reni went on to
produce graceful and
tranquil works such as
this, with none of the
melodrama or exaggera-
tion of some of his
contemporaries.

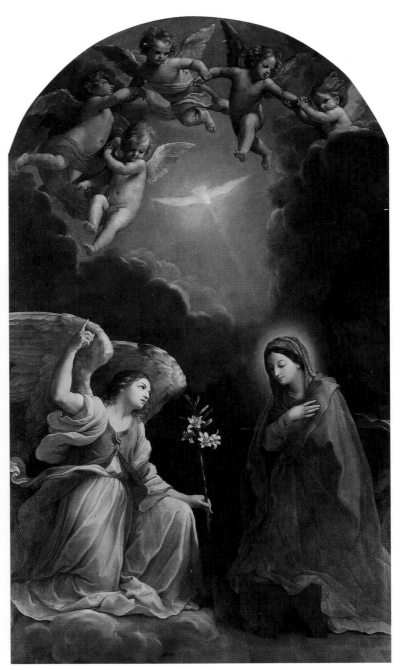

encompasses human figures – to create a feeling
or desire that can lead to a response in the
beholder, usually religious in nature. The
atmosphere or setting thus conveys an attitude
and sets the mood. The dark clouds and mar-
velously lit dove encourage the worshipper (in
this case, the pope) to experience the awesome
mystery and power of the Incarnation (God the
Son made flesh at the moment of the
Annunciation).

4.11 (*opposite*)
GIANLORENZO BERNINI,
The Altieri Chapel with
*The Blessed Lodovica
Albertoni*, 1674.
Marble,
over lifesize.
S. Francesco a Ripa,
Rome.

As in his portrayal of St.
Teresa in the Cornaro
Chapel (see FIG. 1.5),
Bernini has added drama
to the scene by illuminating it from its own hidden light source. But
while still being dramatic,
this is a much more
private work.

Bernini

Gianlorenzo Bernini's Altieri Chapel with *The Blessed Lodovica Albertoni* (FIG. 4.11) was not constructed for a high altar but for a side altar in a private chapel. When constructing a high altar, an artist is somewhat constrained by the setting, which usually does not allow for much elaboration. Because the high altar is visible to the congregation during the celebration of the Mass, it must stand relatively free and unencumbered. But in a side chapel, the artist has more freedom to create a complex environment. This environment was intended by Cardinal Paluzzi degli Albertoni to honor his ancestor Lodovica Albertoni, who had recently been beatified (a stage preceding canonization or election to sainthood). By commissioning the chapel from Bernini, the cardinal certainly hoped to encour-

age the eventual canonization of Lodovica, and thereby promote his own prestige and position within the Church.

In this relatively small and dark chapel, illusionistically foreshortened walls canting in from either side pinch the altar. The altarpiece comprises a separate space occupied by a heaving, almost pulsating shroud, a bed, a convulsed woman, and a painting of *The Madonna, the Infant, and St. Anne* by Giovanni Battista Gaulli. Bernini undoubtedly read the various accounts of Lodovica Albertoni's life that emphasized how she burned throughout her life with divine love and how she was the very epitome of charity, which is aptly conveyed by her hand to her breast (FIG. 4.12). But the meaning of the whole chapel exceeds these fairly standard references to her saintliness and religiosity. It is a testament to Bernini's enormous skills with pictorial devices

4.12 Detail of 4.11:
BERNINI,
*The Blessed Lodovica
Albertoni*, 1674.

Here Bernini seeks to
depict the moment of
death, the moment when
the saint's soul leaves her
body. The mood is much
more restrained and gentle than in the St. Teresa,
with less extravagant
drapery folds, and with
attention being given to
such details as the lace at
the edges of the pillow.

that there probably is no single iconographic reading that will satisfy or explain all of the elements of the chapel's visual richness. Simple interpretations usually do not do justice to Bernini's complexity.

Especially in a side chapel such as this, the worshipper is alone and already inside the sacred space when kneeling before the image. Thus the devotional effect is all the more enveloping – the worshipper's experience of awe and wonder before the divine is inward and highly personal, but at the same time somewhat theatrical. By putting the devotee in a place that simulates another realm altogether, Bernini engages the human imagination. He undoubtedly had in mind the appeal by St. Ignatius of Loyola that one undergoing his *Spiritual Exercises* "see with the sight of the imagination the corporeal place where is found the object [the devotee wishes] to contemplate." With great intensity of feeling, one uses all possible imaginative power to "be" somewhere else.

Vouet

Simon Vouet (1590–1649) painted *The Presentation of Jesus in the Temple* (FIG. 4.13) for the high altar of the church of Saint-Louis-des-Jésuites in Paris (today known as the church of St. Paul and St. Louis). The altar was given as an act of piety by Cardinal Richelieu (see p. 219), a "protector" of the Jesuits. Vouet, painter-in-chief to King Louis XIII, had gone to Rome in 1613, where like nearly everyone else he fell under the spell of Caravaggio. In the 1620s he followed the other Roman painters by switching allegiance to the Bolognese school of Carracci and Reni. What he brought back to France in 1627, therefore, was a synthesis of Italian painting styles and an understanding of the grand manner, that rhetorical attitude of great painterly sweep and dignity. Three and a half centuries after the commission, one is apt to react to this kind of painting as an overstatement. But within a religious and aristocratic culture that sought its identity and attempted to promote its interests through grandeur – one

that associated superabundance with mightiness – this is a perfect altarpiece. The original complex (FIG. 4.14), since destroyed, also contained in an upper tier Vouet's image of St. Louis (now at the Musée des Beaux-Arts, Rouen), King and patron saint of France, ascending into heaven, thereby acclaiming both the glory of France (above) and the presence of Christ (below). Vouet's conception has as much grandeur as anything done in Rome.

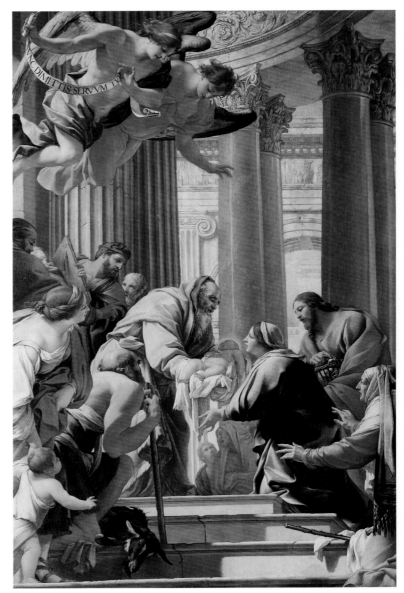

SVMMI ALTARIS IN LVDOICÆA DIVI LVDOVICI BASILICA
APVD PATRES PROFESSOS SOC IESV LVTETIÆ PARISIORVM
EXTANTIS VESTIGIVM RECTAQ DELINEATIO

4.14 Simon Vouet, altar ensemble, an engraving by Edme Moreau, published 1643. Bibliothèque Nationale de France, Paris.

Here, above *The Presentation*, is the *Apotheosis of St. Louis*, the patron saint of Paris, also by Vouet. He is thought also to have painted a *Madonna of the Jesuits*, now lost or destroyed, for the same church. The works on display in the church would probably have been changed to suit particular feast days.

4.13 (*opposite*) Simon Vouet, *The Presentation of Jesus in the Temple*, 1641. Oil on canvas, 12 ft 6¾ in x 8 ft 2½ in (3.93 x 2.5 m). Louvre, Paris.

Vouet spent many years in Rome, where he knew Poussin and was influenced by Bernini and Reni. The *di sotto in su* viewpoint emphasizes the drama of the scene, but the soft light and meticulously rendered classical architecture show evidence of a classicizing approach.

The "Presentation" refers to the Hebrew law that required a new mother to present her male child in the Temple after forty days. The priest Simeon, who believed that he would not die until he had seen the Messiah, takes the infant in his arms and says, "Lord, now lettest thou thy servant depart in peace" (the beginning of the Nunc Dimittis, inscribed on a banner carried by angels). This event is an epiphany, a showing forth of the divinity of Christ. Vouet gives us a clear view of the infant Jesus, his head radiating light (the halo was no longer used). In

addition to the priest, angels, Mary, Joseph, and Jesus, is the old prophet Anna in the lower right-hand corner. Her gesture is one of prophecy, and she speaks to all of the "redemption of Jerusalem." The point of view is slightly from below, with a prospect through paired Corinthian columns into another and larger space, which is not meant in any way to look like the Temple in Jerusalem; it is, instead, an ideal view of Baroque architecture. In the grand manner of Baroque painting, history is now, the past, and forever.

La Tour

St. Sebastian Tended by Irene (FIG. 4.15), by Georges de la Tour, is a far less ornate altarpiece. La Tour (1593–1652) spent most of his life in Lunéville, in the French province of Lorraine, making altarpieces for local churches and painting scenes of ordinary life for the Duke of Lorraine, and before 1640 for Louis XIII. This altarpiece, for a church in Broglie, France, shows St. Sebastian lying near death at the foot of an oak tree, where he had been bound and shot full of arrows. Sebastian, who lived at the time of Diocletian (third century) and served in the emperor's private (Praetorian) guard, was discovered to be a Christian, and therefore was condemned to death. Despite the large number of arrows shot into him, none pierced a vital organ, and he was nursed back to health by Irene and her sisters, who came across his supine and nearly lifeless body in the dead of night. (He later was bludgeoned to death.)

La Tour shows us only a single arrow, and a long sliver of blood; otherwise, all is cool and quiet. Irene takes his pulse while turning her head in the direction of the candle, as if to concentrate better and find some faint throb. One woman's face is lost in her headdress, and a kerchief, which she uses to wipe away her tears, obscures another's face. The gesture of the woman in the middle is like that of Mary when she holds the dead Christ in her lap (the *Pietà*). With her right hand, she questions who this might be or how it could have happened, while

her left seems to capture and restrain the light radiating out from the candle. The gestures appear spontaneous and uncontrived, suggesting that La Tour followed Caravaggio's manner rather than the more grandiloquent vision of Simon Vouet. The body language, though restrained, strikes one as sincere. It communicates respect and humility. The settled composition, secured by a series of upright columns created by the tree, the torch, and the women's bodies, reinforces the mood of benevolence and reverence. The light creates such harsh shadows that we are reminded of the contrasts between light and dark found in woodcuts. The powerfully abstract effect of the painting removes the scene from common-sense experience and puts it somewhere else, in a world of dreams or recollection, those realms to which one gains access through prayer.

El Greco

The Baroque in Spain is heralded by the strange altarpieces and canvases of Doménikos Theotókopoulos, known as El Greco, who was employed after 1580 by Philip II as a court painter. His style reflects the mysticism and devotion of late sixteenth- and seventeenth-century Spain. El Greco was born on the island of Crete, worked in Venice, and passed through Rome on his way to Toledo, Spain, where he arrived in 1576 and remained for the rest of his life. His background therefore is varied: a flat and delicate Byzantine style grows out of his early experience in painting icons; his rich use of colors reflects his experience in Venice and his encounter with Titian and Tintoretto; his strong sense of design comes from his study of Michelangelo, whom he openly disparaged but whom he secretly admired.

Like most of El Greco's paintings, the *Agony in the Garden* (FIG. 4.16) narrates an event in the life of Christ – his visit after the Last Supper to a garden outside of Jerusalem known as Gethsemane, near the Mount of Olives. His soul was sorrowful within him, as he knelt to pray: "'Father, if thou be willing, remove this cup [the

4.15 (*opposite*)
GEORGES DE LA TOUR,
*St. Sebastian Tended by
Irene*, 1649.
Oil on canvas,
5 ft 5¾ in x 4 ft 3½ in
(1.67 x 1.31 m).
Louvre, Paris.

La Tour was a popular and successful artist in his own lifetime, but his work was neglected for nearly 300 years after his death and was only "rediscovered" in the twentieth century. Many of his works show a fascination for candlelight, used, as here, to convey an atmosphere at once intimate and dreamlike.

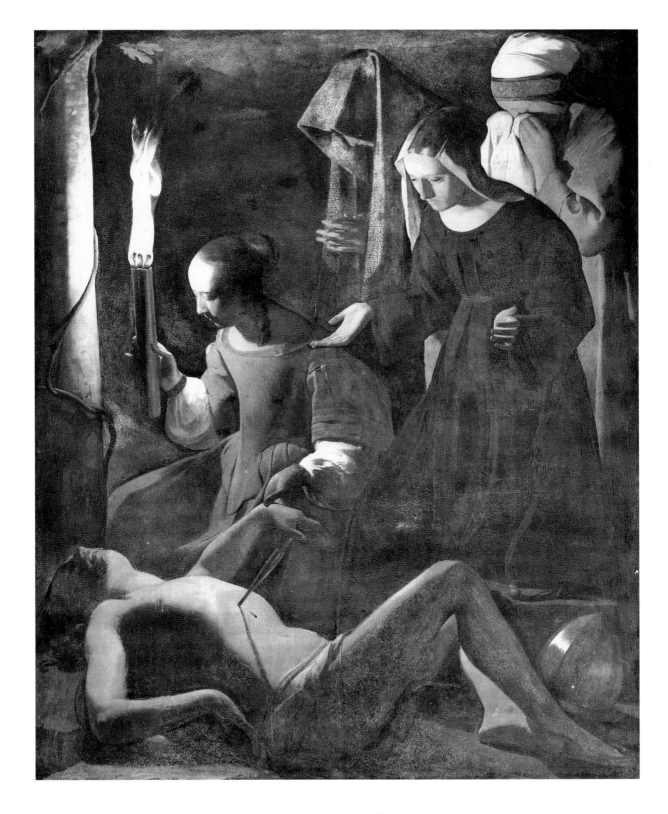

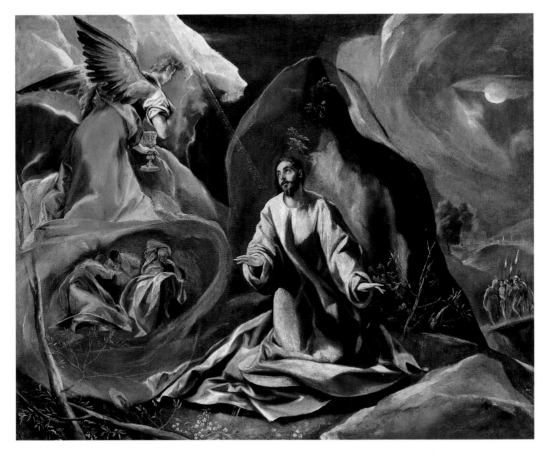

4.16 El Greco, *The Agony in the Garden*, 1590–95. Oil on canvas, 3 ft 4¼ in x 3 ft 8¾ in (1.02 x 1.14 m). Toledo Museum of Art, Ohio.

El Greco spent most of his working life in the Spanish town of Toledo, one of the cities in which Catholic doctrine was most rigorously enforced. Here, rather than following one particular account of Christ's agony, he has taken elements from all four of the gospels.

symbol of his coming sacrifice] from me: nevertheless not my will, but thine, be done.' And there appeared an angel unto him from heaven, strengthening him." (Luke 22:42–3). As happens often in prayer, there is an agony, literally a struggle, in the supplicant's soul. Christ found his resolve, but first acknowledged his fear. El Greco chooses the moment when Christ's eyes still beseech, the instant before the angel encouraged him, and conveys through style and composition Christ's torment and anguish. Although there are intense areas of colors, such as the traditional red and blue of Christ's robes, the overall tonality is gray, cold, dark, and livid. Shapes and spaces confuse and disorient the viewer. A tumultuous cloud encircles and partially shrouds the moon; yet at the same time it seems to overlap the brooding, gloomy rock

immediately behind Christ. Foreground and background become compressed. A miraculous view through the womb-like opening of the angel's robes reveals the sleeping disciples, James, John, and Peter. By defying the normal logic of space and visibility, El Greco emphasizes the spiritual substance of this spectral and apparitional moment. He unnerves us. Although El Greco avoids neat categorization by style – is he mannerist, Venetian late Renaissance, Baroque? – his haunting images have a sense of the Baroque visionary.

Murillo

Born in Seville, Spain, a few years after El Greco's death, Bartolomé Esteban Murillo learned from the Baroque styles of Rubens and

Velázquez. There is still in his art some of the dark and melancholy lighting effects of El Greco, but these have been mitigated by Murillo's experience of several generations of Spanish Baroque painters. Seville, in the Andalusian plain, was an important commercial and artistic center in the seventeenth century, offering numerous opportunities for painters, sculptors, and architects. In 1665 Murillo received a large commission from the Franciscan Capuchin monks to paint altarpieces for the chapels in their Sevillian church, including *St. Thomas of Villanueva Distributing Alms* (FIG. 4.17). St. Thomas of Villanueva was an important, albeit recent, Spanish saint and Archbishop of Valencia, Spain, home to some of the Franciscan monks.

The altarpiece was not meant simply to justify the Church and its saints and to astonish the parishioners – it was instructive. Thomas was known for his simple ways and many acts of charity. Charity, the third of the Theological

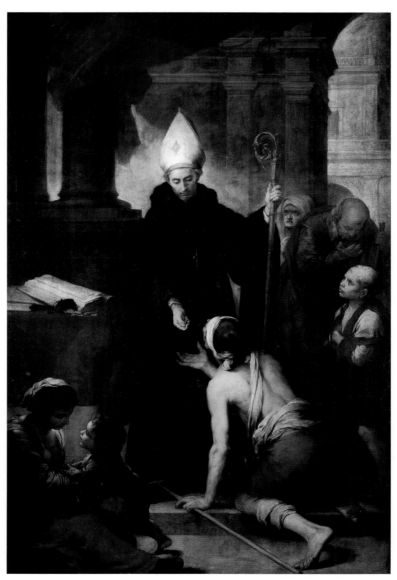

4.17 Bartolomé Esteban Murillo, *St. Thomas of Villanueva Distributing Alms*, 1678. Oil on canvas, 9 ft 3½ in x 5 ft 6¼ in (2.83 x 1.68 m). Museo Provincial de Bellas Artes, Seville.

The saint is seen here turning from his book to give alms, reflecting the Franciscan belief that good works are more important than theology. Murillo was one of the most popular painters of everyday life in the seventeenth century, and is particularly well known for his depictions of children. This aspect of his work is easily explained, since he himself fathered eleven children!

Virtues, is in its essence Divine Love. One loves and helps others through the love of God. To behave benevolently is an act of conscious will. Therefore a painting such as this encouraged the active life, a life of commitment and aid to others.

This altarpiece is less theatrical than Vouet's, and less mystical than El Greco's. These acts of generosity occur in a house of the Lord, a Baroque church suffused with soft miraculous radiances that backlight both St. Thomas and the Virgin and Child in the left foreground, and illuminate the beggar on the step. While modeling in light and shade is common throughout the history of painting, the use of deep pools of shadow is typical of the Baroque (see pp. 164–9).

Rubens

Peter Paul Rubens brought the Italian style in art north of the Alps. Like most young artists at the beginning of the seventeenth century, Rubens, a native of Antwerp, made the journey to Italy. He arrived in Venice, lived and painted in Rome, and took up residence as painter at the court of the Gonzaga dukes of Mantua. The Duke allowed Rubens great freedom, and even employed him as a diplomatic representative to the court of Philip III of Spain, whom he visited in 1608. His *Raising of the Cross* (FIG. 4.18) for Antwerp Cathedral is Rubens' ultimate Baroque statement. No painting of this dimension and style had been seen before in Antwerp. A powerful figure of Christ is tied to the cross, which

4.19 JEAN-BAPTISTE
DESHAYS,
*The Martyrdom of St.
Andrew*, 1759.
Oil on canvas,
14 ft 7¼ in x 7 ft ¼ in
(4.45 x 2.14 m).
Musée des Beaux Arts,
Rouen.

The dog here is derived
from the legend of St.
Andrew, who delivered
the inhabitants of Nicaea
from seven demons which
plagued them in the form
of dogs. It may also,
however, hark back to
Rubens' *Raising of the
Cross* (see FIG. 4.18).
St. Andrew was crucified
on an X-shaped cross,
a fact alluded to in the
two strong diagonal
lines dominating this
composition.

4.18 (*opposite*)
PETER PAUL RUBENS,
Raising of the Cross,
1610–11.
Oil on canvas,
central panel
15 ft 2 in x 11 ft 2 in
(4.62 x 3.51 m);
wings 15 ft 2 in x 4 ft 11
in (4.62 x 1.5 m).
Antwerp Cathedral.

In most early Renaissance
paintings of this subject,
Christ is shown being
nailed to an already erect-
ed cross. The depiction
of Christ being nailed to
the cross before its eleva-
tion became popular in
the late Renaissance and
Baroque periods, perhaps
because it allowed more
opportunity for dramatic
poses and subtly rendered
musculature.

equally robust workers haul into its upright posi-
tion. A stray dog, with no obvious function,
barks at this fearful scene of grunting and sweat-
ing laborers carrying out the order of the Roman
governor in Jerusalem. The violent contrasts
between light and dark have the effect of repeat-
ed bolts of lightning.

What makes this painting Baroque is its
dependence upon spectacle (see p. 24–5). The
struggling workers, dramatic lighting effects,
emphatic modeling of the figures, and powerful
diagonals create drama and sensation. The
impact is marvelous, what the Italians referred
to as *meraviglia* (see pp. 22–4). Rubens
undoubtedly wanted to show his Flemish com-
patriots something new, a scene that would
astonish them.

Deshays

Although Rococo artists abandoned much of the
vocabulary of the Baroque in secular settings,
they often kept it for religious painting. Jean-
Baptiste Deshays' *Martyrdom of St. Andrew*
(FIG. 4.19), although painted more than a centu-
ry after Rubens' death, would have made perfect
sense to him. Deshays (1721–65) married the
daughter of the French painter François Boucher
and rose fairly quickly in the French Academy. A
promising young student, he won the Rome
Prize in 1751 and spent three years in the capital
of the Baroque. It is this cosmopolitanism in the
arts of the seventeenth and eighteenth centuries
– thanks in large part to the power of the art
academies (see pp. 53–6, 62–5) – that encour-
aged the diffusion of certain styles. Still, one is
surprised by Deshays' whole-hearted adoption of
a pictorial mode that had been attacked roundly
throughout the eighteenth century, in Rome as
in Paris, and perhaps even more surprised by its
enthusiastic reception. Before this altarpiece was
sent to the church of St. Andrew in Deshays'
home town of Rouen, it was shown in 1759 at
the Academy's annual exhibition, known as the
Salon. There it created a sensation, the often
acerbic French critic Denis Diderot judging
Deshays to be "the first painter of the nation."

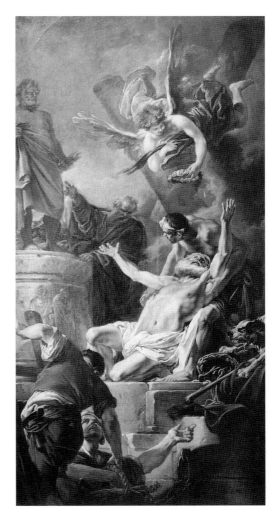

The viewer's eye moves through the composi-
tion along a nervous zig-zag path, beginning in
the lower left-hand corner, plunging past
St. Andrew, then up again along the slanting line
of a tumbling column. The keen aesthetic plea-
sure of this scene of pathos arises from the
painter's ability to excite our senses, even by such
details as the bug-eyed, snarling, and drooling
dog who threatens Andrew's tormentors.

Tiepolo

Another exponent of a late Baroque style was
Giovanni Battista Tiepolo, a painter who was
virtually unknown outside of northern Italy,

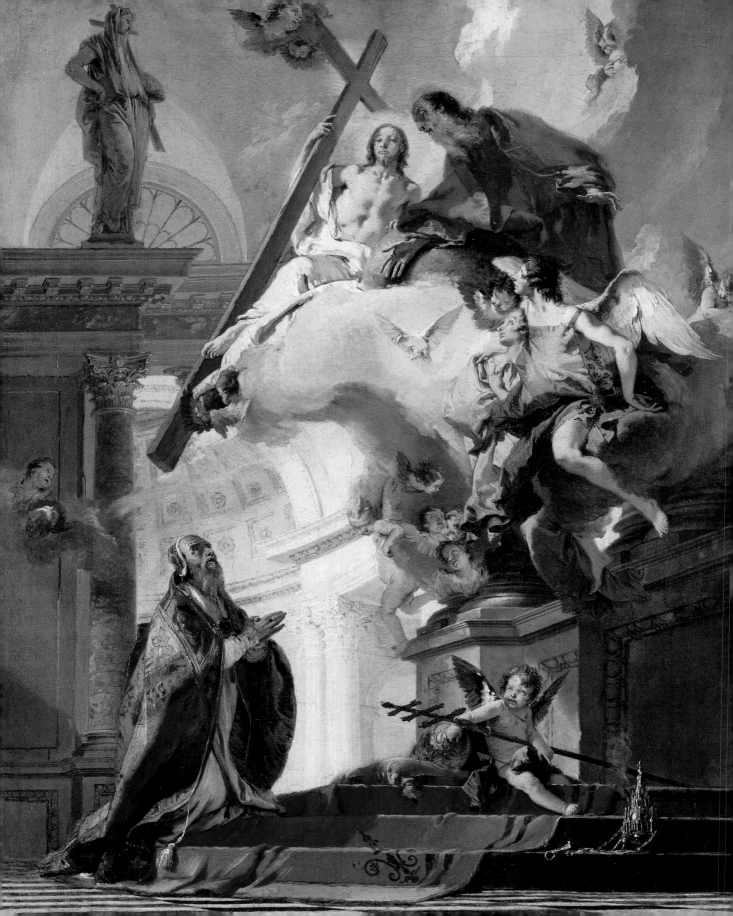

4.20 (*opposite*)
GIOVANNI BATTISTA
TIEPOLO,
*The Trinity Appearing to
St. Clement*, 1730–35.
Oil on canvas,
27¼ x 21¾ in
(69.2 x 55.2 cm).
National Gallery,
London.

This is a *modello* for the
eventual altarpiece, which
was 16 feet (4.9 m) tall.
Tiepolo specialized in
grandiose, large-scale
works, including not only
altarpieces but also
numerous frescoes and
ceiling paintings. As a
result he became a master
of the depiction of air-
borne figures, painted *di
sotto in su*.

4.21 CRISTÓBAL DE
VILLALPANDO,
The Archangel Michael,
1700.
Oil on canvas,
6 ft 1½ in x 3 ft 6¾ in
(1.87 x 1.09 m).
Wadsworth Atheneum,
Hartford, Conn.
The Ella Gallup Sumner
and Mary Catlin Sumner
Collection Fund.

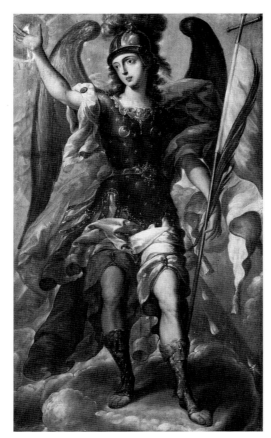

southern Germany, and, in his last years,
Madrid. In *The Trinity Appearing to St. Clement*
(FIG. 4.20), an altarpiece done for Clemens
August, the Archbishop-Elector of Cologne,
Tiepolo represents Pope Clement's vision of the
Holy Trinity, which comes to him when he is
absorbed in prayer. The illusionistic architec-
ture, the brilliant colors, angels, swirling and
unstable forms, are visual analogies for a mysti-
cal vision, one achieved through prayer, grace,
and imagination. Christ lounges with his cross,
at ease, while God hovers slightly above. Angels
watch in adoration, one of them wearing an
amazing blue satin shift, clasped at the thigh,
covering an embroidered under-shirt. The ele-
gance, tranquillity, and composure of this vision
lacks some of the verve of early Baroque visions,
but it has lost none of their theatrical and tran-
scendent values.

Villalpando

Although few artists followed the Jesuits,
Dominicans, and Franciscans to Central and
South America, many local artists found work.
If they did not always have an academic train-
ing, there were prints of sixteenth-century
European paintings to fall back on. There were
guilds for artists in Mexico City, Bogotá, and
Lima; the school in Mexico City flourished
toward the end of the seventeenth century. New
prints, including those of Peter Paul Rubens,
arrived, inspiring a Baroque style of some
sophistication and magnitude.

One of the most talented of the local artists
of this period was Cristóbal de Villalpando (c.
1652–1714). His *The Archangel Michael* (FIG.
4.21) has much of the flourish, brilliance, and
fluttering drapery of the dramatic European
Baroque style. Thus, the figure attests to the
colonial nature of Baroque art in Mexico: by
keeping the native populations out of the acad-
emies, the art establishment in Mexico was
bound to be more reflective of the Old World
and less in tune with the culture of the New.
On the other hand, the proportions of the
body, details of the arms and hands, and for-
mulaic face with sharp eyebrows, straight nose,
and rose-bud mouth reflect the distance of this
impressive altarpiece from its European (and
specifically "Rubensian") origins.

Church Ceilings

As films today are projected onto fabric screens,
so were the miraculous images of the Baroque
projected onto the stone and plaster vaults of a
church. The ceiling is God's realm, and Baroque
fresco painters created a complete heavenly envi-
ronment in the upper reaches of churches. The
worshipper is impelled to look upward upon
entering and while proceeding through the
church. The way in which the visual experience
envelops one is consistent with the idea of the
celestial hierarchy, so important to the Roman

Church. The writings of Dionysius the Areopagite (see p. 17) appealed greatly to the sensibilities of those interested in divine transport and ecstatic visions, whether artistic or religious. Most painters in the seventeenth century would have been familiar with these works, whether or not they had actually read them. They understood, if only at second hand, the literary and visual tradition of mysticism, and strove to construct a believable space that would assist the worshipper in his or her mystical pilgrimage. We have in Baroque ceiling frescoes an intuition of the infinite, a vicarious ecstasy. As the word *ekstasis* literally means, believers "stand outside" of themselves when contemplating such beatific visions.

In contrast to the interior of Dutch churches, where the iconoclastic attitude of the Calvinists forbade the use of images, the Tridentine Church encouraged the use of images as appropriate tools to allure, induce, and persuade worshippers of the truths of the Church. There was always the fear on the part of Church officials that, at the local level, the people through laziness or indifference might fail to attend Church services, and on the international scene, that the Roman Catholic Church might lose ground to the Protestants. Altarpieces told one kind of story, usually depicting scenes for veneration or contemplation that related to the sacrifice of Christ, the suffering and triumph of the saints, or the glory of the Blessed Virgin Mary. Ceilings, on the other hand, showed one the route to heaven.

SANT'ANDREA, ROME

Italian artists had excellent examples before them of ceiling paintings. Nearly every painter was familiar with Michelangelo's frescoes in the Sistine Chapel; north Italian and Venetian painters also had experimented with ceiling paintings in the sixteenth century. So when Domenico Zampieri, known as Domenichino (1581–1641), took on the commission for frescoing the ceiling of the apse and pendentives of the Roman church of Sant'Andrea della Valle in the 1620s, he was following a fairly recent but nonetheless well-established tradition. In his

youth Domenichino studied at the Carracci academy in Bologna (see pp. 54–5) and had traveled to Parma to see the paintings of Correggio. Correggio's fresco of *The Assumption of the Virgin* in the dome of Parma Cathedral (FIG. 4.22) certainly stayed in Domenichino's mind when he took on the commission at Sant'Andrea. In the vortex of Correggio's Heaven-bound whirlpool, the Blessed Virgin Mary appears to us like a swimmer, seen as if from the depths of a pool, about to surface. A myriad of angels caught among cotton-wool clouds adore her from below.

Domenichino's rendering of skied figures plays on the Corregesque tradition, but he makes his figures more vivid and three-dimensional. His *St. Matthew* (FIG. 4.23) projects from the penden-

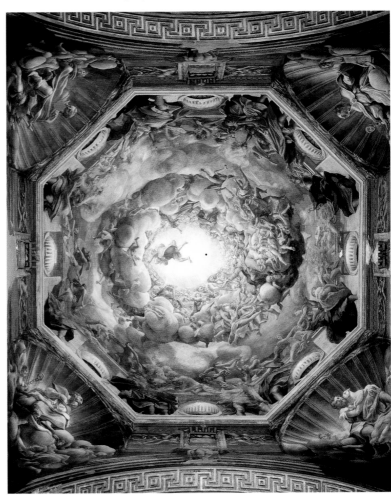

4.23 Domenichino, *St. Matthew*, 1622–27. Fresco, Sant'Andrea della Valle, Rome.

Domenichino's interest here is essentially in the human figure, in the skillful depiction of musculature and *contrapposto*. One problem of this approach, however, is that dynamically posed, massive forms can seem cramped in a confined space such as this.

4.24 Michelangelo, *Ignudo over Jeremiah*, 1508–12. Sistine Chapel, Rome.

Before Correggio, even such masters as Michelangelo did not attempt fully to convey the illusion of the human form as seen from below. Instead the figures were seen as if at eye level, no matter where on the wall surface they appeared.

4.22 (*opposite*) Correggio, *The Assumption of the Virgin*, 1530. Fresco, diameter c. 36 ft (11 m). Parma Cathedral.

The great collector Queen Christina of Sweden paid Correggio the ultimate compliment: she refused to believe the architectural details were an illusion and climbed into the dome of the cathedral to examine the painting. One eighteenth-century critic, however, pointed out the drawback in dramatic scenes depicted *di sotto in su*, when he described Correggio's dome as a "stew of frogs' legs."

tive with the relief of a carved figure. The light source is imagined to come from the dome, so that strong shadows appear to be cast on the pendentive itself, enhancing the sense of a dense mass of figures. Domenichino's invocation of Michelangelo's seated figures from the Sistine Chapel ceiling (FIG. 4.24) shows that he is a Roman, if only by adoption. In a manner that also comments on Michelangelo's style, Domenichino's thrusting and zigzagging composition threatens to burst out of the triangular confines of its space. The deep pockets of shadow and intense highlights organize the design, so that even when it is seen from below, the arrangement of figures remains perfectly legible. All of this excitement suggests a powerful inner force to the figure of St. Matthew, who in fact is merely contemplating and reading what the angels have put on a slate. He then will transfer it to his own book, his Gospel.

4.25 Domenichino, pendentives and choir, 1622–7.
Fresco,
Sant'Andrea della Valle, Rome.

Domenichino grew up and trained in Bologna, which was the center of seventeenth-century ceiling painting. The decoration of Sant'Andrea gave him the opportunity to execute probably the most important project of his career, but it also led to a bitter rivalry with Giovanni Lanfranco, who was given the commission to paint the dome above the crossing.

A view of the crossing of Sant'Andrea (FIG. 4.25), provides some idea of the extraordinary dimensions of the church (in Rome, only St. Peter's has a higher dome), and therefore demonstrates the importance of scale to Domenichino. One can readily imagine the effect upon worshippers, protected by these brilliantly colored and expansive figures towering over them.

SANT'IGNAZIO, ROME

The mystical desire to find a continuum between our imperfect earthly world and the blessed realm of the angels, where one can glimpse the ineffable, the light of God, was greatly aided by those artists most skilled in *quadratura*, which is the painting of an illusionistic architecture that has the effect of extending the real space of the

room. Mysticism is about an immediate, stunning experience of the divine. Andrea Pozzo (1642–1709) gives us that experience by telescoping our space into the infinite.

Pozzo was a lay brother of the Jesuit order, and was trained as a painter, architect, and stage designer. Because of his close religious affiliation, he had an especially strong feeling for the role of the artist as a promoter of religion. When the Jesuit General Padre Giovanni Paolo Oliva summoned him from Turin to Rome in 1681 to paint the interior of the church of Sant'Ignazio, he came willingly and well prepared for the daunting task before him. After painting a false dome and some pendentive figures, he undertook in 1691 the challenge of transforming the ceiling of Sant'Ignazio (FIG. 4.26) into an architectural stage fit for the allegorical representation of the mission of the Jesuit order.

4.26 (*opposite*)
Andrea Pozzo, *Allegory of the Missionary Work of the Jesuits*, 1691–4.
Fresco
S. Ignazio, Rome.

Pozzo's theme provided him with the opportunity for some exotic subject matter. America is represented by a native American Indian woman, accompanied by a lynx; Asia is symbolized by a woman riding a camel; and an African queen is shown holding an elephant tusk. The architectural illusion is achieved entirely through paint; there is no use of stucco to enhance the effect.

Jesuit Missions

FROM THE FOUNDING OF the Society of Jesus in 1540 it was understood that the Jesuits had a special mission. Their motto was "for the greater glory of God and the Church," and their mission (see FIG. 4.26) was to spread the gospel of Christ throughout the world. The Society's founder, Ignatius of Loyola (1491–1556), and his small band of loyal followers took a vow of absolute obedience to the pope and committed themselves to a life like that of the early apostles.

The Jesuits, who forsook a communal life, had a tight, military organization that facilitated their mobility and their worldwide missions. Their first general, Ignatius, kept in touch with his troops through an efficient system of mail delivery. He is known to have written 8000 letters during his generalship. In 1540 a member of his original group, Francis Xavier, boarded a Portuguese ship bound for India. He was the first of the Jesuit missionaries.

Along with Franciscans and Dominicans, the Jesuits converted large numbers of Indians in the Americas, both north and south of the Rio Grande. Because most of the early settlers were single men, there were virtually no pure European offspring. Added to that fact was the Church's policy that no Indian or *mestizo* (of mixed race) could be ordained as a priest. Therefore, the missions with their European base never ceded power to indigenous peoples, although they attempted to work closely with them and respect their traditions.

In Paraguay the Jesuits founded an effective model for other missions by organizing small Christian communities into *reducciones*. In these Indian villages, the priests built churches, taught trades, provided guardianship and protection from other settlers, and instructed the native inhabitants in the elements of Catholic faith.

In China the Jesuits became part of the highly literate court and preached a Christianity that avoided clashing with Confucian precepts. Although China was officially closed to the Church, the Jesuits Matteo Ricci and Michele Ruggieri received special permission to enter. They both studied Chinese customs, learned the language, and dressed as Buddhist monks. Although progress was slow, they had some initial success in converting a small number of natives. By the time of Ricci's death (1610), however, he was regarded as a revered Confucian monk. Ricci followed the principle of "sweet conversion," which meant that the priest did not try to change local habits or customs, so long as these were not in conflict with faith. The Jesuits understood that to try to impose the cultures of France, Italy, or Spain on foreign lands would ultimately be doomed to failure. Ricci taught Christianity as an ethical religion that would supplant Buddhism and complement Confucianism. Although he did not convert many at first, Ricci's method resulted eventually in an edict of toleration in China and the admission of other Jesuits. Finally a dispute among the Dominicans and Franciscans against Jesuit-inspired Chinese rites, and an attempt by the pope to intervene with the Chinese Emperor, led to the expulsion of the missionaries and persecution of Chinese Christians.

Francis Xavier died before he could enter China; but he had already established a Jesuit presence in Japan just before the middle of the sixteenth century. Feudal lords and war lords both admitted the foreigners, who they believed could assist them in trade and in establishing a unified country. The Japanese missionaries also followed the sweet way and lived among their brethren as purely assimilated outsiders. By the early seventeenth century, the Jesuits could claim as many as 220,000 converts. But when the feudal lord, samurai, and imperial minister Hideyoshi (1536/7–1599) succeeded in bringing about unification and centralization of authority in Japan, a period of anti-Christian polemic and sometimes violent suppression began. By the early eighteenth century, there remained a few clandestine Christians among Japan's population. But all those missionaries who had not died as martyrs or who had not converted to other faiths under torture were expelled from the country by the early eighteenth century.

Jesuit missionaries established a foothold in India during the reign of the cosmopolitan emperor Akbar the Great (1556–1605). Akbar ruled with tolerance and foresight. He built roads, regulated taxes, estab-

4.27 *Dominicans Baptizing Indians,* seventeenth century. Castillo de Chapultepe, Mexico.

The Jesuits had to endure a long and intensive period of training, and to agree to go wherever they were sent. In 1540 the order was restricted to sixty members, but this rule was relaxed and by 1626 membership had reached 15,000. The Jesuits' conservatism in matters of theology later made them unpopular, especially in Europe, and the order was suppressed in 1773, only to be restored in 1814.

lished uniform weights and measures, and showed great tolerance to non-Muslims. He was a strong patron of literature and the arts, even European art. He was friendly with Jesuit missionaries, whom he entertained at his court. In order to create a sense of justice and tolerance, and to synthesize Muslim and Hindu traditions, he married a Hindu princess. He hoped for a philosophy that would unite the best of Muslim, Hindu, and Christian traditions. The Nestorians, Christians of Persian and Middle Eastern origin, already were well established in India, and continued to thrive, eventually joining the Roman Church (1599).

Wherever they went, the Jesuits set up schools, provided some protection for the natives from colonists or from the hostile majorities, learned native languages, adapted local customs, accommodated some non-Christian religious practices, and became accomplished ethnologists. With their suppression in the later eighteenth century, their missionary work came to an end for forty years, until 1814. Other European orders took up where the Jesuits left off, and have continued worldwide missions to the present day.

Because the nave is itself divided into three sections (one can see the actual windows above the nave walls in the photograph), Pozzo created a similarly ordered architecture in his fresco. Surmounting each of the real windows is an arch that appears open to the sky, and between the arches are paired columns supporting a projecting architrave. Near the center of the ceiling sits St. Ignatius of Loyola, the founder of the Jesuit order, with divine rays emanating from his head. He is about to enter Heaven. Below Ignatius, between the windows and just above the real architecture of the church, are scrolled tablets with the names of the four corners of the earth, the continents of Asia, Africa, America, and Europe. Each cartouche is accompanied by a personification of that continent: Pozzo is making a clear reference to the universality of the Jesuit order and its global mission. Inscribed on tablets on the short walls are Christ's words, "I have come to bring fire to the earth; and would that it were already kindled" (Luke 12:49), which Ignatius echoed when he told his brethren, "Go and light the flame over the world."

Because this kind of architectural projection originates from a single point of view, there is only one spot below from which it all makes sense. Pozzo was thoughtful enough to mark the place on the floor where one can stand and have the entire ceiling pull together and appear to fade into infinity. Although this fresco, like most ceiling painting, is visionary, it does not draw the worshipper into its own realm. The single-point perspective system keeps one at a distance, rooted to the nave's floor, from which the viewer gazes in admiration at the glory of the mission of the Jesuits.

SANTA CECILIA, ROME

The role of expansive or deep spatial illusion diminished somewhat in Roman ceiling paintings of the eighteenth century. Although there is no simple explanation for this change in the strategies of presentation of heavenly images on church ceilings, one can observe throughout European art the beginnings of a Rococo style that seems less emphatic, aggressive, tortured, and exulting than the Baroque. Sebastiano Conca (1680–1764) had a long and distinguished career in Rome and is traditionally credited with establishing a version of the Rococo in the papal city. By the time he painted *The Crowning of St. Cecilia* (FIG. 4.28) he was already one of the most important Roman painters. Cardinal Francesco Aquaviva, who was a "pro-

4.28 (*opposite*)
SEBASTIANO CONCA,
*The Crowning of St.
Cecilia*, 1725.
Fresco.
S. Cecilia, Rome.

In her childhood St.
Cecilia took a vow of
chastity, and when she
eventually married she
persuaded her husband
to agree to abstinence.
When he agreed, an angel
descended and placed
crowns of roses and lilies
on both their heads. The
story provided an ideal
opportunity for a light,
decorative Rococo
approach.

tector" of the church of Santa Cecilia, commissioned him to paint what was to become the most celebrated of ceiling paintings of its time in Rome. The fresco's success was such that the preparatory drawings, known as cartoons, were sent to the Queen of Spain, and an early model in oils was presented to the Duke of Parma, who was so pleased that he provided apartments in the Palazzo Farnese for Conca to have a studio and places for his students.

Cecilia, the patron saint of music (a small set of organ pipes is being carried by an angel), receives a crown of flowers from Christ while God the Father looks down and a pope or bishop looks up. The composition fits easily within the confines of the frame and assumes an X-shaped arrangement of forms, a fairly stable arrangement that differs from the dynamic zigzag patterns of the seventeenth century. Contours are clear, drapery folds crisp, gestures ample and expressive. Although the fresco is huge, its effect upon the viewer is not overwhelming: one tends to read the composition

rather than to give oneself over to it. The aesthetic sensibility of the eighteenth century is, in general, more rational than that of seventeenth: we may not be shaken, but we are enlightened.

CHURCH OF THE INVALIDES, PARIS

Those commissioning ceiling paintings outside of Rome often chose an artist who had Roman experience or training. Such was the case with the French painter Charles de La Fosse (1636–1716), who received the commission of frescoing the dome and the pendentives of the church of the Invalides in Paris (FIG. 4.29). Not only was he the most important decorative painter in France after the death of Charles Le Brun (see pp. 63–5), he had made the necessary pilgrimage to Parma and to Rome to study Italian ceiling painting.

Rather than showing a Heaven completely occupied by angels, Christ, and historical personages, La Fosse masses most of the figures at the base of the dome, creating a heavier and

4.29 CHARLES DE LA FOSSE, dome of the Church of the Invalides, 1702–5. Fresco, Paris.

De La Fosse's painting is in many ways more like an easel painting than a ceiling fresco. There is little of the decorative profusion that characterizes many Italian Baroque frescoes, and while God, for example, is depicted *di sotto in su*, the king himself is not. Indeed, the political message seems to be at least as important as any expression of religious devotion.

more anchored composition than Correggio's at Parma. Because the Invalides was conceived as a private chapel for the French royal family, the depiction of St. Louis (representing Louis XIV) offering to Christ his sword and shield is an apt gesture of royal obedience to the King of Kings. Still, the propaganda value cannot be missed: the French king bows only to Christ himself. Although in the Baroque age kingship continued as the unquestioned model of power and organization for the state, there was still a perceived need for legitimizing, even sacralizing, royalty through the means of visual representation.

Birnau Pilgrimage Church, Austria

Although far more intimate than Baroque churches in Italy and France, pilgrimage churches in southern Germany and Austria were equally spectacular. Many such churches were burned during the Thirty Years' War, and a flurry of construction took place thereafter. Pilgrimages were on the rise, and local monastic communities were eager to build their elegant churches, which functioned in part as shrines for venerated objects and images.

At Birnau the builder Peter Thumb (1681–1766) designed a large central space that differed dramatically from traditional church design (FIG. 4.31). The side walls are opened with large windows set into two stories, creating a wide space described by one architectural historian as a "praying-hall." Surmounting this space is *The Woman of the Apocalypse* by Gottfried Bernhard Goez (1708–74). Although ceiling paintings are closely aligned with their church's architecture in Italy, in southern Germany and Austria the melding of pictorial and architectural space is if anything more intimate. Goez, for example, chose the color scheme of white and pale pastels for the interior of the church. He certainly had a hand in the overall decoration, which was carried out under the direction of a specialist in interior design. Goez followed in the late seventeenth-century tradition of Andrea Pozzo, so that although the decoration is profuse, the lines of spatial demarcation

4.30 Gottfried Bernhard Goez, *Woman of the Apocalypse*, c. 1749. Fresco, Birnau Pilgrimage Church, Austria.

Goez's focus on themes in the life of the Virgin Mary, throughout the church (his first major work), provide appropriate subject matter for his soft, graceful approach .

are clearer than at Die Wies (see FIGS. 3.37, 3.38). The fresco over the choir (FIG. 4.30) shows Mary trampling on heresy in the form of a snake, as she is borne toward the **oculus** (a round "opening" at the top of the dome), and, beyond that, rays of light symbolizing the Holy Spirit. Goez has learned all the lessons of stage design and *quadratura*. Although this strongly architectural form of painting has been criticized as being in some ways inappropriate to the brightness and openness of the church, the very insistence on *quadratura* emphasizes the tectonic (or architectural) quality of the overall design.

4.31 (*opposite*) Peter Thumb, Birnau Pilgrimage Church, Austria, 1750.

Papal Palace Ceilings

Although strictly speaking independent of our discussion of the church interior, the ceilings of papal palaces may be considered in this chapter, primarily because they further the interests of the Roman Church. Since the sixteenth century there had existed a residence for the pope next to St. Peter's, but popes would build family palaces elsewhere. Because of their princely status, several of the Baroque popes either built or rebuilt existing palaces in the center of Rome, at some remove from the Vatican.

There were several reasons why a pope would choose to establish his residence in a more secular setting. First of all, it is in a palace that court society thrives, and business of a diplomatic nature often took place in the homes of the political and ecclesiastical elite. Thus the various identities of the pope as leader of the Holy Church, head of an important family, and European statesman blended together in the papal palace. One of the pope's means of asserting his various roles was through the deployment of imagery. Nearly every space required the kind of decoration that would both further the political aims of its occupant, or in some other way satisfy his desire for identity and display. These decorations (especially the ceiling paintings) played a crucial role in the rituals and etiquette of court society, and were intended to be viewed by ambassadors or other governmental officials and members of the Church.

THE PALAZZO BARBERINI, ROME

For his palace in Rome Urban VIII decided upon a grand scene on the ceiling of the Gran Salone or main audience hall that would reflect directly on his personal and pontifical identity. Pietro Berrettini, called Pietro da Cortona, labored for nearly seven and a half years on the fresco scheme, the *Glorification of the Papacy of Urban VIII* (FIG. 4.32). There is evidence that he (or his patron) judged his first effort a failure, so he re-plastered the ceiling and began again. Although we do not know the details of why the

first version of the ceiling was unacceptable, one can imagine that with its enormously complex arrangement of architectural frames and illusion of deep space, the artist faced huge problems of perspective.

There are two main entrances to the room, each providing a different angle of sight. In addition, Cortona would have wanted the ensemble to read well from various, secondary points of view as the visitor took a turn about the room, studying individual scenes and particular figures. The illusion of architectural space is created by an ornate painted cornice that is supported at the four corners by herms and atlas figures. Some of the figures seem to float in front of the architectural frames; others "hover" above and beyond the space of the painted architecture (which conforms with the actual surface of the vaulted ceiling).

What we know of the allegorical arrangement and identification of the various figures comes, surprisingly enough, from a servant who was in charge of having the room swept out. He claimed that he was asked about the subject matter so often by visitors that he put together a pamphlet explaining the iconography. He consulted not with Cortona, but with the court poet Francesco Bracciolini, who was Cortona's original advisor. What seems arcane and recondite to us, apparently was equally so to the fresco's contemporaries. A basic interpretation begins with the figure of Divine Providence, who represents the fore-knowing and beneficent care and government of God, sitting atop a pyramid of figures and gesturing toward the Barberini coat of arms. Beneath her are figural emblems of Fate and Time. Each of the smaller scenes involves a virtue – Wisdom (Minerva), Strength (Hercules), Moral Knowledge, and Dignity. Sometimes the allegorical figure rides a cloud between narrative scenes that act out her merits (on either side of Moral Knowledge, for instance, are the drunken, fat Silenus to the right, and a good cupid fighting a bad one to the left). At other times, the main allegorical figure, such as Minerva battling the Titans or Hercules driving out the Harpies, is the primary actor. The allegorical program, though highly complex and

4.33 CARLO MARATTI,
The Triumph of Clemency,
after 1673.
Fresco,
Palazzo Altieri, Rome.

The decoration of the
room was suspended
when the Pope died and
was never resumed. The
original programme,
according to preparatory
drawings that have sur-
vived, apparently includ-
ed pendentives and
lunettes showing scenes
from Roman history and
religious allegories on
the universality of the
Christian faith.

detailed, is essentially a statement about the papa-
cy of Urban VIII: the Pope overwhelms adversi-
ty and promotes virtue (the Barberini coat of
arms is held aloft by the three theological virtues
Faith, Hope, and Charity) and so will receive the
crown of stars, thus signaling both the papacy's
and the family's immortality.

THE PALAZZO ALTIERI, ROME

The Altieri family, already of long and noble
standing in Rome, added a pope to its ranks in
the later seventeenth century. Clement X's reign
(1670–75) was not lengthy, but it was sufficient
to commission a monumental ceiling fresco
that allegorized the Pope and his family in
terms of clemency and the Christian virtues
(FIG. 4.33). With an eye on the Palazzo
Barberini, the Altieri family brought in Carlo
Maratti (1625–1713), one of the most highly
sought-after painters of the day, and also enlist-
ed the talents of Rome's leading intellectual and
critic of the arts, Giovanni Pietro Bellori, as
iconographic adviser.

Maratti's training was with Andrea Sacchi
(1599–1661), a rival of Pietro da Cortona.
Perhaps there was a conscious choice on the part
of the Altieri that they would counter the poten-
cy of Urban's image by hiring a painter from a
different camp. As so often happens in "commu-
nities of interest," such as the Roman Baroque
art world, there were camps that vied with one
other for supremacy in the local market.
Maratti's camp could trace its origins back to the
Bolognese artists of the early part of the century,
and it held a strong position for many decades.
Caravaggio's stock had plummeted shortly after
his death, and the ardent style of Bernini,
Borromini, Cortona, and Gaulli had its detrac-
tors by the last quarter of the century. Therefore
it made sense that the Pope and his family chose
Maratti, an important and expensive painter
with powerful friends. The Altieri probably
chose him for his reputation, rather than because
they found his style perfectly suitable to their
interests in self-promotion. Nonetheless, his style

works well. In the established tradition of alle-
gorical visual language, the composition cele-
brates Clement's clemency, his peacefulness,
mercy, and kindness. Its sense of relative control
is typically Bolognese: the frame remains unbro-
ken; no one floats over its edges; art and life are
kept, for the time being at least, separate. The
figures may be seen from below at a slight angle,
but do not occupy a space that is continuous
with the viewer's. In fact, aside from a few super-
cilious glances, the composition is entirely self-
absorbed.

Conclusion

The Council of Trent created reforms that
opened up the interiors of churches for better
acoustics and better lines of sight. With the
greater visibility of the high altar and the more
intimate participation of the laity in the celebra-
tion of the Mass, visual imagery expanded to
delight and to inform the people. Mass became
less a ritual for the priests themselves and more
one for the larger public.

On the whole, the visual arts served only two
masters in the Baroque and Rococo periods:
court society and the Church. These two realms,
one of this world, one interested in the next, are
not all that different from each other. The pope's
worldly resources were at the service of the
church, and the opposite was true as well.
Similar styles and use of allegory, symbol, and
imagery were employed equally within papal
palaces and Catholic churches.

Whether looking at tombs, altarpieces, or
ceilings, the religious spectator expected and
usually received dramatic visual stimulation. The
power of Baroque and Rococo imagery within
churches and papal palaces arose from its ability
to offer a complete and impossibly rich vision
into another kingdom, where all the allegorical
figures were beautiful, where the pope dominat-
ed – no matter how ancient and ailing – where
the angels and the Madonna and Child lived for-
ever in their splendor, and even where humble
pilgrims might find their home.

CHAPTER 5

Visual Rhetoric

STYLES IN THE
BAROQUE & ROCOCO

JOHANN LISS,
The Inspiration of St. Hieronymus, 1627.
Oil on canvas,
7 ft 4½ in x 5 ft 9 in
(2.25 x 1.75 m).
San Nicolò dei Tolentini,
Venice.

Liss left his native
Germany to be trained in
the Netherlands. Like
many other itinerant
artists of the Baroque, he
kept on the move, visiting
Paris in 1621 and settling
finally in Venice, where
he was the city's most
popular Baroque painter.
The brilliant colors, loose
brushwork, and composi-
tion built on angles and
diagonals make Liss an
important practitioner
of Baroque spectacle.

Rhetoric was taken seriously as a matter of language and communication in the seventeenth century (see pp. 17–19). Although it was thought of primarily in terms of poetry and oration, the concept of rhetoric includes visual as well as linguistic communication. There are, in general, two parts to rhetoric, what one might call the end and the means. The *end* of rhetoric is persuasion, the intention of a written, spoken, painted, or constructed act to convince its reader, hearer, beholder – in short, its audience – of its own validity and inevitability. The *means* or manner of conveying this allurement or inducement is the stuff of language and imagery, the conventions, the metaphors, the allegories, the iconography, and the style.

Style is part of the means of rhetoric. Art historians have traditionally made a distinction between style (or form) and content. In simplest terms, content is the subject matter of a painting or work of sculpture, and style is the way in which it is rendered. One can say that there is a personal style – how a painter moves the brush and arranges colors and forms; a period style – how the Baroque and Rococo have their own "look"; and a national style – how the French differ from the Spanish, for instance. Because style, as generally understood, is *formal*, it does not necessarily include the narrative elements of a painting or statue. If you are doing a stylistic analysis of a work of art, you will be primarily concerned with arrangements of shapes and figures, their configuration, how things relate to one another within the "visual field."

In an explicit discussion of the hierarchy of rhetorical styles, the Roman writer Demetrius wrote in *De elocutione* ("On Style," c. 70 C.E.) that there are four styles: the elevated, the elegant, the plain, and the forcible. Although such a categorization of rhetorical styles does not fit precisely the stylistic choices made by Baroque and Rococo artists, there is at least a general correlation. For instance, one might see the so-called classical styles of Poussin, Carracci, and Domenichino as comparable to the "elevated"

rhetorical mode; for "elegant," one could cite Watteau, Boucher, or Fragonard; the "plain" style seems comparable to some aspects of Dutch painting in the seventeenth century (Hals, Leyster, Dutch landscape painting); and the "forcible" manner could easily be associated with both Caravaggio and Bernini (although for different reasons in each case).

Because of the fear that an artist, speaker, or writer would use whatever means necessary to persuade an audience of a particular point of view, there has been throughout history some suspicion of rhetoric – indeed, some suspicion of art. In Plato's *Phaedrus*, for instance, there is a character who says that the "man who plans to be an orator" does not need to "learn what is really just and true, but only what seems so to the crowd." Plato – notoriously – would have banned artists from his ideal state. Rhetoric in the hands of the artist was a powerful weapon with which to sway the crowd. But we will also see in this chapter that certain styles or rhetorical strategies in the visual arts horrified some patrons and artists, and ultimately led to changes.

Rhetorical Contrasts in Italy

MANNERISM

Beginning about 1520 in Italy a new style appeared that subsequently has been called mannerism. The stylistic category derives from the Italian word *maniera,* which refers to the manner or style of a particular artist. All artists have their own style, of course, but when more standard forms of style and taste give way to the particular and eccentric, and when the odd and whimsical become highly prized, there can be a crisis of taste and some curious results.

The Martyrdom of St. Lawrence (FIG. 5.1) in the Florentine church of San Lorenzo by Agnolo Bronzino (1503–72) is an example of what happens when style becomes self-consciously stylish. In the center St. Lawrence, patron saint of the Medici family and their church of San Lorenzo,

is being burned alive on a grill (he is said to have taunted his tormentors with the remark: "See, I am done enough on one side, now turn me over and cook the other.") This is a strange scene. The Roman prefect on the right (who points to St. Lawrence) twists just so the observer can see his exquisite torso and bony knees. Those arranged elliptically around the saint are the torturers and the poor, whom Lawrence had just – instead of handing over money – presented to the authorities as "the treasures of the Church." (This infuriated the prefect and led to the saint's martyrdom.) Poses are tense and contrived, though ultimately derived from the nudes on the Sistine Chapel ceiling by Michelangelo; the figures – nude for the most part – are overly emphatic in their modeling and studied and affected in their gestures. Also, the way that people are pushed to the edges of the composition, creating something of a hole in the middle, differs from the more balanced and centered compositional devices of the Renaissance.

All of this is rhetorical because Bronzino's fresco creates a version of reality that is as much about pictorial representation and its *maniera* as it is about the historical Lawrence. This art puts style in the foreground and imitates other works of art. Perspective, color, composition, gestures, expression, placement, and so forth have been deployed for the purposes of what Vasari called *la bella maniera,* the beautiful style. He wrote that "*La maniera* became *la più bella* [the most beautiful] from the method of copying frequently the most beautiful things, combining them to make from what was most beautiful (whether hands, heads, bodies, or legs) the best figure possible, and putting it into use in every work for all the figures – from this it is said comes *bella maniera*" (Smyth, p. 35). But the reliance upon convention and repetition, not to mention the derivations from Michelangelo, repulsed some artists and patrons of the sixteenth century. One critic referred to the art of Bronzino and his generation as "mannered mannerism." What many wanted was a return to classical principles.

5.1 (*opposite*)
AGNOLO BRONZINO,
*Martyrdom of
St. Lawrence,* 1550.
Monumental fresco.
S. Lorenzo, Florence.

Agnolo di Cosimo, called Bronzino perhaps because of a dark complexion, was the court painter in Florence to Duke Cosimo I. Although his compositions are strikingly original and the haughty expressions of most of his characters startling and unusual in their apparent disdain, he was, oddly enough, accused of being unoriginal, of copying his figures entirely from paintings by Michelangelo and Raphael. What might strike a modern viewer as eccentric and amusing upset his contemporaries as derivative and mannered.

BOLOGNESE CLASSICISM

Art historians mean by classicism an empirically based art that follows certain compositional principles of fairly strict verticals and horizontals, closed forms, centralized compositions, and an overall sense of calm (see p. 28). The word classicism would have meant little to a seventeenth-century artist or critic; when it was used, which was rarely, it referred generally to Greek and Roman literature. Those who thought about art in the Baroque period had a different idea of classicism to ours, and a different way of expressing it. The Italian biographer and critic Giovanni Pietro Bellori, for example, gave a lecture to the Roman Academy of St. Luke in 1664 entitled "The Idea of the Painter, Sculptor, and Architect" in which he articulated anti-mannerist ideas that had been circulating for some time. From Bellori's point of view, by relying on images in the mind of the artist – the *fantasia* – mannerists were too distant from nature. It is not that nature is perfect, but there is an *idea* of nature to which the artist should turn. *Il bello ideale* (the beautiful ideal) can be found by selecting the most beautiful parts from one's experience of the world (but not, in the first place, of other works of art). The example given by Bellori, who is quoting a story from antiquity, is that of a beautiful woman: the painter should choose the most beautiful parts from a number of women, for no one woman is beautiful in all ways, and recombine them into a single figure. The legendary painter Zeuxis "formed with a choice of five virgins the most famous image of Helen" and by so doing

teaches both the Painter and the Sculptor to contemplate the Idea of the best natural forms in making a choice among various bodies, selecting the most elegant. Hence I do not believe that he could find in one body alone all these perfections that he sought for in the extraordinary beauty of Helen, since nature makes no particular thing perfect in all its parts. (Cited in Panofsky, p. 157.)

The procedure, then, is to contemplate and copy nature, as well as to intuit the intentions of nature, and thereby to close the gap between imagination and reality.

Classicism reappeared in the sixteenth century in Bologna in the academy of the Carracci. We have met Domenichino already as a ceiling painter at the church of Sant'Andrea della Valle (see pp. 142–4). His training with the Carracci in Bologna was based upon study from live models, drawings made by the Carracci, and a thorough understanding of the techniques of *disegno* (see pp. 92–3). His painting of *The Last Communion of St. Jerome* (FIG. 5.2), made as an altarpiece for the Roman church of San Girolamo della Carità, is a perfect example of classicism. At the age of ninety, St. Jerome, gasping and crying out (according to his biographer), asked for the last communion. To the right of the painting are those assisting the priest in his performance of the sacrament, and on the left are Jerome's lion (his constant companion after Jerome drew a thorn from his paw) and his disciples supporting him. Angels monitor the event from above, awaiting the release of his soul, which they will then spirit away to the Heavenly Jerusalem. The space is mathematical in the sense that the light is clearly distributed throughout, the ground plane with its squared patterns is seen frontally and in terms of linear perspective, and the stage is grounded and given monumentality by virtue of the stone arch. The view into the peaceful landscape in the background was described by the nineteenth-century British landscapist John Constable as having a "placid aspect ... like a requiem to soothe the departing spirit." This is certainly a different feeling from the one conveyed by the *Martyrdom of St. Lawrence*! The gestures and expressions on the faces reveal concern, sadness, benevolence, and caring. The entire scene arranges itself according to rules of balance, centeredness, calmness, symmetry, and the ideal. This sense of stately decorum and order epitomizes classicism in art.

Domenichino's painting derives many of its features from a painting of the same subject by

5.2 DOMENICHINO, *The Last Communion of St. Jerome*, 1614. Oil on canvas, 13 ft 9 in x 8 ft 5 in (4.19 x 2.56 m). Pinacoteca, Vatican.

one of his teachers, Agostino Carracci (FIG. 5.3). How could such copying be justified, especially given the criticism levelled at the mannerists for quoting from other artists? Even Domenichino's contemporaries felt that he may have gone too far. His rival Giovanni Lanfranco (1582–1647), hoping to hurt Domenichino's chances of winning the commission for the fres-

coes at Sant'Andrea della Valle, sent a pupil to Bologna to make an etching of Carracci's painting. This was printed and distributed to the artists' community, undoubtedly in the hope that Domenichino's reputation would be damaged. But the copying of masters, even in the Baroque period, was usually considered fitting and proper. One was, after all, drawing inspira-

5.3 Agostino Carracci,
*The Last Communion of
St. Jerome*, 1590s.
Oil on canvas
12 ft 4 in x 7 ft 4¼ in
(3.76 x 2.24 m).
Pinacoteca Nazionale,
Bologna.

Giovanni Pietro Bellori
explained in unambigu-
ous terms how the
Carracci family saved
painting. He begins by
describing the work of
the "divine" Raphael as
the summit of Italian art.
But the Venetians and the
Mannerists brought low
what once had been great.
Bellori continues: "Thus,
when painting was draw-
ing to its end, other, more
benign influences turned
toward Italy. It pleased
God that in the city of
Bologna, the mistress of
sciences and studies, a
most noble mind was
forged and through it the
declining and extin-
guished art was reforged."
Although he is referring
here specifically to
Annibale Carracci,
Bellori and other Italian
critics smiled upon the
entire family.

tion, paying homage, and revealing the extent of one's own learning. Besides, Domenichino owned Agostino Carracci's preparatory drawings for this painting, so would indeed turn to them as part of his research into the relatively unusual subject of St. Jerome's last communion. Nearly half a century later, Bellori commented in his defense of Domenichino that the resemblance does "not merit the name of theft, but of praiseworthy imitation." A great supporter of the Bolognese school, Carlo Cesare Malvasia, wrote in the seventeenth century: "and what painter in some way does not steal? Either from prints or reliefs or nature or works by others, reversing postures, twisting an arm lower, displaying a leg, changing a face, adding a drapery – in sum, judiciously hiding the theft?" (Spear, p. 35).

Another painter in Bologna to whom Malvasia gave great praise, Elisabetta Sirani (1638–65), was also identified with the traditions of Bolognese classicism. After the death of Guido Reni (see p. 130), she was the most celebrated painter in Bologna. Potential patrons, art lovers, the idle, and the curious flocked from all over northern Italy to meet her and to watch her paint. Malvasia, her greatest promoter, told tales of her astounding virtuosity, demure personality, and pure character. She died under suspicious circumstances at age twenty-seven – Malvasia believed that she had been poisoned. Because she painted in the "elevated" manner of Domenichino, Lanfranco, the Carracci, and Guido Reni, Sirani's style and rhetoric remain clearly within the traditions of Bolognese classicism. But her attention to the effects of strong modeling and her interest in scenes of women relate her also to a different visual culture, one which exploited the dramatic potential of *chiaroscuro* and which sometimes included scenes of violence.

Her *Portia Wounding Her Thigh* (FIG. 5.4) shows a scene from Plutarch's *Life of Brutus*. Portia demonstrated her loyalty to her husband Brutus, one of the conspirators and murderers of Julius Caesar, by committing suicide (according to the original story, she took burning coals into her mouth and suffocated). Sirani chooses

5.4 Elisabetta Sirani, *Portia Wounding Her Thigh*, 1664. Oil on canvas, 3 ft 3¾ in x 4 ft 6¾ in (1.01 x 1.38 m). Miles Foundation, Houston.

an earlier moment in the story when Portia, realizing that her husband is involved in some dark and dangerous plot, sends her maidservants from the room (they can be seen in the background), and then thrusts a dagger into her thigh. The purpose of this remarkable act is to get her husband's (and the viewer's) attention. When he asked her why she did it, her reply was: "Brutus, I am Cato's daughter, and I was brought into thy house, not, like a mere concubine, to share thy bed and board merely, but to be partner in thy troubles." (Plutarch, p. 153). She then asked that he confide in her all of his secrets, which he did. Here, then, is depicted a model for the loyalty and strength of a woman who demands in no uncertain terms that she be treated as an equal. There was a significant demand in the Baroque for images of strong women, which explains why such an obscure event was chosen by Sirani.

The sharply directed spotlight on Portia's face, shoulders, arm, and thigh, and the way in which Sirani pushes the figure to one side and cuts off part of the drapery and Portia's left leg, were fairly typical compositional devices for the seventeenth century. But these were formulae adopted more often by artists promoting the more spectacular forms of visual drama. Caravaggio, although more extreme in his modes of presentation, had helped to establish some aspects of Sirani's style early in the seventeenth century. So although Sirani made her short but famous career in Bologna and certainly made use of Bolognese classicism to her own benefit, she also demonstrated a keen awareness of a different tradition.

Subversive Tenebrism

The Italian word *tenebre* means darkness, gloom. Michelangelo Merisi da Caravaggio made a career in shadows, not to mention in the murky underworld of Rome at the turn of the seventeenth century. He came to Rome in the early 1590s with no money, few connections, but with considerable street knowledge. His earliest scenes were of still lifes, musicians, and half-length figures coyly soliciting the viewer for attention (FIG. 5.5). Toward 1600, with a growing clientele and important friends in the Church and among the leading collectors, he graduated to larger paintings with more complex iconography. There was always something scandalous about him; ultimately, he killed an opponent in a tennis match, and ran for his life. He spent his last four years avoiding papal authorities, constantly moving from place to place – Naples, Sicily, the island of Malta – and eventually returning to the Italian coast not far from Rome, hoping for a pardon from the pope. In fact the pope absolved Caravaggio, but the artist never knew. Stricken by a fever, he died a few days before word could reach him.

Caravaggio (the name of the town where he was born) was not an academic artist. He rarely if ever made preliminary drawings for his paintings, and was one who, according to the Dutch writer Karel van Mander, "thinks little of the works of other masters." The biographer Giovanni Baglione described him as "satirical and haughty," one who did not study "the rudiments of design and the profundity of art." He used a method known as **tenebrism**, whereby he placed most objects in shadow and illuminated only a few, almost as a dodge to avoid setting up perspectival space and creating those precise intervals between figures that some artists spent years learning. He used the life around him, apparently avoiding the rules of art and the need for elaborate, studied compositions. "Apparently," because it was Caravaggio's stratagem to give the appearance of the unstudied, spontaneous, vital, and immediate. In fact, he probably labored as long as any other artist to get his "uncomposed" and therefore shocking effects.

So how is it that Caravaggio uses visual rhetoric? His method of producing imagery does not fit any of the three categories mentioned earlier. There is nothing obviously deliberative or flowery about his approach. Nor does he appear to be political in the sense of trying to persuade someone of a particular legislative, judicial, pro-

5.5 (*opposite*) CARAVAGGIO, *Bacchus*, 1595–6. Oil on canvas, 37 x 33½ in (94 x 85.1 cm). Uffizi, Florence.

Just as we cannot quite reach the glass of wine offered to us by Bacchus, we usually cannot get a definitive meaning from Caravaggio's paintings. This heavy-lidded, androgynous, drowsy young Bacchus seems to solicit the viewer and offer more than merely a drink. This act is so close to the oblation of Christ at the Last Supper (the giving of the cup to the disciples) that one could find here a perversion of the Eucharist. But it was precisely Caravaggio's intention to keep his meaning ambiguous.

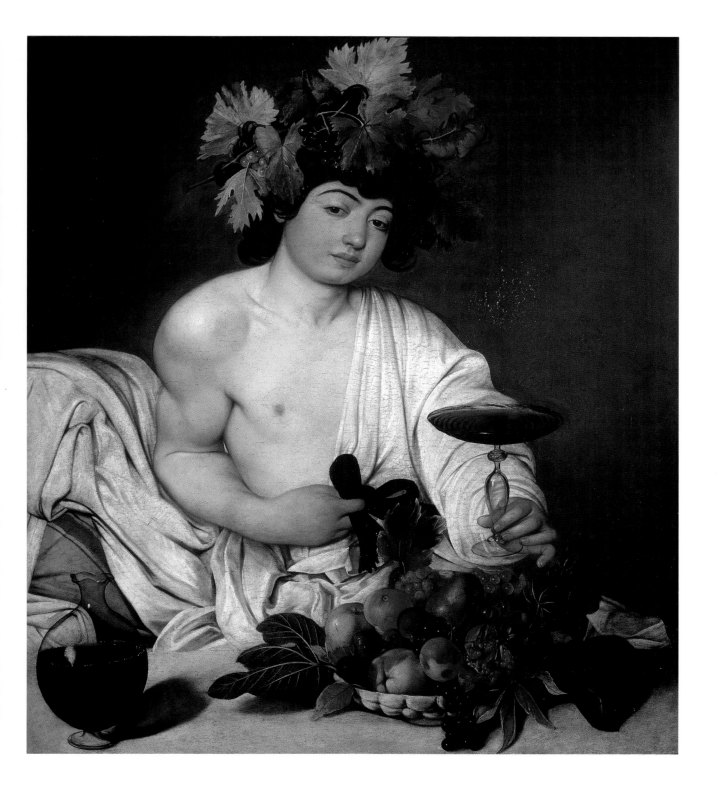

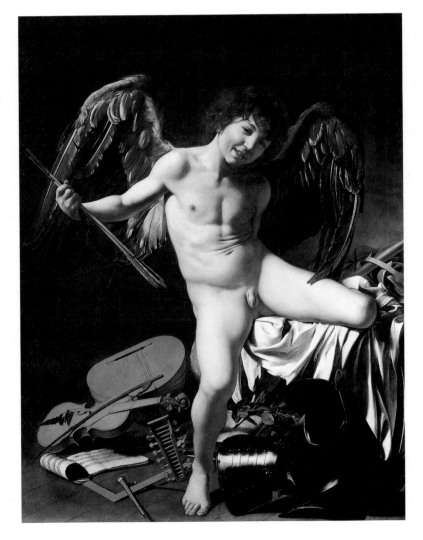

5.6 CARAVAGGIO,
Love Conquers All,
c. 1602.
Oil on canvas,
5 ft x 3 ft 7¼ in
(1.56 x 1.13 m).
Gemäldegalerie, Staatliche
Museen, Berlin.

In the last of his
Eclogues, Virgil wrote
Omnia vincit amor – love
conquers all. This pastoral
convention of the power
of love is rarely demon-
strated in such aggressive
terms. It certainly moved
its owner, Giustiniani.
One of Caravaggio's
biographers, Giovanni
Baglioni, remarked: "The
wonderful color of this
painting was the cause of
the intemperate love of
Giustiniani for the works
of Caravaggio."

cedural, or even theological matter. Caravaggio's art is consistent with popularizing movements within the Church in the late sixteenth and early seventeenth century, tendencies toward making religion more accessible to the unlettered or common people. A tension can be sensed between the formality and great sophistication of the Church hierarchy and its mission to include, welcome, and encourage the simplest of believers. St. Philip Neri, whose circle may have included Caravaggio at one time, wanted Mary to be seen as a common woman, not the Queen of Heaven. Neri's popular movement was dedicated to the assistance of pilgrims and the poor. He was known on

one occasion to have yanked on the beard of a Swiss guard during official ceremonies, just to relieve the tense severity and inflexible nature of some of the Church's proceedings. He believed that sometimes it was necessary to undermine certain behaviors so as to let in fresh air, to make something new and vital again.

Caravaggio used visual rhetoric for subversive ends, to lead to truth by overthrowing stifling conformity. What makes Caravaggio disruptive and rebellious in his paintings is the way in which he plays upon one's expectations, then pulling the rug out from under the viewer. His *Love Conquers All* (FIG. 5.6), which he

painted for the sophisticated and ardent collector Vincenzo Giustiniani, confronts us with a challenging image. A sensual boy – Eros or Cupid – sporting eagle wings stands on tiptoe on one leg among various objects of learning and art; his other leg pushes back a white sheet among whose folds are a scepter and crown. His left hand perhaps supports him or toys with the end of the bow awkwardly grasped in his right hand, which holds two arrows. He coquettishly dips his head and drops his shoulder so that the feathers of one of the wings brush his leg (this is reminiscent of an earlier work by Donatello). One might expect from a painting entitled *Love Conquers All*, which is a reference to an ancient and usually Neoplatonic tradition, that the artist would present a challenging and intellectual allegory of love and worldly accomplishment. The phrase "Love Conquers All" (*omnia vincit amor*) derives ultimately from the transcendental philosophy of Plato, for whom spiritual love triumphed over human learning and statesmanship (represented by all the objects at Cupid's feet and on the table behind him). Caravaggio in a sense does show love prevailing over music, poetry, mathematics, and statesmanship, but he teases us unmercifully. The painting is almost too provocative. Cupid seems more interested in physical love than heavenly love, and the phrase *omnia vincit amor* seems to relate more to the frivolous and secular world of Ovid's *Ars Amatoria*.

Joachim von Sandrart was resident in the Palazzo Giustiniani for about six years and so had some insight into the place of this painting within the enormous collection of more than 600 works that adorned the palace. He wrote that "this piece was shown publicly in a room together with another 120 paintings by the most outstanding artists; but at my suggestion it was given a dark green silk covering, and only when all the others had been seen properly, was it finally exhibited, because it made all the other rarities seem insignificant" (Cited in Hibbard, p. 378). It may indeed have overwhelmed its neighbors, but one can also surmise that the curtain was used to protect the impressionable or virtuous viewer of the Marchese's collection. This painting does not just address the viewer – it collars him. According to the doctrine of decorum, which was an important element in the academic tradition of art, one should not present anything undignified, unseemly, or prurient. "Community standards" were those of the noble class, not of the street. But the noble and obviously sophisticated Vinzenzo Giustiniani, who thought this one of the finest works in his collection, appreciated the unidealized naturalism of the scene, and, one must assume, approved of Caravaggio's parody of a figure by the artist's namesake, Michelangelo (FIG. 5.7).

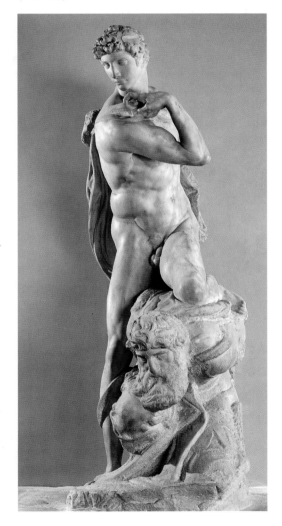

5.7 Michelangelo, *Victory*, c. 1527–30. Marble, height 8 ft 7½ in (2.63 m). Palazzo della Signoria, Florence.

Meant for a niche in the unfinished tomb of Julius II, the Victory is one of Michelangelo's typically convoluted statues, arranged in a spiral that was called a *figura serpentinata* – a serpentine figure. These unique poses fascinated both contemporary and later artists, including Caravaggio.

Born near the end of the sixteenth century, Artemisia Gentileschi (c. 1593–1652/3) grew up in the Roman art world during the heady days when Caravaggio's style was popular. Her *Judith Slaying Holofernes* (FIG. 5.8) is close to Caravaggio's painting of the same subject (FIG. 5.9). Gender and violence come together here in a provocative and terrifying manner. A common reading of the painting identifies Judith with Artemisia herself, who was the victim of repeated rapes by her father's assistant Agostino Tassi. The transcripts for the ensuing trial survive, and reveal as much about the dreadful circumstances of women as victims in an early seventeenth-century papal court as they do about the actual event.

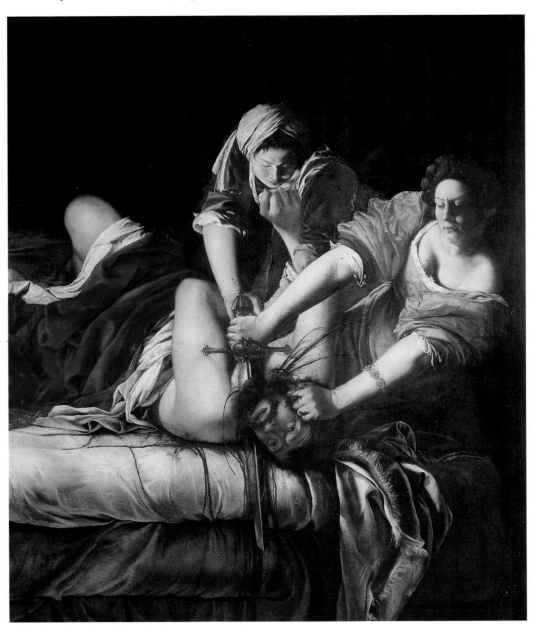

5.8 ARTEMISIA GENTILESCHI, *Judith Slaying Holofernes*, c. 1620. Oil on canvas, 6 ft 6¼ in x 5 ft 4¼ in (1.99 x 1.63 m). Uffizi, Florence.

The story of Judith and Holofernes comes from the Apocryphal Book of Judith. There was much debate in the sixteenth century about the status of the Apocryphal texts in the Bible. Most Protestant communities banned all of the Jewish and Christian apocrypha, while the Council of Trent reaffirmed the sacred status of these texts. Part of the popularity of the story of Judith, then, arose not just from how well told and exciting the story is, but also from the political desire of Catholics to assert the importance of those books recently approved by the Roman Church.

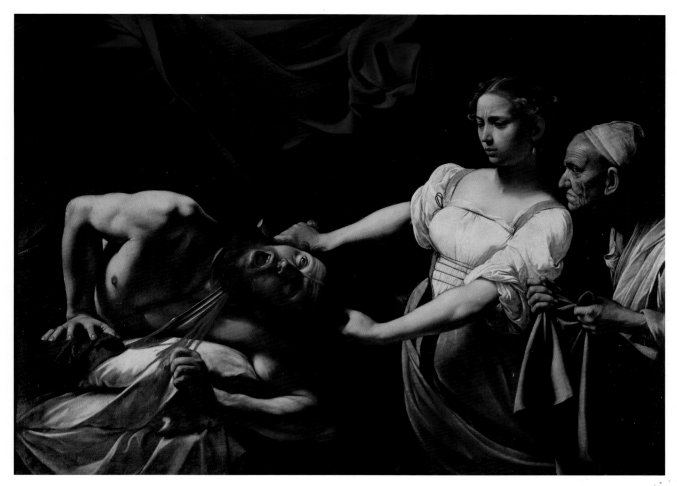

5.9 CARAVAGGIO, *Judith Slaying Holofernes*, 1598–9. Oil on canvas, 4 ft 8¾ in x 6 ft 4¾ in (1.44 x 1.95 m). Galleria Nazionale d'Arte Antica, Palazzo Barberini, Rome.

The subject matter of the painting is biblical. Judith, a beautiful widow, came to the aid of the people of Bethulia, a city described in the Book of Judith (in the Apocrypha) as being in Samaria (roughly corresponding to the West Bank of Israel today). Holofernes, an Assyrian general, was laying siege to Bethulia; Judith came to him and offered to betray her Jewish countrymen by telling him of the best way into the town. The general anticipated his victory by inviting Judith to his table, and afterward to his bed. But she so encouraged him in drink that upon returning to his tent he was helpless against her attack. She cut off his head and ran with it to Bethulia. Upon discovering the leader murdered, the Assyrians broke camp and fled. In this way, Judith saved Judea and Samaria.

The tenebrism in both paintings creates a gloomy and threatening space for the violence. Figures of strength and solidity emerge from the shadow, carrying out the heroic but grim act with determination. Gentileschi's Holofernes is projected forward, toward the viewer, while Caravaggio's is seen more traditionally, across the picture plane. Where Caravaggio's Judith saws, Gentileschi's pulls and severs; where Caravaggio's Judith is more detached and seems slightly repulsed by her action, Gentileschi's Judith assaults her enemy with great power, and concentrates as her strong arms complete the bloody task. Gentileschi's painting is more compact and focused, with Judith and her maidservant pressing down on the powerful Holofernes. This is not art for the faint-hearted. Despite the differ-

Violence & Gender in the Baroque

IN THE LATE EIGHTEENTH century, travelers to Italy were often struck by Baroque images of horror, rape, and violence. British tourists especially were disturbed by paintings of martyrdoms (see FIGS. 4.19 & 5.1), beheadings (see FIGS. 5.8 & 5.9), and crucifixions. The British satirist Tobias Smollett noted a typical sense of unease:

> What pity it is, that the labours of painting should have been so much employed on the shocking subjects of the martyrology. Besides numberless pictures of the flagellation, crucifixion, and descent from the cross, we have Judith with the head of Holofernes, Herodias with the head of John the Baptist, Jael assassinating Sisera in his sleep, Peter writhing on the cross, Stephen battered with stones, Sebastian struck full of arrows, Laurence frying upon the coals, Bartholomew flaed [*sic*] alive, and a hundred other pictures equally frightful, which can only

serve to fill the mind with gloomy ideas, and encourage a spirit of religious fanaticism, which has always been attended with mischievous consequences to the community where it reigned. (p. 257)

Like many an Anglican foreigner in Rome, Smollett regarded Catholic culture with a certain distaste, and attributed the violence that he saw to misguided attempts by the Church to "encourage a spirit of religious fanaticism." The importance of martyrdom stems from the original meaning of the term *martus*, which means "witness." Early Christians who had "witnessed" Christ as savior and who refused to deny their experience in the face of strong disapproval by the pagan authorities were often put to death. Such images were powerful messages to Catholics in the Counter-Reformation period not to turn away from the true Church, but to bear witness to their faith. It should also be remembered, however, that there was a taste for the violent in the early seventeenth century extending beyond the dictates of Rome. The *kult des grässlichen* (cult of the horrible) was popular in the German-speaking countries during the Thirty Years' War and permeated much of Europe, especially in the first half of the seventeenth century.

This taste for violence encompassed rape, one of the more popular legendary and allegorical themes of the Baroque (see FIG. 5.21). Rape had numerous connotations for a seventeenth-century audience. It could be the justifiable abduction of another's "property" so as to secure the future of a people (for example Cortona's *Rape of the Sabine Women*; see FIG. 5.13), or it might be understood as a Neoplatonic allegory of the soul's ascent

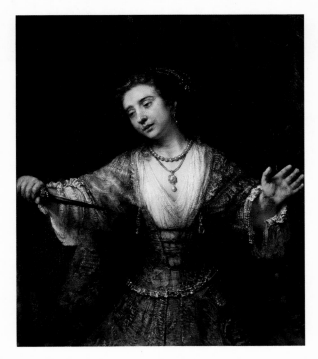

5.10 REMBRANDT,
Lucretia, 1664.
Oil on canvas,
3 ft 11¾ in x 3 ft 3¾ in
(1.2 x 1.01 m).
National Gallery of Art,
Washington D.C.

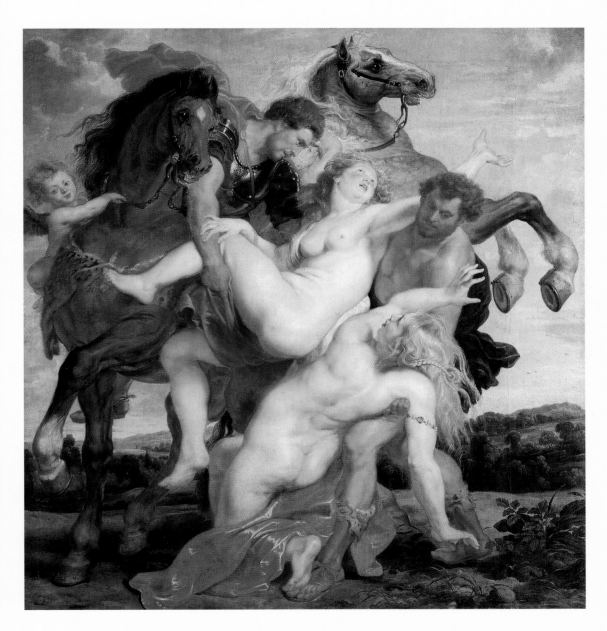

5.11 PETER PAUL RUBENS,
*Rape of the Daughters of
Leucippus*, 1615–18.
Oil on canvas,
7 ft 4¼ in x 6 ft 11 in
(2.24 x 2.11 m).
Alte Pinakothek, Munich.

In the original myth, Hilaera

and Phobe, the Leucippidae
(daughters of Leucippus), had
first been betrothed to anoth-
er set of twins, but married
Castor and Pollux instead.
One legend has it that they
were actually the daughters of
Zeus, having Leucippus as
their adoptive, earthly father.

to the true, the good, and the beautiful. And, as we
shall shortly see, rape had a political dimension as a sign
of princely absolutism. Some painters, such as
Rembrandt and Gentileschi, depicted such scenes in
personal, rather than allegorical or political, terms, con-
centrating on individual reaction and suffering.
Rembrandt's *Lucretia* of 1664 (FIG. 5.10) isolates the
virtuous heroine in a frontal, focused light against a

murky, empty background; the painter lays bare her throat and chest as she unsheathes her knife. Shamed by her own rape, she is about to kill herself; her suicide becomes the masochistic re-enactment of Sextus' sadistic penetration. The rape is shown as integrally connected to the suicide, because Lucretia and Sextus are now different manifestations of the same act; as he possessed her in the rape, she now is "possessed" by him as if by the devil. At the same time, she seems to retain a sense of herself, although it is a fading and dying awareness. She turns from us – her earring swings off to the side, giving evidence of her evasion – and holds up her hand, as if to forestall our intervention and sympathy. This is an astonishingly empathetic rendering of the rape story, one whose compassion touches us.

The art historian Margaret Carroll reads Peter Paul Rubens' *Rape of the Daughters of Leucippus* (FIG. 5.11) as a political allegory in which two of the seventeenth century's superpowers (France and Spain) seal a pact so as to ensure lasting peace (Carroll, pp. 139–59). In her interpretation Castor and Pollux represent Louis XIII of France and Philip IV of Spain, who married one another's sisters, represented in the painting by the daughters of Leucippus. The purpose of these unions was to create a bond between two mighty nations who had a history of conflict. How such an extraordinary painting of writhing figures, sensual glances, and rear-ing horses can be a political allegory requires some explanation. There existed in the sixteenth and seventeenth centuries a tradition of absolutism (see pp. 57–67), a form of government in which princes, kings, or rulers, served by great national armies, wielded nearly unrestricted power. When a ruler sought to assert his authority over another, he often thought of his struggle in gendered terms. The overcoming of difficulties by force was seen as an act of *virtù*, or virtuousness. But the political concept of *virtù* was decidedly masculine (the Latin root *vir* means male), so that a virtuous act was really a demonstration of virility. Conquering an enemy corresponded to conquering a woman. As Ovid, the author of the tale of the rape of the daughters of Leucippus, wrote in his *Art of Love*, "you may use force; women like you to use it."

In myth no beings were more powerful than the youthful twins Castor and Pollux, the offspring of Zeus and Leda. Here they display the daughters of Leucippus for the delight of the viewer, with no apparent intention of gathering them into their arms and hoisting them on to the horses. They are presenting to us their prizes, their guarantors of peace between nations. The women become important elements of exchange in a political act initiated by men; the potential violence between France and Spain is redirected toward women.

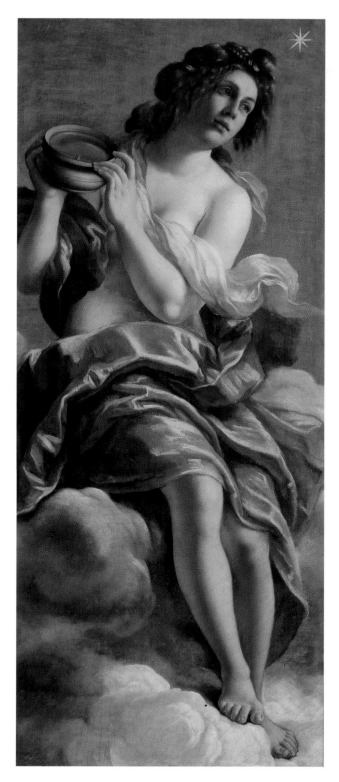

ent ways of treating the composition and of characterizing the heroine, the main elements of the two paintings have the same rhetorical function: to create a dark and disturbing setting for a violent and horrid act.

BAROQUE AS SPECTACLE

Caravaggio's rebellious and often repugnant style soon lost its hold on the Roman art world, but the need for a visual rhetoric that reached a broad audience and that told its story in a potent and thrilling manner continued. Darkness gave way to light, and compositions became clearer. Gentileschi too showed that she could paint in a different style (FIG. 5.12).

Pietro da Cortona's *Rape of the Sabine Women* (FIG. 5.13) is a huge painting that exemplifies the highest of the rhetorical forms, known in oratory as the epideictic, the kind of ornamented speech intended for public events. Artists often referred to this as the *maniera magnifica* – the grand manner. Cortona himself, in a debate held in the Roman Academy of St. Luke, likened his approach to composition, the rendering of figures, and iconography to that of the epic poem, in which the story itself is not complicated, but the details and the episodes comment on and enrich the narrative. This particular narrative concerns the story of the abduction of the Sabine women by the early Romans. The earliest inhabitants of Rome, so the story goes, invited a tribe of Sabines from the nearby hills for a celebration. At a signal from Romulus, each Roman grabbed a woman. The Sabine men who were present failed in their attempt to wrest back their daughters, and left in defeat. This story must have appealed to deep-seated desires of possession and domination among the Roman men even of the seventeenth

5.12 ARTEMISIA GENTILESCHI, *Allegory of Inclination*, 1615–16. Oil on canvas, 59¾ x 24 in (152 x 61 cm). Casa Buonarroti, Florence.

This bright, well-lit allegorical figure is in a style far different from Gentileschi's contemporary tenebrist style; it became the preferred style of her mature period.

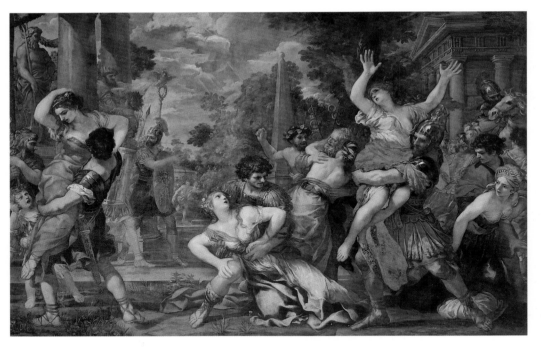

5.13 Pietro da Cortona,
Rape of the Sabine Women,
1631.
Oil on canvas,
9 ft 1 in x 13 ft 10½ in
(2.77 x 4.23 m).
Pinacoteca Capitolina,
Rome.

century, but it also had a moral significance. Such acts were justified because Rome was destined to become a great republic and then empire.

Cortona renders the scene in the heroic mode; it is well organized, brightly lit, and populated by handsome and powerful soldiers carrying off the voluptuous, unmarried Sabine women. In the middle distance between two columns of a temple gestures Romulus, the founder of Rome. By placing him between the columns of a temple, Cortona underscores Romulus' nobility and associates him with a traditional image of the wise Solomon, son of David, king of the ancient Hebrews, and builder of the first Hebrew temple at Jerusalem. The action is confined on either side to a space between Romulus' temple of Neptune (note the statue of a figure holding a trident), and another on the viewer's right; the background is closed off by an obelisk, trees, and a smaller, round temple. This is an ideal, imagined, generically classical Rome. Cortona choreographs the melée with diagonal patterns and groupings of men and women in a powerful but clearly rhythmic dance. As we know from the discussion in the Academy of St. Luke, this ordering of diverse and highly detailed images and events was not meant to be studied by the viewer in all of its intricacies, but was thought to be a spectacle that would overwhelm and please an audience with its general effect. The debaters described the general effect as one of grandeur, harmony, and vivacity, which would satisfy the spectator's desire for marvel and surprise. This is an appeal to the emotions, not the intellect.

Gianlorenzo Bernini also demands the spectator's attention in his *Ecstasy of St. Teresa* (FIG. 5.14). One of the concepts used by Bernini here is the visionary (see pp. 21–2). The sculptor manipulates everything within the Cornaro Chapel to convince the spectator, at least on some level, that what he or she is seeing is not normal but mystical vision.

St. Teresa was a sixteenth-century Spanish nun who had her difficulties with Church authorities but whose writing drew a lot of attention and whose reforms and religious devotion led eventually, in 1621, to her being made a saint. Teresa wrote in a colloquial and unadorned Spanish, hoping to attract the literate but nonetheless common reader. With its embellishments and glittering effects, Bernini's visual rhetoric has a strong appeal to the common

5.14 (*opposite*)
Gianlorenzo Bernini,
Cornaro Chapel, Santa
Maria della Vittoria,
Rome, 1645–52.

Bernini himself described
this as "the most beautiful
work ever to come from
my hand." To emphasize
the mystical drama of the
scene, Bernini ensured
the scene was bathed in
light entering through a
window hidden behind
the triangular pediment
above the sculpture. The
interplay of architecture
with painting or sculpture
for dramatic purpose was
a typical feature of
Baroque art.

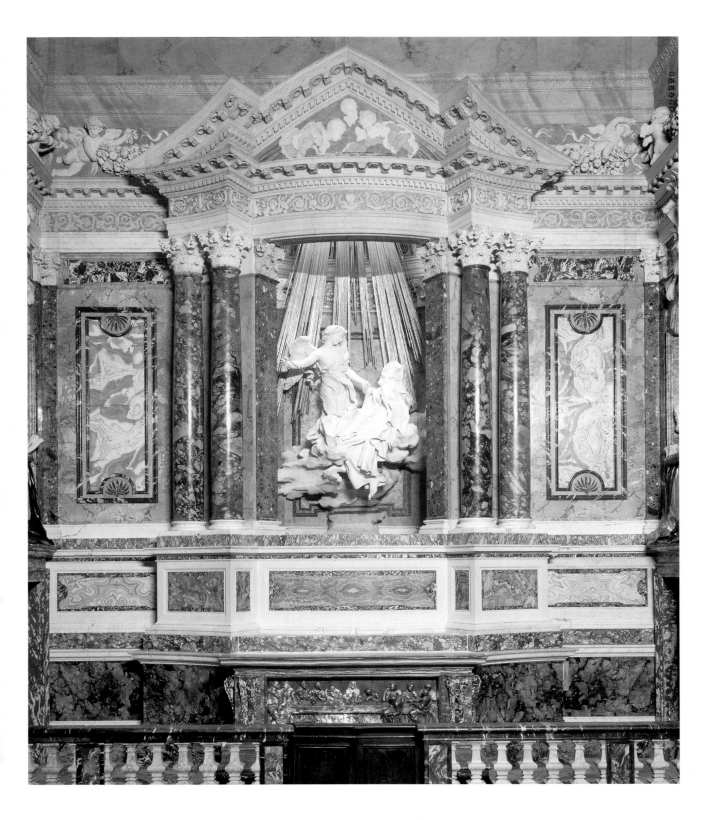

viewer as well. Bernini read Teresa's description of mystical transport and used her words as the "text" of his chapel. Among the many and varied experiences of mystical ascent written about by Teresa is her transverberation, the repeated thrusts of a divine arrow into her chest. She writes about the experience as follows: "the pain was so great that I screamed aloud; but simultaneously I felt such infinite sweetness that I wished the pain to last eternally. It was not bodily but psychical pain, although it affected to a certain extent also the body. It was the sweetest caressing of the soul by God" (cited in Wittkower, p. 25). Teresa throbs on her cloud, eyes turned upward and under her lids. The angel's sweet smile anticipates another blow. Bernini portrays rapture as orgasm.

Everything leads one's eye to the dramatic moment (see FIG. 1.5). The light (which comes in through a hidden window above and behind the group) summons our attention to the angel and the nun. The tabernacle seems to swell outward, as if responding to the Baroque sense of the uncontainable. The patterns in the exquisite marbles on the walls and columns, flickering like small bits of fire, force the spectator to return his or her gaze to the central image. Members of the Cornaro family, who paid Bernini for the chapel, have been sculpted sitting in pews, ranged on both sides, that look like opera boxes. Strangely enough, not one of them has an angle of sight to the actual transverberation. It seems that this writhing image of levitation, which both assaults and caresses our eyes, is reserved for the real spectator, the one standing in the nave of the church. The ensemble is intended to encourage the worshipper in his or her own search for meaning and ascent.

The rhetoric of Baroque spectacle exhorts, urges, and appeals to the spectator to have confidence in and to feel protected by the Church. Bernini's *Teresa* addresses the individual worshipper, the one who hopes for a glimpse of the divine; Alessandro Algardi (1595–1654) uses a very different strategy to inspire a similar sense of confidence. His *Encounter of St. Leo the Great and Attila* (FIG. 5.15) reminds the congregation

and visitors to the mother church of Roman Catholicism of a significant moment in history when a pope with divine assistance defeated one of the most horrifying marauders of all time, Attila the Hun. This great warrior, known as the "Scourge of God," had made many incursions into Italy, and was threatening Rome itself. According to Church histories, in 452 Leo the Great proceeded north from Rome, meeting Attila outside Mantua. Attila was so impressed by His Holiness's majesty that he abandoned his campaign entirely and left Italy. (Other explanations suggest that widespread famine and an outbreak of the plague kept Attila from crossing the Apennine Mountains and descending on Rome.)

Algardi was always in Bernini's shadow, although he ran a shop of considerable size and enjoyed the patronage of the Baroque popes nearly to the same degree as Bernini. Especially in the mid-1640s, when Bernini was out of favor for a few years, owing to the complexities of papal politics, Algardi's star was rising. He had come to Rome from Bologna, where he inherited something of the Bolognese classical manner from his teacher, the now very old Lodovico Carracci. In fact, Algardi never extended the possibilities of the medium nor excited the senses of the spectator as had Bernini.

Algardi's relief, more than 30 feet tall and about 18 feet wide, is bigger than anything else the sculptor did. Under the branch of a tree, Leo makes a pushing gesture with his right hand while pointing upward with his left at Sts. Peter and Paul, swords at the ready. The bearded Attila, with tense and knotted tendons in his neck, turns to leave Italy while yet transfixed by the miraculous vision in the sky. The bunched and lively drapery, deep pools of shadow, excited emotions, and coherent if crowded composition are the Baroque elements of high drama.

For years there had been plans to put a painting here of the same subject, but the microclimate of St. Peter's, with its high humidity and condensation, is not friendly to canvases or even mosaics. So the pope, Innocent X (who general-

5.15 Alessandro Algardi, *The Encounter of St. Leo the Great and Attila*, 1646–53. Marble, height 28 ft 2 in (8.58 m). St. Peter's, Rome.

ly refused to employ anyone associated with his predecessor's reign), chose a sculptural relief. The somewhat diffuse lighting in this part of the basilica (on the north side, not far from the high altar), emphasizes the dullness and grayness of the stone, giving it even more of a sense of ponderousness and ominous physical presence. A painting here could not have the impact of Algardi's relief, which emphasizes both the comforting presence of the Church – only the pope could overawe Attila the Hun – and suggests the hope, perhaps, that the presence of Baroque popes in European imperial politics would once again be equal to that of St. Leo the Great.

THE BAROCCHETTO: THE "LITTLE BAROQUE" OF THE EIGHTEENTH CENTURY

No more than forty years after Bernini's death in 1680, the idea of Baroque spectacle had nearly vanished from Rome. It is not that there were fundamental changes in the visual arts: painting, sculpture, and architecture continued to fulfill their accustomed cultural roles. But there is a new, softer style evident, a form of rhetoric based upon tranquillity and reserve. This art spoke to a calm and perhaps accepting public, one that seems to have had less of a need for the declamatory and stormy Baroque.

For centuries the Church in France had asserted a degree of independence from the pope in Rome, arguing, for instance, that ecumenical councils were the supreme authority to which the pope must submit. The papacy answered with a policy called ultramontism (literally, "beyond the mountains"), which contended that not only was the pope supreme in all ecclesiastical matters, but also he had the right to interfere in the internal operations of the French government. With the rise of absolute monarchy in the seventeenth century, however, Gallicanism (the French position) prospered. Louis XIV denied the Church any role in temporal affairs and insisted upon his right to appoint French bishops (a privilege actually ceded to the king by the pope in the early sixteenth century). It was the political arrogance (as the papacy saw it) of the Four Gallican Articles of 1682 that led Pope Innocent XI to denounce Gallicanism. The effect of this action was to isolate the papacy even further from the major political struggles of the age. When the War of Spanish Succession (which was about the balance of power in Europe) came to a close in the second decade of the eighteenth century, the papacy was not consulted.

As Rome played a smaller role on the international political stage, she focused instead on past glories. In times of political instability and economic downturn, cultures often find solace and inspiration in heritage, some former golden age. In Rome there was a strong return to tradition and a measured celebration of the city's historical legacy. The present gave way somewhat to an expanding past, one that appeared to envelop all times. The appropriate style chosen to express this cultural attitude was one that gave pleasure not through wonder and surprise but through refinement, skill, and smooth surfaces.

The Italian word *barocchetto* means nothing more than "little Baroque," a style that deflates the expansive tendencies of Baroque spectacle. The word is rather vague and gives no indication of the arguments lying behind it. There was a fairly strong reaction against the alleged excesses of Bernini and Borromini, Cortona and Gaulli. Indeed, the tastemakers of the early to mid-eighteenth century felt that there was something verging on the unhealthy and inebriated about the Baroque style. They urged a return to "taste," "soundness," and "appropriateness." These are code words in a far-reaching discussion with political overtones, a debate about the nature of Italian culture, literature, and the arts. A few examples will demonstrate how the visual arts were affected by this so-called returning to a culture's "true nature."

Filippo della Valle came to Rome from his native Florence in 1725 at the beginning of a rising tide of papal commissions for painters, sculptors, and architects. He completed his *Annunciation* (FIG. 5.16) in the years of his full maturity, when he was the leader of the Academy of St. Luke and arguably the most important artist in Rome. His Mary is so demure and self-effacing in her response to the angel's announcement of the Incarnation that she puts her hand to her breast and averts her eyes downward. The drapery patterns are altogether more flattened than in Algardi's relief, and the small-scale detail charms the viewer. The ***putti*** (little angels) who lounge against her basket of sewing seem almost too cute and insouciant to be genuine divine messengers. The overall effect is luxuriant and impressive, which is certainly part of the Roman tradition; at the same time it is sweet, winsome, even adorable. The eighteenth century is the century of the child, when a sentimental approach

5.16 (*opposite*)
FILIPPO DELLA VALLE, *Annunciation*, 1750. Marble, height 30 ft 6 in (9.3 m). St. Ignazio, Rome.

Della Valle's style confers a great deal of attention on small details, such as the straw basket in the lower foreground. This enormous altarpiece, over 30 ft (9 m) tall, is meant to be seen from a considerable distance, beyond the altar rails and toward the center of the Church of St. Ignazio. The sculptor must have understood that those lovingly rendered details would be lost in the murky light of this vast church. No matter: here the quality of sculpture is an end in itself.

5.17 GIOVANNI
BATTISTA TIEPOLO,
The Annunciation,
1765–70.
Oil on canvas, 22¾ x 15¾
in (58 x 40 cm).
Duchess of Villahermosa,
Pedrola, Spain.

Although best known for
his ceiling paintings popu-
lated with a multitude of
empyrean creatures, and
painted with rhetorical
splendor, Tiepolo had his
quieter moments, as repre-
sented by his *Annunciation*.

to childhood first appears in literature. Through
its ability to charm us, this *barocchetto* style cre-
ates a self-effacing, natural appearance. With
enough small children present, even something
as remarkable as a gathering of the Archangel
Gabriel, God the Father, and a rather large dove
as the Holy Spirit, appears to be reasonably cus-
tomary and not so very startling.

Giovanni Battista Tiepolo, della Valle's almost
exact contemporary, spent most of his professional
life in Venice, with trips to southern Germany and
Spain. Although he was trained and came to matu-
rity in a tradition that differed in many respects
from della Valle's Florentine and Roman environ-
ments, his style shares some of that sense of relax-
ation and quiet familiarity. His *Rinaldo and
Armida in Her Garden* (see FIG. 1.22) has already
been presented as an instance of easefulness or
otium, that mood in which intimacy is invited
because no struggle or anxiety is evident. Tiepolo's
Annunciation (FIG. 5.17) was painted in the last
years of his life, when with his son Giandomenico
he was working in Spain. The setting chosen by
Tiepolo is a comfortable but simple Spanish house,
with Mary standing in an elegant and somewhat
aloof version of **contrapposto** (twisted body pose).
In adoration Gabriel flattens himself on the floor.
Heads of *putti*, borne on wings, waft through the
window behind the dove of the Holy Spirit, while
golden clouds, like so much smoke from a brush
fire, curl in and around the figure of Mary. Despite
the awkward inconsistency of ceiling beams with
the floor tiles (either the artist is suggesting anoth-
er and holier realm where normal rules of perspec-
tive no longer apply, or some part of this has been
repainted), we are welcomed to the scene: it is a
very pleasant privilege to watch an extraordinary
but homely event. This is one way in which the art
of the *barocchetto* puts us at ease.

The Baroque in Flanders

When the Southern Netherlands declared their
independence from Austria in 1798 they adopt-
ed the traditional name Belgium, after the Gallic
tribe of the Belgae. Before that time, this "Low
Country" south of the Dutch provinces was gen-
erally known as Flanders, after one of its
provinces. In the sixteenth century all of the
Netherlands revolted against the Spanish govern-
ment, splitting eventually into two leagues, one

Calvinist (the Northern Netherlands, known as the Union of Utrecht) and one Roman Catholic (the Southern Netherlands – Flanders – known as the Union of Arras). The Union of Utrecht repudiated Spanish claims in 1581 and eventually became an independent republic. Flanders, however, capitulated to the Spanish forces and remained loyal to the Spanish crown and the Habsburg dynasty.

RUBENS

Historians credit Peter Paul Rubens with bringing the Baroque style north. Because of his father's Protestantism, he was born as an exile in Germany. When his father died in 1588 the young Peter and his mother returned to Antwerp, and he converted to Catholicism almost immediately. The political struggles of the times may have dislocated the Rubens family, but Peter gave every sign of being the resilient child who could adapt and adjust to his circumstances. He entered a Latin school where he studied ancient literature and rhetoric. Afterward, as a page to a local noble woman, he learned something of courtly society, a social milieu that was to be his natural environment (but one against which he also chafed) through most of his life. The young Rubens trained with the best known mannerist painters active in Antwerp at the end of the sixteenth century, including Otto van Veen (1556–1629) (FIG. 5.18). His eight years in Italy (1600–1608), an artistic pilgrimage important to an ambitious young artist at the turn of the seventeenth centu-

5.18 OTTO VAN VEEN, *Mystic Marriage of St. Catherine*, 1589. Oil on wood, 6 ft x 4 ft 9½ in (1.83 x 1.46 m). Musée d'Art Ancien, Brussels.

Otto van Veen was one of the most prominent painters active in Antwerp in the 1590s. He had studied in Italy in the later 1570s, where he learned an academic version of later Mannerism. From him Rubens learned the rudiments of composition, figure drawing, the preparation of paints, canvases, and panels, as well as getting a grounding in the *studia humanitas*, the humanities. Styling himself with a Latin form of his name, Voenius would have regarded himself as a learned painter.

ry, completed his training. His altarpiece of the *Raising of the Cross* (see FIG. 4.18) established his reputation in Flanders; it wasn't long before he was internationally famous.

Peter Paul Rubens was the supreme artist of Baroque spectacle. His knowledge of languages – Latin, Dutch, French, Italian – his classical learning, his familiarity with the art of German, Flemish, and especially Italian masters, his remarkable skills as a courtier and diplomat, his inventiveness with compositions, and his facility with colors and brushwork made him the epitome of the Baroque artist, suave, rich, famous, with a keen eye and prodigious energy.

In the Marie de' Medici cycle (see FIG. 6.5), Rubens showed his skill in political allegory. He also had a deep understanding of the pastoral, a literary genre that was perfect for painting (see pp. 33–4). The pastoral tradition is about shepherds and shepherdesses in love, living in peace and harmony in lush but rustic settings. Rubens' updated version of an ancient tradition can be seen in his *Garden of Love* (FIG. 5.19), done when he was in his early fifties, having just married for the second time (FIG. 5.20). In his garden of love (see pp. 34–5) human desire is acted out in images that are the stuff of dreams. Led by a pair of doves, which are sacred to Venus, several cupids tumble into the pictorial space from the upper left. In his left hand, the leading cupid holds a yoke, symbol of marriage. Another hefty *putto* pushes a woman into the garden. Her companion, with a beseeching and inviting expression, looks into her eyes and urges her forward. What an ensemble awaits her! An allegorical sequence may be acted out by the

5.19 PETER PAUL RUBENS, *Garden of Love*, 1630–32. Oil on canvas, 6 ft 6 in x 9 ft 3½ in (1.98 x 2.83 m). Museo del Prado, Madrid.

Rubens personalizes his allegory of love not just by including his wife (see FIG. 5.20), but by placing the scene next to his own country house, Het Steen. The porch to the left with large rings circling the columns is ornamented in the Mannerist style, and is reminiscent of his villa.

5.20 Detail of 5.19: Helena Fourment, from Rubens, *Garden of Love*, 1630–32.

three seated women, who represent earthly love, with celestial love represented by the woman behind, whose eyes turn toward Heaven. Another of Venus' assistants carries a torch into the dark grotto, undoubtedly a symbol of sexuality, where a statue of Venus herself spouts water from her breasts. Others seem intent upon, perhaps even astonished by, something that lies deeper in the cave.

In this painting, Rubens employs the conventions of the idyllic or pastoral tradition of love poetry. The garden is an apt setting for love, for it is neither the field nor the town – it is an intermediate zone, one with architecture but no set boundaries. It is a borderline, on the threshold between the imaginary and the real. Here is an invitation to love, one that applies to the beholder as much as to the tentative young woman on the left.

Rubens' *The Rape of Lucretia* (FIG. 5.21) shows the violent rhetoric of "love," that of passion, dominance, and betrayal. The story of Lucretia and Sextus recounts events that led to the banishment from Rome of the tyrant Tarquin and his family. Sextus, son of Tarquin, was so taken with the beauty of Lucretia, wife of a Roman nobleman, that he pleaded with her and offered her bribes to sleep with him, and finally threatened her with shame. He said that should she refuse him, he would slit her throat and that of a slave, and lay the two together so as give the appearance that they had been caught in the act of love and punished forthwith. Rather than experience the humiliation to herself and her family, she relented, and afterward wrote a

5.21 PETER PAUL RUBENS, *The Rape of Lucretia*, c. 1610. Oil on canvas, 6 ft 1½ in x 8 ft ½ in (1.87 x 2.14 m). Formerly Potsdam-Sanssouci, Bildergalerie (now lost).

letter to her husband explaining what had happened. She then killed herself.

Lucretia, the typical Rubensian nude, powerful yet milky white, lies in the spotlight, attempting to cover herself. Sextus hides his dagger behind his back, but by his gesture and expression there can be no doubt of his threats and his intention. A cupid, who has urged on Sextus, may now express some concern at the unintended consequences of his action. Man's passionate brutality manifests itself as the old hag Tisiphone, a Fury, a goddess of blind vengeance who seems delighted by Sextus' behavior. Because this painting was done in all likelihood soon after his return from Italy (and after a diplomatic mission to Madrid, where he saw Titian's version of the same theme), Rubens composed the scene in the tradition of Caravaggio, with threatening figures emerging from evil darkness. The imagery impinges on the space of the viewer, alarming us with its physicality and danger.

Rubens' rhetoric is that of Italy and Baroque spectacle. His figures are large, his compositions active and crowded, and their atmosphere redolent of grandeur, love, and fear. Red, yellow and blue, known to artists as the major triad, were chosen more often than any other combination by painters of the Renaissance and Baroque, and Rubens follows tradition in his choices. But his colors have great intensity – the reddest reds, the bluest blues, the yellowest yellows. He always sought maximum visual impact. The sensuous appeal of his nudes is emphasized by skin tones that are translucent, showing the veinous bluish hues beneath the creamy skin. His paintings are often panegyric, that is, in praise of their subject and fit for public viewing. At other times they are cautionary tales, warning us of the effects of war and violence. Yet even when the impact is disturbing, as in *The Rape of Lucretia*, there is a quality to the execution and a richness of surface that pleases the spectator. Rubens sent his paintings throughout Europe, to churches and courts, making Baroque spectacle an international style, a rhetoric of praise, blame, celebration, and pure pleasure.

VAN DYCK

Anthony van Dyck (1599–1641) was younger than Rubens by nearly a generation. He was born in Antwerp in far better circumstances than his predecessor and eventual colleague. His father, a cloth merchant, grew wealthy and lived in some splendor, and the biographer Giovanni Pietro Bellori commented that van Dyck's life was "more like a prince's than a painter's." In 1616 he began his professional career as a "disciple" of Rubens, a title that suggests that he was not really a student (he was quite accomplished even as a teenager) but a younger collaborator of the more famous Rubens, whose studio turned out paintings like a factory.

One of van Dyck's early paintings, *The Mocking of Christ* (FIG. 5.22), was owned by Rubens until his death in 1640, after which it was bought by Philip IV of Spain. The importance of reds and blues and varicolored flesh are probably things that van Dyck learned in Rubens' studio, as is the arrangement of light and shade, powerfully rendered anatomy, broad gestures, a barking dog (directly from Rubens' *Raising of the Cross*), and the display of various textures and surfaces (note especially the armor of the soldier placing the crown of thorns on Christ's head). Even though van Dyck gives us some gnarled faces and leering by-standers – typical of the immediacy of Caravaggio's street scenes – this is very much part of the grand style of large, formal, and elegant paintings, packed with figures, alive with differing expressions and emotions, based upon a traditional theme.

The Gospels of Matthew, John, and Mark tell of Christ's mocking. Mark writes that Christ was taken into Pilate's house, where the soldiers "dressed him in purple, and having plaited a crown of thorns, placed it on his head. Then they began to salute him with, 'Hail, King of the Jews!' They beat him about the head with a cane and spat upon him, and then knelt and paid mock homage to him" (Mark 15:17–19). The Gospels relate the events of Christ's life with the purpose of changing the reader, of making him or her see the divinity of Christ and the manner in which God

5.22 (*opposite*)
ANTHONY VAN DYCK,
The Mocking of Christ,
c. 1620.
Oil on canvas,
7 ft 3¾ in x 6 ft 5¼ in
(2.23 x 1.96 m).
Museo del Prado, Madrid.

works through him so as to offer salvation. In other words, this sort of scene would not have been read by van Dyck as an interesting story of a well-known heroic figure. He would have understood the inner meaning of Christ's suffering as necessary for eventual salvation, and he would have wanted his painting to convey that sense of a divinely ordained event. Baroque painting in this sense proclaims a truth, by announcing it in vivid terms. It is a decree, a public pronouncement.

Baroque Rhetoric in France: Classicism & Tenebrism

Seventeenth-century French styles in painting owe much to the contemporary Italian traditions. Nicolas Poussin spent most of his professional career in Rome, where he was friend to those intellectuals most steeped in humanist and classical learning. His paintings, likewise, are generally classical in nature. They contain less Baroque spectacle than the work of either Rubens or van Dyck, and the figures project less forcefully and gesture with less stridency than in

Carracci. Poussin never was comfortable working on the scale of Cortona, either; instead, he worked on easel-sized canvases that he sent to patrons, mostly in France. Baroque spectacle usually commands a large field and insinuates a community of viewing; that is to say, spectacle has a tendency to control both the gaze and the consciousness of all or a part of society. Poussin's art does not make such large claims.

But distinguishing Poussin from the purveyors of Baroque spectacle does not explain enough about what makes him classical. The critical term classicism was rarely used before the nineteenth century, and then it was employed in comparison to Romanticism. What generally was meant by "classical" or "classicism" was a kind of rhetoric that was old-fashioned, severe, arranged (when speaking of the visual arts) according to principles of verticality and horizontality, and epitomized (in terms of affect or mood) by simplicity and grandeur, calmness and serenity. When saying that Poussin's rhetoric has classical elements, one means that the French painter favored biblical and historical themes, composed his paintings so as to achieve balance and harmony, and sought moods of equanimity and peacefulness.

His *Finding of Moses* (FIG. 5.23) is a "cabinet picture," which means that it is not large (about

5.23 NICOLAS POUSSIN, *The Finding of Moses*, 1638.
Oil on canvas, 36½ x 47¼ in (93 x 120 cm).
Louvre, Paris.

For Poussin the city of Rome stood for the ancient world. The biblical account in Exodus tells of Moses' mother, who, fearing a proclamation from Pharaoh that all children were to be massacred, fashions a bassinet of bulrushes and places

her infant son at the edge of the Nile. Pharaoh's daughter discovers the infant, and recognizing that it is Hebrew, seeks a Hebrew nurse, who turns out to be Moses' actual mother. Turning the Nile into the Tiber is consistent with a Christian reading of the story: Moses being hidden from Pharaoh prefigures the Massacre of the Innocents under Herod's orders, when the infant Jesus was carried into the safe haven of Egypt by his parents.

5.24 Nicolas Poussin, *The Holy Family on the Steps*, 1648. Oil on canvas, 28½ x 44 in (72.4 x 111.7 cm). Cleveland Museum of Art, on deposit at the Louvre, Paris.

Classical painting often exists in a state of being rather than of becoming. The triangular arrangement of figures isolates them from their surroundings and from the beholder; the low viewpoint further separates the ensemble from us, the living. In these ways, the figures take on a sacred being, and become proper objects of devotion.

four feet wide) and was intended for viewing on the wall of a relatively small room. The painting is first recorded in the collection of the French landscape artist André Le Nôtre (1613–1700), and one can imagine that this inventor of the rational landscape at Versailles (see pp. 327–35) would have responded quite strongly to the tranquillity and precise arrangement of figures and landscape forms in Poussin's work. When visiting France in the 1660s, Gianlorenzo Bernini told his host that Poussin painted with his head, a fairly common compliment in an age that valued the intellectual accomplishments and high status of the artist. But it seems particularly apt for Poussin. His kind of visual rhetoric depends upon detail and exact placement of figures and other compositional elements. The rarefied atmosphere – the outlines of the bridge and the edges of the pyramid remain sharp – reveals such precise images that it assists the viewer in his or her act of contemplation. We can share with the artist a sense of the reality of the place and the characters. Gestures seem affected and abrupt, but that is only Poussin's way of denaturing or defamiliarizing the scene. There is a tendency

toward geometrical abstraction in his paintings, as if to refer us to an ethereal realm of quiet moments, still time, and pure geometry – the place of classicism.

His *Holy Family on the Steps* (FIG. 5.24) presents the familiar family portrait of Joseph, the Christ Child, Mary, John the Baptist, and his mother Elizabeth resting calmly and quietly on the steps of a temple. In a sense, this painting is also about the principles of centeredness, pyramidal construction, and cubic architectural forms. There is, in other words, a self-consciousness about Poussin's classicism, a tendency for the paintings to exhibit in a fairly obvious way their basic structural principles. One is not invited to read these paintings simply as straightforward narratives of well-known stories and themes; rather, one tries to come to terms with the entire notion of representation – the rhetorical, the painterly, and the literary/biblical tradition. This is not easy art, nor was it intended to be.

Simon Vouet, like nearly every other artist in the early seventeenth century, went to Rome. But even before that, this remarkably talented

5.25 SIMON VOUET, *Birth of the Virgin*, early 1620s. Oil on canvas, 7 ft 1½ in x 10 ft 9½ in (2.17 x 3.29 m). San Francesco a Ripa, Rome.

young artist had made several trips, one to London when he was fourteen to make a portrait of a noble woman, and then at the age of twenty-one he left for Constantinople, where he spent a year making portraits, including one of the Sultan Achmet I. After traveling to Venice in 1612, he reached Rome sometime in 1613, and quite naturally succumbed to the spell of Caravaggio and Carracci.

His *Birth of the Virgin* (FIG. 5.25) still resides in the dark chapel for which it was originally painted. A remarkable bulbous-shaped bronze basin, in which the infant Mary has just been washed, sits directly at the vanishing point of the perspective system. Such a strategic placement establishes the rotundity of the forms, in Anne's (Mary's mother) lap, in the swirling draperies of her women attendants, and in the way in which the draperies hang at the left and above. It is part of Baroque rhetoric, whether of spectacle, tenebrism, or classicism, to create powerful, three-dimensional forms that create a strong presence within the illusionistic space of the painting. The dense figures and crisp shapes intercept the light

coming from above and to the right (in point of fact, the painting is just below a window on an outside wall, so that the actual light of the chapel interferes with one's viewing of the painting). Deep shadows and an empty background resonate with the spectator's recent experience of Caravaggio's tenebristic paintings. At the same time, the clear patterns on the floor and the glimpse of a fireplace to the left signify a measurable and determinate space, one that is associated with the art of the High Renaissance, Raphael, and especially Annibale Carracci. Caravaggio's art makes things simultaneously vivid and incoherent; Carracci's imagery has as much intensity, if less immediacy, than Caravaggio, but he rarely subverts the viewer's expectations. Vouet's intentions, like those of Carracci, are very clear.

Vouet's art remakes and comments on both Caravaggio and Carracci. The influence of the former waned once Vouet had returned to France in 1623, yet even at the very end of his life, Vouet still did not forget Carracci. His *Assumption of the Virgin* (FIG. 5.26) bears a remarkable similarity to

5.26 Simon Vouet, *Assumption of the Virgin*, 1647.
Oil on canvas,
6 ft 5½ in x 4 ft 3¼ in
(1.97 x 1.3 m)
Musée des Beaux Arts, Reims.

Setting the stage with light coming from the left and an angled view of the tomb, Vouet shows the disciples looking in wonder at the empty tomb and gazing heavenward to Mary, as she is borne into Heaven by angels. Having shed the influence of Caravaggio, Vouet gives us Baroque spectacle by way of Bolognese classicism.

5.27 ANNIBALE CARRACCI, *Assumption of the Virgin*, c. 1590. Oil on canvas, 51¼ x 38¼ in (130 x 97 cm). Museo del Prado, Madrid.

Carracci's own *Assumption of the Virgin* (FIG. 5.27). As with the case of Domenichino's *Last Communion of St. Jerome* (see FIG. 5.2), the issue is not so much one of plagiarism as it is of the power of images to impress themselves upon an artist's imagination, and that anxious relationship between generations of painters. It also may be testament to the usefulness of Carracci's art (and, before that, Raphael's) – how easily it lends itself to imitation and appropriation. The clear style satisfies the needs for a declamatory art that has a broad appeal.

The Rococo in Eighteenth-Century France

The French painters of the eighteenth century were trained in ways not so very different from their seventeenth-century predecessors. They studied before live models, learned about anatomy and proportionality, practiced perspective constructions, mixed their colors as artists had for centuries, and studied a kind of art history when listening to lectures on the paintings of

Raphael and Poussin. But the social and political settings were different. Patrons and artists found interest in different stories than before (although religious painting continued to be the highest expression of an artist) and they had new notions about what constituted "good taste" (see pp. 31–2). Further, courtly societies discovered something new: love. Even if the tradition of love poetry was anything but new, the market for paintings of trysts and titillation, love and loss, music and musings was unprecedented.

It is not entirely clear why there was such a taste for stories of the loves of elegant young couples, members of the troupes of "strolling players," and shepherds and shepherdesses in the theater and in paintings, but it may have been connected with changes at court. With the death of Louis XIV in 1715, many aristocrats returned from Versailles to Paris, where they built small homes with intimate rooms, appropriate for gatherings known as salons, which could be highly literary and philosophical meetings, or on the other hand might end up as raucous and licentious debauches. Philippe, Duc d'Orléans, ruled during the childhood of Louis XV (1715–23) and was something of a tastemaker.

He moved to his own home in Paris, which became the lavish showcase for the new rococo style of interior decoration. While proving himself an able and hard-working administrator for the crown, he lived the life of the libertine, creating scandal in Paris, while at the same time encouraging, by example, others to play dangerous games of love, and, by direct encouragement, to invest heavily in (ultimately) disastrous stocks. Artists such as Watteau, Boucher, and Fragonard made their careers on the images of love and prospered from the luxury trades.

Watteau

Jean-Antoine Watteau, a French painter born in Flanders, studied with a specialist in theater scenes and scenery, Claude Gillot (1673–1722). Watteau's clients, generally members of the French upper classes and aristocracy, lived in a world of theater, dance, music, and polite conversation. In *La Gamme d'amour* (FIG. 5.28), a strolling player strums a bit of music that he is attempting to read from the book in his companion's hands. She should be singing from the same book, but seems to have paused to look at

5.28 Jean-Antoine Watteau, *La Gamme d'amour*, 1715–18. Oil on canvas, 20 x 23½ in (50.8 x 59.7 cm). National Gallery, London.

Watteau's actors behave like the singing shepherds in pastoral poetry, delicate in their feelings, poised in their attitudes, sometimes melancholy, always attentive to the nuances of the games of love, and separate from the world of great thoughts and heroic deeds.

him. What really is going on here? Nothing very explicit, but there are the rhythms of music (*La gamme d'amour* means the "[musical] scale of love"), the gestures of conversation, the leaning and swaying of bodies toward one another. The man is dressed as Mezzetino, one of the stock characters in what was known as the *commedia dell'arte* – the Italian comedy, a troupe of actors who performed plays in parks and on the streets. The stories were often mimed or given in Italian, since only the Comédie Française was permitted to perform in French. The plots were well known and endlessly repeated, centering on intrigue and buffoonery and involving stock characters. The woman in the painting is theatrically dressed, too. Something of the same kind of quiet communing, idle conversation, perhaps even affec-

tionate reassurance goes on in the background. We see actors who are not performing in their scripted roles, yet they are acting in some way. Love is certainly in the air, but in the sense that the "air" is an attitude – the poise, bearing, and comportment of the figures, and an ambiance or setting. The little grove has two openings onto a larger stretch of land, but is itself a copse or pleasance (see pp. 34–5), a place of love where the ground tilts and the lover inclines toward his beloved. Their right elbows and left knees parallel one another, underscoring their connection and affection. The little music practice is about to lead to something more interesting.

Looking at another of these paintings of mixed genre, *Fêtes vénitiennes* (FIG. 5.29) the modern spectator is once again not entirely sure

5.29 JEAN-ANTOINE WATTEAU, *Fêtes vénitiennes*, 1717–18. Oil on canvas, 22 x 18 in (55.9 x 45.7 cm). National Gallery of Scotland, Edinburgh.

The couple are about to begin their dance, at some remove from one another. The others pay no attention to them, engaged in their own private, even whispered conversations. Everything here is vignette and episode, set-piece and fragment. There is no story or narrative to pull the painting together; rather, the mood is one of slightly restless, desultory activity.

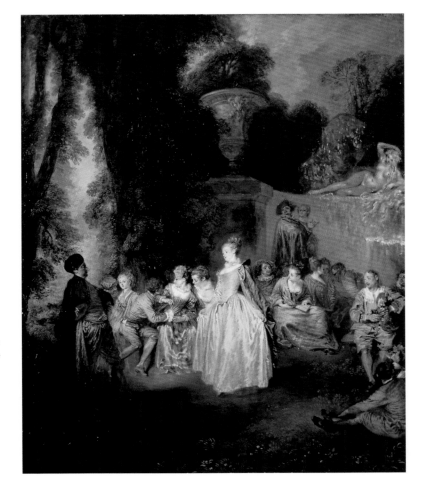

5.31 (*opposite*) JEAN-ANTOINE WATTEAU, *Reclining Woman After Titian (La Buveuse)*, Sanguine, black, and white chalks, 6¾ x 7¾ in (17 x 19.4 cm). Musée Cognacq-Jay, Paris.

5.30 (*right*)
Jean-Antoine Watteau,
Seated Young Woman,
1715–16.
Sanguine, black, and
white chalks,
10 x 6¾ in
(25.5 x 17.2 cm).
The Pierpont Morgan
Library, New York.

It is often in unposed
moments that a figure
may seem most herself, as
she idly scratches her arm
and turns her attention to
someone who has just
spoken. Watteau had a
remarkable ability to find
beauty and grace in such
unremarkable events.

of the place, theme, or even *type* of the painting. The title *Fêtes vénitiennes* (literally Venetian feasts or parties) appeared on an engraving of the painting, and is the name of a particularly popular dance (and opera) at the time. But it probably was not Watteau's title. The man playing the bagpipes may be Watteau himself, and the man striking a theatrical pose in oriental fancy dress on the left is a friend of Watteau's, Nicolas Vleughels. The woman with whom he dances may be an actress, a famous mistress of Philippe d'Orléans. Again, this is a pretend world, a landscape of the mind, carefully constructed and choreographed by Watteau.

Watteau had sheaves of drawings of individual figures, pairs, and groups. In these studies he worked out poses, the articulation of arms and legs, and the attitudes of faces and shoulders. The way a figure stands, sits, rises, turns, and gestures often relates closely to etiquette, the codified human behavior of members of the upper classes. Standing figures also often assume a dance pose. Still other drawings appear to be studies of models relaxing or acting out a scene, such as that of a bacchante (FIGS. 5.30, 5.31). Watteau put his paintings together by cutting and pasting from his

drawings (in fact, he simply copied many images from his extensive archive of sketches). The result is a curious but remarkably coherent assemblage that looks like anything but collage.

Boucher

The next generation of "painters of love" is led by François Boucher, one of whose early commissions was to make engravings after Watteau's drawings. Boucher was trained by his father, a painter and designer of lace, one of those luxury trades that were becoming significant in the eighteenth-century French economy. His beginnings may not have been grand, but he rose about as far as a painter could in his day. While his father was a member of the Academy of St. Luke, François belonged to the more prestigious Royal Academy of Painting, Sculpture, and Architecture. In 1765, at the height of his fame, he was elected Director of the Royal Academy and was appointed First Painter of the King. A man of prodigious energy, he produced by his

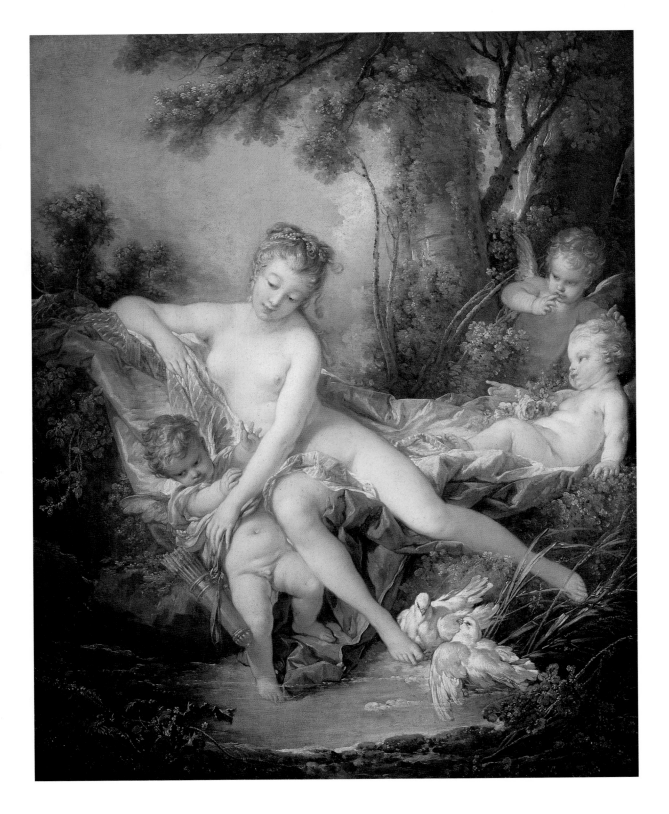

As a promoter of moral painting, the French critic Denis Diderot (see FIG. 6.11) despised Boucher. In his Salon reviews of 1765 he wrote: "I don't know what to say about this man. Degradation of taste, color, composition, character, expression, and drawing have kept pace with moral depravity And then there's such a confusion of objects piled one on top of the other, so poorly disposed, so motley, that we're dealing not so much with the pictures of a rational being as with the dreams of a madman."

own estimation as many as 10,000 drawings and 1000 paintings. He sold paintings both to patrons and on the open market. He produced designs for and directed the royal manufactory of tapestries. He designed sets for operas. He was driven by the demands of his career and the desire to make money and to live in the highest circles of French courtly society.

His *Venus Consoling Love* (FIG. 5.32) was commissioned by Louis XV's mistress, Jeanne Antoinette Poisson, the Marquise de Pompadour (see pp. 230–2), who hung it in the Château de Bellevue until 1758, when it was transferred to the Elysées Palace in Paris. Madame de Pompadour (a title given her by the King) was from that class the French call *arrivistes*, or *nouveaux riches*, born into modest circumstances, but succeeding in society through ambition and shrewd financial dealings. In 1725 her father had fled France because of his black-market activities, but she was raised by her mother and a tutor who saw to it that she had, if not a classical education, one that was based upon "taste," with an appreciation of literature and the visual arts. She was, in short, groomed for polite society and the hand of a rich husband. By the later 1740s she was one of the most powerful women in France. Together with Louis XV and her brother, the Marquis de Marigny (who, through her patronage, became the superintendent of royal buildings), she supervised projects in Paris (what came to be known as the Place de la Concorde), at Versailles (the Petit Trianon Palace), and the construction of her château at Bellevue.

Venus Consoling Love, commissioned specifically for Bellevue, would not have been seen as a narrative painting meant to improve one's moral education (in fact Boucher was criticized by the writer Denis Diderot precisely because he was not a "moral painter"). But this painting surely would have been an example of good taste, refinement, and erotic pleasure – and in that sense it was didactic. It was hung at Bellevue as decoration (probably above a doorway), and as confirmation of La Pompadour's knowledge of the current fashion for images of charming mythology and happy dalliance. The

French writer Fontanelle said that the pastoral can bring human happiness so long as it manifests "a concurrence of the two strongest passions, laziness and love." Neither the King nor his mistress were lazy, but they understood the erotic and pleasurable charge of indolence. The goddess of love, Venus, teases her son Cupid, while a couple of his assistants – those fat, little, dimpled *putti* – rest or lean in idle curiosity. Venus herself is at ease; this *otium* (see pp. 37–8) engages our deepest desire for pleasure and contentment.

Many critics have dismissed or denounced Boucher for his "frivolous" subject matter (it may be the most common adjective ascribed to him in English). But it takes a narrow and puritanical nature to miss the importance of these paintings of human dreams and wishes, joyful visual glosses to the art of love and the necessity of play. Boucher's brushwork is as abandoned as the mood of his paintings. Not that he was messy or thoughtless in his technique; he simply understood that painting can bewitch the spectator with its sheer audacity, its exuberant love of the act of fashioning paints into luxuriant forms. There is an extraordinary spontaneity, a breaking through of normal boundaries, and a transcendence in Boucher's happiest paintings – a secular counterpart to Bernini's mystical transport (Boucher much preferred Bernini to Michelangelo, making many studies after the Baroque master during his Italian trip). With their implications of deftness and deception, the zigzag arrangement of figures and isolated, utopia-like settings created the psychic counterparts to the political world of intrigue and manipulation at the court of Louis XV.

FRAGONARD

Boucher's pupil Jean-Honoré Fragonard continued painting Rococo pictures in the pastoral genre into the next generation, and faced many of the same criticisms as his mentor. By Fragonard's death in 1806, the Rococo was out of style, and to an extent has been dismissed or denigrated ever since. Fragonard was from a shop-keeping family

of no prestige or wealth, but when he moved with his parents to Paris in 1738, he worked alongside Jean-Baptiste-Siméon Chardin (1699–1779), painter of still lifes and domestic scenes (see FIGS. 6.33, 6.44). The young Jean-Honoré's talent was soon recognized by Boucher, who brought him into his studio. Fragonard won the Royal Academy's Rome prize in 1752, arrived there in 1756, and remained for five years, copying the old masters and enjoying the gardens at Tivoli. Upon his return to Paris in 1761 he found considerable success, and was soon to join the French Royal Academy.

His most important commission of the 1770s, *The Progress of Love* (FIGS. 5.33, 5.34) was also his biggest failure. The last of Louis XV's mistresses,

Marie-Jeanne Bécu, Comtesse du Barry (1743–93), was not very popular at court, nor did she have the education in art and literature or the political sense of Madame de Pompadour. Madame du Barry's intrigues created so many enemies that when Louis XV died, she was banished to a nunnery (she was eventually guillotined in 1793). But she was a liberal patroness of the arts and enjoyed, as La Pompadour had before her, decorating the estates given her by the King. For her villa at Louveciennes, she commissioned Fragonard to paint a series of large pictures depicting the loves of the shepherds. Perhaps what Fragonard presented to her was more than she bargained for. Although she left no record of her displeasure with these paintings, there must have

5.34 (*opposite*)
JEAN-HONORÉ
FRAGONARD,
*The Progress of Love:
The Lover Crowned*,
1771–3.
Oil on canvas,
10 ft 5 in x 7 ft 11¾ in
(3.17 x 2.43 m).
Frick Collection,
New York.

5.33 JEAN-HONORÉ
FRAGONARD,
*The Progress of Love:
The Meeting*, 1771–3.
Oil on canvas,
10 ft 5 in x 8 ft
(3.17 x 2.44 m).
Frick Collection,
New York.

been something unsettling about the images, something beyond the fact that Fragonard's Rococo style was going out of fashion. She rejected the works and replaced them with tamer versions of similar scenes by the painter Joseph-Marie Vien (1716–1809) (FIG. 5.35).

Madame du Barry had asked for paintings that would provide a thinly disguised narrative of the relation between Louis and her. Of course the lovers (and it is not altogether clear that the same young man and woman appear in each scene) are far younger than the King and his mistress, and are dressed in utmost finery (and in contemporary dress, unlike their counterparts in Vien), which makes them aristocratic, not real, shepherds. The riots of flowers, gushing fountains, abundant nature, and coy gestures relate this series to a genre known as the "mock heroic," a literary form that makes fun of heroic scenes. Not that game-playing is insignificant, but it is not necessarily valiant and courageous. When the young lover scales the walls of the young woman's citadel, he gazes upon her with unabashed lust. She pretends not to hear or see him, thus refusing to acknowledge his voyeurism. In fact, in none of the scenes does she actually look at him. It is as if she wishes to remain forever the object of desire and beauty, always the focus of the amorous gaze but never the fully committed participant. As with many a satirist, Fragonard presents his scenes with relish and excitement, splashing the paint across the canvas with sureness but apparent wantonness. He displays the well-used pastoral conventions of his age in all their glorious artificiality. The pastoral is a serious type of poetry, and these are serious paintings, but the actors are themselves shallow and coquettish. The woman teases, flirts, manipulates. The somewhat foolish man acts the role of the besotted lover. It is likely that Madame du Barry saw herself as the object of mockery, of a stunningly beautiful parody. The Rococo – like love – can be dangerous. It is an amusing scene to imagine these two powerful figures, both from lower-class backgrounds, at odds over the meaning and function of painting in this most exquisite setting of one of the most pleasure-loving court societies ever.

After the French Revolution, the Rococo style became identified with the "old regime," the world of the "corrupt" values of a self-indulgent and privileged class. This was a tragedy, because Rococo, especially in the art of the great pastoral painters Watteau, Boucher, and Fragonard, stands as one of the highest moments in European painting.

The Northern Netherlands

REMBRANDT: CHIAROSCURO & MYSTERY

The late sixteenth century was a bloody time in France, Spain, and the Netherlands. In the event, the Southern Netherlands (Flanders) stayed with the Spanish monarchy, but the Northern Netherlands (also known as the United Provinces, or Dutch Republic) persisted in their revolt. Because so much of the Dutch Republic lay beneath sea level, dikes could be opened and land flooded if ever the Spanish troops attempt-ed to invade. Having failed to conquer the Anglo-Dutch fleet with his "Invincible Armada" in 1588, Philip II all but gave up his desire to end the Dutch revolt, rid himself of Queen Elizabeth, and stop Protestantism. By 1608 in the United Provinces there was a peace of sorts, one that was made formal in 1648 by the Treaty of Münster.

The Dutch were great capitalists, who nearly had a stranglehold on trade throughout the world and had an enormously profitable fishing opera-tion in the North Sea. There were banks that assisted trade by exchanging foreign currencies, insurance companies that guaranteed deliveries, and state-of-the-art shipping and overland car-riage to speed commerce. Perhaps as much as half the population of the port city of Amsterdam was well-to-do, living in comfortable, immaculate homes. And they had some money to spend dec-orating them. Rembrandt van Rijn arrived in this teeming city, then the financial center of Europe, in 1631. It was the logical place for an ambitious young Dutch artist. Many of the burghers (town dwellers) wanted portraits of themselves; in addi-tion, the corporations or guilds (see p. 25) com-missioned group portraits. Rembrandt also found private patrons who wanted paintings with legendary and religious subject matter. The mar-ket for religious paintings was quite healthy, even though the Netherlands was officially Calvinist, which meant that images were forbidden in the churches.

Rembrandt worked briefly in the studio of Pieter Lastman (1583–1633), who had absorbed the art of Caravaggio and the grand manner of Baroque spectacle from his visit to Rome (1603–6). Rembrandt therefore saw something of the Italian tradition through his teacher's eye, and probably also looked at the work of other Dutch artists who had recently returned from Rome. What Rembrandt learned from his dis-tant view of Italy and Italian art always informed his art, but he also brought something personal to narrative painting. He studied human psy-chology and could evoke nuances of expression missed by most painters.

Compare Pieter Lastman's *Susanna and the Elders* (FIG. 5.36) with Rembrandt's depiction of the same subject (FIG. 5.37). The story comes from the Apocryphal Book of Susanna. It tells us of the fate of the beautiful Susanna, who was falsely accused of adultery by a pair of old judges, elders of the community who secretly lusted after her themselves. They sneaked up on her when she was bathing in her garden one day, and demanded sexual favors from her on pain of being accused of adultery. Rather than sin, she cried out and the elders fled. But they acted on their threat and accused her. The assembly con-victed her and sentenced her to death, the Mosaic punishment for an unfaithful wife. The young Daniel separated the old men and ques-tioned them about the circumstances of the adul-tery that they had claimed to witness. Since they had not gotten their stories straight between them, he was soon able to prove their guilt. Susanna was saved, and they were executed.

The artists of both pictures certainly knew the story in all its details; in the Rembrandt, however, the body language and facial expres-sions are less specific, yet more evocative of what might be called the "inner meaning" of the event. The view through the lush foliage onto the architecture of the city of Babylon is similar in both paintings, giving evidence of Lastman's continued presence in his student's imagination. But Rembrandt's figures appear less declamatory, less given to making speeches; his narrative is quieter, more psychological. One of Rembrandt's

elders actually tries to pull Susanna's towel from her as he clenches his fist and hisses into her ear. Susanna looks at us. Why? Lastman has her looking past the figures and into the air, beseeching God as her witness. But Rembrandt breaks the fourth wall, that imaginary barrier between the work of art and its audience, and creates an upsetting, even baffling psychological relationship. Her averted eyes strike one as an uncontrived reflexive gesture, responding to an unexpected touch and unfamiliar voice; but we cannot avoid the way in which she implicates and implores us as all-seeing observers. Rembrandt's light selects her figure from the shadowed garden. This *chiaroscuro*, the separation of the clear from the obscure, forces the spectator's gaze to be knowing and acknowledging, even though we can do nothing. Compare

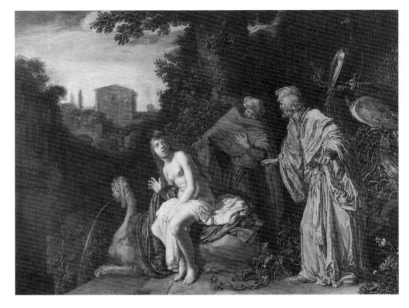

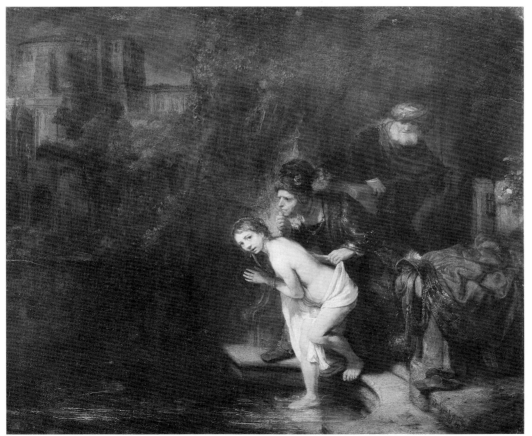

5.36 (*above*)
PIETER LASTMAN, *Susanna and the Elders*, 1614.
Oil on oak panel,
16¼ x 22¾ in
(41 x 58 cm).
Gemäldegalerie, Staatliche Museen Preussischer Kulturbesitz, Berlin.

The closed garden (in Latin *hortus conclusus*) shown in Susanna's story would also have called to mind Mary's garden, a symbol of her virginity. In the popular religious imagination of the time, both Mary and Susanna were seen as embodiments of purity and innocence.

5.37 REMBRANDT, *Susanna and the Elders*, 1647.
Oil on mahogany panel,
10½ x 36½ in
(26.6 x 92.7 cm).
Kaiser Friedrich Museum, Berlin.

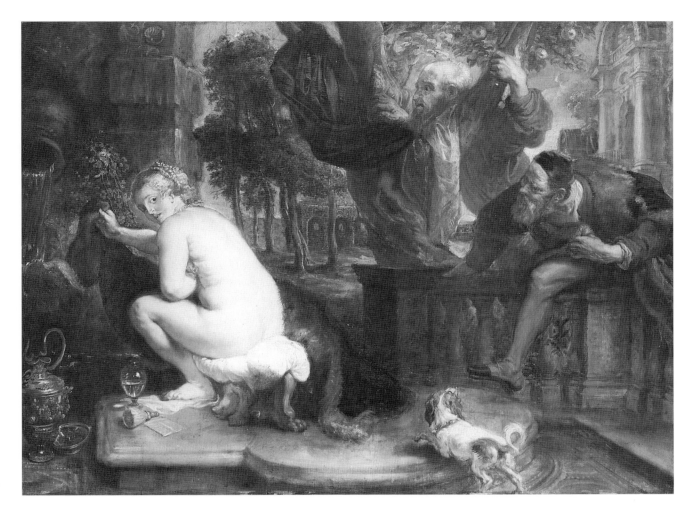

5.38 Peter Paul Rubens, *Susanna and the Elders*, c. 1636–9. Oil on oak wood, 30¼ x 43¼ in (77 x 110 cm). Alte Pinakothek, Munich.

this approach with the very different Susanna by Peter Paul Rubens (FIG. 5.38), in which the beautiful young woman exposes to the viewer her fleshy back. We are not disinterested observers here, but rather engaged in the same lurid gawking as the old men emerging from the trees.

Susanna's timidity and vulnerability in Rembrandt's painting matches our own helplessness, and we are moved and identify with her. This is what Aristotle called *catharsis*, that cleansing and emotional moment when we share the pain of the protagonist but realize, because of our aesthetic distance, that we are safe. In our omniscient position of having already read the story in the Bible, we also know that she will be saved.

In short then, Rembrandt used the many devices of tenebrism (which he learned from followers of Caravaggio) to create imagery that reminds one also of the rhetoric of Baroque spectacle. But he is different from Lastman and Rubens, who in general share his rhetorical interests, because his understanding of Susanna's plight is deeper. The tradition of *ut pictura poesis* – the intimate association of art and literature – suggests that a painting is a mute poem. That is, it does not spell out in words (which could be spoken aloud) the state of someone's soul or the implications of the narrative. The viewer, by being attentive to the cues given by Rembrandt, infers rather than reads the meaning and mood.

Paintings use visual rather than verbal language, but can convey complex messages just the same.

Rembrandt's *Aristotle Contemplating the Bust of Homer* (FIG. 5.39) again portrays an "inner meaning." The idea of rhetoric is that an orator speaks in public to an audience, but with Rembrandt one does not sense that the painting is a highly public statement. When John Stuart Mill wrote in the early nineteenth century that "eloquence is to be heard, poetry to be over-heard," he might almost have had Rembrandt's paintings in mind. We seem to happen upon an event and eavesdrop a little, observing some-

thing private and confidential (it is a clever and dramatic device on the part of the artist to convince his audience that they are not necessary). The painting has long carried a title that identi-fies the bearded man in floppy hat, with gold chain slung from shoulder to hip, as the Greek philosopher Aristotle, who greatly admired the blind poet Homer, mentioning him and the *Iliad* and *Odyssey* many times in his *Poetics.* The bust on the table certainly looks like the stan-dard image of Homer known to us at least from Hellenistic times. (The face on the medal hang-ing from Aristotle's chain, however, very likely

5.39 REMBRANDT,
Aristotle Contemplating the Bust of Homer, 1653.
Oil on canvas,
4 ft 8½ in x 4 ft 5¾ in
(1.44 x 1.35 m).
Metropolitan Museum of
Art, New York.

Like Caravaggio, Rembrandt relies on con-trasts between light and dark to create ambiguous spaces and to convey an attitude toward the sub-ject matter. The differ-ence is that Caravaggio's highlights are pure daubs of white and his darkness is impenetrable. Rembrandt's darker areas are always shadowed, but some very dim light remains. The effect of Rembrandt's *chiaroscuro* is to unite the entire canvas in tonal values and to suggest a quality of tem-porality, as if we were wit-nessing a fleeting moment of time.

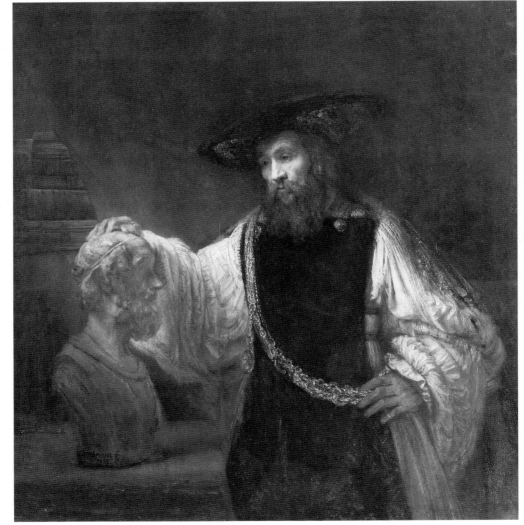

belongs to Alexander the Great, Aristotle's most famous pupil.) The books in the corner complete an image that was common enough in the seventeenth century: a scholar puts a bust of a famous poet on a desk in his library and then touches it, perhaps for inspiration, perhaps as a gesture of affection.

Aristotle wears a most remarkable gown covered in front by a dark apron, unlike anything one could have found in antiquity or any other period for that matter. This very Baroque garment contrasts acutely with the dark, rugged face, and shadowed, deep-set eyes. Of the philosopher's inner thoughts we can only speculate. It is Rembrandt's refusal to interpret or to convey to us a single meaning that forces us to complete the image in our own minds. The absence of anything that might suggest a frame, such as a wall, door, or other confinement of this "room," the darkness that becomes a substance of its own – finally just thick paint – and the irregular light that comes from Aristotle's right but highlights the left side of his face are all miscues, things that lead us to an impasse. As one finds in the paintings of Caravaggio, it is not easy to locate the images in a particular space, and therefore it is hard to know where we, the viewers of the painting, seem to stand. By frustrating us in our acts of seeing and interpreting, Rembrandt throws back on us, the spectators, the requirement that we turn inward and examine ourselves. This is the rhetoric of the minister or the priest, one who calls upon the deepest devotional urgings of the individual. It is also the rhetoric of the poet, who allows us to share his or her own meditations. The man who bought this painting, the Sicilian Antonio Ruffo, must have experienced something of the mystery of the scene: when asked by the Italian painter Guercino what the subject was, he simply did not answer.

Rembrandt had prospered as a young artist, but by the time this painting was delivered to Ruffo, his fortunes had declined. The romantic biographies of Rembrandt emphasize his estrangement from patrons and contemporaries, and interpret his sad, final years as evidence of the creative artist working in isolation, misun-

derstood by his less visionary and sensitive critics. There is more than an element of truth in this picture. Rembrandt is supposed to have said, when questioned about his habit of going among the poor, "When I want to relax my mind, it is not honor that I seek but freedom." He must have felt very much at home in the poor districts of Amsterdam, free of "honor," of maintaining a certain behavior and manners, free to think about the human spirit rather than rank and wealth. And free to paint a picture of inexplicit meaning, filled with a brooding, pensive, self-communing mood.

HALS, LEYSTER, VERMEER, & THE ART OF THE "UNCONTRIVED"

In seventeenth-century Holland, artists were often employed to describe the life, the times, and the images of the Dutch middle and upper classes, the countryside, and the city (see also Chapter 7). The impact of such paintings does not often strike one as rhetorical in the same sense that other paintings of the seventeenth century are rhetorical. If rhetoric is, among other things, the art of persuasion, what do these descriptive images really try to convince us of? We seem to move from the art of persuasion to the art of expression, or as it is sometimes called, the art of describing.

This is still a matter of rhetoric, however, because there is a point to these paintings: they give us images not from history or religion, but from common experience. They are not "mere" mirrors of reality, although they have a rather self-effacing quality to them, making them seem very much life-like. They appear to be spontaneous and uncontrived, as if presenting to the viewer an unmediated vision of reality. But it is that very simulation that creates such an irresistible shiver of excitement on the part of the spectator. On the one hand, we are impressed by the artist's technical virtuosity and his or her ability to convince us of the actuality of what is represented, and on the other we (and this would

hold true for seventeenth-century viewers as well) are moved by the power of an image that seems to be utterly familiar. Knowledge is familiarity, and our relation with the familiar is deep, abiding, and pervasive. The more common an image, the more satisfying can be its impact – especially when the image reminds us of home, the routine, the normal, and the orderly.

A Dutch artist of the first part of the century who captured the new and vital spirit of the rising Dutch urban class, their self-confidence, and their pleasures was Frans Hals. *The Merry Drinker* (FIG. 5.40) addresses the spectator much like a modern advertisement: with his left hand he offers us a drink while his right hand opens in a gesture of good cheer and welcoming. The parted lips, head set at a raking angle, and sparkling eyes add to the sense of immediacy and charm.

Hals' technique is one of carefully contrived spontaneity. Individual brushstrokes, which give the appearance that this was dashed off in the heat of the moment, can be detected even in a cursory examination. But studies show that Hals worked diligently, consciously, and slowly to create this effect of the immediate, instinctive, and apparently uncontrived. By this painstaking layering and arranging of brushstrokes, he attempts to describe a particular moment and experience rather than to narrate a well known story drawn from the Bible, history, or legend. In this way, the Dutch artist frequently differed from his or her counterpart in Italy or France.

Judith Leyster (1609–60) similarly describes a common-place scene with her *Young Flute Player* (FIG. 5.41). Leyster was a follower of Hals, and although she never developed as painterly a tech-

5.40 FRANS HALS, *The Merry Drinker*, c. 1628–30. Oil on canvas, 32 x 26¼ in (81 x 66.5 cm). Rijksmuseum, Amsterdam.

This is anything but an allegory of temperance. The Dutch were by all accounts cheerful and enthusiastic drinkers. Beer was produced in large quantities, statistics suggesting that in Haarlem every man, woman, and child consumed at least a barrel of beer each year – and that accounts only for locally produced beer. Paintings of Dutch drinking scenes were especially popular in the seventeenth century.

5.41 JUDITH LEYSTER, *The Young Flute Player*, c. 1630–5. Oil on canvas, 28¾ x 24½ in (73 x 62 cm). National Museum, Stockholm.

The broken top slat of the ladder-back chair, the dazzling effect of daylight, and the empty nail holes in the wall emphasize the fugitive and almost accidental quality of this scene. The only awkward passage is found in the over-sized middle bout on the right side of the violin, but that may in fact correspond with the broken chair as something intentionally irregular.

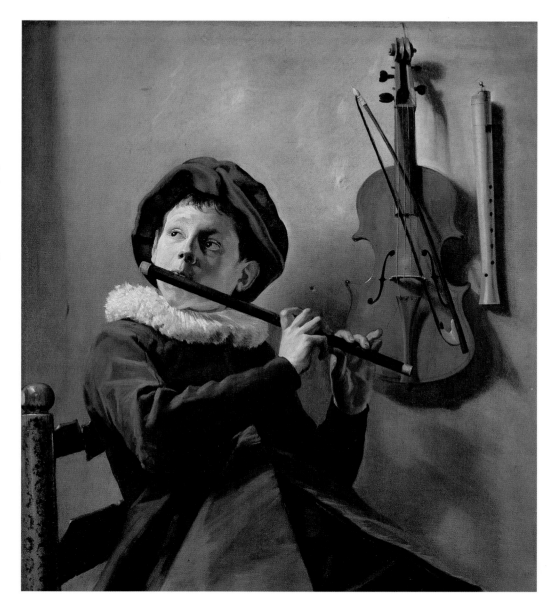

nique, her ability to give the impression of the casual within a carefully produced and strategically assembled room is comparable to that of her teacher. Perhaps more than Hals, she is able to convey a sense of the fall of light, the way it washes over objects and walls, creating highly differentiated shadows, with subtle and interesting shifts in tone and color. Again, there is nothing inherently meaningful here, no deeply concealed emblems or messages. Primarily this is a celebration of the unexceptional, normal, and usual, without in any way suggesting a coarseness or vulgarity. Neither mediocre nor trite, the well known as depicted by Dutch artists is familiar and comforting, reassuring and friendly.

Jan Vermeer remains something of an enigmatic figure to art historians. Although a successful artist who charged relatively high prices for his canvases, there are few mentions of him by contemporaries, nor are there many records pertain-

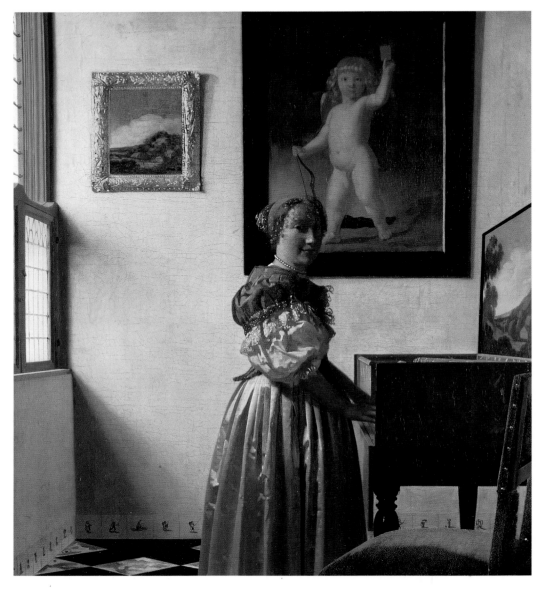

5.42 Jan Vermeer, *A Young Woman Standing at a Virginal*, c. 1670. Oil on canvas, 20 x 17¾ in (51.5 x 45.5 cm). National Gallery, London.

ing to him in the archives of Delft, a small town of about 25,000 inhabitants, in the middle years of the seventeenth century. His small painting of *A Young Woman Standing at a Virginal* (FIG. 5.42) might strike the viewer as a reasonably straightforward description of a woman playing a musical instrument (a precursor to the piano). Vermeer does not demonstrate the bravura of Baroque brushwork, nor does he confuse our eye with sharp contrasts between light and dark, clear areas and obscure areas. We see an exquisitely dust-free, splendidly well-kept room in a well-to-do Delft home. The white light admitted by the wood-framed, leaded-glass windows pours into the room, creating several grades of shadow just below the window ledge, along the many folds of her skirt, and even on her hands as they rest above the keyboard. A well-dressed woman in full skirt, beribboned blue jacket, and flounced sleeved chemise looks toward us and smiles.

There is a moralizing tendency in Dutch painting and culture of the seventeenth century, and whoever bought this painting must have seen the paintings on the back of the virginal and on the rear wall as all suggesting virtuous domestic values, above all the idea of strict monogamy (the cupid holding up a single card). But this painting cannot be reduced to a lesson. It also provided for the owner a sense of self and place, a warmth and domesticity. The idea of a "home" hardly existed before the Dutch invented it in the seventeenth century, and here it is bodied forth in Vermeer's image as fully realized, with all the associative values of order, prosperity, cleanliness, and a mother/wife at the virginal. The view is slightly from below (Vermeer undoubtedly sat at his easel and therefore represented his scenes from his own point of view), giving us an angle utterly familiar to a child. This painting must have had a powerful impact on the psyche of a Dutch burgher, who would have been both warmed and reminded of his or her place in social and domestic reality.

Conclusion

The paintings and sculptures discussed in this chapter have demonstrated the remarkable range of rhetoric and style in Europe in the seventeenth and eighteenth centuries. They are also evidence of that odd phenomenon – the passing of styles. Mannerism had its day, but was found to be overly stylized and so was rejected. Critics objected to Caravaggio's confusing images and almost fiendish manner of representation. Artemisia Gentileschi moved away from images of blood, violence, and gore. The exaggerated Baroque spectacle of Cortona and Bernini came to be loathed by critics of the later seventeenth and early eighteenth centuries. The sweet and charming style of della Valle, the pastoral lyrics of Watteau, the robust and excited images of love of

Boucher and Fragonard – all had their critics. Rembrandt lost commissions and declared personal bankruptcy. Neither Hals nor Vermeer ever could make enough money. Styles were repudiated by critics, biographers, philosophers, and historians for apparently deeply serious reasons. These writers nearly always saw something suspicious, as if the very devil himself were lurking behind brushstrokes and within chisel marks. It is an unsettling and instructive experience to read the reasons given by past critics, to see how seriously they judged, and how certain they were of their correct stance.

Rhetoric, as I have indicated, is more than a matter of style. There were many subtle forms of communication in the visual arts of the seventeenth and eighteenth centuries. Both the oratorical mode of public (and mostly Catholic) painting, sculpture, and architecture, as well as the violence and astonishing effects typical of Caravaggio and Gentileschi, made use of a large range of expressive devices. Rembrandt's ambiguity, Hals's, Leyster's, and Vermeer's deceptively graphic representations, and the poetic musings of the French Rococo painters cannot be reduced to a discussion of how they handled their materials. A discriminating analysis of brushstrokes and lighting is not sufficient for interpretation. I have adopted the word rhetoric as a way of making sense of Baroque and Rococo art because it implies interaction among artist, culture, and spectator. These artists were not holding up a mirror to the world, they were engaged in complicated visual games that involved belief systems (ideologies), the power of institutions, the history of art itself, and some deep urges and desires within the individual. The visual arts of the seventeenth and eighteenth centuries negotiated all kinds of things among all kinds of people – citizens, believers, artists, and creators of culture, religion, and government. The arts were not at the margins of life, but at its very center.

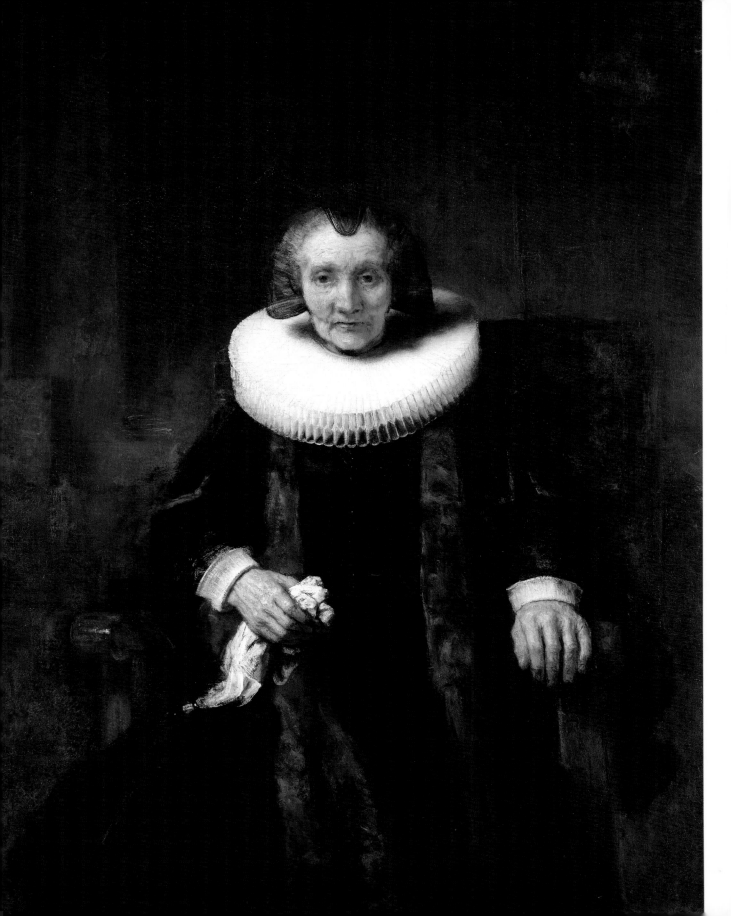

CHAPTER 6

The "Minor Arts"

PORTRAITS, STILL LIFES, &
GENRE PAINTING

REMBRANDT,
Margaretha de Geer,
1661.
Oil on canvas,
51 x 38 in
(130.5 x 97.5 cm).
National Gallery,
London.

Margaretha de Geer was
wife of the successful
merchant and patron
Jacob Trip; this portrait
formed one of a pair with
her husband, who died in
the year they were paint-
ed. The stark contrasts of
light and dark, the frontal
pose and pyramidal com-
position, together with
the candid treatment of
the sitter's ageing yet vig-
orous features combine to
create one of Rembrandt's
most arresting portraits.

The French Royal Academy drew sharp distinctions between what the academicians called *les genres*, by which they meant types of painting. History painting (treating the subject matter of ancient literature, religion, history, and legend) was considered the highest form of art. André Félibien (1619–95), an important theoretician in the French Academy, established a hierarchy of values, which treated everything "beneath" those traditional narrative themes as lesser types of painting: he called landscapes, portraiture, still life, scenes of daily life, animal paintings, and so on the "minor arts." The debate rages even in our own day between the so-called "high" arts and "low" crafts, or between high art and popular art. Charges of triviality on the one hand or elitism on the other are heard constantly in contemporary artistic controversies.

It had been generally accepted since the Renaissance that these "minor arts" were less significant. Then, with Félibien's explicit formulation of a hierarchy of types, it became doctrine, which made it increasingly difficult for artists who practiced them to achieve a very high level of prestige. But these kinds of paintings sold well, so artists continued to produce them in large numbers. The reason an academy sanctioned a hierarchy of types is simple. Artists wanted status and they wanted to make a living, desires that sometimes were in conflict with one another. An academy of art tended to worry first about status, assuming that financial issues would resolve themselves once the standing of the artist was settled. Most of the artistic campaigns in Spain in the seventeenth century, for instance, were carried out in support of recognizing painting, sculpture, and architecture as liberal arts. The reasons for these arguments and lobbying efforts were immediate and practical. As a result of expensive military campaigns, the Spanish royal treasury found itself in dire need of funds. Therefore, all work produced by living artists was considered craft and subject to a sales tax known as the *alcabala*. Those who argued for a noble status for the visual arts, equal to poetry and music, were successful in making their case,

as a series of court decisions favoring the arts and freeing them from the tax demonstrated.

Demand for the visual arts grew. With the founding of academies of art throughout Europe in the sixteenth and seventeenth centuries, the practice of the visual arts had increased. From its earliest days, the Church had demonstrated a substantial interest in painting, sculpture, architecture, manuscript writing and illumination, stained glass windows, and metal and enamel work. With the great reform movements in Catholicism beginning in the 1500s and continuing for centuries afterward, the call for art to serve religious ends was ever stronger. Such successful employment of the arts by the Church led to a spill-over into the secular world. For a variety of reasons having to do with expanding economies, monarchical claims, the growth of both smaller and larger courts, urban development, the consumption of art by wealthy individuals (both aristocratic and bourgeois), city governments, the rise of tourism, as well as the professionalization of the arts, this development of secular art moved along with dramatic speed. As so often happens in an expanding area of production, specialization set in. Landscapes, still lifes, view paintings, genre paintings, and portraits had been around in one form or another since the fifteenth century (and still-life painting was known in antiquity), but now, despite being categorized as lesser forms by virtually all of Europe's academies, they could generate enough interest in the art market to support an artist, although often meagerly, throughout an entire career. An artist might paint landscapes and portraits in addition to the religious and historical scenes by which he prospered and with which he identified himself most closely. But still life and genre scenes were usually (although not exclusively – one thinks of Carracci, Caravaggio, and Velázquez as exceptions) produced by masters who concentrated their skill and technical abilities in a single area. With the growth of a merchant class, especially in the Netherlands, there was increased interest in non-historical subjects.

And there were more generally philosophic and cultural issues at stake. Scenes from the Bible, legend, and history were imaginary, based upon both artistic convention and an artist's creative capacity – what was referred to in the traditions of rhetoric as "invention." The success of *les genres* (to use Félibien's term), by contrast, depended upon the artist's ability to observe and then render something real, a scene that corresponded closely to a fund of commonly held visual experience. This distinction between invention and imitation strikes very close to the distinction between the ideal and the real. Baroque art theory, caught up as it was in the academy and the search by artists and their promoters for legitimacy and prestige, usually valued the invented over the simply observed, creation over copying. The beautiful ideal, after all, cannot be found in nature, which is imperfect. In the real world there is error, deformity, decay, and death. The academic artist, driven in part by the aristocratic model of esteem and honor, sought an intellectual and rational standard of perfection, and found it, ironically enough, in nature. The method most often recommended by the academy and by artists can be characterized as the doctrine of selectivity. The artist studied and then selected the best parts of nature so as to combine them in a new and more nearly perfect manner (see pp. 158, 160).

Notwithstanding the powerful demand for the perfect and the beautiful, it was the disinterested (that is, objective) study of nature that formed the basis of the emerging sciences in the early modern world. Both Galileo and Newton developed telescopes; Leibniz and Newton invented modern calculus so as better to understand gravitational forces. There were important discoveries in navigation, metallurgy, agriculture, and mining. The Dutch scientist Antony van Leeuwenhoek (1632–1723), using an early version of the compound microscope (again, a Dutch invention), discovered microbes, protozoa, and spermatozoa. He also studied human blood, which, as William Harvey (1578–1657) proved, circulated throughout the body.

Empiricism, induction, skepticism, experimentation, classifying and measuring, exploring, gazing at the stars, and looking at those things

beneath the threshold of normal visibility – these are the activities and habits of mind of the seventeenth century. Empiricism as a philosophical and scientific method claims that all of our knowledge of the world comes from what we can see, touch, feel, smell, or hear. In order to understand the world, we must build up data we have gathered from observing it. From that information base we may be able to infer or induce some principle, some hypothesis about the workings of nature (and if he or she is an artist, discover the beautiful ideal). An empiricist makes no judgments of value, and does not necessarily seek the beautiful ideal, but does search for the truth. What is, is. There is no simple connection between science and art in the Baroque and Rococo periods, but one can track in many areas – such as map-making, natural history, geography, astronomy, microscopy – a more highly detailed interest in *this* world (or *this* universe), not just in the next one. Empiricism was part of Baroque and Rococo visual culture (see FIG. 6.1 and box, "Intellectual and scientific currents in the seventeenth century").

Just as the elite thinkers of the seventeenth century realized that they could not have complete knowledge of the cosmos, but could only describe and hypothesize about small parts of it, so visual artists, especially those who were not so much interested in the beautiful ideal and were not history painters, also studied and recorded small parts of the world, those that constituted common experience. Everyone had seen flowers, domestic interiors, recognizable and identifiable faces, buildings, street scenes, and landscapes. There was, in other words, a sharply *empirical* cast to these scenes, which corresponds to and parallels a growth in the empirical sciences.

For the individual forms of representation there are other corresponding tendencies in the larger culture. As we will see, analogous to the interest in portraiture is a growing literature on psychology and the individual. Similarly, one can find in the popularity of paintings of still life evidence of a wider interest in horticulture. The regard for scenes of daily life is paralleled by extensive writings on the moral and social signif-

icance of domesticity; much of the genre painting of the Dutch Republic, in particular, constructs and critiques ideals of courtship, marriage, family, and home for a nascent middle class.

Portraits

Because a portrait deals with a human subject, Félibien ranked it above animal painting and landscapes. Indeed, by the seventeenth century the portrait in European art already had a history of some distinction. From the fourteenth century, with profile images of monarchs (sometimes called numismatic portraits because of their similarity to portraits on coins), through the patronage portraits of the Flemish artists in the fifteenth century (donors ranked on either side of a religious scene), to the more socially expressive portraits of the *cinquecento*, the role of the portrait had grown. The sixteenth-century Portuguese writer Francisco de Hollanda, who was Michelangelo's pupil, maintained that portraiture, by virtue of its imitation of the human face with its God-given features, ranked as the most important form of art. Although his evaluation was not to prevail, the portrait remained important – regardless of academic attitudes – for a number of reasons.

Artists had recognized that one of the values of visual representation is its ability, as Alberti had written, to make the absent present. There is something almost magical in such a power, especially when that which is absent is a real person. The German painter Albrecht Dürer (1471–1528) observed that the art of painting "preserves the likeness of men after their death." In an age before photography, portrait painting commemorated an individual for posterity as part of a family history or for broader, social purposes. If these images are of noble men, for instance, then as with pictures of saints, they become reminders of admirable and virtuous behavior, important examples for others to follow. A series of portraits can also map for the sitter (and for the artist, too, when they are self-portraits) how his or her appearance changes with time, and how the face reflects one's inner being (following the old idea that the eyes are the

Intellectual & Scientific Currents of the Seventeenth Century

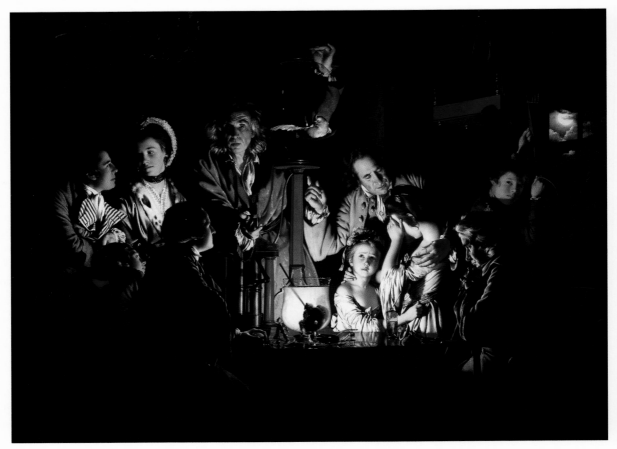

6.1 JOSEPH WRIGHT
OF DERBY,
*An Experiment on a Bird in an
Air Pump*, 1768.
Oil on canvas,
6 x 8 ft (1.8 x 2.4 m).
National Gallery, London.

This compelling painting is a
demonstration of the growing
popular fascination with the
wonders of science. As air is
pumped out of the glass
receiver, the white cockatoo
gasps and slumps to the bot-
tom of its cage – to the evi-
dent distress of the girls high-
lighted in the center of the
composition. The human
skull in the glass jar reminds
us of mortality and makes this
in part a *vanitas* painting (see
p. 252).

WHEN LEONARDO DA VINCI wrote in his notebooks
that "anyone who argues on the basis of authority
does not exploit his insight but his memory," he ques-
tioned the whole edifice of scholasticism. A medieval
churchman such as Thomas Aquinas argued *deduc-
tively* from received truths; and, even though he also
believed in the importance of the senses and of experi-
mentation, his world was one of revelation. In
scholastic philosophy, which owes much to Aquinas'
writings, truth is already known. In other words, one
argues from memory. We just *recall* the truth that has
been certified by the Catholic Church. The philoso-
pher's task is to expound upon and deduce certain

other conclusions from accepted first principles. Leonardo, however, disavowed simple authority and asked the artist to begin in experience so as to end up in reason. This movement from experience to principle or reason is *induction*, which is the scientific method. Although we tend to think of the scientific method as one that leads to certainty, it begins, ironically enough, in skepticism.

The circumstances after the Renaissance that led to so much doubting were not unlike those that plague the modern world. The voyages of discovery throughout the first half of the sixteenth century opened up new worlds and shook the Eurocentric beliefs that had prevailed for many centuries. The notion that "primitives," those not civilized in the ways in which the dominant classes of Europe considered themselves civilized, could in fact have values of equal or greater significance than those of the Renaissance, disturbed many intellectuals of the sixteenth and seventeenth centuries. Further, traditional (and university) learning was so savaged by Erasmus of Rotterdam's *In Praise of Folly* that it never recovered. Martin Luther and the Protestant Reformation shook Europe's spiritual center, the Roman Catholic Church. By the time that Michel de Montaigne (1533–92) had doubted every bit of wisdom and truth at one time held sacred and valid by the intellectuals of Europe, nothing remained certain.

The skeptical philosophy of the sixteenth and early seventeenth centuries held that we cannot be sure of the differences between appearance and reality, that all truths are based upon convention and assumed beliefs. There are no first principles by which we can be convinced of the existence of the world and of the values that we impose upon that social milieu. Montaigne pointed out the problems we face in seeking solid ground: "To judge the appearances that we receive of objects, we would need a judicatory instrument; to verify this instrument, we need a demonstration; to verify the demonstration, an instrument: there we are in a circle" (Frame, p. 454). Nor did he consider it likely that

one could put our scattered thoughts, experiences, and observations into coherent systems (Cohen, p. 358):

> The learned divide and define their ideas more specifically and in detail. I, who have no deeper insight into these things than unsystematic practice affords me, present mine tentatively and in general terms. As here, I deliver my thought disjointedly, article by article, as something that cannot be expressed all at once and as a whole. Connectedness and conformity are not to be found in low and commonplace minds, like ours. … I leave it to artists – and I do not know whether they will succeed in so perplexed, so detailed, and so risky a task – to marshal this infinite variety of appearances into companies, to resolve our inconsistencies and reduce them to order. Not only do I find it difficult to connect our actions one with another, but I have trouble too in designating each one separately by some principal quality, so ambiguous and variegated do they appear in different lights.

By the third decade of the seventeenth century, skepticism had raised doubting to such an art form that there was a crisis of conscience and culture in Europe. In 1620 the Englishman Francis Bacon (1561–1626) attempted to address such widespread philosophical doubt and intellectual insecurity by writing in his *New Organon* about the inductive method. Look at the variety of experience, he admonished his readers, without preconception; by systematic study of the data and phenomena of nature, one can come to reliable conclusions and escape our uncomfortable perplexity. In *The Advancement of Learning* (1623) and *The New Atlantis* (1627), Bacon brought forward the scientific method and proposed that it be applied in practical matters. *The New Atlantis* is a utopian tract in which science leads to a perfect social world for humankind. Insofar as experience is the inductive method, Bacon was arguing against skepticism with its

own point of view. Our experiences do have a shape and order to them so that we can form hypotheses and arrive at tentative conclusions, conclusions that can have the practical effect of improving our lives. However, because Bacon did not participate fully in scientific experimentation and discovery, he neither shared his ideas with other scientists nor were his theories widely acknowledged.

It remained for René Descartes (1596–1650) to formulate the best-known and most persuasive response to skeptic philosophies. His famous saying, "I think therefore I am" (*Cogito ergo sum*) formed the basis for an indubitable philosophy (in fact, Descartes is often referred to as the "father" of modern philosophy). Having been trained as a Jesuit priest, Descartes decided that scholastic philosophy could not sustain a secure belief in God. In his *Meditationes de prima philosophia* (Meditations on First Philosophy) of 1641, he formulated his extreme doubt by saying that even if everything that appears to us through our senses, and every idea we have in our heads, is uncertain, at least we can know that we think and therefore exist. Building on this secure knowledge, Descartes argued back to the existence of God. The French priest and philosopher believed that he could claim logically two kinds of things that were created by God: *res cogitans,* which is our mind, our ability to think (cogitate) and to be spiritual; and *res extensa,* which is matter that moves and extends into space. We as humans are first of all thinking beings; no other species has the ability to be self-aware. And secondarily we are body, which means that we are physical and have material lives. But primarily we are mind. A skeptic might respond that "Maybe I think, perhaps I am." But skepticism was never the same after Descartes. Even in the twentieth century, with theories of language that assert that we think in words and that in fact language is contrived, public, and therefore uncertain in its origin, most people believe in their self-awareness. Among non-philosophers, whether conscious of it or not, Descartes' formulation is an abiding faith.

From his philosophy of nature, Descartes was able to develop a co-ordinate geometry that remains important until the present. He also hoped, as he wrote in his *Discourse on Method,* that men might discover:

> a practical philosophy, by which, knowing the nature and behavior of fire, water, air, stars, the heavens, and all the other bodies which surround us, as well as we now understand the different skills of our workers, we can employ these entities for all the purposes for which they are suited, and so make ourselves masters and possessors of nature. This would not only be desirable in bringing about the invention of an infinity of devices to enable us to enjoy the fruits of agriculture and all the wealth of the earth without labor, but even more so in conserving health, the principal good and the basis for all the other goods in this life. (p. 45)

It is clear that we cannot know the external world in its essence, in its fundamental meaning. Nonetheless, what we can observe in terms of our experience and the data that we record tells us something. Sir Isaac Newton (1642–1727) gave us information about the physical universe in his *Philosophiae naturalis principia mathematica* (Mathematical Principles of Natural Philosophy) of 1687, which defined mechanical laws. The first law is the law of inertia, in which objects are averse to changing either their motion or velocity. The second law is about the force necessary to accelerate an object. The third law states that for every action there is an equal and opposite reaction. Newton's theories are about the empirical world of things, not about true nature with its underlying motives. In other words, Newton describes God's universe, but he does not explain why God created it, or what it means at its deepest level.

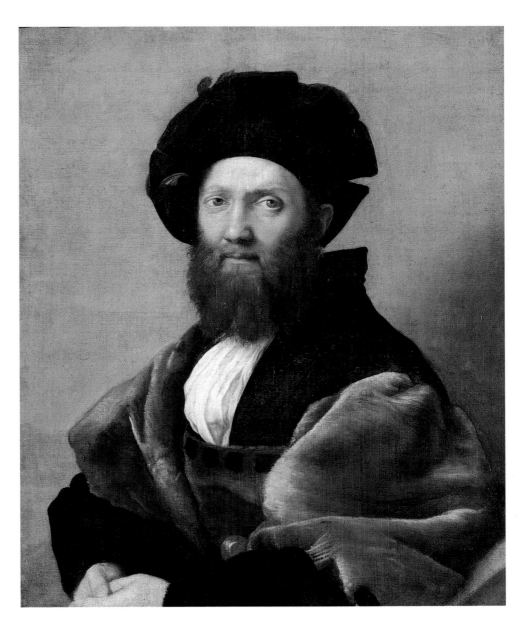

6.2 RAPHAEL,
Portrait of Baldassare Castiglione, 1514–15.
Oil on canvas,
32¼ x 26½ in
(82 x 67 cm).
Louvre, Paris.

Raphael painted two portraits of Castiglione: in the first he alluded to his baldness, but here it is disguised under a fashionable hat. The colors may be sober, as espoused by Castiglione himself in his *Book of the Courtier*, but they are marshaled so subtly, and the textures are so rich, that the effect is one of restrained luxury. Raphael's direct approach to portraiture influenced Rembrandt, Titian, and Velázquez, among others.

window of the soul), thereby assisting self-knowledge. And a portrait preserves the likeness of someone who hopes for immortality.

Portraits record identity. There are, as we shall see, two basic ways of understanding selfhood. One is the inner, or subjectively felt experience that can be called self-awareness or self-consciousness. The other side of identity is social, an identity established and mirrored by those around us. One's socially constructed identity derives from social status, gender, kinship, profession, and place of origin.

To determine how personal and socially constituted identities might turn up in pictures, let us look at an example of sixteenth-century portraiture. Raphael's *Portrait of Baldassare Castiglione* (FIG. 6.2) shows his good friend Castiglione (1478–1529) as the model of the

6.3 HANS HOLBEIN,
The Ambassadors, 1533.
Oil on wood,
6 ft 9½ x 6 ft 10½ in
(2.07 x 2.09 m).
National Gallery,
London.

This portrait of the
French ambassador
Jean de Dinteville and
Georges de Selve, Bishop
of Lavour, was painted
when Dinteville was on
a diplomatic mission to
Henry VIII of England.
The central still life is
full of scientific and
symbolic interest, and
the yellow shape in the
foreground turns out to
be a skull when seen
obliquely. Renaissance
portraits were more
interested in philosophy
than in the psychology
if the individual.

Renaissance courtier, a man of letters, culture, and diplomacy. He was the court of Urbino's ambassador to the pope, and also the pope's emissary in official diplomatic missions to the kings of England, France, and Spain. But Raphael does not give us a reading of Castiglione's place in the upper reaches of Italian Renaissance culture in any traditional or discursive sense. He does not, in other words, pose his subject, as Hans Holbein (1497–1543) does in *The Ambassadors* (FIG. 6.3), among objects of learning and accomplishment. Raphael's approach, like much of the portraiture of the seventeenth and eighteenth century, developed the sitter's identity, whether personal or social, through strategies of presentation, through appearance and countenance.

One can infer from Castiglione's costume and bearing, as well as from his self-possessed demeanor, that here is a man of some substance. Raphael shows Castiglione from the waist up, with a strong silhouette of dark clothing, mostly in gray and black with very muted reds, greens, and browns, set against a light background. This emphatic positioning of the figure establishes his presence. In a more subtle sense, the highlights of his clothing and the nuanced, finely textured rendering of light around his eyes bring out a sense of the man. That is to say, Raphael uses something visual – light – to comment on the sitter's character and identity. Raphael was certainly not the first to conceive of light in this way. Light, because of its association with religious values, was well understood as a symbol in European art of the fifteenth and sixteenth centuries. The spiritual identities of both Mary and Jesus were often conveyed by haloes, or a nimbus, or merely a glowing light. Thus light can shift from its accustomed role of providing physical illumination and clarification to comment in an understated manner on tact, delicacy, and good taste.

The apparent unconcern and level gaze of Castiglione, so obvious in Raphael's portrait, remind us that he promoted the appearance of *otium* (see pp. 37–8), so that one feigned an unruffled appearance and indifference to matters of personal and political struggle. The courtier also esteemed *sprezzatura*, which is a mode of behavior that privileges effortlessness and nonchalance in the accomplishing of difficult tasks. Castiglione was one of those Renaissance men who had to learn to invent himself in relation to the various powers that existed in his time. The feudal period in Italy was gone, and someone in Castiglione's position no longer had a set role in society, so he had to establish who he was. That was the point of his *Book of the Courtier*, which was the most important handbook of the age with which courtly society could define itself. Raphael's portrait is one more element or chapter in the book.

BAROQUE PORTRAITS: IMAGES OF POWER

As the jockeying for power among the nations of Europe grew more frenzied and more dangerous throughout the seventeenth and eighteenth centuries (national armies were growing to unprecedented sizes, and the forces for reform – political, social, economic, and religious – were more insistent and revolutionary), the personality and image of the pope, queen, or king became more important. The portrait painter was an image-maker, a "playwright" of sorts.

In this section I examine images of individuals whose social, political, and religious identities were paramount. Monarchs or popes utilized portraits to assist them in discovering and making their own identities, identities that had vital importance in terms of their relationships to complex social forces. Ultimately, they wanted to radiate an aura of power, even though they may have presented themselves in their portraits as an example of virtue, even humility, or as a friendly figure of authority and welcome.

6.4 PHILIPPE DE
CHAMPAIGNE,
Cardinal Richelieu,
1635–40.
Oil on canvas,
8 ft 6¼ in x 5 ft 10 in
(2.6 x 1.78 m).
National Gallery,
London.

De Champaigne

Philippe de Champaigne's (1602–74) portrait of *Cardinal Richelieu* (FIG. 6.4) gives us a man who had to fashion himself according to his changing fortunes. First Armand-Jean du Plessis, Duc de Richelieu (1595–1642), occupied a position of power in France, and then (because of King Louis XIII's suspicions of his motivations) he lost it. But later he was appointed cardinal, and finally he moved beyond his ecclesiastical office to become the chief minister of France (1624–42) during the reign of Louis XIII, who once again trusted him. This portrait may well have been associated with a gallery of illustrious men in Richelieu's Palais Cardinal in Paris (we do know from contemporary accounts that Richelieu had asked Philippe de Champaigne to paint him life-size for the gallery). This image, in other words, may have been intended for a kind of pantheon of men of repute, examples of virtue and doers of great deeds, unlike Castiglione's portrait, which was intended for his family.

In the painting, Richelieu holds his cardinal's hat (the *biretta*) in front of him, as he stares at the observer. In the background is a view that appears to show part of the garden of his own home. The large swags of drapery behind him theatricalize the Cardinal in a manner fairly typical of the Baroque period (a full-length portrait with drapery behind had been popularized by both Rubens and van Dyck). As in a theatrical performance, the chief minister must be portrayed in a carefully modulated manner so that he is perceived in noble and virtuous terms. Although the Cardinal was at the very center of power, he was not himself the king of France. Therefore his graceful piety needed to be emphasized as well as his stature – he needed to be portrayed as one who serves rather than dominates.

The Order of the Holy Ghost – a secular honor granted by the King of France – hangs prominently from Richelieu's neck, while the *biretta* – potent symbol of church office – also assumes distinction by virtue of the way in which he holds it, as if it were a humble offering rather than an article of clothing. Richelieu

found himself in the difficult position of negotiating between Pope and King, and took the improbable but brilliant position of asserting the divine right of both. This position earned him many enemies, but ultimately succeeded. The King was frequently warned against Richelieu as one who conspired to gain too much power. It is a testament to Richelieu's political intelligence that he largely triumphed as first minister and ecclesiastical notable, furthering the unification of France and the consolidation of power in the monarchy, while containing the spheres of influence of the other major European powers. One important weapon that helped to secure this success was the image of himself that he – and de Champaigne – created.

Rubens

As Cardinal Richelieu was building up his power base, that of Marie de' Medici, wife of the assassinated king Henry IV, was on the wane. Exiled to Blois by her son Louis XIII, this one-time regent of France found herself locked out of the political machinations at the Parisian court (see p. 60). In the early 1620s, after one reconciliation and before the final split between her and her son, Marie decided to commemorate her life with Henry IV, her regency, and her tumultuous relations with Louis XIII by commissioning a series of paintings from the Flemish artist Peter Paul Rubens (see p. 182). What resulted was a series of twenty-four large paintings, each about 13 by 10 feet, that use every available allegorical, emblematic, and symbolic device known to glorify a life that was inordinately rich and profoundly troubled.

It is enlightening to see how a Baroque painter of Rubens' colossal talents abandons the typical conventions of portraiture to glorify the history of a life, a history that has been "created" for the needs of a rejected widow, regent, and mother. *The Disembarkation at Marseilles*, which combines a likeness of Marie de' Medici, history, mythology, and allegory, depicts Marie's arrival in Marseilles *en route* to Lyons for her

marriage to Henry (FIG. 6.5). Arrivals and departures are so often ceremonial, and this arrival is excessively so. It is attended by an allegorical representation of Fame blowing two trumpets, a huge triumphal arch, booming cannon (mostly we see the smoke), various sea creatures and deities – Nereids, Neptune, Proteus, and a Triton – allegorized representatives of the town of Marseilles and the area of Provence, and a completely superfluous Knight of Malta (the man in black with a red cross on his chest). Rubens' Baroque style presents the viewer with imagery of unforgettable presence and richness. By the time this self-congratulatory series of paintings was completed, Marie was once again in exile, never to return. They hung mostly unobserved in a wing of her Parisian palace, the Luxembourg. Only in the twentieth century have they been reunited in the Louvre.

Several times in his career Rubens was called on to create the kind of regal image that would convey great power. Ideologically similar to the grandiose Marie de' Medici cycle was a series of canvases placed on the ceiling of the Banqueting Hall in Whitehall, an area of London near the Houses of Parliament, which elaborates on the virtues of King James I of England.

Rubens' diplomatic career abetted his profession as painter: although he had anticipated the painting of the ceiling of the Banqueting Hall as early as 1621, it was only after a successful diplomatic mission to the Court of St. James in 1629–30 that he secured the commission from Charles I, the son and heir of James. We can assume that he had an opportunity to speak with Charles I, who recognized the Flemish artist's great ability to work on a vast scale and to promote the mission and glory of the British monarchy.

The Banqueting Hall, built by the English architect Inigo Jones in 1619, was a public place intended for diplomatic receptions and theatrical performances. The typical audiences, therefore, consisted of both ambassadors and representatives from abroad and the London elite. The language of the paintings is allegorical. The central scene, the *Apotheosis of James I* (FIG. 6.6), shows

the deification of the monarch. Although the British monarchy was Protestant, and therefore from an "official" point of view heretical, Rubens' Catholic style seems well suited to Charles's political intentions. Allegorical representations assist King James' glorification in numerous ways: Wisdom and Victory hold a laurel wreath, while groups of *putti* fight over a second laurel crown, blow a horn, carry the King's helmet, and generally disport themselves in a playful fashion. Seen from below, the King and his otherworldly attendants spiral upward in an eddy of Baroque space. While few observers of the Whitehall ceiling would have believed literally in the deification of James I, most would have understood the magnitude of Stuart claims, their claims of divine right, their wealth, and their power. James may have been long dead before this allegorical portrait was conceived and painted, but his identity remains powerful because it is clothed in the idea of British destiny and divine kingship. But all the glory that Rubens could muster, however impressive it was to the English court and the diplomatic corps, did little to stir the admiration of Charles' enemies. When Charles I was led to execution in 1649, he walked through the Banqueting Hall. Perhaps his last view of the painting bolstered his own sense of his divine right, but it did not protect him from the scaffold.

Van Dyck

Nine years before the executioner's axe fell, Charles I was immortalized by his court painter, the Flemish Anthony van Dyck, a protégé of Rubens. Although Charles believed as much as his contemporaries in absolute power, his particular claim, the one that undid him finally, was that he was king by divine right (see p. 65–7). He believed that he inherited his right to govern from his ancestors, and did so according to the laws of God and of nature. Thus, his responsibility to his subjects and to Parliament was negligible. One potent way of asserting a right that struck many of his contemporaries as insupportable was to use artistic representation. In an age

when nearly all shows of strength and social stability were conveyed through some system of representation – visual, literary, legal, military, courtly – the services of a gifted artist were much in demand.

In his *Equestrian Portrait of Charles I* (FIG. 6.7) van Dyck captures nearly every reference and sentiment necessary to confront the viewer with a visual commentary on divine kingship. The tablet hanging from a tree limb reads CAROLUS REX MAGNAE BRITANIAE: Charles, King of Great Britain. The King invokes traditions of leadership and service by appearing on horseback and by wearing the medallion of a Garter Sovereign. The King as Prince of Wales was, according to a later decree, a "constituent part" of the Order of the Garter, an ancient and "most noble" (as it describes itself) knightly order that was founded in the fourteenth century. Here as sovereign (rather than simply as prince), Charles, dressed in armor and carrying a ceremonial baton, leads his knights into some battle of mythic proportions. To the right a page holds the King's helmet. Portraying a leader as a military commander on horseback summons up a visual tradition that goes back to the mid-second century C.E. (see FIG. 2.12).

Whether or not van Dyck's image impressed many outside of the King's immediate court, we can only surmise. It is not likely, however, to have moved Oliver Cromwell, who as leader of the English Revolution defeated Charles' army and ordered the King's eventual beheading. Cromwell possessed even greater power than Charles, but did not see fit to avail himself of the services of an artist of van Dyck's rank and quality.

Bernini

Gianlorenzo Bernini was in France for six months in 1665, at the court of the young Louis XIV, and was invited by the King to make his portrait. Bernini was arguably the most famous artist in Europe in the mid-1660s, and had been recommended to Louis by Pope Alexander VII Chigi himself. Now in his late sixties, Bernini was asked to devise architectur-

6.7 (*opposite*)
ANTHONY VAN DYCK, *Equestrian Portrait of Charles I*, 1638. Oil on canvas, 12 ft ½ in x 9 ft 7 in (3.57 x 2.92m). National Gallery, London.

Rubens' most gifted pupil, van Dyck set the standard for successive generations of English portrait painters. This picture gains much of its power from the contrast between the self-assured and tranquil figure of Charles I and his fiery charger, with its foaming mouth and rippling muscles. The King's melancholy expression was subsequently taken as a portent of his tragic end on the scaffold eleven years later.

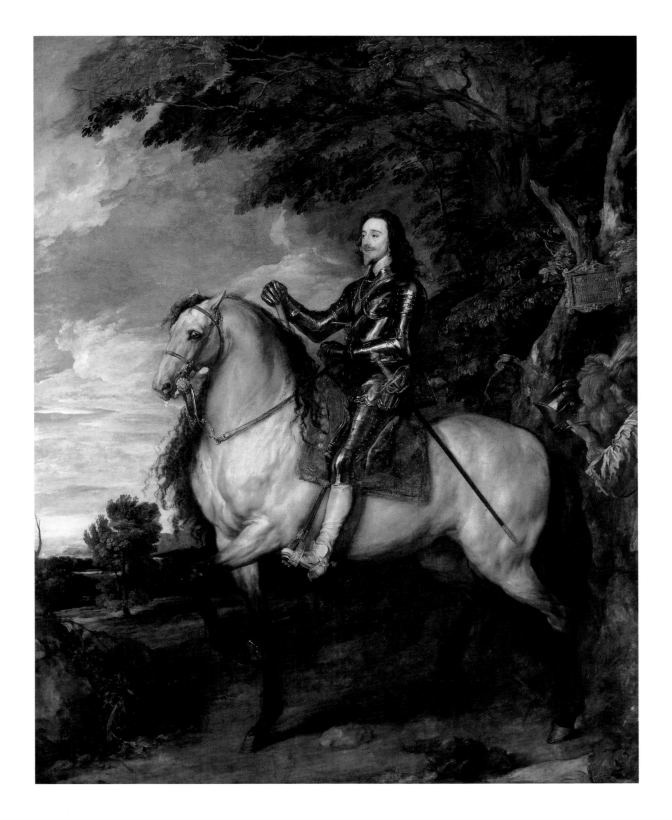

al projects for the Louvre (FIG. 6.8), an undertaking that had vexed local architects. For any number of reasons – some of them undoubtedly owing to the jealousies of French architects and Bernini's own undiplomatic comments about French art – his plans never came to fruition. But his portrait of Louis (FIG. 6.9) still resides in a place of prominence at Versailles (it was originally in the Louvre).

The story of the portrait's execution is recounted in considerable detail by Bernini's host in France, Paul Fréart, Sieur de Chantelou, one of Louis's household masters. Bernini studied Louis as he went about his daily activities. From these observations the sculptor was able to make rapid sketches that captured something of the transience and mobility of the king's bearing and behavior. Afterward Louis came for thirteen sittings. By all accounts Bernini worked insistently, even to the point of exhaustion, to finish the sculpture in a remarkable forty-eight days of labor. At one point, he warned the king, "I am

stealing your likeness"; and breathlessly to Chantelou he confided, "The king and I must finish this." The final bust – which shows Louis in the full flower of arrogant youth, unlike the portrait done by Hyacinth Rigaud (see FIG. 2.13) – has Bernini's characteristic flamboyance. The drapery twists into a tight knot to our right, as the King focuses sharply in the opposite direction. The pose, with head turned to the side, chin in the air, and curly flowing locks, would have been recognizable to most observers as similar to that of ancient images of Alexander the Great. Because the marble was friable, and thus likely to crumble, Bernini used a drill rather than a chisel to detail the King's hair and the amazingly intricate Venetian lace shirt front. Louis' superintendent of buildings and close adviser, Jean-Baptiste Colbert, recognized the *majesté*. He also asked that Bernini cover the King's brow with hair, but the sculptor objected, saying that for so noble a face, a high forehead was preferable – nonetheless he engraved in shallow relief a few wisps of hair.

6.8 GIANLORENZO BERNINI, first project for the Louvre, 1664–5. Engraving.

6.9 (*opposite*) GIANLORENZO BERNINI, *Bust of Louis XIV*, 1665. Marble, Height 31½ in (80 cm). Château of Versailles.

Despite all the time that Bernini spent studying the King himself, this famous bust is not a faithful likeness: Louis's forehead was not so high, nor were his eyes so large. The artist idealizes his subject to portray the King as the representative of God.

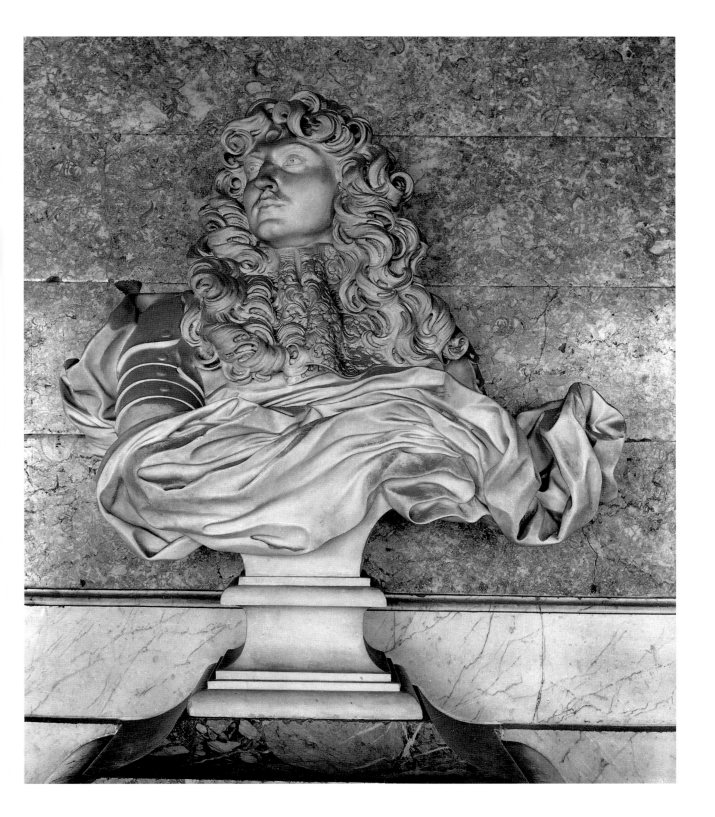

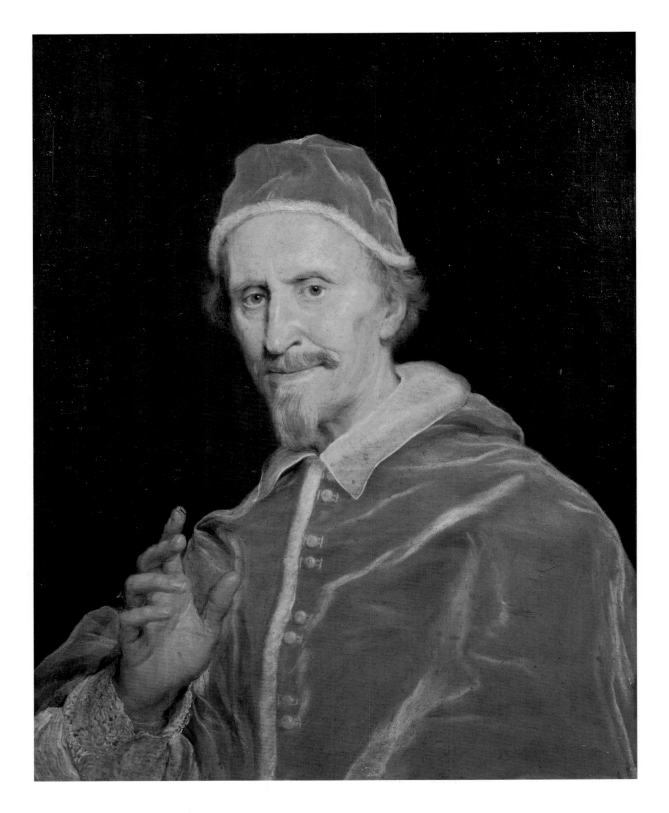

6.10 (*opposite*)
GIOVANNI BATTISTA
GAULLI (BACICCIO),
Pope Clement IX, 1667–9.
Oil on canvas,
29½ x 24¼ in
(75 x 61.5 cm).
Palazzo Barberini,
Galleria Nazionale d'Arte
Antica, Rome.

Baciccio painted portraits
of all the popes from
Alexander VII to Clement
XI, but this is his finest.
He allows the light to
play on the sitter's fea-
tures, bringing out the
subtle skin tones. The
strong reds of the pope's
mantle stand out even
more against the dark
background of the paint-
ing; they add vitality to
the frail figure, while also
pointing up the contrast.

Thinking of the best way to set off the por-
trait, Bernini also drew up plans for a base that
would be covered with emblematic references.
His idea was to have at the very bottom an
arrangement of elegant drapery with images of
victory and virtue, all rendered in colored enam-
el. Resting on the drapery was to be a globe, with
land and sea done in different colors. The globe
would have been inscribed "picciola Base,"
which was a reference to Louis's grandeur: the
world is but a small stage for the King's actions.
The large, white bust of Louis floating above the
world would have made an impressive ensemble,
but the base was never made, probably because
no French artist wanted to carry out Bernini's
plans. As the portrait is displayed now, there are
modern trophies on either side, emblems of a
generally triumphal but less interesting meaning
than those proposed by Bernini.

Baciccio (Giovanni Battista Gaulli)

Although a pope is as exalted a personage as a
king, the concept of "la gloire" is usually less per-
tinent. Baciccio's portrait of Clement IX
Rospigliosi (r. 1667–9) (FIG. 6.10) presents a less
glorified image, but one of greater immediacy.
His lips appear slightly pursed, as if he were
ready to speak, and his glittering eyes with light
irises rivet the observer in a gaze of intimacy.
One button is nearly undone. His large forehead
and sharply observed nose (pushed slightly out
of line with the rest of his face so that it appears
more nearly in profile, which was considered the
characteristic view) call attention to that part of
his face where one could intuit the sitter's state of
mind. The seventeenth-century essayist and
biographer Karel van Mander observed that the
brow revealed the thoughts; a furrowed brow and
wrinkled forehead, for example, showed a sor-
rowful and anxious spirit. Clement's brow, how-
ever, reveals no tension, his forehead no creases:
he seems a profoundly peaceful man. His beauti-
fully foreshortened hand gestures toward the
viewer as both a welcoming and a blessing.
Although Baciccio is better known for his spec-
tacular ceiling paintings (see pp. 30–1), here he

succeeds with an intimate portrait of a pope who
was known for his kindness and his poetry. This
kind of portrait does not portray the sitter as an
actor on a great stage; rather, it focuses more on
the individual, one whose social and spiritual
identity was paramount, but whose disposition
and singularity are also significant.

LATE BAROQUE & ROCOCO PORTRAITS: THE CULT OF SENSIBILITY

Throughout the seventeenth and eighteenth cen-
turies there remained a strong demand for por-
traits of the elite. The motivations behind these
images are many and varied, as might be expect-
ed. The human desire for representation was
based not so much on vanity as it was on the
need for self-expression and self-understanding
in visual and therefore social terms. As the soci-
ologist Daniel Lerner has pointed out, there was
in Europe in the sixteenth and seventeenth cen-
turies a marked change in consciousness, one
that led to what he terms a "mobile sensibility so
adaptive to change that rearrangement of the self
system is its distinctive mode" (p. 49). The
appearance in the history of consciousness of this
phenomenon of a personality or identity that can
change and adapt according to circumstances has
considerable significance in explaining the efflo-
rescence of portraits in the seventeenth and eigh-
teenth centuries.

The greater mobility, choice, and power of the
individual in these centuries was to a great extent
a function of the intellectual current known as the
Enlightenment. So much of our modern liberal
education owes its origins to the thinkers of the
early modern periods. Our beliefs in rationality,
the scientific method (see pp. 210–11), ethics,
benevolence, equality, curiosity about the past,
and even democracy spring in large part from the
fertile minds of such writers as Montaigne,
Descartes, Diderot, Montesquieu, Franklin,
Voltaire, Mary Wollstonecraft, and Rousseau.
Although these men and women were not without
their own prejudices and blindspots, their hatred
of ignorance and superstition, their distrust of

monarchy and repressive religion, their contempt for received opinion, intolerance, and the heedlessness of popular opinion mark them as the true ancestors of today's liberally educated citizens and intellectuals.

Although there were different points of view among the *philosophes* (Enlightenment thinkers; FIG. 6.11), there was widespread agreement on basic principles, for example the ultimate authority of reason and the need for active political and social reform. Thanks in large part to the greater accessibility of schools and an increasing growth in capital, both the reading public and the middle class expanded rapidly in the eighteenth century. The prospering members of the bourgeoisie were eager for new ideas, and for putting the unhappy past behind them. Many people throughout Europe came to accept the notion of an enlightened eudemonism, which is the optimistic belief that if we as a society institute the proper policies, the quality of life will improve. The *philosophes* believed in the need for a fresh start in European civilization. In order to accomplish this, men's and women's hearts had to be changed, they needed to be enlightened – or, as we might say today, their consciousness had to be raised.

Thus while court society – monarchical in France and papal in Italy – sought styles of architecture, furnishing, garden design, and etiquette that promoted permanence, the growing middle classes embraced values that embodied change and accompanied transition, though by the mid-1700s, we can find evidence of a more fluid conception of the self even among the nobility and royalty (see FIG. 6.14). The individual realized that he or she was the possessor of a "mobile personality," one that could find a personal version of a better life. The individual had the freedom to make choices, had a high degree of self-awareness, and could project himself or herself, by way of a portrait, into a kind of visual environment that would give expression to that identity.

At the risk of oversimplification, we can say that in the middle ages human nature was understood in terms of one's distance below God; in the Renaissance it was understood in terms of one's distance above the animals and uncivilized or uneducated humans; in the Baroque and Rococo, it was understood in terms of one's ability to reflect upon one's own identity as a rational and potentially creative being capable of change and even reinvention. Portraits in the seventeenth and eighteenth century permitted an individual to display an image that would comment on and attract attributes that go toward constituting an identity. Our images are not ourselves, but they are like ourselves, and both assist and direct us in finding ourselves.

6.12 (*opposite*)
FRANS HALS
Portrait of Isaac Massa and Beatrix van der Laen (?),
c. 1622.
Oil on canvas,
4 ft 8 in x 5 ft 5¼
(1.4 x 1.66 m).
Rijksmuseum,
Amsterdam.

In Hals's only double portrait of husband and wife, the artist has broken with convention by setting the couple to one side. The wife is at the center of the scene, her intensely lit face shining with happiness above a huge starched ruff, her white cap laced with pink ribbon bringing out the colors in her cheeks. Yet the husband's more imposing figure and the dynamic diagonals of his body and hat make him of equal importance in the painting.

6.11 JEAN HUBER,
The Philosophes at Dinner,
1750. Engraving.

The *philosophe* with his arm raised is Voltaire (1694–1778), writer, radical, and embodiment of the Enlightenment; to his left is Denis Diderot (1713–1784), philosopher and editor of the great *Encyclopédie*; opposite them, with his back to us, is the Marquis de Condorcet (1743–1794), philosopher and politician.

Hals

Frans Hals' double portrait of *Isaac Massa and Beatrix van der Laen (?)* (FIG. 6.12) represents the private pleasure – even playfulness – between husband and wife. Although double portraits of husband and wife had been popular in the Netherlands since the fifteenth century, the informal manner of presentation was new. Here is a charming and friendly relationship, with husband and wife self-consciously acting out an introduction to the beholder. Massa's affectionate candour (as though he were introducing an old friend to his new bride) engages the viewer in an intimate, familial moment and also makes him or her aware of the staging of the scene. Massa was a successful diplomat, merchant, and intellectual, which probably accounts for the cosmopolitan flavor of this picture – the garden setting, casual posture and unusual full-length pose. Despite the impromptu atmosphere, Hals has incorporated several symbolic allusions to marriage, such as the "faithful" vine curling round the tree trunk, and the foreground thistle, a plant renowned for its aphrodisiac qualities.

The idea of frank and friendly presentation is in keeping with a certain *joie de vivre.* As is typical of Hals, his aptitude for using paint in a fresh and spontaneous fashion (an effect laboriously achieved, of course) assists us in our perception of an ephemeral moment caught by the artist, crystallized but not deprived of vitality. Their "now" is our now. Where Hals' talent lay, and what made his technique suitable and pertinent for the painting of portraits, was in its intuition. However carefully he planned his paintings (especially with his studiously applied brushwork), the resulting imagery tends not to support a sense of solid, dense shapes precisely separated from one another; rather, his pictures have that impact Impressionists were later to study: a visual sensation that creates sympathy between the actors within the painting and between the painting and spectator.

The "mobile sensibility," unaffectedness, and animation captured by Hals is more typical of eighteenth-century portraiture. What has often been called the cult of sensibility or sentimentality in culture and literature began as a conscious reaction on the part of the middle and intellectual classes against the grandeur and gravity of court society (see also Chapter 8). Philosophers and writers, especially in Britain – such as John Locke (1632–1704) and the 3rd Earl of Shaftesbury, Anthony Ashley Cooper (1671–1713) – wrote about human understanding in terms of a natural, inner morality, sentiments or feelings, and the ways in which these feelings as well as our recollections bring to mind many other associations. Shaftesbury's notion of a natural morality contrasted with the Catholic doctrine of inherent sinfulness. His optimistic belief professed that the individual is not condemned to a wretched moral life (one that the Church taught was redeemed by a belief in Christ) because of the Fall of Adam and Eve. Shaftesbury assumed that we have an innate capacity for discernment, taste, sensible judgment about right and wrong, and apperception of beauty. The Scots–Irish writer and philosopher Francis Hutcheson (1694–1746) reflected Shaftesbury's alliance of morality and aesthetics and belief in an inner

sense. In *An Inquiry into the Original of our Ideas of Beauty and Virtue* (1725) he explained: "The origin of our perceptions of beauty and harmony is justly called a 'sense' because it involves no intellectual element, no reflection on principles and causes."

Boucher

In the early years of Louis XV's somewhat erratic leadership, his mistress the Marquise de Pompadour (1721–64) secured a great deal of power in the governing of France. For more than two decades, she served Louis as an executive secretary and supervised all appointments to office. Anyone who questioned her right to make large withdrawals from the public treasury found themselves confined to the Bastille. Her power depended upon her status as the King's mistress and the alliances of those whom she had appointed. Tenuous though it was, she held on to that power until her death in 1764.

She also was a vigorous patron of the arts. Her portrait (FIG. 6.13) by François Boucher demonstrates once again how the artists of the Baroque and Rococo could reveal through painting what had been achieved in society. This painting is not meant as a precise recording of the Marquise's appearance nor a rendering of a typical setting for her. As a portrait it is a *construction* of her identity through the presentation of various devices and strategies of placement. Her puff-sleeved, satin dress with a tight bodice and widely spreading skirts is not fashionable; it is a vaguely Spanish-looking prop used by Boucher on more than one occasion and for more than one sitter. The books refer to the accepted intellectual pursuits of the age. In the tradition of the educated woman of the Enlightenment, she looks over a volume of verse, having perhaps already mastered the wisdom and enrichment contained in the texts beneath her left arm. But she now pauses to respond to "nature," in the voice of a nightingale. She is at once sensitive to book learning and the influences of a prettified natural setting. Her leafy bower is that highly convention-

6.13 (*opposite*) FRANÇOIS BOUCHER, *Portrait of Madame de Pompadour*, 1758. Oil on canvas, 20½ x 22¾ in (52.4 x 57.8 cm). Victoria and Albert Museum, London.

Boucher's portrait shows the Marquise reclining in a heavily wooded garden, the silvery gray-green shrubs and pink flowers providing a perfect complement to her gray satin dress. The setting is also intended to indicate the pastoral mode; indeed, the book in the Marquise's lap may be a copy of Cardinal de Bernis's pastoral poetry, her favorite reading matter. Both figure and setting are conventional, and reveal nothing of her true character.

al pleasance or "place of love" (see pp. 34–5), cherished by elegant society in the eighteenth century.

Vigée Le Brun

Prior to the French Revolution, Elisabeth-Louise Vigée Le Brun (1755–1842) also painted what we can call portraits of sensibility, even when making images of the queen. Her portrait of Marie-Antoinette *en chemise* (FIG. 6.14) raised a few eyebrows at the Salon (the official exhibition of members of the French Royal Academy) in 1783; indeed, under pressure she withdrew the painting from the exhibition. Because this very expensive, casual clothing – known as a *chemise en robe* – was associated by many with lingerie, the artist was perceived as having broken rules of

decorum. But we know that the Queen loved this relaxed, even intimate, portrait of herself. What the cult of sensibility has done, perhaps without either the Queen or her artist being very conscious of the fact, was to undermine, or compromise, the power of the monarchical portrait, such as Bernini's and Rigaud's portraits of Louis XIV (see FIGS. 2.13, 6.9) by a new sensitivity. Delicacy and taste now were linked less with rigid forms of aristocratic and courtly etiquette than with the free expressions of one's feelings. The cult of sensibility valued that which welled up from within, rather than that which was imposed from without.

In the portrait of the Queen, shapes and outlines of forms project, recede, and undulate. Her plumed hat, casually looped and knotted sash, loose hair, and bare forearms give the painting a

6.14 ELISABETH-LOUISE VIGÉE LE BRUN, *Marie-Antoinette en chemise*, Salon of 1783. Oil on canvas, 35½ x 28¼ in (90 x 72 cm). Schloßmuseum, Darmstadt.

By placing the queen against a plain, dark background, Le Brun emphasizes the outlines set up by the studied yet natural pose. Arms, ribbon, and hat plume enclose the face in a sweeping curve, and the diagonal lines of the forearms and brim of the hat converge on the bunch of flowers, which complements the queen's face.

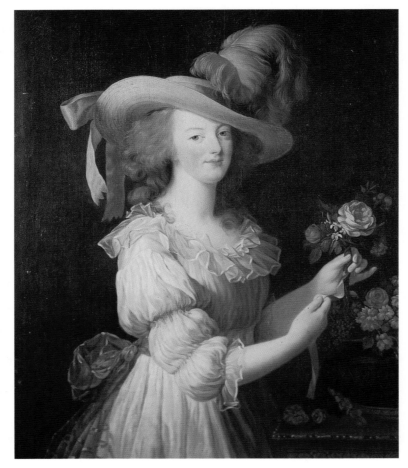

6.15 JOSHUA REYNOLDS, *Mrs. Siddons as the Tragic Muse*, 1784. Oil on canvas, 7 ft 9 in x 4 ft 9 in (2.3 x 1.4 m). Henry E. Huntington Library and Art Gallery, San Marino, California.

This portrait of Sarah Siddons (1755–1831), which was regarded by Reynolds and his contemporaries as his masterpiece, is a good example of the artist's ability to give his portraits multiple associations. The great tragic actress is portrayed with the attributes of Melpomene, the Muse of Tragedy, and her pose resembles that of the prophet Isaiah by Michelangelo on the Sistine chapel ceiling. In this way Reynolds raised the status and tone both of the sitter and of the painting.

fleshy and erotic piquancy. Her nearness to the picture plane and smiling face capture our attention and invite an indecorous intimacy. She wraps a silk ribbon around a rose, the flower of love and valentines, the flower with which she so closely identified. This is the woman widely believed to have said (although there is no evidence for it), when told that there was no bread for the peasants: "Let them eat cake." This is the woman who loved to play milkmaid. Perhaps she was not so much trying to escape reality as she was indifferent to – or perhaps trying to redefine – queenly presence. For her the cult of sensibility had exquisite appeal and, finally, as she approached the guillotine, acute irony.

Reynolds

The British portrait painter of the eighteenth century most concerned with status and elegance was Sir Joshua Reynolds, the first Director of the British Royal Academy. Although temperamentally opposed to sentimental portraits, sometimes the effects of his portraits were as nonchalant as Vigée Le Brun's. His portraits were sought by aristocratic Londoners as the epitome of contemporary refinement and fashion. His portrait of Mrs. Siddons (FIG. 6.15) seems to illustrate his advice in his *Discourses* (the annual lectures he gave to the members of the British Royal Academy of Arts): "If a portrait painter is desirous to raise and improve his subject, he has no other means than by approaching it to a general idea." One does this by changing "dress from a temporary fashion to one more permanent, which has annexed to it no idea of meanness from its being familiar to us." Reynolds, in other words, took the precise opposite path of Vigée Le Brun, whose *chemise* for the Queen was the latest fashion, just imported from London. Mrs. Siddons, by being shown enthroned as an ancient Greek muse – in this case, one who inspires the tragic poet – is a perfect example of the Grand Style most assiduously promoted by Reynolds.

Reynolds' Grand Style did not exclude the sense of play and sentiment typical of the age. Sarah Siddons was the most famous tragic actress

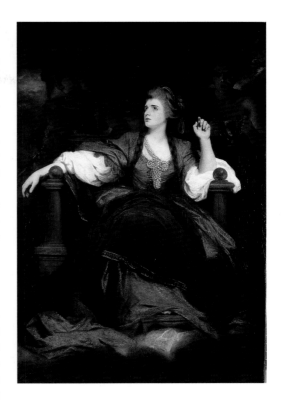

of her time, especially renowned for her portrayal of Lady Macbeth in Shakespeare's play *Macbeth*. The British writer William Hazlitt said of her that "passion emanated from her breast as from a shrine. She was tragedy personified." Yet her pose here is nonchalant – it gives an appearance of being effortless or unposed. One of the stories associated with the painting tells us that Sarah Siddons, late for her sitting, rushed into Reynolds' studio, threw herself on the throne, removed her bonnet, rested her head momentarily in her hand, then turned to the painter and asked, "How shall I sit?" "Just as you are," Sir Joshua replied. Mrs. Siddons also related to another painter that the pose came from an idle moment when Reynolds was preparing some colors and she happened to turn and look at another of the artist's paintings hanging on the wall. He saw the expression and pose, and asked that she hold it. A third explanation of the pose can be given in Mrs. Siddons' own words (Wendorf, pp. 153–5):

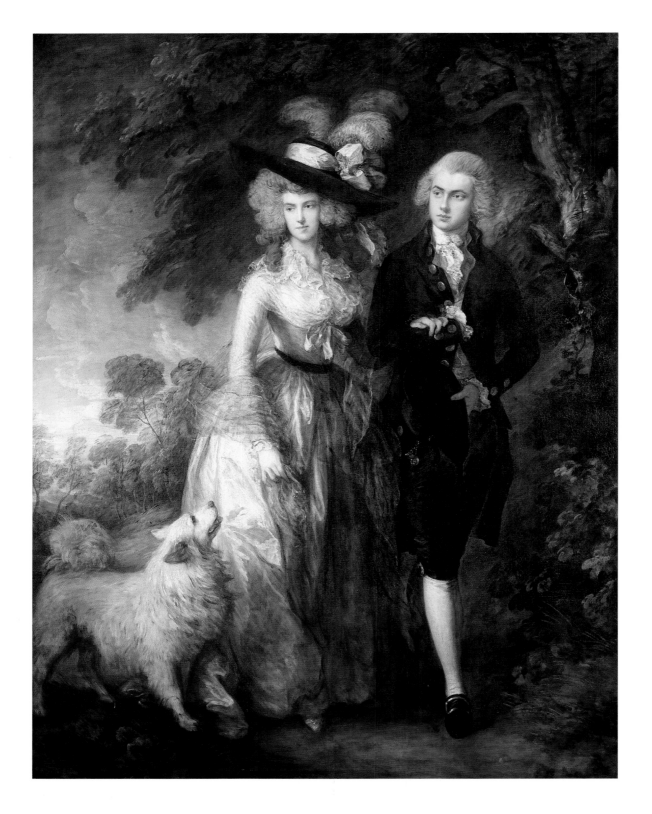

At the very end of his
career, Gainsborough
painted this society cou-
ple embarking on a new
life together. The newly-
weds' serene elegance is
conveyed by a light and
feathery touch – evident
too in the fur of the
Spitz dog and Elizabeth
Hallett's gauzy shawl.
The artist achieved this
vaporous effect by using
six-foot-long brushes,
placing the canvas mid-
way between himself and
his sitters.

When I attended him for the first sitting,
after many more gratifying encomiums
than I dare repeat, he took me by the
hand, saying, "Ascend your undisputed
throne, and graciously bestow upon me
some grand Idea of the Tragick Muse." I
walkd up the steps & seated myself
instantly in the attitude in which She now
appears. This idea satisfyd him so well that
he, without one moments hesitation,
determined not to alter it.

These anecdotes communicate the importance
of the spontaneous and (apparently) unrehearsed
pose, one that appeared natural, in a sense play-
ful, and certainly theatrical.

Gainsborough

Reynolds always had in mind the setting of the
Royal Academy and its annual exhibitions. He
understood that for a painting to look good in
that space, he had to give it a sense of weight and
solidity. Thomas Gainsborough (1727–88) pros-
pered greatly from the portrait trade, but both he
and his patrons preferred a light and airy version
of the sentimental portrait, what Joshua
Reynolds in not very complimentary terms
called "fancy pictures." Because he objected to
the great height at which pictures were hung in
the Royal Academy, Gainsborough quarreled
with the organizers of the exhibition in 1784 and
refused thereafter to participate, preferring to
show his paintings at his own home, where he
had control over the lighting and display. He
insisted upon a close view: his conception of a
picture was of something delicate and fine, not
ponderous and dense.

Gainsborough's *Morning Walk* (FIG. 6.16) is
a fine representation of the casual yet elegant
life chosen by many of the younger elite – in
this case, William Hallett and his wife Elizabeth
– near the end of the eighteenth century. In
this, the first stroll of the sitters the day after
their wedding, Gainsborough can combine his
own love of landscape painting with an almost
vaporous rendering of a graceful young couple.

This may be an idle and pleasant morning
stroll, but it is typical and therefore deeply
meaningful in the sense that daily rituals are the
very stuff of life. Observers have called this a
mood picture, filled with romance (although
the couple pay no attention to one another),
and wistful associations. The nineteenth-century
Romantic French poet Théophile Gautier
remarked that when looking at this painting he
felt a "strange retrospective sensation, so intense is
the illusion it produces of the spirit of the eigh-
teenth century."

In general, seventeenth- and eighteenth-century
portraits represent individuals who define them-
selves in relation to their place in family and soci-
ety, and, to a degree at least, in terms of which
portraitist they choose. But many of those things
that define an individual or the self are also
important. A "mobile sensibility," in Lerner's
phrasing, appears in many guises in the portraits
of this period. Marie Antoinette often chose to
have herself shown as a friendly confidante in
court society. Mrs. Siddons looked for some-
thing more exalted, the tragic muse. The couple
in the *Morning Walk* viewed themselves as part of
the independent and landed gentry, who wore
their fancy clothes with apparent nonchalance
and great aplomb. The number of individually
and socially determined guises that one could
choose in the seventeenth and eighteenth cen-
turies was limited only by imagination, wealth,
and the availability of a talented portrait painter.

SELF-PORTRAITS

Princely portraits and portraits of gentlemen and
ladies usually show socially constructed identities.
Baciccio's *Pope Clement IX* (see FIG. 6.10) may
appeal to our desire for a personal relationship
with the pope, but that is because he is the Holy
Father. A constructed identity has been carefully
crafted according to conventions of the age, the
needs and interests of the sitter, and suggestions
of the artist. The intention of such images is often
to present a persona that turns outward toward
the world rather than inward. A self-portrait may

also be carefully tuned so as to create an image as a garment to cover the self. But self-portraits focus on the individual, too, upon the elements of selfhood, subjectivity, personality, and inner being. Portraits that penetrate deeply into the human psyche generally isolate the figure from a larger context, so that there are few props, little or no sense of environment, and no narrative.

Rembrandt

Rembrandt van Rijn painted, drew, and etched as many as one hundred self-portraits that reflect both a public persona and another more private one in which the emotions, the soul, and the multifaceted nature of the artist's self draw the viewer's attention. Although he would have considered himself a history painter first of all, his remarkable number of self-portraits betray a life-long interest in who he was and how that changed over time. There is no evidence, however, that he kept these works together as a group for the purpose of personal reflection. Indeed, he seemed to feel no compelling need to hold on to them once they were painted. Inventories of his private collection show that they were all sold, probably soon after he made each one. It is perhaps surprising that in the seventeenth century there was a lively market for portraits, even if the sitter were unknown to the buyer.

Even if Rembrandt did make these self-portraits for the market rather than for himself, they are in a profound sense records of who he was. We need not worry that we are viewing these images in terms of modern psychology – and therefore imposing an anachronistic interpretation upon them – for in Rembrandt's own age there was a pervasive interest in questions of emotion, identity, and physiognomics (the reading of character from gestures, expression, and physical appearance). As evidence of self-reflection and an interest in psychology, one can mention the essays of Montaigne in the sixteenth century ("The greatest thing in the world is for a man to know how to be his own"), the philosophy of René Descartes (see p. 214), and the lectures given by Charles Le Brun to the students at

the French Royal Academy of Painting, Sculpture, and Architecture in 1668 on the expressions of the human body and face and how these reflect the inner emotions and "state of the soul" (see pp. 64–5 and 365–6).

One of Rembrandt's early self-portraits, done when he was only twenty-three, shows him wearing a fancy costume (FIG. 6.17). This is not a deeply introspective work; rather, he is giving us a self-fashioned image of the successful young artist. The lovely blue beret with ostrich plume and the dramatic lighting that cuts across his face like a crescent moon are highly theatrical devices appropriate for a public performance. The chain and medallion would seem to advertise himself as the recipient of some important honor; however, unlike Velázquez, Bernini, or Rubens, Rembrandt never won a knighthood or other accolade to enhance his prestige. He cheats a little here – perhaps that is why the light is somewhat eccentric, so that we cannot read the medallion.

Rembrandt's late self-portrait of 1658, however, displays a more pensive – perhaps even dispirited – mood (FIG. 6.18). Once again the artist dons a peculiar costume, something he may have picked up at a public rummage sale. Filippo Baldinucci, who had reliable correspondents in the Netherlands, wrote that Rembrandt "often visited public auctions where he bought used and old-fashioned clothes which appeared to him bizarre and picturesque. And these, in spite of their sometimes being filthy, he would hang along the walls of his studio among the beautiful things which he also delighted in possessing" (Wittkower, p. 276). The face is passive. As psychological experiments have shown, a face which seems to have no expression will be read as conveying any number of different emotions, depending upon the mood of the spectator or what kinds of images might be displayed near by. This confirms that there is a powerful need on our part to understand faces, no matter what kinds of cues are presented. The intimations of this face are quite subtle. As in the earlier picture, there are hints of a princely status. But the ungainliness of pose, strangeness of costume (especially within the context of seventeenth-century Amsterdam), and the

6.17 (*opposite*)
REMBRANDT, *Self-portrait*, 1629. Oil on canvas, 35 x 29 in (89 x 73.5 cm). Isabella Stewart Gardner Museum, Boston.

Many of Rembrandt's early self-portraits are experiments in technique, mood, and expression. Here, for example, the extravagant plume on his hat serves as a means to show off his skill, and the lighting appears partly from behind and partly from in front of the picture, which creates a dramatic and mysterious effect. The scale and meticulous finish of this painting, however, are something new, and point towards the later, more complex, studies in human identity for which he is so famous.

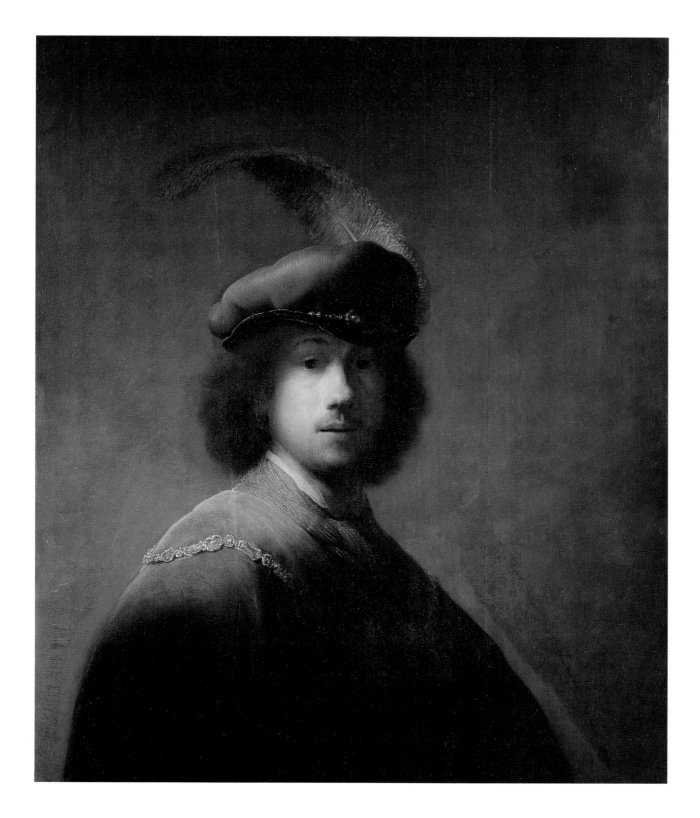

6.18 REMBRANDT,
Self-portrait, 1658.
Oil on canvas,
4 ft 4¾ in x 3 ft 4¾ in
(1.34 x 1.04 m).
The Frick Collection,
New York.

In no other self-portrait
does Rembrandt use so
much extravagant brush-
work and bright color –
great expanses of red and
yellow applied freely and
with vigor, and then cov-
ered with glazes of the
same colors. The strong
pyramidal composition,
with arms outstretched
and legs slightly apart, is
also striking. And yet the
overall effect is one of
sadness and vulnerability.

roughness of texture suggest that the intentions are mainly ironical. He seems to be saying, "I am not the prince of painters, I have no pretensions to a higher class, but I am a man who makes images, and in order to do that I must know myself." Although Rembrandt continued to sell paintings, and especially portraits, right up to the end of his life, he was not quite so popular as he had been in his earlier years. His finances were in a mess. He had to auction off all of his personal belongings, including numerous paintings, drawings, sculptures, armor, and many props for his paintings. At the time he painted this picture, he had just declared insolvency.

This is therefore the self-portrait of a troubled man. The casting of the face into shadow follows a tradition of suggesting a melancholic temperament, one frequently associated with artists. Aristotle had written that "[a]ll extraordinary men distinguished in philosophy, politics, poetry, and the arts are evidently melancholic" (Wittkower, p. 102), commenting on Plato's notion that geniuses suffer from a kind of mania, one associated with creativity and inspiration.

The painting also provides physical evidence of Rembrandt's individuality and creativity. When looking closely at this portrait, one becomes highly aware of the thickness of the paint and the artist's gesture, the way the pigment has been pushed about by the butt-end of the brush. The effect is to mix objective and subjective imagery. You look at Rembrandt's eyes

and hand; then you look at the drips and smears of paint. The artist's hand movement, his hand-writing as it were, draws you close to the act of creation. Then the image of the man and his features reasserts itself. One knows the artist by his appearance and by his traces.

Perhaps no other artist declared himself more completely than Rembrandt. As Montaigne had asserted in the sixteenth century, the self is not a simple and stable concept, but shifts its ground and never completes its work. An autobiography, like a self-portrait, is an unfolding of self. "I am myself the matter of my book," said Montaigne; Rembrandt might have said, "I am myself the matter of my painting."

Rubens

Peter Paul Rubens had less of an interest in self-portraits than did Rembrandt. Instead it was his landscape paintings, especially those that recorded the property that he owned and knew best, that seemed to have had deep personal meaning for him. When he did paint a self-portrait (FIG. 6.19), it was at the request of another, in this instance Charles, Prince of Wales, later King of England. He wrote that Charles "has asked me for my portrait with such insistence that I found it impossible to refuse him. Though to me it did not seem fitting to send my portrait to a prince of such rank, he overcame my modesty" (pp. 101–2). We

6.19 PETER PAUL RUBENS, *Self-portrait*, 1622–3. Oil on canvas, 33¾ x 24½ in (85.9 x 62.3 cm). The Royal Collection, Windsor Castle.

The description of Rubens by the French aesthetician Roger de Piles (see p. 366), based on information given him by the artist's nephew, accords well with this self-portrait: "He was of tall stature, of stately bearing, with a regularly shaped face, rosy cheeks, light-brown hair, eyes bright but with restrained passion, a pleasant expression, gentle and courteous." Rubens usually depicted himself as wearing a wide-brimmed hat, partly to conceal his premature baldness.

can assume that Rubens was as self-regarding as the next person and was deeply pleased to send his image to the king of England. But it is equally apparent, both from his words and from the finished product, that he was not as captivated by his own image as was Rembrandt. Although Rubens presents himself with a degree of elegance, he does not make himself out to be a prince. His costume is appropriate for the upper-middle classes, and his expression seems candid, forthright, and unpretentious. It would seem that Rubens had little interest in showing anything other than his public persona, one that had been carefully crafted in intellectual, artistic, and diplomatic circles. There is nothing intimate, introspective, or deeply moving in this self-portrait.

Gentileschi

When Artemisia Gentileschi made her portrait as an allegory, or image, of Painting (FIG. 6.20), she was engaged in the well-established tradition of personifying virtues, forces, and activities. The figure of Painting (La Pittura), however, was a relatively recent characterization, appearing first in emblem books of the late sixteenth century. For painting to be allegorized or personified signaled a rise in the position of the artist, who now occupied a place in the hierarchy of values on a par with other professionals (see pp. 53–6); painting had become comparable in value to poetry and music. Although the question of why the personification of painting should be portrayed as a female allegory has not been answered (it probably has something to do with the established association of the feminine form with beauty), it was fortuitous for Gentileschi. In merging her own appearance with that of the powerful image of La Pittura she could present herself with pride as that unusual phenomenon, a woman artist.

Like Rembrandt's self-image of 1629 (see FIG. 6.17), she wears a chain and medallion, but not to suggest an honor won. This is the badge of art: as another reference to painting, it shows a woman in profile, so that there is an allegory within an allegory. These visual references were

available in a handy guidebook of the period known as *Iconologia*, by Cesare Ripa; this describes the profile mask on the medal that dangles from a golden necklace worn by the allegorical figure of Painting. Ripa suggests writing the word *imitatio* ("imitation") below the image. Artemisia Gentileschi (contemporary engraved portraits confirm that these are her features) does not just stand in for a figure that already is a stand-in for an abstract idea – she takes it over. She is not just *inside* the allegorical idea, she also wears it as a medal and shows her own intention and determination. Personifications can be idealized and static figures who, by simply posing in the most economical way to represent their overarching ideas, have no independent motivation.

6.20 (*opposite*)
ARTEMISIA GENTILESCHI,
Self-portrait as the Allegory of Painting, 1630.
Oil on canvas,
38 x 29 in
(96.5 x 73.4 cm).
The Royal Collection,
Kensington Palace,
London.

No other self-portrait gives such a sense of the physicality and labor of the painter. Gentileschi is so absorbed in her work that she seems unaware both of her spectators and of the image of Painter that she personifies. Apart from the mask on the medal that represents imitation, the Painter's skill in handling color is suggested by the dress of changing hues, and her active imagination by the loose hair.

But the Baroque rhetoric here adds vigor and animation to this tradition. Compare, for instance, Bernini's allegorical representations of Charity and Justice in his *Tomb of Urban VIII* (see FIG. 4.3) with Guglielmo della Porta's figures of Prudence and Justice in his late Renaissance *Tomb of Paul III* (see FIG. 4.1). In a similar fashion, Gentileschi inhabits La Pittura's figure aggressively, leaning toward an (unseen) canvas, with unkempt hair and powerful shoulders.

Poussin

Another allegorizing self-portrait as painter is by Nicolas Poussin (FIG. 6.21). The face of La Pittura now appears as a detail on a picture in the background. On the back of another canvas there is a Latin inscription that spells out that this is an image of Nicolas Poussin in his fifty-sixth year, painted in Rome in 1650 during the Jubilee, a Catholic celebration that took place every fifty years. The urge to supply precise documentation seems to fit with what we know of Poussin. He gives himself a creased forehead, a tensed brow, and a slightly frowning mouth. The room and the squared-off canvases are as severe as the expression on the face. Here is a painter who discloses little other than official information, yet his association with the Church, with the noble pursuit of painting, and with the old tradition of the Latin epitaph (usually reserved for tombs) is clear and powerful.

6.21 NICOLAS POUSSIN,
Self-portrait, 1650.
Oil on canvas,
38½ x 29¼ in
(98 x 74 cm).
Louvre, Paris.

Poussin painted two self-portraits; this one, done at the height of his powers, he regarded as "the better painting and the better likeness," perhaps because it summarized the discipline, rectitude, and determination of his art and character. The canvases and the door behind him are a view of his studio; the effect is one of geometric severity. The uncompromising color scheme of the work reinforces the theme.

Carriera

Rosalba Carriera (1675–1757) of Venice began her working life in the luxury lace trade, having learned from her mother the method known as *point de Venise*. When that industry failed – probably as a result of poor management rather than from a lack of demand – she turned to painting miniature scenes in oil on snuff boxes. She soon set aside these tiny ivory panels and turned to portrait painting, which was becoming the largest art commodity of the eighteenth century.

Her success was immediate. She became a member of the Academy of St. Luke in Rome and the Royal Academy in Paris. Her portraits were in demand by members of the elite societies of Germany, Poland, France, and England. When she travelled to Paris in 1720, it was at the invitation of Pierre Crozat, an extremely wealthy financier, the King's treasurer, and an avid patron and collector of art. Once the regent Philippe, duc d'Orléans, had paid a visit to her in Crozat's town house, her status was assured and she was inundated with demands for portraits. The British Consul to Venice, Joseph Smith, pursued her relentlessly, amassing a collection of nearly forty works by her. August III, King of Poland and Elector of Saxony, was another important customer. She went to Vienna in 1730 and lived for six months under the patronage of the Holy Roman Emperor, Charles VI; the empress became her pupil.

There were other portraitists in Venice, but none attracted so much attention as Carriera. There were better painters in Europe, but few if any could compete with her for commissions. Her extraordinary success apparently stemmed from her ability to create intimate, charming, and feminine images (even of men), the kind that were in ever-increasing demand from those members of polite society who followed the "cult of sensibility" (see pp. 226–34). The new psychology of the eighteenth century had positive implications for both men and women. It became not only permissible but fashionable to cry in public. In contrast to the stoic tradition, which condemned as weak any expression of

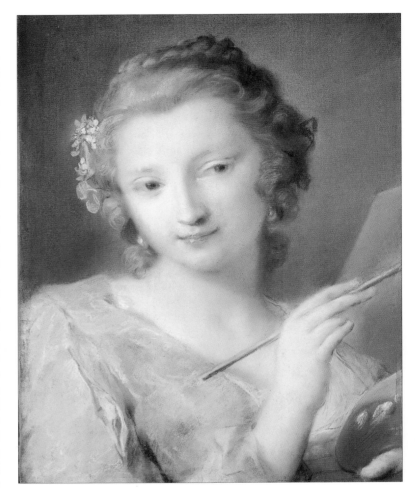

grief or poignancy, sensibility encouraged a sympathetic understanding of one's passions. The Catholic Church may have distrusted human emotion because of its association with humanity's fallenness, but the sophisticated, secular society of the eighteenth century embraced it. In 1735, for example, the British periodical *The Prompter* identified the person of feeling as one who "is not satisfied with good-Natured actions alone, but feels the Misery of others with inward Pain. It is then deservedly named Sensibility."

The association of sensibility with women and the emerging concept of the "feminine" were both products of this period. In the nineteenth century the Goncourt brothers, who wrote extensively on Rococo art, observed that pastel

6.22 ROSALBA CARRIERA, *Allegory of Painting*, c. 1720. Pastel on paper, 17¾ x 13¾ in (45.1 x 35 cm). National Gallery of Art, Washington.

pictures, introduced by Carriera to France, were because of their intimacy and sensibility an "art exercised by women and appealing to women" (p. 163). Carriera could capture sensibility in visual terms.

Before looking at her self-portrait, let us turn to Carriera's *Allegory of Painting* (FIG. 6.22) for which she chose her favorite pupil, Felicità Sartori, as the sitter. This is one of the artist's "fancy pictures," an allegory or personification of an abstract idea. Carriera preferred the impressionistic effect achieved with pastels to oil painting. The sense of immediacy and incompeteness in the rendering of tones and the modeling of forms, along with the disordered chemise, sparks the observer's interest. The color and value of the eyes, dress, shadows, ribbon, and flower in the sitter's hair pull the painting together with a powerful sense of

unity. She lowers her head shyly and submissively. The image almost begs to be possessed, clasped to one's breast.

The French newspaper *Mercure de France* described the *Muse Chasing Apollo* of 1720, which was Carriera's reception piece for the Royal Academy in Paris, in terms of the "gracefulness" of the image, the "lightness" of touch, and the dazzling, jewel-like qualities of the color. The delicate attention of this language to subtle effects reflects the taste of sensibility. Others commented on the "charm" of her pictures, using in a modern, eighteenth-century sense an old word redolent of enchantment and the oracular.

These erotic and feminized effects worked beautifully for her portraits and fancy pictures, but for her *Self-portrait* (FIG. 6.23) she produced an image of unflattering directness. Carriera was nearing seventy, about to go blind. Her great

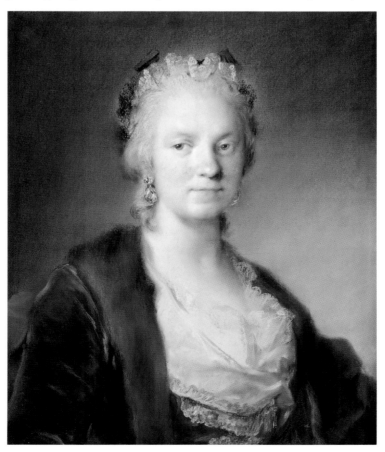

6.23 ROSALBA CARRIERA, *Self-portrait*, c. 1745. Pastel on paper, 22½ x 18½ in (57.2 x 47 cm). Royal Collection, Windsor Castle.

patron, Joseph Smith, asked for her image as the capstone to his large collection of her pictures. Although she used pastels, brought her own face close to the picture plane, and kept the background indistinct and vaporous, one experiences something other than an emotion of sensibility. There is here an unnerving proximity to a beautiful woman nearing the end of her life, one who has no pretensions, no sense of ostentation, no need to beguile or seduce the viewer. She seems to drop the stock-in-trade of her professional life and to reach for something more true.

An artist makes a self-portrait for a number of reasons. As a practical studio exercise, he or she may want to work out, when there is no model handy other than oneself, certain visual problems having to do with gesture and expression. Bernini did this with his *Anima Dannata* (FIG. 6.24). Other painters, such as Poussin or Rubens, gained sufficient fame for a patron to request their image. It was a matter of prestige for the collector to own such a self-portrait. Or a painter may advertise herself, as Artemisia Gentileschi did with her self-portrait as an allegorical representation of painting. The more intricate and problematic self-portrait finds the artist involved in a profound reckoning with his or her own character, often toward the end of life. Such works by Rembrandt and Carriera, seen above, take on a moral charge as the artists strive to weigh up the significance of their lives. Capturing a "likeness" is perhaps less important here than the struggle, through painting, to make sense of themselves as individuals. Individualism as a political idea had little currency before the late eighteenth and nineteenth centuries (when Alexis de Toqueville coined the term), but its later political manifestation can be inferred in a nascent form from Baroque self-portraits.

Individuals identify themselves independently from state or even professional institutions, value their autonomy, define themselves, are themselves an end rather than a means in a larger social scheme, and conceive of themselves as inferior to none. Catholic cultures tend to downplay the role of the individual on earth (although

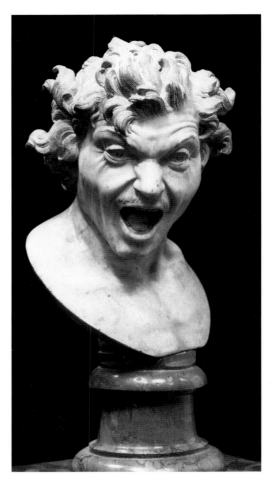

6.24 GIANLORENZO BERNINI, *Anima Dannata*, c. 1619. Marble, lifesize. Spanish Embassy to the Holy See, Rome; on loan to the Galleria Borghese, Rome.

Bernini's hair-raising self-portrait as a soul in hell gains much of its power from the prominent crossed diagonals caused by his facial expression, accents that are reinforced by further crease lines on the cheeks and brow. Although the sculptor was a pious man, he may have used this image as a means of exploring or releasing the darker side of his nature, but also simply as a technical exercise.

the individual soul is paramount in importance), as do monarchies. Dutch society in particular, significantly Calvinist and capitalist, provided an environment sympathetic to individualism.

Still Life

A love of the typical and fascination with the unremarkable, normal, and therefore familiar informs a genre that was well established in the seventeenth and eighteenth centuries – the still life. Despite being slighted by such critics as Félibien and Reynolds, the still life was hugely popular. One of the great strategies of visual rhetoric is to put the audience at ease, to create the fiction that a painted scene, for instance, is so common and familiar that one unconsciously

accepts its presence. Still-life painting seems to address that human desire to be near those things that are so often displayed on tables, like food and flowers, and which are usually unremarked but necessary and often loved companions. It can also be used to celebrate the conspicuous and the luxurious. Beautiful flower arrangements, tropical fruits, Japanese porcelain, silver goblets, and other splendid objects of the table attest to the wealth of the prosperous middle-class patron and appeal to his or her love of the rare and the exotic.

STILL LIFES IN SOUTHERN EUROPE

Although still-life painting found a comfortable home in the Netherlands (see pp. 247–52), it existed elsewhere. There is some debate whether or not Caravaggio developed his own ideas about still-life painting independent of Netherlandish examples; in any case, his rendering of a basket of fruit (FIG. 6.25) is typically his. Caravaggio's visual strategies were usually worked out against academic and classical styles (see pp. 164–7). For

instance, here he places the basket at the edge of a table; in fact, it is slightly over the edge, ready to fall into the viewer's lap. This challenging of the traditional separation between pictorial and real or viewer's space breaks one of the unities of classical art, which insists upon the purity of the self-enclosed pictorial environment, isolated from and apparently indifferent to the presence of an outside gaze. By threatening the "personal space" of the viewer, Caravaggio plays on our expectation that we will remain unimplicated and unseen in the act of viewing the work of art. Then, upon closer inspection, we see that the leaves are bug-eaten and that fruit is bruised and has worm-holes, a rueful provocation of the expectation (especially for a seventeenth-century viewer) that art should idealize and improve upon nature. We are reminded, instead, of the transience of all things. Add to this the unusually light background and low point of view, so that the edge of the table seems to be precisely at eye level, making it difficult for us to guess the depth of space, and one has a still life that is almost surreal.

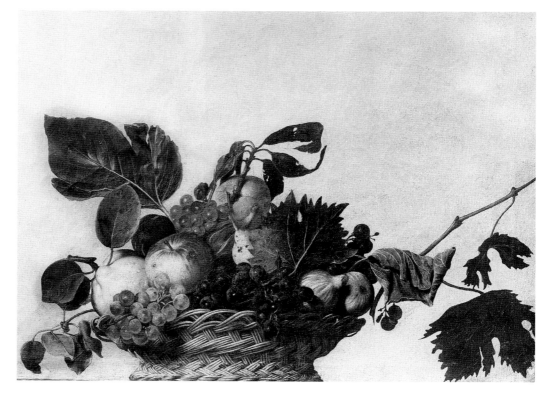

6.25 CARAVAGGIO, *Basket of Fruit,* 1598–1601. Oil on canvas, 18 x 25 in (45.7 x 63.5 cm). Pinacoteca Ambrosiana, Milan.

The basket of fruit appears to have been arranged haphazardly, yet in such a way as to reveal each element clearly. The effect is a celebration of the various shapes, colors, and textures of the fruits and leaves, and even of the straw of the basket. The leaves are at different stages of life – or decay: the leaf on the upper left is full of vitality, whereas those drooping on the lower left and right are withering and dying.

In contrast, Juan Sánchez Cotán (1561–1627) secures his objects within a frame-like space, with a bottom ledge, side walls, a dark background, and even cast shadows (of which Caravaggio had none). Many of his paintings of food date from the time around 1604 when he became a Carthusian monk. Perhaps in their simplicity they reveal the humbleness of the life he sought in his religious withdrawal. In *Still Life with Quince, Cabbage, Melon, and Cucumber* (FIG. 6.26) his usual placement of a handful or small armful of comestibles on a framed ledge suggests an abiding interest in those non-human things that sustain us, those humble victuals without which we do not survive. At the same time as he pays homage to that most communal of all commodities, he seems as well to give them the status of art objects, as things that are so carefully arranged that we can hardly imagine them moved about without destroying the unity and the organic perfection that he unerringly achieves in his painting.

These paintings are as much about art as they are about food. Caravaggio pushes fruit into our laps; Sánchez Cotán seems to ask for a more contemplative and perhaps engrossing

6.26 JUAN SÁNCHEZ COTÁN, *Still Life with Quince, Cabbage, Melon, and Cucumber*, c. 1602. Oil on canvas, 27 x 33¼ in (69 x 84.5 cm). San Diego Museum of Art, California.

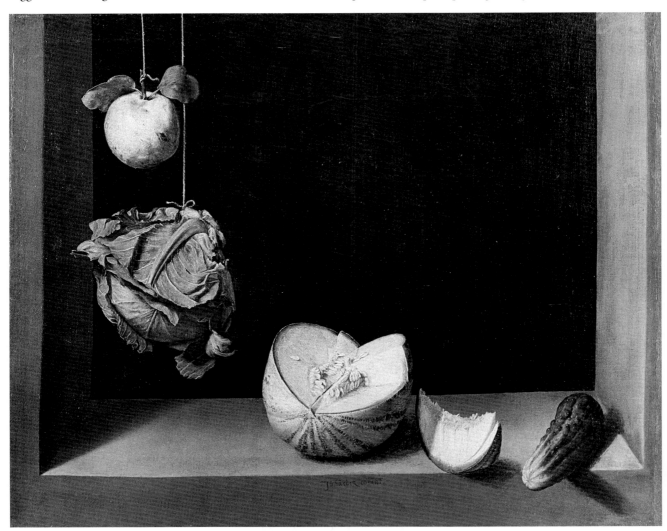

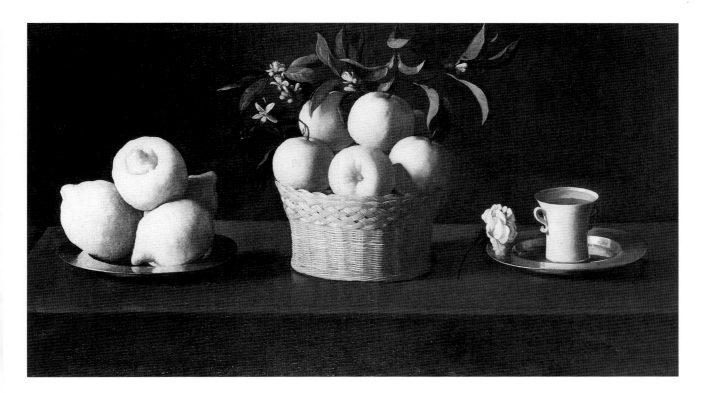

6.27 Francisco de Zurbarán, *Still Life with Lemons, Oranges, Cup, and a Rose*, 1633. Oil on canvas, 24½ x 43 in (62.2 x 109.2 cm). The Norton Simon Foundation, Pasadena.

In Spain, as elsewhere, flower and fruit paintings were downgraded by the artistic elite as easy and frivolous in comparison to serious history and figure painting. In this light, perhaps we should see Zurbarán's only securely attributed still life as a virtuoso showpiece – an entertainment – rather than as a piece with more serious, even religious, intent.

relationship of the viewer with the minutely detailed objects.

Even in his narrative scenes, the Spanish painter Francisco de Zurbarán (1598-1664) emphasized the tangible quality and independence of objects rather than an overall unity of composition (see p. 365). In his still life painting (FIG. 6.27) he gives to the viewer a precise three-part arrangement of lemons, oranges, and cup with saucer and rose caught in a raking light against a dark background. Although these objects have no overt symbolism, the straightforward and emphatic manner in which they are presented perhaps responds to or prompts some need within us. This, Zurbarán's only signed still life, has been compared to a work of religious devotion. The semiotics of a still life, especially when there is no apparent moral lesson, is open to speculation, and one cannot easily explain how these images create meaning. It is obvious, however, that these objects have been arranged for a spectator; it is equally apparent that the hard-edged modeling, overly emphatic contrasts

between the lighted surfaces and impenetrable background, and the mathematically precise distancing of one article from another (and from the viewer) is hardly welcoming. The separation between the objects represented and us – between what seems immediately accessible and what we cannot have – creates an unresolved tension.

DUTCH STILL LIFES

As the best horticulturists in Europe, the Dutch especially loved flower pieces. The financial speculation in tulip bulbs (imported from Turkey in the mid-sixteenth century) reached levels of frenzy in the 1630s, which suggests something of their national obsession with exotic flowers. And those who specialized in flower painting were among the best-paid artists of their time.

Ambrosius Bosschaert the Elder (1573–1621) was the first of several family members who were successful flower painters. In his

Bouquet in an Arched Window (FIG. 6.28), Bosschaert's use of the arched window reveals the influence of traditional Renaissance themes, which often favored precisely centered views through windows onto a pacific and imaginary landscape. It is unlikely that he worked directly from the flower arrangements themselves. For one thing, he combined flowers that have different growing seasons. And secondly, his technique is precise and obviously laborious: it must have taken him much longer to paint a flower than a cut flower could have survived, even in fresh water. Apparently Bosschaert worked from an album of watercolors that he had prepared directly from the flowers when they were fresh. But his final paintings were not meant to express that spontaneous viewing that one associates with watercolors; instead, he meticulously rendered the fall of light and surface details, creating a precious and expensive object.

Because the markets for all kinds of products and services were so diverse in the Netherlands, it comes as no surprise that there also were any number of subcategories to the still life. Clara Peeters (1594–c. 1657) was among the first Dutch painters to specialize in pictures that combined flowers with food. Little is known about Peeters (even her birth and death dates are uncer-

6.29 (*opposite*)
CLARA PEETERS,
Still Life with Flowers, a Goblet, Dried Fruit, and Pretzels, 1611.
Oil on panel,
20½ x 28¾ in
(52 x 73 cm).
Prado Museum, Madrid.

Clara Peeters was one of a small group of Antwerp painters who specialized in breakfast pieces: this is a combined breakfast piece and flower painting, executed with clarity and intensity. All four paintings in the series are substantial and of exceptional quality, which belie the youth of the artist. Note the popular *trompe l'oeil* of the image overlapping the stone ledge into the viewer's space.

6.28 AMBROSIUS BOSSCHAERT THE ELDER, *A Bouquet in an Arched Window*, c. 1620. Oil on panel, 25¼ x 18 in (64 x 46 cm). Mauritshuis, The Hague.

The meticulously painted blooms and their illusionistic setting on a window ledge initially impress the viewer with their realism. Yet our realization that these flowers could not actually have been combined soon sets up a delicious tension, which invests this piece with a degree of surrealism. The exotic shells and insect included on the ledge seem to suggest that the bouquet should be part of an (un)natural history display.

tain), but there are more than thirty signed works, most of which date from the second decade of the seventeenth century. In her *Still Life with Flowers, a Goblet, Dried Fruit, and Pretzels* (FIG. 6.29), she combines on a stone ledge various foods with flowers, and glass and silver goblets. This is part of a larger series of four paintings that represent typical early seventeenth-century meals – separate plates of fish and game, a full dinner, and dried nuts and fruits (as shown here). Although the painting does not exult in the abundance of the world (see FIGS. 6.30 and 6.31), the realism is just as intense, with the pretzels given the same deliberate attention to detail as the rendering of a silver goblet.

A more riotous style of flower painting became popular later in the seventeenth century. The Dutch painter Rachel Ruysch (1666–1750),

daughter of a professor of anatomy and botany, probably studied rare examples of beautiful flowers even in her childhood. Her clientele was composed of members of the rich merchant classes, who often tended flourishing gardens in the narrow lots behind their houses. Because of her preeminent reputation for flawlessly painted, complex masses of flowers brought close to the picture plane, Ruysch commanded unusually high prices for her paintings, earning twice what Rembrandt did for much larger pictures. Although married and the mother of ten, she was able to attend to her career. Ruysch received commissions from the most eminent patrons in Europe, and between 1708 and 1713 worked as court painter to the Elector Palatine, Johan Wilhelm von Pfalz. In 1716 she sent to Cosimo III de' Medici, the Grand Duke of Tuscany, her

6.30 Rachel Ruysch,
Fruit, Flowers, and Insects,
c. 1716.
Oil on canvas,
35 x 27¼ in
(89 x 69 cm).
Palazzo Pitti, Florence.

Fruit, Flowers, and Insects (FIG. 6.30). A riot of flowers, clusters of grapes, bunches of fruits, and a bird's nest with eggs are dramatically lit and arranged diagonally amid a murky wooded setting. Lizards and insects slither and scurry over this presentation of the bounty of nature. This breathtaking display of God's ingenuity was meant to invoke in the beholder a sense of wonder and admiration, both for the exotic character of the species on show and for the surpassing skill with which Ruysch brought their images into being.

The most successful still-life painter of the Dutch Baroque was the Rotterdam-born Willem Kalf (1619–93), who was one of the relatively few artists who prospered both in his art and later in art dealing (which he concentrated on after 1680). One of the variations on the Dutch *stilleven* (the origin of the English term "still life") was the "deluxe" still life, or as the Dutch termed it, the *pronkstilleven*. As bankers, investors, and especially as Europe's premier traders, those Dutch with their pockets full of money were nearly as desirous of worldly goods as today's consumers. The Dutch East India Company (see p. 70) brought back luxury goods from throughout the world, and especially from Dutch colonies newly taken from the Portuguese. Part of the appeal of the *pronkstilleven* would have been the pride taken by the Dutch in their own colonial power; Kalf's still-life paintings thus satisfied

a taste for the luxurious and symbolized the possession of the spoils of a remarkably successful Dutch industry in shipping and trade.

His *Still Life* (FIG. 6.31), commissioned in 1653 for the glory of the Amsterdam Archers' Guild, demonstrates an often-quoted observation by the German playwright and poet Goethe – in reference to another painting by Kalf – that "one must see this picture in order to understand in what sense art is superior to nature and what the spirit of man imparts to objects. For me, at least, there is no question that should I have the choice of the golden vessels or the picture I would choose the picture" (Rosenberg *et al.*, pp. 199–200). Of course Goethe's observation, coming as it does a century and a half later, does not necessarily reflect the values of Dutch Baroque culture, but it does hint at the great worth placed on the magnificence – not just of

6.31 WILLEM KALF, *Still Life with the Drinking-horn of the Saint Sebastian Archer's Guild, Lobster and Glasses*, c. 1653. Oil on canvas, 34 x 40¼ in (86.4 x 102.2 cm). National Gallery, London.

6.32 CIRCLE OF FRANS FRANCKEN THE YOUNGER, *Allegory of Worldly Riches (Miser's Dream)*, 1600. Oil on canvas, 20 x 29¼ in (50.8 x 74.3 cm). Wadsworth Atheneum, Hartford, Connecticut.

what is represented but on the act of representation as well. Certainly the guild members would have enjoyed looking at the picture, not necessarily because Persian rugs, lobsters, and drinking horns were beyond their means, but because of a fascination with extraordinary virtuosity. Here is a Dutch example of *meraviglia* (see pp. 22–4), a wonderful *tour de force* in which exquisite objects have been represented exquisitely.

By contrast, some ornate still-life paintings carried an implicit moral message. In these so-called *vanitas* paintings, one was given a visual warning, as it were, of the dangers of excess and of the "vain" or spiritually empty and transient beauties of this world (FIG. 6.32). This would be expressed in such symbols as hour-glasses, pocket watches, or human skulls. As many a Dutch moralizer was apt to quote, unlike all living things God's word is constant: "The grass withers, the flower fades; but the word of our God will stand forever" (Isaiah 40:8). These paintings are paradoxical, in that they depend upon the enjoyment of beautiful objects in a fine painting while simultaneously admonishing the viewer to beware of material preoccupations.

STILL LIFES OF THE FRENCH ROCOCO

Jean-Baptiste-Siméon Chardin, the son of a respectable but lowly carpenter, seemed to attach moral value to enjoying austerity, in sharp contrast to the *pronkstilleven*, or even to his contemporary François Boucher, who delighted in luxury. Although he was unsurpassed as a still-life painter, being admitted to the Academy because of his talent for depicting fruits and animals, he always regretted that his father lacked the means to provide him with a humanistic education and therefore prepare him for history painting, the most prestigious of all forms of art in the Baroque and Rococo periods. And despite the praise of the Goncourt brothers in the following century, who said that "Still life was the specialty of Chardin's genius. He raised this secondary branch of painting to the highest level of art" (p. 114), Chardin's contemporaries, while acknowledging that he was the best of his class, looked down upon the still life as the easiest thing of all to paint, and therefore the least worthy.

Chardin conferred dignity on his lowly subject matter, refining it by working with homogeneous groups of simplified objects, as in *Fruit, Jug, and a Glass* (FIG. 6.33). He arranged his shadows carefully and had a strong discernment and awareness of tactile values – of the apparent touchability of the objects that he painted. There is nothing unusually beautiful about the specimens that he selects, but there is a strong sense of substance and geometry, as if he were aware that lying beneath these humble forms were the principles of the cone, the cylinder, and the sphere – the basic geometries of nature. Just the same, for all their careful structure, Chardin's still lifes appear unstudied and natural.

The French painter Eugène Delacroix perceived that "when we look at the objects around us, we observe a sort of *liaison* between them, produced by the atmosphere that envelopes them and by all kinds of reflections which somehow make each of them partake of a general harmony … Yet how few of the great masters have been concerned with this" (cited in Rosenberg, p. 68). Chardin would have agreed with Delacroix on what constitutes harmony in a work of art. His technique was to prime his canvases with a sizing (a pasty substance used to seal the coarse cloth of the canvas), which was then covered by some dense paint, such as a mixture of white lead with reddish brown. This gave Chardin the dark background from which he would then work up his images. Thus he painted from dark to light, adding the lightest part toward the end. His final pass over the painting would be with a varnish that would "pull it together," create an overall tonality (FIG. 6.34). What results in Chardin's painting is a satisfying, balanced composition, as well as a unified

6.34 (*right*)
Detail of 6.33: Chardin,
Fruit, Jug, and a Glass,
c. 1755.

tonality. As competent and even spell-binding as Chardin's still-life paintings may be, they do not compete with the illusionistic objects within. We do not like his painting because we want to eat one of his peaches. In that sense there is a less tense relationship between his imagery and its execution than in Kalf.

Genre Painting

Because of the original meaning of "genre" as a *type* of painting, it is not a very good choice of term to cover just one, and one very specific, type. But since the eighteenth century the word has stuck as a label for the painting of everyday life. Although genre painting had a relatively low social and aesthetic value, many artists understood and appreciated what one might call the poetics of meagerness and scarcity. There is a tradition, coming from St. Francis in the thirteenth century, of the "glory" of the poor. And there were those who preached of the necessity of steadfastness in the face of widespread poverty in the seventeenth and eighteenth centuries. The English writer of proverbs, Thomas Fuller, stated in 1732 that "Poverty is not a shame, but the being ashamed of it is." The dispossessed, the needy, the indigent, were everywhere, serving as a reminder of the need for Christian love, or, as it was more commonly known, charity.

SOUTHERN EUROPE: VELÁZQUEZ & RIBERA

The towering figure of Spanish Baroque art Diego de Silva y Velázquez began as a genre painter and ended as the court painter of Philip IV, King of Spain. It is instructive to see how his early imagery of "ordinary" life informed his later, courtly art.

In his *Water Carrier of Seville* (FIG. 6.35) Velázquez almost startles the viewer with the convincing detail of the condensation on the outside of the water jug in the foreground, the grizzled face and torn garment of the water carrier himself, and the remarkable reflections of light in his glass. There may be no manifest or obvious political, moral, allegorical, or religious significance here, yet one can infer a sympathy with these street people. A familiar scene in seventeenth-century Seville has been rendered in all its hard-edged, physical reality. His use of tenebrism and *chiaroscuro* melds the composition into a unity, and creates an overall atmosphere and mood. Accomplished illusionism and compositional sophistication were highly valued in the Renaissance and Baroque periods for their own sake, and often were seen as proof of a painter's skill.

A disconcertingly moving image of the seedy, deformed, and supposedly miserable is Jusepe de Ribera's (1591–1652) *Club-footed Boy* (FIG. 6.36). Here the viewer is confronted by the image of a beggar, one whose social standing is beneath that of the lowliest worker. Ribera, born near Valencia, Spain, but active for all his adult life in Naples, gives us an ironic image of a disfigured (and probably mute) youth beseeching us for a handout. Seen from a somewhat lowered point of view – thereby making his portrayal seem incongruously majestic – the club-footed boy smiles at us, utterly unconscious of the

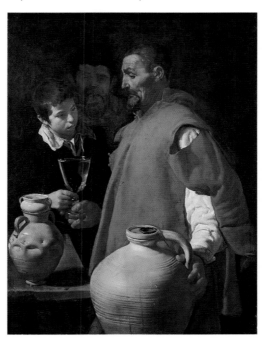

6.35 DIEGO VELÁZQUEZ, *Water Carrier of Seville*, c. 1619. Oil on canvas, 42 x 31¾ in (106.7 x 81 cm). Wellington Museum, London.

The water carrier hands a glass of water to a boy, while another boy, in the shadows behind, drinks from a jar. There is a fig at the bottom of the glass to freshen the water. A shaft of daylight has illuminated this simple act, the *chiaroscuro* contributing substance and drama. The restricted palette and tones of this painting add to its power rather than diminish it.

6.36 Jusepe de Ribera,
The Club-footed Boy,
1642.
Oil on canvas,
64½ x 36¾ in
(164 x 93.5 cm).
Louvre, Paris.

Beyond Genre

Velázquez' Las Meninas

Velázquez' best known and most interpreted painting is *Las Meninas*, or the Maids of Honor, of 1656 (FIG. 6.37). By this time the artist had ambitions of rising in rank at the court to become a knight of the Order of Santiago (the emblem of which is the red cross on his chest; it was painted on later, when he achieved his knighthood), and although he was busy with

numerous duties for King Philip IV and painted less than he had in his earlier years, he nonetheless produced some of his most important works in these last decades of his life. This is a royal portrait and a self-portrait, but because of its apparent casualness and rendering of a typical interior, it has close ties with genre painting. In fact, the painting defies easy categorization or

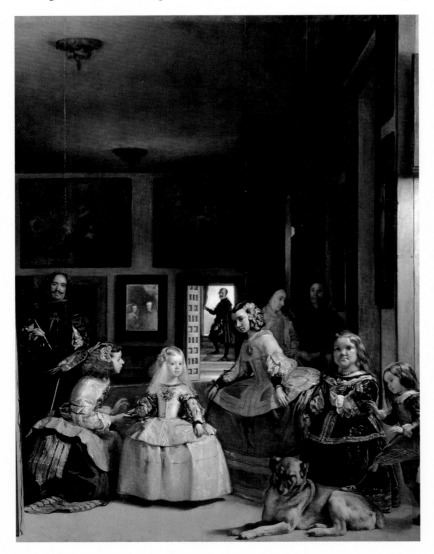

6.37 Diego Velázquez, *Las Meninas*, 1656. Oil on canvas, 10 ft 5¼ x 9 ft ¾ in (3.18 x 2.76m). Prado, Madrid.

interpretation. When the Italian painter Luca Giordano saw *Las Meninas*, he called it the "Theology of Painting." Although we cannot be sure exactly what he intended by such a comment, we can surmise that Giordano saw embodied here the essence of the accomplishments of Baroque art. Perhaps the best way to "unpack" this large painting (it has the proportions and size of the painting depicted within the painting), is to begin analyzing it at its most basic level of narration, before moving on to the idea of a "theology" of art.

Las Meninas was always identified in the palace inventories as "the picture of the family." With the information about the family that survives, we can identify everyone in the painting, beginning with the artist himself who looks out into the space of the viewer. We know that the room depicted actually existed in the Alcázar palace, and that the girl in the middle, surrounded by her ladies in waiting, is the Infanta Margarita, daughter of King Philip and Queen Mariana. The two adults in shadow behind the ladies in waiting are functionaries and officials of the palace (the widow Marcella Ulloa inclines her head slightly), and in the background, silhouetted against the light of the doorway, is José Nieto, another palace official, known as an Apostentador. The most interesting "portrait" is the double image of Philip IV and Mariana shown in reflection in the mirror on the back wall. So the King and Queen have stopped by the painter's studio (as was their habit) to see him at work. But at work on what? The size of the canvas shown to us from the back is too large for a single or even double portrait. Because it appears to be about the size of the actual painting upon which we are gazing, we can assume that we are watching the artist at work on this painting, even though he seems to be looking into the space "occupied" by the King and Queen (and us). It is this deceptive doubling of intention and product, of what we expect and what we get, that creates such a fascination and that justifies characterizing this as the "Theology of Painting." Not only does Velázquez create levels of illusion and reality, he makes us aware of the idea of painting itself as a particularly noble occupation, just as *he* has ambitions of becoming a nobleman. The status of the artist had slowly been

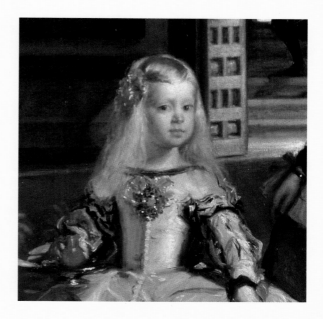

6.38 Detail of 6.37: The Infanta Margarita, from

Velázquez, *Las Meninas*, 1656.

rising since the fifteenth century, but in Spain it was still unusual to think of a painter as a gentleman. By demonstrating for us the "magic" of the art of representation, and by putting the King and Queen in the artist's studio, Velázquez dignifies both himself and genre painting and thereby creates an "aesthetic theology," a premise for a belief in the power of art.

Velázquez depicts atmosphere and coloration in a manner anticipating the Impressionist painters of the nineteenth century. Unlike most artists of the Renaissance, the Spanish painter allows forms to become less distinct as they recede from the viewer's eye; the figures in the middle and far distance are rendered with fewer and darker brushstrokes. Even the main figure, the Infanta Margarita (FIG. 6.38) is obviously **painterly**. The colors and forms are rendered generally rather than exactly so that the human form is hinted at rather than precisely defined. In a sense, Velázquez paints *how* we see rather than simply *what* we see, and this is what makes his image painterly, and him a painter's painter—an artist acutely self-conscious of the act of making art, something of a "high priest" of the theology of painting.

6.39 Louis Le Nain, *Landscape with Peasants*, c. 1640. Oil on canvas, 18 x 22½ in (46.5 x 57 cm). National Gallery of Art, Washington D.C. Samuel H. Kress Collection.

Peasant children watch curiously in the foreground, an old woman watches them in turn from the shade of a high wall, and behind them all is played out the drama of an immense landscape before sunset in the artist's native Picardy. The result is one of the most serious products of the genre tradition, an early precursor of nine-teenth-century Naturalism.

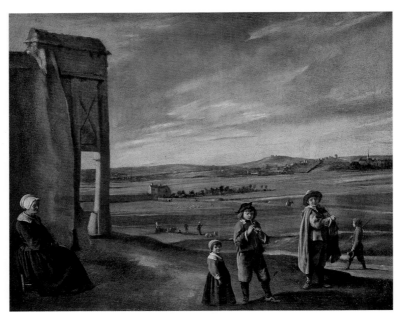

impression, noble and poignant at the same time, that he makes. His walking stick is slung across his shoulder like a rifle or a sword, and clutched in his left hand is a carefully printed note that translates from the Latin as "Give me alms for the love of God." Ribera gives a human face to the poor and despised, to those who were a ubiquitous presence on the streets, but who were rarely depicted in paintings. Here, in large format, we confront a Neapolitan urchin in all his "glory," in a pastoral setting that this urban dweller would not have known.

FRANCE: LOUIS LE NAIN

The most highly regarded style in France in the seventeenth century was classicism, and its most famous practitioner was Nicolas Poussin. Poussin's contempt for genre painters was palpa-ble, as evidenced by his observation that "those who elect mean subjects take refuge in them because of the weakness of their talents" (cited in Walker, p. 320). This disdain expressed by the doyen of the grand manner was not shared by all patrons, however. The Le Nain brothers, Antoine, Louis, and Mathieu, spent their lives painting sober and carefully balanced scenes of

the lower classes, especially peasants. They met with success and even were accepted into the Royal Academy.

Louis Le Nain's *Landscape with Peasants* (FIG. 6.39) represents a peasant family in the fore-ground of a peaceful countryside. It is late in the day, and the viewer's prospect jumps from a relatively detailed foreground to a more general-ized middle and far distance. The light origi-nates from a point behind the partially observed building to the left and expands like a funnel to the right. Le Nain does not create the orderly ideal landscape for which Poussin was famous (see FIG. 7.4), nor does he represent the literary pastoral of Claude Lorrain (see FIG. 7.7). This is rural landscape as a model of cultivated and well-tended fields. One is encouraged not to find a narrative content here, but to associate the peasant class with virtuous, almost biblical, tenancy.

As in the tradition of the Book of Ecclesiastes, a landscape painting such as this one invokes the goodness of earth and life. There certainly is some association between the humble peasants, their blessed landscape, and the advice of the narrator of Ecclesiastes: "Go, eat your bread with enjoyment, and drink your

wine with a merry heart; for God has long ago approved what you do … Whatever your hand finds to do, do with your might." (7:7-12). Such popular wisdom is consistent with the effect and mood of many genre paintings that extol the rural life.

THE DUTCH REPUBLIC: DE HOOCH, STEEN, & VERMEER

The interiors of middle-class houses were painted in huge numbers in the seventeenth century, especially in Holland. Where hearth and home had been the center of industry in previous centuries, now it was given over entirely to a new kind of activity, the nurturing of family, and the providing of a warm, comfortable, and secure place in which to live. Men rarely appear in the paintings of Pieter de Hooch (1629–84), but that is not because of their lack of importance; it is, rather, their very absence that marks their significance. Without the thriving Dutch economy, men would not be able to free women and children from participating in labor and com-

merce. De Hooch, who lived in Rotterdam, Delft, and Amsterdam, lovingly renders the immaculate interior according to precise rules of perspective and balanced patterns of light and shade. In *A Mother Beside a Cradle* (FIG. 6.40) the little girl looks out into a lighted courtyard, while in another room the mother gestures toward her infant, whom she has just nursed. The older practice of sending a child to a wet-nurse was discouraged by physicians in seventeenth-century Holland. Jacob Cats (1577–1660), affectionately known to his reading public as "Father Cats," wrote highly successful books filled with moral advice for parents. On breast feeding, he stated: "She who bears her children is mother in part,/ But she who nurses her children is a complete mother."

Breast feeding is only one of the values of human relationships that de Hooch confirmed for the Dutch Calvinist community. The typical Dutch family of the seventeenth century was close knit and nuclear, with the father as provider and moral leader. But the home was ruled by the *huisvrouw* or housewife. The orderly household

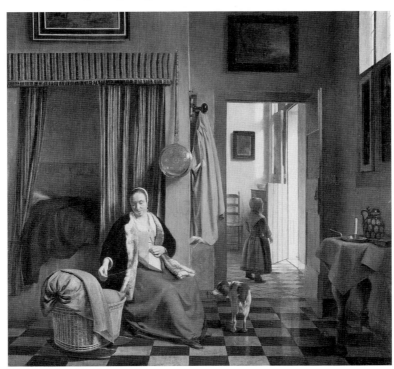

6.40 PIETER DE HOOCH, *A Mother Beside a Cradle*, c. 1659–60. Oil on canvas, 37½ x 40¼ in (95.2 x 102.5 cm). Staatliche Museen, Berlin-Dahlem.

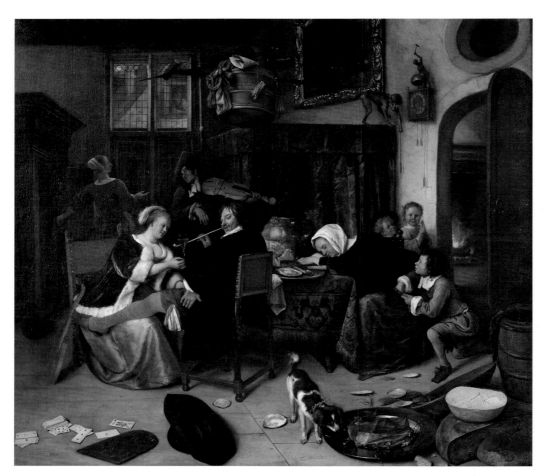

6.41 Jan Steen, *The Dissolute Household*, c. 1668. Oil on canvas, 31¾ x 35 in (80.6 x 88.9 cm). Wellington Museum, London.

The cards scattered on the floor in front of the prostitute, combined with the huge flagon of wine on the table by the drunken wife, refer to the popular Dutch saying "Cards, women, and drink have ruined many a man." The hat on the floor alludes to another saying on the theme of recklessness, and the reckoning slate to its right reminds us that this account of moral disintegration has to be settled.

was an essential part of an orderly society, in which everyone had a place. And the place of women and children was in the home. De Hooch's mastery of space and light, often with views through several rooms or glimpses into a courtyard, correlates with the moral values of harmony and domestic management.

Although Jan Steen (1626–79) found great humor and energy in dissolute households (FIG. 6.41), he was not celebrating them. Where de Hooch's interiors honor peaceful, neat, and well-organized homes, Steen's paintings admonish his audience by showing what happens when things go terribly wrong. Although Steen was undoubtedly every bit as good at rendering perspective as de Hooch, his cluttered interiors display no sense of order, reflecting the chaos

6.42 Detail of 6.41: Steen, *The Dissolute Household*, c. 1668.

6.43 Jan Vermeer, *The Geographer*, 1669. Oil on canvas, 20¾ x 18¼ in (53 x 46.5 cm). Städelsches Kunstinstitut, Frankfurt.

The Geographer may have been commissioned and produced as a pair with a painting of an astronomer (1668), which uses the same model in the same room. Vermeer's late paintings are sometimes viewed as technically inferior to his earlier, more "perfect," paintings, perhaps because of ill-health. But the artist may simply have been experimenting with giving his colors and shadows greater sharpness and intensity.

and moral degeneration of a typical "Jan Steen household" (a phrase still used to describe a rambunctious and disorderly family). The man smoking a long pipe and appearing to wink at the spectator (probably a self-portrait of the artist) throws his leg over the lap of a young woman who in all likelihood is a prostitute. His wife lies in a drunken doze, while her children and a servant girl go through her pockets stealing money and jewelry. Oysters (symbols of lasciviousness) lie scattered on the floor, a dog nibbles at a neglected plate of food, a monkey stops the clock (FIG. 6.42; time is lost in foolish activity), and another young man tries to seduce a maid by playing love songs on his fiddle. She seems more interested in opening the family's chest and filching their treasures. Steen was able to have it both ways. His uproarious paintings undoubtedly gave rise to hilarity, and yet they could always be judged highly moral because

they revealed the consequences of ribald, wicked, and lewd behavior.

The world of Jan Vermeer's geographer (fig. 6.43) is altogether more orderly than that depicted in a Jan Steen household. Vermeer's painting is not so much a specific portrait of an erudite mapmaker as it is a summing-up of the spirit of exploration so characteristic of the seventeenth century.

The geographer has been identified tentatively as the Dutch lens grinder, microscopist, and surveyor Anthony von Leeuwenhoek, with whom Vermeer was most likely acquainted. Pausing in his study of what appear to be ocean charts on vellum, the young man turns toward the light, which washes brilliantly over the right side of his face. Nearly everything about this painting emphasizes scientific curiosity. The Persian carpet is pushed aside so that he has a hard surface on which to consult a book and

make calculations, using his dividers. The shadows have the precise demarcations a cartographer would appreciate. On the back wall the painter signs his name, separating the "Ver" and "Meer" (meaning in Dutch "sea," which also appears on the chest panel behind the geographer's head). The framed map shows "all the Sea coasts of Europe," while the terrestial globe is turned toward the Indian Ocean (*Orientalis Oceanus*). The cross staff, an instrument used for celestial navigation, can be seen attached to the center jamb of the windows.

Genre painting emphasizes the particularity of the here and now, the experience and mood of being in the world at a particular time and place. Vermeer juxtaposes the immediate security of home with a gaze that contemplates the indefinable distance. That place

beyond description is about to be measured and located, giving evidence to an intelligence that can understand, calculate, and perhaps yearn for that which lies beyond one's immediate horizon.

ROCOCO FRANCE: CHARDIN

We have already encountered Jean-Baptiste-Siméon Chardin as a still-life painter (see pp. 252–4); he also rendered a number of absorbing domestic scenes. Chardin's contemporaries admired the truth and simplicity of his images of common life, which were painted (and prints made after them) for a bourgeois audience. The values of simplicity, truth, and naturalness were much promoted in the seventeenth and eighteenth centuries as an antidote to the

6.44 JEAN-BAPTISTE-SIMÉON CHARDIN, *The Governess*, 1738. Oil on canvas, 18¼ x 14¾ in (46.5 x 37.5 cm). National Gallery of Canada, Ottawa.

A housekeeper brushes the boy's hat before sending him out to school: the open door frames the little figure and acts as a reminder of his duty (to modern eyes also, perhaps, as a threat). The moment of contact between the two figures is nicely caught, and the contrast between the housekeeper's workbasket and the boy's scattered toys is pointed.

corruption of the court and of the city. The disasters of the final years of Louis XIV's reign, followed shortly by a catastrophic stock market crash in Paris in 1720, encouraged many to seek modest values and personal virtue. The work ethic promoted by the middle class went hand in hand with a strong attachment to family and the pursuit of prosperity.

Chardin's painting *The Governess* (FIG. 6.44) illustrates an important lesson, and one much touted in the eighteenth century. The governess reproves her young charge for his inappropriate behavior: he should remember that schooling is important (he apparently is on his way there) and to keep his games at home. Much was written in the eighteenth century on the education, both moral and practical, of children. The most advanced theories of the age suggested that figures of authority and parents treat children with gentleness, that they be educated not through threats or severe reprimands, but sweetly and by moderate promptings. Chardin's quiet and unaffected style seems suitable to the subject and fitting for the middle-class sensibility of eighteenth-century France.

Conclusion

Still-life and genre paintings make up two of the categories of the so-called "lesser" genres. From an academic point of view, as we have seen, these were not illustrious artistic activities. But the market for art demonstrated little concern for such niceties of hierarchy and status. Collectors – and they were many and varied in the seventeenth and eighteenth centuries – wanted images of things that they knew, objects and individuals that they could see and touch. The uses to which these images were put ranged from the political to the moral, domestic, and aesthetic.

As the middle class grew, its mores and social roles became more precisely defined. Genre paintings capture and reflect these newer life styles, domestic scenes, and economic circumstances. The paintings also comment on daily life and sometimes even lecture to their audience. Genre paintings in the Baroque and Rococo eras functioned much as film, photography, and video do today. These art forms represent the world around us and allow us, in a sense, to step outside of ourselves and to see ourselves as the "other," to give us a sense of objectivity, so that we can know and judge ourselves within society and our daily lives.

CHAPTER 7

Landscapes & Views

DEPICTIONS OF THE NATURAL

& MANMADE WORLD

JACOB VAN RUISDAEL,
*View of Haarlem with
Bleaching Grounds,*
1670–5.
Oil on canvas,
24½ x 21¾ in
(62.2 x 55.2 cm).
Kunsthaus, Zurich.

This is one of a series of
panoramic views of
Haarlem (near Amsterdam)
that Ruisdael painted in
the 1670s, many of them
in a similarly vertical for-
mat with low horizons and
buoyant cloudscapes care-
fully arranged to echo the
patterns of light on the
earth below. As in many
Dutch landscapes, the sky
occupies two-thirds of the
picture, and the imposing
church of St. Bavo marks a
similar proportion hori-
zontally. In the foreground,
bathed in sunlight, are the
famous linen bleacheries
on which the city's pros-
perity was based.

The notion of space – whether of the city or of the country – underwent radical shifts in philosophical thinking from the Renaissance through the eighteenth century. When European men and women of the middle ages looked out onto the world, they saw something that was divinely ordained and filled with religious meaning. Nature was beautiful because God made it so. It also was hierarchical, constituted by a great chain of being from God and Jesus Christ through the angels, saints, the Church, humans, animals, insects, rocks, down to the tiniest grain of sand. Gradually, people's conception of the world changed, not only from a geocentric to a helio-centric model, but from a nature that was the product of God's intention to a world of mechanical forces, mathematical order, and physical causes. Aesthetics, a term first used in the eighteenth century, was increasingly con-cerned with the appreciation of natural beauty independent of any divine intention. Symmetry and pattern in nature were regarded as intelligent

and organized, but not as devised for any specific end. The forces of nature were immanent (indwelling), not transcendent. By the seven-teenth and eighteenth centuries, we also find ref-erences to the glory and beauty of the natural world, which was expressed in the aesthetic phe-nomenon of the sublime. There were philosophi-cal writings on the pleasure of perceiving nature, and scientific explanations of the geological and other natural forces at work in shaping the world.

Beginning in the Renaissance and continu-ing for centuries thereafter, the city became the site of culture and society. Some Enlightenment figures, such as Voltaire and Adam Smith, found the countryside hierarchical and rude, while cities provided, in their view, a liberal mixing of social strata. John Locke complained when living in the country, "I am in the midst of a company of mortals that know nothing but the price of corn and sheep, that can entertain discourse of nothing but fattening of beasts and digging of ground and never thank God for anything but a fruitful year and fat bacon" (cited in Thomas, p. 252). The utopian cities

described by Thomas More in the sixteenth century and Tommaso Campanella in the seventeenth were perfect geometrical forms that were meant to harmonize with the geometric qualities inherent in the universe.

Landscape and view painting reflected all these new perceptions of the world, as well as the values and the market forces of their times.

Landscapes

The social meanings of the physical landscape changed in the seventeenth century. The reclaiming of land from the sea in the Netherlands, the seizing of large tracts of land by the wealthy gentry in England, and the continued establishment of religious and governmental domains in France, Spain, Portugal, and Italy, meant that there was an ever greater need for accurate surveying. The seventeenth century saw the development of numerous tools and methods for land surveying, one of which was the creation of logarithmic tables, enabling surveyors to make calculations using theodolites – small, portable instruments that allowed for accurate sightings and measuring of horizontal and vertical angles. Some landscape painters undoubtedly availed themselves of measuring devices, just as view painters used the camera obscura (see p. 72).

One might expect that this greater precision in mapping and measuring the land would be reflected in more realistic depictions of the countryside. Not so. The beauty of landscape painting, with its visions of paradise, eternal rest, and satisfaction, can in fact blind one to the depredations of the countryside already underway in the seventeenth century in Italy, for instance. Mercenary armies had been sweeping through the countryside since the fifteenth century, exacting enormous "tributes" from nobles and communes, burning fields, and destroying crops. Popes kept the cost of foodstuffs artificially low, thereby nullifying the peasants' ability to make any money from the land. Many of the nobility's great estates both in Italy and France were abandoned or neglected.

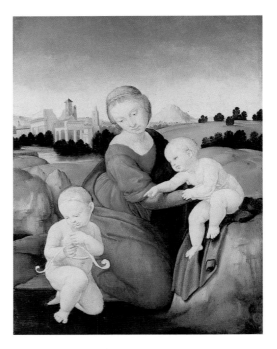

7.1 RAPHAEL, *Esterhazy Madonna*, 1508. Tempera and oil on panel, 11¼ x 8½ in (28.5 x 21.5 cm). Museum of Fine Arts, Budapest.

Raphael, like many of his contemporaries, admired the landscape backgrounds of Netherlandish paintings and their influence can be seen in some of his pictures. Recession into the background is suggested here by the series of overlapping ridges, painted in different colors, brownish in the foreground, green in the middle and different shades of blue in the distance. The Classical ruins on the left recall the Temple of Vespasian in Rome.

The Renaissance artist had thought of landscape as something of a stage for the depiction of events, such as biblical or historical scenes. Raphael, for example, placed the Holy Family in a pristine landscape, replete with river, a few trees, and a couple of bluish hills in the background (FIG. 7.1). Nature in this instance plays a subordinate role, one that is not insignificant, but not one in which nature and landscape appear as the substance of the work. As a setting, the landscape reflects the beauties of nature as evidence of divine goodness. By the seventeenth century, the landscape often becomes the central theme of the painting, so that a view on to nature becomes the primary conveyor of meaning.

PRECURSORS OF THE BAROQUE LANDSCAPE

In the *Treatise of Art* (1584) by Giovanni Paolo Lomazzo, different kinds of landscapes and views are described – both real and fantastic, including images that are "clear and of serene air, in which buildings, houses of princes, pulpits, theaters,

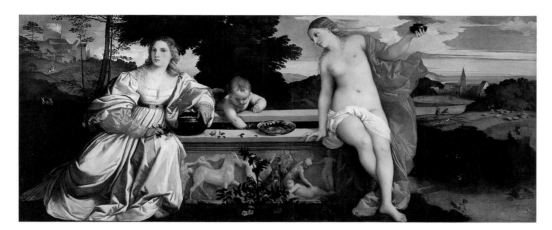

7.2 Titian,
Sacred and Profane Love,
1514–16.
Oil on canvas,
3 ft 10½ in x 9 ft 1¾ in
(1.18 x 2.79 m).
Galleria Borghese, Rome.

7.3 (*below*)
Annibale Carracci,
River Landscape, late 1590s.
Oil on canvas,
28¾ x 56¼ in
(73 x 143 cm).
Gemäldegalerie,
Berlin-Dahlem.

Carracci's early years in
Bologna had exposed him
to the work of both north-
ern European landscape
painters and Venetian
artists. This painting blends
the naturalistic detail of the
former with the harmonious
compositions and atmos-
pheric effects of the latter.
But whereas his earlier land-
scapes are essentially genre
scenes with numerous fig-
ures engaged in everyday
activities, here the human
presence is incidental.

thrones and all the magnificent and real things
are represented; other places of delight, in which
there are fountains, lawns, gardens, seas, shores,
baths and places where one dances" (cited in
Gombrich, p. 120). In the painting of these
kinds of scenes, the Venetian artist Titian, he
insists, was peerless. Like all pre-Baroque
painters, Titian used landscape as a backdrop for
his narrative paintings, but what he did with
country scenes impressed the artists of the seven-
teenth century. In his *Sacred and Profane Love*
(FIG. 7.2), the serene background landscape
includes hunters with a dog, a shepherd with his
sheep, rabbits, a lake, some trees, lovers, and a
church. Clouds streak the pink and blue sky. Is
this a moralized landscape reflecting the themes
of earthly (profane) and sacred love, or is it
something more descriptive? In one interpreta-
tion, Titian's painting is a wedding portrait of
Laura Bagarotto, the clothed woman on the left.

The clothing is appropriate for a bride in the
early sixteenth century. Venus is the goddess who
champions love and therefore marriage. The rab-
bits are suitable as signs of marital fertility, while
the barely glimpsed couple in the background
further underscores love and love-making. The
fortress can be seen as a symbol for the stable
institution of marriage. Whatever the interpreta-
tion of Titian's painting and its background land-
scape, his gentle rendering of a peaceful place
signals a new attitude toward nature in art, one
that Baroque artists will explore in considerable
detail. The mood of the landscape suffuses the
figures and unites the entire composition.

Annibale Carracci painted the *River Landscape*
(FIG. 7.3), his only "straight" landscape, in the
later 1590s, shortly after he was called to Rome
by Cardinal Odoardo Farnese. Within the exist-
ing hierarchy of genres, landscapes did not rank
very high – there is no traditional narrative here,
and no overt message about religion or virtue.
Instead, the river, bridge, trees, and buildings
(perhaps suggesting the Tiber Island in Rome) are
intended as a "place of delight," an image fit for a
private collector interested in displaying some-
thing about his domestic circumstances.

Carracci's landscape may be decorative, but it
is organized along strict "classical" lines. A classical
landscape – also called an ideal landscape, or a
paysage composé (composed landscape) – is one in
which culture, represented by the presence of
human structures, dominates and controls nature.
Nature is now architectonic, arranged according

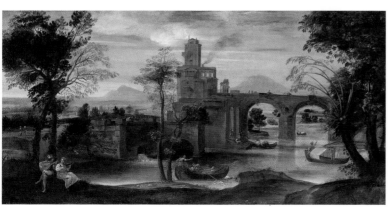

to rules of symmetry, with verticals, horizontals, and weighty masses dominating. This particular view of nature, with its carefully balanced and limited segment of countryside, and with foreground, middle distance, and far distance, became quite popular in Rome in the seventeenth century.

THE CLASSICAL LANDSCAPE IN BAROQUE ITALY

Poussin

Finding little market for his art in France, Nicolas Poussin arrived in Rome in 1624 at the age of thirty and soon was introduced to the intellectual community of the papal city by Cassiano del Pozzo, a high-ranking official during the reign of Urban VIII. Poussin's *Landscape with St. John on Patmos* (FIG. 7.4) demonstrates how much he had learned from Carracci about the way to compose nature, although this painting has a specific historical reference. St. John sits on the island of Patmos in the eastern

Mediterranean composing the book of *Revelation*. According to tradition, *Revelation* was written in the first century, and tells of the end of the world of Satan and the Second Coming of Christ. The painting includes a miscellany of references to ancient civilization, from the remnants of a Greek temple in the middle distance, to an obelisk, a broken bridge, and, in the foreground, a pedestal empty of its statue, with broken columns and tablets scattered about. All allude to the decline and fall of great empires. John sits facing the light contemplating his text before him, as he writes about the passing away of all earthly things. This is a strangely peaceful setting for an apocalyptic vision, but one can see already the crumbling of the pagan world (the passing away of the old world) and the resurgence of nature (the coming of a new order with Christ's judgment) in some now forgotten agora or forum. The very ruination of the ancient marbles lends a heroic if melancholy aspect to the scene.

Poussin's characteristic compositional devices underscore the essential seriousness of the scene.

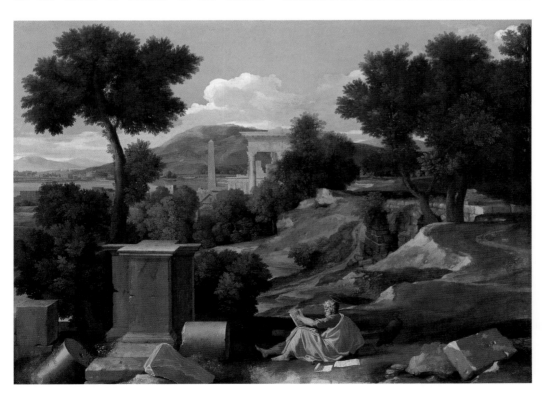

7.4 NICOLAS POUSSIN, *Landscape with St. John on Patmos*, 1640. Oil on canvas, 3 ft 3¼ in x 4 ft 5½ in (1 x 1.36 m). The Art Institute of Chicago.

Compared to works by Claude Lorrain (FIGS 7.7–7.9), this painting exemplifies Poussin's more heroic and monumental art. The stress is on logic and clarity – nothing is superfluous, nothing unclear; the natural elements are simplified, the sunlight is stronger, the forms are more sharply defined and the confusion of nature is subordinated to principles of mathematical order.

7.5 Nicolas Poussin, *The Arcadian Shepherds*, 1628–9. Oil on canvas (sides, top, and bottom normally hidden by frame), 39¾ x 32¼ in (101 x 82 cm). Devonshire Collection, Chatsworth.

The warm coloring and golden light, the robust, athletic figures, the freedom of brushwork, and the treatment of trees and sky all manifest the influence of Titian, as does the approach to antiquity, which is poetic rather than archeological. The lighting and the composition, based on diagonals, enhance the drama of the action, as the shepherds rush forward to examine the inscription.

Upright trees frame the picture on the right and near to the left border. The obelisk and the temple in the center repeat their verticality. A winding path leads the eye carefully through the various zones of the scene, from foreground to the middle distance. The architectural principles of rectilinearity, verticality, and horizontality control the work. Even the rising clouds echo the outline of the distant hill. The rules of art command the forms of nature.

Poussin's classicizing tendencies can be demonstrated by comparing two paintings of Arcadian shepherds. There would have been a fairly wide acceptance in the seventeenth century that the emotional and intellectual capacities of the human mind were to be clearly distinguished. The genius for rational thought marked the difference between humans and animals; the emotions, while important evidence of the state of the soul, were thus considered inferior. Poussin's two versions move from the emotional to the rational. In the earlier version (FIG. 7.5) shepherds and a shepherdess, idly hiking up her skirts, look upon an ancient sarcophagus jutting upward and toward the spectator. Written in Latin is the phrase "Et in Arcadia ego" (I [death] too am in Arcadia). Arcadia is the mythical realm in which shepherds and shepherdesses live in harmony, practice the musical arts, make love, and are close to nature (see p. 33). To discover death in this blessed realm is a shock to these innocent, barely literate beings (one shepherd's finger traces the outline of a letter to help him scan the line; and in case he does not get it, a skull gapes toward him). In the later version (FIG. 7.6) everything is much tidier and clearer.

7.6 Nicolas Poussin, *Et in Arcadia Ego*, c. 1640. Oil on canvas, 33½ x 47¾ in (85 x 121 cm). Louvre, Paris.

The more austere classicism of this painting compared with *The Arcadian Shepherds* (FIG. 7.5) reflects the influence of Poussin's studies of Roman sculpture. The mood is now quiet and contemplative; the landscape is calm and sunny, without the contrasts of the earlier work. Emotion is conveyed by telling gestures and expressions, and by the echoing poses of the harmoniously arranged figures.

Rather than looming in an unsettling diagonal, as in the earlier version, the sarcophagus in the Louvre version sits level and is more nearly parallel to the picture plane, a "quieter" and less threatening presence.

Claude

Poussin's countryman and near contemporary Claude Gellée (1600–1682), known as Claude Lorrain, or in English simply as Claude, painted landscapes that were close to Poussin's own earlier style. His beginnings were not auspicious. Brought up by poor parents who offered him little or no education, he learned as a young boy to be a pastry cook. When he was twelve his parents died, and so within a few years he left France for Rome, where there was a large educated class associated with the papal court eager to collect art. But first he needed training, which he received from Agostini Tassi, a specialist in the painting of illusionistic architecture (see p. 26). Like Poussin, Claude returned to France for two years, but found that his career was in Rome. It is not that all Claude's clients were in Rome (or Poussin's, for that matter); in fact, he sent paintings throughout Europe, but Rome was a good cultural nexus for an artist in Claude's position, a place where there were many artists living in his neighborhood (between the Piazza di Spagna and the Piazza del Popolo), many contacts, and an adequate postal system for sending out pictures.

Like Poussin, Claude painted the ideal landscape, using the Roman countryside, known as the Campagna, as his main visual source. But Claude concentrated more on light and the elusive qualities of mood. He populated his paintings with shepherds and shepherdesses, along with some mythological and biblical characters. Claude explored the ancient literary mode of the pastoral (see pp. 33–4), which was once again gaining popularity throughout Europe. The place of the pastoral is Arcadia, a realm as much of the spirit as it is geographical, and the light and atmosphere of Claude's paintings assist the viewer in making the imaginative leap to a landscape

of the mind. And who was this viewer? Claude's clientele was perhaps a bit grander than Poussin's, consisting of popes, cardinals, and princes, among others. They probably chose Claude's paintings for their popularity (he was enough of a success to fear unauthorized copies, so he kept a set of drawings for the purpose of authenticating all of his paintings) and also for their private appeal. They were probably kept in small rooms and were intended for intimate viewing.

Claude's *Landscape with Dancing Figures* (FIG. 7.7) shows country dancers performing for a group of peasants, shepherds, and cowherds. Large flagons of what must be wine, and a basket of food await them all, making this a delightful, rural picnic. The shadowed glade in the foreground contrasts with the sun-drenched landscape behind, with the cool river and murmuring falls in the very center. This is a representation of something typical, apparently ordinary, yet occurring in the "golden age" rather than at any particular time in history. The time of the day in Claude's paintings is usually evening or morning, so that the light can glow with an otherworldly radiance. He rarely if ever shows a landscape bathed by the sun at high noon. Here it is late in the day, with the sun low in the sky, masked by dense foliage.

Claude was just as contrived and controlling as Carracci and Poussin, ordering his trees, patterns of light and shade, devices for leading the eye throughout the composition (path, bridge, river), and buildings so as to create a sense of harmony and consonance. Claude probably would have agreed with the ancient Greeks that poetry is more interesting than history because it deals with universal themes rather than particular stories. The ancient and medieval architecture is historical, but broadly so; and the natural world he depicts is timeless.

This landscape has also been entitled *The Marriage of Isaac and Rebekah*. The idea that the dancing figures may have something to do with the wedding of these biblical figures is based upon an old inscription on a copy of this painting, which perhaps related to the original owner, Camillo Pamphilj, who had rejected his recent

7.7 (*opposite*)
CLAUDE LORRAIN,
Landscape with Dancing Figures (The Marriage of Isaac and Rebekah), 1648.
Oil on canvas,
4 ft 10¾ in x 6 ft 5½ in
(1.49 x 1.97 m).
National Gallery,
London.

Claude's biographer, Joachim von Sandrart, recorded that the artist would spend whole days in the fields, observing light effects, mixing the colors on his palette for use in the studio, and making oil sketches and drawings from nature. The artist would then choose the motifs that accorded with his dreamlike vision and work them into carefully ordered compositions through numerous preparatory drawings.

appointment as a cardinal so that he could marry, and had to withdraw from Rome to Frascati in disgrace. Camillo may have chosen to see this scene as the wedding of Isaac and Rebecca, for which there is no corroboration in the Bible or in tradition, because it offered him some sense of peace. As pastoral landscapes lack a specific narrative, they invite the viewer to project his or her own meanings into the scene, and thus can lend themselves to almost any interpretation their owners foist upon them.

There is a bit more historical specificity to *View of Delphi with Procession* (*Sacrifice to Apollo*) (FIG. 7.8) which is the pendant (the other half of the pair) to the *Landscape with Dancing Figures.* But again, one is not looking at a historical event in the usual sense. The low sun filtered through the clouds backlights the trees and figures, and shines in our faces, making it more difficult to grasp the reality or tangibility of the scene. A device that simultaneously makes visible and yet interferes with that very act of seeing tantalizes the viewer. We desire what we know about indirectly, what we lack; full possession cancels desire. The assumption lying behind much if not all of pastoral poetry and pastoral painting is that we want to inhabit that space, hear that music, drink that wine, and lounge in that evening splendor.

7.8 Claude Lorrain, *View of Delphi with Procession (Sacrifice to Apollo),* 1650. Oil on canvas, 4 ft 11 in x 6 ft 6¾ in (1.5 x 2 m). Galleria Doria Pamphilj, Rome.

In the 1640s Claude began to paint many landscapes with mythological themes, often evoking the emotions associated with a journey. Here pilgrims arrive at the shrine of Apollo at Delphi, which is represented by a fantastic, classicizing building that is very loosely based on the Pantheon in Rome. The elegant figures in the foreground are indebted to his studies of frescoes by Raphael.

These are, as Sigmund Freud would say, the landscapes of fantasy – dreams and wishes.

Because dreams are, according to Freud, censored desires turned into images, a psychoanalytic approach to pastoral landscapes gives some insights into their captivating power. Dreams are an odd mixture of apparently obvious or "manifest" narratives – what has happened to one during the day, for instance – with deeper (what Freud called "latent") meanings relating to the struggles and desires that exist in one's unconscious mind. The obvious or manifest content of figure 7.7, for example, is dancing peasants. The latent content is a return to infancy, protection, comfort – a kind of Garden of Eden, which lurks below the visual threshold but is closely related to the landscape forms, a source for the sunlight, shadows, streams, and ancient and medieval buildings – the very stuff of what Freud's follower Carl Jung called the collective unconscious. Pamphilj's own, deepest wishes for marriage rather than the much coveted and extremely

prestigious cardinal's hat add another level to the "deep structure" of the painting.

One of Claude's grandest paintings of the 1640s is more seascape than landscape. In his *Seaport: The Embarkation of St. Ursula* (FIG. 7.9), Claude paints beautifully detailed seventeenth-century ships in a seaport dominated by a building quite similar to the Villa Medici in Rome and a porch taken from Pietro da Cortona's Santa Maria della Pace (compare with FIG. 3.20). The story comes from the thirteenth-century *Golden Legend,* a popular source since the middle ages for tales of saints and biblical characters. Ursula was a British princess who set off to Rome accompanied by 11,000 virgins. On her return journey she and her companions were set upon and massacred by Huns in the city of Cologne. Here Ursula watches as her companions stream out from under this over-sized Baroque portico, chattering away excitedly about their journey. The grandeur created by the architecture, the late afternoon gloaming, the glinting waves of

7.9 CLAUDE LORRAIN, *Seaport: The Embarkation of St. Ursula*, 1641. Oil on canvas, 3 ft 8½ in x 4 ft 10½ in (1.13 x 1.49 cm). National Gallery, London.

Claude invented the seaport picture, but later versions include fewer figures, and any buildings shown are imaginary and often ruined.

the harbor, and a sense of ordinariness conveyed by the grunting porters readying the smaller crafts create a strange scene that must have sent chills up the spine of its original owner.

Despite the relative contempt held by the French Academy for landscape painting (see p. 209), Poussin and Claude not only helped to establish it as a legitimate form of painting but also a highly desired one. Poussin's name remains ever associated with the composed and classical landscape, while Claude created pastoral moods so compelling to collectors that many by the eighteenth and nineteenth centuries wanted to see nature as if through Claude's eyes. The so-called "Claude Glass," a convex lens often with color filters, was

used by artists and tourists alike to view picturesque landscapes. One would usually stand with his or her back to the scene, and use the glass to project in miniature on a sheet of paper a Claudian composition, one in which the colors merge and details disappear. Life imitates art.

ROSA'S ITALIAN LANDSCAPE OF THE SUBLIME

Salvator Rosa (1615–73) painted the kinds of violent landscapes that inspired the eighteenth-century British writer Horace Walpole to exclaim, as he looked about him in a perilous crossing of the Alps: "precipices, mountains, torrents, wolves,

rumblings – Salvator Rosa." Rosa is in many ways the dark side of Claude Lorrain. He was born in Naples and spent the first twenty years of his life there, but once he had the opportunity to flee northward to Rome, he did so without a backward glance. Rosa was a consummate self-promoter – fashioning himself as a philosopher, poet, musician, and actor – and enjoyed considerable success, especially with his storm-tossed landscapes.

Two paintings of St. Paul the Hermit demonstrate how Rosa made his landscapes frightening, even without monsters or threatening figures. In the *Landscape with St. Anthony and St. Paul* (FIG. 7.10), St. Anthony Abbot, ninety years old,

finds his 113-year-old fellow hermit St. Paul. Like the torn pages of an old book hanging off the end of a table, an outcrop of rock forms a natural arch over the opening to Paul's cave. The ancient saints seem to have hit upon something marvelous to talk about as they confront each other in the pit of this churning landscape. In *St. Paul the Hermit* (FIG. 7.11) painted for a Milanese cardinal, Luigi Omodei, we meet Paul again, wrapped in his woven palm leaves, hair and beard flying, hands aloft, as he stares with rapture past a tree recently blasted by a bolt of lightning, a reference to the extraordinary power of nature. In his letters of these years Rosa writes of the "terrific beauty" and

7.10 SALVATOR ROSA, *Landscape with St. Anthony and St. Paul,* 1650s.
Oil on canvas, 24¾ x 19¼ in (63 x 49 cm).
Collection of Denis Mahon C.B.E., F.B.A, London.

The painting appears to have formed part of a series depicting hermits, a favorite theme of the artist throughout his career. As in Rosa's other works, it derives its somber and disturbing power from rich, expressive brushstrokes, dark tones, uneasy colors and dramatic *chiaroscuro*.

"savage wildness" of landscapes that he had visited, and of his longing for a quiet hermitage. These two landscape paintings and a number of others like them were made in Rosa's middle years, when he fell into despair over the controversy of his literary satires (which some saw as attacking certain papal privileges and patronage). It makes sense to see these landscapes, in part at least, as offering for their maker a degree of consolation and retreat from his own turbulent life and times.

Just the same, we know that Rosa perceived a market for his landscape paintings, perhaps because they did indeed have an effect upon world-weary viewers who appreciated the need for solitude and the contemplation practiced by the hermit saints of the early Christian era. These night visions of the landscape came to be associated in the eighteenth century with the concept of the sublime, a natural force or presence (such as great forests and mountains) of such magnitude that human reason cannot grasp it. When in its company we may experience a certain pleasurable terror or deep longing for something inchoate, vague, unformed – perhaps simply a hermitage, a cave somewhere in the wilderness.

RUBENS: PRIDE OF OWNERSHIP

The landscapes of Peter Paul Rubens, although often filled with exciting detail, never inspire that sense of awe that mark Rosa's conception of nature. When the English miniature painter Edward Norgate visited Rubens' studio near the end of the Flemish painter's life, he observed Rubens' love of landscape painting and remarked that the painter "quitted all other practice in Picture and Story, whereby he got a vast estate, to studie this [landscape painting], whereof he hath left the world the best that are to be seen" (p. 46). Despite Norgate's observation, Rubens never gave up the bread-and-butter of his trade, the great narrative paintings, but he did buy an estate and he certainly produced a respectable body of landscape paintings, often using the left-over wood (his landscapes are usually on panel) from his busy shop. This cobbling together of

7.12 PETER PAUL RUBENS, *Autumn Landscape with a View of Het Steen in the Early Morning*, c. 1636. Oil on wood, 4 ft 3¾ in x 7 ft 6½ in (1.32 x 2.29 m). National Gallery, London.

Rubens, like his Antwerp contemporaries, was steeped in Classical literature, and this painting, with its contented peasants tending a fertile estate, conveys the ideal of good husbandry found in Virgil's *Georgics*. The bustle of activity around the house contrasts with the tranquillity of the fields, while the verticals of the trees counterbalance the low horizon, to which the eye is drawn by the sunlight and the sweeping diagonals.

7.13 Detail of 7.12: family by bridge, from RUBENS, *Het Steen*, c. 1636.

odd pieces of material suggests that Rubens had no intention of putting his landscapes on the market (where more exacting standards obtained), but made them for his own pleasure and as a reflection on his own life.

What Norgate referred to as Rubens' "vast estate" was Het Steen, just outside Antwerp, which he bought in 1636 and occupied for the rest of his life. The *Autumn Landscape with a View of Het Steen in the Early Morning* (FIG. 7.12) depicts both the house and a vast panorama of the countryside, extending many miles in the direction of the next town, Mechlen, whose cathedral tower is prominent on the horizon. This painting reflects on Rubens' satisfaction and undoubted pride of ownership. The viewer not only can discern several members of the Rubens family leaving the château for a morning walk (FIG. 7.13), but identify chrysanthemums, berry bushes, and the stream Baerebreek in the middle distance. A farm hand takes a wagon to market, while another stalks game in the brush; peasants tend flocks in the distance. The point of view is like that of the owner's as he stands back to admire the land, yet the vista or prospect is beyond the realm of the literally observable, as the earth's

curvature would forbid it. In this way, the painting satisfies both the Flemish tradition of a "world landscape" (made popular by the bird's-eye views of Pieter Brueghel in the sixteenth century) and a proprietor's desire to survey that which he has in trust and must protect.

Although there is no specific information about where this painting hung, it is likely that Rubens kept it not in his Antwerp house, whose rooms are too small for such a painting, but at the château. It was a fairly well-established tradition to hang views of one's estate in one's castle. This, then, gives us some clue to the meaning and function of the painting. By buying the estate of Het Steen Rubens became Lord of Steen, a title that was important enough to him to be included in the Latin inscription on his tomb in Jacobskerk in Antwerp. Although what we know about Rubens suggests that he had no real ambition to be an aristocrat, his love of the countryside and a good middle-class pride in his accomplishments and wealth indicates that this painting has something important to do with Rubens' own sense of self and position in the world.

DUTCH LANDSCAPE: A DEMOCRATIC TOPOGRAPHY

The extraordinary achievement of draining bogs and building dikes to keep out the North Sea undoubtedly led the Dutch to take a wide interest in landscape paintings, the most popular of all genres in seventeenth-century Holland. The common expression that "God made the world but the Dutch made Holland" suggests something of their attitude toward the land. In so far as paintings have a way of naturalizing experience for the men and women of a particular culture, landscapes showed the Dutch something about their own land and their nature as a people.

Dutch landscapes were bought by most if not all levels of society. Town dwellers were aware of the importance of agriculture and of something of the Dutch "spirit," which had to do with nationalism and religion and an awareness of their economic and cultural place on the continent. Landscape paintings were relatively cheap and often showed up for sale at street fairs, where they were snapped up by Dutch burghers eager to decorate their homes. This is the time when an awareness of domestic space among the middle class was growing. What the bourgeoisie hung on their own walls reflected something about how they saw themselves, what they valued, and what they wanted represented around them.

Much of Dutch landscape painting, in fact, does not just record specific topographies; rather, it combines buildings and views, settings and figurative elements. It is a pastiche. The Dutch painter and writer Karel van Mander advised artists in his *Schilderboeck* to go into the field and make sketches, to draw *naer het leven* – from life. But he emphasized the importance of skill, training, and brainwork as well. He understood, as did most of the Baroque theorists, that art is about convention and invention, observation and calculation, emotion and ratiocination.

Not all Dutch were followers of Calvin, but his ideas on predestination and an ascetic lifestyle had a profound impact on Protestantism and the work ethic. The land as shown in Dutch landscape paintings is the site of work and often shows the evidence of peasants' efforts. It may also have some reference to the fate of the soul (see FIG. 7.15). An individual's concern with his or her destiny and salvation encouraged one to be productive, abstemious, and determined in the face of nature's and society's difficulties. Calvin believed and taught that the Christian soul was predestined for salvation or damnation; one could nonetheless demonstrate one's piety and therefore "election" to the blessed state through the accumulation of wealth and the cultivation of land.

The Dutch, except for the highest classes, did not like Italianate views or pastoral landscapes.

They preferred scenes that were familiar and more or less descriptive of their own environment; generally there was no biblical or historical narrative. The time in these paintings is usually the present. An idealized past with Romantic ruins rarely, if ever, entered the Dutch landscape vocabulary in the seventeenth century.

Jan van Goyen

Jan van Goyen (1596–1656) was restless. Born in Leiden, he lived also in The Hague, worked in Haarlem, and is known to have traveled to France for two years. In addition to painting marine pictures, landscapes, and cityscapes, he was an art dealer, investor in real estate and tulip bulbs. He went all over the Netherlands painting landscapes. Like so many artists competing in the crowded and chaotic art market of the seventeenth century, he never quite succeeded. Yet when he was young, he hit upon a subject and a formula that brought, for a time at least, a modicum of success. From a relatively low point of view, he painted monochromatic dunes with lowering sky (FIG. 7.14).

The formula was simple, but effective. Some irregular ruts in the sand lead the eye along the wavering, difficult path recently taken by a wagon. The landscape plunges somewhat to the left, and rises to the right. Farmers stop for a while to visit on this lonely stretch of polder (land reclaimed from the sea); it is a damp and threatening day. Above the hillock to the right, a peasant seen from the back carries a piece of lumber toward some new project, while in the middle distance are decrepit if venerable houses and barns. The actual polder was flatter and the houses newer, but part of the appeal of this sort of view for a contemporary collector has to do with how the painted landscape shows more variety, is older and therefore more picturesque than the real landscape. By subtle acts of transformation and a tight control of tonality, the artist twists reality enough to catch the attention of those who recognize the setting but like it tricked out in atmosphere and mood.

7.14 JAN VAN GOYEN, *Dunes*, 1629. Oil on oak panel, 11½ x 20 in (29 x 51 cm). Staatliche Museen, Berlin-Dahlem.

This picture is quite unlike van Goyen's works of the earlier 1620s – village or beach scenes full of bustling figures and painted in bright local colors. Here the colors are more natural, dominated by gray-browns and greens, and the tonal qualities are emphasized; the figures are incidental, enhancing the bleakness of the landscape.

Ruisdael

Jacob van Ruisdael (1628/9–82) was the most formidable of Dutch landscape painters in the Baroque period. His landscapes convey not only a familiar topography, but also a mood, high visual drama, and have a classical sense of heroic form. The three tombs in the middle of *Jewish Cemetery* (FIG. 7.15) are actual graves that still can be seen in the cemetery at Oudekerk on the Amstel River, but Ruisdael has transformed the rest of the setting so as to create a pictorial allegory on death. The ruined church, the rainbow, and the threatening skies have connotations of hope, loss, and peril. The theme of life's transience becomes the pretext for a superb Baroque painting with a scheme of lights and darks and a com-position that leads the viewer through the work as if he or she were in a dream or on a surrealistic stage. A barren tree directs us to the tombs; a blasted stump grows sidewise near one of the sepulchers, its now dead roots having caused it to crack at some remote point in time. Even human institutions like the church have passed away.

This is more than a passive recording of a particular place. Ruisdael's subject is one of great magnitude, and he matches that subject with a grandiose, exaggerated style. This kind of painting appealed to the nineteenth-century Romantic sensibility. The German poet and playwright Goethe wrote of the *Jewish Cemetery*: "Even the tombs in their ruined condition point to the past beyond the past: they seem to be tombs of themselves."

7.16 (*opposite*) JACOB VAN RUISDAEL, *Winter Landscape*, c. 1670. Oil on canvas, 16½ x 19½ in (42 x 49.7 cm). Rijksmuseum, Amsterdam.

This picture conveys the somber atmosphere of a bleak winter's day, and contrasts with the festive scenes on ice typical of earlier Dutch artists. The massive forms and compact structure of the composition create a monumental effect, while the emphasis on the towerlike building looming over the road and the strong contrasts of light and shade impart a sense of drama.

7.15 JACOB VAN RUISDAEL, *Jewish Cemetery*, c. 1660. Oil on canvas, 33 x 37½ in (84 x 95 cm). Staatliche Kunstsammlungen, Gemäldegalerie Alte Meister, Dresden.

The overtly allegorical character of this work is exceptional in Ruisdael's output, and critics from the time of Goethe have disagreed over its precise interpretation. With the exception of the marble tombs, which still stand in the Jewish cemetery in the Ouderkerk outside Amsterdam, the motifs are typical of him – the contrast between flourishing and dead trees, running water, a foreboding sky with racing clouds, and ruins.

When rendering a scene whose ordinariness matches that of Jan van Goyen, Ruisdael could infuse it with larger-than-life effects. In his *Winter Landscape* (FIG. 7.16), for example, the houses stand erect against a darkened sky. Snow burdens the roofs, lines the canals and the branches of the leafless tree, and covers the roadway along which the citizens walk. Although this is just as apparently topographical as van Goyen's *Dunes*, its images have a higher degree of pictorial power, a vividness and strength that probably would not have interested the earlier artist.

THE WOODLAND, LANDED ESTATE, & CLASSICAL LANDSCAPE IN BRITISH PAINTING

Political theorists associated the ownership of land in eighteenth-century Georgian Britain with citizenship and the power of the gentry, as opposed to the divine right of monarchs. Good management of the land was seen as a metaphor for good statecraft. Because England was a mercantilist nation with a great navy and extensive private shipping, the need for timber and hence wooded landscapes was paramount (some plantations were even

named after naval officers). Also the pasturing of animals and the planting of wheat were vital activities in a strongly agrarian economy. The British gentry enclosed large tracts of land in the eighteenth century, combining plantations and displacing the peasants into towns. This encouragement of private ownership reflected ideas of individualism, freedom from court society, and enlightened tenancy. The agrarian reforms, the empowerment of the prosperous but non-aristocratic land-owning class, and the generally sympathetic attitude toward the land went hand in hand with a certain set of deeper cultural assumptions. The "natural," rather than referring to the wild and untamed, came to be seen in opposition to the affected, the artificial, and, metaphorically, the courtly. The eighteenth-century scientific revolution (see box, pp. 212–14) influenced this conceptual framework. Isaac Newton had discovered that the universe conformed to divinely ordained physical laws; this underlay a conservative model of the social system in which everyone had their appointed place.

As the cities grew (between 1700 and 1800 the proportion of the population that lived in towns grew from 13 percent to 25 percent) and the land became deforested (by the end of the eighteenth century, England had fewer woodlands remaining than any other European country), attitudes shifted from those of domination of nature to those of great understanding for and identification with it. The English landscape became equated with the English character. One of the results of this new empathy for the countryside was an overlapping of the natural, social, and aesthetic realms, giving rise to the concept of the picturesque. In a picturesque landscape, cultural and aesthetic forms come together, whether in painting, an actual parcel of land, or in a literary description. The journalist Joseph Addison wrote in the *Spectator* in June 1712 that "we find the Works of Nature still more pleasant, the more they resemble those of Art." The art that picturesque landscapes were supposed to resemble was that of Claude Lorrain, even though the painter Thomas Gainsborough doubted that nature could ever rise to such a level.

He wrote that "with regard to *real views* from Nature in this country, he has never seen any place that affords a subject equal to the poorest imitations of Gasper or Claude" (cited in Clark, p. 68). It was a common enough idea in the Baroque and Rococo periods to see nature as in many ways inferior to art, because the artist could improve on what lay before his eyes by getting rid of imperfections through rearrangement, invention of new details, and by idealization. In England this artistic attitude came to be associated with the making of gardens and enormous estates (see pp. 354–5). The British attitude toward land and landscapes is closely bound up with notions of personal liberty and a sense that not just the aristocracy had rights to land ownership; further, these new owners understood that they were custodians of a precious commodity that was to be well managed for the needs of the state and of posterity. (Many of the harsher realities of country living, of course, were glossed over by the poets and the artists.)

Gainsborough

British painters responded to the growing taste for landscape painting, especially in the eighteenth century, learning their techniques from the Dutch and from Claude Lorrain. Thomas Gainsborough, a prominent landscape painter who began his career imitating Jacob van Ruisdael, shows us in his style something of his origins and his approach to nature.

The Romantic poet William Blake referred contemptuously to Gainsborough's "blots and blurs," while the head of the Royal Academy of Painting, Sir Joshua Reynolds, wrote that he was enchanted by the landscapist's "powerful impression of nature." Certainly Gainsborough had a light touch and a love of fleeting light effects and diaphanous forms. Blake wanted something more substantial, while Reynolds saw the power of an art that was about optical impressions, the way light detaches itself from solid objects and seems to flit about in all its purity. Gainsborough had made many copies of landscapes by Ruisdael and even had repaired works by the Dutch master.

7.17 (*opposite*)
Thomas Gainsborough, *Gainsborough's Forest*, 1748. Oil on canvas, 4 ft x 5 ft 1 in (1.22 x 1.55 m). National Gallery, London.

Although portraiture was his profession, Gainsborough confessed in later years that landscape was his favorite genre. This early example shows the crisp shadows, ordered perspective and meticulous observation of Dutch seventeenth-century landscape painting, but there is also something of the freshness of Watteau and a sensitivity to the light and atmosphere of the English landscape. Gainsborough's later landscapes became increasingly idealized and mannered.

His painting popularly known as *Gainsborough's Forest* (FIG. 7.17), which he called one of his "imitations of little Dutch landscapes," reflects the tradition of Dutch painting that remained popular in England throughout the eighteenth century. It is also a good example of the picturesque, because the artist finds in nature many of the conventions of seventeenth-century landscape painting – especially, in this instance, those of Ruisdael. The artist in imitating nature also imitates art. This is an inhabited if not completely tamed and controlled landscape. The cows, the pond, the buildings in the background, the man tying up wood, the travelers on the

winding road, the rich sky, the dense foliage – all of this makes "Gainsborough's" forest a compendium of landscape conventions, rendered in that vaporous, impressionist style that endeared Gainsborough to late nineteenth-century French painters and that satisfied British landscape tastes in the late eighteenth century.

In his *Mr. and Mrs. Andrews* (FIG. 7.18) Gainsborough combines the genres of portrait and landscape painting, while representing a specific place and circumstance. Although there is still a brilliance to his light (especially in the folds of Mrs. Andrews' dress), the painting has less of the feel of an impressionist work than

many of his other landscapes. Here the painter represents a well-ordered plantation, fully fenced, gated in the most modern manner, and with an abundance of livestock and wheat. William Gilpin, a theorist of the picturesque, observed in 1791 that "there are few who do not prefer the busy scenes of cultivation to the greatest of nature's rough productions. In general indeed, when we meet with a description of a pleasing country, we hear of haycocks, or waving cornfields or labourers at their plough" (p. 166). Gainsborough's image of Robert Andrews and his wife depicts the modern landholder as one whose tenancy is beneficial. The bright, organized landscape to the right attests to the Andrews' diligence as proprietors whose concern is in the best interest of cultivation and conservation. This somewhat provincial couple – much too well dressed actually to work on the farm – are shown in all their self-satisfaction against the darkening clouds of an English autumnal afternoon.

Wilson

When the Welsh painter Richard Wilson (1713/14–82) journeyed to Rome in the 1750s, the French landscapist Joseph Vernet expressed surprise that a landscape painter of such ability should have wasted time in painting portraits. Wilson took heart from this comment, gave up what probably would have been a lucrative trade in portraits, and devoted himself entirely to landscapes. He died penniless, but his eerie and evocative renderings of Claudian-style views remain today as high watermarks of eighteenth-century landscape art bought by the British, as well as give visible form to complex British attitudes toward the land.

Wilson's *Cicero and Two Friends, Atticus and Quintus, at his Villa at Arpinum* (FIG. 7.19) evokes that *genius loci*, that spirit of a place, a sense of a beautiful and idyllic location, which pleased the British landed gentry. Although the topography has certain associations with his native Wales, Wilson drew directly from a particular painting

7.18 THOMAS GAINSBOROUGH, *Mr. and Mrs. Andrews*, 1749. Oil on canvas, 27½ x 47 in (69.8 x 119.4 cm). National Gallery, London.

The young couple are depicted at their Suffolk estate of Auberies, near Sudbury, at the point where the parkland meets the cultivated land; the church of All Saints where they were married is in the background. The way in which the figures are set in front of the landscape derives from Watteau; in later works Gainsborough would integrate his sitters more closely into their landscape setting.

The evocation of the
moral values of ancient
Rome was a common
theme in Wilson's work,
and was intended to
address a classically edu-
cated British aristocracy,
to equip them for their
roles as public figures.
The use of tonal banding
to indicate distance, the
extensive vista, fore-
ground figures and the
use of trees as a framing
device are all typical of
his landscape views.

by Claude Lorrain, the *Landscape with St. George
and the Dragon* (FIG. 7.20) to refer to the concept
of a harmony between nature and men. When
Wilson exhibited his painting at the Royal
Academy in London in 1770, he included in the
accompanying catalogue a quotation from
Cicero's *De legibus*, in which Cicero's friend
Atticus refers to this very spot as a "delicious
retreat" and Cicero comments that it is here that
he finds the ideal place "for undisturbed medita-
tion, or uninterrupted reading or writing." The
tranquil landscape of his painting evokes an
ancient world as product of divine grace, at peace
and in harmony with the soul of a profound
writer and a statesman much admired by the
eighteenth-century English gentleman. Sir Joshua
Reynolds observed that following Wilson's mean-
ing "requires a mind thrown back two thousand
years, and, as it were, naturalized in antiquity."

The Pastoral

THE PREVAILING THEORIES OF painting in the seventeenth and eighteenth centuries stressed the sisterhood of painting and poetry. Active in the first century B.C.E., the Roman writer Horace, often quoted by Baroque and Rococo critics, mentions the concept of *ut pictura poesis* several times in his text *Ars Poetica* (the Art of Poetry). *Ut pictura poesis* translates into "as is painting, so is poetry." An earlier formulation of this idea comes from the Greek writer Simonides of Ceos, who stated the proposition in more exact terms: "Poetry is a speaking picture, painting a mute poetry." Although few artists and writers of the Baroque and Rococo would have believed that painting and poetry are simply different names for the same thing, most agreed that the connections between the visual and verbal were many and complex (FIG. 7.21).

Probably the most important poetic genre for painters was the pastoral, a form of poetry dating as far back as the third century B.C.E. The pastoral poem often, but not necessarily, describes the lives of shepherds and shepherdesses (the word *pastor* means shepherd) and extols the values of the simple life. As a convention, it is bound up with the notion of a Golden Age, when love existed without loss, music prevailed over cacophony, and human happiness was not fleeting. The late Renaissance and Baroque periods were rich times for the intimate connection between the pastoral and painting. Poussin, Claude Lorrain, Boucher, Fragonard, Watteau, and Wilson all used pastoral conventions in their paintings. And such sixteenth- and seventeenth-century poets as Tasso, Ariosto, Spenser, Shakespeare, and Milton wrote pastoral poems, and did so as if they were trying to paint with words.

Just as the concept of *ut pictura poesis* was coming under attack in the eighteenth century, so too did the feverish interest in pastoral poetry and painting. The eighteenth-century British essayist Samuel Johnson, who saw himself as a voice of reason, asserted his distaste for the pastoral when he wrote about Milton's *Lycidas*: "In this poem there is no nature, for there is no truth; there is no art, for there is nothing new. Its form is that of a pastoral, easy, vulgar, and therefore disgusting" (cited in Poggioli, p. 159). In painting, the advent of Neoclassicism marked the end of the pastoral tradition; in poetry, the rise of Romanticism created a taste for more precise imagery, rooted more firmly in experience.

7.21 FRANCESCO FURINI,
Poetry and Painting, 1626.
Oil on canvas,
6 ft 10¾ in x 4 ft 8¼ in
(1.8 x 1.43 m).
Galleria Palatina,
Pitti Palace, Florence.

ARCADIA IN EIGHTEENTH-CENTURY FRANCE

Although few got rich from painting landscapes, the market stayed strong because people identified with nature and all of its associated values (the historian of ideas A. O. Lovejoy found no fewer than sixty-seven definitions of nature in eighteenth-century French literature and criticism). In France, the popular taste was for the pastoral and for the natural man, free from the unnecessary luxuries of life. Just as Cicero avoided the great palaces with their frescoed walls, bronze statues, and marble floors so that he could ponder matters of philosophy and statesmanship, so European artists and collectors looked to nature as a setting most appropriate to simple man, he who pondered the cooing of doves, the splashing of water, the buzzing of flies, and the lowing of the herds.

The actual world of this natural man (for which read "peasant") in eighteenth-century France was small, dirty, and demanding. At the same time as the *ancien régime* was idealizing "natural" life in their art, in reality peasants were treated brutally and their suffering was ignored. As Jean de La Bruyère (1645–96) wrote in his *Characters*:

One sees certain wild animals, male and female, scattered over the country, black, livid, and burned by the sun, who are chained, as it were, to the land they are always digging and turning over with an unquenchable stubbornness; they have a sort of articulate voice, and when they stand up, they exhibit human features: they are men. (p. 206)

The dark reality of this landscape was of no interest to François Boucher, whose *Landscape with a Water Mill* (FIG. 7.22) may have reassured some gullible members of the public that in fact peasants were happy because their lives were simple. Boucher enjoyed playing with the picturesque, a term the French Academy admitted into French dictionaries by the 1730s, using a poet's voice and an artist's eye to create a fictional idyll (the word "idyll," used frequently to describe tranquil country scenes, derives from the Greek *idyllion*, meaning little picture).

Did anyone really believe that Boucher's creations reflected reality? Did Marie Antoinette and her small court, who frolicked about in their own Boucheresque village built on the grounds of Versailles, really believe that milk-

7.22 FRANÇOIS BOUCHER, *Landscape with a Water Mill*, 1755. Oil on canvas, 22¾ x 28¾ in (57.2 x 73 cm). National Gallery, London.

Boucher is best known for his light-hearted mythological scenes and idyllic representations of rural life with pretty peasant girls. He objected to nature because it was "too green and badly lit." The technique here is fluid, and applied equally to all the elements of the composition – figures, trees and buildings – so that they appear to be of one substance.

Fragonard produced most
of his works for private
collectors, painting idyl-
lic, small-scale landscapes
populated with lovers,
which reflect his fondness
for romantic and pastoral
poetry, particularly by the
Italian poets Tasso and
Ariosto. Executed with
verve and spontaneity in
bright colors, the pictures
responded well to the
taste for wit and gallantry
that characterized the
courtly culture of Louis
XV's France.

maids had more fun than queens and princesses? Of course not. The pastoral form is a complex convention, one involving games and masks that invite confusion. Lest we take this world too seriously, Boucher lets it end just beyond the bridge in his painting, where the trees turn suddenly from blue to silver, and then to mist. Boucher's paintings intrigue the modern critic and scholar precisely because of their indeterminate or confused ontological status. We admire his talent at realizing in compelling terms a little painterly world, but we shudder at the hidden reality of that world.

But these pastoral paintings, however much they are implicated in their own times, are not really *about* them. The age to which they refer is outside of time; they evoke not so much the past as the yearning for a less difficult and confused time. This is the nature of pastoral, to make the complicated simple, and to make daily life and its games seem truthful, natural, and artless. Jean-Honoré Fragonard's *A Game of Horse and Rider* (FIG. 7.23), which is in the pastoral mode even though it contains no shepherds or peasants, contrasts the flirtatious couple with a group of boys rough-housing as horses and riders. On one level at least the boys seem less sophisticated and artificial than the couple, but it is not very hard to infer from their cavorting that they are acting out games that are just as complicated and just as social. In fact, the couple's flirtation is a prelude to a more physical game – the one referred to by the boys' rough-and-tumble.

Views

The Italian word *veduta* describes something narrower than what the English word "view" suggests; it means a view of a building or a cityscape. Portraits of buildings and cities were a relatively new genre of painting in the seventeenth and eighteenth centuries. There can be several reasons for representing a particular locale, an important one being the need for a souvenir or *ricordo*. Because populations in Europe could be fairly mobile, the city governments in such places as Rome and Venice wanted to insure the continuation of the pilgrimage and tourist trades. Not only did pilgrims visit Rome for the purposes of receiving indulgences (though of course they no longer paid for them) but there was a fairly large, semi-permanent foreign population of artists, diplomats, and connoisseurs. By the eighteenth century, both in Rome and Venice, the steady flow of foreigners – many on the Grand Tour – encouraged an industry of view paintings which advertised and promoted the cities and thereby contributed to the urban economies.

There were also views for those who were not visitors, but who in fact lived in the very places described by the artist. The only difference in style between the "domestic" view and the one made for export has to do with formality. The export view tended to present the proud face of a foreign city. The domestic view, typical of the Dutch art market, did not so much excite memory as it recreated the familial and the familiar.

One of the first "view" paintings of the Renaissance was Brunelleschi's picture of the Baptistry in Florence. The painting does not survive, but we have a description of it in Leon Battista Alberti's treatise on painting. Brunelleschi set up a square mirror next to an easel and then painted what he saw in the mirror, which reflected the Baptistry. He chose not to view the Baptistry directly, because then it would have been "unformatted"; framing, arrangement, and positioning were important aspects of paintings in the early modern period. It may be curious that visual art is more often connected with mediated rather than spontaneous seeing, but it is precisely through these calculated orderings that the viewer – the subject – has mastery of the view – the object. What Brunelleschi was trying to figure out was linear perspective, that visual code used for a rational reproduction of visual experience, for transforming the three-dimensional world onto the two-dimensional canvas. One of the motivations for view painting is the desire for control and perspective.

Italian Views (I): Rome

Michelangelo Cerquozzi (1602–60) was born in Rome when Caravaggio was at the height of his popularity. A versatile artist, he turned out genre scenes, flower pictures, still lifes, battle scenes, religious subjects, and, when he teamed up with Viviano Codazzi (1603–70), view paintings. The precise nature of their collaboration is still unclear, but the tradition that Codazzi did the architecture and Cerquozzi did the figures is probably reliable. Their best-known work of art is *The Revolt of Masaniello* (FIG. 7.24), which combines a historical event (a peasant revolt against tax collectors in Pozzuoli) with a view into the center of Naples and out toward Mount Vesuvius.

Codazzi's *Architectural View with an Inn* does not record an actual location but it embodies an important visual fashion for interpreting reality. The past in its ruins coexists with the present, revealing one of the significant ways employed by the present (the Baroque) to think about their world and the tradition of antiquity. Tradition in this sense refers to the persistence of an ancient civilization and its visual forms. Ancient architecture with its cracks and clefts, its collapsed vaults, peeling stucco, and wrecked ornamentation, nonetheless provides a familiar and comfortable setting for a repast and reflection. Codazzi also shows the mixing of the classes, with a gentleman in fashionable dress offering a coin to a beggar. In order to paint such a *veduta*, Codazzi had to have training in architectural principles and in *quadratura* or practical geometrical perspective.

Codazzi was quite capable of rendering a recognizable setting as well. *The Cowpasture* (FIG. 7.26), although not entirely correct, nonetheless gives a credible view of the Roman Forum as it appeared in the seventeenth century. Even the Romans must have enjoyed the pastoral and somewhat ironic effect of cows and sheep grazing through the heart of what was once the grandest and most powerful city in the Mediterranean world. The feelings associated with eclipsed glory fired the longings and melancholy of Roman nobles.

7.24 Michelangelo Cerquozzi and Viviano Codazzi, *The Revolt of Masaniello*, 1647–8. Oil on canvas, 37¾ x 52¾ in (96 x 134 cm). Galleria Spada, Rome.

The Piazza del Mercato in Naples is accurately shown, although some details are modified for effect – the tower of the church of S. Maria del Carmine, for example, is increased in size. Cerquozzi was noted for his animated figures and observation of homely details. In the foreground is an upturned basket of figs, thrown over by its owner, who objected to paying taxes on his produce.

7.25 Viviano Codazzi,
*Architectural View
with an Inn,*
c. 1647.
Oil on canvas,
28¾ x 38½ in
(73 x 98 cm).
Uffizi, Florence.

7.26 Viviano Codazzi,
The Cowpasture, 1682–4.
Oil on canvas,
8¼ x 37½ in
(72 x 95 cm).
Galleria dell'Accademia di
S. Luca, Rome.

The picture shows the
Roman Forum, with the
remains of the Temple of
Castor and Pollux in the
center, the destroyed
church of S. Maria
Liberatrice to the left,
and the tower of the
Palazzo del Senatore
on the Capitol in the
background. Codazzi
specialized in realistic
architectural views, often
painting ruins with
dramatic perspective
effects, in dark browns
and grays. The figures
were painted by a
different artist.

The Grand Tour

Many young ladies and gentlemen of means wished to complete their education with a Grand Tour of France, Italy, Austria, and Germany. In the eighteenth century Samuel Johnson gave voice to the commonly held belief that "All our religion, all our arts, almost all that sets us above savages, has come from the shores of the Mediterranean." Germans, Swedes, Poles, French, and above all the British descended upon Italy (and especially Rome and Venice) for their edification and excitement. Lady Mary Wortley Montagu, with a certain skepticism, said that "the boys only remember where they met with the best Wine or the prettyest Woman" (Ingamells, p. 25). Tourism began in earnest and the local economies responded by offering hotels, rooms in palazzi, and souvenirs by the best painters and copies of ancient sculpture by the best sculptors.

The first of the view painters who directly served the interests of the Grand Tourists was the Dutch-born and trained Gasper van Wittel (1653–1736), known to the Italians as Gasparo Vanvitelli. He arrived in Rome in 1675 and immediately joined the Bent (from *Bentveughels*, which means roughly "birds of feather"), a raucous group of Northern artists who lived in a small colony near Rome's Piazza del Popolo. One of his first paintings is indeed of the Piazza del Popolo (FIG. 7.27), an important view for tourists of the late seventeenth and eighteenth centuries, as most of them would have entered the city through this piazza. (Wittel also worked with a Dutch engineer who hoped to use all of Rome's obelisks as sundials; this painting may be associated with that project.) Many visitors kept journals or *Tagebücher* in which they could record their first impressions of the *caput mundi* – the capital of the world, as it had been known since the early middle ages. This picture undoubtedly served similar ends, but in visual rather than literary terms. Long after his visit to Rome and his writing of the *The History of the Decline and Fall of the Roman Empire* (1776–8), the British author Edward Gibbon wrote (Wilton-Ely, p. 137):

> at the distance of twenty-five years, I can neither forget nor express the strong emotions which agitated my mind as I first approached and entered the Eternal City. After a sleepless night, I trod, with a lofty step, the ruins of the Forum; each memorable spot where Romulus stood, or Tully [Cicero] spoke, or Caesar fell, was at once present to my eye; and several days of intoxication were lost or enjoyed before I could descend to a cool and minute investigation.

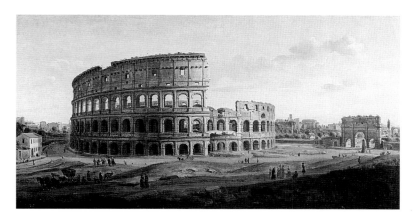

Throughout the eighteenth century, visitors trembled as they glimpsed from afar the twin churches of S. Maria di Montesanto and S. Maria dei Miracoli, which served as nodal points for the three streets converging on the piazza.

As poignant as the entry to the city would have been, the goal was the center of the old town and its ruins. Wittel's view of *The Colosseum with the Arch of Constantine* (FIG. 7.28) bathes the magnificent Flavian amphitheater in the shades and failing light of evening, thus evoking that

"intoxication" experienced by Gibbon and many another traveler to Rome. Here the sublime arises from a sense of the vastness of time and the power of the past, with its hoary and withered arms (in Gibbons' rhetoric), to assert its presence across many centuries.

The mania for collecting souvenirs of ancient and modern Rome was addressed rather efficiently by the view painter Giovanni Paolo Panini (1691–1765). He not only painted the views, he painted a shop where the views could be bought. His *View of Ancient Rome with the Artist Finishing a Copy of the Aldobrandini Wedding* (FIG. 7.29) pulls the curtain back on a picture gallery that literally combines ancient and modern architecture. Here a few connoisseurs watch as a no less exquisitely dressed painter puts the finishing touches on a copy of an ancient fresco, now in the Vatican collection. Stacked floor to ceiling in a Baroque interior (which regresses to elements of ancient Roman villa architecture – like Hadrian's in Tivoli – in the background) are Panini's views of all the important spots of ancient Rome, displayed as if ready for price tags.

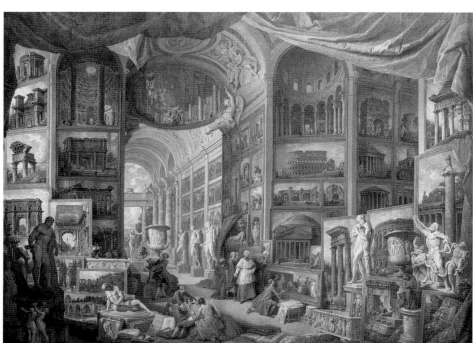

7.29 GIOVANNI PAOLO PANINI,
View of Ancient Rome with the Artist Finishing a Copy of the Aldobrandini Wedding, 1758.
Oil on canvas,
6 ft 8¼ in x 8 ft 1¼ in (2.04 x 2.47 m).
Louvre, Paris.

Prolific and versatile, Panini was an architect and stage designer as well as a painter, which helps to explain the theatrical character of this view. He would manipulate scale and perspective to capture the grandeur of the ancient buildings, and populate them with crowds of lively little figures in contemporary dress.

The Imaginary View
Giovanni Battista Piranesi's Prisons

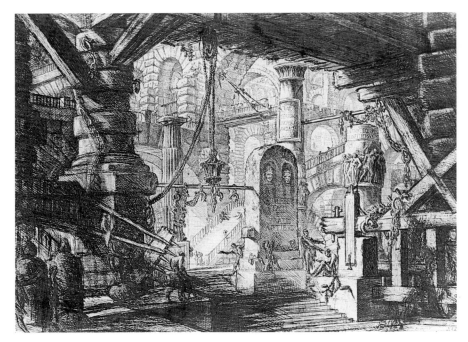

7.30 Giovanni Battista Piranesi,
The Pier with Chains (from the "Prisons" series), 1761.
Etching,
16¼ x 22 in (41 x 55.7 cm).
Private collection.

The technical understanding of construction seen here reflects Piranesi's training as an engineer and architect in Venice, but the imaginative interpretation has more to do with the traditions of Baroque stage design. As in Panini's view, scale is exaggerated and perspective exploited in order to make the buildings appear more monumental, but the contrasts of light and shade are more dramatic, accentuating the sense of disorientation.

We are all conceived in close prison; in our mothers' wombs, we are close prisoners all; when we are born, we are born but to the liberty of the house, prisoners still, though within larger walls; and then all our life is but a going out to the place of execution, to death
> John Donne (c. 1572–1631), *Sermon 27*

Not all views were of ideal or real cities. Those of Giovanni Battista Piranesi (1720–78) sometimes plumbed the deep recesses of human fear. His *Carceri* (prisons) series distills and typifies the idea of prisons (FIG. 7.30). In order to achieve some universal sense of melancholy terror, he used the medium of etching, which produces, in black-and-white, soft, blurry lines, thereby enhancing mystery, melancholy, and dreamlike impressions.

His prisons can be labyrinthine interiors of blind openings, stairways that lead to nowhere, disused but horrifying instruments of torture. The scale is immense, dwarfing the beholder, and the contrasts between light and dark areas pronounced. Although he published views of contemporary and ancient Rome, his *Prisons* series remains his most popular, probably because of its timeless quality and its ability to haunt the contemporary mind.

ITALIAN VIEWS (II): VENICE

The British admired Venice's stable government. Even as the city declined in power and wealth in the eighteenth century, the wheels of government turned as they always had, and the Doge and the Grand Council maintained order and carried on business. The British Consul in Venice, Joseph Smith, befriended the young painter Antonio Canale, called Canaletto (1697–1768), bought dozens of his Venetian views (George III acquired more than fifty of them from Smith in 1763), and introduced him to the wealthiest British tourists, who delighted in his straightforward, even literal, approach to view painting. Canaletto had cabinets filled with his master drawings from which his paintings were made. Whenever there was a change in one of Venice's buildings, his assistants would update the archival drawing. When an order came in, the drawing was pulled from its drawer, assistants started the painting, and then Canaletto would finish it, varying the people, the sky, and the lighting.

Canaletto's *The Clock Work in the Piazza San Marco* (FIG. 7.31) is a view looking north along the eastern edge of Piazza San Marco. The long shadow cast by the campanile in the left fore-ground divides up the scene into geometric units. Many view painters were expert at the architectonics of the painting but had difficulty with figures. Not so with Canaletto, who had an ability to sketch his figures with a remark-able economy of brushstrokes, to give an impression, but virtually no recognizable detail.

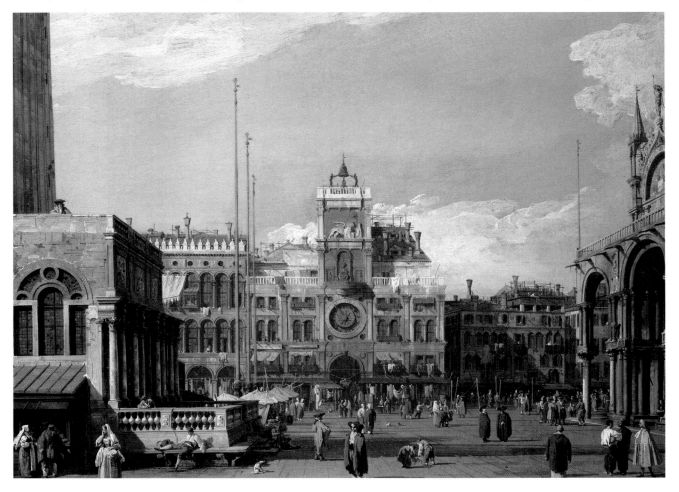

7.33 (*below*)
CANALETTO, *The Regatta on the Grand Canal*, 1733–4. Oil on canvas, 4 ft 9¾ in x 7 ft 1¾ in (1.47 x 2.18 m). Marquess of Tavistock and the Trustees of the Bedford Estate.

The view looks north-east from the first bend on the Grand Canal, with the Palazzo Balbi on the left and the Rialto Bridge in the far distance. On the extreme left is the "macchina," a temporary floating structure from which prizes were distributed. The perspective of this view may owe something to Canaletto's early training with his father, a scene painter.

7.32 (*opposite*)
CANALETTO,
The Bucintoro Leaving from the Molo on Ascension Day, 1733–4.
Oil on canvas,
4 ft 9½ in x 7 ft 1¾ in (1.46 x 2.18 m).
Marquess of Tavistock and the Trustees of the Bedford Estate.

On the right is the prison and the Doge's Palace, with the Campanile rising behind it; on the far left is the church of Santa Maria della Salute. The Doge has just left the palace, and his ducal umbrella and standards are visible above the crowd. The Bucintoro was richly carved and gilded inside and out; it was driven by eighty-four oars, each rowed by four men.

7.34 (*right*)
FRANCESCO GUARDI, *View of the Venetian Lagoon with the Tower of Malghera*, 1770s.
Oil on wood,
8¾ x 16¼ in (21.3 x 41.3 cm).
National Gallery, London.

It was the practice of Guardi's family studio to borrow compositions from other artists, and this view probably derives from an etching by Canaletto. The free, loose brushwork, luminosity and lighter color of Guardi's later work are all apparent here. He took liberties with the actual topography of Venice to produce atmospheric views that capture the fleeting effects of light.

These people blend into the crowd and achieve the status of generic humanity, part of the daily ebb and flow of visitors detached from their environment but buzzing with excitement and curiosity. It is just such a sensation of rambling crowds in an exquisitely detailed city that can excite the memory.

Two paintings by Canaletto were bought by Joseph Smith as a pair for John Russell, the 4th Duke of Bedford, who had made the Tour in the early 1730s. Both are festival pictures, displaying the extraordinary richness of the ritualized life of Venice. The Bucintoro in the first (FIG. 7.32) is the Doge's grand barge that took him out of Venice's lagoon each Ascension Day so that he could re-enact Venice's marriage with the sea by tossing a ring into the Adriatic. In *The Regatta on the Grand Canal* (FIG. 7.33), oars slice deep into the water while pivoting on their oar locks, and gondoliers race up the Grand Canal toward the Rialto Bridge while Venetians and tourists cheer them on. The British Shakespearean actor David Garrick saw one of these regattas and judged it "a dream or a fairy tale realiz'd." One can imagine John Russell back at his Bedford estate pointing delightedly at these pictures while regaling his guests with stories of his own Grand Tour.

In the generation after Canaletto, Francesco Guardi (1712–93) painted more atmospheric and individual views than those of Canaletto. His painting of *The Tower of Malghera* (FIG. 7.34) may have functioned as a souvenir, but not of the public Venice. To the left are fishermen in one of the quieter recesses of the lagoon; in the distance on the right is an old tower that once figured as part of Venice's fortifications. The ordinariness of the scene – however exotic it may appear to us today – arises partly from the sameness of gray and blue tonalities. The sky and the sea merge, with only the thinnest horizon line separating them. Guardi's figures have the same level of anonymity that one finds in Canaletto, but here they are fishermen, workers who perform the most basic chores for the purpose of subsistence. They have nothing to do with the grandeur of Venice, the Doge, the Council of Ten, or the tourists. They are creatures of the water, just as much as the fish they seek. Guardi's images have a way of creating a self-sufficient world, one cut off from the life that was teeming near by. It is the forgotten or the barely noticed that caught Guardi's attention, and that had an appeal to his customers. Nevertheless, his popularity never reached the heights of his predecessor's.

DUTCH VIEWS

Jan Vermeer's *View of Delft* (FIG. 7.35) is very different from the views of Rome and Venice described above. There are different associations lying behind Dutch view paintings. First of all, Delft has no antique past, so there are no correlations with tradition or that lost world of learning and glory so important to Rome. Nor is Delft exotic like Venice, or a religious center on a par with Rome. This is not to say that it was a city without status: it was a medieval city, venerable and with a rich history. In the seventeenth century it was home to William of Orange, the great patriot and leader in the Dutch wars against Spain. His enormous tomb is in the Nieuwe Kerk (New Church), whose tower rises in brilliant sunshine just to the right of the center of the painting. And the status of the city has some role to play in the interest that this painting would generate.

Dutch city views had appeared earlier in the seventeenth century as thumbnail sketches on the margins of maps. Here Vermeer has raised the cityscape to more grandiose proportions and has created an essay on the nature of visibility itself. Dutch artists – and especially Vermeer – had such powers of description and observation that one senses that the idea of *how* something is seen was important for them in and of itself. Vermeer probably made use of a camera obscura (see p. 72), a gadget fitted with lenses and mirrors that transferred optical impressions onto a sheet of paper. No documentary evidence survives to prove that he used one, but he probably did. There are ways in which the slightly unfocused edges to the forms in *A View of Delft* are consistent with images projected by the camera obscura. But Vermeer's own means of layering paint so as to get subtle effects of translucence and texture go far beyond anything mechanical.

7.35 JAN VERMEER, *View of Delft*, 1661. Oil on canvas, 38½ x 46¼ in (98 x 117.5 cm). Mauritshuis, The Hague.

This is one of two surviving townscapes by Vermeer; the other is a simple composition of a house in Delft (see FIG. 2.23). His unique technique of *pointillés* – tiny dots of paint applied around the contours of objects to suggest the sparkle of light – appears on the shadowy hulls of the boats, capturing the flickering reflections of light on water.

7.36 ABRAHAM RADEMAKER, *View of Delft with Schiedam and Rotterdam Gates*, n.d. Pen on paper, 8¾ x 17¾ in (22.5 x 45 cm). Stedelijk Museum Het Prinsenhof, Gemeente Musea, Delft.

The data of visual experience – such as the differing qualities of light on the buildings in shadow versus the buildings in light, the slightly greenish, grayish clouds versus the whiter ones, the way the different forms reflect in the water – are worked so intricately that one can get lost in the nuances of paint. Comparisons between this view and drawings done by others (FIG. 7.36) reveal that Vermeer's angles and view are not entirely consistent with the rules of optics. We can infer from such evidence that he made his adjustments for the sake of a unified and somewhat simplified composition. In other words, it is the describing itself – the visibility encoded within the paint – that draws our attention, not only the thing described, the "real" city of Delft.

Jan van der Heyden (1637–1712) moved with his family to Amsterdam in his early teens. Although a specialist in view painting, he also did some still lifes and landscapes. His interest in urban planning shows up in several projects that he undertook to improve firefighting and enhance lighting in Amsterdam's streets. He traveled throughout the Netherlands and into the Rhineland as well. His *A View in Cologne* (FIG. 7.37) depicts an early summer morning in

7.37 JAN VAN DER HEYDEN, *A View in Cologne*, early 1660s. Oil on oak, 13 x 16 in (33.1 x 42.9 cm). National Gallery, London.

Heyden was one of the first Dutch painters to specialize in townscapes, but he was concerned less with topographical accuracy than with conveying the distinctive character of a place. But although his views are idealized, details such as bricks and foliage are rendered meticulously. There is no trace of the items he invented such as street lighting.

the German town. The view from the west of Cologne Cathedral (near the center of the picture) corresponds to what the church looked like in the middle years of the seventeenth century. The crane on top of the tower to the right of the façade had been in place already two hundred years and was to remain so until the church was finished in the nineteenth century. The view has no specific story. It shows us the banal – on the left one dog sniffs another; the everyday – the unremarkable but pleasant view of strolling citizens; and the city itself, which is not rendered in a strictly topographical manner (Heyden often moved around details and introduced alien architectural elements for compositional reasons).

What clearly is an invention is Heyden's *An Architectural Fantasy* (FIG. 7.38), in which one finds a mixture of architectural styles, from a medieval tower on the left to a vaguely Venetian looking structure behind the tree, and then to a

small classical temple form – perhaps a city gate or triumphal arch – which reflects the brilliant sunlight from its white marble. The imaginary landscape, fantasy, or – as the Italians referred to it – *capriccio*, was generally understood to represent the power of the artist's imagination. It is, in other words, a demonstration of the artist's intellect and his knowledge of architectural forms. In addition, both the fantasy and the topographical view (a more or less accurate rendering of a known place) tap into the same consciousness that one finds evoked in landscape painting, that of harmony. Architecture, which has been referred to as "frozen music" since antiquity, may address the human appreciation for balance, and symmetry, and the feeling of well-being that results from such appreciation.

The absence of a narrative element in Dutch views, along with their powerful and detailed description, has led critics to regard Dutch view painting as more realistic than other kinds of

7.38 JAN VAN DER HEYDEN, *An Architectural Fantasy*, late 1660s. Oil on oak, 20 x 25 in (51.8 x 64.5 cm). National Gallery, London.

This view illustrates Heyden's liking for picturesque contrasts between structures and trees, and between contemporary – but mostly imaginary – buildings and ancient ones. An engineer and inventor as well as a painter, his interests lay in architecture rather than figures, which were often painted, as here, by a specialist artist.

view painting. The eighteenth-century British painter Joshua Reynolds reported after his journey to the Netherlands that "merit" in Dutch painting "consists in the truth of representation alone" and "[i]t is to the eye only that the works of this school are addressed" (Alpers, p. xviii). The nineteenth-century French critic Constantin Huygens, who also very much liked Dutch art, commented that here one finds "a strong and sensitive observation of what is" (Alpers, p. xix). In a modern variation on Reynolds and Huygens, the art historian Svetlana Alpers writes that "northern images … show that meaning by its very nature is lodged in what the eye can take in – however deceptive that might be." Nevertheless we should remain sensitive to the ways in which Dutch view paintings are not so much dealing with reality as they are representing the sites, the mood, and the community important to middle-class citizens and art buyers.

Conclusion

Landscapes and view paintings in the seventeenth and eighteenth centuries appealed to enduring human aspirations and dreams, as well as calling on one's remembrance of things past, lost, or missing. Art consumers and spectators often found escape and pleasure in images of ideal landscapes, hermitages for saints, a golden age, an ancient sage or philosopher, contented peasants and shepherds, and well-ordered and brightly lit modern cities of harmonic design and profound associations. Painters knew how to deliver these images through certain devices of staging, detailed and topographic recording, picturesque manipulations, subtleties of light and mood, and the cunning placement of the viewer in a position of strength and omniscience before a setting or environment that adheres to the values of careful and rectilinear construction.

CHAPTER 8

Town & Country Planning
ROME, AMSTERDAM, & VERSAILLES

L andscape and view paintings, as we have seen in Chapter 7, document in compact, visual terms some of the attitudes toward the town and the country in the seventeenth and eighteenth centuries. This chapter will investigate three specific places – Rome, Amsterdam, and the royal French château at Versailles – as models of urban and rural planning. Emphasis will be placed on the construction of palaces and fountains in Counter-Reformation Rome, the impact of capitalism and rational planning on Amsterdam in the new Dutch Republic, and Versailles as the supreme expression of Louis XIV's absolutism. Because each of these Baroque sites was a vital center of power, its organization and appearance reveal a great deal about city and court, and about the social, political, and artistic concerns of the time as expressed in and interpreted through a specific location.

Baroque houses, with a variety of typically Dutch gables, line a canal in modern-day Amsterdam.

Rome

Rome is the quintessential city of the Baroque in southern Europe. In order to consider its role in architecture, style, and urban planning during the seventeenth century, it is necessary to go back a little, to the second half of the 1500s, when the Roman Catholic Church was completing its deliberations on internal reform, known as the Council of Trent (see pp. 47–9). Soon after the last session of the Council in 1563, attitudes toward Rome began to shift, and popes began the revitalization of the city as an image of the Holy City. The Protestants by the beginning of the seventeenth century were no longer a threat, and the progress of Islam, the other great menace to Catholic Christianity, had been stalled by the Church's victory (with considerable Spanish assistance) over the Turks at Lepanto in 1571. The world now seemed safe for Catholicism.

To celebrate this new-found strength and self-conscious religious and cultural pride, the popes used Rome as the theater and showplace of their assurance and optimism. The papacy was an absolute monarchy in its structure, permitting the pontiff wide-ranging powers in the Papal States (those areas of Italy controlled by the pope) and especially in Rome. Although the city government of Rome was technically separate from the Vatican, the bureaucratic complexities of the city and its entanglements with the Holy See (the world-wide administration of the Vatican) meant that the pope could make, through his delegates, most if not all decisions relevant to the city of Rome. Sixtus V (1585–90) thus launched an urban renewal project that was to have reverberations throughout the seventeenth and eighteenth centuries. His intention was to enable everyone to see, as a contemporary expressed it, "the most holy testimonies of our redemption and the images of the founders of the Apostolic See." Sixtus wanted these sights to bring to life the holy images that he carried around in his own mind. And he hoped that the traveler would experience that same sense of the spirit made flesh, in buildings and monuments. This was no mean task. Centuries of neglect had left the city with a warren of streets that meandered about with no overarching logic, a ruined sewerage system, crumbling walls, a greatly depleted water system, and a reduced population. The magnificence of ancient Rome's center, the Forum Romanum, had degenerated to a cattle market, and the area around and inside the Colosseum was a pasture.

The population of Baroque Rome (about 115,000) was not much greater than it had been in the second century B.C.E, which meant that the 2000-year-old town had a fair amount of open space remaining within the old walls

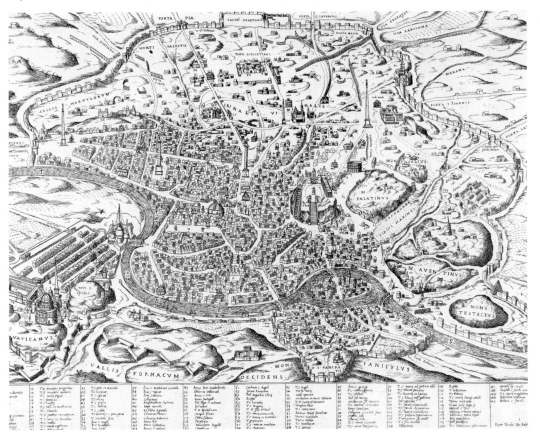

8.1
Plan of Rome from Giovanni Battista Piranesi's *Vedute di Roma* (*Views of Rome*), 1748.

Not much more than a quarter of Rome's available land within the Aurelian walls (built in the second half of the third century C.E.) was occupied during the Baroque. Most of the old walls still stood, girding Rome for about 12.5 miles (20 km) and enclosing a land mass of about 5.3 square miles (13.6 sq. km). The medieval city was massed along the Tiber north as far as Piazza del Popolo, and south into Trastevere. The Renaissance, Baroque, and eighteenth-century city slowly expanded in the direction of the old walls.

Before he became pope, Sixtus (Felice Peretti) had been an inquisitor in Venice, a position which was withdrawn from him because of the severity of his judgments. Although he had been promoted to cardinal in 1570, he resigned to pursue scholarly interests. Once elected to the papacy, he reformed the Vatican's finances, repressed banditry throughout Italy, and put into place bureaucratic offices that would enforce the decrees of the Council of Trent.

(FIG. 8.1). Sixtus launched or completed a remarkable number of urban renewal projects in his five years as pope (FIG. 8.2). In addition to his street projects, fountains, and re-erection of ancient obelisks (to be discussed below), he saw the completion of St. Peter's dome, put statues of St. Peter on top of the column of Trajan and of St. Paul on top of the column of Marcus Aurelius (to symbolize how Christian Rome had conquered pagan Rome), rebuilt the Vatican library, and placed monumental ancient statues on the Quirinal Hill (in front of the papal palace, which he also commissioned) and on the Capitoline Hill. He walked about the city, making plans, moving ancient monuments, building new ones, keeping the artists busy, revivifying Rome.

In Pope Sixtus' master-plan for the city, he drove broad, straight avenues through the town (see p. 311). The introduction of the horse-drawn coach for the nobles and members of the Church hierarchy at about this time meant that travel throughout the fairly extensive network of Roman streets was greatly enhanced and accelerated. But the older streets needed to be widened and made free of obstructions. Wooden porches, galleries, and rooms that had been cobbled onto the

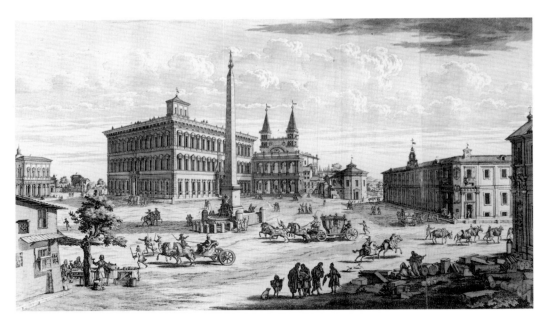

8.3 Domenico Fontana, Lateran Palace, Rome, 1585–90, showing obelisk in front; engraving from Jean Blaeu, *Du Nouveau Théâtre d'Italie.*

The nineteenth-century archeologist Rodolfo Lanciani explained the origin of the obelisk: "[It] was brought from Heliopolis to Alexandria by Constantine, and was transferred to Rome in the year 357 by Constantius, on a vessel or craft manned by three hundred oarsmen, which landed at the Vicus Alexandri, three miles below Rome. The hieroglyphic inscription commemorates King Thothmes III of the Eighteenth Dynasty."

outsides of palaces were removed, and people were forbidden to hang their washing across the street.

In addition to improving streets, Sixtus set up obelisks. As we saw in Chapter 2, Egyptian obelisks had existed as powerful symbols in Rome since antiquity. One of these great monoliths, more than 100 feet high, which now stands outside the north entrance to the basilica of San Giovanni in Laterano (FIG. 8.3), was discovered in Rome's Circus Maximus (having originally been brought to Rome from Egypt in 357 C.E.) and brought to San Giovanni in 1587. It was re-

erected by the architect Domenico Fontana (1543–1607), who had designed machinery for just this purpose a few years earlier, in 1586, when he had raised the obelisk in front of St. Peter's (FIG. 8.4). Fontana spent four months bringing the obelisk at St. Peter's to its upright position, and used 44 winches, 900 workers, and 140 horses. At a crucial point, a crowd of Romans gathered to witness this stupendous feat. They were admonished to keep silence on pain of death, so worried were the architect and engineers that the slightest disturbance could foil the work-

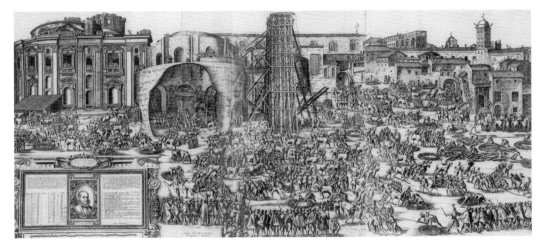

8.4 The moving of the Vatican Obelisk in 1586; engraving from Jean Blaeu, *Du Nouveau Théâtre d'Italie.*

ings of the ropes and the hauling of the 400 ton obelisk into its upright position. The ropes strained and sang. Risking his life, one sailor in the crowd, knowledgeable about ropes and the hoisting of heavy weights, cried out: "Aqua alle tende!" (put water on the ropes). This was quickly done, and the moistened ropes held. Not only was the sailor forgiven his outburst, but his family was given the concession – supposedly held to this day – of selling palm leaves on Palm Sunday.

Sixtus and succeeding popes also cleared out city squares (*piazze*), and built fountains, palaces, and churches. We have looked at a number of Roman churches as vessels of Catholic ideology and mystery (see pp. 79–93). It remains for us to study palaces and that typically Roman phenomenon, fountains.

PALACES

Roman papal palaces were built not to provide comfortable housing for celibate men during their relatively brief tenure as popes (the Roman pontiff resided at the Vatican and in the Palazzo Quirinale); rather, they were erected and largely paid for by the pope for his family. This was an obligatory gesture to tradition, a responsibility of the pope to acknowledge his new status and to confer on his family, usually through his nephews, the dignity that accompanies that standing. Papal palaces stood as visible testimony to the diplomatic and spiritual pre-eminence of the leader of the Roman Catholic Church and his family, who usually held on to the building long after the pontiff's death. The rituals of ecclesiastical and daily life were acted out in the carefully arranged interiors of these buildings.

Roman codes of behavior were formalized in etiquette books. Because of the differences in civil behavior among European countries and cultures, it was necessary that there be a guidebook for each court society, especially for Rome where foreign dignitaries often remarked on and even protested at what they took to be the oddity of precedence and rank in that city. Apartments within Roman palaces were

arranged according to strict matters of protocol. Their typical layout (FIG. 8.5) suggests by the number, size, and shape of rooms the stages of protocol necessary for daily life and social commerce. Because the formal rooms of a Roman palace were on the main floor or *piano nobile* (corresponding to the second floor in American usage), the steps from the entry level where one would be let down from a carriage were an important part of the ceremony of paying a visit. Depending upon the ranks of the visitor and the occupant, after ascending the main stairway, the visitor would pass through several rooms, moving from the sparsely to the more elaborately furnished, before entering the *camera d'udienza*, or meeting room. The occupant (often a cardinal) would have his own room further away, to which only the most esteemed visitor would be admitted. The etiquette manuals specified who was to meet whom in which room and what pleasantries were to be exchanged, who was to speak first, who was to bow, who was to be seated, how chairs were to be positioned, what were the

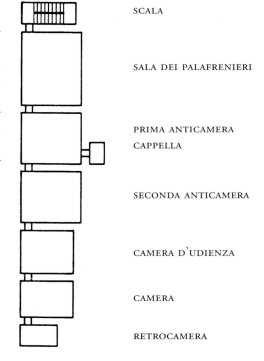

SCALA

SALA DEI PALAFRENIERI

PRIMA ANTICAMERA
CAPPELLA

SECONDA ANTICAMERA

CAMERA D'UDIENZA

CAMERA

RETROCAMERA

8.5 Plan of the apartment in seventeenth-century Rome.

appropriate sizes of chair, and so on. Naturally, the appearance of the palace itself as well as the size and decorations of these formal apartments were crucial to the overall meaning of ambassadorial receptions. Social, diplomatic, and ecclesiastical life was a matter of negotiation; art and architecture were crucial mediating terms in these encounters.

The basic form of a Baroque palace derives from ancient sources and Renaissance designs. Michelangelo's Farnese Palace (FIG. 8.6) has the shape and appearance of what came to be the standard for the Roman palace. Virtually cubic in shape, it rises in three stories, with each floor articulated by a series of windows framed with columns and surmounted (for the upper stories) by round-headed and triangular pediments. In the center is a door large enough for a grand horse-drawn carriage to enter into the inner courtyard; from there one would get down from the coach and mount the stairs.

The architectural vocabulary of the Farnese Palace – and subsequently of the typical Roman palace of the seventeenth and eighteenth centuries – harks back to ancient styles. The columns and the pediments, the sharp projection of the cornice, the severe horizontal strips (string courses) and decorated corners (coins) could have been borrowed from nearly any building of Imperial Rome. The use of ancient forms underscores the belief in permanence and persisting values, and therefore stability, strength, constancy, and durability. An architectural vocabulary and syntax that echoes the most powerful culture in the Mediterranean world at the time of Christ's birth, in the very city where the great apostles Peter and Paul were martyred, is eminently suited to and expressive of the dignity and decorum of its ruling class.

The Palazzo Barberini

Urban VIII built his family's palace, the Palazzo Barberini, in 1629–33. It is on the slope of a hill, so as to be visible from many locations in Rome (it can be seen from in front of St. Peter's, more than two miles away, for instance). The family lived there until 1949. The first wing he constructed was the north one (FIG. 8.7), built for the papal nephew Taddeo Barberini (the south wing was for Taddeo's brother, Cardinal Francesco Barberini).

The basic lines of an earlier house, owned by the Sforza family at the end of the sixteenth cen-

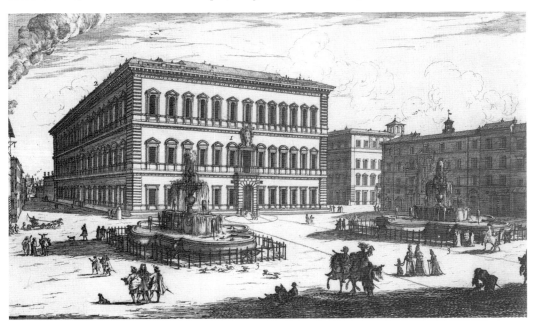

8.6 MICHELANGELO AND ANTONIO DA SANGALLO THE YOUNGER, façade of the Palazzo Farnese, Rome, begun 1517; engraving from Giovanni Battista Falda, *Il Nuovo Teatro*.

Alessandro Farnese, the future Paul III (r. 1534–49), had asked for a relatively modest palace for his family. He told the original architect Antonio da Sangallo that the exterior should be relatively plain, with no classical orders. He did not want his family's palace to look like the Strozzi or Medici Palaces in Florence. Although Michelangelo's vigorous treatment of doorway and windows strengthened the articulation of the façade, the palace still carries the severe aspect demanded by Alessandro.

8.7 Carlo Maderno and Gianlorenzo Bernini, assisted by Francesco Borromini, long northern façade of the Palazzo Barberini, Rome, 1628–33; engraving from *Veduta di Alessandro Specchi.*

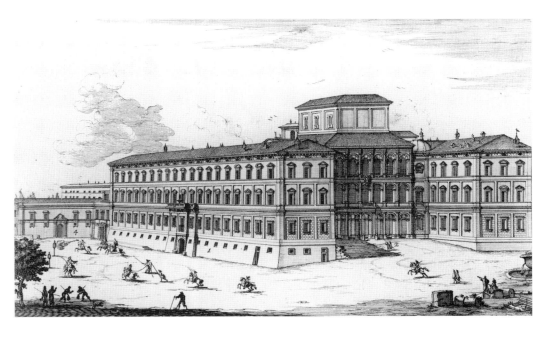

8.8 Carlo Maderno and Gianlorenzo Bernini, assisted by Francesco Borromini, western façade of the Palazzo Barberini, Rome 1628–33.

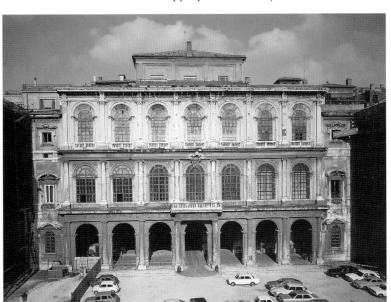

tury, were continued and enlarged upon by the Barberini and their architect Carlo Maderno (see pp. 82–3), nephew of Domenico Fontana. What we see today is a long wing with a modest porch on the ground floor that covers three bays; there are then eight bays ranging to the left and to the right. The apartments within were constructed with appropriate stairways and antechambers (along the lines of the plan reproduced in figure 8.5). The apartments of the central bays included the common rooms, a formal entryway, and the gran salone with the fresco by Pietro da Cortona (see pp. 153–5). The articulation (or detailing) of the façade follows along the traditional forms already discussed with relation to the Farnese Palace. After the rough masonry of the foundation there is the smoother effect of ashlar masonry on the first level, with a plain stucco surface defining the bays of the next level. The top level is the attic and has the fewest elements of decoration and jointing of all.

The western approach to the palace (FIG. 8.8), which is the approach one takes today, is less formal, but more interesting and more welcoming. It shows that the building is a combination of town house and country villa. The villa is usually integrated with the surrounding land through a process of projection and recession. In this case, the central, seven-bay loggia is the receding part; the two wings, viewed from their ends, project. The effect is to integrate garden and household. The seven bays of the loggia were intended to appear as unglazed (although above the ground floor they do indeed have glass) and therefore airy passages. In fact, the

arrangements of the rooms behind these arched openings do not correspond to what appears to be three floors. What we have, then, is the three-tiered loggia as a screen, something almost of a theatrical nature, but whether its lack of co-ordination with the internal arrangement of rooms was intended from the start is not clear. In fact, the entire project seems to have changed as it went along, being directed first by Carlo Maderno, then upon his death by Gianlorenzo Bernini and Francesco Borromini. There is not sufficient documentation surviving to indicate for sure who was responsible for which parts and precisely when and how additions and changes were made. What we have remaining to us, just the same, is a unique contribution to the Baroque palace design, an amalgamation of building styles and types that may not cohere into a perfect unity, but one which "works" as a gracious and magnificent palace for the Barberini family, ennobled by the pre-eminence of their most famous member, Maffeo Barberini, Pope Urban VIII.

Although modern Rome extends far beyond the Barberini Palace to the east and south, at the time it was built the palazzo was near the edge of town. Part of its function, therefore, was to mark the boundary of Baroque Rome with a palace that is also a villa, a magnificent building meant to be approached from more than one direction. It backs into a hill and simultaneously looks over a piazza that defines the declivity between the Quirinal and the Pincian Hills. It has both the severe appearance of a dominating Roman palace and the enchantment of the surburban villa.

Part of the charm of Rome, one that was eagerly exploited by Gianlorenzo Bernini (see pp. 315–18 below), is that the streets curve in and out of piazze and undulate across the seven hills. Sixtus' large boulevards were never intended to create a grid pattern within the city. The marking points for shorter (and longer) vistas or *vedute* were characteristically churches, palaces, and fountains. The Lateran Palace, for example (see FIG. 8.3), attached to the exterior of the church of San Giovanni in Laterano, commands an edge of the Esquiline Hill, but does not do so as the nodal point of a long street bearing directly toward it. One usually approached Roman palaces from an angle. The effect of a straight-on view is imperial and usually works best from a stationary point (it is especially evident at Versailles); an angled approach is more attractive to a moving viewer – a visitor or pilgrim, for instance. Despite its size and the grandeur of its buildings, Rome can also provide more intimate effects.

The Corsini Palace

When construction began on the Corsini Palace in 1736 by the Florentine architect Ferdinando Fuga (1699–1781), Pope Clement XII was already quite old and in poor health. He also claimed poverty. He wrote that "the higher I rise the lower I get. As a priest I was rich. I became a bishop and was comfortably off. I became a cardinal and was poor. Now I am pope I am ruined." He certainly exaggerated, for his family were bankers in Florence and had for generations commanded great wealth. But despite his rhetorical overstatement, he probably had spent much of the family's fortune. Those who lived in courtly society and rose in the Church did not do so for money. They usually had to spend vast amounts, in fact, just to maintain their dignity and status; to rise, they had to spend even more. It is not that the wealth of the papacy allowed Clement to build this palace; his elevation to the papacy demanded it.

The Corsini Palace was built for Clement's nephews Don Bartolomeo and the so-called Cardinal Protector, Neri Corsini. There is nothing humble about it, although the rooms are somewhat smaller than in seventeenth-century palaces. And the usual arrangement of ante-rooms and audience chambers are to be found here in nearly the same numbers and grandeur as in the earlier period (FIG. 8.9). Constructed just north of Trastevere, it is in an area of Rome not considered very fashionable in the eighteenth century. Charles de Brosses, the President of the French Academy in Rome, observed that no one would go so far to visit the papal nephews once the old pope died (which he was soon to do). We

8.9 (*opposite*) FERDINANDO FUGA, Second Room of the Corsini Palace, Rome, begun 1736.

Before the Corsini had taken over this property and rebuilt it, one of the grandest celebrities of Baroque Rome had lived here. Not far from the Second and Great Rooms one still can visit the original bedroom of Queen Christina of Sweden, who had abandoned her throne for the Catholic religion, and had made Rome her home. She died here in 1689.

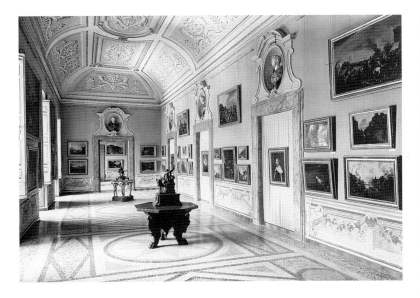

symmetrical or centralized organization of the city of Rome. And what recommended this site to Corsini and Fuga was its excellent placement at the foot of the Janiculum Hill. There already were exquisite and extensive gardens on this site, landscaped by the Riario family. (The nearby gardens of the Arcadian Academy were judged by Roman doctors to be exceedingly salubrious.) Finally, the view from the top of the Stairway of the Eleven Fountains back toward the palace was breathtaking and evocative of the Romans' love of vistas (FIG. 8.10).

The street façade (FIG. 8.11) is typical of the Roman palazzo, with its three-story elevation, unbroken string courses, and windows "dressed" with architraves and pediments. It is twenty-one bays long with relatively little variation in design or decoration, except for the slight projection of the seven bays in the center. Because the definition of the windows, including the moldings, architraves (the horizontal projections above the ground-floor windows), and pediments (round-headed on the *piano nobile* and triangular on the top floor), is not as thick nor as imposing as it is

have no indication, however, that the Corsinis' social prominence dropped any more than would be expected after the passing of Clement XII. It was, in fact, part of an informality of attitude that often accounted for the location of palaces and the interesting but not very

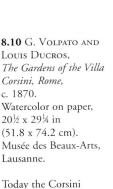

8.10 G. VOLPATO AND LOUIS DUCROS, *The Gardens of the Villa Corsini, Rome,* c. 1870. Watercolor on paper, 20½ x 29¼ in (51.8 x 74.2 cm). Musée des Beaux-Arts, Lausanne.

Today the Corsini gardens cover about 30 acres (12 hectares) on the Janiculum Hill, with more than 8,000 plants from all over the world. It now belongs to Rome's Università degli Studi.

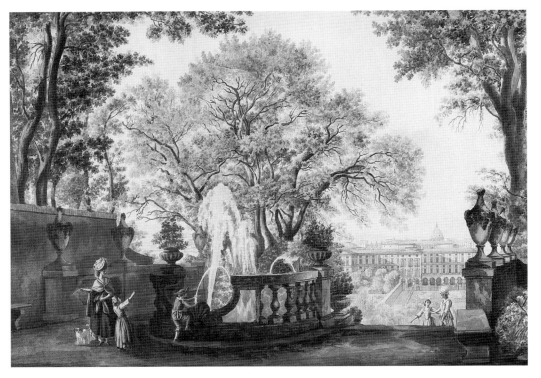

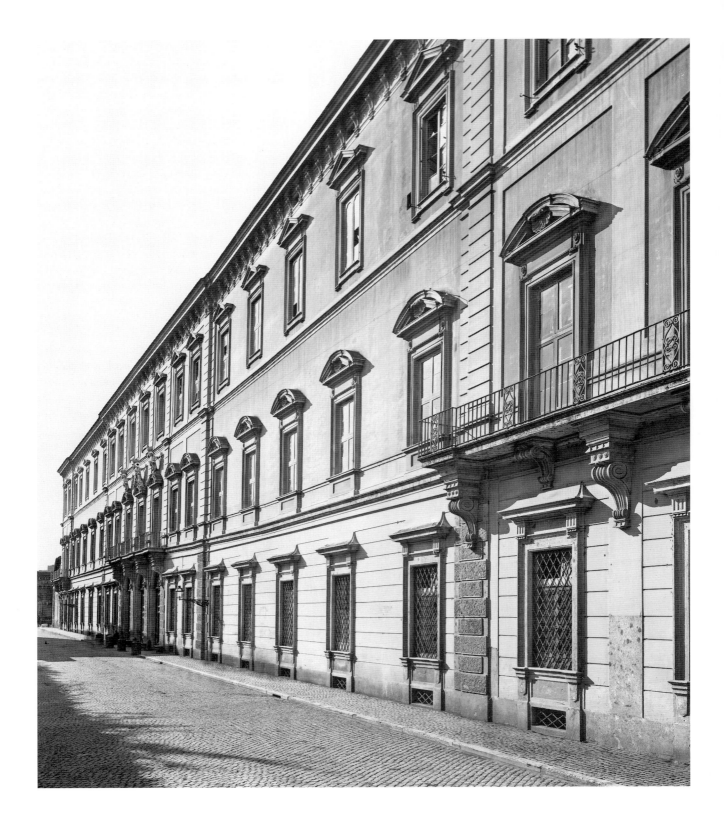

8.11 FERDINANDO FUGA,
Street façade of the
Corsini Palace, Rome,
begun 1736.

on the Lateran or Barberini palaces, the effect on the pedestrian is less overpowering. It may not seem to be a major change to simplify and refine the abstract patterns of design on the front of a palace, but in fact the more delicate and fastidious application of traditional architectural elements signals a shift in taste in the eighteenth century. The new idea of *buon gusto* or "good taste" has an anti-Baroque cast to it (see pp. 31–2), and is typical of the sensibility that valued a "return to nature."

Nature, however, was on the other side of the building. The garden façade is the aspect of the palace that Fuga and the Corsini undoubtedly preferred. Just as the Barberini Palace is a combination of villa and palace, so too is the Corsini, although here the character of the building depends upon whether one looks to the front or the back. In fact, the garden façade is the main one. Fuga had the freedom on the garden façade to open up the walls with larger windows, to create more elaborate frames for these windows, and to construct a beautiful arcaded walkway that joins two projecting wings.

Many Roman palaces of the seventeenth and eighteenth centuries had a "secret garden," which was usually a small space bordered on all four sides by the inner walls of the palace. But the secret garden was more than a place for privacy and withdrawal, it was an integral element in Baroque and Rococo town planning. These inner courtyards and more extensive gardens (although usually not as large as the Corsini's) were where much of the informal and out-of-door living went on. Trying to understand Roman town planning just from street level does not work. One needs to peruse the interiors, courtyards, entryways, and gardens of the palaces of the seventeenth and eighteenth centuries.

Although these palaces of the elite certainly raise questions about power, dominance, and exclusion – the character of the façades can be forbidding – one must remember that the easy-going lifestyle of eighteenth-century Rome made these palaces more accessible than they are today. The poorer tradesmen lived in simple apartments or tiny rooms built at street level. The average hovel may have had no more than 75 square feet of living space for an entire family, but owing to the mild climate and the very publicness of Rome, much of lower-class living was done out of doors. Fountains were built for the public to use. All of the churches remained open for several hours in the morning, and several more after lunch and the midday siesta. The major churches – such as St. Peter's – were and continue to be open throughout the day. Most palaces were accessible to the idle and the curious. The other side of the extreme formality of diplomatic and ecclesiastical receiving was the remarkable sincerity and welcoming of a Roman hospitality that admitted nearly anyone who wished to visit.

FOUNTAINS

Rome is the city of fountains. Between the late fourth century B.C.E. and the third century C.E. eleven aqueducts were built by Roman engineers that brought fresh water into Rome from points as far as sixty miles away. Some of these aqueducts were above ground and spanned large valleys; many others were below-ground tunnels made of clay, bronze, lead, and wood. All of the Roman aqueducts operated on the principle of gravity, which meant that the engineers had to calculate minute degrees of descent over great distances. Aqueducts brought water into central reservoirs, from which it was dispersed to baths, fountains, and private homes. Excess water was never stored but was used each day to clean out Rome's great drainage and sewerage system. With the decline of the empire and the depopulation of the city in the middle ages, most of the aqueducts either were destroyed by invading hordes (the Goths cut the last aqueducts in 537 C.E.) or simply fell into disuse and disrepair. In the middle ages, small fountains fed by wells still existed in the atrium or forecourt of churches, placed there as symbol of purification and the "water of life." It remained for the Renaissance and Baroque popes to restore the water supply of Rome to its former glory and to make of the fountain a centerpiece of town planning.

Roman fountains of the seventeenth and eighteenth century were both practical and ornamental. Their utilitarian function was as a communal water supply for each neighborhood. Their ornamental or iconographic function had to do with commenting on the importance of water, the patronage and care of the reigning pope, and the meaning of their particular location.

The Moses Fountain

One of Felice Peretti's first acts as Pope Sixtus V was to order the building of the first new Roman aqueduct in thirteen hundred years, the aptly named Aqua Felice. Domenico Fontana, who was responsible for so much of Sixtus' town planning, took over the task of engineering the aqueduct from the hopelessly incompetent Matteo Bartolani (whose calculations were so poor that there were places in his construction where the water ran backward, away from Rome). To commemorate this new source of water, Sixtus commissioned Fontana to build the Moses Fountain (1585–7) at the terminus of the aqueduct, near to the ruined baths of Diocletian, one of the greatest of watering places in Imperial Rome. An inscription on the aqueduct itself claims that Sixtus had "gathered the waters from afar and brought them to Rome." So plentiful are the waters and so powerful the pressure, that the Aqua Felice serves from this location a dozen other fountains in Rome (the valves are still in a room beneath the basin).

Consistent with the idea of Christian Rome not only replicating but trumping pagan Rome, Sixtus glorifies himself with an enormous inscription in the attic story of a Roman-style triumphal arch. To the right and left are reliefs depicting Old Testament water stories: on the right is *Gideon Leads his Soldiers and People over the Jordan*, and on the left *Aaron Leading the Jews to a Well*. In the middle there is a gigantic and ill-proportioned statue of Moses (FIG. 8.12), criticized almost from the moment that it was unveiled, who strikes a rock and brings forth a miraculous source of water. By choosing these Old Testament themes, Sixtus encouraged a ven-

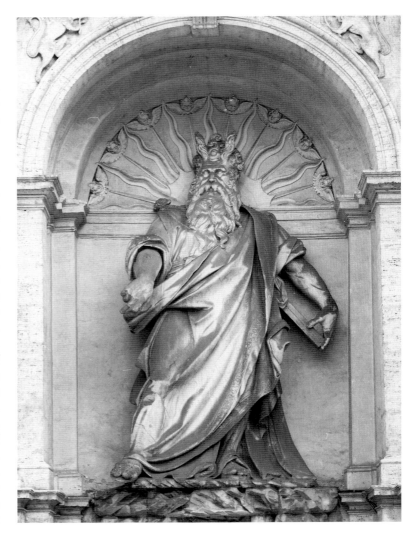

erable tradition that compared New and Old Testaments, Christian and Jewish worlds. The so-called Old Dispensation gave way to a new world in which Christian popes can eclipse the power of Israel and ancient Rome.

Likewise, four marble lions made in ancient Egypt once lay on the plinths between the water basins and spat into them – the original lions, because of their great antiquity, were put into the Vatican museum in the nineteenth century and replaced with the lions that we see there now (FIG. 8.13). These animals are presented as ferocious spirits who are tamed by the beneficent act of Sixtus, who has helped to make the

8.12 Leonardo Sormani and Prospero Bresciano, statue of Moses, 1585–8. Marble, over lifesize. Aqua Felice, Rome.

8.13
Lions, 1585–8.
Marble, over lifesize.
Aqua Felice, Rome.

The four lions *in situ* are
copies of original
Egyptian antiques that
were removed by Pope
Gregory XVI to the
Egyptian Museum, which
was founded by him and
situated in the Vatican.

city habitable, healthy, and comfortable; they
are also pharaonic lions, representatives of the
great empire conquered by the pagan Romans
(who, of course, were conquered by the
Christian Romans). The net effect on the pil-
grim or spectator is that he or she be reminded

and impressed by the pontiff's generosity and
awed before his power.

The Fountain of the Four Rivers

The Fountain of the Four Rivers (FIG. 8.14) is
Rome's best-known fountain today; the Piazza
Navona, in which it stands, is probably the most
popular gathering place for tourists and Romans
alike. With the gentle plashing of the water –
especially in the coolness of a summer's evening
– no place seems more inviting for a *passegiato*,
that charming pre-dinner walking about in
which the natives can display their *bella figura* –
their elegant appearance. What may strike one as
a triumph of Roman town planning, however,
came about in anything but a carefully consid-
ered manner. There is no hint from the outside
of what one is to see. The effect on the visitor,
therefore, is usually one of surprise, with the
scene unfolding as one turns a corner or emerges
from a narrow alleyway.

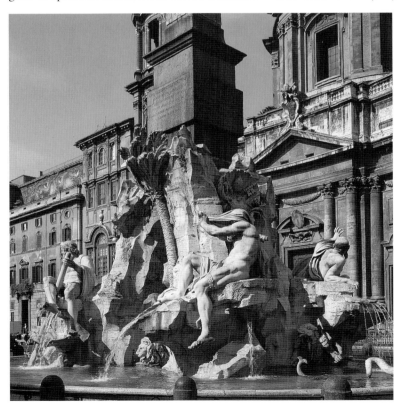

8.14 GIANLORENZO
BERNINI,
Fountain of the
Four Rivers in Piazza
Navona, Rome.
Travertine, marble figures,
granite obelisk,
1648–51.

"The Pope wanted to
inspect the fountain prior
to its unveiling in mid
1651. Bernini said he was
sorry that the conduits
were not ready; the Pope
gave his blessing and
turned to go when, with a
great roar, water began to
flow from all sides.
Innocent declared this
surprise added ten years
to his life and although
he lived less than five
years more, his delight
may well be imagined."
(Hibbard, pp. 121–2)

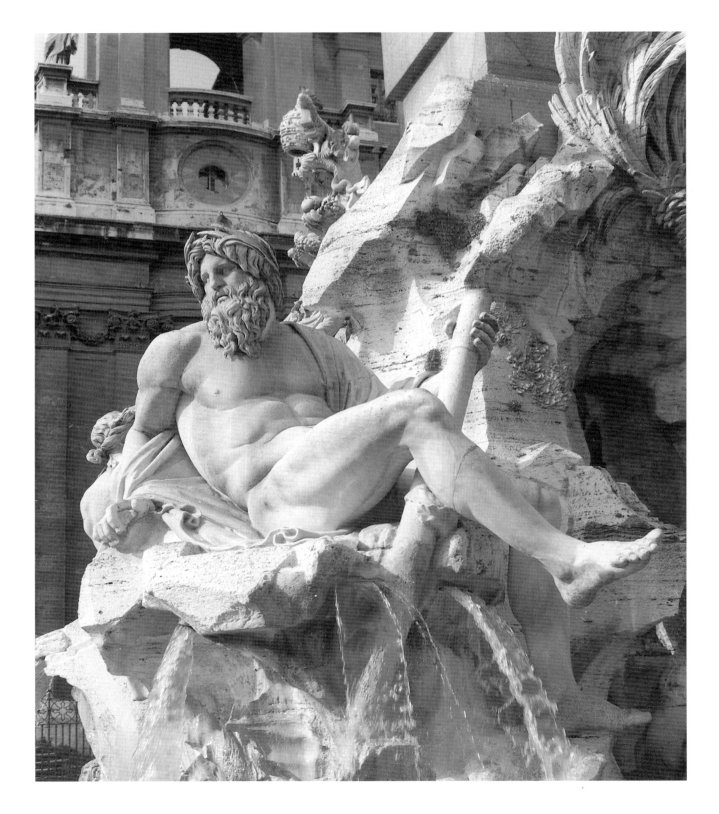

Before he became pope, Innocent X Pamphilj (r. 1644–55) lived in the family's palace on the west side of the piazza. But upon his elevation to the papacy in 1644, he and his sister-in-law, the formidable Olimpia Maidalachini, together with other members of the family, decided to enlarge their palace, build the church of Sant'Agnese, and erect a large fountain surmounted by an obelisk that Innocent, following in the footsteps of Sixtus V, had brought from the Appian Way outside of town. Innocent intended to employ Francesco Borromini (see pp. 87–90) in the construction of the fountain, just as he already had for the church of Sant'Agnese and the enlargement of the palace. He avoided Gianlorenzo Bernini, who was closely associated with the previous regime of Urban VIII. But Bernini undoubtedly sensed that the old pope could be influenced and cajoled. He therefore collaborated both with Donna Olimpia Maidalachini and Prince Ludovisi (the Pope's nephew), to place a model of his proposal (one account says that it was of

solid silver) in a room the Pope was expected to pass through. One day Innocent did indeed see Bernini's model, and was utterly delighted. He is reported to have commented, "We must indeed employ Bernini: although there are many who would not wish it; the only way to resist him is not to see his work."

Bernini promptly took over some of Borromini's ideas to make this a river fountain, a fairly common approach in antiquity. He was told to incorporate the obelisk, a 54-ft-tall piece of Egyptian granite, which according to its hieroglyphs had been dedicated to the sun. After making numerous sketches, trying out various ways of supporting an obelisk, deploying statues of the rivers, and incorporating a fairly powerful source of water, Bernini finally came up with a reasonably symmetrical composition. Because this is a freestanding fountain, one that is meant to be experienced from all sides by a strolling spectator, the symmetry is not absolute, but rather loosely achieved. He chose to carve the basic rock-like structure out of the relatively soft local stone known as travertine. Bernini's idea was to create a kind of grotto typical of the ancient Greek and Roman fountain known as a nymphaeum, which traditionally depicted nymphs lounging amid cascades of water in cool, below-ground caverns.

But instead of nymphs, Bernini depicts the four continents represented by four river gods (each of which is matched by a smaller creature inside the grotto). Because of its reputed navigability, the Ganges (Asia, FIG. 8.15) holds an oar. Rio della Plata (America), represented as a black man, grasps coins in one hand and gestures upward toward the church of Sant'Agnese in shock or amazement (giving rise to stories – completely unfounded – that Bernini was expressing horror at Borromini's architecture). The figure of the Nile (Africa, FIG. 8.16) covers his head, suggesting the unknown origin of the river (this was well before the discovery of the Victoria Falls). And finally there is the Danube (Europe), who looks in awe at the Pamphilj coat of arms surmounted by the crossed keys of St. Peter and the Pope's crown or tiara. The four

earthly rivers echo the so-called Four Rivers of Paradise, which sometimes were depicted in medieval images as flowing from the base of Christ's cross. Rising up from the structure is the obelisk, symbol of the long-conquered Egyptian empire. Innocent directed that his own personal symbol, the dove (which is also the symbol of peace and of the third person of the Trinity), surmount the entire ensemble.

In sum, within the confines of the Pope's piazza, in front of his family's palace and their parish church, a fountain that is a "well of living waters" (a well-established reference to the Virgin Mary) stands testament to his beneficent care and government and represents the four corners of the earth, the rivers of Paradise, eternity (the obelisk), peace, and the Pamphilj family. The meaning is personal and universal, proud and dominating, inclusive, celebratory, and utterly urban.

In the heat of August the drains would block and the fountain was allowed to overflow, filling the entire, elliptical piazza (which follows the lines of an ancient race course). Then the fun would start, with children splashing, dogs swimming, and horse-drawn carriages racing wildly through the newly formed lake, often as not hitting some submerged object and turning over. It must have been quite a spectacle (FIG. 8.17).

The Counter-Reformation popes inherited a large and largely disorganized city, but they imposed some order on the streets, cleared out piazze, rebuilt and built anew several hundred churches and palaces, brought in water, built fountains, and paved the streets. The result of the urbanism of the seventeenth and eighteenth centuries was not a particularly coherent city, but it was a city in which certain overarching patterns were established, such as the streets uniting the major basilicas, sighting lines, such as obelisks, erected, and enormous buildings in traditional styles of both a private and public nature built.

Although the power of the popes in international affairs dwindled throughout the Baroque and Rococo eras, their wealth and their prestige remained fairly steady. Rome continued as a great spiritual and cultural center, attracting the

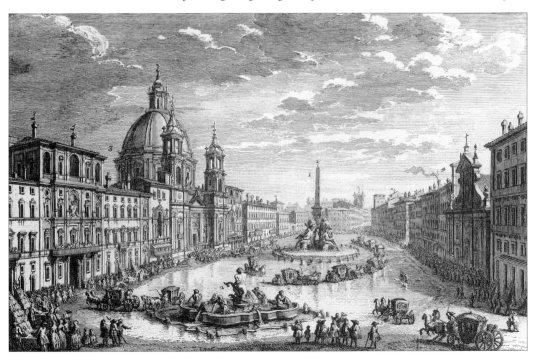

8.17 GIUSEPPE VASI, The flooding of the Piazza Navona. Eighteenth-century engraving.

In *Outre Mer* (1833–5), the American poet Henry Wadsworth Longfellow describes his view of the Piazza Navona: "Our windows look out upon the square, which circumstance is a source of infinite enjoyment to me. Directly in front, with its fantastic belfries and swelling dome, rises the church of St Agnes; and sitting by the open window, I note the busy scene below, enjoy the cool air of morning and evening, and even feel the freshness of the fountain, as its waters leap in mimic cascades down the side of the rock."

best talent in Italy for positions in the Curia, or papal court, and, because of the money available for commissions, the top artists in Europe. Pilgrims, tourists, men and women of letters, the idle and the ambitious all flocked to the Eternal City. Notably absent were businessmen. Rome did not bring in much in the way of commerce and industry, since the greater part of its funds was tied up in buildings (which provided a considerable amount of work for stonemasons, architects, sculptors, and painters, but did not produce wealth once erected) and Vatican bonds (known as *monti*) that returned a stable interest rate and therefore a living income for those who had the money to invest. But the capital of the *monti*, rather than invested in commerce, was put into ornate chests in the Castel Sant'Angelo as insurance against devastation or attack by the Turks. There the money remained, earning no interest and financing no enterprises, at least until the end of the eighteenth century.

There were major projects carried out in the nineteenth century after Rome became the capital of Italy, and in the twentieth under the Fascist regime of Benito Mussolini. But Baroque Rome is still there, never swept away, nor overwhelmed. It stands now as it stood then, a unique metropolis, the City of God and the City of Men and Women in one place, a city of powerful nobles, intellectuals, artists, and prelates, the home of the Roman Catholic Church, a diplomatic and artistic center, a place of no commerce but of considerable political activity, a place of art, and a place to live.

Amsterdam

Although Rome's population remained fairly static, growing from about 100,000 to 150,000 between 1600 and 1800, Amsterdam's quadrupled in the seventeenth century alone, from 50,000 to 200,000. The reason for the increase in population can be ascribed to the rapidly expanding economy and the promise of religious toleration. The modern appearance of Amsterdam, with its pie-shaped arrangements of canals,

islands, and bridges, is a direct result of Baroque town planning.

It was – and is – an exceptional city. Like much of the Netherlands, Amsterdam was reclaimed from the sea, and remains in intimate connection to it. A long canal leads to the North Sea, and the city itself is at the end of the so-called IJ, an arm of the IJseelmeer (once known as the Zuider Zee). The Amstel River, branching into many canals, runs through the center of town, veering around the Dam, now the city square in front of the old Town Hall (since the time of Napoleon called the Royal Palace). The Amstel and the Dam gave the city its name. Amsterdam, sitting on a mud bank more than 40 feet deep, has 90 islands, which are connected by 400 bridges. The houses, shops, warehouses, docks, shipyards, churches, synagogues, banks, and now restaurants and hotels rest on countless piles driven through the mud into the solid ground below.

Owen Feltham, an Englishman of the seventeenth century, wrote contemptuously of all of Holland as the "great bog of Europe … an universal Quagmire." But the English and other foreigners of every stripe and religion flocked there in the 1600s. One had freedom in the Netherlands – not only for worship, but also freedom to invest money, freedom to work hard and to become rich.

The largest foreign population was made up of the Flemish, who fled the Southern Netherlands to avoid religious persecution or rule by Spanish governors. The religious population included, besides the Dutch Calvinists, Jews from throughout Europe, English Anabaptists, Mennonites, English Barrowists and Quakers, French Huguenots, Greek, Armenian, and other Levantine Orthodox, as well as both foreign and Dutch Catholics (which was the only proscribed religion, although one could practice it with a modicum of concealment).

As opposed to the absolute monarchies of France, Spain, and Rome, with their hierarchies of royal and papal families, aristocrats, cardinals and priests, elaborate bureaucracies, and central

planning, Amsterdam's political organization of burgomasters, city council, and aldermen worked to serve the needs and encourage the expansion of a middle-class society dedicated to business, trade, and productivity. The central government in The Hague had little impact on the daily life of Amsterdamers.

Amsterdam had remained a Catholic city longer than had many Dutch towns, but when the city's inhabitants sided with William of Orange against the Spanish Habsburger kings in 1568, a religious change was imminent. In 1578 the Protestants took over. A few years later, in 1585, the Spanish seized the town of Antwerp and closed the Scheldt River, cutting the city off from the sea and destroying its commercial potential. Amsterdam then became the largest city in the Low Countries (so called because they were below sea-level) with access to the sea; she grew immediately and prodigiously. The Dutch sailed the world's seas, and Amsterdam was soon (almost literally) awash with whale-oil factories and shipyards.

The city council realized that the medieval town had to grow. In 1612 the Three Canals Plan was devised; the city was to increase from

8.18
Seventeenth-century map of Amsterdam.

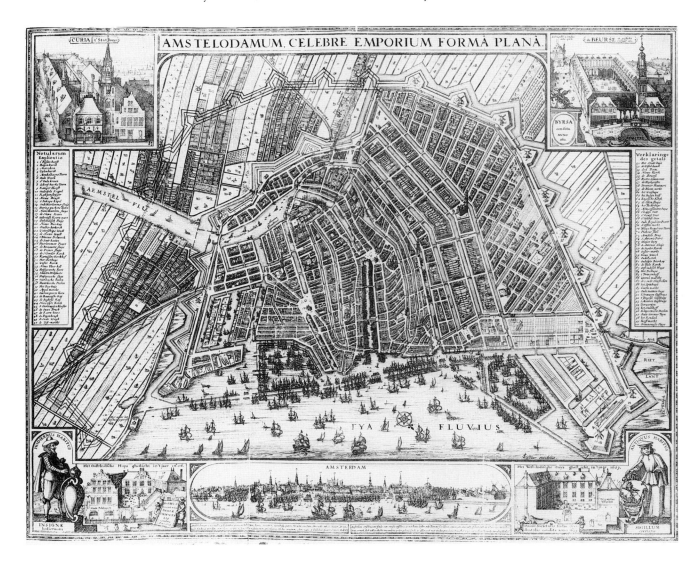

8.19 G.A. BERCKHEYDE,
*The Bend in the
Herengracht*, 1685.
Oil on canvas,
20¾ x 24½ in
(53 x 62 cm).
Rijksmuseum,
Amsterdam.

Lots on the Herengracht
were typically twice as
expensive as the next
most expensive gracht.
And on the Herengracht
the grandest homes were
clustered on the Golden
Bend (Gouden Bocht).
Because of the narrowness
of the lots, wealthy
capitalists and merchants
often bought double lots
to accommodate their
grand houses.

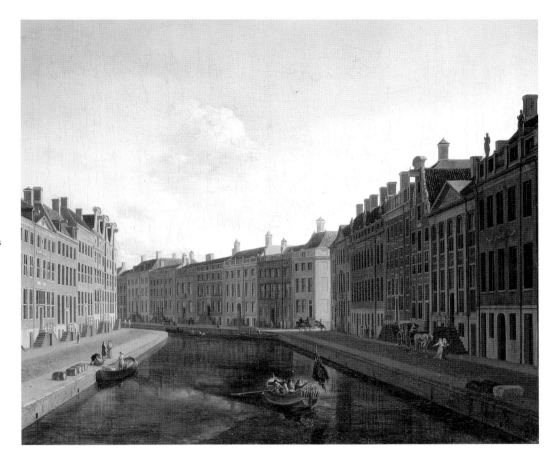

180 hectares (c. 487 acres) to 720 hectares
(c. 1780 acres). The reclaimed land was divided
into lots, subject to strict land-use require-
ments, which separated concentric canals
(FIG. 8.18). The westernmost part of town was
reserved for small industries and middle-class
houses. Then came the three grand *grachts*
(canals), each about 100 feet wide, with an
approximately 40-foot quay: the Herengracht
(FIG. 8.19), the Keizersgracht, and the
Prinsengracht. The most desirable and expen-
sive houses were built on the Herengracht, with
the less grand but still prestigious homes con-
structed on the other two *grachts*. In order to
maintain tranquillity, no noisy crafts, such as
metalwork or barrel-making, were permitted in
the neighborhood. Each lot, about 25 feet wide
by 50 feet deep, was laid out with mathematical
precision, with direct streets leading to the cen-

ter of town. Amsterdam's walls were rebuilt,
with twenty-six bastions and handsome new
gates on the roads to the major neighboring
towns of Haarlem, Leiden, Utrecht, Weesp, and
Muiden.

CANALS, HOUSES & CIVIC BUILDINGS

Before the sixteenth and seventeenth centuries,
most of the houses in Amsterdam were built of
wood. But that was impractical and sometimes
resulted in disastrous fires. At about the time
that the Three Canals Plan was underway, the
preference of the wealthy was for stone and
brick and Italian architectural elements.
Pediments, pilasters, and entablatures appeared
on the typical Dutch façade, such as the Huis
Bartolotti (FIG. 8.20) built by Hendrick de

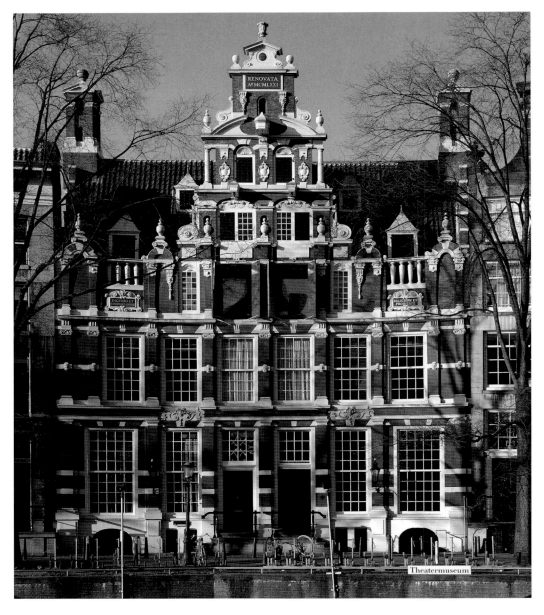

8.20 HENDRICK DE KEYSER, Huis Bartolotti, 1617. Amsterdam.

The Bartolotto family, Italian religious exiles, held one of the great fortunes of seventeenth-century Amsterdam, estimated at nearly half a million gold florins. Members of the family were underwriters for individual trading operations and investors in the French and Dutch East Indies Corporations. Perhaps as an act of solidarity with their Dutch partners they chose not an Italianate but a native Dutch style of architecture for their house.

Keyser in 1617 on the prestigious Herengracht. The steep-pitched roof spans six bays, which makes this a double façade (because of the narrow lots, most houses were only three windows wide). At the very top of the stepped gable is a small triangular pediment. The pilasters provide decoration and articulation of the gables, and the large, tall windows admit light to the narrow and deep rooms behind. A superb example of the more typical three-window façade is Philips Vinckboons' house on Keizersgracht, built in 1639 (FIGS. 8.21, 8.22). Just below the gabled area of the sandstone façade are twin pediments supported by paired pilasters. The gable itself is surmounted by a pediment with garlands, scrolls, vases, and oval windows.

Because he was Roman Catholic, Philips Vinckboons (1614–78), son of the painter

8.21 (*right*)
PHILIPS VINCKBOONS, design for a house on Keizersgracht (no. 319), Amsterdam, 1639.

Vinckboons includes a number of Italian details for this narrow canal house. Paired pilasters support the triangular pediments on the second story, and above that are oval windows, vases, scrolled volutes, swags and garlands, and another triangular pediment.

8.22 (*far right*)
PHILIPS VINCKBOONS, Groundplan of house on Keizersgracht (no. 319), Amsterdam, 1639.

One enters the house through a main door elevated slightly above the street. The first room is an entranceway, with the larger living room located beyond the vestibule. The next room probably functioned as a parlor, which would have been employed rarely, and only for special occasions. The kitchen is at the back.

David, probably received few – if any – civic commissions. But his publication of two volumes of designs for canal houses (*Oeuvres d'architecture*, 1648 and 1674) provide detailed information on the external appearance and the disposition of internal rooms of such houses. His interest in symmetry and classical detail informs his façade designs, although typically classical Italian interiors were impossible to achieve, given the narrow and deep lots behind the quays of the grand *grachts*.

A more thoroughgoing Italian house is the Trippenhuis by Philips' brother, Justus Vinckboons, a double house on Kloveniersburgwal (FIG. 8.23). He designed and constructed this seven-bay, four-story house for the two Trip brothers, wealthy Amsterdam merchants. This is one of the few houses in Amsterdam that

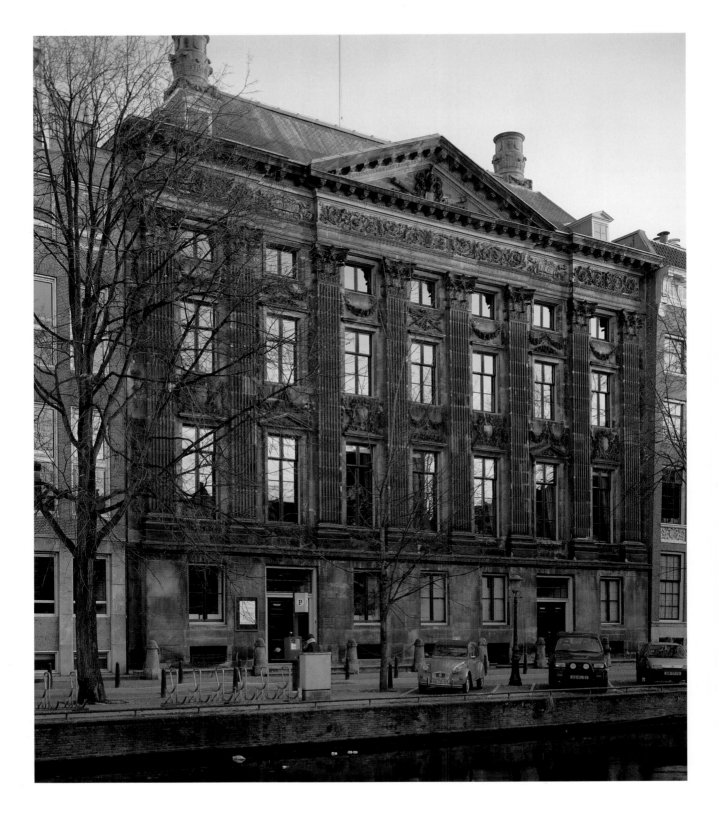

8.24 Jacob van Campen, Town Hall/Royal Palace, 1648. Amsterdam.

The construction of the town hall was an enormous undertaking, with more than 13,000 piles being driven into the soft mud beneath the dam. Work proceeded slowly, perhaps because the city wanted to finish the tower of the neighboring Nieuwe Kerk first. In the early nineteenth century the building was given to William I, and still belongs to the king, whose official residence is in the The Hague.

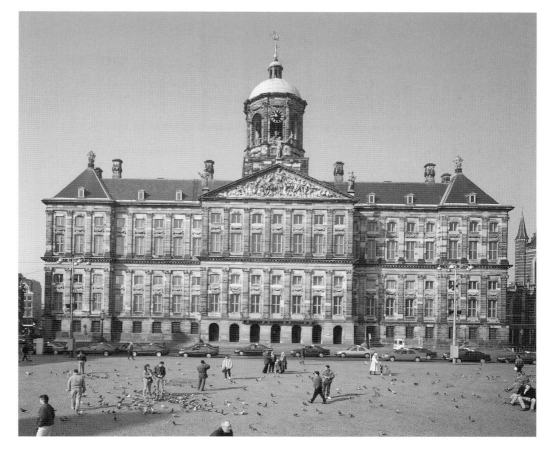

8.23 (*opposite*) Justus Vinckboons, Trippenhuis, Kloveniersburgwal, 1662. Amsterdam.

The original owner, Trippen, was an arms merchant, and asked that the chimneys be made to look like cannons. Because of its great size, the Trippenhaus served as the city's Rijksmuseum until the present museum building was constructed in 1874.

rivals a Venetian palazzo built on the Grand Canal. The colossal Corinthian pilasters organize the broad, sandstone façade through its height and width. Pediments cover the windows on the first story, and there are garlands looping between the windows. The entablature is richly decorated. The colossal order (pilasters running through the upper two and attic stories) was normally reserved for grand country houses, but Vinckboons probably had in mind the Town Hall of Amsterdam, and its classical arrangement.

The wealthiest merchants who could afford two lots thus were able to have homes closer to the aristocratic ideal, in which the stately reception rooms rivaled in appearance and proportion Roman, Spanish, French, and English town and country homes. Usually these receptions rooms, either one large space or two

smaller ones, were at the front of the double houses, facing the canal, with the private apartments in the rear.

The Town Hall (FIG. 8.24), begun in 1648 by Jacob van Campen (1595–1657), is the most important piece of Baroque architecture in Amsterdam. Van Campen was a highly learned and quite successful architect who was interested in both Italian and French styles of architecture, of a fairly conventional but well-wrought classical style. Like the French architecture of Louis Le Vau and François Mansart (see pp. 352 and 98), the Town Hall stands as an enormous block of stone and brick with projecting pavilions at either end and a broad seven-bay frontispiece of two levels of two stories each. The precise demarcation between levels and the emphasis upon a clear silhouette are classical rather than dramatic Baroque elements, which betray van Campen's

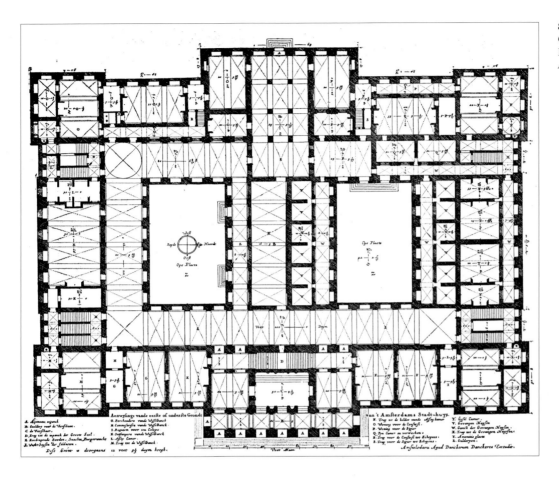

(and the burgomasters' and city council members') interest in a more conservative tradition.

The ground plan (FIG. 8.25) shows the long ranges of rooms surrounding two smaller courtyards. In the center of the building is the grand hall, larger than the gran salone at the Barberini Palace in Rome (see FIG. 4.32), and equal to the Banqueting Hall in London (see FIG. 6.6). The grandeur of scale and richness of ornamentation remind us that the Town Council was not popularly elected but was appointed by a smaller coterie (four in number) of burgomasters, who often were life-long civil servants. Although not so class-riven as the English, Spanish, French, or Italians, social and economic hierarchies were important, and a certain fear of the common people was in evidence. The central hall of the Town Hall was separated from the main entrance

by smaller passageways, and one can observe at the bronze gates on either end of the room embrasures for muskets, in case crowds forced their way into the Town Hall's largest room.

The Town Hall dates from the very year in which the Dutch signed a treaty with the Spanish, officially ending the Eighty Year War (although there had been no hostilities since the early years of the century). It is the largest civic building in the Netherlands, comparable (as contemporaries would have noted) to structures of ancient Rome, and larger than the Town Hall in Antwerp. It announces the new-found power of the wealthy elite in Amsterdam, who supported the culture of money, credit, and banking, manufacturing, trade, and investment, and who were to dictate the direction and extent of urban expansion.

Versailles: the French Royal Château

In the middle of the seventeenth century, France consolidated its social, economic, and monarchical position in Europe under Cardinal Richelieu (see pp. 217–19), who ruled as France's First Minister from 1624 to 1642. He allowed the Protestants their liberty in this still overwhelmingly Catholic country, but kept them from having any political power. He also tempered the hand of the pope in French internal policies, thereby strengthening the government at the expense of the papacy. Provincial government also lost power, as the Cardinal continued the process begun earlier in the century of fortifying the central government.

Soon after Richelieu's death in 1642, Louis XIV became king at the age of five. Richelieu's successor as Minister of France, Cardinal Mazarin, pursued similar policies, so that by the time Louis shouldered the full responsibility for governing France in 1661, he found himself in a most advantageous position. The feudal nobility had lost most of its traditional powers and functions. These aristocrats were not businessmen, but gentlemen and ladies. Historically their group had been at the apex of society and culture, but now they were to be employed by Louis XIV as his personal attendants. They had an understanding of culture, the arts, and social ritual or manners. These Louis indulged, while he saw that they remained cut off from their historical and political functions. The King carried out his social engineering at his hunting lodge, Versailles (see box, "The Memoirs of the Duc de Saint-Simon"). Although the French Royal Palace was the Louvre in Paris, Louis needed to be away from the city to have the freedom to fulfil his grandiose royal ambitions through architecture.

GROUNDS & FAÇADE

Although Louis's original plans for the château were relatively modest, the building grew throughout this and the next century until it became a vast complex of rooms stretching about a third of a mile on its low promontory overlooking the immense gardens (FIG. 8.26). Louis, with his superintendent Jean-Baptiste Colbert, constructed château and gardens in such a way as to project his grand political designs onto the landscape. His politics and culture were to overwhelm nature. Everything the King did at Versailles had the ceremonial significance of a state action, because his household, the château of Versailles, was the state in microcosm.

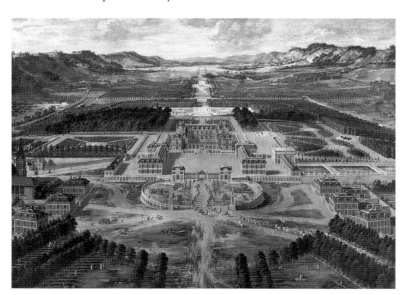

8.26 PIERRE PATEL (SNR.), *View of Versailles*, 1668. Oil on canvas, 5 ft 3½ in x 3 ft 9¼ in (1.61 x 1.15 m). Châteaux of Versailles and Trianon.

Louis XIV commissioned this bird's-eye view from Patel to show the state of the château in the later 1660s and to anticipate the westward extension of the canal, as it was then planned. Work had not yet begun on Le Vau's and Hardouin-Mansart's buildings.

The Memoirs of the Duc de Saint-Simon

8.27
Louis XIV and his court in the Parc de Versailles. Engraving (n.d.) by Lallemond, after Yvon.

WE KNOW ABOUT LIFE at Louis's court from a number of sources (FIG. 8.27). Perhaps the most entertaining and wicked accounts come from the *Memoires* of the Duc de Saint-Simon. Although no great friend of the King himself, Saint-Simon managed to ingratiate himself with other members of the family – especially Louis's great-grandson the Dauphin – and live in a

suite of apartments at Versailles in the waning years of Louis's monarchy. He kept diaries throughout his life of the events and gossip of the court, but these were not intended to be read by his contemporaries. Only long after the court of Versailles had ceased to exist, when the *ancien régime* was but a memory, did his delightful reminiscences and observations become available to a

fairly large public. The nineteenth-century French essayist Chateaubriand wrote that the Duc de Saint-Simon "wrote like the Devil for posterity."

At the death of Louis XIV's son, for example, Saint-Simon made this observation:

As for his character he had none; he was without enlightenment or knowledge of any kind, radically incapable of acquiring any; very idle, without imagination or productiveness; without taste, without choice, without discernment; neither seeing the weariness he caused others, nor that he was as a ball moving at hap-hazard by the impulsion of others; obstinate and little to excess in everything; amazingly credulous and accessible to prejudice, keeping himself, always, in the most pernicious hands, yet incapable of seeing his position or of changing it; absorbed in his fat and his ignorance; so that without any desire to do ill he would have made a pernicious King. (pp. 690–1)

Of the King's love of celebration and his sumptuous palace at Versailles, Saint-Simon has the following to say:

He liked splendour, magnificence, and profusion in everything: you pleased him if you shone through the brilliancy of your houses, your clothes, your table, your equipages. Thus a taste for extravagance and luxury was disseminated through all classes of society; causing infinite harm, and leading to general confusion of rank and to ruin.

As for the King himself, nobody ever approached his magnificence. His buildings, who could number them? At the same time, who was there who did not deplore the pride, the caprice, the bad taste seen in them? (p. 898)…

Versailles … the dullest and most ungrateful of all places, without prospect, without wood, without water, without soil; for the ground is all shifting sand or swamp, the air accordingly bad.

But he liked to subjugate nature by art and treasure. He built at Versailles, on, on, without any general design, the beautiful and the ugly, the vast and the mean, all jumbled together. His own apartments, and those of the Queen, are inconvenient to the last degree, dull, close, stinking. The gardens astonish by their magnificence, but cause regret by their bad taste. You are introduced to the freshness of the shade only by a vast torrid zone, at the end of which there is nothing for you but to mount or descend; and with the hill, which is very short, terminate the gardens. The violence everywhere done to nature repels and wearies us despite ourselves. The abundance of water, forced up and gathered together from all parts, is rendered green, thick, muddy; it disseminates humidity, unhealthy and evident; and an odour still more so. I might never finish upon the monstrous defects of a palace so immense and so immensely dear, with its accompaniments, which are still more so. (pp. 889–90)

8.28 Pierre Le Pautre, engraved plan of the gardens of André Le Nôtre, Versailles, begun 1660.

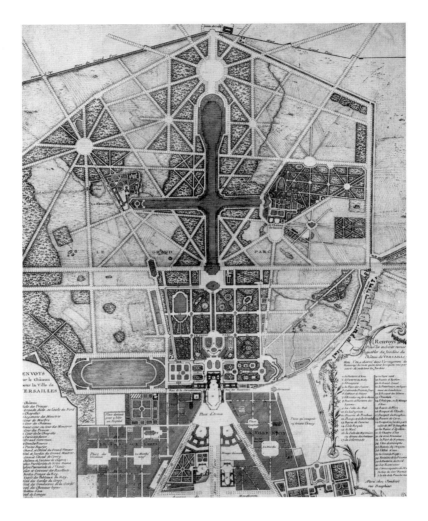

8.29 (*below*) André Le Nôtre, Grand canal and the Basin of Apollo (central group sculpted by Tuby, 1671, after a drawing by Charles Le Brun), Versailles.

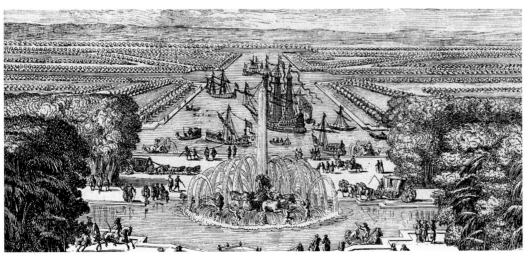

8.30 (*opposite*) Louis Le Vau and Jules Hardouin-Mansart, garden front, center block. Versailles, 1669–85.

The original building of the *Enveloppe* contained twenty-five bays on the terrace or garden side (shown here). The seven bays to left and right projected forward as lateral wings, with the central eleven bays forming a set-back *corps-de-logis*. When the middle part of the façade was filled in by Hardouin-Mansart's Hall of Mirrors (see FIG. 8.32), the effect of endless repetition of identical architectural elements was established. By the eighteenth century, these bays stretched to more than a third of a mile.

330

Three expansive avenues converge on the façade of the château and connect it to Paris (FIG. 8.28). The grand canal (in which Louis had a fleet of Venetian gondolas and even a few warships, purely for pleasure) stretches a mile in the midst of the gardens (FIG. 8.29). Le Nôtre planted full-grown trees along the avenue that connects with the canal, so as to create an unbroken line of sight. Just emerging from the waters of the basin in the center of the canal, and in unobstructed view of the château, is the chariot of Apollo. In this Baroque conceit, Louis saw himself as the sun king, and so naturally identified with Apollo the god of the sun, prophecy, civilization, reason, and art. So, as Apollo arose from the basin in the gardens of Versailles, he "flew" in his circuit of the sky over the château and the

bedroom of the King. Louis too made a ritual of his arising in the morning, his *levée*, at which he was attended by his nobles.

The architecture of Versailles (FIG. 8.30) follows in its repetition and regimentation, its classical vocabulary and refinement of detail, the authoritarian nature of the monarchy itself. This building is no more French than were the rituals of the aristocratic class. The style and the culture are universal, transcending boundaries of time and place. Louis succeeded in stripping the vigorous French nobility of its identity, of imprisoning it in splendor, of weakening it to the point that it could no longer create any risk. For Louis, art became not just an expression of grandeur and splendor, it functioned at the same time as a tool of repression. The detail of the façade is

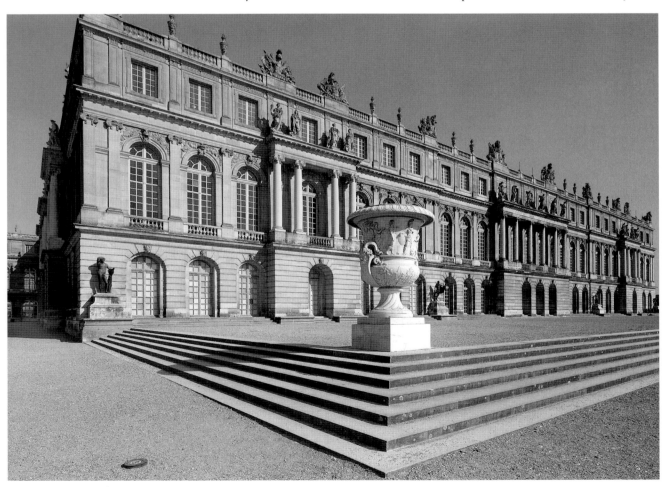

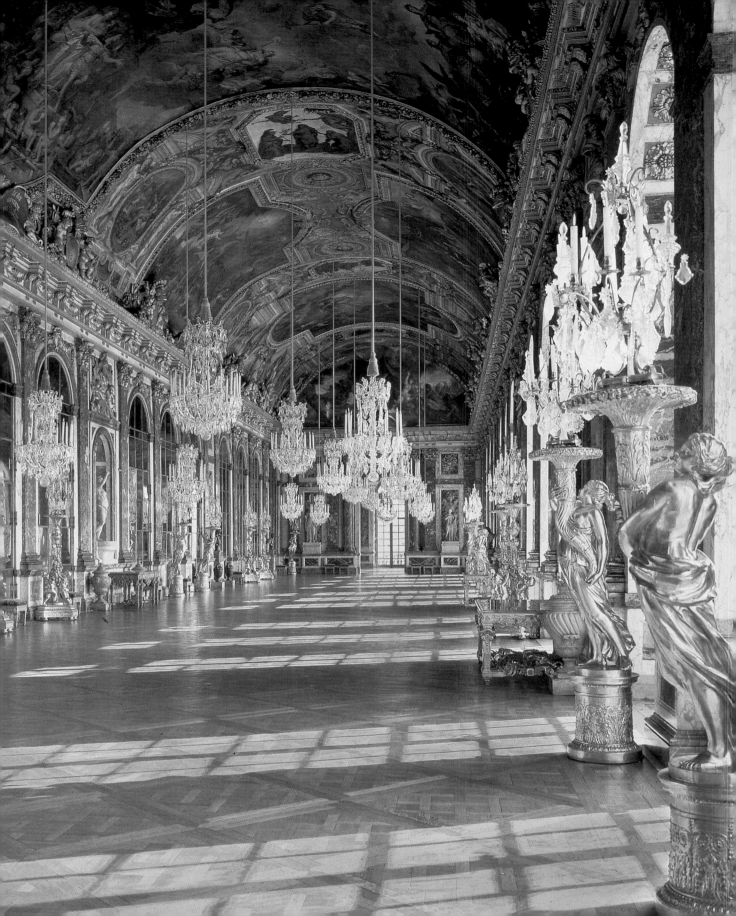

8.31 (*opposite*)
LOUIS LE VAU AND JULES
HARDOUIN-MANSART,
Hall of Mirrors,
Versailles,
1678.

intricate and finely wrought; the pilasters divide the entire garden front of Versailles into neat bays. The balustrade across the roof creates an unbroken horizon line. None of this is typical of the native French château style. No longer are there remnants of bastions, high-pitched roofs, or curtain walls.

THE HALL OF MIRRORS

With the Peace of Nijmegen of 1679 Louis XIV gained some important concessions and added to France's territories, thereby establishing himself as an important player on the European military stage. To mark what Louis saw as his triumph, he ordered the enlargement of Versailles. The architecture of the Hall of Mirrors (FIG. 8.31) was designed by Jules Hardouin-Mansart (see pp. 100–2), while the interior design was carried out under the direction of Charles Le Brun, the King's First Painter. So as to enhance court life and to encourage ever greater attendance by France's nobility on the person of the King, Louis and his minister Colbert wanted a room of grand proportions on the garden side of the palace. This would become the site of significant social and diplomatic events in the court's ritual. It would serve, for example, as the setting for nightly games of cards, of gambling, and of dancing. The room once held numerous large tables and chairs of solid silver, and full-sized fruit trees that freshened and enlivened the somewhat close and dank atmosphere of thousands of bewigged, powdered, but unwashed courtiers.

Louis wanted his own exploits depicted on the ceiling of the room, so there was need for ample lighting. Hardouin-Mansart's solution was to invent the French window – which goes from the floor to the beginning of the ceiling – and to pair each of these magnificent openings on the opposite side of the room with expensive Venetian mirrors, thus doubling the illumination and making Le Brun's frescoes all the more legible. The painter at first conceived of an allegorical program depicting Apollo, the deity with whom Louis closely identified, and Diana, the goddess of the hunt (Versailles was built as a hunting lodge). This gave way to the Labors of Hercules, which everyone would read as a thinly disguised allegory of Louis' achievements. But Louis wanted himself on the ceilings, with suitable allegorical accoutrements. And so the plan proceeded, with Colbert making the discreet comment that "there should be nothing there which did not conform with truth, nor anything too irritating to the foreign powers who might figure there." In the central scene (FIG. 8.32) Louis is shown in that royal pose somewhere between sitting and standing, with his famous shapely legs well exposed. He wears Roman armor and the French royal cape. Opposite him, Minerva, patroness of learning and the arts but also goddess of war, heads the cast of allegorical characters who will inspire, assist, and instruct Louis in the arts of war. The lowering sky probably suggests the mischievous intentions of Europe's leaders, whom Louis will successfully fight and restrain in the name of *la gloire* and peace.

Le Brun could have painted the scenes in what would be the more progressive Italian manner for the latter years of the seventeenth century, that is, in terms of *di sotto in su* rather than *quadri riportati* (see pp. 26–31). In other words, although there may be some concession to the fact that these are seen from below, the primary point of view is straight on, as if the works were originally conceived as easel paintings which then were transferred to the ceiling. Although one can only speculate as to Le Brun's reasons for choosing a slightly older model of representation, it seems likely that he consciously avoided what he may have seen as exorbitant and bizarre.

The destructive wars of the end of the century finally depleted the royal treasury, requiring that the King melt down his fabulous furniture. The death knell tolled for the age of Louis le Grand, but not for court society. After the death of Louis XIV in 1715, the court shifted to Paris and the home of the regent Philippe d'Orléans at the Palais Royale. But the court was more dispersed now, and the

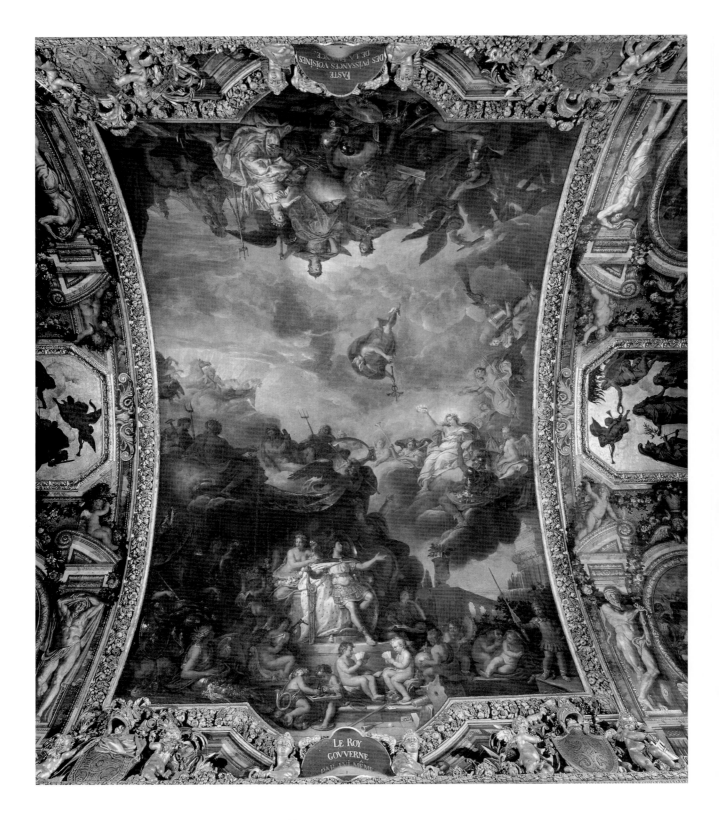

8.32 (*opposite*)
CHARLES LE BRUN,
*The Assumption of
Personal Rule by Louis
XIV*, 1681.
Canvas glued to ceiling.
Hall of Mirrors,
Versailles.

The other panels in the
ceiling depict events from
the wars against Spain,
the Dutch Republic, and
the Holy Roman Empire,
which ended with France
gaining notable territorial
advantages. The message
to diplomatic and foreign
visitors was clear: if one
were to challenge the Sun
King, there was much to
fear. These scenes in the
Hall of Mirrors help to
establish the fundamen-
tally important political
significance of Versailles,
and thereby transform a
hunting lodge into a
building of state.

nobles did not live at Philippe's home; they bought their own town houses. When Louis XV came of age and took over the government in 1723 from the regent, he moved the court back to Versailles, where there was a continuation of the etiquette, fashionability, conviviality, and ceremony of the Baroque age. Even though the etiquette became increasingly empty and a source of irritation to the nobility, it remained powerful because it was the one social code of behavior that allowed the nobil-ity to grade in minute detail the rank and status of one another. No one wanted to abandon it com-pletely. Even with the French Revolution and the demise of the *ancien régime*, aristocratic forms of etiquette remained at least as a memory and were transferred to bourgeois social life.

Whether building fountains or palaces in Rome or country houses in France, the classical style prevailed because it fitted the needs of the ruling classes. The classical form in architecture, literature, or painting was understood to repre-sent the highest and the best. Its very antiquity recommended it to patrons and their painters, sculptors, and architects. It seemed to achieve timelessness and therefore universality. Its rigid-ity and regularity paralleled the inflexibility and control needed by the Church hierarchy and aristocratic courtly society. As we will see in Chapter 10, however, the fierce grasp of the cult of antiquity was challenged in some of the art theories of the eighteenth century.

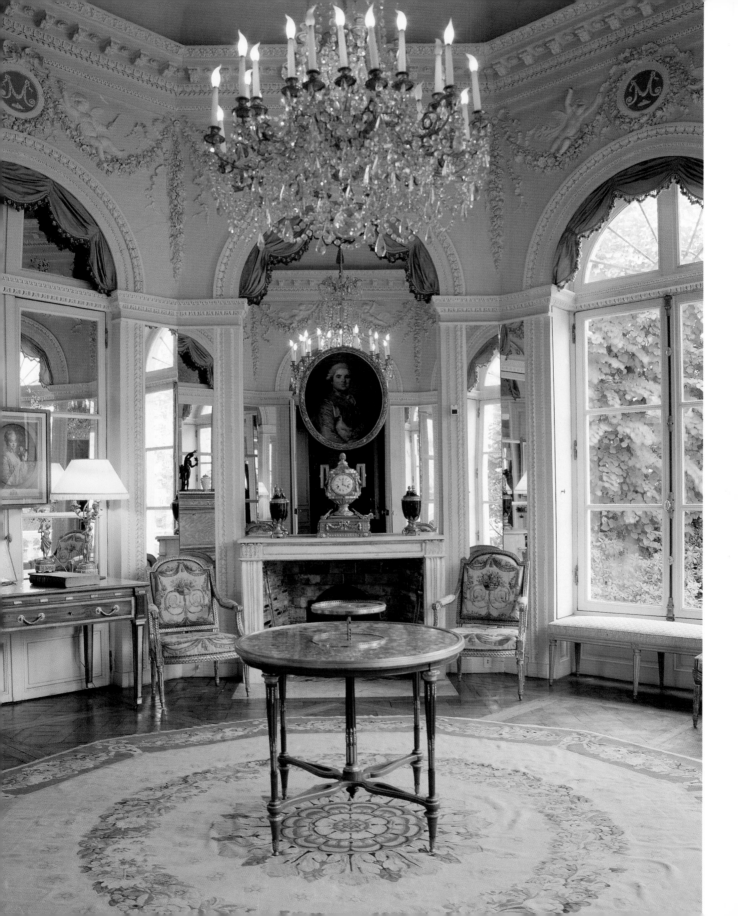

CHAPTER 9

Domestic Spaces

INTERIORS & GARDENS

JEAN-FRANÇOIS
CHALGRIN,
octagonal salon in the
Countess of Provence's
garden pavilion,
Montreuil, France,
1784.

This chapter begins on the inside and moves out. We will be looking at some aspects of everyday life in the Baroque and Rococo, but through a highly refined and somewhat disfiguring lens: the lens of art. The interiors will be seen by way of paintings and architecture; the exterior spaces of the home, where private meets public, will be examined by way of horticulture – gardens. Considering both realms gives us further insights into the visual culture of the Baroque and the Rococo.

By interior, we mean domestic spaces both as places occupied and lived in, and also as opportunities for representation by artists. Painters have points of view that are determined by their political, religious, and general ideological assumptions, their skills, their attitudes toward their profession, and their own personal artistic styles and visions. There is no such thing as a picture that simply replicates or reveals a particular room, event, or location as it "really" was. Paintings of interiors, therefore, do not so much imitate rooms and the people and objects in

them as they participate in, and help create, a system of visual codes that have to be interpreted in terms of class, gender, location, social structures, and so on. An eighteenth-century Venetian aristocrat looking at a "conversation piece" by Pietro Longhi (1702–85), for instance, would bring to his or her viewing an understanding of the quality of the painting itself, the social etiquette of the time, the cost and the particular types of the furnishings represented in the painting, and some reaction to the masked figure who incongruously slouches in his chair with his feet extended (FIG. 9.1). Longhi's paintings were described by a contemporary as *parlanti caricature*, or caricatures of people in conversation. The idea of a caricature here is that through his staging and execution of the painting, Longhi may have achieved enough exaggeration to call attention to the underlying and probably insidious significance of the social interaction. In order to recreate or uncover the meaning of this domestic picture, a student of visual culture would sift through the historical record to find as much as possible about practices of etiquette, the enduring Venetian custom of

9.1 Pietro Longhi, *The Masked Visit*, 1760. Oil on canvas, 24½ x 19¾ in (62 x 50 cm). Ca' Rezzonico, Venice.

Longhi's earliest works and success were in the tradition of grand narratives from history, legend, and the Bible. He turned gradually to scenes of domestic life among Venice's nobility, with whom he was on comfortable and intimate terms. He was not a conscious critic of aristocratic life, but one can often sense in his works that attitude evoked by Montesquieu's well-known observation that "my eyes are very pleased by Venice; my heart and mind are not."

wearing masks, the values and circumstances of Venetian aristocrats, and the role of intrigue and game-playing in their culture. One is interested not only in how an eighteenth-century Venetian aristocrat would read the picture, but how she would enjoy it, employ it as an adornment of her own interior, and how she might judge it.

As we shall see in this chapter, apparently "natural" depictions of domestic interiors can be read in a variety of ways: as displays of social status and taste; as illustrations of the tension between wealth and religion; as lectures on the moral significance of a well-run household; and as indications of changing attitudes to social class. Looking at pic-

tures about daily life is not a casual task, nor, as we shall see, is there some simple pleasure in becoming "as one" with nature in a Baroque or Rococo garden. Seventeenth- and eighteenth-century gardens were artfully contrived spaces, the setting for rituals of display, power, relaxation, and entertainment. Whether we are looking at the highly regimented, symmetrical shrubbery of a French château or the rolling parkland of an English country house, we can gain insights from the different ways in which nature was molded and shaped on the margins of the domestic sphere.

Painting & Interior Design

DUTCH BAROQUE INTERIORS

In the tradition of Jan Vermeer, Pieter de Hooch, and Jan Steen, the domestic interiors of the Delft painter Cornelis de Man (1621–1706) represented and commented on typical events with ethical or moral overtones. In *The Gold Weigher* (FIG. 9.2), a man in heavy coat and hat watches with great care as he balances coins in a scale. Wrapped in a fur-

9.2 CORNELIS DE MAN, *The Gold Weigher*, c. 1670–75. Oil on canvas, 32 x 26½ in (81.5 x 67.5 cm). Otto Naumann Ltd, New York.

The prosperous bourgeois Dutch merchant could afford a private home and therefore keep business separate from domestic life. De Man seems to suggest here that the gold weigher does not have the patience to go to his place of business, but must disrupt highly valued domestic order.

trimmed coat, his wife warms her hands, while a young boy puts peat into the fireplace. It is a cold, winter morning, when the sun is still low in the sky. The gold weigher with his steady hand has no difficulty carrying out the important calculation even before there is a warming fire. Behind him the curtained bed chamber has yet to be made up for the day, with the mattress and bedding rolled up in haste and stashed on a chair or small chest. It is as though he cannot put off counting his money; a trunk in the foreground with another bag of money awaits his attention.

This is a well-appointed (if chilly) domestic interior, typically high-ceilinged, with handsomely carved wooden panels on the back wall and over the mantle, and high-quality stone and ceramic tiles on the floor and flanking the fireplace opening. The oak draw-leaf console (the lower leaves can be drawn out to make a much larger dinner table), with its cloth unceremoniously pushed aside, dominates the space and becomes the bank (the original meaning of "bank" was bench). In the morally charged atmosphere of Dutch Protestant culture, in which mercantile values and religious piety sometimes coexisted uneasily, this scene could be taken as an instance of avarice. But where one straight-laced observer may have scowled at this man's interest in gold in the presence of the small roundels of Jesus and Mary in the background, another more liberal observer could just as easily have said that here is an industrious Dutch businessman observing the pieties of religion (Jesus and Mary) and state (the portrait over the fireplace of Prince Maurits of Orange). However, because the middle-class literature of the time generally saw the woman as the uncontested ruler of hearth and home, there might be the suggestion here that the husband is imposing himself and causing some confusion. He seems impatient; she appears to glower, hardly pleased to be sitting by idle, when there are the morning chores to do.

Netherlandish artists rendered the fall of light with great delicacy and exactitude. Because subsidence was a problem in the marshy lands of the Low Countries, walls were less thick, allowing for larger windows. The Dutch developed sash windows, shutters, and window curtains. The light so carefully modulated by painters reveals not only daily activities, but the simple and fine furnishings. Walls were not covered with paper, but were bare plaster, although often hung with fine paintings, maps, and expensive mirrors.

Despite the sense conveyed to the modern viewer of snugness (the word derives from the Dutch), these homes were not altogether comfortable. There usually were no indoor bathrooms, for instance. So, although the houses themselves were immaculate, those who lived in them were not. An Englishman by the name of Brickman observed that the Dutch kept "their houses cleaner than their persons, and their person [cleaner than] their souls" (cited in Sutton, p. lxxv). We may dismiss this last comment as pure prejudice, but his observation on cleanliness confirms what we see in the carefully staged paintings of the period and underlines the distinctive nature of Dutch attitudes toward household space: clean but not remarkably commodious. Although the Dutch climate is not frigid, it is damp and cold in the winters. The large fireplaces fed by peat were not very effective in generating heat. Chairs and benches had little or no upholstery and certainly were not designed for lounging. The sofa appeared only in the eighteenth century, when Turkish and Arabic forms of furniture, with their elegant Rococo silhouettes, were introduced into Europe. The Dutch were slower to adopt them than the French. For all of the appeal and coziness suggested by Dutch interiors, comfort was not at the top of the list for those who chose the furnishings (it was probably done by the wives) in the Dutch seventeenth century.

In seventeenth-century Dutch towns, private homes usually were built on narrow but fairly deep lots. One entered into a small hallway, which contained doors into a room to the right or left, and onto another hallway that provided access into the back parts of the house. There often was a staircase that took one to upper floors. It was not until the eighteenth century when,

after the French fashion, the household of a prosperous and perhaps ambitious member of the upper bourgeoisie was divided into a public space where one would entertain close friends, a large reception room for formal and more conspicuous receptions, and the private family quarters.

The Dutch domestic interior as shown to us by contemporary artists is often a site for moral display and drama, but, it also has its nonnarrative function as well, where a mood and an ambience of domesticity convey meanings that strike deep into the human psyche. In Pieter de Hooch's *The Linen Chest* (FIG. 9.3), for instance, the sense of light, order, and domestic tranquillity are unmistakable. Above the door leading out to the sunlit canal beyond stands a statuette of Mercury, god of commerce, holding a money bag. De Hooch thereby forges an intimate connection between the disciplined, well-ordered household and the thriving Dutch economy – by implication, the father's domain – that under-

writes family life. The painting certainly does provide a model for the earnest Dutch citizen on how to order one's household affairs, but in addition there arises an aesthetic pleasure associated with that arrangement. From a child's point of view especially (and children feature frequently in Dutch paintings), there must have been some spiritual comfort in the bright and tidy homes. Where would one find a better sense of self, belonging, and security than in a domestic interior as painted by Pieter de Hooch? Because of their uncluttered appearance, reliance upon precise, perspectival renderings of rooms giving onto other rooms, with a view finally to the outside world, his images function as visual archetypes for one's sense of place in the world, for a view that begins with the individual, moves to the regular, dependable, and almost ritual workings of the family, and then extends to the place that harbors and comforts them – the home – and on to the outside world. These paintings of

9.3 PIETER DE HOOCH, *The Linen Chest*, 1663. Oil on canvas, 28¼ x 30½ in (72 x 77.5 cm). Rijksmuseum, Amsterdam.

The perfect Dutch wife was immortalized by the most popular of moralizers in the seventeenth century, Jacob Cats. In a paean to "The Heroic Housewife" he wrote of "A wife that by all virtue goes/ Yet of her gifts but little knows … / No slut at home no doll outdoors/ A wife that puts her best step forth in virtue fair … / A wife, a still and peaceful wife/ A foe to all that's woe and strife/ A wife that never breaks the peace/ And ne'er too loud or shrill of speech … ."

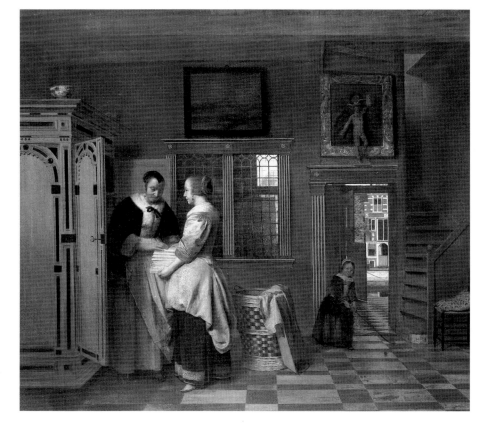

rooms function in their own way as spiritual spaces just as much as the painted ceilings of Roman Baroque churches.

It was the contention of the German sociologist and political economist Max Weber, author of *The Protestant Ethic and the Spirit of Capitalism* (1904–5), that the Protestant religion – and in particular Calvinism – dominated the ordering of everyday life in seventeenth-century Netherlands. The very spirit of capitalism, he contended, with its emphasis upon rational economic systems, was not only encouraged by Protestantism, but was sanctioned as a moral imperative. Just as the Jesuits adhered to their motto of "for the greater glory of God and the Church," so too did the upper bourgeoisie in the Netherlands believe deeply that they were glorifying God with their industriousness and their accumulation of money, which was therefore pursued in an attitude of modesty and asceticism.

So we see that, in the influential account of Weber, a painting by de Hooch crystallizes in visual terms an ethical situation. According to Calvin, one's election to grace occurred not as a result of good works or a moral life, but was pre-ordained by God and utterly inscrutable. One simply had no idea whether or not one was among the elect. Yet the need to glorify God existed regardless of that status, and so one lived *as if* among the elect. A peaceful, commodious if austere, and well-regulated home served one's ethical obligation to live in a certain way. These paintings encourage their audience to visualize, in archetypal fashion, the inner relationships between day-to-day life and the claims of religion.

FRENCH ROCOCO INTERIORS

The quiet domesticity of the Dutch interior in the seventeenth century was very different from the French interior of the same period. Louis XIV's Versailles hardly promoted intimacy or privacy. It was the King's desire to oversee everything that took place, to deny his court, in other words, any possibility of seclusion or "personal space." A horror of royal surveillance, together with the now widely known Dutch tradition for more intimate interiors, undoubtedly contributed to the development of different kinds of living arrangements for the French elite of the eighteenth century. With the death of Louis XIV in 1715 and the removal of the court to Paris during Philippe d'Orléans' regency (see p. 191), the building of magnificent but nonetheless discreet town houses or *hôtels* in Paris announced a shift in the values of French domestic architecture. This shift, in turn, opened up opportunities for painters to represent these interiors in ways that took advantage of the social meanings of greater intimacy and familiarity.

Before the bottom fell out of his fiscal schemes, John Law (1671–1729), a Scottish monetary reformer in the employ of Philippe d'Orléans, helped to earn many Parisians instant wealth, which sent them on buying sprees the like of which had not previously been seen outside of the royal family. Philippe had hoped to reduce the enormous public debt incurred during the later years of the reign of Louis XIV, and initially Law's plans worked. He supervised the founding of a bank that would issue notes, replacing scarce gold and silver currency, and paper money was issued in large quantities. Before the paper currency lost most of its value, Law's strategy had a significant impact on building activity in Paris. Suddenly, it seemed, many had the means to build or renovate existing structures, and furnish them with paintings, marble busts, and the beautiful cabinetry, sofas, and chairs produced by the craftsmen who had once been in the employ of Louis XIV.

Jacques-François Blondel (1705–74), Louis XV's architect, became a spokesman for how domestic architecture should look and function in eighteenth-century France. Blondel claimed to be a follower of Vitruvius, the first-century Roman architect and theorist, in endorsing what Blondel called "commodity, firmness, and delight." The idea of commodity means not just the useful and convenient, but also the commodious or comfortable. Although a building should hold true to sturdy traditions of architecture ("firmness") and display the aesthetics of the age ("delight"), it must also be comfortable.

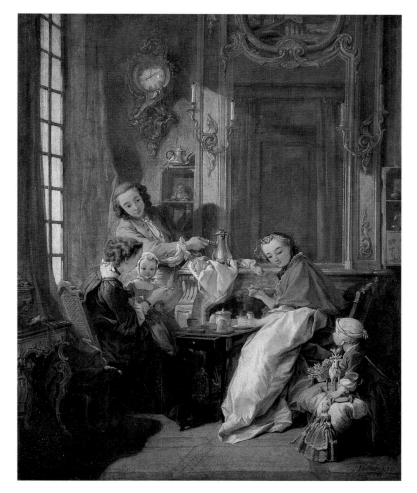

9.4 François Boucher, *Le Déjeuner*, 1739. Oil on canvas, 32 x 25¾ in (81.5 x 65.5 cm). Louvre, Paris.

The Chinese figurine on the shelf to the left of the mirror reminds us of the French taste for Chinese objects and scenes. Louis XIV had built the *Trianon de porcelaine* at Versailles, which established the fashion for Chinese pagodas and decorations. The little man is known as a *Pu-tai*, and was thought to be a symbol of domesticity and family life.

Comfort was hardly a quality sought by Louis XIV and his architects. Nor, as we have seen, was it of primary importance to the Dutch. But comfort of a luxurious and – to a certain extent, at least – oriental nature appealed to the prosperous salon society of early to mid-eighteenth-century Paris.

Blondel understood that the French nobility needed homes that would have a grand room for ceremonial purposes, a reception room that was smaller yet still public, and private *appartements* for the members of the family. The Rococo *hôtel* was constructed for a family, a husband, wife, and children. Domestic servants were kept in separate rooms (often above the low-ceilinged bedrooms), or in their own apartments. Therefore, the private

spaces – even the salon, which was both a reception room and a place for banquets – were built on a scale that would easily accommodate but not overwhelm the nuclear (rather than extended) family and their occasional guests.

One of those painters who prospered from representing these new interiors was François Boucher. Although he preferred glades or garden-like settings for his paintings, he found that there was a strong market for interiors and vignettes of the *haut monde* (fashionable society), the details of which his clients never seemed to tire of studying. Boucher's *Le Déjeuner* (FIG. 9.4) gives us a view into one of these typical spaces, belonging to a prosperous bourgeois family in France around 1740. This family portrait shows

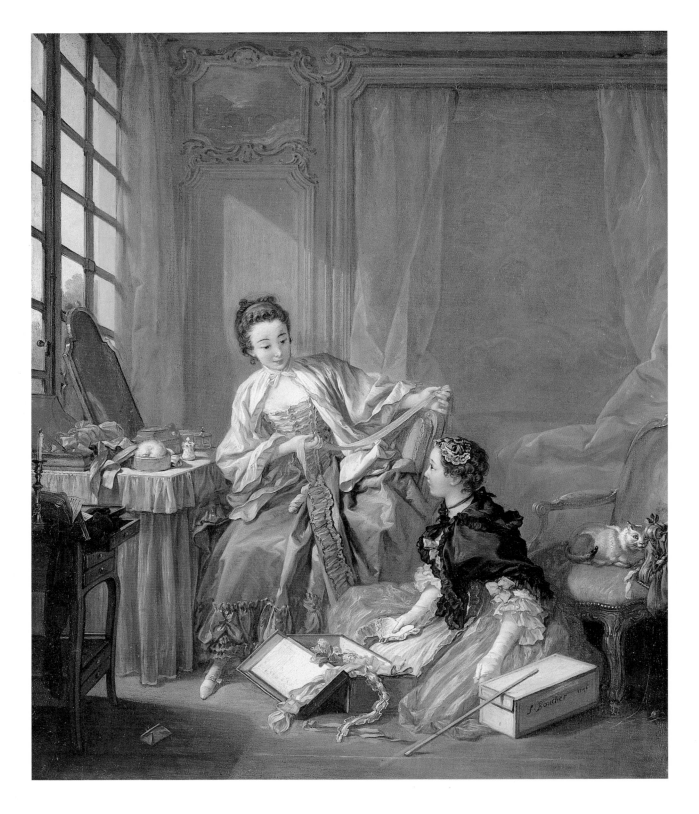

Boucher had a wonderful sense of composition and style that combined elements of Rococo design with Baroque brushwork. The Rococo curves are evident in the Louis XV chair and the curvilinear patterning of the paneling surrounding the bed chamber. Both the handling of highlights and shadows and the agitated drapery patterns in the two figures are typical of the Baroque, as is the rising diagonal reaching from the *marchande de modes* on the lower right through the seated lady of the house (probably a portrait of Mme Boucher) to the patterns of light and the window panes in the upper-left corner of the picture.

a young husband (or, because he is wearing an apron, an overly familiar servant), his wife (to the viewer's right), and two small children. The young man may indeed be the artist himself, for the wife is clearly a portrait of Madame Boucher. The woman feeding the little girl may be Boucher's sister. Boucher's own daughter was not to be born for another year, but his son would have been about the age of the boy possessively holding his toys, leaning on a plump pillow, and dressed elegantly with a tiny helmet to protect his head from falls.

Whether or not it is a portrait of Boucher's own family, the picture functions as a set piece of an upper middle-class family in a corner of their fashionable salon or boudoir. Their coffee table is a small, ebony gaming table, portable enough to serve its elegant purpose. An observer with an eye for detail would have remarked on the exotic and expensive wood. Throughout the middle ages and Renaissance, nearly all furniture was made of oak; now, with the development of world trade, hard woods from around the globe were available. Coffee, only recently introduced from the French colonies in the West Indies, was *à la mode,* as were the bulbous coffee pot and the ceramic cups and plates. The mother offers her little boy a sip from her spoon of the now cooled elixir; he seems hesitant, if interested. Chairs are typical for the Louis XV period, with their canting backs and set-back arms that allow for voluminous skirts and ample wigs.

The exaggerated curves of the wall sconces (candle holders) and the clock were typical of the very latest styles. And we glimpse to the left a console table with cabriolet legs of "c" and reversed "c" scrolls and shell motifs typical of the Rococo style. It supports a blue Chinese vase and probably was set beneath another mirror. Mirrors expanded the small interior and directed light. The fireplace that the family gathers round is typical of those built after 1710, when designers found a way to make them smaller, less smoky, and more efficient. This family is undoubtedly more comfortable than the one in de Man's painting (see FIG. 9.2).

Another painting by Boucher, known as *The Milliner*, or *Morning* (FIG. 9.5), gives us an added and revealing view of upper-class domesticity. Boucher made this painting to order for the Swedish ambassador to France, Count Tessin, who was acting on behalf of the Swedish Crown Princess Lovisa Ulrica. The ambassador, one of Boucher's best patrons, had requested a series of four pictures depicting the four times of day and a woman's typical activities – she undoubtedly found the minute aspects of French fashionable living charming, interesting, and worth emulating, and wanted it faithfully recorded. Boucher for his part complained of failing eyesight and the great difficulty of making such pictures, and although he promised his good friend the entire series, he never got beyond this morning scene. Afterward, Boucher abandoned the painting of such genre pictures altogether.

We see here the accoutrements of what Tessin's request called *figures de mode, avec les jolis minois qu'il sait peindre* ("fashionable figures with the pretty little faces that he knows how to paint"). It is morning and the woman of the house is in her domain, the boudoir, with its carved paneling, painted decorative scenes, large window, dressing table, powder, perfume, a cast-off letter (perhaps a *billet doux,* or love letter), and a cat with its knowing gaze fixed on the viewer. The woman who sells the luxury goods does not take a chair but kneels on the floor and brings out samples from her box for the lady of the house to examine in the morning light. Boucher knew well the luxury trades in France, as his father had been a lace designer. What he may not have been aware of was the near slavelike conditions endured by those who worked in silk manufacturing in the *ancien régime*. Indeed, the modern viewer, when confronting the refined charm of these enchanting boudoirs and salons, is rarely conscious of the exploitation that underpins many aspects of their creation.

A number of the rooms of French *hôtels* of the *ancien régime* survive. One of the best known and most delicately created is the Salon de la

Princesse (FIG. 9.6) in the Hôtel de Soubise in Paris. Germain Boffrand (1667–1754) built the salon to commemorate the marriage of Mériadec de Rohan-Rohan, Prince de Soubise, to Marie-Sophie de Courcillon, the nineteen-year-old widow of the Duc de Picquigny. Boffrand's space for the salon falls between both social and private worlds, where comfort and display come together in an uneasy tension.

In these spaces there is the possibility of familiarity and the promise of a fleeting equality. Strict distinctions between classes were not so obvious in the eighteenth century as they had been in the previous two or three centuries. The aristocracy mixed with government bureaucrats, lawyers, merchants, bankers, writers, gamblers, and tax farmers (the collecting of taxes was "farmed" out to independent operators). This is not to say that French society was egalitarian; it certainly was not. There were as many class distinctions as before, and the court society when it moved back to Versailles upon the coming-of-age of Louis XV in the mid- to later 1720s once again became stratified and rigid. Nonetheless, in the salons and boudoirs of Paris *hôtels* one could observe a more diverse mix of peoples. The Rococo architectural style with its emphasis upon the comfortable, elegant, expensive, and private did not discriminate between classes and ranks as successfully as did the classical style. So long as one were rich, one could enter into the world of conspicuous consumption populated by fashionable urbanites. The rise of a public sphere in financial, intellectual, and cultural matters meant that court society, although it maintained considerable power, no longer dominated the French elite.

There also is something about the Rococo style that by its very nature works against clear demarcations and precise definition of spaces. The curves and filigree, festoons and shell motifs, swags and curlicues, coved ceilings, glittering surfaces, and ornate and intricate details dazzle the eye with their labyrinthine patterns. And the presence of mirrors creates ambiguous, specular spaces. First of all, mirrors were precious and fragile; it was recommended, because of their tenden-

cy to collapse, that they not exceed about ten feet in height, which makes the ones in the Salon de la Princesse fairly large by contemporary standards. Given the fact that defects were almost impossible to avoid, these mirrors have a tendency to refract images, further confusing spatial relations and suggesting through reflections that such spaces are both intimate and open, but open in a paradoxical and doubling sense. The space is not grand, yet replicates itself through numerous images, likenesses, and representations.

There is no evidence that the Princess de Soubise was herself a *salonnière*, one of those women who presided over gatherings of philosophers, writers, pamphleteers, clerics, and *amateurs*, the forerunners of the Enlightenment

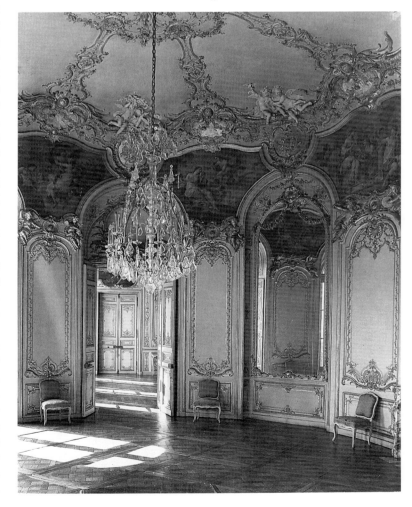

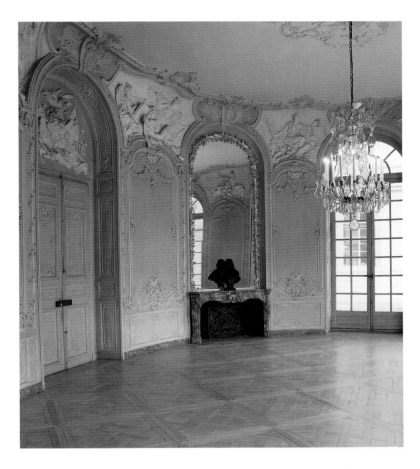

9.7 GERMAIN BOFFRAND, Salon du Prince, Hôtel de Soubise, 1737–8. Paris.

9.6 (*opposite*)
GERMAIN BOFFRAND, Salon de la Princesse, Hôtel de Soubise, 1737–8. Paris.

Rococo ornamentation was sometimes referred to as *le petit goût*, the small taste. Denis Diderot feared that it was effeminate and insufficiently grand, and Boffrand himself expressed concern about the sacrificing of dignified public display to comfort and the incorrect mixing of the social orders. This danger, he thought, stemmed from a lack of architectural discipline.

philosophes. Had she been a *salonnière*, this indeed would have been a suitable space for a mixed gathering of intellectuals to discuss the public, literary, and aesthetic issues of the day.

Perhaps it was the very ambivalence and confusion of these spaces that encouraged a certain degree of social mobility between the middle and upper classes. There were two main tiers of aristocracy, the *noblesse d'epée* and the *noblesse de robe*. The former was considered more ancient and exclusive, the latter a rank to which the middle class could aspire. Many commentators on social life protested the lack of clarity in class distinctions in the *ancien régime*. Perhaps in response to this, the Salon du Prince (FIG. 9.7) at the Hôtel de Soubise is more heroic and grand, linear and contained, with clearer demarcations between the spaces. The architectural ornament is still within the taste of the Rococo, but its treatment is more traditional and restrained. Architects understood the importance of *caractère*, the emotional and expressive side of architecture. In the more masculine and formal room – also known as the Salon de la parade (the parade or ceremonial room) – one is not so likely to lose sight of rank and identity.

The Rococo style in architectural ornament did not simply create a pleasing interior environment, one that might, because of its expense, promote one's social position and self-esteem. The decorative style also helped to create an environment in which classes and interests could mix, promote political agendas, bask for a while, if not in equality, at least in a kind of parity. These homes may have been domestic, containing the first genuinely private spaces in European architecture, but they also were the sites of desirable lifestyles on display as well as of significant cultural and social events.

The Dissemination of Images

ALTHOUGH TRAVEL WAS FAR more common in the seventeenth and eighteenth centuries than it had been before, it still was often impractical for lovers of art and architecture to visit actual sites. Therefore, one could study the academies, châteaux, homes, and gardens of the age by looking at illustrated architectural texts, prints, and ground plans, and in handsome and informative books of engravings.

Images of all sorts became more common and popular throughout Europe at this time. Although religious imagery remained much in demand, printmakers reproduced portraits, scenes of domestic life, politics, ancient and modern historical events, geography, travel, views of cities, landscapes, and copies after famous paintings. Jacques Callot (1592/3–1635) created precise etchings of small figures seen from a distance called the "Miseries of War," bringing to a fairly wide audience for the first time the brutality and violence associated with a contemporary conflict (the Thirty Years' War). After Watteau's death in 1721, his friend Jean de Julienne produced engravings of all his paintings and many of his drawings, thus making the intimate scenes of *fêtes galantes* available to other artists and to a relatively large public.

Although wood-cutting, engraving, and etching had been around for several centuries, it was not until the Baroque and Rococo periods that illustrated books were available explaining how printmaking worked. Abraham Bosse's illustration of a printing press (FIG. 9.8), was the first widely dispersed image Europeans had seen of the fairly new technology. With his depictions of presses, tools, and techniques, one could learn the rudiments of engraving.

One of the first to attempt to create a market and realize a large profit from prints was Peter Paul Rubens. In his shop in Antwerp he organized a large crew of workers who busied themselves making copies of his paintings. These prints were distributed by a corporation of which he was a member. Because of his success and wealth, he was able to employ the best engravers available in the Netherlands and Flanders. When unauthorized copies of his prints began to show up, he sought European-wide support for the first copyright legislation.

9.8 ABRAHAM BOSSE, *Interior of an Intaglio Printer's Shop*, 1642. Etching.

9.9 Rembrandt,
Christ Healing the Sick
(the "hundred-guilder print"),
c. 1648–50.
Etching,
11 x 15½ ins (28 x 39.3 cm).
Rijksmuseum, Amsterdam.

Unlike the canny Rubens, Rembrandt experimented with etching techniques more for personal and artistic reasons than for financial gain. However, his *Christ Healing the Sick* (FIG. 9.9), is popularly known as the *Hundred-Guilder Print* because of the high price it is supposed to have fetched. An etching is made by using a needle to scratch an image through a resinous material (usually gum from the pine tree) that has been applied to a copper plate. The plate is then dipped in an acid bath, which does not dissolve the resin but does eat into the plate where the gum has been scratched away. The resin, which is soluble in alcohol, is then cleaned so that the plate can be inked and run through a press with paper. Rembrandt was particularly adept at this medium, and was able to create skillful impressions of light and shade, to use with assurance and deftness the etching needle to cross-hatch, outline, and detail figures and setting. The resulting image is usually small (about 11 x 15½ inches here), but can be moving and absorbing for all that. One can "read" the various reactions to Christ's words, and in effect enter imaginatively into the moment.

The ready availability of prints made it possible for scholars to study the history of art and develop theories of aesthetics. The German writer Gotthold Ephraim Lessing wrote his fundamental treatise on the visual arts, the *Laocoon; or, On the Limits of Painting and Poetry,* in 1766, even though he had never seen the statue that served as the central metaphor for the text. He only knew it through prints. Most ideas of Greek art were garnered through a perusal of *The Antiquities of Athens* by two English architects, James Stuart and Nicholas Revett, which appeared in three parts in 1762, 1789, and 1795. Before his Italian tour in the 1770s, Johann Wolfgang von Goethe claimed that because he knew the prints of Piranesi he had already visited Rome.

Societies in the Baroque and Rococo eras were becoming more conscious of and inquisitive about a wide range of subjects, and the market for reproducible images of homes, paintings, and contemporary scenes began to burgeon. Although presses were not yet powered by steam, and paper was not yet machine-produced, once can clearly discern the birth of the modern culture of visual mass media.

Garden Design

Baroque and Rococo gardens helped to shape an external environment that complemented the interior space. The aristocratic garden defined in cultured and worldly terms complex attitudes toward environment and nature. The garden is the most domesticated form of nature: it is distant from wild and untrammeled forests, more tranquil than busy squares and streets, and more human than pasture and field. Surrounding the home, it creates a transition or buffer zone between the most familiar and private of spaces and the rest of the world in all its commotion, haste, and noise.

THE VILLA BORGHESE, ROME

Italian gardens usually were formal, contrived, and redolent of status and wealth. Taking architecture as his model, one Italian landscapist stated that "things planted should reflect the shape of things built." Therefore, the controlling principle was geometric, but not to the point that natural lushness was subdued (as it was in France). One of the great public and private gardens designed in Rome in the early seventeenth century was the Borghese garden on the Pincian Hill (c. 1610–20). A sign at the gate announced the following (Ehrlich, p. 12):

> I, custodian of the Villa Borghese on the Pincio, proclaim the following: Whoever you are, if you are free, do not fear here the fetters of the law. Go where you wish, pluck what you wish, leave when you wish. These things are provided more for strangers than for the owner. As in the Golden Age when freedom from the cares of time made everything golden, the owner refuses to impose iron laws on the well behaved guest. Let proper pleasure be here as the law to a friend, but if anyone with

9.10 GIOVANNI BATTISTA FALDA, plan of the vineyards at Villa Borghese, Rome. Engraving from *I giardini di Roma* (Rome, 1670), plate 16.

In the nineteenth century all of the interior walls of the Borghese gardens were taken down in order to make the landscaping conform to the new style of the English garden. In 1901 it was purchased by the state and became a public park.

trees. The formal woods were usually opened to the general public. These woods did not lead one's eye to the casino, or villa, of the Borghese family, although one would eventually see it as he or she penetrated further into the garden. Whereas French formal gardens usually directed the visitor's eye directly to the château, which commanded the surrounding space, it was more typical in an Italian garden park for the residence to appear to be integrated with, rather than dominating, the landscape. Although Italian princes wished to display their power through their homes, their suburban villas (as opposed to town palaces) tended, because of their relative informality, to do so in a less assertive fashion.

Many of the plantings, especially those in the private garden, were arranged according to geometrical principles, although the extensive grounds were not reshaped in any fundamental manner – the terrain remained more or less as it was. The fountains and small lakes were established to water the animals, birds, and plants; nature here was not cleared, cut, or recontoured in any radical fashion. This is a magnificent garden, but one which would have been perceived as being in harmony with nature, gentle in its crafting.

The building of relatively small garden structures known as pavilions or tribunes allowed the inhabitants of an urban palazzo to enjoy the tranquillity of tamed nature in the comfort of an open and airy architectural setting. Often these tribunes contained ancient sculpture or were decorated with frescoes of mythological scenes. A prince and his entourage or family often took a late summer's meal in one of these spots.

One of the most appealing of these pavilions is the Casino of Aurora (the Roman goddess of dawn) at the Palazzo Rospigliosi-Palavicini (FIG. 9.11), begun in 1612 probably by Carlo Maderno and/or Giovanni Vasanzio (1550–1621). The central loggia, a room open to the garden and air by way of a large central arch and two smaller passageways, has a fresco by Guido Reni on the ceiling (FIG. 9.12). Beneath this lighthearted painting, the Borghese family (who

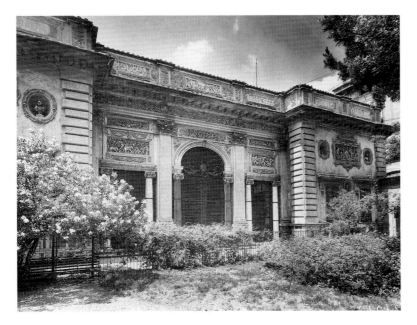

9.11 CARLO MADERNO AND GIOVANNI VASANZIO Pavilion at the Palazzo Rospigliosi-Palavacini, Rome, 1612.

deceit and intent should transgress the laws of hospitality, beware lest the angry steward break his token of friendship.

Not only was the garden designed for the family, but the public was permitted – indeed encouraged – to come in and view the surroundings, to admire the magnificence of the Borghese Villa and its setting, and to participate as observers in the display of family fortune and prominence (Camillo Borghese had just been elected Pope Paul V).

The gardens designed for the Villa Borghese (FIG. 9.10) originated as vineyards owned by the Borghese family (see p. 52). When they were transformed into a garden, a large amount of water had to be brought in from the aqueduct known as the Aqua Felice (see p. 314) for water basins, lakes, and fountains. The entire area was enclosed by a wall about three miles in length, within which were three different woods. In the area immediately behind the villa was the formal garden for the private use of the family; in front were the formal woods (about 400 trees); and to the north (in the upper part of Falda's engraving) was the more informally designed forest for hunting, which contained perhaps a thousand

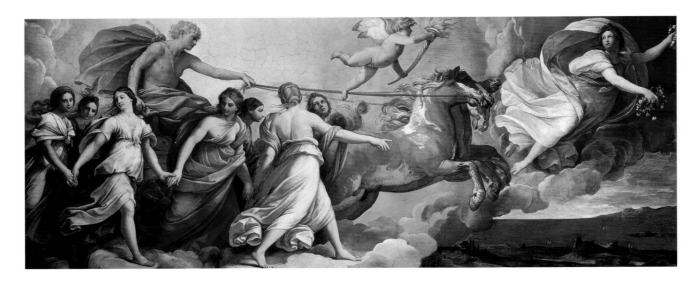

then owned the property) would have enjoyed the conviviality of wine, food, music, and animated gossip about the papal court. The garden that the little pavilion faces was elevated above the other grounds surrounding the palace, making it something of a secret garden for intimate dining and discussions, which perhaps went on late into the night until Aurora's carriage, as one sees in the fresco, led the way for Apollo and the sun.

VAUX-LE-VICOMTE, NEAR PARIS

The best-known French gardens of the seventeenth century were by André Le Nôtre, who was to become a favorite of King Louis XIV. His immense formal gardens tamed and controlled nature in a way that Italians did not attempt.

Vaux-le-Vicomte (FIG. 9.13) anticipated the glory and the gardens of Versailles. It was built by Nicolas Fouquet, the Lord High Minister of Finance for the young Louis XIV, who employed Charles Le Brun as decorator and painter, Louis le Vau as architect, and André Le Nôtre as landscape architect. With what seems to have been limitless amounts of money, Fouquet bought 15,000 acres of land, leveled three villages, dug canals and lakes, and moved immense quantities of earth near the town of Vaux, about 20 miles south of Paris. Toward completion of the building campaign there were as many as 2000 work-

ers employed on a project that lasted from 1657 until 1661. The result is of such magnificence that it brought the rhetoric of domestic architecture to new heights: Vaux-le-Vicomte, by virtue of its size and extraordinary gardens, was intended to demonstrate his power and to persuade all in the realm of the minister's nobility and honor.

On 17 August 1661 Fouquet dedicated the house with a brilliant party, to which 6000 people were invited. There was music by the court composer Giovanni Battista Lully, and a new play by Molière was performed in the gardens. Louis XIV, having just taken over full responsibility for the government, was the guest of honor. His minister Colbert, however, an enemy

9.13 LOUIS LE VAU AND ANDRÉ LE NÔTRE, entrance façade, Vaux-le-Vicomte, France, 1657–61.

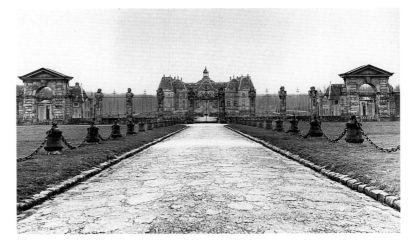

9.12 (*opposite*)
Guido Reni,
Aurora, 1615–18.
Fresco in the Palazzo
Rospigliosi-Palavacini,
Rome.

The pavilion that contains the *Aurora* is open to visitors only one day a month, and even then relatively few people come to view it. In the nineteenth century, however, this may have been the most famous painting in Rome. Anna Jameson complained in her *Diary of an Ennuyée* (1826) that Reni painted this fresco on the ceiling: "Would it were not! For I looked at it till my neck ached, and my brain turned giddy and sick."

of Fouquet, realized that one of the King's subjects had committed the unpardonable sin of living in greater splendor than the Sun King himself. Within a few weeks, Fouquet was arrested for corruption and treason and his lands seized. The architect le Vau and landscapist Le Nôtre were immediately transported to Versailles, where an older hunting lodge built by Louis XIII was being dismantled so that the new king could live in the splendor to which he was growing accustomed and so that he would have the space for virtually unlimited expansion and growth (see pp. 327–35). Outsized grandeur was for royalty and the government – not for poor Nicolas Fouquet, who died after languishing for nearly twenty years in prison.

Le Nôtre arranged the garden to complement the château (FIG. 9.14). The great landscape axis runs in the front door of the house and out the back, continuing in either direction for a considerable distance. The severe geometrical ordering of smaller and larger sections with their precisely shaped shrubs and the creation of long avenues create a sense of harmony comparable to le Vau's architecture. The château is left to stand alone, with no bushes or other elements to obscure the view of the proud residence. The lands rise and fall, creating within the overall unity a sense of variety and even of surprises. For instance, one cannot see the moat until one is almost upon it. The fences and gates at the very limits of the grounds function as boundaries to this enormous effort to "force nature" (as Le Nôtre put it) in the accepted forms of royal culture. The gate also frames the entrance to the château in such a way as to create the main line of perspective. As one sees in figure 9.13, at a particular distance from the gate, the stanchions outline the frontispiece or entry bay to the house, and the decorative ironwork fits perfectly within the pediment above the doors.

But the ceremonial character of the daily life to which Fouquet aspired (and never attained), found apt expression out of doors, within the intricacies of carefully hedged, pruned, and constructed geometries of nature.

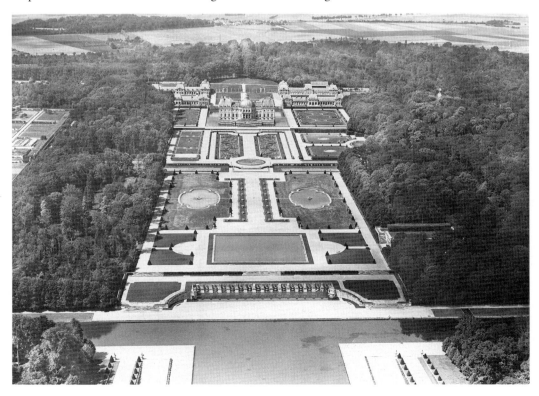

9.14 Louis le Vau and
André Le Nôtre,
general view,
Vaux-le-Vicomte,
France, 1657–61.

PETWORTH PARK, ENGLAND

When the eighteenth-century British writer Horace Walpole reminded contemporary landscape architects that nature "abhors a straight line," he simply was reinforcing a widely held feeling that the French gardens of the seventeenth century had gone against nature in a particularly violent way. His fellow countryman Anthony Ashley Cooper, 3rd Earl of Shaftsbury (see p. 230), also called for the "natural" garden, and the writers Alexander Pope and Joseph Addison argued against carving trees and bushes into unnatural, geometrical patterns. The landscape paintings of Claude Lorrain (see pp. 270–4), with their soft modulations of light and color, smooth transitions from foreground to background, verdant trees and fields, and

meandering streams, enjoyed enormous popularity during the eighteenth century in Britain. Although art did, then, influence the way that nature was shaped, the effect was less contrived even than in Italy. Furthermore, the British were loath to disturb too greatly the agrarian land and the thick woods already in existence.

Lancelot "Capability" Brown (1715–83) dominated the making of gardens and the creation of landscapes in Britain in the second half of the eighteenth century. The preference for loose organization, avoidance of French avenues and sculpted trees, and a respect for nature already existed. "Capability" Brown (so named because he believed that any site had "capability of improvement") took these ideas, and added his own notion that, even beyond Walpole's assertion, the undulating line is the line of beau-

9.15 Lancelot ("Capability") Brown, Park at Petworth House, 1751–7. West Sussex, England.

Brown's apparently casual grouping of trees remained important to British landscape design long after his own time. Commenting on the appearance of trees in clumps and as shelter belts, a traveler observed in 1811 that "English park trees [have] a character of picturesque magnificence unequalled anywhere else."

ty. Like a painter he composed his landscapes in terms of water, trees, earth, and even skylines to create the most artificial of "natural" landscapes.

Petworth in Sussex (FIG. 9.15) reveals Brown's ability to solve the problem of giving a country house a genuine sense of being in the country, even when it is part of a small town. From the vantage point of figure 9.15 one cannot see Petworth town, which is right next to the house, other than the tip of the church's tower peeking slightly above the roof line of the house. We might be deep in the Sussex countryside. The winding stream with low trees planted along the banks and within the water itself, a precisely excavated and contoured knoll with trees on top (but none on the upward-sweeping sides), and the grand compass of sky can give one the impression of utter naturalness, however contrived. Petworth Park has been preserved in almost its original form, even to the deer park extending all the way to the main house. Whereas one is meant to view Le Nôtre's landscapes along axes that are arranged at right angles to one another, here one is invited to stroll about, to take in vistas from almost any direction.

Rooms, gardens, and landscapes were not just comfortable spaces in which to pass idle moments. These environments, whether interior or exterior, helped to define who one was in terms of status or power. Artistic expressions are freighted with ideas and ideologies that enable individuals to see themselves and others within certain frames and contexts. How one lives at home and in the immediate landscape helps to determine how one constructs an identity that is both personal and social.

CHAPTER 10

Epilogue

THE BAROQUE & ROCOCO
IN THEORY

CHARLES LE BRUN,
*Martyrdom of St. John in
Front of the Porta Latina*,
1641–2.
Oil on canvas,
9 ft 3 in x 7 ft 4¼ in
(2.82 x 2.24 m).
St. Nicolas du
Chardonnet, Paris.

According to legend,
St John was thrown into a
cauldron of boiling oil,
but emerged unscathed.
The realism of the
Roman standards and
fasces (bundles of rods),
symbols of the emperor's
authority, reveals Le
Brun's archeological inter-
ests. The painting was
executed just before he
went to Rome in 1642,
where he developed a
more classical style under
the influence of Poussin.

This chapter does not attempt to survey the whole of artistic theory in Europe during the seventeenth and eighteenth centuries. Instead, it discusses some of the elements of this theory, and provides a few examples of the interplay between theory and artistic practice.

Some Aspects of Baroque Theory

When in the late nineteenth century Heinrich Wölfflin (see box, pp. 28–9) directed art historians' attention to the opposition between classical and Baroque styles, he helped establish a way of looking at the art of the early modern period. The problem was that virtually no one in the seventeenth century wrote about the Baroque in Wölfflin's terms – indeed, there was no genuine Baroque theory of art at all. Why?

The critical language of the nineteenth century would have made no sense in the early seventeenth century. In the Baroque period the visual arts were only just beginning to find a degree of social respectability and economic independence, to achieve a status more or less comparable to that of literature and poetry. New theoretical languages do not spring forth fully formed; they develop by analogy from existing critical discourse. As a result, those intellectuals who concerned themselves with the meaning of the visual arts as something more than tools of religion and products of manual skill needed not just new words but an entire language with which to give expression to the value of art. And the traditions upon which they drew were those of literature, oratory or rhetoric, philosophy, and theology. By Wölfflin's time, in contrast, the academic discipline of art history was well established and there was a growing body of writing on aesthetics and art criticism, not to mention a complex vocabulary in the related disciplines of psychology and philology (as the study of language and literature was known in the nineteenth century).

In the Baroque, there were certain assumptions made about art: that it should be noble, balanced, ideal, decorous (correct, respectful), and that it relied heavily on *disegno*. As we have seen (pp. 92–3), this originally Florentine concept, largely accepted by theoreticians throughout Italy (with the possible exception of Venice), is related to painting being empowered with the artist's own rationality and imagination. *Disegno* literally means to draw. By extension, then, the word refers to a sense of structure created by lines and sharply contoured, dense forms.

There certainly were many terms specific to the visual arts that were used in the writing of art criticism. But theoretical discussions about value and style in the art of the seventeenth and eighteenth centuries depended a great deal on literary modes, and these tended to favor the classical style.

These literary terms developed from the writings of Aristotle, who placed tragedy ("classic" in Baroque terms) and the epic ("Baroque spectacle" or "dramatic Baroque") at the pinnacle of the types of poetry. Aristotle judged the epic – a long poem that tells the story of heroes and heroic events – to be inherently dramatic and based upon human events and broad sweeps of narrative action. An epic has extraordinary range, uniting heaven and earth, great cycles of world history, allegory and symbol, light and dark, struggle and resolution, bounded and infinite space, angels, heroes, ordinary mortals, and demons. The epic in its complexity and totality is nonetheless easily grasped as a unity, whether in poetic form, such as the *Iliad* or *Odyssey*, the *Aeneid* or *Paradise Lost*, or as a work of art that fuses the different art forms of painting, sculpture, and architecture, such as Baciccio's ceiling of Il Gesù (see pp. 30–1).

This unity or unifying tendency in the arts is exemplified by Bernini. According to Bernini's biographer Filippo Baldinucci, "the opinion is widespread that Bernini was the first to attempt to unite architecture with sculpture and painting in such a manner that together they make a beautiful whole [*bel composto*]." Bernini's success with the *bel composto* certainly aided a certain

kind of artistic/religious experience, one that is highly charged with emotion and the vivid, vicarious experience of Heaven and Hell. In his *Spiritual Exercises*, St. Ignatius of Loyola repeatedly called upon the "eye of the imagination" (as well as the smell, the taste, the sense of touch, the sound, and so forth), and the *representatio loci* – the representation or composition of a particular place. Ignatius' followers, the Jesuits, understood the value of the epic fusion of the arts on a prodigious scale in order to lead the worshipper through an imaginary space for the purposes of religious devotion.

Those who mistrusted a highly emotional as opposed to a keenly intellectual experience of religion showed little sympathy for the dramatic Baroque, however. By the end of the eighteenth century, the Jesuit order was suppressed (only to reappear in the early nineteenth century). One of the leading intellectuals of the Roman eighteenth century, Giovanni Bottari, argued forcibly against the effects of the *bel composto* in the visual arts, and called once again for the clear separation of media.

Even in the seventeenth century, however, the dramatic Baroque could not hold its own against the more severe kinds of classicism in art. As we shall see below in the discussion of Guercino's change in style, there was among those who wrote on art a bias in favor of a simpler and more compact mode of expression.

Guercino's Change of Style: a Case Study

The art historian Denis Mahon has convincingly shown in his landmark study on Guercino's stylistic shift in *Seicento Art and Theory* that classical art theory lay behind that change. When the painter, probably self-trained and certainly familiar with the art of Bologna and Venice, came to Rome from his home near Ferrara in 1621, he brought with him a style that was fairly close to that of Caravaggio. There are enough similarities between Guercino's *Martyrdom of St. Peter* (FIG. 10.1) and Caravaggio's painting of the

10.1 Guercino,
Martyrdom of St. Peter,
c. 1619.
Oil on canvas,
10 ft 6 in x 6 ft 4 in
(3.2 x 1.93 m).
Galleria Estense, Modena.

The naturalistic figures,
fluid brushwork and rich
colors show the influence
of Venetian painting.
According to Guercino's
biographer, Scannelli,
patrons objected to such
peasant types and the way
in which the strong con-
trasts of light and shade
obscured details, making
his pictures look unfin-
ished. In later works, such
as figure 10.3, the light-
ing is more even and the
figures more idealized,
with stronger contours.

same subject (FIG. 10.2) to hold our attention for a moment. The sharply foreshortened man who ties St. Peter's left leg in Guercino's painting is clearly a worker, unidealized and unrefined. The emphasis upon his brawny forearms highlights his similarity to the man in Caravaggio's painting who embraces the saint's legs and helps to lift the bottom of his cross. Also the figures of St. Peter are remarkably alike in body type, beard, hair, and facial features. The point here is not to draw a line of influence from the older artist to the younger, but to suggest that these styles are close enough to one another that contemporaries would have placed the painters in the same artistic category. Both rely heavily on the model, show indecorous detail (dirty feet, torn clothes), and use awkward compositions and dramatic lighting. Despite the popularity of this style, theoreticians were suspicious of it and noted its lack of idealization, harmony, and decorum.

Soon after Guercino's arrival in Rome, however, his art changed dramatically – he rethought his style. The writer Giovanni Battista Agucchi, whose *Trattato della pittura* (Treatise on Painting) was known in manuscript form among the critics and art lovers of Rome, was almost certainly influential in this respect. As a number of writers on art had done before him, Agucchi told the story of painting as a linear progress from primitive beginnings through to greater and greater sophistication, with each generation of artists building on the accomplishments of its predecessors. After the perfection of Raphael (who died in 1520), however, there was an unfortunate decline into mannerism, before, in the early seventeenth century, Raphael's style returned in triumph in the guise of the Carracci.

According to Agucchi, painters began by imitating nature. Artists of greater intelligence learned to go beyond what they had observed to imitate nature's intention rather than her simple product, which usually falls short of perfection. Therefore, an artist should know how to pick and choose, to combine the best that he or she sees in this all-too-imperfect world. Guercino may have reacted with some unease to Agucchi's judgment that the least sophisticated people will like the art of one who simply imitates without understanding the importance of improving upon nature. Caravaggio, according to Agucchi, was one of those unintellectual and corrupt realists. The Carracci, on the other hand, were the saviors of art.

Guercino's later style is very much like that of the Carracci. Take, for example, his *Presentation in the Temple* (FIG. 10.3), which was probably painted about 1623, after his conversion to a classical style. Guercino establishes the setting and clarifies the space with architectural elements, such as the Temple in the background and the steps and altar in the foreground. The lighting, now purged of the theatrical effects of strong highlights and deep shadows, is clear and evenly dispersed throughout the composition. Figures are arranged at fairly regular intervals and do not bunch up into crowds. Having thus switched sides in the theoretical battle of the seventeenth century, Guercino moved to Bologna,

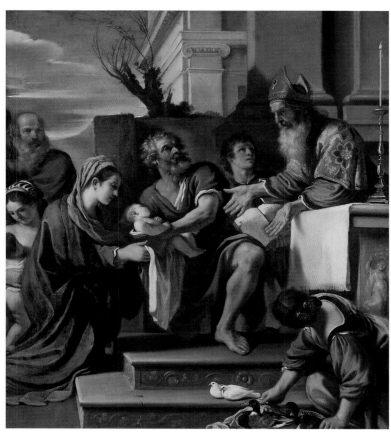

and upon the death in 1642 of Guido Reni, the famous pupil of the Carracci's academy (see pp. 54–5), he became the leader of the school until his death nearly a quarter of a century later. Although one can never say with certainty why Guercino moved in the direction of the classical style, it seems clear enough that Agucchi's theories were decisive. They helped to define a certain attitude toward the ideal and the classical, denigrating unidealized realism and those who depended most heavily on spectacle and drama.

Theoretical Disputes in the Academies

Agucchi may have held some sway over Guercino, but very often artists remained indifferent to theoretical issues. The first director (or *principe*) of the Academy of St. Luke in Rome (see pp. 55–6), the learned mannerist painter Federico Zuccaro (1540–1609), found out how difficult it was to instruct young artists in the rudiments of theory as well as practice. Zuccaro gave his Roman palace to the artists for their studios and instituted a lecture series. He himself spoke on the subject of *disegno*, but seems only to have mystified his audience. He scheduled other presentations by well-known painters, sculptors, and architects. The architect Giacomo della Porta begged off. The sculptor Taddeo Landini was elected to speak on sculpture, but failed to show up. The marble carvers said that it was easier to turn out a couple of figures than to talk about sculpture. Zuccaro soon tired of chasing such reluctant speakers. At least in its early years, there was no explicit theory in his academy.

In the mid-1630s, however, there was a debate in the Academy of St. Luke that bore directly on matters of literary theory and how one "read" a painting. As in so many academic quarrels, there were two sides, one arguing for fewer figures in a painting, the other for more. Those who argued on the side of simplicity had Aristotle's theories of tragedy and the accompanying prescriptions on the unities – of time, place, and action – in mind. With relatively few figures (Alberti had suggested no more than ten) in a history painting, one could easily study each figure in terms of its relation to other figures and its intentions or motivation, as conveyed by gestures and facial expression. With few figures the painter could easily keep the composition and meaning unified; this he or she accomplished by following the unities, which required showing only a single event, occurring at one time, in one place. The opposition, which was on the side of Pietro da Cortona, painter of the Barberini ceiling (see FIG. 4.32), promoted large compositions with many figures and episodes. This love of richness and expansiveness characterized the literary genre of the epic. Those who preferred short, concise, bare-bones compositions turned to tragedy as their literary model. In either case, the archetype to which the debaters referred was a literary one, and even though the terms of the debate have some bearing on the elaborateness of Baroque spectacle, there is little or no discussion of compositional devices or such intrinsically artistic matters as brushwork or drapery patterns.

The French Academy also launched a lecture series, but this one met with considerably more success than St. Luke's. The French students were offered salaries, studio space, and freedom from the guild system (FIG. 10.4), so that when they were asked to attend lectures, they did so in good faith, perhaps even with alacrity. Often the public lectures took the form of *conférences*, which were not so much conferences in the English sense of the word, as discussions based upon specific paintings.

We have seen how in 1667 there was a *conférence* on Nicolas Poussin's painting *The Gathering of the Manna* (see pp. 64–5), in which Charles Le Brun, the director of the Academy, analyzed the painting in terms of composition, drawing, proportion, expression, and lighting effects. This *conférence*, along with the others in the Academy, was published with a preface by André Félibien in 1669. Félibien, whom we have already met as the originator of

10.4 Illustration of life-drawing class at the French Royal Academy.

The drawing shows the stages of instruction followed by a student at the Academy. He would first copy the works of approved old masters, especially Raphael and Poussin, first in drawing, then in painting (note the squared paper). Next he would copy casts from the antique. Only then would he be allowed to draw from life.

the "hierarchy of genres" (see p. 209), used this publication to expound his theories of what the French call the *doctrine classique*. At the core of Félibien's writing is Aristotle's emphasis on the importance of the unities for drama, especially the unity of action.

Félibien pointed out that the single subject of Poussin's painting is conveyed by a composition so arranged that all the figures are subordinated to the idea of the picture, and all the secondary figures are subordinated to the primary figure. Because so many different activities are recorded, Poussin's painting may at first glance seem to defy the idea of a unity of action. But Félibien, by referring to the Aristotelian notion of beginning, middle, and end, showed how Poussin's painting describes the early part of the story (starvation), the middle of the story (appearance of the manna), and the results (salvation). Félibien was also insistent upon the *ligne de liaison*, the compositional device that united one figure with another. This abstract element in Poussin's painting, which provides a path for the eye to follow when it moves – usually left to right – through the composition, helps with the unity, causality, and logic of the narration.

Although a painting, unlike a poem, does not in fact unfold in time – one sees it all at once – Félibien's model was literary (Poussin used the very verb "read" to describe how one engaged his paintings). A painting may be there all at once, but it takes time to go through it, to read it. What Félibien seemed to miss was how the work of art strikes the viewer with an immediate and emotional impact. He understood the moving and sometimes fervent effect of music, but believed that the visual arts were dispassionate and intellectual.

Caravaggio, as is so often the case, provides a counter-example to the French critic's classical theory. In *The Calling of St. Matthew* (FIG. 10.5), the subject would seem to be unified in the sense that the biblical text itself is quite simple: "As Jesus was walking along, he saw a man called Matthew sitting at the tax booth; and he said to him, 'Follow me.' And he got up and followed him" (Matthew 9:9). But in Caravaggio's painting the principal figure, Christ, is seen only as a fragment. St. Peter has stepped in front of him, almost literally stepping on the Savior's "line" and thereby canceling his dramatic presence. St. Peter gestures as well. Why is Jesus' finger not enough? Matthew responds also by pointing, but

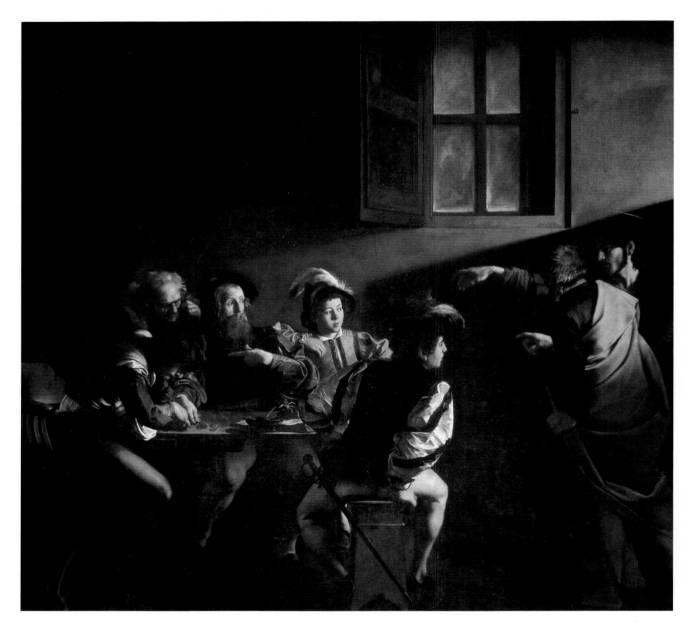

toward whom? Himself? Not quite; his finger really seems to denote the man next to him. These "indexical" signs (using the index finger to indicate something) are confusing and work at counter-purposes. Another device for establishing a coherent narrative is the gaze. Does everyone in the group focus intently on the same object? By no means. We can only imagine what the young dandy in the foreground, sitting astride a bench, sees. He looks past Christ and Peter toward something else, something for which neither the painting nor the subject matter provides a clue. Caravaggio destroys the unity of action. And as for the unity of place, does this event occur inside a room or in an alley outside? According to the Evangelist's own account, Jesus called him when he was sitting beside a customs house in Capernaum on the Sea of Galilee. For

This, Caravaggio's first public commission, was painted for a chapel in the church of San Luigi dei Francesi, Rome, in fulfilment of a French cardinal's will. The strong light not only models the forms, it also symbolizes the divine will, reinforcing Christ's gesture and recording the individual reactions of the figures. The realistic figure types and the bold *chiaroscuro* are both characteristic of Caravaggio.

Caravaggio a table, wall, and a window covered by oiled paper seems to be enough. Félibien must have thrown up his hands at a painting by Caravaggio.

The Spanish painter Franciso de Zurbarán's *Christ and the Virgin in the House at Nazareth* (FIG. 10.6) also avoids those details of unity favored by the French Academy. As the young Jesus pricks his finger, Mary his mother falls into a swoon, sensing her son's fate. This is not a scene from the Bible, so Zurbarán was thrown upon his own devices in working out the narrative. The darkness of the room, the introversion of the figures, and the seemingly haphazard placement of objects work toward creating a sense of isolation and sadness. Unlike Caravaggio, Zurbarán did not make so many conscious choices to undermine the unities; rather, his means of presenting a scene served the needs of devotion and prayer, highly contemplative states that do not necessarily require a beginning, middle, and end, nor a unity of action.

Félibien justified his art theory with such words as *convenance*, *bienséance*, and *vraisemblance*, all of which have similar meanings of fitness, decorum, and appropriateness. In an admirable painting the right people should be in the right places, and the characters' appearance and behavior should be consistent with the etiquette of the elite.

Félibien's colleague at the Royal Academy, Charles Le Brun, was particularly interested in teaching the art students about the human face. His sources tended toward the psychological. Since antiquity writers on art had advised painters and sculptors to show the state of the human soul through the proper rendering of facial expressions. In a lecture delivered at one of the *conférences* in 1668, Le Brun drew on the theories of René Descartes to explain and categorize the ways in which the face reveals emotions. "Subtle vapors" make their way to the pineal gland, causing it to flutter and trigger outward reflexes. Le Brun agreed with Descartes that

Christ has pricked his finger while weaving a crown of thorns, a prefiguration of his martyrdom. The setting is homely, with commonplace objects scattered about (some with symbolic meaning – the lilies allude to the Virgin's purity), there is meticulous attention to detail, and the reactions of the figures are true to life. This straightforward realism is akin to early works by Velázquez.

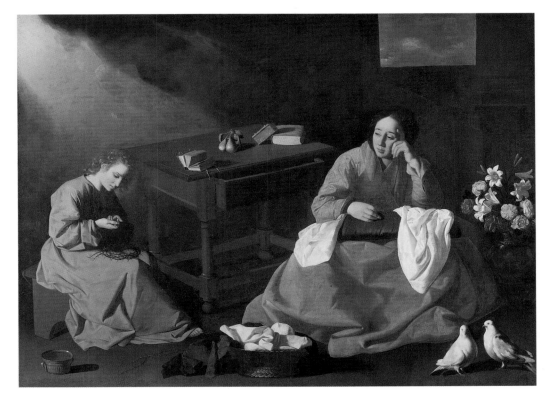

10.7 Charles Le Brun,
Fright,
plate 17 from *Expressions des Passions del'Âme* (*Expressions of the Soul's Emotions*), 1727.

l'Effroy 17

Roger de Piles & Rococo Theory

these expressions or passions on the human face were sufficiently mechanical and predictable that one could categorize them, which he did with a series of drawings that he showed to the academicians (FIG. 10.7). By appealing to Descartes and his theories of the human passions, Le Brun most likely was animated and motivated by a desire to inform the visual arts with cutting-edge philosophical thinking. As a good academician, his desire was to professionalize the arts, to give to them the language of a discipline like law, medicine, or literature. His drawings of facial expressions were intended as prescriptions to the young academicians, formulas backed by the authority of modern science.

Roger de Piles was a collector, adviser, critic, and writer on art in France in the late seventeenth and early eighteenth century. His *Cours de Peinture par Principes* (The Principles of Painting) was published in 1708. The Royal Academy did not admit him as a painter or official theoretician, but in 1699 he entered as an amateur, one who was a "lover" of art.

De Piles complained that Le Brun's paintings were too recondite and that no one bothered trying to decode them. He also found Le

Brun's rendering of the passions too reductive: "his pictures were like so many enigmas, which the spectator would not give himself the trouble to unriddle." And Le Brun "studied the passions with extraordinary application, as appears by the curious treatise he composed on them, which he adorned with demonstrative figures; nevertheless, even in this, he seems to have but one idea, and to be always the same, degenerating into habitude, or what we call manner" (Bryson, p. 59). Instead, de Piles insisted that a painting should be an illusionistic object, one that deceives the observer. And it must be attractive. It was de Piles' belief in "enthusiasm" (in the nonreligious sense of the term) that led him to concentrate on the force or impression made by a work of art on an observer. Even though the dramatic Baroque depended so heavily on mood for its emotional impact, no writer before de Piles had given so much attention to the mood of a work of art.

The inclination to "read" a work of art, which is what Félibien and Poussin recommended, usually puts one into a contemplative state of mind, so that one is ready to find the meaning through careful study of the subject matter. The classical way of arranging a composition – in terms of straight lines, right angles, triangular arrangement of forms, balance, symmetry, and so on (see box, pp. 28–9) – depends on one's inner capacity for quiet observation and careful examination of a text. By emphasizing mood, however, de Piles dethroned narrative content, and by extension literary theory, as the controlling concepts and elements in a painting. He did not ignore the importance of a theme in a work of art – he certainly did not call for abstract painting – but the priority and ascendance of subject matter begins to recede.

Whereas Félibien was concerned with a hierarchy of genres, de Piles had larger interests. Félibien wanted to divide up painting into certain types, as if he were doing taxonomies of plants and animals. De Piles, moving in the opposite direction, cared more for understanding the very nature of painting itself. His *Principles of Painting* sought to pinpoint the essence of painting, what it is that makes painting unique and different from other human activities, such as poetry. He decided that mood was conveyed by color more than by design. De Piles understood that painting depended on both color and design, but the artist "must form a special idea of his art only by coloring, since, by this difference, which makes him a perfect imitator of nature, we distinguish him from those as have only design for their object, and whose art cannot come up to this perfect imitation which painting leads to" (Puttfarken, p. 43).

De Piles uses the French verb *frapper*, which means "to strike," as his operational term. A painting strikes the eye (*frappe les yeux*) of the beholder. That is aggressive, and it gets our attention. The perfect imitation that de Piles refers to is one that strikes the eye and "carries so beautiful a probability, as often appears to be more true than truth itself" (Puttfarken, p. 49). A beautiful probability is not usually something real. Agucchi's interest in the ideal, which was shared by many other theorists of the seventeenth century, was based upon selection and improvement of images found in nature. The purpose of this enhancement was to achieve a higher reality, the reality toward which nature yearns, but which it rarely achieves. For de Piles, the ability to *tromper* – to fool the eye – was most important. The best imitation was that which produced something new, that which was different rather than similar to the real world. He valued illusion over reality, emotion over reasoning, and artistic beauty over natural beauty. One scholar has coined the verb "ecstasize" to describe what de Piles wanted a painting to do to a viewer – to send him or her into rapture.

Therefore it is not surprising that de Piles championed the art of Peter Paul Rubens over that of Nicolas Poussin. These two painters could not have been more different. Even a brief perusal of two paintings that depict dances reveals a fundamental conflict between the French painter and the Flemish painter. Poussin's *Dance to the Music of Time* (FIG. 10.8) shows us four dancing figures, holding hands and dancing with their backs to one another.

10.8 Nicolas Poussin, *Dance to the Music of Time*, c. 1639–40. Oil on canvas, 33½ x 42¼ in (84.8 x 107.6 cm). Wallace Collection, London.

10.9 Peter Paul Rubens, *The Kermis*, c. 1635–8. Oil on wood, 4 ft 10¾ in x 8 ft 6¾ in (1.49 x 2.61 m). Louvre, Paris.

The Kermis was a peasant festival, and all aspects are shown: vomiting and urinating as well as love-making, drinking and dancing. Rubens's painting clearly follows in the tradition of Pieter Bruegel, but there is an unpleasant undercurrent here that is lacking in Bruegel's work. The treatment is reminiscent of bacchic pleasure scenes of the Classical gods and goddesses.

They skip quietly while a winged image of Father Time strums a lyre in what seems to be a slow-paced and regular rhythm. Rubens' *The Kermis* (FIG. 10.9), which was bought for Louis XIV, shows a multitude of figures arranged along a rising diagonal from lower left to upper right. The couples feast, dance tempestuously, and rush off toward the trees for love-making. Rubens' reds are more deeply saturated, his greens more lush and glistening, and his yellows more vibrant than anything in Poussin. The whirlwind effect of Rubens is created by fusing and blending colors and dynamic groupings and couplings of figures. Poussin's dancers are shown in precise poses, almost in suspended animation, with perhaps a leg lifted slightly, now ready to descend again. The effect is like a relief sculpture in a classical frieze. Rubens' peasants stretch their limbs in every possible direction, before rushing headlong into the background. The way the paint is applied gives us a simulation of real movement.

The battle between the "Poussinists" and the "Rubensists" in the visual arts was paralleled in literary circles by what was known as the Quarrel of the Ancients and Moderns. It had long been assumed that the literature of ancient Greece and Rome established once and for all the standards of excellence. But with the rise of modern science, especially in the person of René Descartes, and modern government under Louis XIV and his able administrators, some began to think that the modern age was not just a period of decline, but one in which the accomplishments of its monarchs, scientists, and artists surpassed the achievements of antiquity.

These debates were, in both cases, challenges to established power and received opinion. The Ancients defended the traditional values of permanence, stability, and authority. They feared that a victory for the Moderns would make it increasingly difficult to find reliable standards in the shifting sands of contemporary taste. Likewise the principles of the academy would be undercut by the idea that color and deception were the quintessential elements of painting. The Poussinists chafed at the slipperiness of an art

theory dependent on illusion, emotion, and excitement.

The debate was so heated and divisive that in 1672 Charles Le Brun, director of the French Academy, hoped to put an end to the contention by declaring that "the function of color is to satisfy the eyes, whereas drawing satisfies the mind." Even Colbert, Louis XIV's chief adviser, was called in to calm the waters. Despite their best efforts, however, the Rubensist position finally prevailed, and the art of the eighteenth century in France owes much of its inspiration to a seventeenth-century Flemish painter.

Conclusion

In this chapter I have sought to demonstrate how artistic language and theory have been tied to certain discourses. The language of art in the early seventeenth century was closely allied with the language of poetry and literary criticism and especially the writings of Aristotle. The Greek writer's emphasis on imitation (*mimesis*) and the ideal gave critics a vocabulary for critiquing the classical style as well as for rejecting the anti-idealism of Caravaggio and his followers. The limitation of a discourse growing out of Aristotle and literary theory is revealed when we try to use it to clarify the stylistic and aesthetic strategies of Bernini, Rembrandt, Hals, Cortona, Borromini, and other Baroque artists. Other than a somewhat obscure debate in the Academy of St. Luke about the epic and the tragic, there seems not to have been any criticism in the seventeenth century that enlightened us as to the inner workings of Baroque spectacle.

De Piles' importance for the history of Baroque theory can therefore hardly be overstated. He began a discussion about painting on its *own* rather than on literary terms, an argument that was to be continued and expanded throughout the following two centuries. De Piles' view of painting emphasized the psychological or emotional impact that it has on the viewer, how it depends upon color, and how it holds together as a formal structure. This last point has to do more

with style than with content. It is to de Piles that we turn to discover how it is that a painting is received rather than read, experienced rather than analyzed. What he developed was a language and a way of looking at art that privileged the styles of Baroque spectacle and drama.

Chronology of the Baroque & Rococo

1600–1760

CHRONOLOGY OF THE BAROQUE & ROCOCO 1600–1760

DATE	POLITICAL & RELIGIOUS EVENTS	SCIENTIFIC & CULTURAL EVENTS
PRE–1600	• Council of Trent 1546–63 • Ignatius of Loyola: *Spiritual Exercises*, 1548 • Wars of Religion 1562–98 • Antwerp recaptured for the Spanish Netherlands; exodus of Protestants to the North (1585) • Pope Sixtus V (r. 1585–90) CARAVAGGIO, *Judith Slaying Holofernes*, 1598–9 (see FIG. 5.9)	• Castiglione, *The Book of the Courtier*, 1528 • Machiavelli, *The Prince*, 1532 • Castelvetro's edition of Aristotle's *Poetics*, 1571 • Microscope invented by Zacharias Janssen 1590
1600	• James I becomes King of England 1603 (d. 1625) • Pope Clement VIII dies 1605 (r. from 1592) • Paul V becomes Pope 1605 (d. 1621) • Declaration of Twelve Years Truce between Dutch Republic and Spanish Netherlands (1609)	• Shakespeare, *Hamlet*, 1600 • Karel van Mander, *Het Schilderboek*, 1604 • Jamestown colony, Virginia, founded 1607 • John Milton (English poet) born 1608 (d. 1674) • Galileo's astronomical telescope, 1609
1610	 POUSSIN, *The Arcadian Shepherds*, 1628–9 (see FIG. 7.5) • Henri IV of France assassinated 1610 (r. from 1589) • Louis XIII becomes King of France 1610 (d. 1643) • Marie de' Medici regent of France 1610–15 • Thirty Years' War starts 1618	• Henry Hudson's voyage to Hudson's Bay 1610–11 • Mercury thermometer invented by Santorio Santorio 1615 • Cervantes, *Don Quixote*, 1615 • William Shakespeare dies 1616 (b. 1564)
1620	• Gregory XV becomes Pope 1621 (d. 1623) • Philip III of Spain dies 1621 (r. from 1598) • Philip IV becomes King of Spain 1621 (d. 1665) • Urban VIII becomes Pope 1623 (d. 1644) • Charles I becomes King of England 1625 (executed 1649)	• Miguel Cervantes (Spanish writer) dies 1615 (b. 1547) • "Pilgrim Fathers" arrive at Cape Cod 1620 • Molière (Jean-Baptiste Poquelin; French playwright) born 1622 (d. 1673) VIGNOLA AND DELLA PORTA, Il Gesù, c. 1568–84 (see FIGS. 3.4–3.6)

CHRONOLOGY OF THE BAROQUE & ROCOCO 1600–1760

PAINTING & SCULPTURE	ARCHITECTURE	DATE
• Academy of Design (Florence) founded 1563 • Carracci's Academy (Bologna) founded 1582 • Academy of St. Luke (Rome) founded 1593 • Carracci, Farnese Ceiling, 1595–1600 (see FIG. 1.11) • Caravaggio, *Calling of St. Matthew*, 1599–1600 (see FIG. 10.5)	• Vignola and della Porta, Il Gesù, Rome, c. 1568–84 (see FIGS. 3.4–3.6) • Fontana, Aqua Felice, Rome, 1585–8 (see FIG. 2.5)	PRE-1600
• Claude Lorrain born 1600 (d. 1682) • Caravaggio, *Martyrdom of St. Peter*, c. 1601 (see FIG. 10.2) • Rembrandt van Rijn born 1606 (d. 1669) • Annibale Carracci dies 1609 (b. 1560)	FONTANA, *Transporting the Vatican Obelisk*, 1590 (see FIG. 2.4) • Maderno, nave and façade of St. Peter's, Rome, 1607–26 (see FIG. 3.8, 3.9)	1600
• Caravaggio dies 1610 (b. 1573) • Reni, *Annunciation*, 1610 (see FIG. 4.10) • Rubens, *Rape of Lucretia*, c. 1610 (see FIG. 5.21) • Domenichino, *Last Communion of St. Jerome*, 1614 (see FIG. 5.2) • El Greco dies 1614 (b. 1541)	• Borghese garden, Rome, c. 1610–20 (see FIG. 9.10) • Louis Le Vau born 1612 (d. 1670) • André Le Nôtre born 1613 (d. 1700) HALS, *Banquet of the Officers of the St. George Civic Guard Company*, 1627 (see FIG. 1.8) • De Keyser, Huis Bartolotti, Amsterdam, 1617 (see FIG. 8.20) • Inigo Jones, Banqueting Hall, London, 1619	1610
• Gentileschi, *Judith Slaying Holofernes*, c. 1620 (see FIG. 5.8) • Bosschaert, *Bouquet in an Arched Window*, c. 1620 (see FIG. 6.28) • Rubens, *Disembarkation at Marseilles*, 1621–5 (see FIG. 6.5) • Guercino, *Aurora*, 1622–3 (see FIG. 1.10) • Hals, *The Merry Drinker*, c. 1628–30 (see FIG. 5.40) • Pieter de Hooch born 1629 (d. 1684) • Rembrandt, *Self-portrait*, 1629 (see FIG. 6.17)	• Guarino Guarini born 1624 (d. 1683) • Bernini commissioned to finish St. Peter's, Rome, 1629 • Maderno, Palazzo Barberini, 1629 • Carlo Maderno dies 1629 (b. 1556) • San Estevan, Acoma, New Mexico, begun 1629 (see FIGS. 3.43, 3.44)	1620

CHRONOLOGY OF THE BAROQUE & ROCOCO 1600–1760

DATE	POLITICAL & RELIGIOUS EVENTS	SCIENTIFIC & CULTURAL EVENTS
1630	• France enters Thirty Years' War 1635 Velázquez, *The Surrender at Breda*, 1634–5 (see p. 40)	• John Donne (English poet) dies 1631 (b. 1572) • Antony van Leeuwenhoek (Dutch biologist) born 1632 (d. 1723) • John Locke (English philosopher) born 1632 (d. 1704) • Harvard College founded 1636 • Descartes, *Discourse on Method*, 1637
1640	• English Civil War 1642–8 • Louis XIV becomes King of France 1643 (d. 1715) • Innocent X becomes Pope 1644 (d. 1655) • Peace of Münster: legal recognition of Dutch Republic (1648)	• Galileo Galilei (Italian astronomer) dies 1642 (b. 1564) • Isaac Newton (English physicist) born 1642 (d. 1727) • Gottfried Wilhelm Leibniz (German mathematician) born 1646 (d. 1716) • French Academy of Painting and Sculpture founded 1648 Borromini, lantern of Sant'Ivo, 1642–60 (see FIG. 3.17)
1650	 Bernini, *Ecstasy of St. Teresa*, 1645–52 (see FIG. 1.5) • Oliver Cromwell Lord Protector of England 1653–58 • Alexander VII becomes Pope 1655 (d. 1667)	• René Descartes (French philosopher) dies 1650 (b. 1596) • Hobbes, *Leviathan*, 1651 • Edmund Halley (English astronomer) born 1656 (d. 1742) • Pendulum clock invented by Christiaan Huygens, 1656 • William Harvey (English physician) dies 1657 (b. 1578)

CHRONOLOGY OF THE BAROQUE & ROCOCO 1600–1760

PAINTING & SCULPTURE	ARCHITECTURE	DATE
• Leyster, *Young Flute Player*, c. 1630–5 (see FIG. 5.41) • Cortona, *Rape of the Sabine Women*, 1631 (see FIG. 5.13) • Jan Vermeer born 1632 (d. 1675) • Zurbarán, *Christ and the Virgin in the House at Nazareth*, c. 1635–40 (see FIG. 10.6) • Rubens, *Het Steen*, c. 1636 (see FIG. 7.12) • Poussin, *Gathering of the Manna*, 1638 (see FIG. 2.17) • Van Dyck, *Equestrian Portrait of Charles I*, 1638 (see FIG. 6.7)	• Longhena, S. Maria della Salute, Venice, begun 1631 (see FIG. 3.24) • Christopher Wren born 1632 (d. 1723) • Vinckboons, house on Keizersgracht, Amsterdam, 1639 (see FIG. 8.21) VAN CAMPEN, Amsterdam Town Hall, 1648 (see FIG. 8.24)	1630
• Poussin, *Et in Arcadia Ego*, c. 1640 (see FIG. 7.5) • Peter Paul Rubens dies 1640 (b. 1577) • Ribera, *Club-footed Boy*, 1642 (see FIG. 6.36) • Bernini, *Ecstasy of St. Teresa*, 1645–52 (see FIG. 1.5) • Vouet, *Assumption of the Virgin*, 1647 (see FIG. 5.26) • Claude, *Landscape with Dancing Figures*, 1648 (see FIG. 7.7) • Rembrandt, *Christ Healing the Sick* ("Hundred Guilder Print"), c. 1648–50 (see FIG. 9.9)	• Borromini, Sant'Ivo della Sapienza, Rome, begun 1642 (see FIGS. 3.14–3.17) • Mansart and Lemercier, Val-de-Grâce, Paris, begun 1645 (see FIG. 3.26) • Jules Hardouin-Mansart born 1646 (d. 1708) • Van Campen, Town Hall, Amsterdam, 1648 (see FIG. 8.24)	1640
• Artemisia Gentileschi dies 1652/3 (b. c. 1593) • Kalf, *Still Life with Drinking Horn*, c. 1653 (see FIG. 6.31) • Velázquez, *Las Meninas*, 1656 (see FIG. 6.37) • Vermeer, *The Little Street*, 1657–8 (see FIG. 2.23) • Rembrandt, *Self-portrait*, 1658 (see FIG. 6.18) • De Hooch, *A Mother Beside a Cradle*, c. 1659–60 (see FIG. 6.40)	• Cortona, Santa Maria della Pace, Rome, begun 1655 (see FIGS. 3.18–3.20) • Johann Fischer von Erlach born 1656 (d. 1723) • Le Vau and Le Nôtre, Vaux-le-Vicomte, Paris, begun 1657 (see FIGS. 9.13, 9.14) • Bernini, Sant'Andrea al Quirinale, Rome, begun 1658 (see FIGS. 3.11–3.13)	1650

DE HOOCH, *A Mother Beside a Cradle*, 1659–60 (see FIG. 6.40)

CHRONOLOGY OF THE BAROQUE & ROCOCO 1600–1760

DATE	POLITICAL & RELIGIOUS EVENTS	SCIENTIFIC & CULTURAL EVENTS
1660	BACICCIO, *Pope Clement IX*, 1667–9 (see FIG. 6.10) ● Charles II becomes King of England 1660 (d. 1685) ● Charles II becomes King of Spain 1665 (d. 1700) ● Great Fire of London 1666 ● Clement IX becomes Pope 1667 (d. 1669)	● Molière, *Tartuffe*, 1664 ● Racine, *Andromaque*, 1667 ● Milton, *Paradise Lost*, 1667 ● Reflecting telescope invented by Isaac Newton 1668
1670	● Clement X becomes Pope 1670 (d. 1676) ● Innocent XI becomes Pope 1676 (d. 1689) HOBBEMA, *The Avenue, Middelharnis*, 1689 (see FIG. 1.1)	● Pascal, *Pensées*, 1670 ● Louis de Rouvray, duc de Saint-Simon (French writer) born 1675 (d. 1755) ● Thomas Hobbes (English philosopher) dies 1679 (b. 1588
1680	● James II becomes King of England 1685 (deposed 1688) ● Alexander VIII becomes Pope 1689 (d. 1691) ● William III and Mary II become joint rulers of England 1689 (Mary d. 1694, William d. 1702)	● Johann Sebastian Bach (German composer) born 1685 (d. 1750) ● George Frederick Handel (German composer) born 1685 (d. 1759) ● Newton, *Principia Mathematica*, 1687 WREN, St. Paul's Cathedral, 1675–1710 (see FIG. 3.32)

CHRONOLOGY OF THE BAROQUE & ROCOCO 1600–1760

PAINTING & SCULPTURE	ARCHITECTURE	DATE
• Diego Velázquez dies 1660 (b. 1599) • Vermeer, *View of Delft*, 1661 (see FIG. 7.35) • Bernini, *Bust of Louis XIV*, 1665 (see FIG. 6.9) • Nicholas Poussin dies 1665 (b. 1594) • Baccicio, *Pope Clement IX*, 1667–9 (see FIG. 6.10) • Steen, *Dissolute Household*, 1668 (see FIG. 6.41) • Rosa, *St. Paul the Hermit*, 1661 (see FIG. 7.11)	• Le Nôtre, gardens of Versailles, begun 1660 (see FIGS. 8.26, 8.28) • Cano, façade of cathedral of Granada, 1664 (see FIG. 3.40) • François Mansart dies 1666 (b. 1598) • Francesco Borromini dies 1667 (b. 1599) • Guarini, Chapel of the Holy Shroud, Turin, begun 1668 (see FIG. 3.21) • Le Vau and Hardouin-Mansart, Palace of Versailles, begun 1669 (see FIGS. 8.30–8.31)	1660
• Van Ruisdael, *Winter Landscape*, c. 1670 (see FIG. 7.16) • De Man, *The Gold Weigher*, c. 1670–5 (see FIG. 9.2) • Maratti, *Triumph of Clemency*, after 1673 (see FIG. 4.33) • Bernini, *Blessed Lodovica Albertoni*, 1674 (see FIG. 4.11) • Murillo, *St. Thomas of Villanueva Distributing Alms*, 1678 (see FIG. 4.17) MURILLO, *St. Thomas of Villanueva Distributing Alms*, 1678 (see FIG. 4.17)	• French Academy of Architecture founded 1671 • Hardouin-Mansart, Church of the Invalides, Paris, begun 1674 (see FIG. 3.30) • Wren, St Paul's Cathedral, London, begun 1675 (see FIGS. 3.31–3.33)	1670
• Gianlorenzo Bernini dies 1680 (b. 1598) • Jean-Antoine Watteau born 1684 (d. 1721) • Hobbema, *The Avenue, Middelharnis*, 1689 (see FIG. 1.1)	• Peter Thumb born 1618 (d. 1766) • Baldassare Longhena dies 1682 (b. 1598) • Domenikus Zimmermann born 1685 (d. 1766) Façade of Santa Maria de la Defensión, Jerez de la Frontera, 1667	1680

CHRONOLOGY OF THE BAROQUE & ROCOCO 1600–1760

DATE	POLITICAL & RELIGIOUS EVENTS	SCIENTIFIC & CULTURAL EVENTS
1690	• Innocent XII becomes Pope 1691 (d. 1700) • Spanish crown bankrupt 1692	• Locke, *Two Treatises on Government*, 1690 • Voltaire (François-Marie Arouet; French writer) born 1694 (d. 1778)
1700	• Clement XI becomes Pope 1700 (d. 1721) • War of the Spanish Succession starts 1701 (ends 1713) • Anne becomes Queen of England (later Great Britain) 1702 (d. 1714) • Act of Union unites England and Scotland 1707	• Benjamin Franklin (American inventor) born 1706 (d. 1790) • De Piles, *Principles of Painting*, 1708 • Samuel Johnson (English writer) born 1709 (d. 1784)
1710	• George I becomes King of Great Britain 1714 (d. 1727) • Louis XV becomes King of France 1715 (d. 1774) • Philippe d'Orléans regent of France 1715–22	• David Hume (Scottish philosopher) born 1711 (d. 1776) • Jean-Jacques Rousseau (French philosopher) born 1712 (d. 1778) • Defoe, *Robinson Crusoe*, 1719
1720	• Innocent XIII becomes Pope 1721 (d. 1724) • Benedict XIII becomes Pope 1724 (d. 1730) • George II becomes King of Great Britain 1727 (d. 1760)	• Immanuel Kant (German philosopher) born 1724 (d. 1804) • Swift, *Gulliver's Travels*, 1726

RIGAUD, *Portrait of Louis XIV*, 1704 (see FIG. 2.13)

LE BRUN, *Fright*, 1698 (see FIG. 10.7)

CARRIERA, *Allegory of Painting*, c. 1720 (see FIG. 6.22)

CHRONOLOGY OF THE BAROQUE & ROCOCO 1600–1760

PAINTING & SCULPTURE	ARCHITECTURE	DATE
• Pozzo, *Allegory of the Missionary Work of the Jesuits*, 1691–4 (see FIG. 4.26) • Giovanni Battista Tiepolo born 1696 (d. 1770) • Canaletto (Giovanni Antonio Canale) born 1697 (d. 1768) • Jean-Baptiste-Siméon Chardin born 1699 (d. 1779)	• Fernando Fuga born 1699 (d. 1781) FISCHER, Karlskirche, 1716–33 (see FIG. 3.35)	1690
• François Boucher born 1703 (d. 1770) • Rigaud, *Portrait of Louis XIV*, 1704 (see FIG. 2.13)	• Jacques-François Blondel born 1705 (d. 1774)	1700
• Ruysch, *Fruit, Flowers, and Insects*, c. 1716 (see FIG. 6.30) • Watteau, *Fêtes vénitiennes*, c. 1717–18, (see FIG. 5.29)	• Lancelot "Capability" Brown born 1715 (d. 1783) • Fischer, Karlskirche, Vienna, 1716 (see FIG. 3.35)	1710
• Carriera, *Allegory of Painting*, c. 1720 (see FIG. 6.22) • Watteau, *Pilgrimage to Cythera*, 1721 (see FIG. 1.18) • Joshua Reynolds born 1723 (d. 1792) • Thomas Gainsborough born 1727 (d. 1788)	• Robert Adam born 1728 (d. 1792)	1720

WATTEAU, *L'Indifférent*, c. 1716 (see FIG. 1.16)

DATE	POLITICAL & RELIGIOUS EVENTS	SCIENTIFIC & CULTURAL EVENTS
1730	THUMB, Birnau Cathedral, 1750 (see FIG. 4.30) ● Clement XII becomes Pope 1730 (d. 1740)	● Franz Joseph Haydn (Austrian composer) born 1732 (d. 1809) ● Flying shuttle loom invented by John Kay 1733 ● Chronometer invented by John Harrison 1733
1740	● Benedict XIV becomes Pope 1740 (d. 1758) ● War of the Austrian Succession 1740–48	● Handel, *Messiah*, 1741
1750	CANALETTO, *The Bucintoro ...*, 1733–4 (see FIG. 7.32) ● Lisbon (Portugal) destroyed by an earthquake 1755 ● Seven Years' War starts 1756	● Lightning conductor invented by Benjamin Franklin, 1752 ● Wolfgang Amadeus Mozart (Austrian composer) born 1756 (d. 1791) ● Voltaire, *Candide*, 1759
POST–1760	● Louis XVI becomes King of France 1774 (executed 1792) ● George II becomes King of Great Britain 1760 (d. 1820) ● American Declaration of Independence 1776 ● French Revolution 1789	● Rousseau, *Social Contract*, 1762 ● Ludwig van Beethoven (German composer) born 1770 (d. 1827)

PAINTING & SCULPTURE	ARCHITECTURE	DATE
• Canaletto, *Regatta on the Grand Canal*, 1733–4 (see FIG. 7.33) • Jean-Honoré Fragonard born 1732 (d. 1806) • Chardin, *The Governess*, 1738 (see FIG. 6.44) • Boucher, *Le Déjeuner*, 1739 (see FIG. 9.4) CASAS Y NOVA, Santiago de Compostela, 1738 (see FIG. 3.41)	• Fuga, Corsini Palace, Rome, begun 1736 (see FIG. 8.11) • Boffrand, Salon de la Princesse, Hôtel de Soubise, Paris, 1737–8 (see FIG. 9.6) • Casas y Nova, façade of Santiago de Compostela, begun 1738 (see FIG. 3.41)	1730
• Tiepolo, *Rinaldo and Armida in Her Garden*, 1742 (see FIG. 1.22) • Della Valle, *Monument to Innocent XII*, 1743 (see FIG. 2.8) • Gainsborough, *Mr. and Mrs. Andrews*, 1749 (see FIG. 7.18)	• Thomas Jefferson born 1743 (d. 1826) • Zimmermann, Die Wies, Bavaria, begun 1745 (see FIGS. 3.36–3.39) CHALGRIN, Montreul pavilion, 1784 (see p. 336)	1740
• Royal Society of Arts founded in London 1754 • Boucher, *Portrait of Madame de Pompadour*, 1758 (see FIG. 6.13)	• Thumb, Birnau Pilgrimage Church, Austria, 1750 (see FIG. 4.30) • Brown, park at Petworth House, England, 1751–7 (see FIG. 9.15)	1750
• Fragonard, *The Swing*, 1767 (see FIG. 1.20) • Vigée Le Brun, *Marie-Antoinette en chemise*, 1783 (see FIG. 6.14) • Reynolds, *Mrs. Siddons as the Tragic Muse*, 1784 (see FIG. 6.15) CHARDIN, *The Governess*, 1738 (see FIG. 6.44)	• Gabriel, Le Petit Trianon, Versailles, begun 1762 • Jefferson, Monticello, Virginia, begun 1770	POST–1760

GLOSSARY

aedicula An architectural shrine, often in the form of a niche, that is framed by a pediment above and **pilasters** or columns on either side.

ambulatory In a church's apse, the walkway that usually surrounds the choir. Often used for processions.

architrave The bottom part of an **entablature**; a horizontal molding above a colonnade or arcade that surmounts and joins columns or pilasters.

attic The top story of a building, above the **entablature** and immediately beneath the roof.

cartouche An ornamental sculpted or painted tablet, usually presented in the form of a scrolled parchment, that carries either a message or an image.

chiaroscuro Italian, meaning literally "clear" (*chiaro*) and "obscure" (*scuro*). A technique in painting that creates intense contrasts between deeply shadowed and highlighted areas.

clerestory The area of a building, usually a church, that rises above the roof which covers the side aisle. It forms the upper part of the nave wall.

concetto Italian, meaning concept, conceit, or idea. It is the controlling image or idea informing a work of art. According to Italian theorists of the Renaissance and beyond, the *concetto* exists as both a divine idea and as an image in an artist's soul. The artist must make that inner image concrete. In literary terms a *concetto* operates as an extended and complex metaphor, one which draws together dissimilar images.

contrapposto Italian, meaning counterpoise, equilibrium, or counterbalancing. The arrangement of a painted or sculpted human figure so that one leg is straight, the other bent; the hip above the straight leg is higher; one shoulder is higher and one lower; one arm usually is bent and the other straight. In Western art, *contrapposto* originates with Greek sculpture in the fifth century B.C.E.

crossing The area in a church building where the transept crosses the nave at right angles.

disegno Italian, meaning design or drawing. *Disegno* suggests the intellectual core of a work of art, the form that makes an idea or *concetto* concrete. An artist consciously employs rational principles in his or her *disegno* so as to create idealized compositions and recognizable imagery.

di sotto in su Italian, meaning literally "from below up." It is a perspective technique employed especially by painters working on the higher areas of walls or on ceilings so as to create a viewpoint consistent with the placement of a painting. One sees, in other words, the composition and figures literally from below. *Di sotto in su* has the effect of extending the observer's space, often into infinity.

drum The cylindrical area (it may also be square or polygonal) beneath a dome that rests on a supporting structure (often **pendentives**).

entablature The area of a building above the columns, including **architrave**, frieze, and pediment.

frontispiece The entrance bay on the façade, often given prominence by being projected away from the plane of the building and framed by columns, pilasters, pediment, and so on.

locus amoenus Latin, meaning the place of love. In Rococo painting, any grove with rich foliation and other trappings of love, such as a statue, fits this category. Here a couple will be seen in an embrace or in conversation.

locus uberrimus Latin, meaning the place of excitement. In Rococo painting, the *locus uberrimus* is the setting in which a feverish love scene takes place.

meraviglia Italian, meaning the marvelous, a term used in literature and the visual arts. A *meraviglia*, such as Bernini's Baldacchino, was thought to be unprecedented and fantastic, so wondrous that words could not provide an adequate description.

oculus An "eye"-shaped window or opening that admits light, usually at the top of a dome.

order The word used to describe which system of architectural support and articulation is used. The major architectural orders of antiquity are the Doric, the Ionic, and the Corinthian.

otium Latin, meaning place of rest (deriving originally from military usage for a solidier on "liberty"). In Rococo painting (and pastoral literature), *otium* designates the mood of a scene in which figures are reclining or relaxing.

painterly An English word coined to translate the German word *malerisch*, used by Heinrich Wölfflin (see box, pp. 28–9). By this he meant to convey the broad approach of artists such as as Rubens, Tintoretto, and Velázquez, who privileged color, irregularity, and a free handling of paint over the academic emphasis on line.

pavilion An architectural unit, especially for houses, such as a wing that projects from the main body of the building. It also can be a free-standing pleasure house with few rooms, meant for occasional entertainment.

pendentive The portion of a domed vault that descends into the corner of an angular building where a dome is placed on a square base, or **pier**.

pier An upright mass of masonry in a circular, square, or polygonal shape that supports an upper wall or dome.

pilaster A flat column, attached to a wall surface, that usually frames an opening.

putto/i Italian, meaning a cupid-like or angelic child, usually naked and with wings. Popular in seventeenth- and eighteenth-century painting and sculpture.

quadratura Italian, meaning feigned architecture. Perspective painting of architecture, often continuing the real architectural scheme, that is intended to fool the eye (Fr.: *trompe l'oeil*).

quadro riportato Italian, meaning literally "a painting taken somewhere else." Like *quadratura*, it is an illusionistic device employed by painters to give the impression of paintings being attached to ceilings (for instance). The illusion is completed when a frame is painted round the scene.

retable Elaborately painted and sculpted altar, rising like a large tablet; often found in Spanish-inspired churches.

rotunda Circular area immediately inside the entrance to a building. It usually is circular, square, or polygonal and capped by a dome.

spectacle Aristotle described spectacle as the visual part of a tragedy. As applied to the Baroque, spectacle refers to the overtly dramatic impact of a painting (with a strong dependence upon *meraviglia*) as opposed to its iconography.

tabernacle A space similar to an **aedicula** that contains a religious (often miraculous) image.

tenebrism From the Italian, *tenebre* (darkness, gloom). Like **chiaroscuro**, a manipulation of lighting effects in paintings. Tenebrism does not so much emphasize the contrast between light and dark as it creates a shadowy and dismal mood. In a tenebrist painting the darkest areas are impenetrable.

vanitas Latin, meaning vanity or emptiness. A *vanitas* painting presents images (a skull, a watch etc.) that remind the beholder of the transience of wealth and worldly goods, thereby urging one to think of the everlasting soul.

volute A scrolled element on an Ionic capital; by extension, any scrolled element, such as the end of a violin.

BIBLIOGRAPHY

This listing brings together three categories of books: those that are cited, by author's surname, in the main text; those consulted by Vernon Minor during the preparation of the manuscript; and well-known or note-worthy texts in which readers can profitably pursue various aspects of the era 1600–1760. More often than not, these categories overlap.

Svetlana Alpers, *The Art of Describing: Dutch Art in the Seventeenth Century*, Chicago: The University of Chicago Press, 1983.

Svetlana Alpers and Michael Baxandall, *Tiepolo and the Pictorial Intelligence*, New Haven and London: Yale University Press, 1994.

Matthew Smith Anderson, *Europe in the Eighteenth Century, 1713–1783*, 3rd ed., London and New York: Longman, 1987.

Ronald Asch, *The Thirty Years War: The Holy Roman Empire and Europe, 1618–48*, New York: St. Martin's Press, 1997.

Maurice Ashley, *The Golden Century: Europe, 1598–1715*, New York: Praeger, 1969.

Dore Ashton, *Fragonard in the Universe of Painting*, London and Washington, D.C.: Smithsonian Institution Press, 1988.

Charles Avery, *Bernini: Genius of the Baroque*, Boston: Little, Brown and Co., 1997.

Moshe Barasch, *Theories of Art from Plato to Winckelmann*, New York: New York University Press, 1985.

William L. Barcham, *Giambattista Tiepolo*, New York: Harry N. Abrams, 1992.

Renato Barilli, *Rhetoric*, trans. by Giuliana Menozzi, Minneapolis : University of Minnesota Press, 1989.

John Bender and David E. Wellbery (eds.), *The Ends of Rhetoric: History, Theory, Practice*, Stanford, Calif.: Stanford University Press, 1990.

Robert W. Berger, *In the Garden of the Sun King: Studies on the Park of Versailles under Louis XIV*, Washington, D.C.: Dumbarton Oaks Research Library and Collection, 1985.

Ann Bermingham and John Brewer (eds), *The Consumption of Culture 1600–1800*, London and New York: Routledge, 1995.

Leo Bersani and Ulysse Dutoit, *Caravaggio's Secrets*, Cambridge, Mass., and London: MIT Press, 1998.

Pieter Biersboer, et al., *Judith Leyster: A Dutch Master and Her World*, Worcester Art Museum, New Haven: Yale University Press, 1993.

Jeremy Black, *Eighteenth-century Europe, 1700–1789*, New York : St. Martin's Press, 1990.

Anthony Blunt, *Art and Architecture in France, 1500–1700*, 2nd ed., Harmondsworth: Penguin, 1970.

Anthony Blunt (ed.), *Baroque and Rococo Architecture and Decoration*, New York: Harper and Row, 1978.

Anthony Blunt, *Borromini*, Cambridge, Mass.: Harvard University Press, 1979.

Anthony Blunt, *Nicolas Poussin*, London: Pallas Athene, 1995.

Anton W.A. Boschloo (ed.), *Academies of Art: Between Renaissance and Romanticism*, The Hague: SDU Uitgeverij, 1989.

Bruce Boucher, *Italian Baroque Sculpture*, London: Thames and Hudson, 1998.

Giuliano Briganti, *The View Painters of Europe*, trans. by Pamela Waley, London and New York: Phaidon, 1969.

Christopher Brown, *Images of a Golden Past: Dutch Genre Painting of the 17th Century*, New York: Abbeville Press, 1984.

Jonathan Brown, *Francisco de Zurbarán*, New York: Harry N. Abrams, 1974.

Jonathan Brown, *Images and Ideas in Seventeenth-century Spanish Painting*, Princeton, N.J. : Princeton University Press, 1978.

Jonathan Brown, *Velázquez: Painter and Courtier*, New Haven: Yale University Press, 1986.

Georges Brunel, *Boucher*, New York: Vendome Press (distributed in the U.S.A. by Rizzoli International Publications), 1986.

Jean de La Bruyère, *Characters*, trans. by Henri Van Laun, New York: Oxford University Press, 1963.

Norman Bryson, *Looking at the Overlooked: Four Essays on Still Life Painting*, Cambridge, Mass.: Harvard University Press, 1990.

Norman Bryson, "Two Narratives of Rape in the Visual Arts: Lucretia and the Sabine Women," in Sylvana Tomaselli and Roy Porter (eds.), *Rape: An Historical and Cultural Enquiry*, Oxford and New York: Basil Blackwell, 1986.

Norman Bryson, *Word and Image: French Painting of the Ancien Régime*, Cambridge: Cambridge University Press, 1981.

Robert C. Cafritz, Lawrence Gowing, and David Rosand, *Places of Delight: The Pastoral Landscape*, The Phillips Collection in association with the National Gallery of Art, Washington, D.C., New York: Clarkson N. Potter, 1988.

C. T. Carr, "Two Words in Art History: I. Baroque," *Forum for Modern Language Studies*, vol. 1, No. 2, pp. 175–90, and "Two Words in Art History: II. Rococo," vol. 1, No. 3, pp. 266–81.

David Carrier, "Caravaggio: The Construction of an Artistic Personality," *Principles of Art History Writing*, University Park, Pa.: Pennsylvania State University Press, pp. 49–80.

Lodovico Castelvetro, intro. and notes by Andrew Bongiorno, *Castelvetro on the Art of Poetry: Abridged Translation of Lodovico Castelvetro's Poetica d'Aristotele vulgarizzata e sposta*, Binghamton, N.Y.: Medieval and Renaissance Texts and Studies, 1984.

H. Perry Chapman (et al.), *Jan Steen: Painter and Storyteller*, Washington D.C.: National Gallery of Art, 1996.

H. Perry Chapman, *Rembrandt's Self-portraits: A Study in Seventeenth-century Identity*, Princeton, N.J.: Princeton University Press, 1990.

Kenneth Clark, *Landscape into Art*, New York: Harper and Row, 1976.

David R. Coffin, *Gardens and Gardening in Papal Rome*, Princeton, N.J.: Princeton University Press, 1991.

Corpus Rubenianum Ludwig Burchard; an illustrated catalogue raisonné of the work of Peter Paul Rubens based on the material assembled by the late Dr. Ludwig Burchard in twenty-six parts. Edited by the Nationaal Centrum voor de Plastische Kunsten in de XVIde en XVIIde Eeuw, London and New York: Phaidon, 1968.

The Complete Works of Montaigne: Essays, Travel Journal, Letters, trans. by Donald M. Frame, Stanford, Calif.: Stanford University Press, 1967.

Denis E. Cosgrove, *Social Formation and Symbolic Landscape*, Madison, Wisc.: University of Wisconsin Press, 1998.

Matthew Craske, *Art in Europe, 1700–1830*, Oxford and New York: Oxford University Press, 1997.

William R. Crelly, *The Painting of Simon Vouet*, New Haven: Yale University Press, 1962.

Thomas Crow, *Painters and Public Life in Eighteenth-century Paris*, New Haven and London: Yale University Press, 1985.

Charles Dempsey, *Annibale Carracci and the Beginnings of Baroque Style*, Villa I Tatti, the Harvard University Center for Italian Renaissance Studies, Gluckstadt: Augustin, 1977.

Charles Dempsey, *Annibale Carracci: The Farnese Gallery, Rome*, New York: George Braziller, 1995.

René Descartes, *Discourse on Method and Meditations*, trans. by Laurence J. Lafleur, New York: The Liberal Arts Press, 1960.

Diderot on Art, intro. by Thomas Crow, I: *The Salon of 1765 and Notes on Painting*, II: *The Salon of 1767*, both trans. by John Goodman, New Haven and London: Yale University Press, 1995.

Brendan Dooley (ed. and trans.), *Italy in the Baroque: Selected Readings*, New York and London: Garland Publishing, 1995.

Kerry Downes, *The Architecture of Wren*, New York : Universe Books, 1982.

William Doyle, *The Old European Order, 1660–1800*, Oxford and New York: Oxford University Press, 1978.

Irene Earls, *Baroque Art: A Topical Dictionary*, Westport, Conn.: Greenwood Press, 1996.

Tracy L. Ehrlich, "The Villa Borghese and the Rise of the Baroque Garden Park," *Landscape*, vol. 32, no. 2, 1994.

Robert Enggass, *Early Eighteenth-century Sculpture in Rome: An Illustrated Catalogue Raisonné*, 2 vols., University Park: Pennsylvania State University Press, 1976.

Robert Enggass, *The Painting of Baciccio, Giovanni Battista Gaulli, 1639–1709*, University Park: Pennsylvania State University Press, 1964.

Robert Enggass and Jonathan Brown, *Italian and Spanish Art 1600–1750: Sources and Documents*, Evanston, Ill.: Northwestern University Press, 1992.

A. Félibien, *Conférences de l'Académie Royale de Peinture et de Sculpture,*. Paris: 1668.

H. W. Fowler, *A Dictionary of Modern English Usage*, Oxford: Oxford University Press, 1944.

S. J. Freedberg, *Circa 1600: A Revolution of Style in Italian Painting*, Cambridge, Mass.: The Belknap Press of Harvard University Press, 1983.

Luba Freedman, *The Classical Pastoral in the Visual Arts*, New York: Peter Lang, 1989.

Max J. Friedländer, *Landscape, Portrait, Still-life: Their Origin and Development*, trans. by R. F. C. Hull, New York: Schocken Books, 1963.

Walter F. Friedländer, *Caravaggio Studies*, New York: Shocken Books, 1969.

Walter F. Friedländer, *Mannerism and Anti-mannerism in Italian Painting*, New York: Columbia University Press, 1957.

Mary D. Garrard, *Artemisia Gentileschi*, Princeton, N.J.: Princeton University Press, 1989.

Ivan Gaskell and Michiel Jonker (eds.), *Vermeer Studies*, National Gallery of Art, Washington, New Haven and London: Yale University Press, 1998.

Allan H. Gilbert, *Literary Criticism: Plato to Dryden*, Detroit: Wayne State University Press, 1962.

William Gilpin, *Remarks on Forest Scenery*, vol. II. London: R. Blamire, 1791.

Carl Goldstein, *Teaching Art: Academies and Schools from Vasari to Albers*, Cambridge: Cambridge University Press, 1996.

E. H. Gombrich, *Norm and Form: Studies in the Art of the Renaissance,* New York and London: Phaidon, 1971.

Edmond and Jules de Goncourt, *French Eighteenth-century Painters*, London: Phaidon, 1948.

Lawrence Gowing, *Vermeer*, Berkeley, Calif.: University of California Press, 1997.

Jan van Goyen, 1596–1656, Poet of the Dutch Landscape: Paintings from Museums and Private Collections in Great Britain, London: Alan Jacobs Gallery, Bradford: Distributed by Lund Humphries, 1977.

Karsten Harries, *The Bavarian Rococo Church: Between Faith and Aestheticism*, New Haven, Conn.: Yale University Press, 1983.

Francis Haskell, *Patrons and Painters: Art and Society in Baroque Italy*, New York: Icon Editions, 1973.

Arnold Hauser, "The Concept of the Baroque," in *The Social History of Art*, Vol. II, 4 vols., trans. in collaboration with the author by Stanley Godman, New York: Vintage Books, 1958.

Howard Hibbard, *Bernini*, Baltimore: Penguin Books, 1965.

Howard Hibbard, *Caravaggio*, New York: Harper and Row, 1983.

Howard Hibbard, *Carlo Maderno and Roman Architecture, 1580–1630*, University Park, Pa.: Pennsylvania State University Press, 1971.

Henry Russell Hitchcock, *Rococo Architecture in Southern Germany*, London: Phaidon, 1968.

Frima Fox Hofrichter, *Judith Leyster: A Woman Painter in Holland's Golden Age*, Doornspijk, The Netherlands: Davaco Publishers, 1989.

R. Po-Chia Hsia, *The World of Catholic Renewal, 1540–1770*, Cambridge and New York: Cambridge University Press, 1998.

David Hume, *The History of England*, vol. 11. Oxford: Talboys and Wheeler, 1826 (original edition 1757).

John Dixon Hunt, *The Figure in the Landscape*, Baltimore and London: The Johns Hopkins University Press, 1989.

John Ingamells, "Discovering Italy: British Travellers in the Eighteenth Century," in A. Wilton and I. Bignamini (eds), *The Grand Tour: The Lure of Italy in the Eighteenth Century*, London: Tate Gallery Publishing, 1996.

Stephen Jones, *The Eighteenth Century*, Cambridge and New York : Cambridge University Press, 1985.

Ludmila Kagane, *Bartomole Esteban Murillo: The Spanish Master of the 17th Century*, Bournemouth: Parkstone Publishers/St. Petersburg: Aurora Art Publishers, 1995.

Wend von Kalnein and Michael Levey, *Art and Architecture of the Eighteenth Century in France*, trans. of part 2 by J.R. Foster, Harmondsworth: Penguin Books, 1972.

Pál Kelemen, *Baroque and Rococo in Latin America*, 2 vols., New York: Dover Publications, 1967.

George Kennedy, *The Art of Persuasion in the Roman World (300 B.C.–A.D. 300)*, Princeton, N.J.: Princeton University Press, 1972.

George Kennedy, *The Art of Persuasion in Greece*, Princeton, N.J.: Princeton University Press, 1963.

Peter van Kessel and Elisja Schulte (eds.; in collaboration with Laurie Nussdorfer, Henk van Nierop, Michele Di Sivo), *Rome and Amsterdam: Two Growing Cities in Seventeenth-century Europe*, Amsterdam: Amsterdam University Press, 1997.

Fiske Kimball, *The Creation of the Rococo*, Philadelphia: Philadelphia Museum of Art, 1943.

W. Chandler Kirwin, *Powers Matchless: The Pontificate of Urban VIII, the Baldachin, and Gian Lorenzo Bernini*, New York and Washington, D.C./Baltimore: Peter Lang, 1997.

George Kubler and Martin Soria, *Art and Architecture in Spain and Portugal and their American Dominions, 1500–1800*, Harmondsworth, Middlesex: Penguin Books, 1959.

Margaretha Rossholm Lagerlöf, *Ideal Landscape: Annibale Carracci, Nicolas Poussin and Claude Lorrain*, New Haven and London: Yale University Press, 1990.

Erik Larsen, *The Paintings of Anthony van Dyck*, Freren: Luca, 1988.

Irving Lavin, *Bernini and the Unity of the Visual Arts*, New York: Oxford University Press, 1980.

Irving Lavin (ed.), *Meaning in the Visual Arts: Views from the Outside (A Centennial Commemoration of Erwin Panofsky)*, Princeton, N.J.: Institute for Advanced Study, 1995.

Cynthia Lawrence (ed.), *Women and Art in Early Modern Europe: Patrons, Collectors, and Connoisseurs*, University Park, Pa.: Pennsylvania State University Press, 1997.

James Lees-Milne, *Saint Peter's: The Story of Saint Peter's Basilica in Rome*, Boston: Little, Brown, 1967.

Daniel Lerner, *The Passing of Traditional Society: Modernizing the Middle East*, New York: Free Press, 1964.

Michael Levey, *Giambattista Tiepolo: His Life and Art*, New Haven and London: Yale University Press, 1986.

Michael Levey, *Painting in Eighteenth-century Venice*, Ithaca, N.Y.: Cornell University Press, 1980.

Michael Levey, *Rococo to Revolution: Major Trends in Eighteenth-century Painting*, New York: Praeger, 1966.

Torgil Magnuson, *Rome in the Age of Bernini*, vol. I: *From the election of Sixtus V to the death of Urban VIII*; vol. II: *From the Election of Innocent X to the Death of Innocent XI*, Stockholm: Almqvist & Wiskell, 1982 and 1986.

Denis Mahon, *Studies in Seicento Art and Theory*, Westport, Conn.: Greenwood Press, 1971.

David Maland, *Europe in the Seventeenth Century*, New York: St. Martin's Press, 1966.

Nina Ayala Mallory, *El Greco to Murillo: Spanish Painting in the Golden Age, 1556–1700*, New York: Icon Editions, 1990.

Louis Marin, foreword by Tom Conley, *Portrait of the King*, trans. by Martha M. Houle, Minneapolis: University of Minnesota Press, 1988.

Giambattista Marino, "Mentre la sua donna si pettina" – "While his Lady Combs her Hair" (trans. Frank J. Warnke), in *European Metaphysical Poetry*, New Haven and London: Yale University Press, 1974.

John Rupert Martin, *Baroque*, New York: Harper and Row, 1977.

John Rupert Martin and Gail Feigenbaum, *Van Dyck as Religious Artist*, The Art Museum Princeton University, Princeton: Princeton University Press, 1979.

Jane Martineau and Andrew Robison (eds.), *Art in the Eighteenth Century: The Glory of Venice*, Royal Academy of Arts, London, National Gallery of Art, Washington, D.C., New Haven and London: Yale University Press, 1994.

Frederick J. McGinness, *Right Thinking and Sacred Oratory in Counter-Reformation Rome*, Princeton, N.J.: Princeton University Press, 1995.

Harold Alan Meek, *Guarino Guarini and his Architecture*, New Haven: Yale University Press, 1988.

Walter S. Melion, *Shaping the Netherlandish Canon: Karel van Mander's Schilder-boeck*, Chicago: University of Chicago Press, 1991.

Memoirs of Louis XIV and His Court and of the Regency, by the Duke of Saint-Simon, vol. II, New York: P.F. Collier & Son, 1910.

Ronald Forsyth Millen and Robert Erich Wolf, *Heroic Deeds and Mystic Figures: A New Reading of Rubens' Life of Maria de' Medici*, Princeton, N.J.: Princeton University Press, 1989.

Vernon Hyde Minor, *Passive Tranquillity: The Sculpture of Filippo della Valle*, Philadelphia: American Philosophical Society, 1997.

W. J. T. Mitchell (ed.), *Landscape and Power*, Chicago: University of Chicago Press, 1994.

Alfred Moir, *Anthony van Dyck*, New York: Harry N. Abrams, 1994.

Jennifer Montagu, *Alessandro Algardi*, 2 vols., New Haven and London: Yale University Press, 1985.

Jennifer Montagu, *Roman Baroque Sculpture: The Industry of Art*, New Haven and London: Yale University Press, 1989.

Michel de Montaigne, *Essays*, trans. by J. M. Cohen, New York: Penguin Books, 1958.

Colin Mooers, *The Making of Bourgeois Europe : Absolutism, Revolution, and the Rise of Capitalism in England, France and Germany*, London and New York: Verso, 1991.

Franco Mormando (ed.), *Saints and Sinners: Caravaggio and the Baroque Image*, McMullen Museum of Art, Boston College, Chicago: Chicago University Press, 1999.

Thomas Munck, *Seventeenth-century Europe: State, Conflict and the Social Order in Europe, 1598–1700*, New York: St. Martin's Press, 1990.

John J. Murray, *Amsterdam in the Age of Rembrandt*, Norman, Okla.: University of Oklahoma Press, 1967.

John S. Nelson, Allan Megill, and Donald N.J. McCloskey, *The Rhetoric of the Human Sciences: Language and Argument in Scholarship and Public Affairs*, Madison: University of Wisconsin Press, 1987.

Robert S. Nelson and Richard Shiff (eds.), *Critical Terms for Art History*, Chicago: University of Chicago Press, 1996.

Benedict Nicholson and Christopher Wright, *Georges de La Tour*, London: Phaidon Press, 1974.

Edward Norgate, *Miniatura or the Art of Limning* (ed. Martin Hardie). Oxford: Oxford University Press, 1919.

Konrad Oberhuber, *Poussin, The Early Years: The Origins of French Classicism*, Kimbell Art Museum, Fort Worth, New York: Hudson Hills Press, 1988.

Erwin Panofsky, *Idea: A Concept in Art Theory*, trans. by Joseph J. S. Peake; Belloti trans. by Victor A. Velan, New York: Harper and Row, 1968.

Erwin Panofsky, *Tomb Sculpture: Four Lectures on its Changing Aspects from Ancient Egypt to Bernini*, ed. by H. W. Janson. New York: Harry N. Abrams, 1964.

Erwin Panofsky, "What is Baroque," in Irving Lavin (ed.), *Three Essays on Style*, Cambridge, Mass.: MIT Press, 1995.

William Park, *The Idea of Rococo*, London and Cranbury, N.J.: Associated University Presses, 1992.

Geoffrey Parker and Lesley M. Smith (eds.), *The General Crisis of the Seventeenth Century*, 2nd ed., London and New York : Routledge, 1997.

D. Stephen Pepper, *Guido Reni: A Complete Catologue of His Works with an Introductory Text*, Oxford: Phaidon, 1984.

Nikolaus Pevsner, *Academies of Art Past and Present*, New York: Da Capo Press, 1973.

Plutarch's Lives (trans. B. Perrin), vol. V, Loeb Classical Library: London, 1961.

Renato Poggioli, *Oaten Flute: Essays on Pastoral Poetry and the Pastoral Ideal*, Cambridge, Mass.: Harvard University Press, 1975.

Donald Posner, *Antoine Watteau*, Ithaca, N.Y.: Cornell University Press, 1984.

Thomas Puttfarken, *Roger de Piles' Theory of Art*, New Haven and London: Yale University Press, 1985.

Theodore K. Rabb, *The Struggle for Stability in Early Modern Europe*, New York: Oxford University Press, 1975.

Richard Rand (et al.), *Intimate Encounters: Love and Domesticity in Eighteenth-century France*, Hood Museum of Art, Dartmouth College, Princeton: Princeton University Press, 1997.

Sir Joshua Reynolds, *Discourses*, ed. with intro. by Pat Rogers, London and New York: Penguin Books, 1992.

Jakob Rosenberg, *Rembrandt: Life and Work*, Ithaca, N.Y.: Cornell University Press, 1980.

Jakob Rosenberg, Seymour Slive, and E.H. Ter Kuile, *Dutch Art and Architecture: 1600–1800*, Baltimore, Md.: Penguin, 1966.

Pierre Rosenberg, *Chardin*, Cleveland, Ohio: World Publishing Company and Editions d'Art Albert Skira, 1963.

Thomas G. Rosenmeyer, *The Green Cabinet*, Berkeley, Calif.: University of California Press, 1969.

Peter Paul Rubens, *The Letters of Peter Paul Rubens* (ed. Ruth Saunders Magurn), Evanston, Ill.: Northwestern University Press, 1955.

Rémy G. Saisselin, *The Enlightenment against the Baroque: Economics and Aesthetics in the Eighteenth Century*, Berkeley, Calif.: University of California Press, 1992.

Simon Schama, *The Embarrassment of Riches: An Interpretation of Dutch Culture in the Golden Age*, New York: Random House, 1987.

Simon Schama, *Landscape and Memory*, New York: Alfred A. Knopf, 1995.

Gary Schwartz, *Rembrandt: His Life, His Paintings*, London: Penguin Books, 1991.

Jonathan Scott, *Salvator Rosa: His Life and Times*, New Haven and London: Yale University Press, 1995.

John Beldon Scott, *Images of Nepotism: The Painted Ceilings of Palazzo Barberini*, Princeton, N.J.: Princeton University Press, 1991.

Katie Scott, *The Rococo Interior*, New Haven and London: Yale University Press, 1995.

Sam Segal, *Flowers and Nature: Netherlandish Flower Painting of Four Centuries*, The Hague: SDU Publishers, 1990.

John K.G. Shearman, *Mannerism*, Harmondsworth: Penguin, 1967.

Mary D. Sheriff, *Fragonard: Art and Eroticism*, Chicago: Chicago University Press, 1990.

Mary D. Sheriff, *The Exceptional Woman: Elisabeth Vigée-Lebrun and the Cultural Politics of Art*, Chicago : University of Chicago Press, 1996.

Seymour Slive, *Frans Hals*, 2 vols., London and New York: Phaidon, 1970.

Bruno Snell, "Arcadia: The Discovery of a Spiritual Landscape" in *The Discovery of the Mind: The Greek Origins of European Thought*, trans. by T. G. Rosenmeyer, Oxford: Basil Blackwell, 1953.

David H. Solkin, *Richard Wilson: The Landscape of Reaction*, London: Tate Gallery, 1983.

Richard E. Spear, *The "Divine" Guido: Religion, Sex, Money, and Art in the World of Guido Reni*, New Haven and London: Yale University Press, 1997.

Richard E. Spear, *Domenichino*, New Haven and London: Yale University Press, 1982.

Wolfgang Stechow, *Dutch Landscape Painting of the Seventeenth Century*, London and New York: Phaidon, 1966.

Victor I. Stoichita, *Visionary Experience in the Golden Age of Spanish Art*, London: Reaktion Books Ltd, 1995.

David Summers, *Michelangelo and the Language of Art*, Princeton, N.J.: Princeton University Press, 1981.

John Summerson, *Architecture in Britain, 1530–1830*, 5th ed., Harmondsworth, Middlesex: Penguin Books, 1969.

John Summerson, *Sir Christopher Wren*, Hamden, Conn.: Archon Books, 1965.

Peter Sutton, "Life and Culture in the Golden Age," in *Masters of Seventeenth-century Dutch Genre Painting*, Philadelphia: Philadelphia Museum of Art, 1984.

Peter Sutton, *Pieter de Hooch, 1629–1684*, Hartford, New Haven, Dulwich Picture Gallery, Wadsworth Atheneum: in association with Yale University Press, 1998.

Paul Taylor, *Dutch Flower Painting 1600-1720*, New Haven and London: Yale University Press, 1995.

Keith Thomas, *Man and the Natural World: Changing Attitudes in England 1500–1800*, Oxford: Oxford University Press, 1983.

Janis Tomlinson, *From El Greco to Goya: Painting in Spain, 1561–1828*, London, New York, and Upper Saddle River, N.J.: Calmann & King, Harry N. Abrams, Prentice Hall, 1997.

Geoffrey Russell Richards Treasure, *The Making of Modern Europe, 1648–1780*, New York: Methuen, 1985.

Marc Treib, *Sanctuaries of Spanish New Mexico*, Berkeley: University of California Press, 1993.

Carolyn Vallone, "Women on the Quirinal Hill: Patronage in Rome, 1560–1630," *Art Bulletin*, Vol. LXXVI, No. 1, 1994, pp. 129–46.

John Varriano, *Italian Baroque and Rococo Architecture*, New York: Oxford University Press, 1986.

John Varriano, *Rome: A Literary Companion*, London: John Murray, 1991.

Johannes Vermeer, National Gallery of Art, Washington, New Haven and London: Yale University Press, 1995.

Mary Vidal, *Watteau's Painted Conversations*, New Haven and London: Yale University Press, 1992.

Rosario Villari (ed.), *Baroque Personae*, trans. by Lydia G. Cochrane, Chicago and London: The University of Chicago Press, 1995.

Victor J. Vitanza (ed.), *Writing Histories of Rhetoric*, Carbondale: Southern Illinois University Press, 1994.

Evelyn Carole Voelker, *Charles Borromeo's Instructiones Fabricae et Supellectilis Ecclesiasticae, 1577. A Translation with Commentary and Analysis*, Ph.D. dissertation, Syracuse University, 1977.

E. John Walford, *Jacob van Ruisdael and the Perception of Landscape*, New Haven and London: Yale University Press, 1991.

John Walker, *National Gallery of Art*, New York: Harry N. Abrams, 1974.

Guy Walton, *Louis XIV's Versailles*, Chicago: University of Chicago Press, 1986.

Martin Warnke, *Political Landscape: The Art History of Nature*, Cambridge, Mass.: Harvard University Press, 1995.

Ellis Waterhouse, *Painting in Britain, 1530–1790*, 4th ed., Harmondsworth, Middlesex: Penguin Books, 1969.

Richard Wendorf, *Sir Joshua Reynolds: The Painter in Society*, Cambridge, Mass.: Harvard University Press, 1966.

Mariët Westermann, *A Worldly Art: The Dutch Republic, 1585–1718*, London, New York, and Upper Saddle River, N.J.: Calmann & King, Harry N. Abrams, Prentice Hall, 1996.

Arthur K. Wheelock, *Jan Vermeer*, New York: Harry N. Abrams, 1981.

Christopher White, *Rembrandt*, London: Thames and Hudson, 1984.

Richard Wigley, *The Origins of French Art Criticism from the Ancien Régime to the Restoration*, Oxford: Clarendon Press, 1993.

John Wilton-Ely, "Rome," in A. Wilton and I. Bignamini (eds.), *op. cit.*

John Wilton-Ely, *The Mind and Art of Giovanni Battista Piranesi*, London: Thames and Hudson, 1978.

Rudolf Wittkower, *Art and Architecture in Italy, 1600–1750*, 3rd rev. ed., Harmondsworth, Middlesex and New York, N.Y.: Penguin Books, 1980.

Rudolf Wittkower, *Bernini: The Sculptor of the Roman Baroque*, 4th ed., London: Phaidon Press, 1997.

Rudolf Wittkower and Irma B. Jaffe (eds.), *Baroque Art: The Jesuit Contribution*, New York: Fordham University Press, 1972.

Rudolf and Margot Wittkower, *Born Under Saturn*, New York: W.W. Norton, 1963.

Heinrich Wölfflin, *Principles of Art History: The Problem of the Development of Style in Later Art*, trans. by M. D. Hottinger, New York: Holt, 1932.

Perez Zagorin, *Rebels and Rulers, 1500–1660*, Cambridge and New York : Cambridge University Press, 1982.

E. Albèri Zanotti, *Tesoro della prosa italiana, dai primi tempi della lingua fino al di nostri*, 2nd ed., Florence, 1841.

PICTURE CREDITS

INDEX